150 Years of **Britain** in Pictures

150 Years of

Britain
in Pictures

AMMONITE
PRESS

**PRESS
ASSOCIATION**
Images

First Published 2010 by
Ammonite Press
an imprint of AE Publications Ltd,
166 High Street, Lewes, East Sussex, BN7 1XU

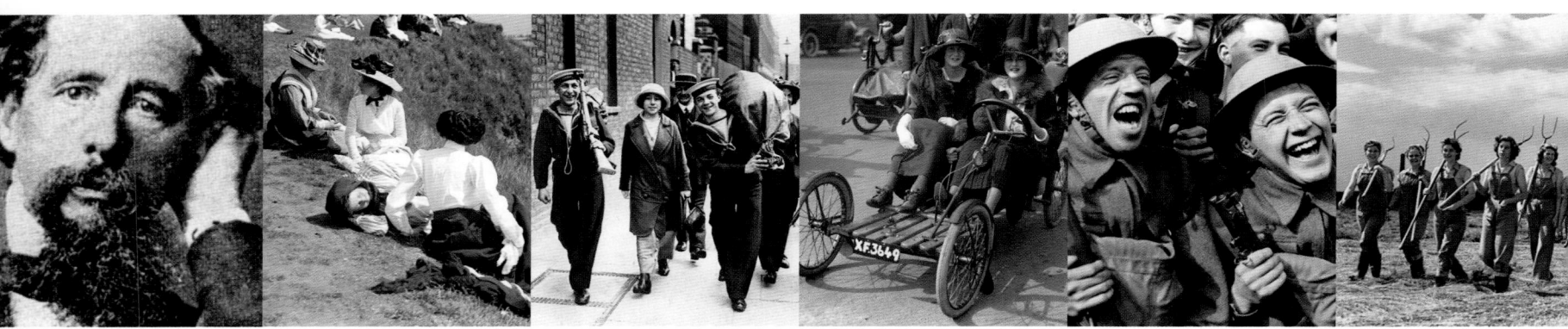

ISBN 978-1-906672-60-7

British Cataloguing in Publication Data.
A catalogue record of this book is available
from the British Library.

Editor: Ian Penberthy
Managing Editor: Richard Wiles
Picture research: Press Association Images
Design: Gravemaker+Scott
Cover design: Adam Carter

Typeface: TheMix
Colour reproduction: GMC Reprographics

Printed and bound in China by
Hung Hing Off-Set Printing Co. Ltd

Contents

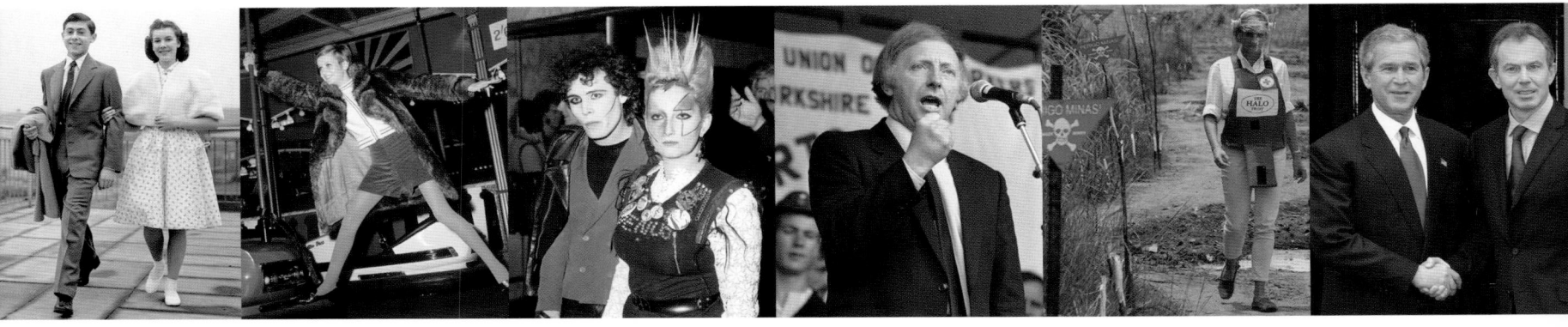

Introduction

The period between 1860 and 2010 spans an age of major social and technological change in Britain, and thanks to the medium of photography, we can actually see the people and events that contributed to that change. This book is crammed with photographs from the Press Association's extensive archives, an unrivalled collection of over 15 million images that form a visual history of the nation.

It is easy looking back to imagine a past that is neatly partitioned into clearly defined periods dominated by major milestones: wars, political upheaval, and economic ups and downs. But the photographic archive tells a different story: alongside the significant events that constitute formal history are found the small things that had equal – if not greater – significance for ordinary people at the time. And while the photographers were working for that moment's news, rather than posterity, the camera is indiscriminate, recording everything in its view: to modern eyes, it is often the backgrounds of these pictures, not their intended subjects, that provide the greatest fascination.

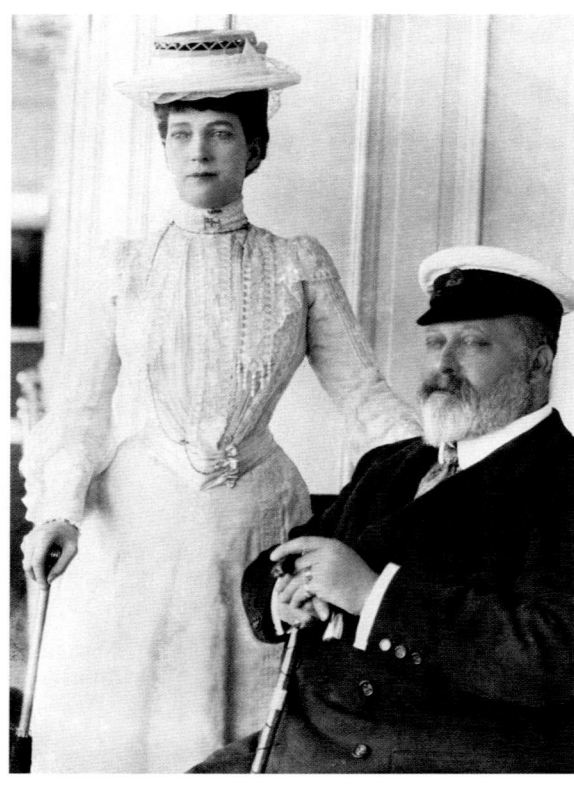

King Edward VII and Queen Alexandra at Cowes in the Isle of Wight. Hand in hand with many social changes, attitudes toward the Royal Family altered significantly between the Victorian era and the 21st century, not least because of the attention of the media. For most of that time, they were treated with utmost deference; they did not mix with ordinary people, and most photographs of them were formal portraits.

1907

The second half of the 19th century saw a surge of energy in Great Britain as Victorian engineers and entrepreneurs went about creating the infrastructure of a mighty industrial nation, bolstered by the profits from an Empire on which the sun never set. Thus the country entered the 20th century as a self-assured imperial power, but changing times would soon force it to reassess its place in the world. There was social unrest; great strides were being made in the development of transport, most notably the aeroplane. By the middle of the second decade, Britain, along with the rest of Europe and many other nations, was immersed in the horrors of the First World War, which saw the deaths of over 15 million. No doubt in response

to the dark days of war, the 1920s was a hedonistic period that gave rise to a celebrity culture that continues to this day.

The 1930s, however, was a darker time, with mass unemployment, the economic doldrums of the Depression and the rise throughout Europe, Britain included, of fascism, which led to war again. The Second World War dominated the first half of the 1940s, while recovering from it occupied the second half and part of the 1950s too. By the 'Swinging Sixties', though, life had taken an upward turn once more with the emergence of a vibrant youth culture and an explosion of creativity, in fashion, music and the arts.

Despite the outrageous and colourful fashion excesses of the 1970s, much of that decade fell under the gloom of nationwide transport and power strikes, and IRA bombing campaigns. By contrast, an upbeat mood seized the country during the 1980s, when money and technology became the twin pillars of life, with the growth of property speculation, and increasing ownership of mobile phones and personal computers. In the 1990s, though, the bubble burst. Property prices began to fall and interest rates to grow, while the death of a princess plunged the nation into mourning.

The arrival of a new millennium gave cause for hope and celebration, but the first decade of the 21st century would be difficult for many, with more financial problems, the constant spectre of war and the revelation that many of Britain's MPS were on the take. But Britons are nothing if not resilient, and despite everything, throughout the past century-and-a-half, they have always found plenty of reasons to be cheerful.

Here then are the personalities, the leaders, the celebrities and the ordinary folk; here are the events, the wars, the triumphs, the tragedies and the amusing moments that make up the story of 150 years of Great Britain.

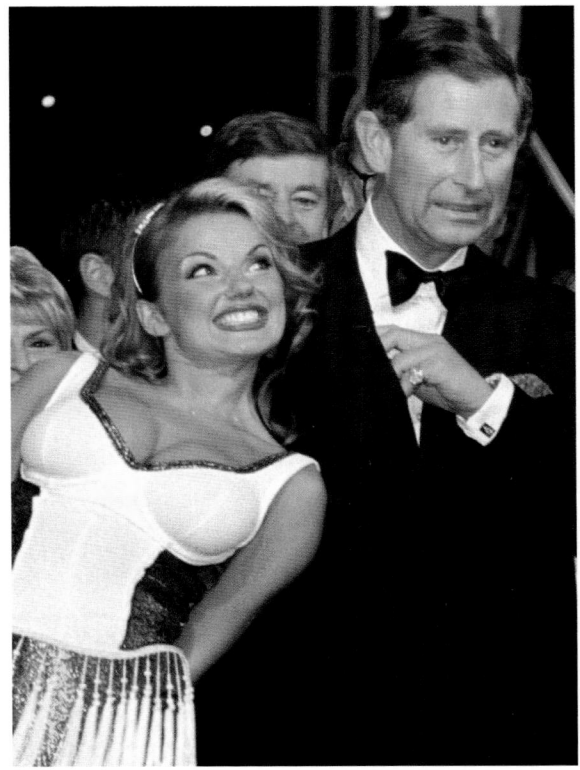

The Prince of Wales with Geri Halliwell of the Spice Girls at the end of the Royal Gala celebrating 21 years of the Prince's Trust in Manchester. This photograph shows how attitudes toward Royalty have changed, and how members of the Royal Family have had to adapt to those changes. Princes have occasionally dallied with 'showgirls', but until very recently the familiarity displayed by Halliwell would not have been tolerated in public.

9th May, 1997

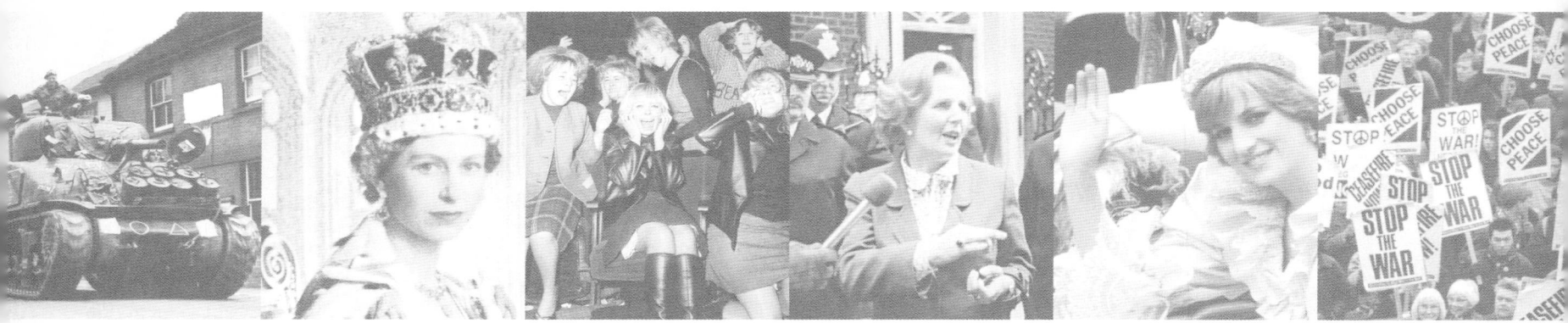

1800s

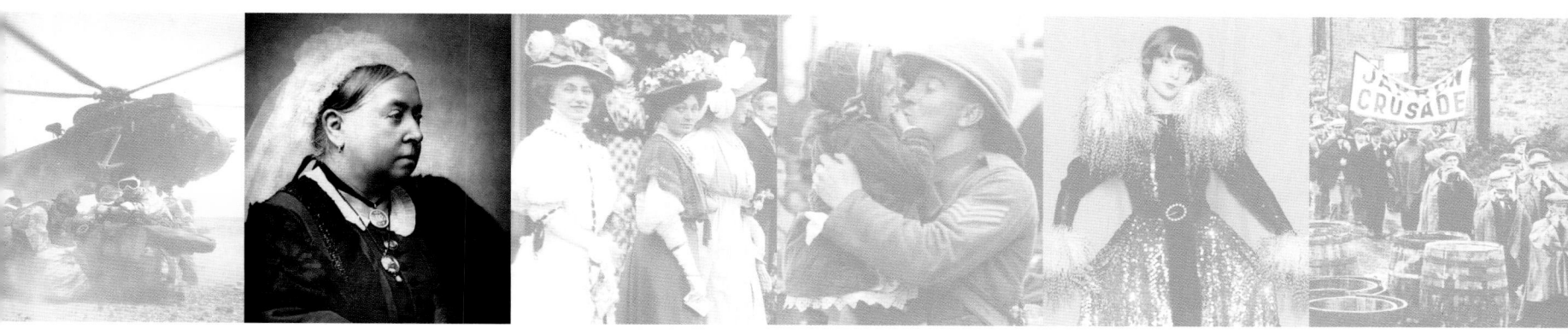

Queen Victoria ascended to the throne on 20th June, 1837, at the age of 18, and would continue to reign for the remainder of the 19th century, giving her name to the period – the Victorian era. It was an age of great prosperity for Britain, thanks to the profits from a global empire, and the efforts of her energetic and determined engineers, who ensured that it was a time of substantial industrial advancement. Their engineering wonders are legendary, not least the development of the railways. Several Britons also made important contributions to the newly developed science of photography, among them William Fox Talbot, John Herschel and Frederick Scott Archer. Indeed, Herschel coined the term 'photography', unaware that French-Brazilian experimental photographer Hercules Florence had used the French term '*photographie*' to refer to his work some four years before.

It wasn't long before photographs began to find their way into newspapers, mostly in the form of portraits, since in those early days it was only practical to photograph subjects that remained still because of the long exposures required. And this new technology was embraced by a news gathering agency recently founded by a consortium of newspaper publishers: the Press Association, whose work in the Victorian era is showcased here.

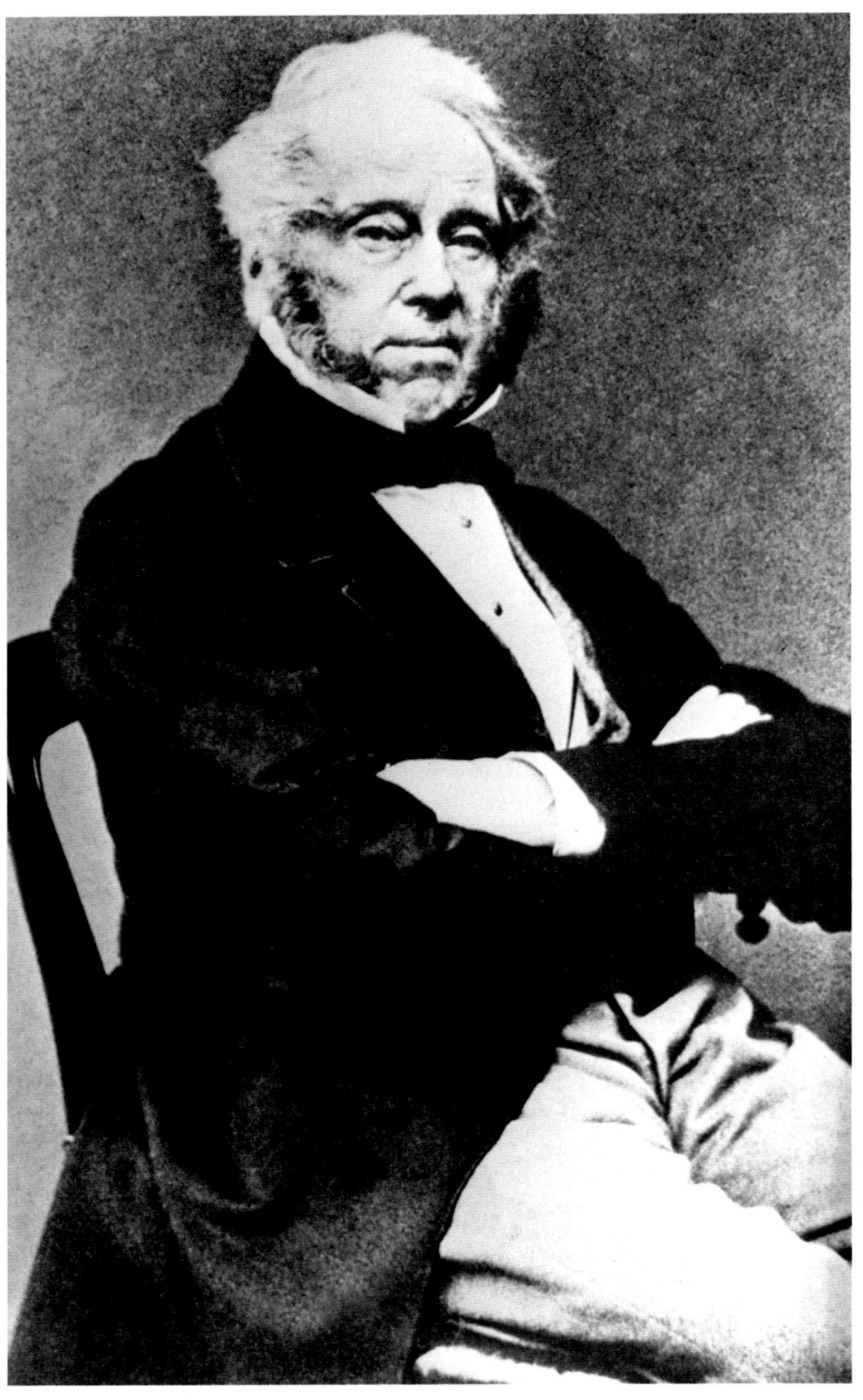

Left: Henry John Temple, 3rd Viscount Palmerston, British statesman, foreign secretary and twice prime minister (1855–8, 1859–65). Palmerston's talent lay in foreign affairs, but he earned a reputation as a British nationalist for his so-called 'Gunboat Diplomacy'. He was the last British prime minister to die in office.

1860

Right: Edward, Prince of Wales (later King Edward VII) and his bride, Princess Alexandra of Denmark, after their wedding at St George's Chapel, Windsor. Edward was the longest serving heir apparent in history, for 59 years, 2 months and 14 days, although this period may be surpassed by Prince Charles in April 2011. Because Edward was excluded from power for much of his life, the couple led a socialite existence, entertaining their friends on a lavish scale, something of which his mother, Queen Victoria, disapproved.

10th March, 1863

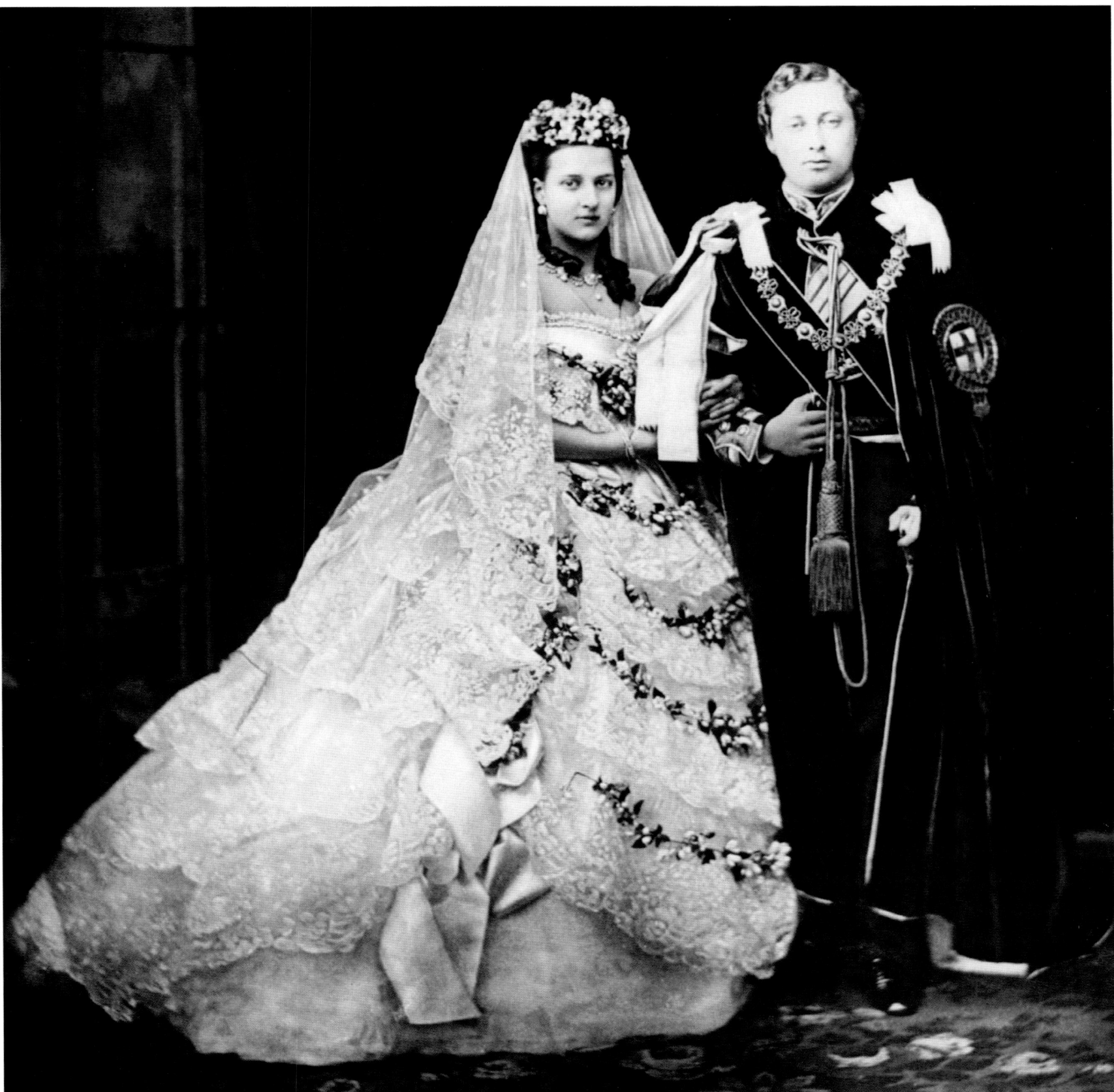

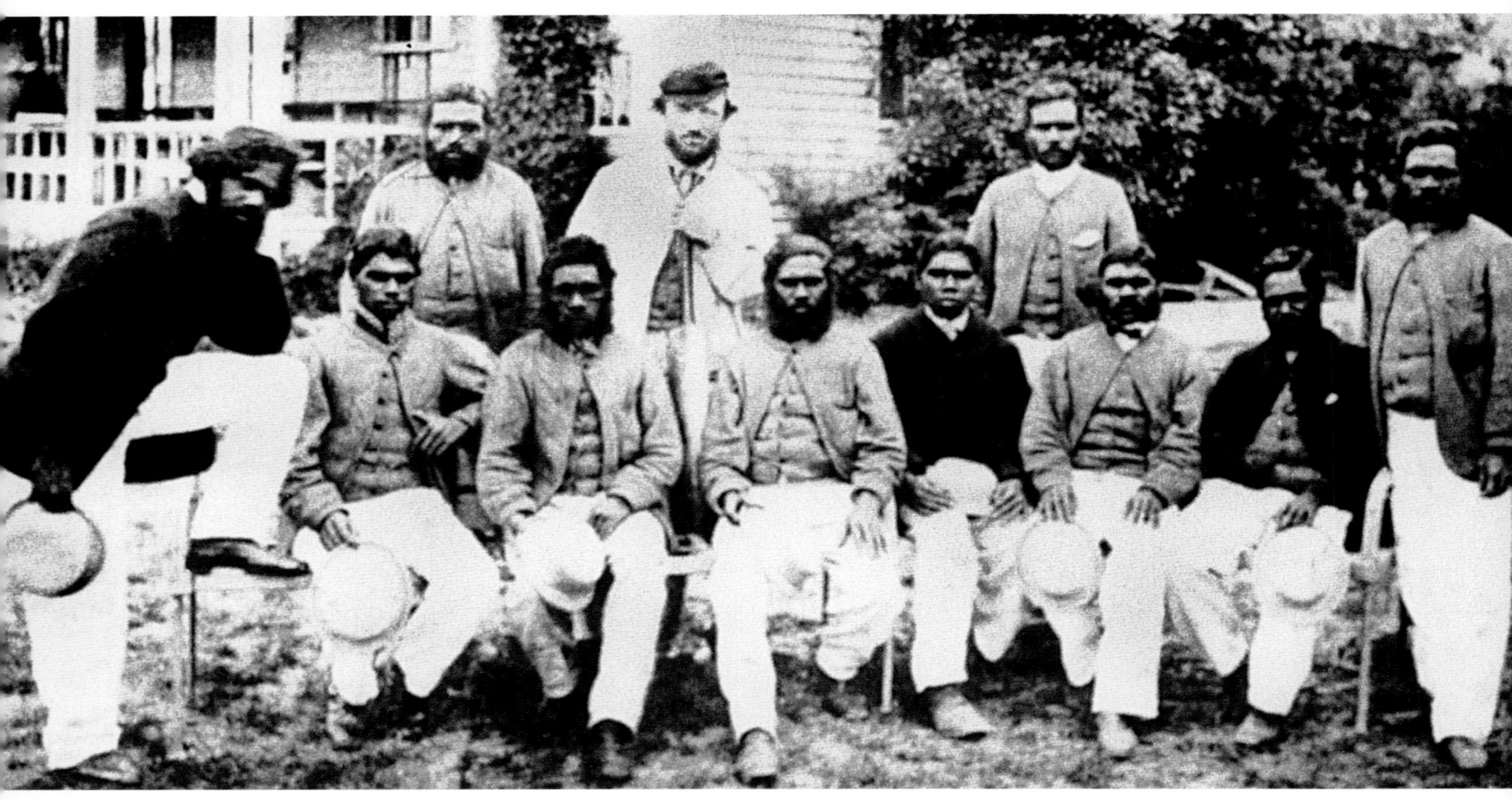

Above: The first Australian cricket team to tour England was made up of
Aborigines, who are seen here with their captain, Tom Wills, at the Albert Ground,
Sydney: (back row, L–R) Tarpot, T.W. Wills, Johnny Mullagh (front row, L–R) King
Cole, Jellico, Peter, Red Cap, Harry Rose, Bullocky, Johnny Cuzens, and Dick-a-Dick.
The team would arrive in England in May 1868, being given a mixed reception.
The Times described the team as "*a travestie upon cricketing at Lord's*" and "*the
conquered natives of a convict colony.*" *The Daily Telegraph* said of Australia,
"*Nothing of interest comes from there except gold nuggets and black cricketers.*" In
all, the team played 47 matches, winning 14, losing 14 and drawing the remainder.

2nd February, 1867

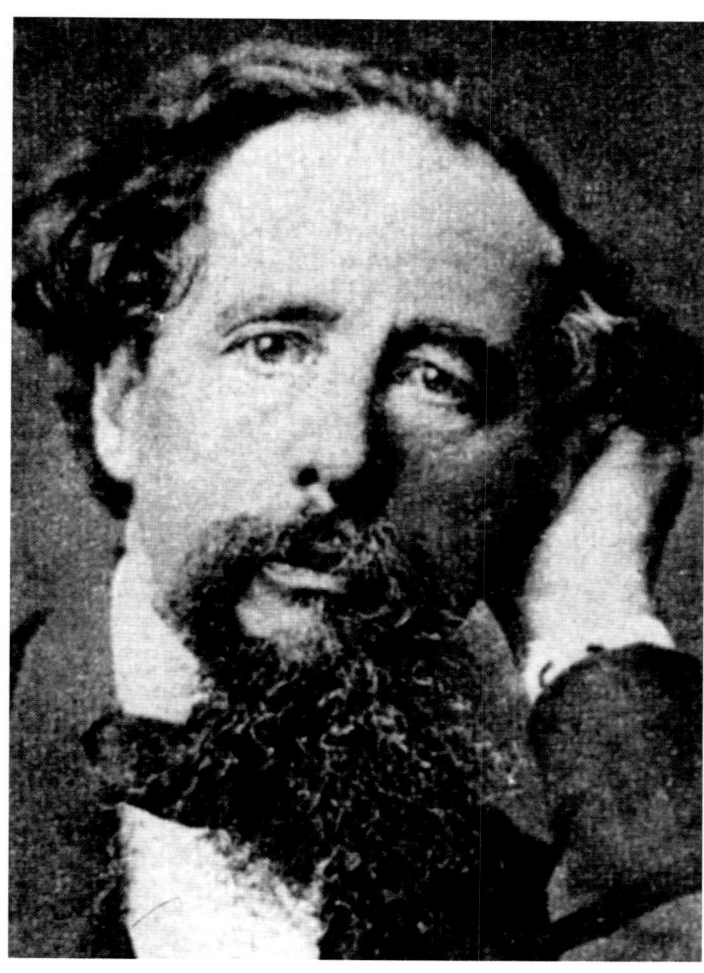

Above: Charles Dickens, the most popular novelist of the Victorian era. Much of his work was published initially in magazines in serialized form. He died on 9th June, 1870, leaving his final novel, *The Mystery of Edwin Drood* unfinished.

1868

Above right: The English composer Sir Arthur Sullivan, best known for his operatic collaborations with W.S. Gilbert, including *HMS Pinafore*, *The Pirates of Penzance* and *The Mikado*."

1870

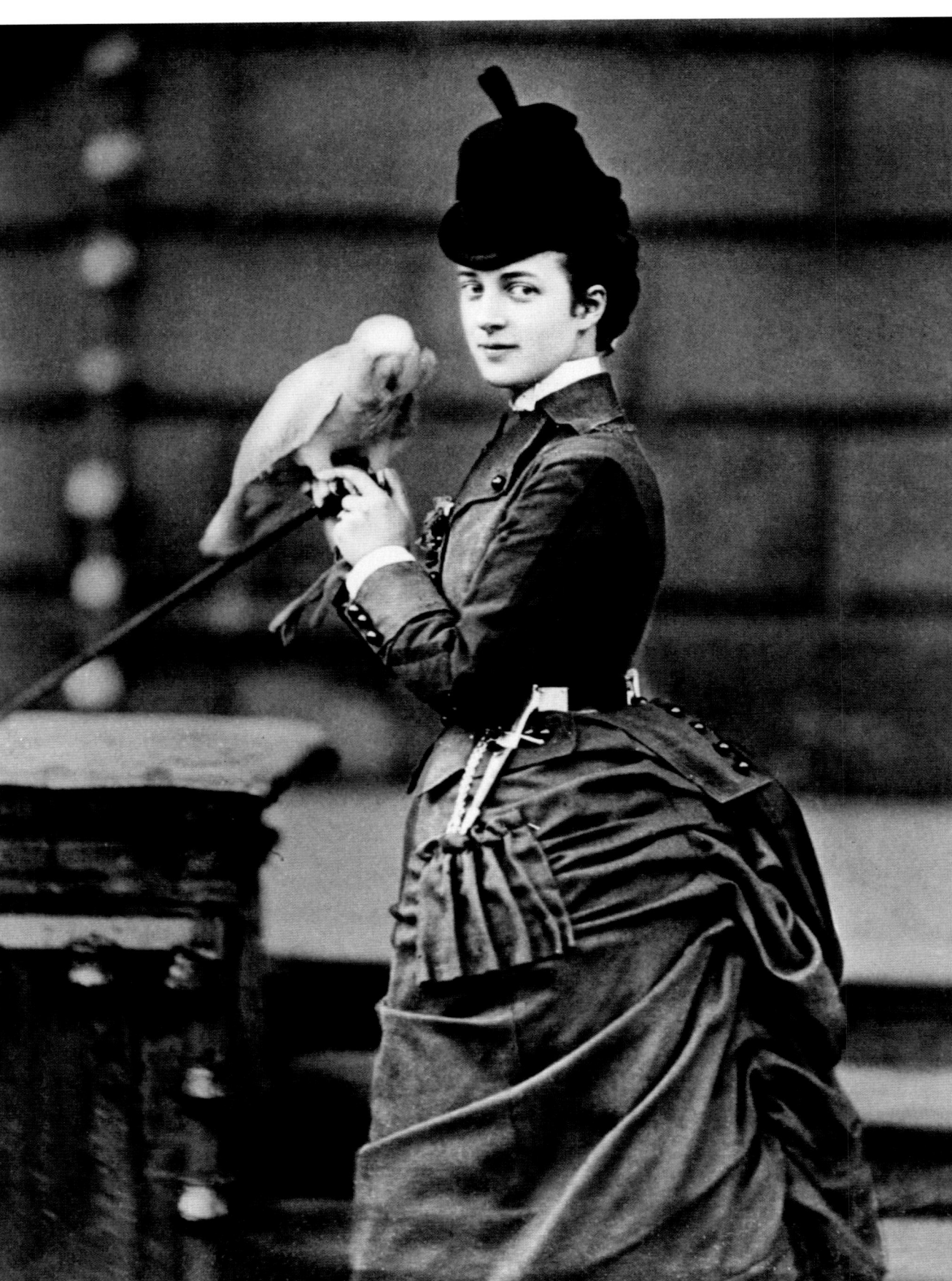

Right: Alexandra, Princess of Wales with her pet parrot. Like a much later Princess of Wales, Alexandra was immensely popular with the public and her style of dress was followed by fashion-conscious women throughout the country.

1872

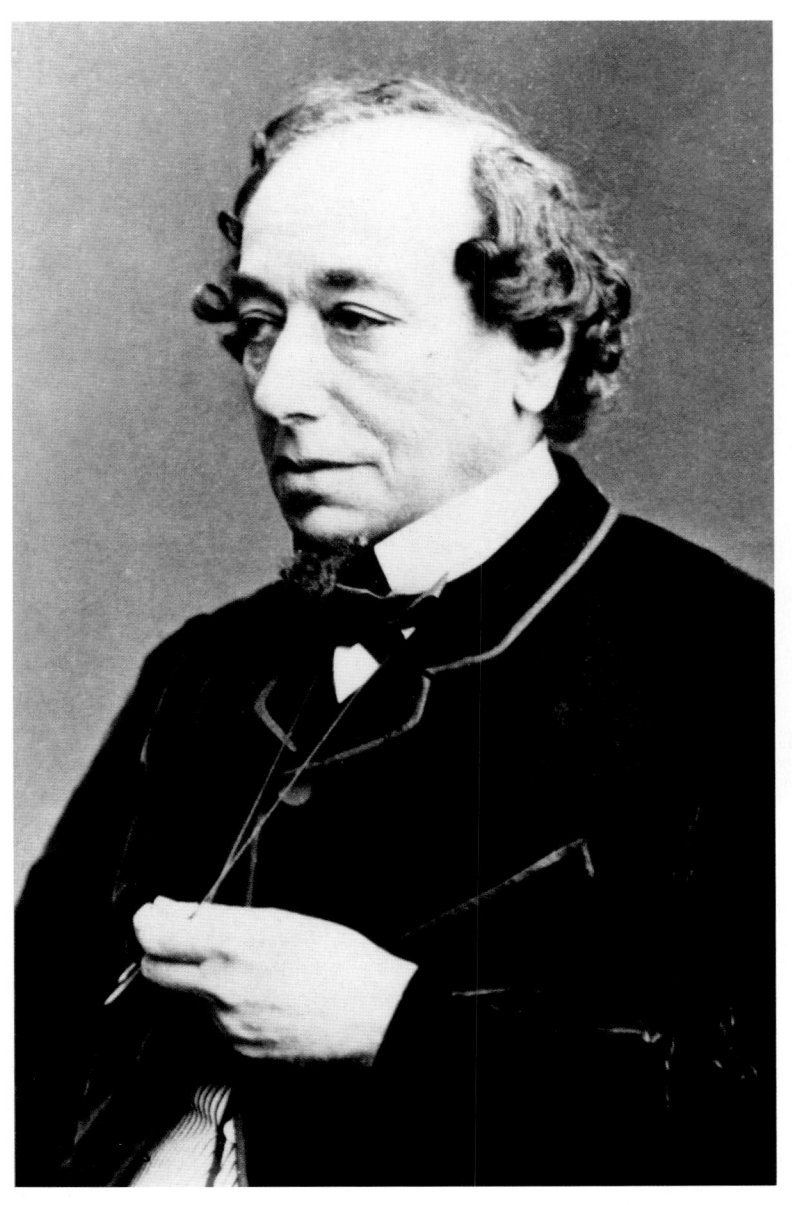

Above: Karl Marx, the German philosopher and political theorist who founded modern Communism. He wrote *The Communist Manifesto* in 1848. Marx died in March 1883 and is buried in Highgate Cemetery, London. His tombstone bears the inscription, "*WORKERS OF ALL LANDS UNITE*", the last line of his famous work.

1875

Left: Benjamin Disraeli, 1st Earl of Beaconsfield. The British Conservative politician and novelist was first elected to Parliament in 1837. He served two terms as prime minister (1868, 1874–80) and enjoyed a warm friendship with Queen Victoria. He died in April 1881, at the age of 76.

1873

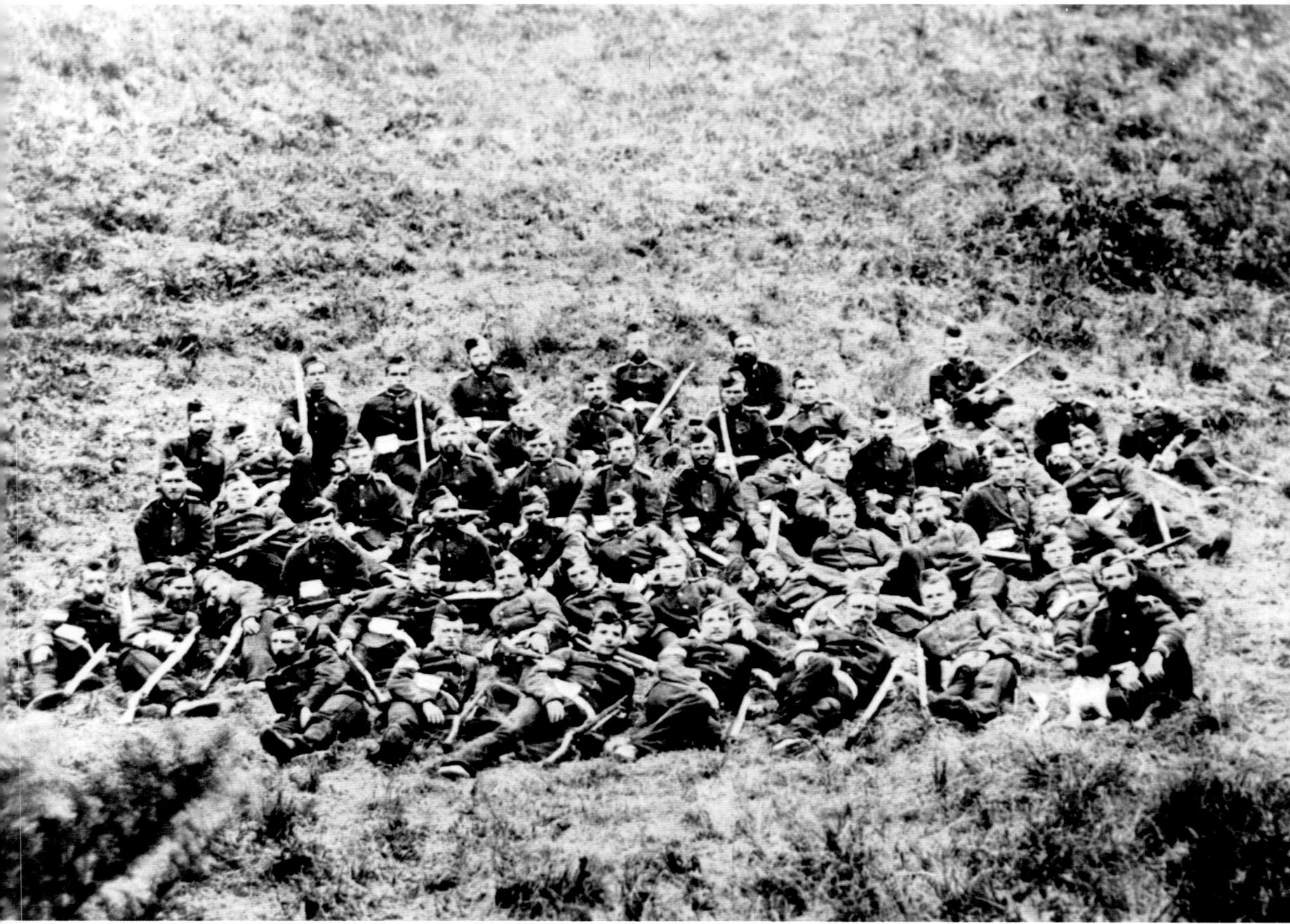

Above: Soldiers belonging to the 24th Regiment of Foot, some of the small garrison of about 150 men who defended the mission station of Rorke's Drift against an assault by about 4,000 Zulus during the Zulu War in South Africa. The battle began on 22nd January, 1879, but despite being nearly overwhelmed, the small British force managed to hold off their attackers until the following day, when a relief column arrived. Remarkably, only 15 of the defenders were killed; 11 were awarded the Victoria Cross for bravery.

26th January, 1879

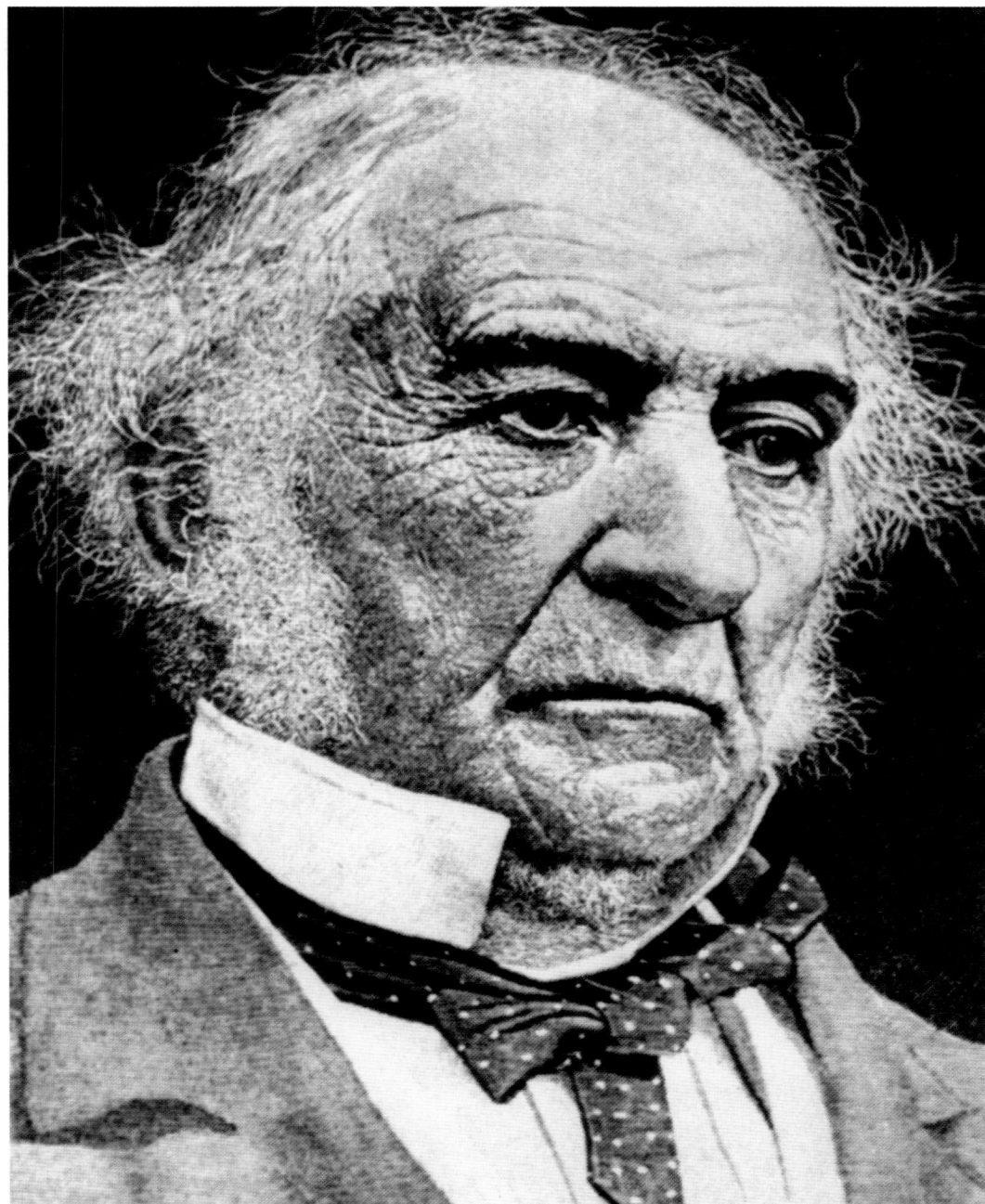

Right: William Gladstone, Liberal leader and statesman who, in a political career that spanned 60 years, was prime minister on four occasions (1868–74, 1880–85, 1886, 1892–94). When he resigned for the final time, he was 84, making him Britain's oldest prime minister. Gladstone was popularly known as the 'GOM', which stood for 'Grand Old Man', although his great Conservative rival, Benjamin Disraeli, preferred *"God's Only Mistake"*. Queen Victoria never warmed to Gladstone, either, and once said of him: *"He always addresses me as if I were a public meeting."* Gladstone died in 1898 at the age of 88.

1880

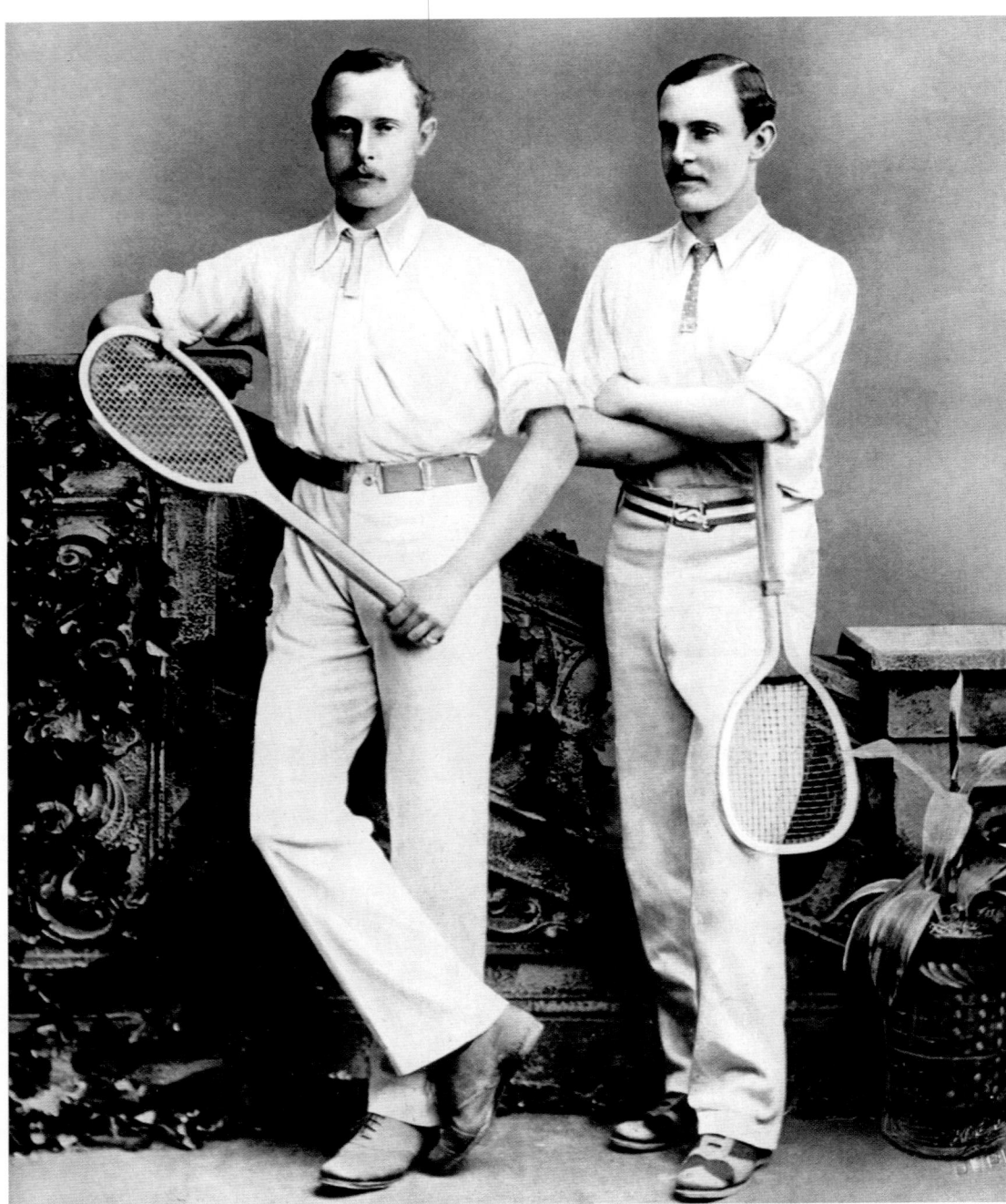

Left: Tennis players William Renshaw (L) and his twin brother, Ernest, Wimbledon men's doubles champions in 1880. The pair would win a total of six other Wimbledon doubles finals during the following decade. In addition, William would take seven men's singles titles. He is considered by many to be the greatest British male player of all time, and with his brother, he dominated the sport at the time. Indeed, the rise in popularity of tennis at that time was referred to as the 'Renshaw Rush'.

1st June, 1880

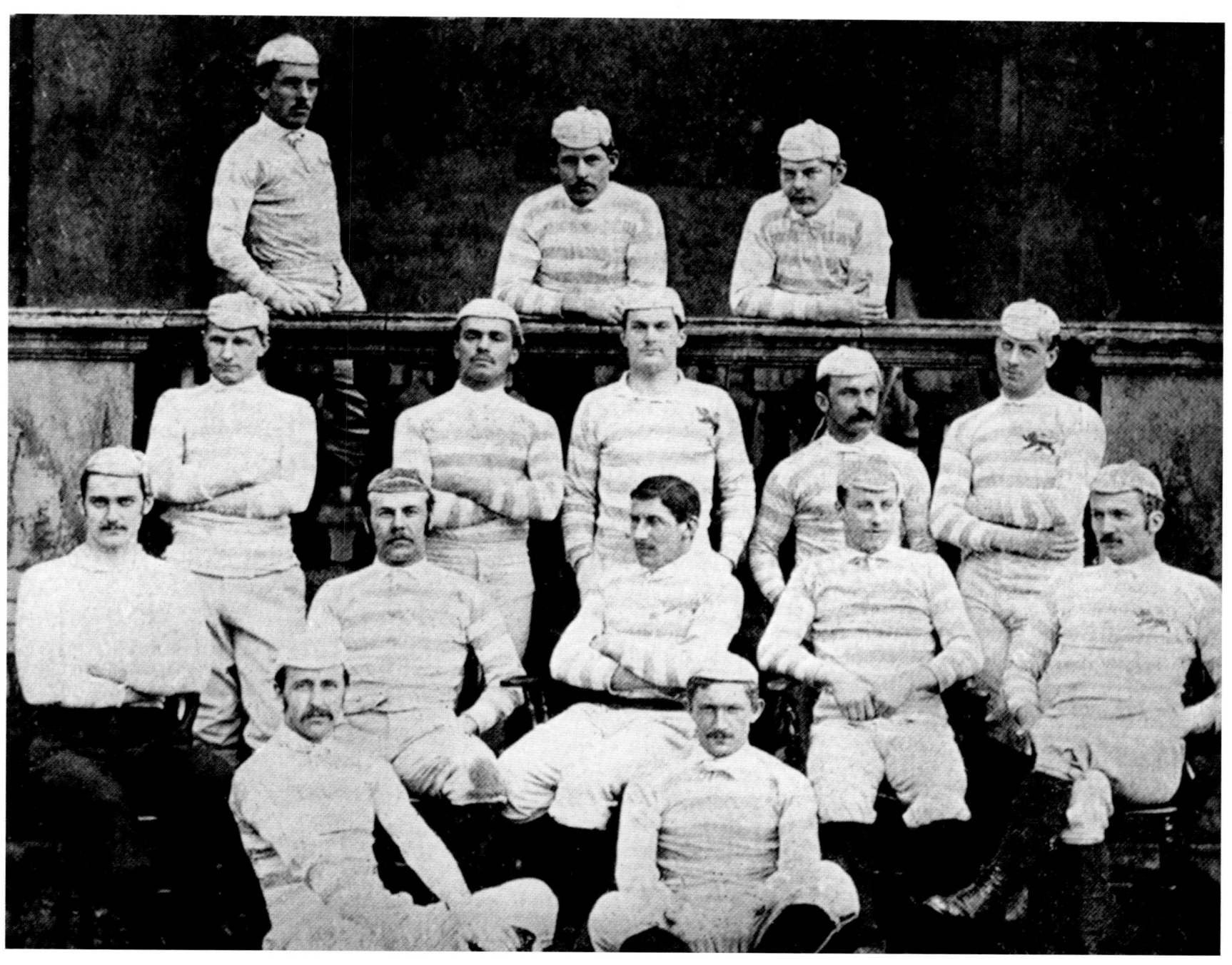

Above: Cambridge University rugby team 1881–2: (back row, L–R) H.S. Cooper, R. Threlfall, R.M. Yetts; (second row, L–R) E. Rice, A.R. Pattisson, C.J.B. Marriott, J.L. Templer, C.E. Chapman; (third row, L–R) A.S. Taylor, H.G. Fuller, H.Y.L. Smith, Andrew Don Wauchope, S. Pater; (front row, L–R) J.W. Dickson, J. Hammond.

1st October, 1881

Above: Lord Randolph Churchill, third son of the 7th Duke of Marlborough and father of Britain's famous statesman, Winston Churchill. His high standing in the ranks of the Conservative Party would be undermined by the loss of his seat and rivalries with other Tory MPs. His health would go into decline during the early 1890s, leading to his death in 1894, at the age of 45.

1885

Right: William Holman Hunt, an English painter and one of the founders of the Pre-Raphaelite Brotherhood. His works were notable for their attention to detail and vivid colours, although his early paintings were criticized in the art press for their clumsiness and ugliness.

1885

Right: Sir William S. Gilbert, prolific English dramatist, best known for his 14 comic operas produced in collaboration with the composer Sir Arthur Sullivan, of which the most famous are *HMS Pinafore*, *The Pirates of Penzance* and *The Mikado*. Although the partnership with Sullivan was extremely fruitful, at times the relationship was strained, each feeling that their work was being subjugated by the other's.

1886

Above: British soldiers and civilians outside the boarded-up North of Ireland Bottled Whisky Store in the Old Lodge Road, Belfast, which was wrecked by a mob during the 1886 riots. Rifles can be seen in the shop doorway. Figures are blurred due to the long exposure times of the period. Sporadic rioting continued through to the early autumn between the Protestant opponents and the Catholic supporters of Home Rule for Ireland.

8th April, 1886

Right: *The Flying Scotsman* express service between London and Edinburgh began operation in 1862. Here, the train passes Holloway Station (closed in 1915) between King's Cross and Finsbury Park, London. It is being drawn by a Great Northern Railway Stirling 4-2-2 8-footer locomotive, No.53, which had been built in 1875. In 1888, the time for the journey had been reduced to 8½ hours.

1888

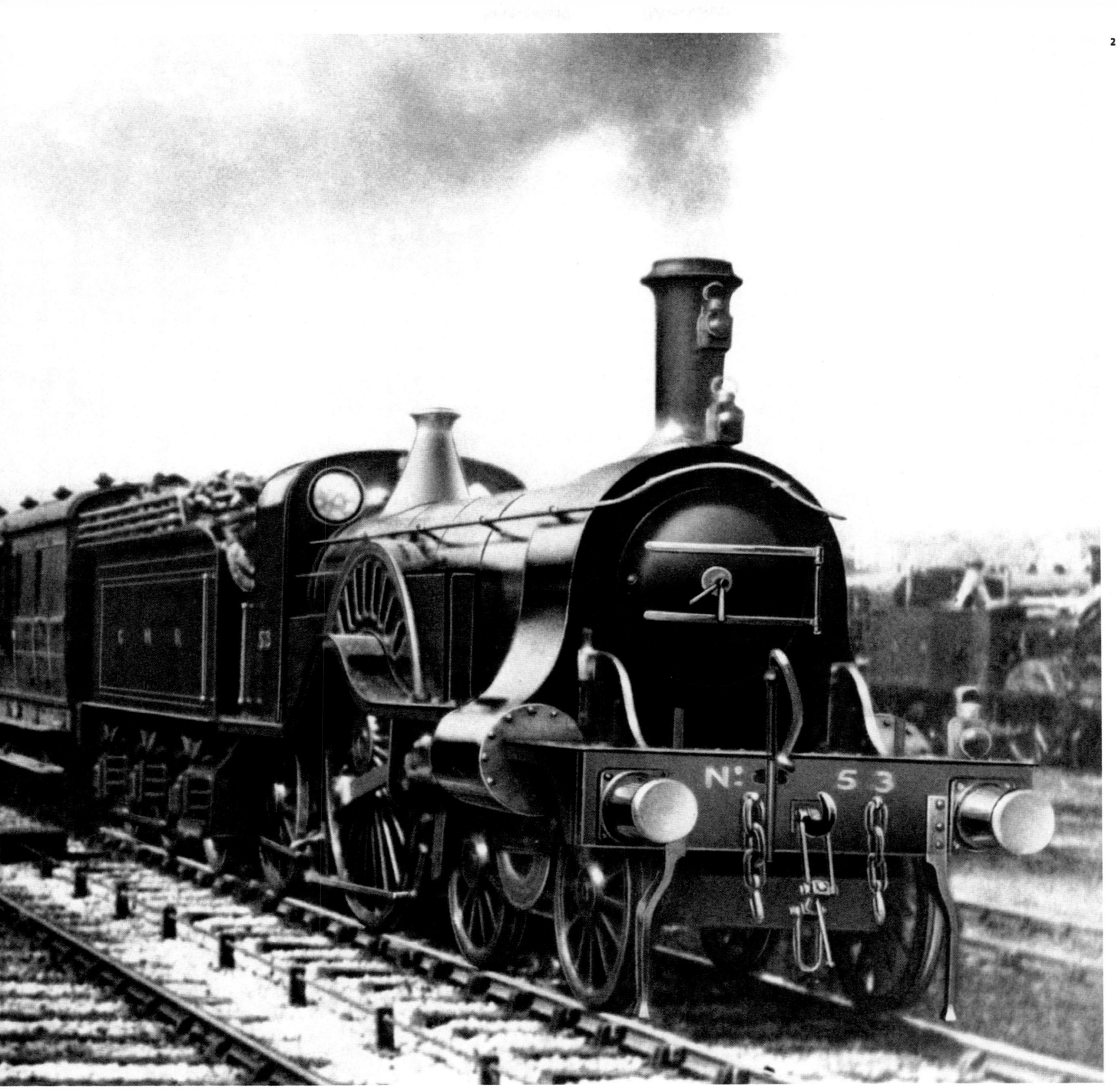

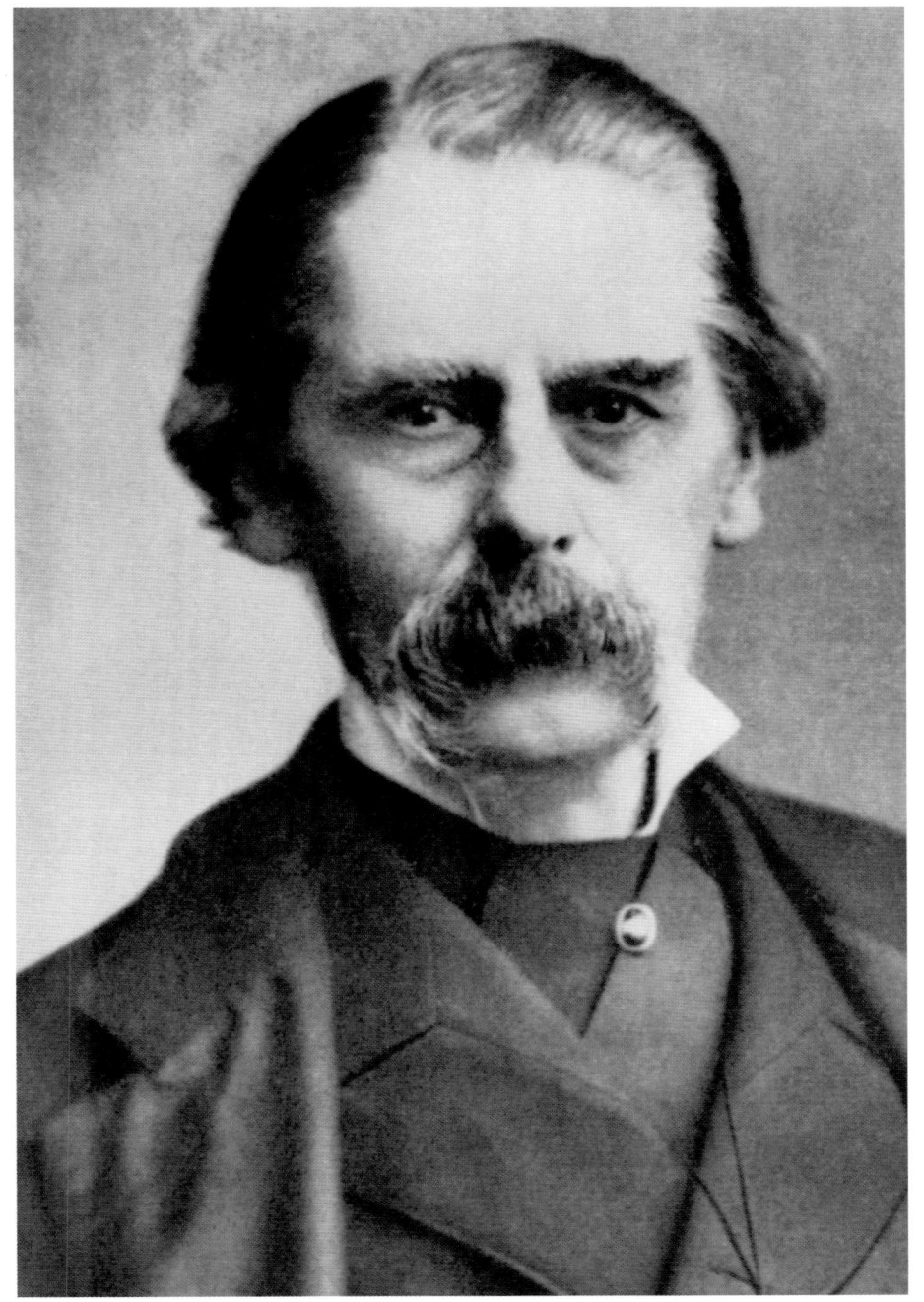

Left: Victoria, Queen of the United Kingdom and Empress of India. She had ascended to the throne in 1837, at the age of 18 and would reign for 63 years, 7 months, longer than any other British monarch before or since. In 1840, she married Prince Albert of Saxe-Coburg and Gotha, but he would die in 1861, having contracted typhoid from the insanitary conditions in Windsor Castle. His death would devastate Victoria, who would mourn her late husband for the rest of her life.

1890

Right: Sir Henry Thompson, a British surgeon who specialized in genito-urinary surgery, for which he developed a number of operative techniques. He also took a foremost part in founding the Cremation Society of Great Britain, and was an accomplished amateur artist.

1890

Right: Jem Mace, born in
Beeston, Norfolk, in 1831, was
a bare-knuckle prizefighter
who, after the introduction of
the Queensberry Rules of 1867,
toured the USA and Australia
helping to promote gloved
boxing. He became the first
heavyweight boxing champion
of the world, after defeating
American champion Tom Allen
on 10th May, 1870. In later life he
was an exhibition boxer and last
appeared in the ring aged 78.
Having squandered his money
on gambling, he ended his life
as a penniless busker in 1910.

19th May, 1890

27

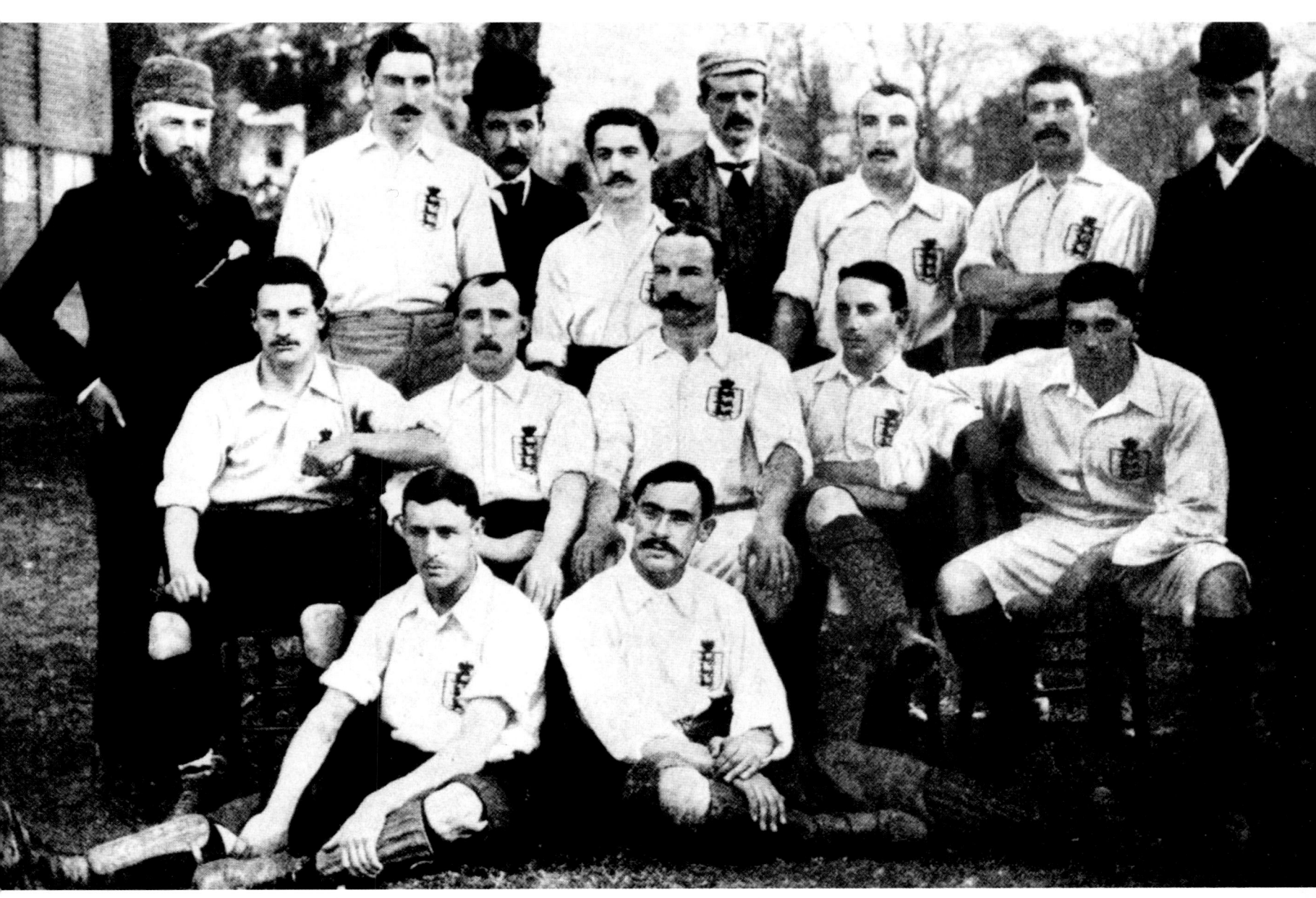

Above: The England football team that beat Scotland 5–2 at Richmond Athletic Ground on 1st April, 1893: (back row, L–R) W. McGregor (founder of the Football League), Robert Gosling, J.J. Bentley (McGregor's successor as president of the Football League and later vice-president of the Football Association), Jack Holt, J.C. Clegg (referee), George Kinsey, Bob Holmes, J. Goodall; (middle row, L–R): Billy Bassett, Jack Reynolds, George Cotterill (captain), Leslie Gay, Alban Harrison; (front row, L–R) Fred Spiksley, Edgar Chadwick. Having previously beaten Wales and Ireland, the win gave England victory in the British Home Championship for the third consecutive season.

1893

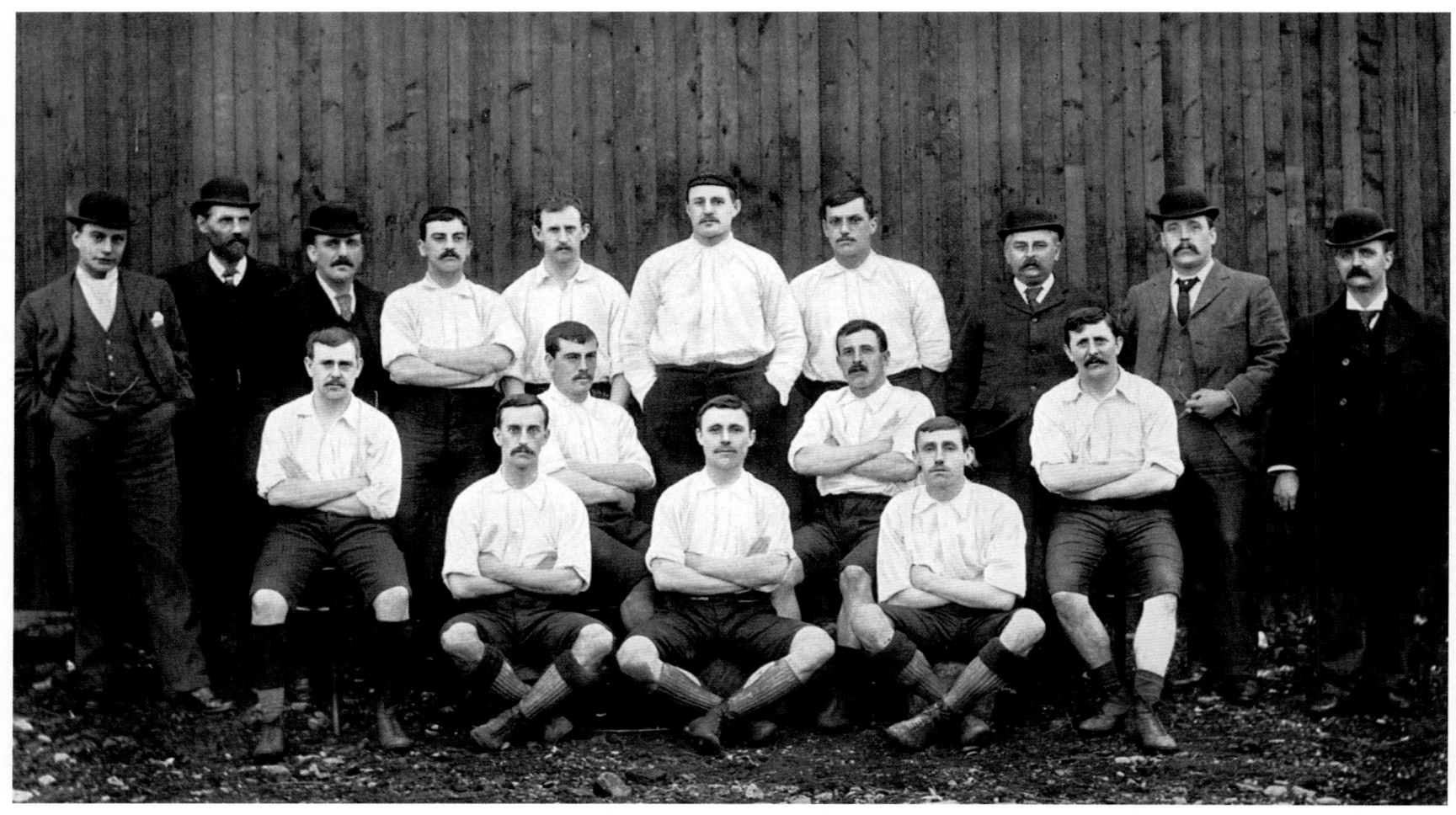

Above: Bolton Wanderers football team, who made it to the final of the FA Cup in 1894. They played Notts County at the Goodison Park ground, Notts County winning the match 4–1. Wanderers had been formed originally by the Reverend John Farrall Wright as Christ Church FC in 1874, but the team went their own way after falling out with the vicar, changing their name to Bolton Wanderers in 1877.

1894

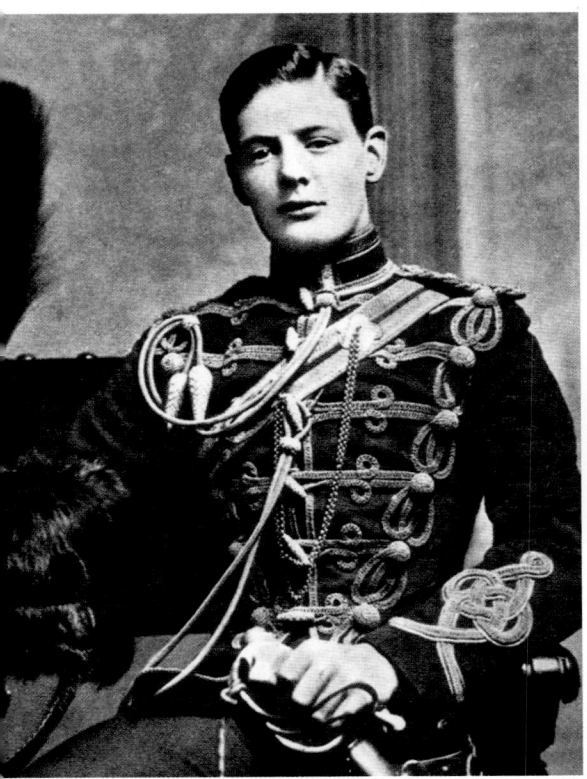

Above: Millwall Athletic, Southern League Champions 1894–95: (back row, L–R) trainer W. Lindsay, chairman C. Gordon, A. Law, J. Dewar, treasurer E.R. Stopher; (third row, L–R) T.B. Kidd, G. King, J. Matthew, J. Graham, W. Davis, H. Matthews, J. Higson; (second row, L–R) W. Jones, M. Whelan, captain A. Geddes, D. McInroy, G.A. Saunders; (front row, L–R) E. Clark, J. Rhodes, C. Leatherbarrow, secretary C. Beveridge. The Southern League was a competition for both professional and amateur clubs that was founded in 1894 through an initiative of Millwall Athletic to cater for teams in southern England that were unable to join the Football League.

1st August, 1895

Above left: Winston Churchill as a cornet (second lieutenant) in the 4th Queen's Own Hussars. He had joined the regiment on 20th February, 1895, having graduated from the Sandhurst Royal Military College in December 1894. In 1941, Churchill would be appointed honorary colonel of the Hussars.

1895

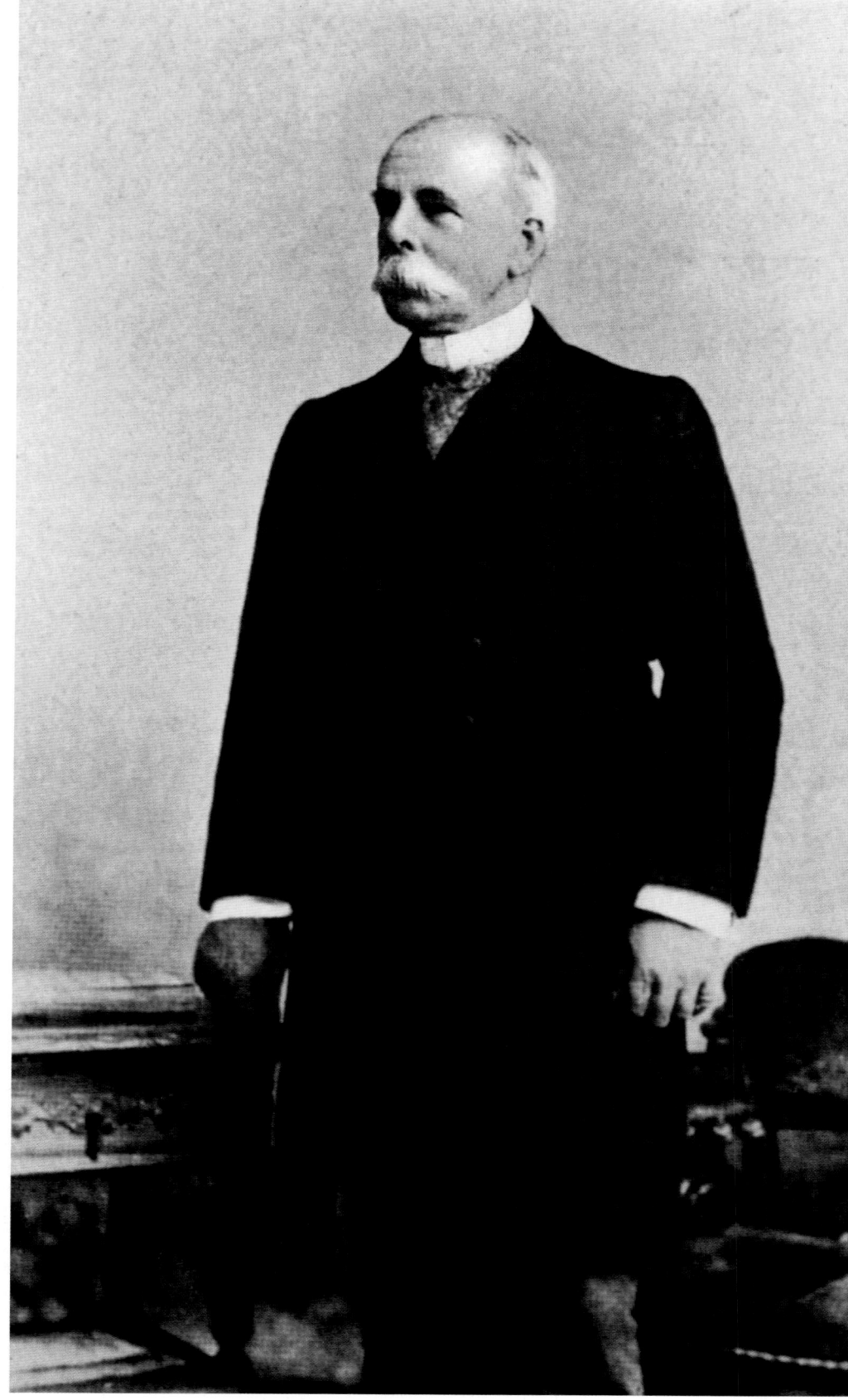

Right: Vice president of the Football Association Charles
Alcock. A former player himself, Alcock instigated the first
ever international match, between England and Scotland.
Also he was responsible for creating the FA Cup competition,
and acted as referee for the 1875 and 1879 Cup Finals. In
addition, he compiled the first *Football Annual* in 1868. Alcock
was a notable cricketer, too, having captained Middlesex in
the first county match in 1867, before playing for Essex. He
organized the first Test match between England and Australia
at London's Oval cricket ground in 1880, and acted as editor
of the *Cricket* newspaper for 25 years and *James Lillywhite's
Cricketers' Annual* from 1872 to 1900.

18th August, 1895

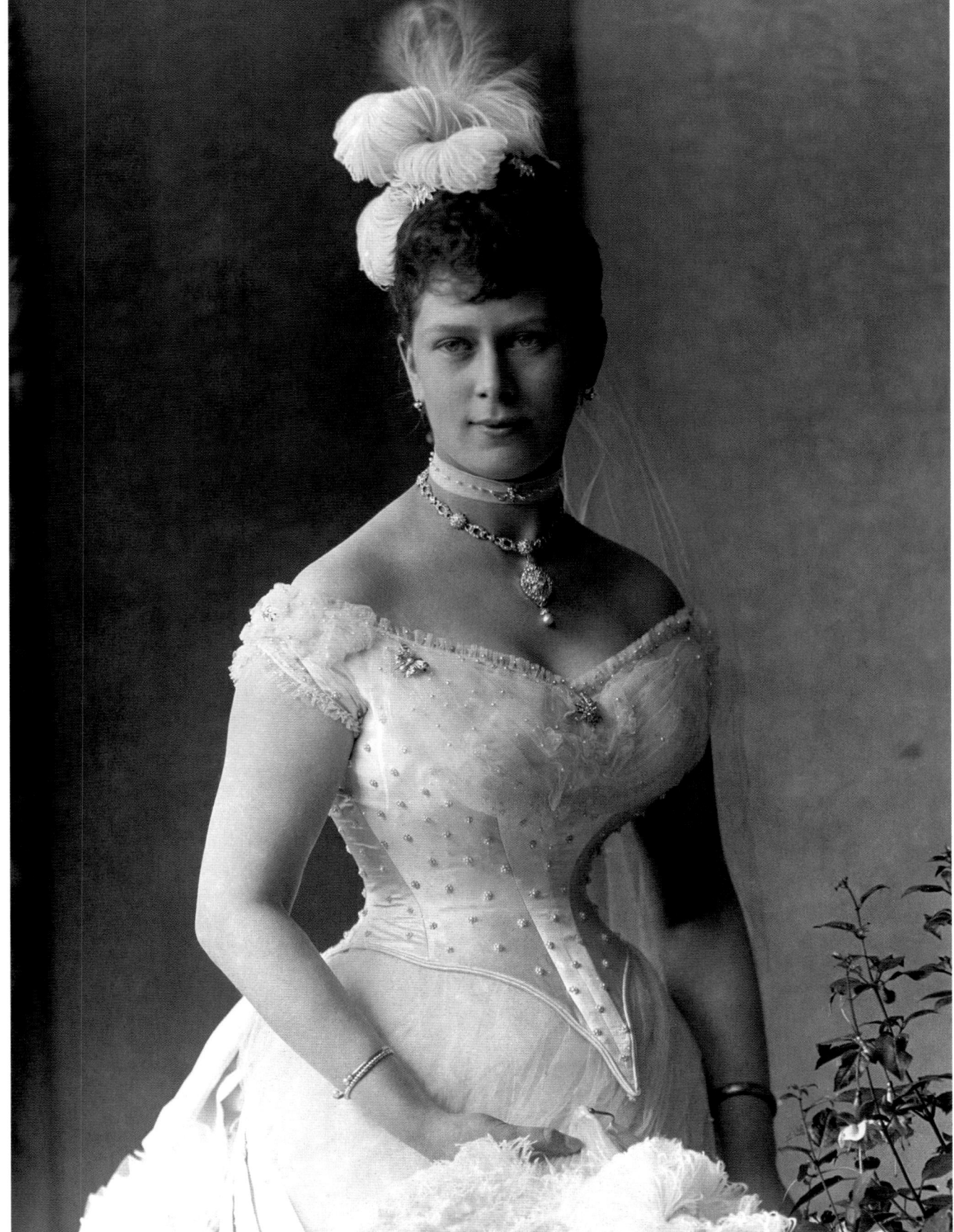

Right: Princess Mary of Teck, in Württemberg, who was also the Duchess of York, having married Prince George, Duke of York, the son of the Prince of Wales (later King Edward VII) in 1893. Mary had been engaged to George's elder brother, Prince Albert, who was her second cousin once removed. Albert, however, had died within a few weeks of the engagement from influenza, but during the period of mourning, she became close to George, and eventually the couple fell in love and married. She would become Queen Mary upon George's accession to the throne in 1910. She would die only ten weeks before her granddaughter Elizabeth's coronation in 1953.

1896

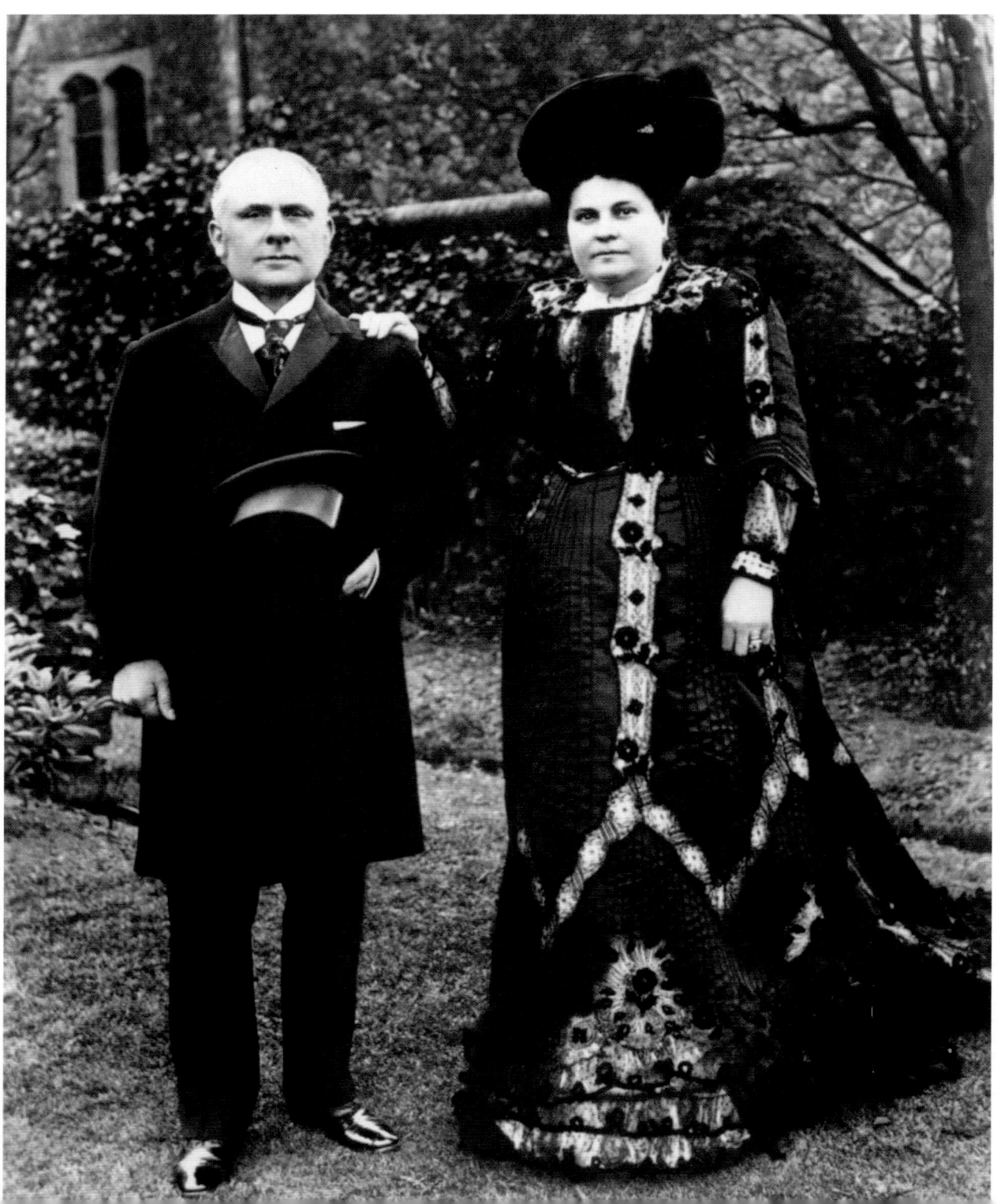

Left: John James and Mary Ann Sainsbury, who founded the Sainsbury's grocery chain. Their first shop was at 173 Drury Lane in London, where they sought to offer quality goods at competitive prices with the accent on cleanliness and service. In the early days, when funds were short, they shared the cramped accommodation above their little shop with three other families. By the time of John Sainsbury's death in 1928, the couple had built a chain of 128 shops across the country. Today, the business owns over 820 supermarkets, although no member of the Sainsbury family is involved in the management of the company. This photograph was taken on the wedding day of their eldest son, John Benjamin, by which time they had become quite prosperous.

1st May, 1896

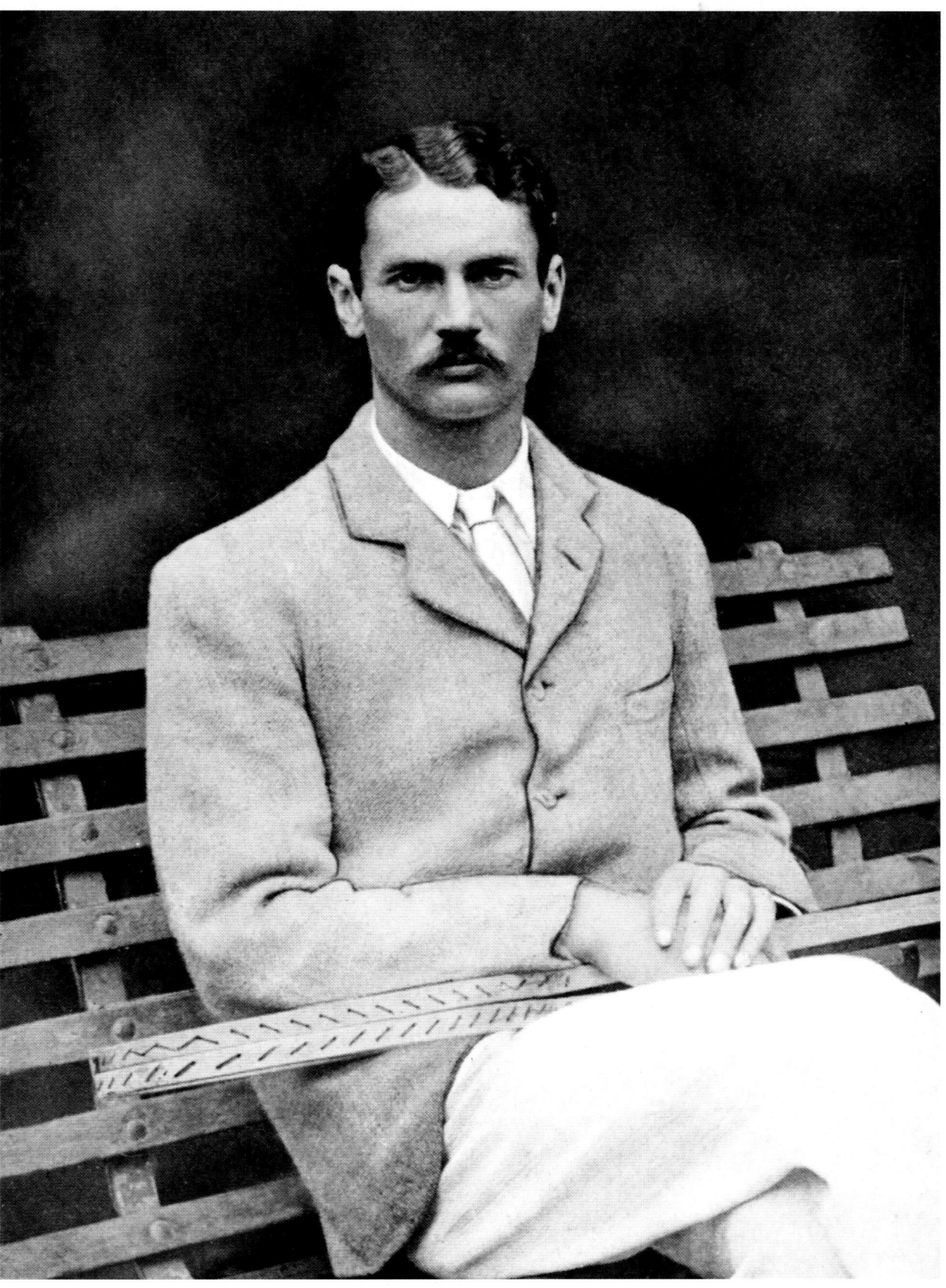

Left: Scottish-born tennis player Harold S. Mahoney, who became Wimbledon men's singles champion in 1896 at the sixth attempt. He had defeated Wilfred Baddeley in an epic 57-game match that remained a Wimbledon record until 1954, when Jaroslav Dobny defeated Ken Rosewall in 58 games. A *"giant of a man"* at 6ft 3in, the debonair Mahony was a pioneer of serve-and-volley play. At the 1900 Olympics in Paris, he would win three medals.

14th June, 1896

34

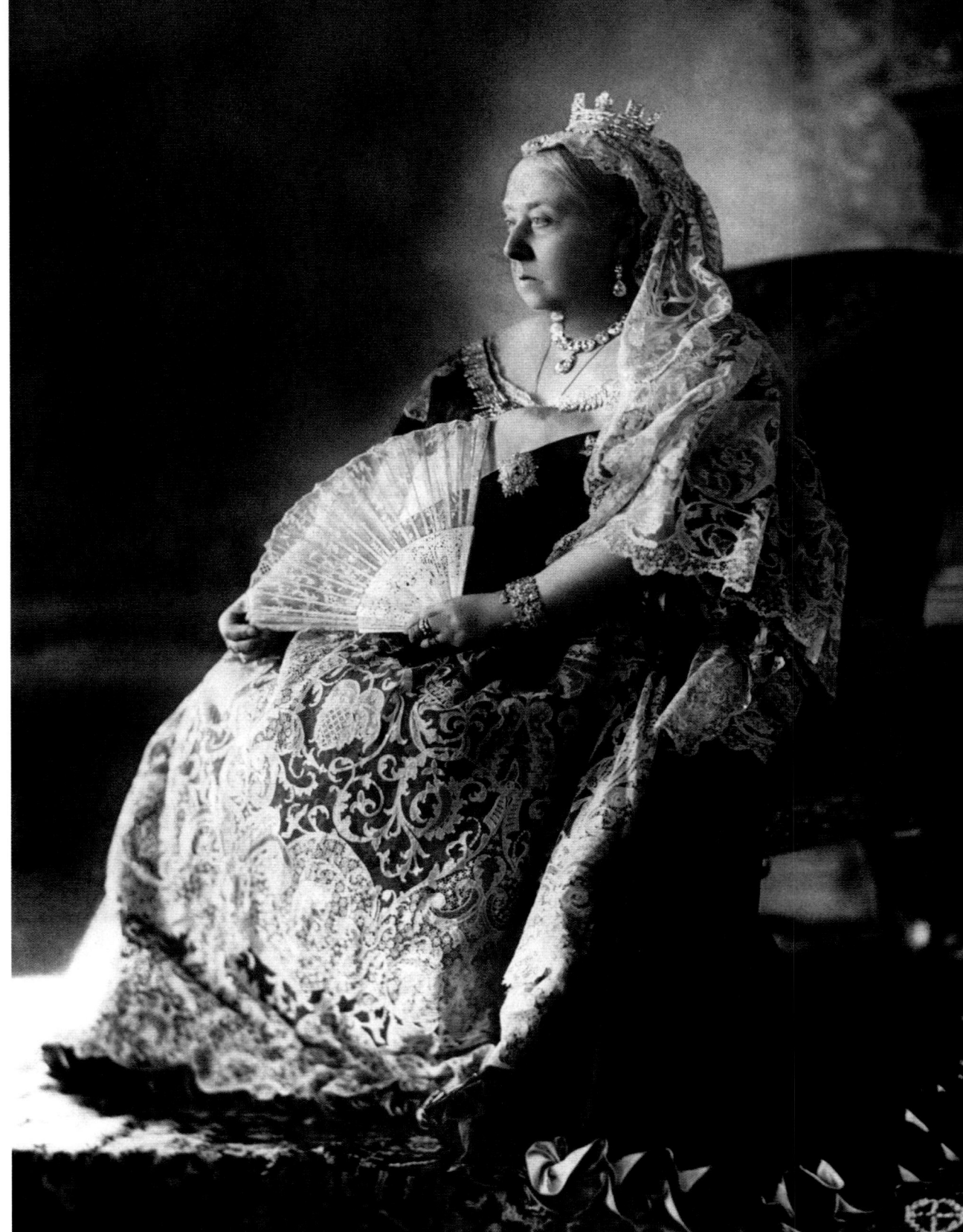

Right: A formal portrait of Queen Victoria, taken to celebrate her Diamond Jubilee. She had become the longest reigning British monarch on 25th September, 1896, but at her request, the celebrations were postponed until her Diamond Jubilee in the following year. The Jubilee was turned into a Festival of the British Empire, with the prime ministers of all the self-governing dominions and colonies arriving in London to pay their respects to their Queen, while soldiers from all those countries took part in a huge procession through the city.

1897

Above: The Aston Villa football team that won the FA Cup and League double in 1896–97: (back row, L–R) G.B. Ramsay (secretary), J. Grierson (trainer), H. Spencer, J. Whitehouse, J. Margoschis (chairman) A. Evans, J. Crabtree, T. Lees (director), C. Johnstone (director); (front row, L–R) Dr V. Jones (director) J. Cohen, C. Athersmith, J. Campbell, J. Devey (captain), F. Wheldon, J. Cowan, J. Reynolds, F.W. Rinder (director).

10th April, 1897

Right: Reggie 'R.F.' Doherty, Wimbledon men's singles champion in 1897, 1898, 1899 and 1900. He was the older brother of another noted tennis player, Laurie 'Little Do' Doherty. The two brothers also competed in the men's doubles tournaments, winning at Wimbledon every year from 1897 to 1905 with the exception of 1902, when they were runners-up, as indeed they were in 1906.

13th June, 1897

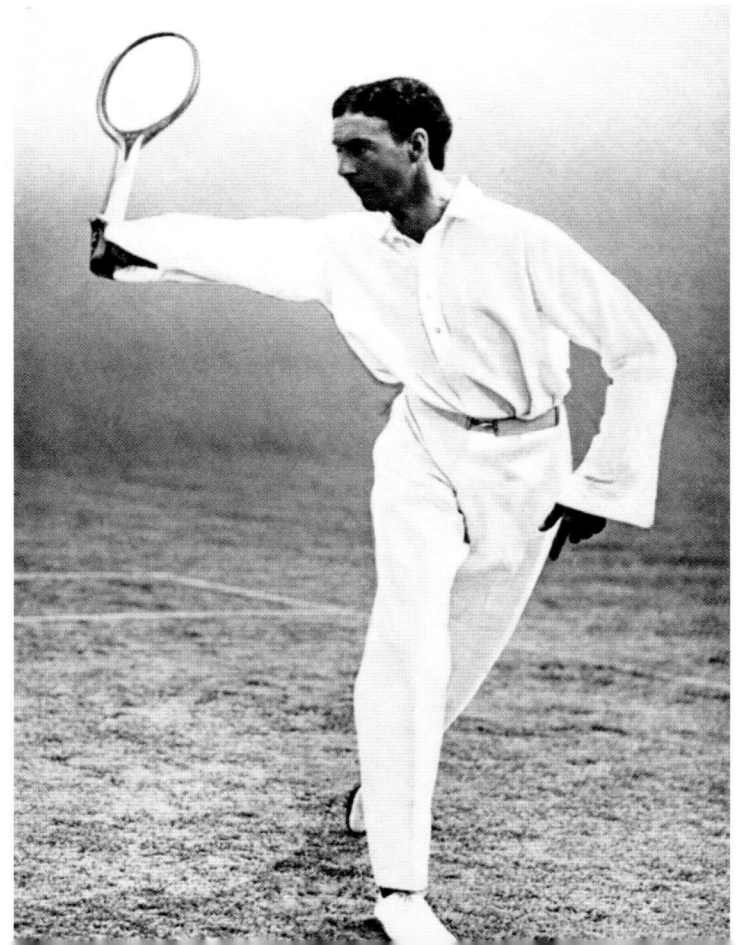

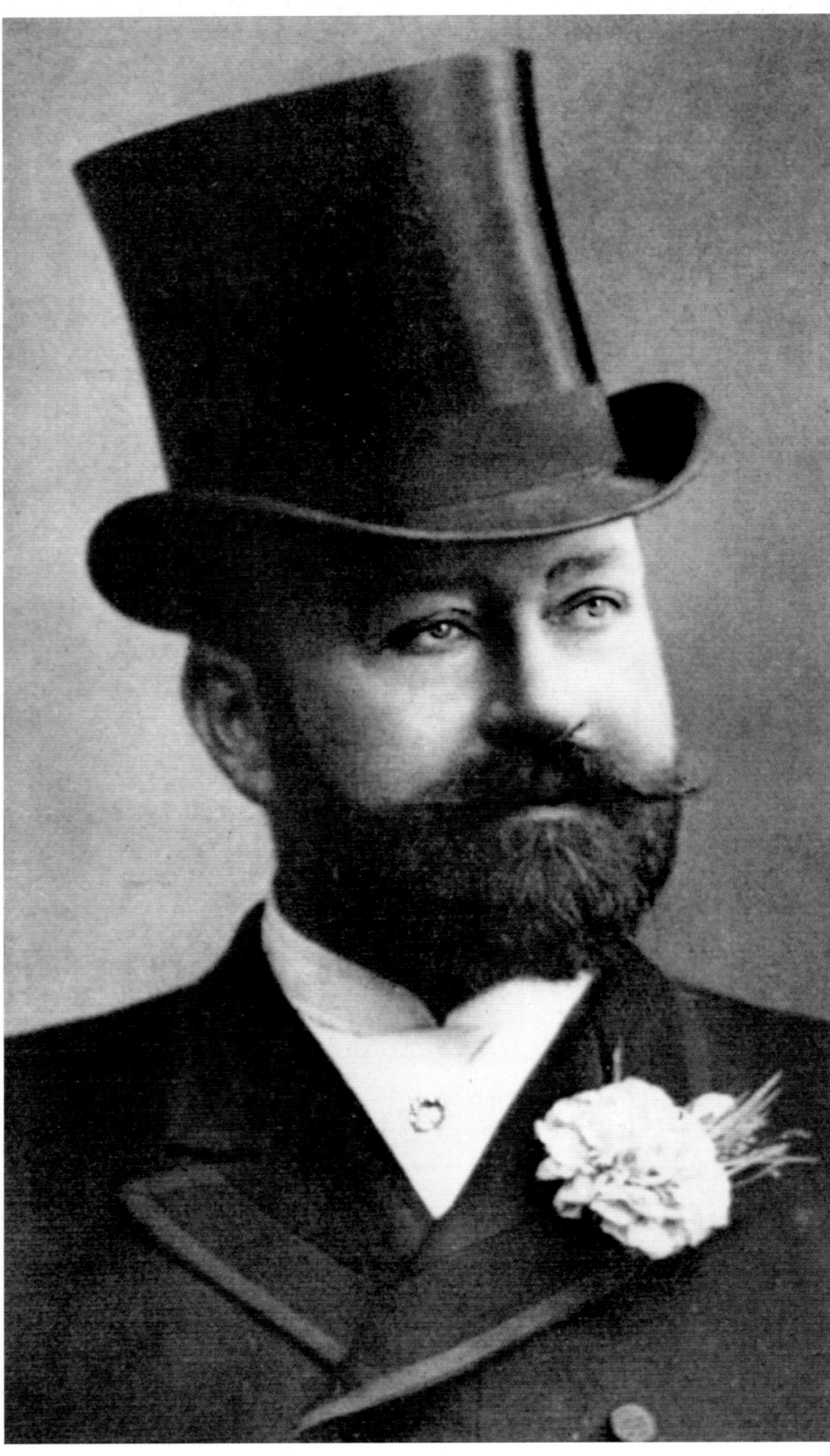

Left: George R. Sims, English journalist, poet, dramatist, novelist and philanthropist. A prolific writer, Sims began submitting humourous pieces to *Fun* magazine and *The Referee*, but he soon began to concentrate on social reform, particularly the plight of London's poor. He wrote several novels and plays, as well as breeding bulldogs, and lived a wealthy lifestyle. That said, by the time of his death, in 1922 at the age of 75, he had largely gambled away his fortune.

1898

Right: Lena Thomson is presented with the trophy for winning the British Ladies Amateur Golf Championship by the captain of the Great Yarmouth and Caister Golf Club. The championship had been founded by the Ladies' Golf Union in 1893, and until the advent of women's professional golf in 1976, it was the most important women's golf tournament in Great Britain. Eventually, it began to draw players from Europe and the United States, and it continues to this day.

17th September, 1898

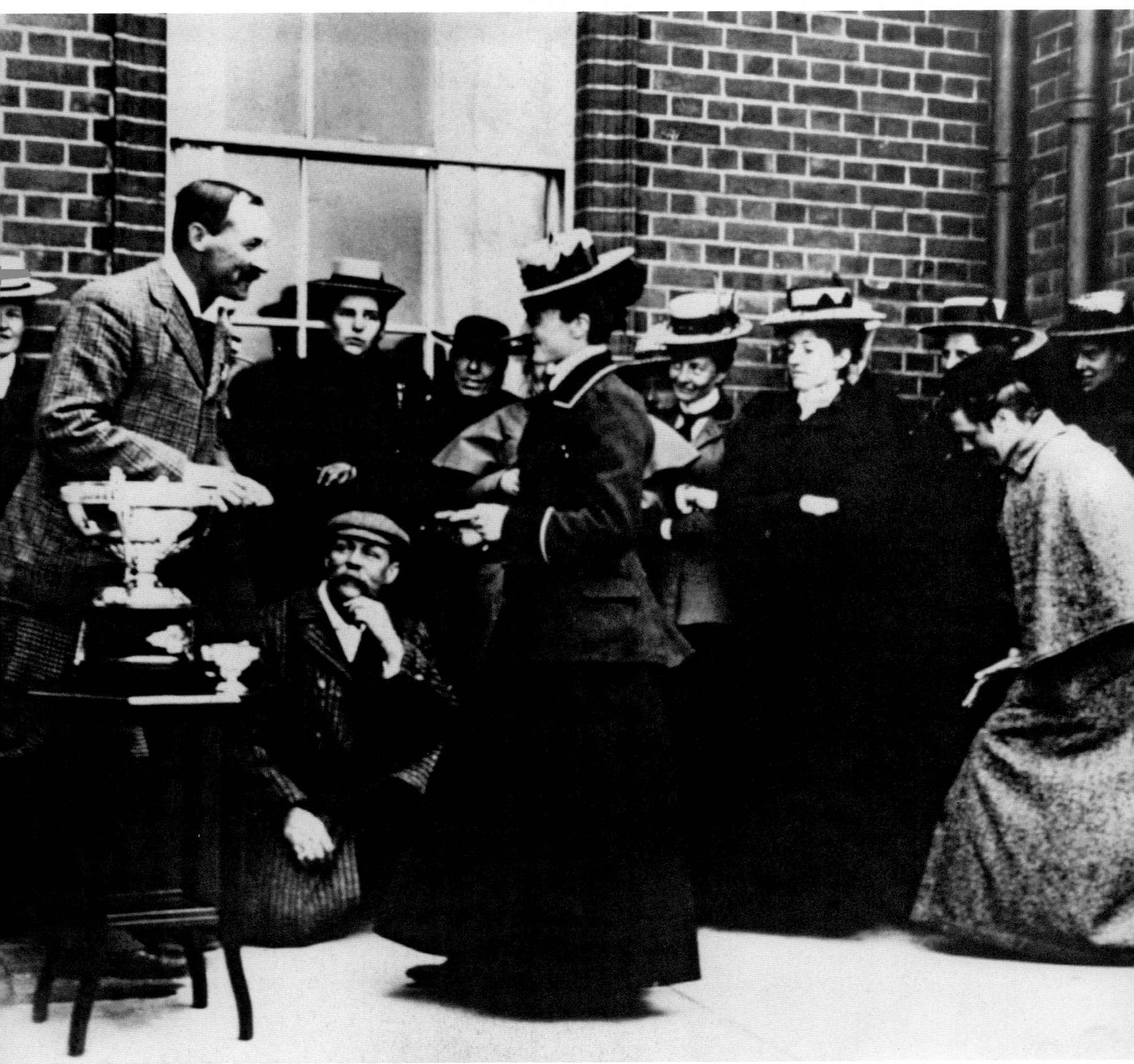

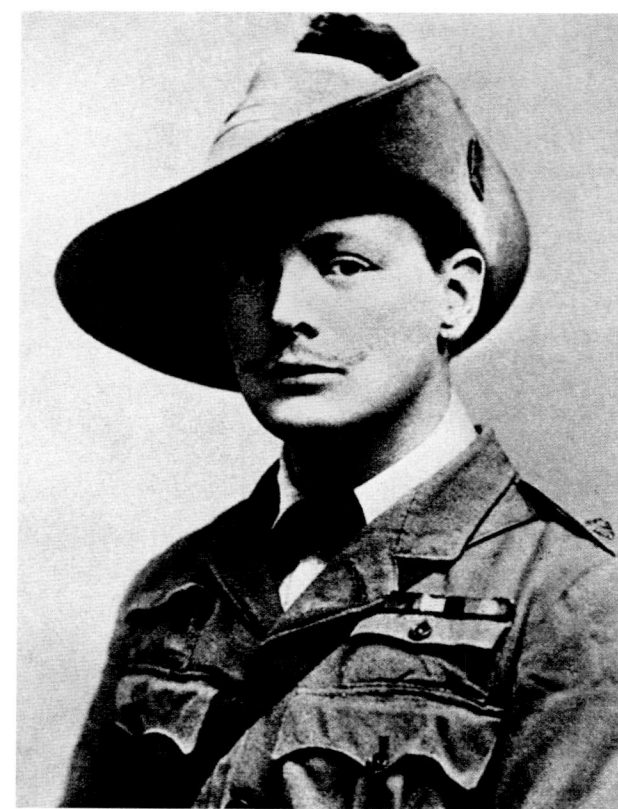

Above: When Winston Churchill was commissioned as a cornet in the 4th Queen's Own Hussars, he quickly realised that his salary was less than half of what he needed to match the lifestyle of his fellow officers. His mother, Lady Randolph Churchill, made him an allowance, but he was frequently overspent. As a result, he began to act as a war correspondent for several newspapers, as well as writing books about the campaigns. This brought a significant improvement in his finances. This portrait was taken while he was war correspondent for *The Morning Post* during the Boer War.

1899

Left: Winston Churchill as Conservative candidate for Oldham in 1899, having resigned his commission in the Army earlier in the year. It was the first election to be fought by the future prime minister. The mood in the country at the time was against the Conservatives, however, and he lost the election.

7th July, 1899

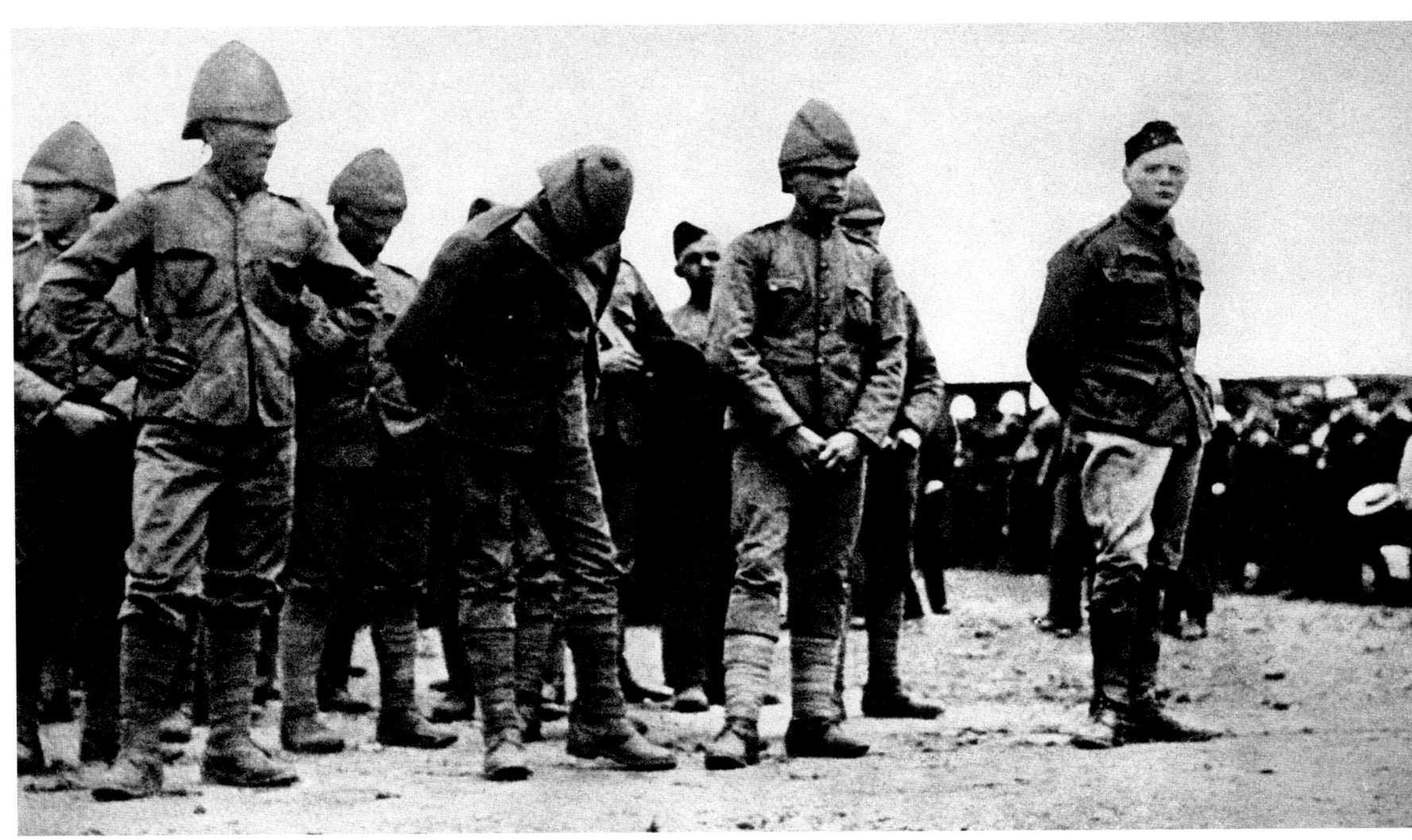

Above: Winston Churchill (R) in a Boer prisoner-of-war camp in Pretoria, South Africa. He had been aboard a British armoured train on a scouting mission when it was ambushed, and he was captured and imprisoned, even though he was a civilian. He managed to escape, however, and make his way 300 miles (480km) across country to Lourenço Marques on the coast of Portuguese East Africa (now Mozambique). Instead of returning home, Churchill went back to his job as a war correspondent and also accepted a commission in the South African Light Horse, seeing action at Ladysmith and Pretoria.

1st November, 1899

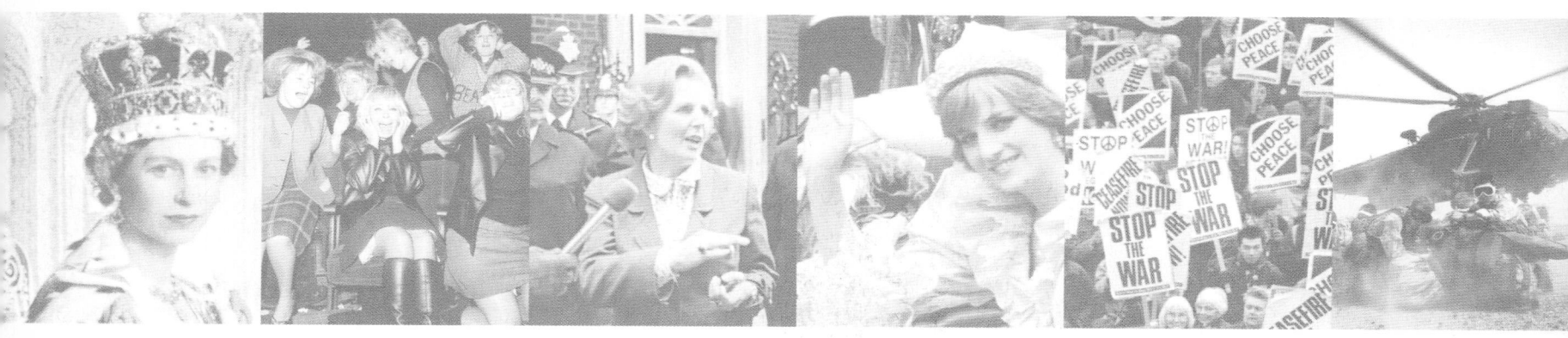

1900s

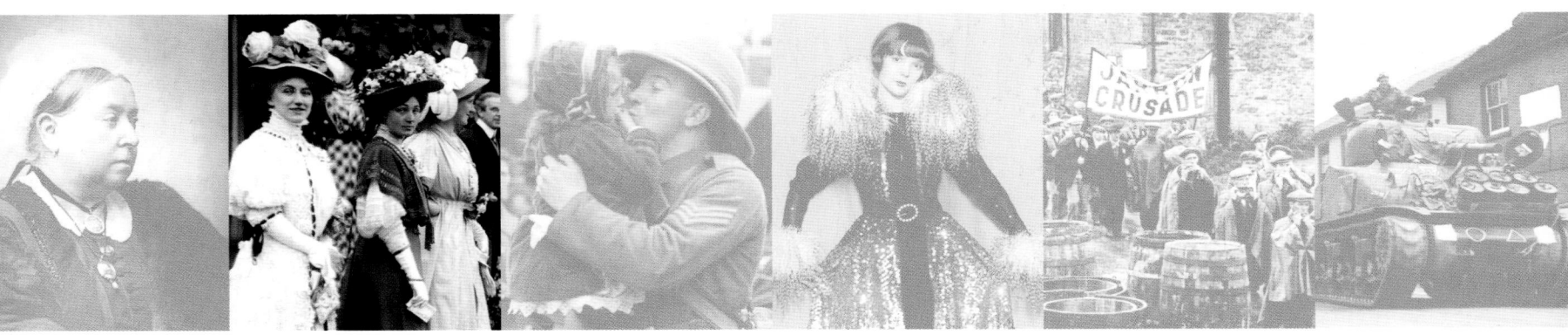

Britain entered the 20th century brimming with confidence and pride. The nation was truly a great power: Britannia ruled the waves and much more besides. Times were about to change, however, and the country would be forced to reassess its position in the world. The first decade of the new century saw the end of the Victorian era and the dawning of the Edwardian age, a time of technological and social change. Motor vehicles entered widespread use and the first powered flight was achieved: Blériot's crossing of the English Channel by air made it clear that Britain was no longer an island. The period saw the rise of socialism, the labour movement and women's suffrage. Even so, in 1909 there was still a stubborn, often brutal, refusal to consider the right of women to vote.

While many of the news photographs of the period focus on the personalities of the day, sometimes the original reason for a photograph has been eclipsed by subsequent events, taking on a greater significance as a result: a photograph from 1909 features the Romanovs together with the British Royal Family; another shows Winston Churchill with the German Kaiser Wilhelm II – of moderate interest at the time, but truly poignant a few years later.

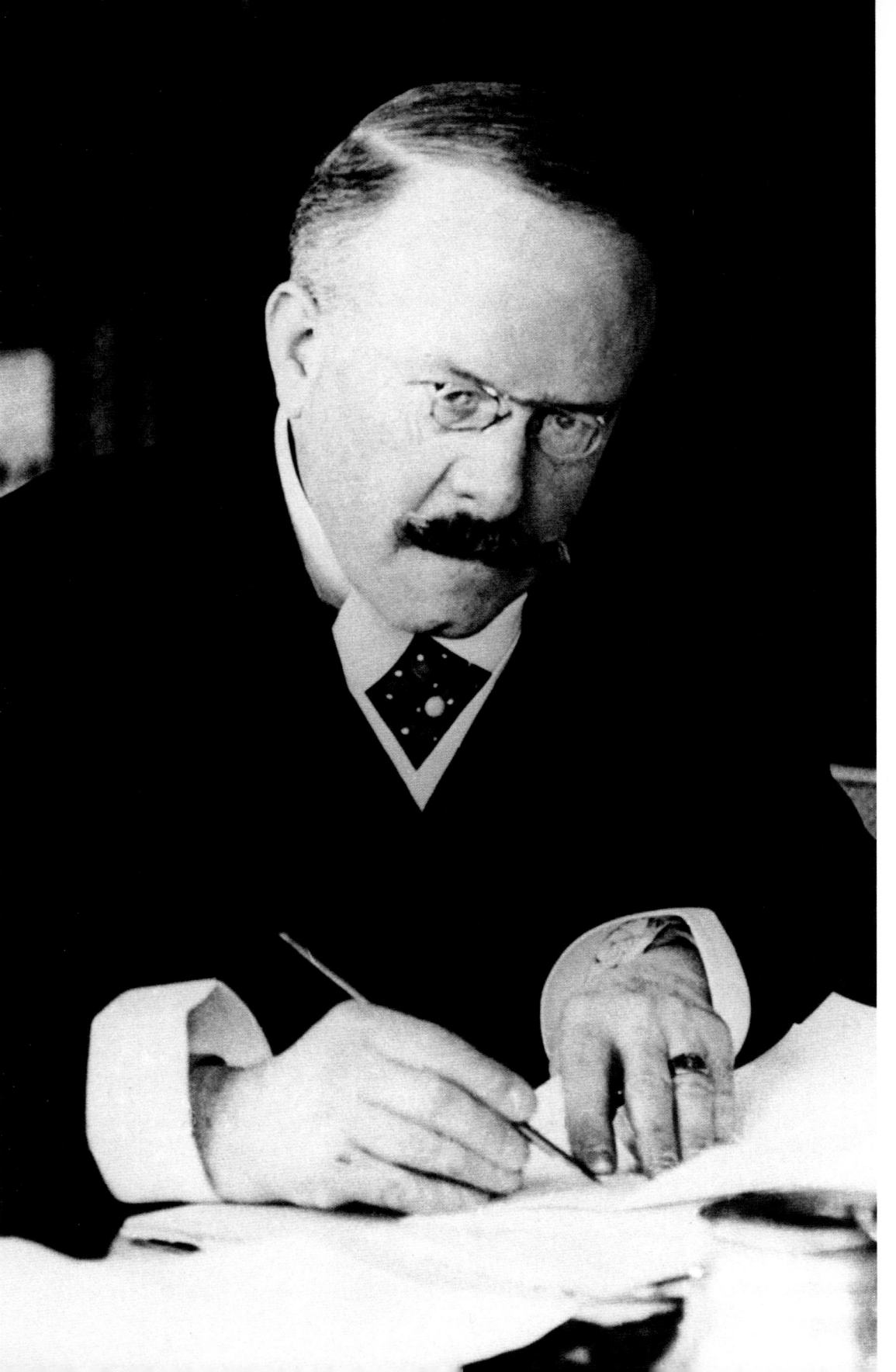

Left: Doctor Thomas John Barnardo, Irish philanthropist, and founder and director of homes for destitute children. Barnardo's first home was opened in 1870, and between then and his death, on 16th September, 1905, almost 60,000 children were rescued and set on the road to a new life.

1900

Below: King Edward VII in Scottish dress. Edward ascended to the throne on 22nd January, 1901, following the death of his mother, Queen Victoria. He was the first British monarch from the House of Saxe-Coburg and Gotha, later renamed the House of Windsor by his son, George V, in an attempt to distance the Royal Family from its German roots during the First World War.

1901

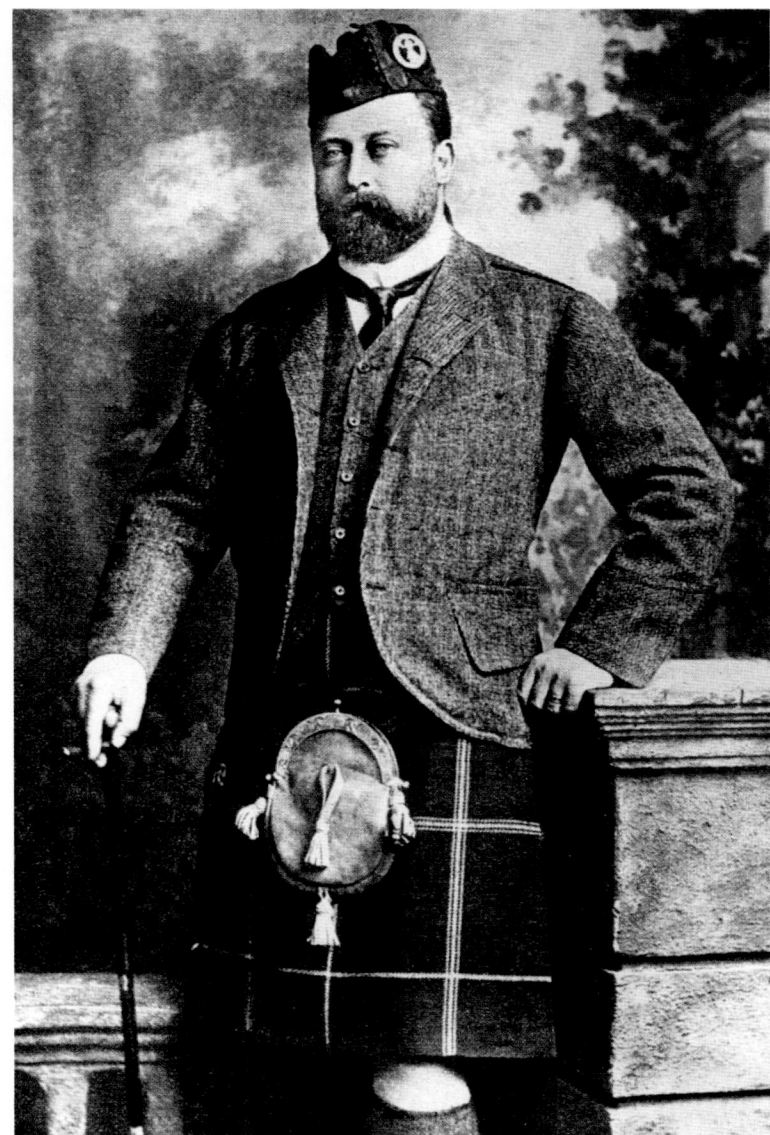

Above: The original Bank underground station near Mansion House, London. The first station opened on 25th February, 1900, when the City & South London Railway (now part of the Northern Line) inaugurated an extension from Borough to Moorgate.

1st August, 1901

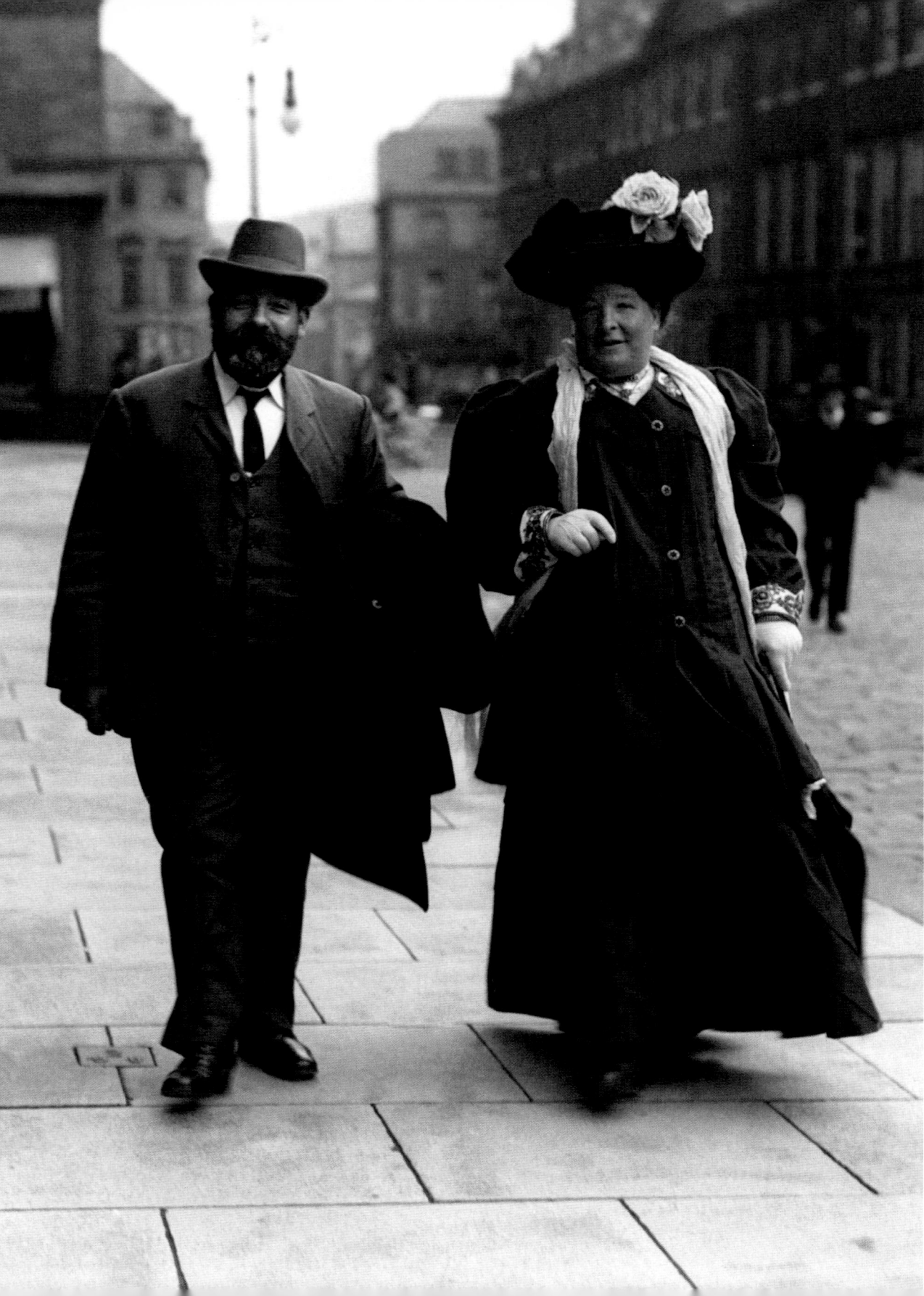

Left: The noted trades unionist and London's first Labour mayor, Will Crooks, seen in his home borough of Poplar, London with his second wife, Elizabeth. Among his many social reform achievements was the Infant Life Protection Bill, which ended baby farming in London.

1901

Right: RRS *Discovery* was the last wooden three-masted ship to be built in the British Isles. She had been designed for Antarctic research and was launched on 21st March, 1901. Her first mission was to transport the British National Antarctic Expedition, led by Robert Falcon Scott, on its successful journey to the Antarctic in 1901. Today, *Discovery* is preserved as a visitor attraction in Dundee, where she was built.

6th August, 1901

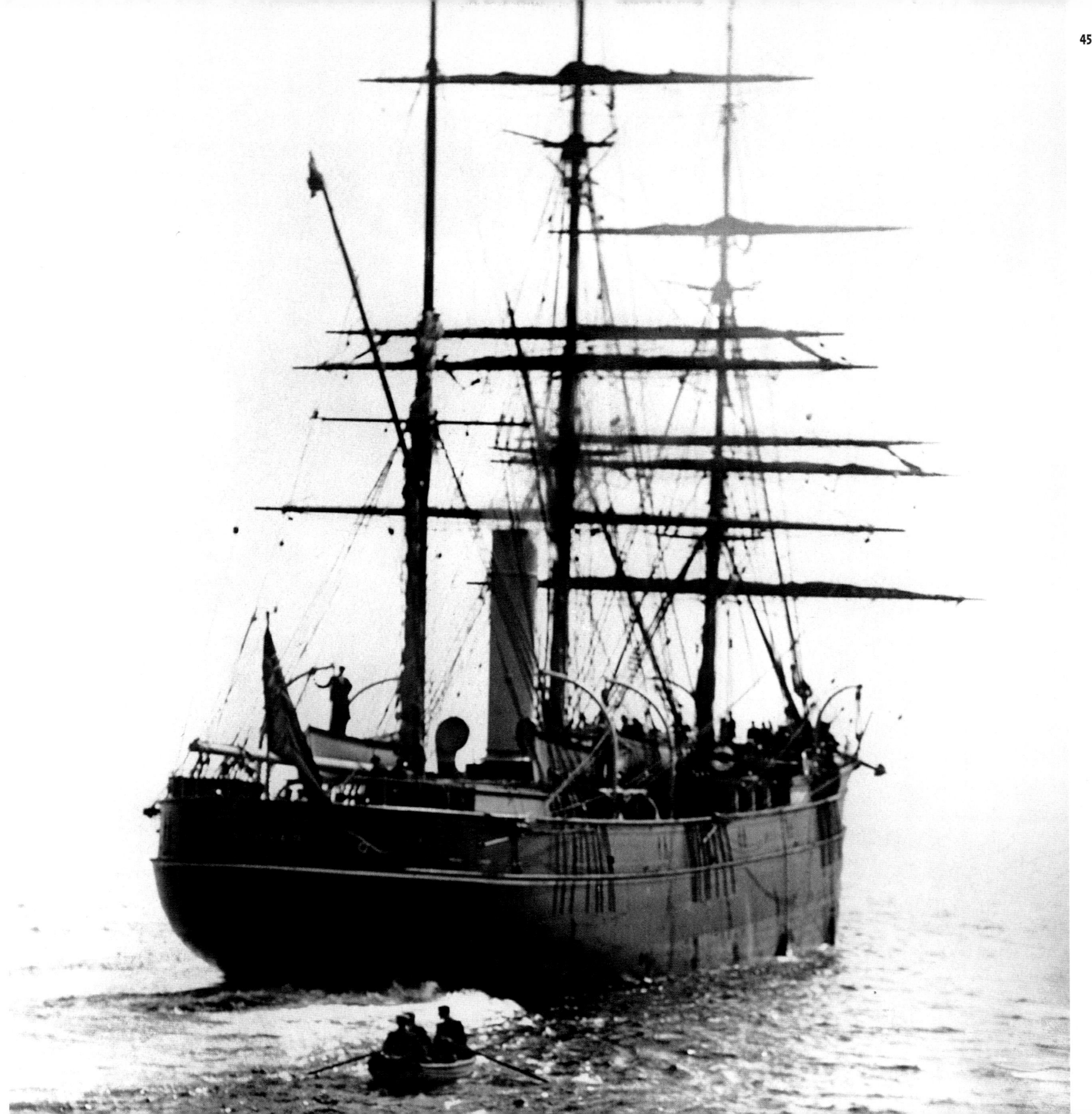

Above: The England cricket team that toured Australia: (back row, L–R) Dick Lilley, Albert Knight, Arthur Fielder, Ted Arnold, Albert Reef, Len Braund; (middle row, L–R) Johnny Tyldesley, Tip Foster, Pelham 'Plum' Warner, George Hirst, Bernard Bosanquet, Tom Hayward; (front row, L–R) Bert Strudwick, Wilfred Rhodes.

1903

Right: Dorothea Douglass, Wimbledon Ladies' Singles champion in 1903, 1904, 1906, 1910, 1911, 1913 and 1914. Author of *Tennis For Ladies* (1910), she is one of only two women (the other is Stefi Graf, French Open, 1988) to win a Grand Slam singles final without losing a game: 6–0, 6–0, Wimbledon, 1911.

5th June, 1903

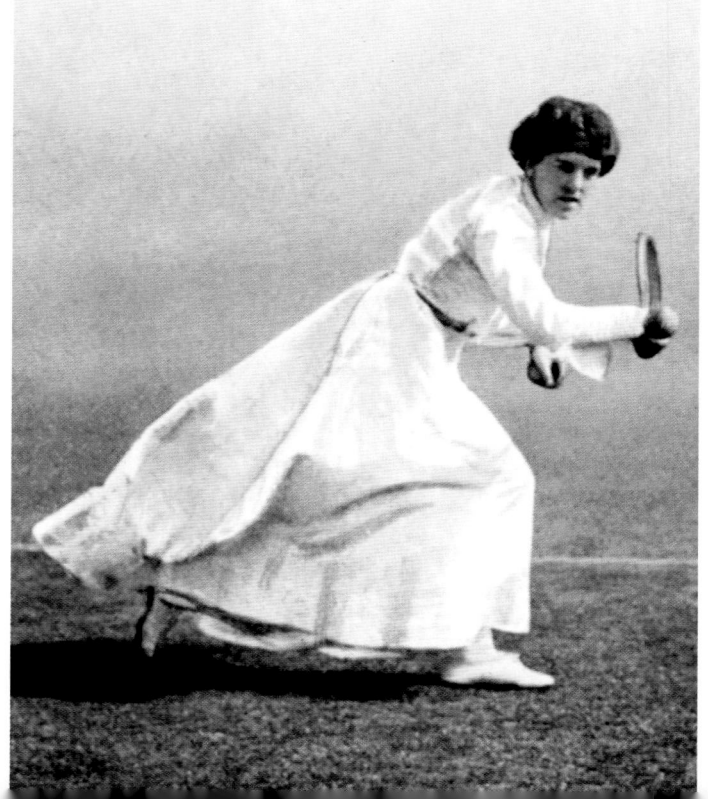

Right: Emmeline Pankhurst, the founder of the Women's Social and Political Union, and a leading light in the suffragette struggle to gain women the vote.

1903

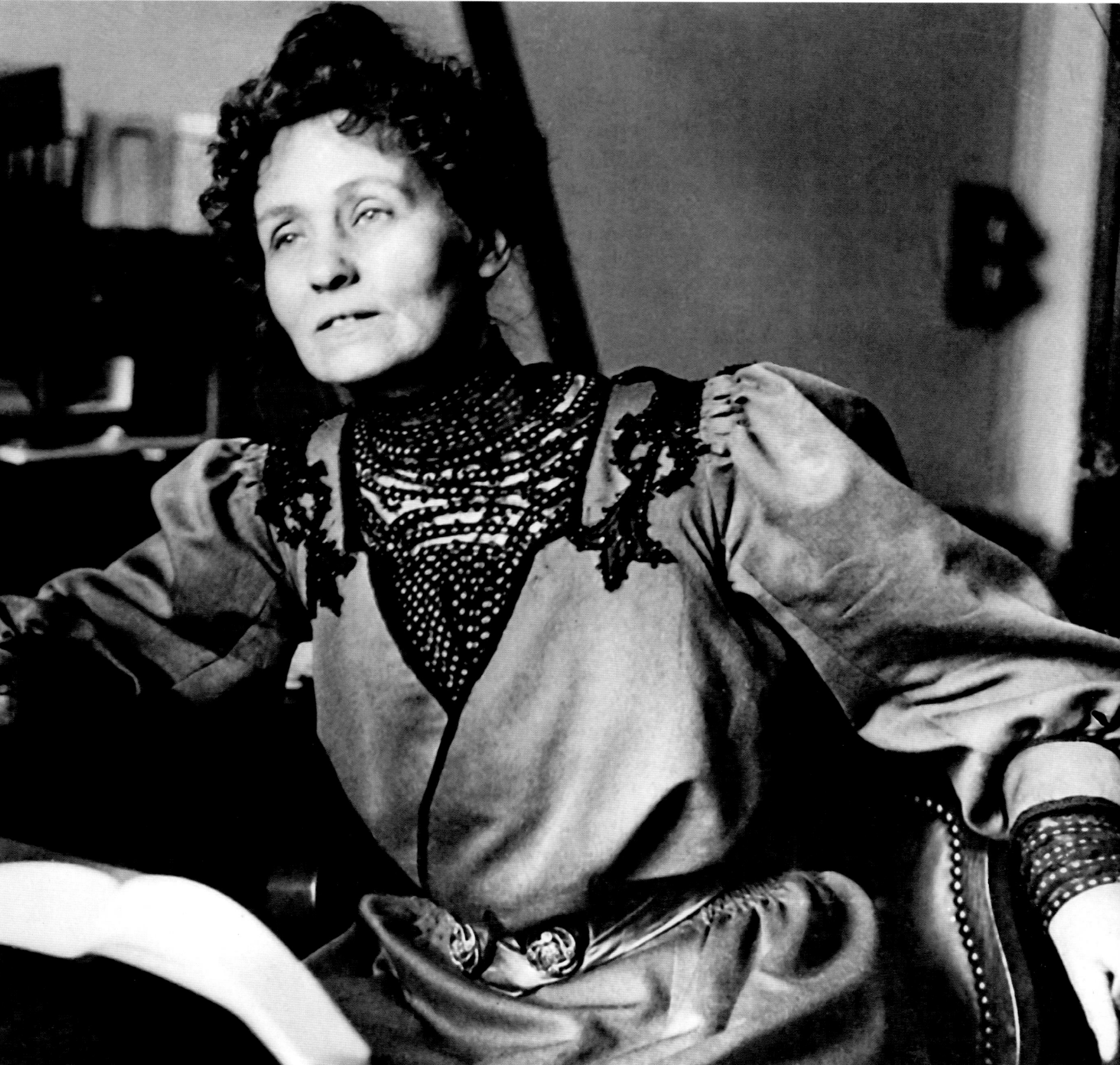

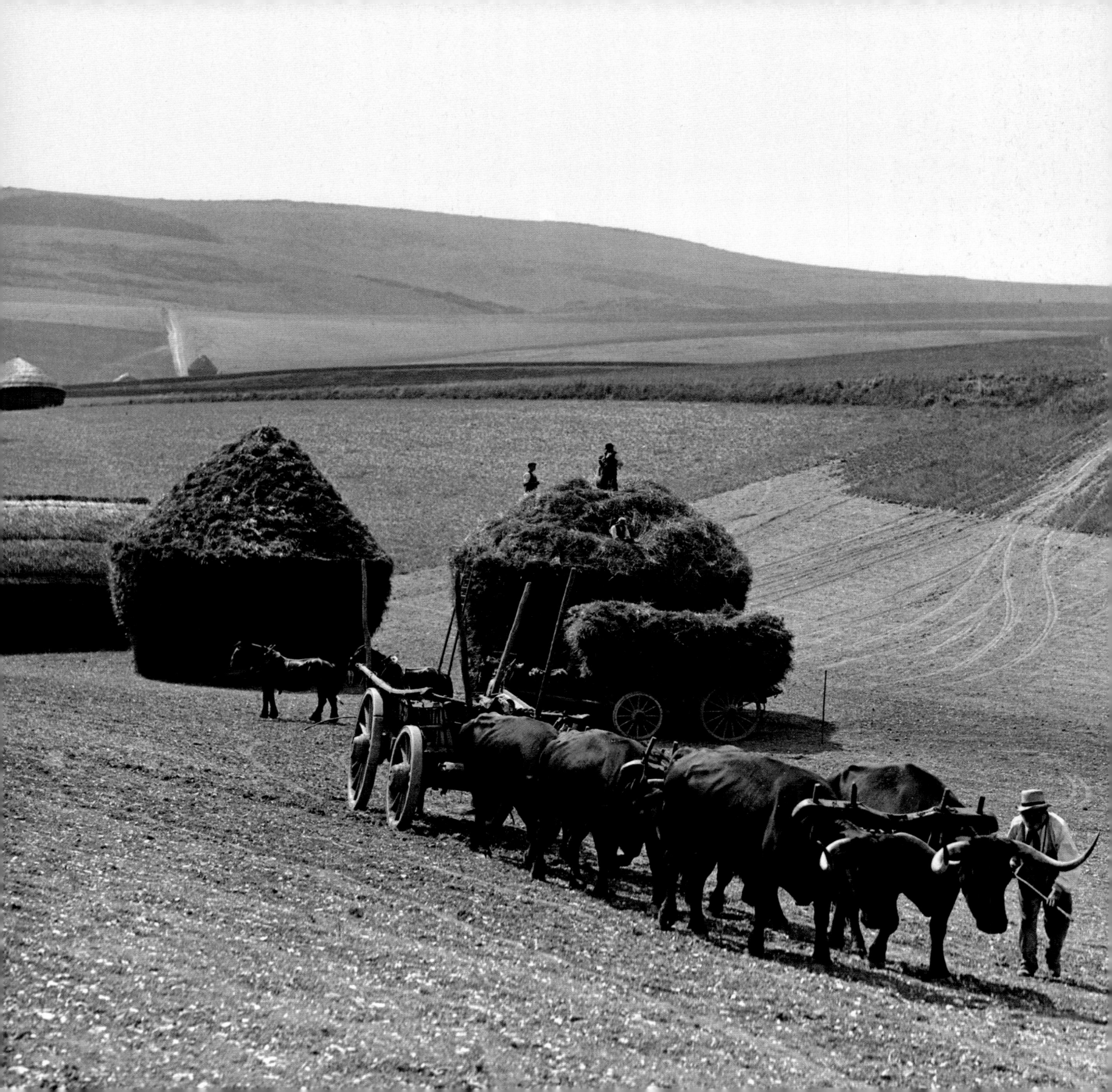

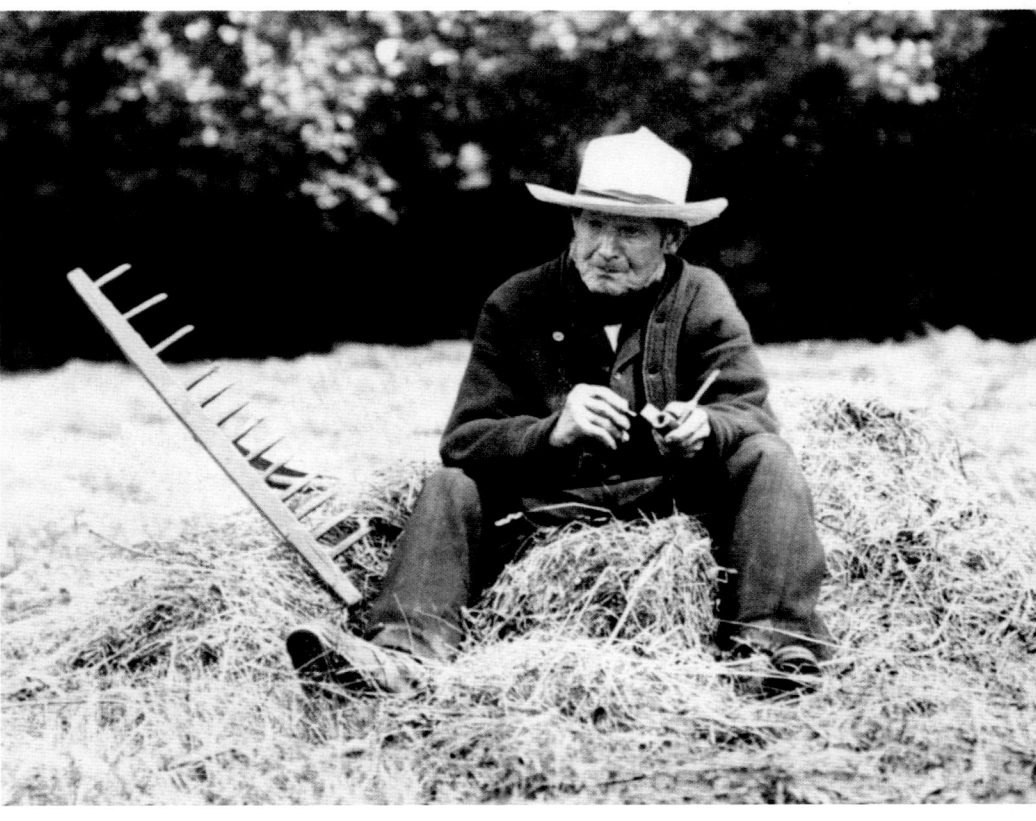

Above: Dan Gumbrell, a typical English farm worker, lights his pipe while taking a break during the wheat harvest.

1st September, 1903

Left: Mr Richardson and the team of oxen he handled for 38 years during the wheat harvest at Lades Farm, Falmer, near Brighton, on the South Downs. The working oxen – a rarity even in 1903, despite being used in Sussex up to the late 1920s – were eventually sold by the farmer's heir.

1st September, 1903

Above: French artist and sculptor Auguste Rodin,
a regular visitor to Britain. His statue 'The Thinker'
is one of the most well known of sculptural works.

1905

Left: Trams running along Victoria Embankment.
The ancient Egyptian obelisk, known as 'Cleopatra's
Needle', can be seen in the background.

1st February, 1904

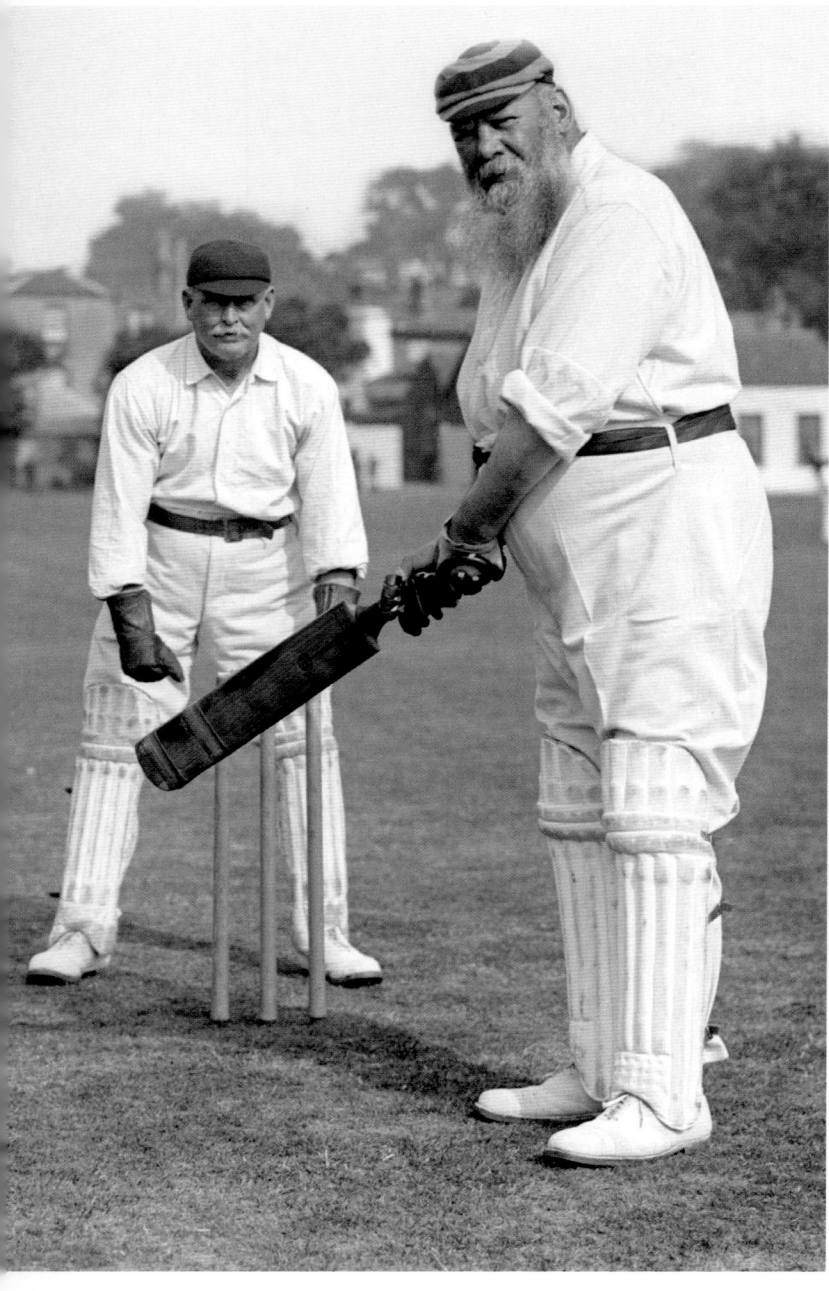

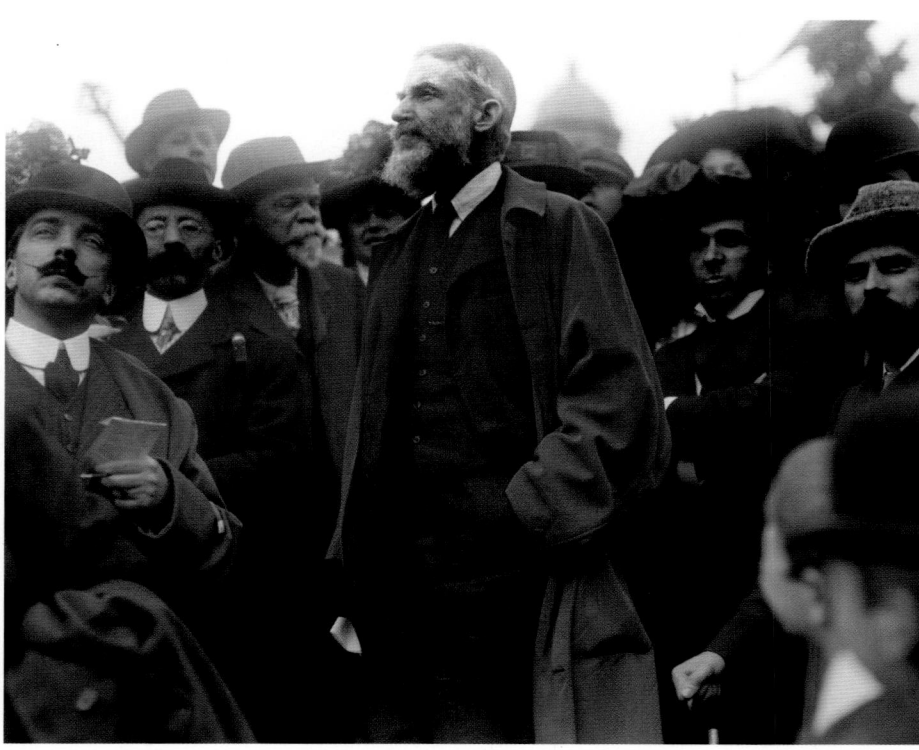

Above: George Bernard Shaw attending a socialist rally as a member of the Fabian Society, of which he was a co-founder.

1st June, 1905

Left: The famous cricketer W.G. Grace. He played in the first Test match in England – against Australia in 1880 at the Oval – and was the first English batsman to score a Test century.

1905

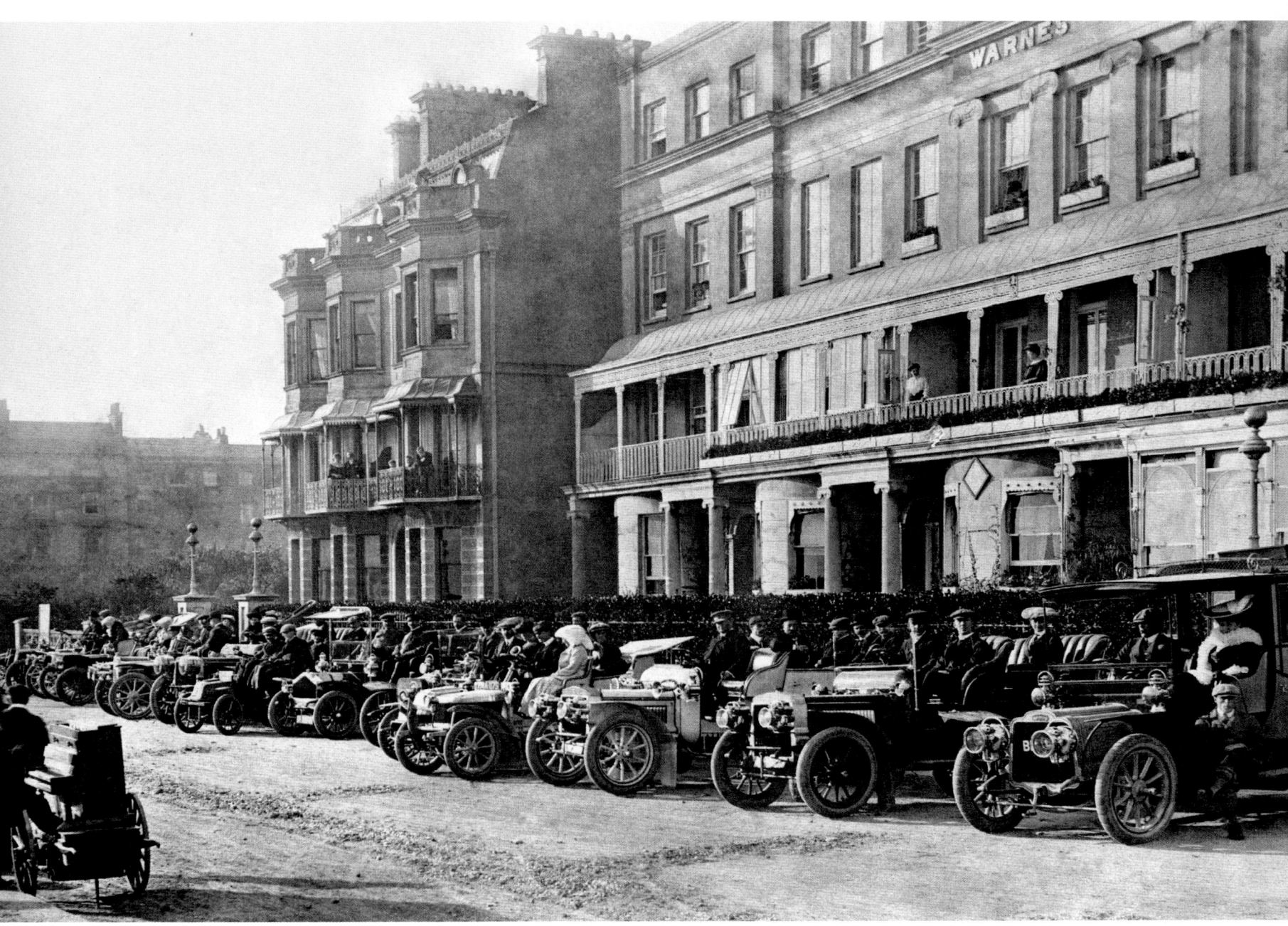

Above: Competitors in the first
South Coast Motor Rally outside
Warne's Hotel, Worthing, Sussex.

1st June, 1905

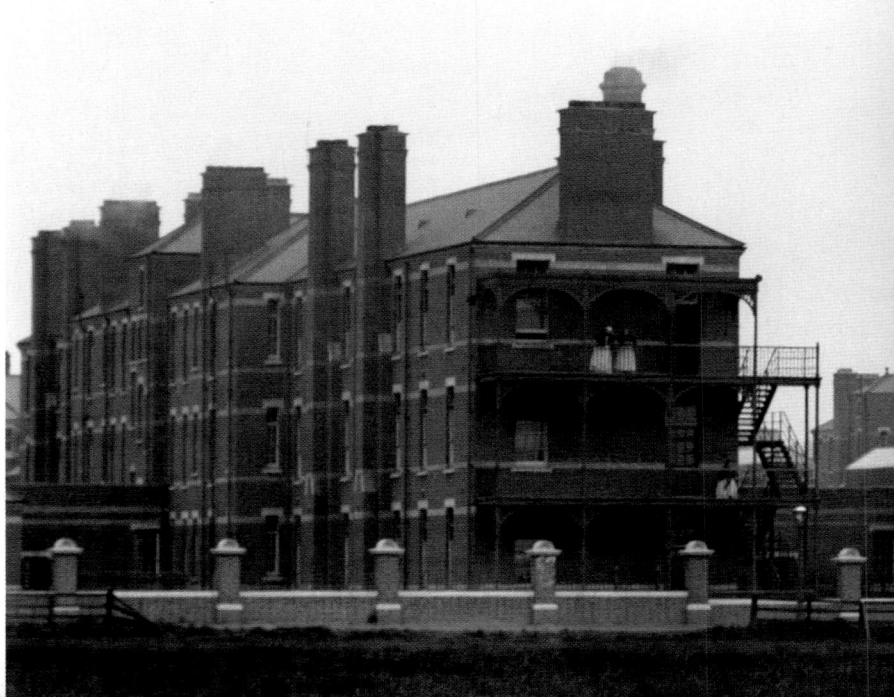

Above: Crowded into a vast workshop, dozens of men hunch over their work in a factory making footballs and football boots.

1st September, 1905

55

Right: Bill 'Fatty' Foulke, Chelsea goalkeeper. When playing for Sheffield in the 1902 Cup Final, Foulke famously angrily, nakedly and allegedly pursued the referee, a Mr Kirkham, who took refuge in a broom cupboard, in protest at his allowing the opposing team's equalizing goal.

11th September, 1905

Below: The newly opened Hammersmith Infimary and Workhouse, London. The extensive buildings included the administrative building shown, flanked by pairs of pavilion ward blocks for men and women, linked by central corridors, with a laundry, boiler-house and workshops at the centre of the 14-acre site. The site still serves as Hammersmith Hospital, although many of the original buildings have been replaced or altered. Of the workhouse, only the administrative block survives.

1905

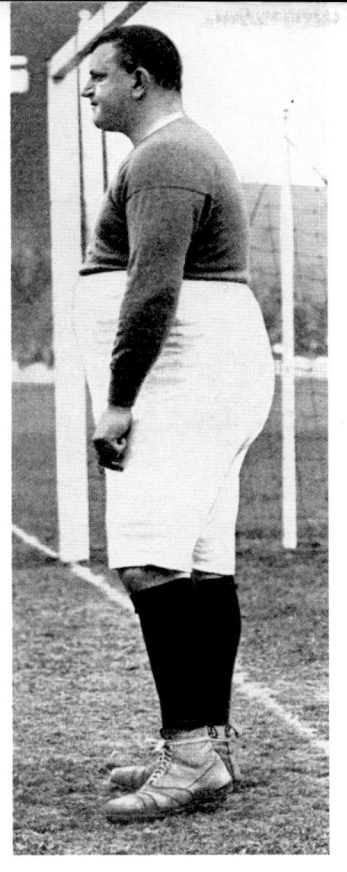

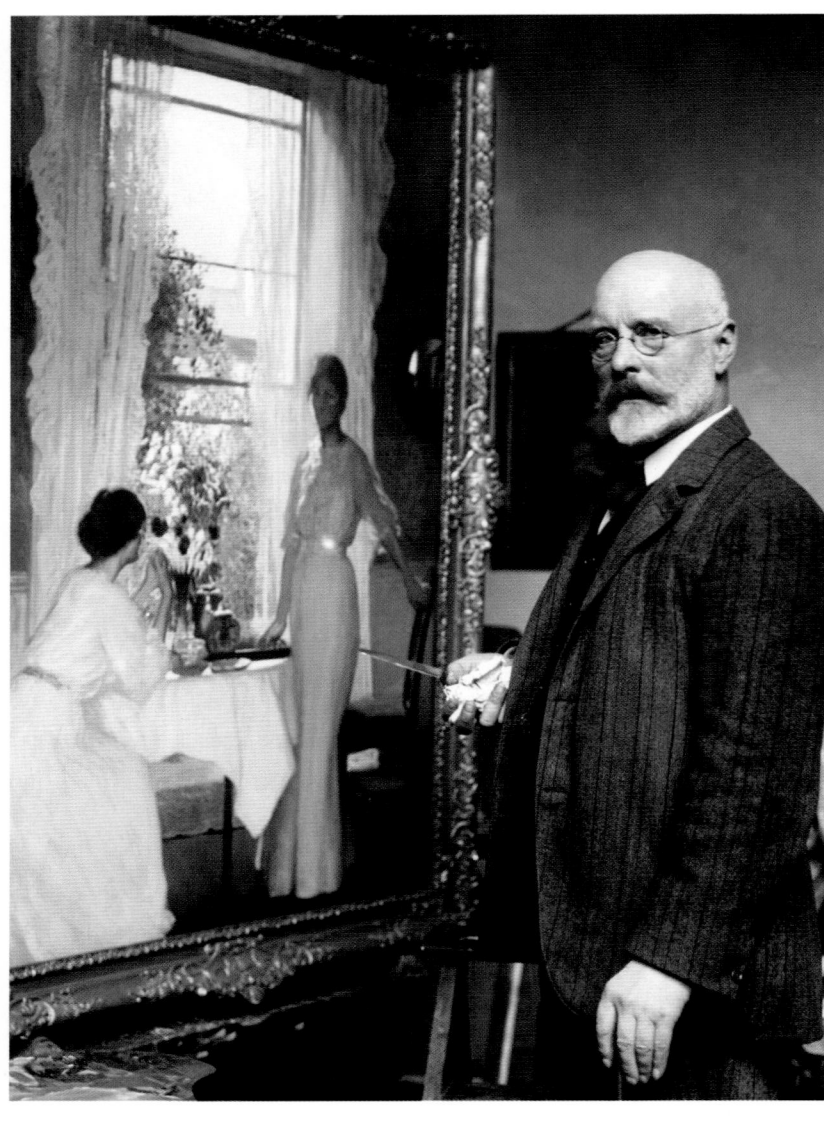

Above: George Clausen, English artist. A founder member of the New English Art Club, Clausen became Professor of Painting at the Royal Academy in 1906 and was knighted in 1927.

1906

Right: Ladies watch tennis during a party to celebrate actress Edna May's wedding. Edna May (C, facing camera) retired from the stage after marrying an American millionaire. Following her final appearance, some of her (many) male admirers unhitched the horses from her carriage and pulled it themselves to the Ritz Hotel, where she was dining that night.

1st August, 1906

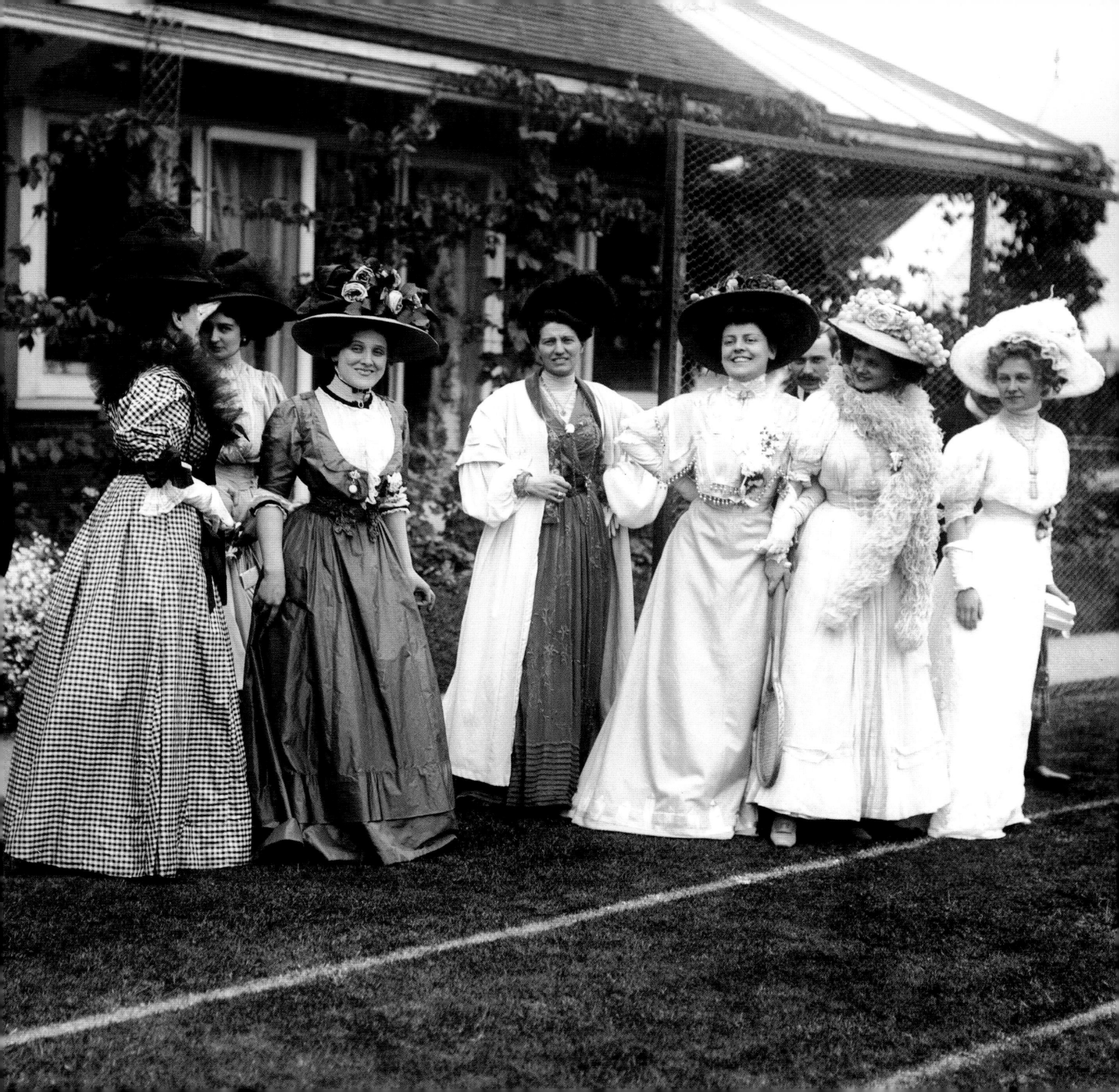

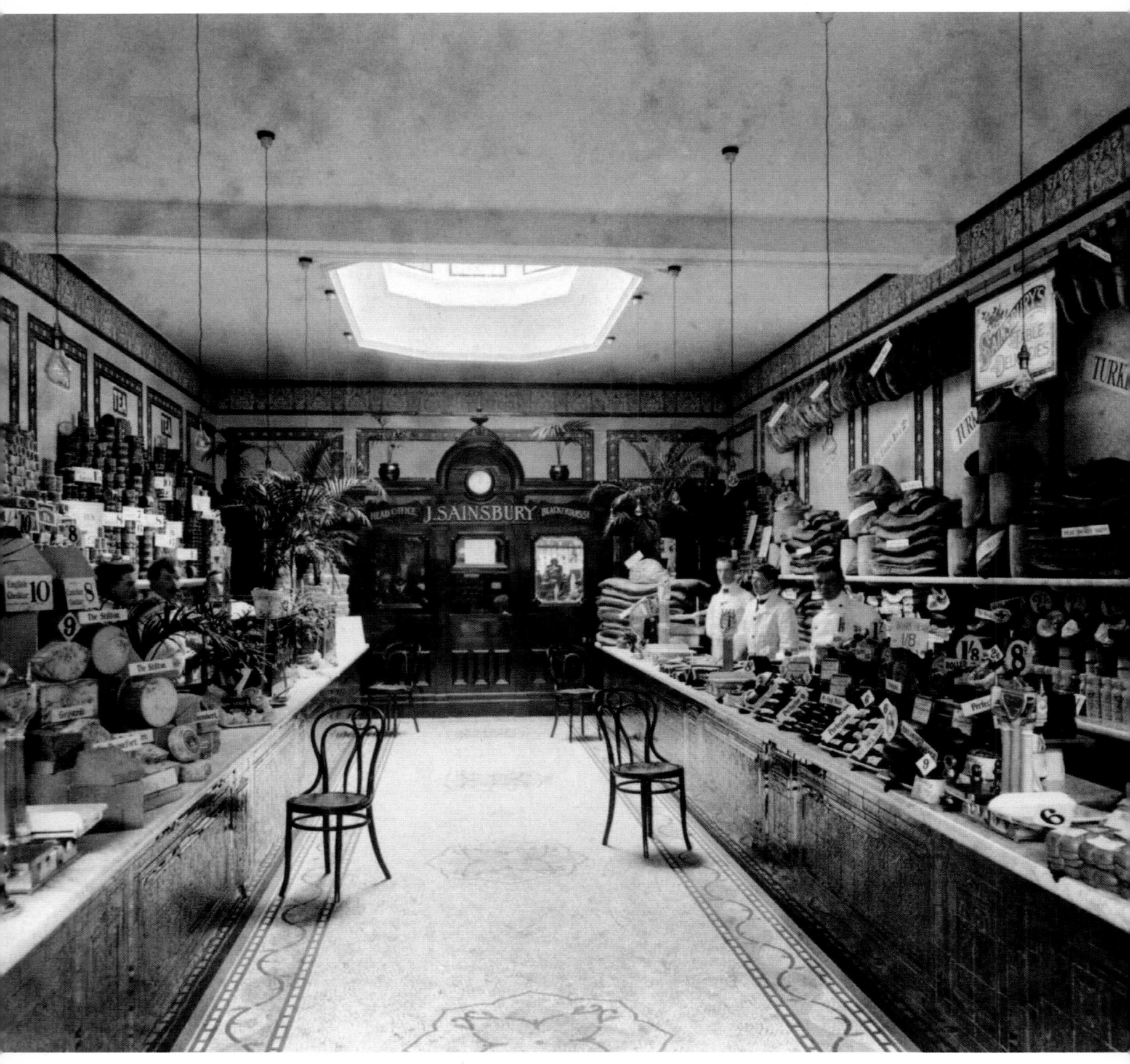

Left: Opening day at Sainsbury's store in Guildford, Surrey. The layout is typical of the counter-service shops opened by the company from the 1890s until 1939. The tiled walls, marble-topped counter and ceramic floor formed an instantly-recognizable 'house style' that was functional as well as being decorative.

16th November, 1906

Above right: British philosopher and pacifist Bertrand Russell, Third Earl Russell. Considered to be one of the 20th century's foremost logicians, Russell was imprisoned during the First World War for his pacifist activism. In later years, he campaigned against Adolf Hitler and for nuclear disarmament. He died on 2nd February, 1970, at the age of 97.

1907

Right: Pioneering French fashion designer Gabrielle Bonheur 'Coco' Chanel. Although Chanel had affairs with many influential men, she never married. The reason is suggested by her reply when asked why she had not married the Duke of Westminster: "*There have been several Duchesses of Westminster. There is only one Chanel.*"

1907

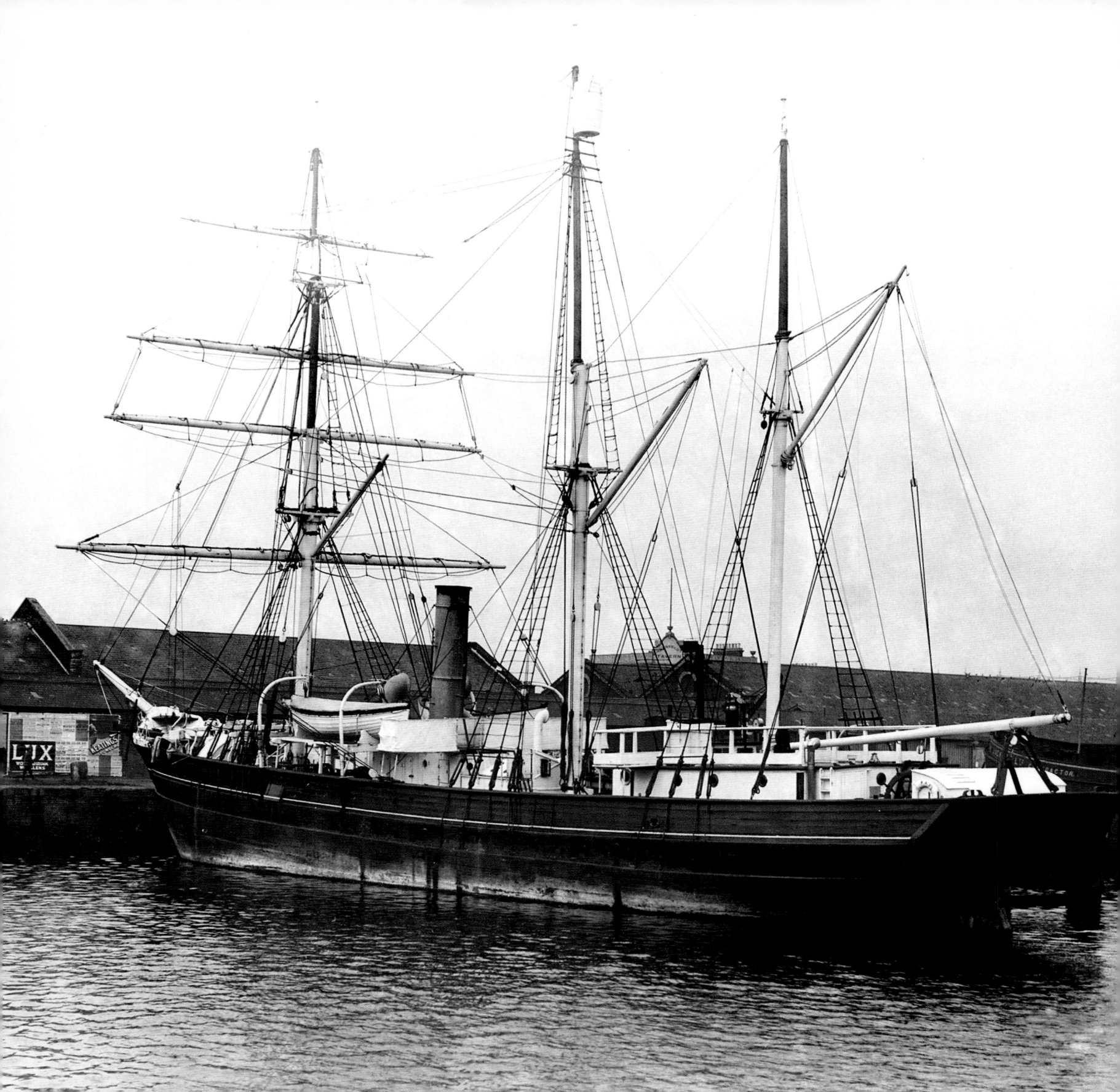

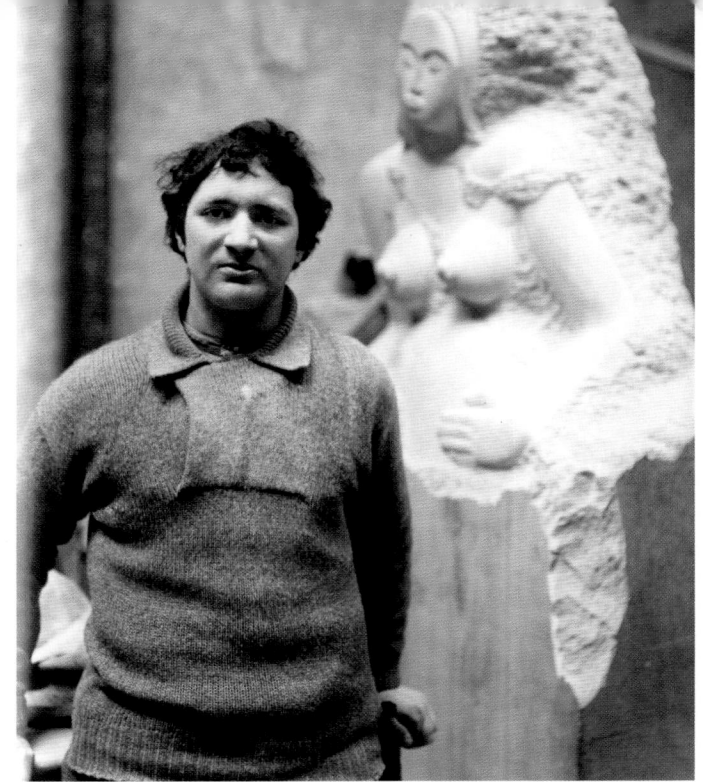

Left: The *Nimrod* at East India Docks in London. This was the ship chosen for the British Antarctic Expedition of 1907–09 led by Ernest Shackleton. The expedition lacked government support and was beset by financial problems, only able to afford a vessel that was half the size of Scott's *Discovery*. Nevertheless, much useful geological, zoological and meteorological work was carried out, while valuable experience in dealing with the harsh conditions was gained. Upon his return, Shackleton received public acclaim and was knighted by King George VII.

1907

Above right: Jacob Epstein, the American-born sculptor who worked chiefly in the UK, where he pioneered modern sculpture.

1907

Right: Douglas Mawson (L), an Australian explorer, with fellow Antarctic explorer Ernest Shackleton, whose *Nimrod* expedition he joined. Later, he turned down a place on Scott's ill-fated *Terra Nova* expedition to lead his own, of which he would be the only survivor.

1907

Left: A demonstration by the Labour Party, which had been formed by trades unions and a variety of left-wing organizations in 1900. Among the activists is Ramsey MacDonald (C, bare-headed).

20th January, 1907

Right: American inventor and businessman Thomas Alva Edison. Among his many inventions were the phonograph, the motion-picture camera and a practical, long-lasting light bulb. He originated the concept of electric power generation and distribution for domestic and business use, building his first power station on Manhattan Island, New York in 1882. A year later, he formed the Edison & Swan United Electric Light Company in Britain with British inventor Joseph Swan, selling bulbs developed by the latter. Known as Ediswan, the company would go on to produce thermionic valves and cathode ray tubes.

1st June, 1907

64

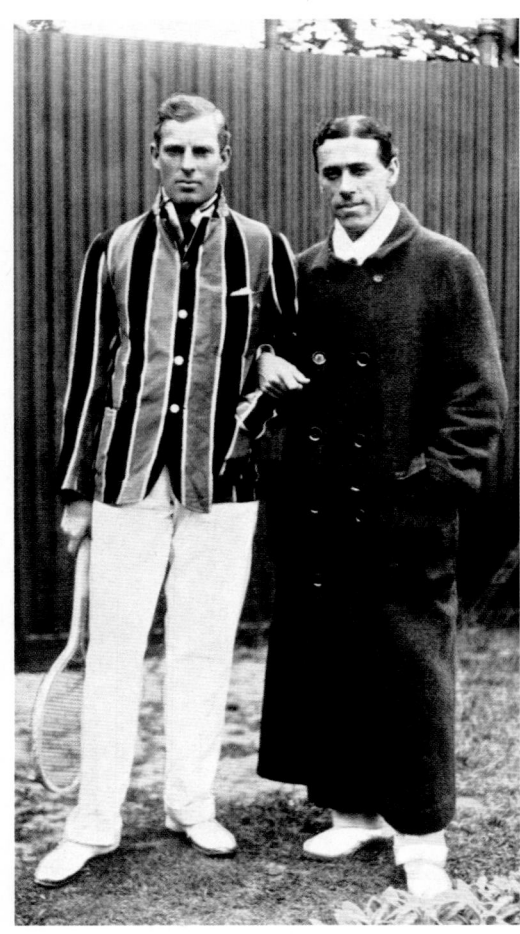

Above: Anthony Wilding (L) and Norman Brookes, Wimbledon Men's Doubles champions in 1907 (Wilding won the Singles in 1910, while Brookes won it in both 1907 and 1914).

10th June, 1907

Right: Watched by a pressing crowd, the Lord Mayor's coach passes along Fleet Street at Temple Bar in London, during the annual Lord Mayor's Show.

1st November, 1907

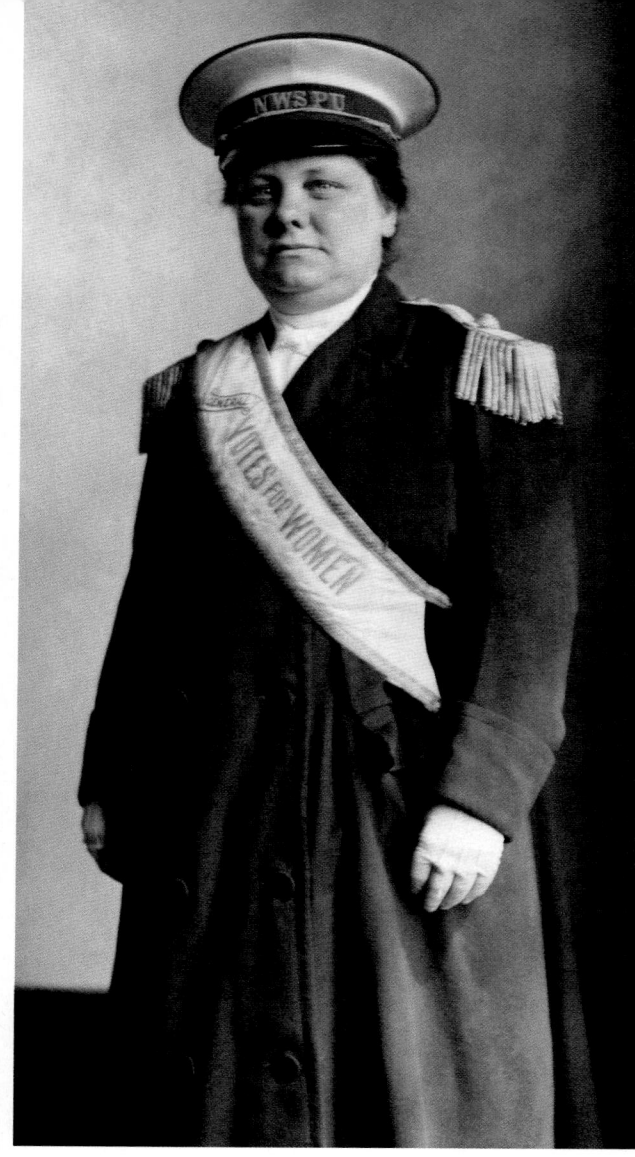

Above: Suffragette Flora Drummond, organizer of rallies for the Women's Social and Political Union, was known as 'The General' for her habit of leading marches sat astride a large horse and clad in a military-style uniform, complete with officer's cap and epaulettes. She was an accomplished orator and was imprisoned nine times for her activities on behalf of the women's suffrage movement.

1908

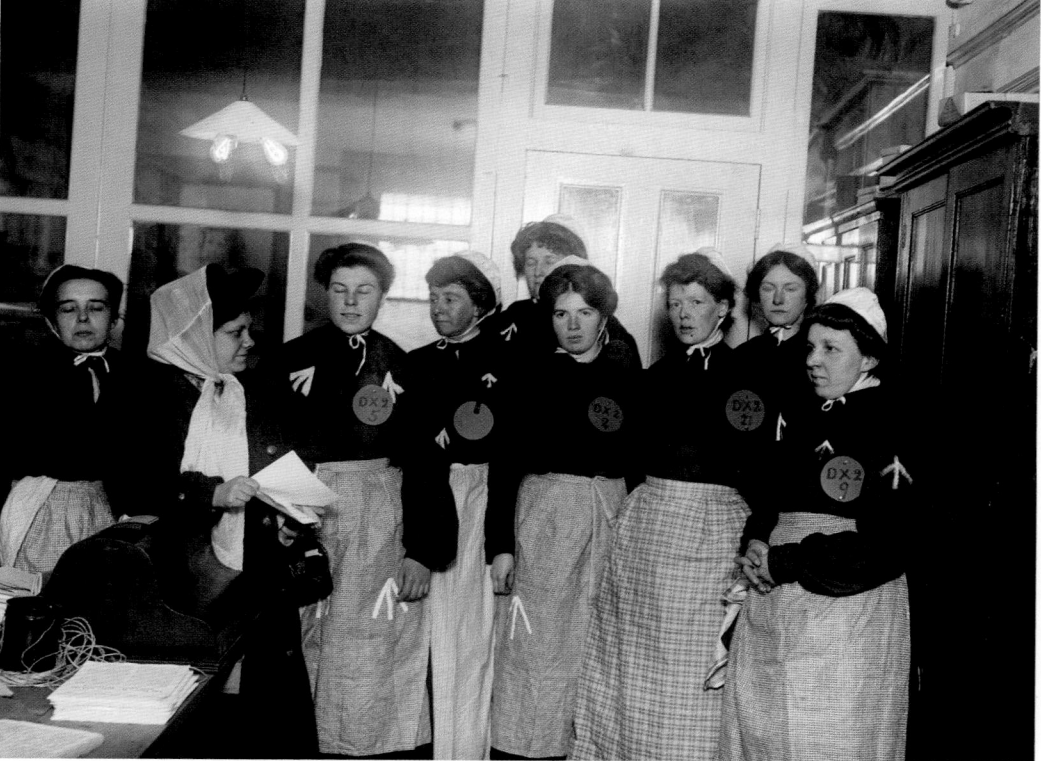

Above right: Flora Drummond (second L) instructs suffragettes dressed as prisoners. Flora had qualified as a postmistress, but was not allowed to work in the trade, as she was below the regulation height of 5ft 2in (1.57m). During her time in prison, she taught other inmates Morse code so that they could communicate in the cells.

1908

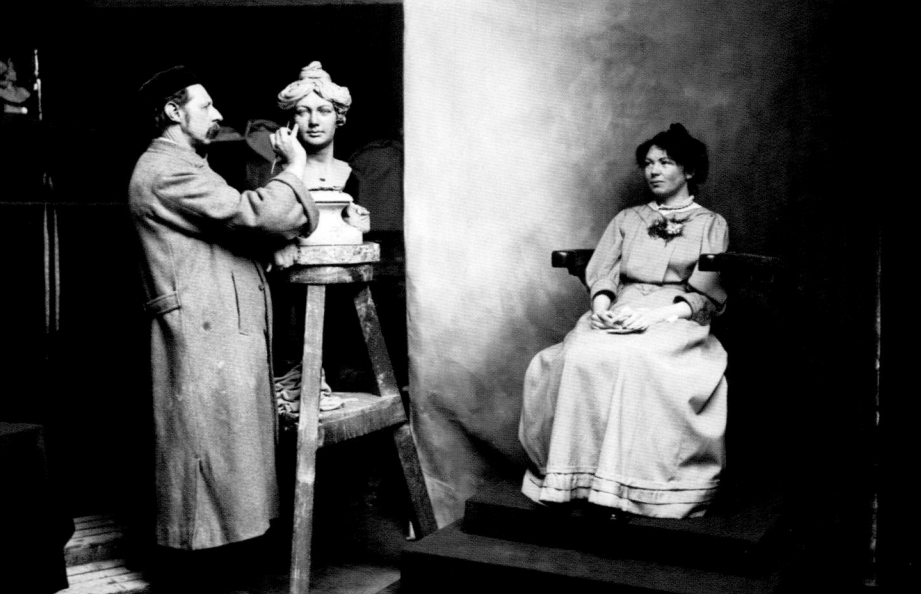

Above: Led by a brass band, suffragettes celebrate their release from prison with a march through the streets.

1908

Left: Christabel Pankhurst, daughter of Emmeline and a committed suffragette, sits for John Tussaud (Madame Tussaud's great-grandson) while he creates her likeness in wax.

1908

Right: Winston Churchill pays off a taxi. In 1908, Churchill was appointed to the Cabinet as president of the Board of Trade. At the time, he was MP for Manchester North West, but the law required that newly appointed Cabinet members seek reselection through re-election. He resigned his seat, but lost it in the subsequent by-election. He soon returned, however, as MP for Dundee. One of his achievements during his time at the Board of Trade was the setting up of Labour Exchanges to help the unemployed find work.

1908

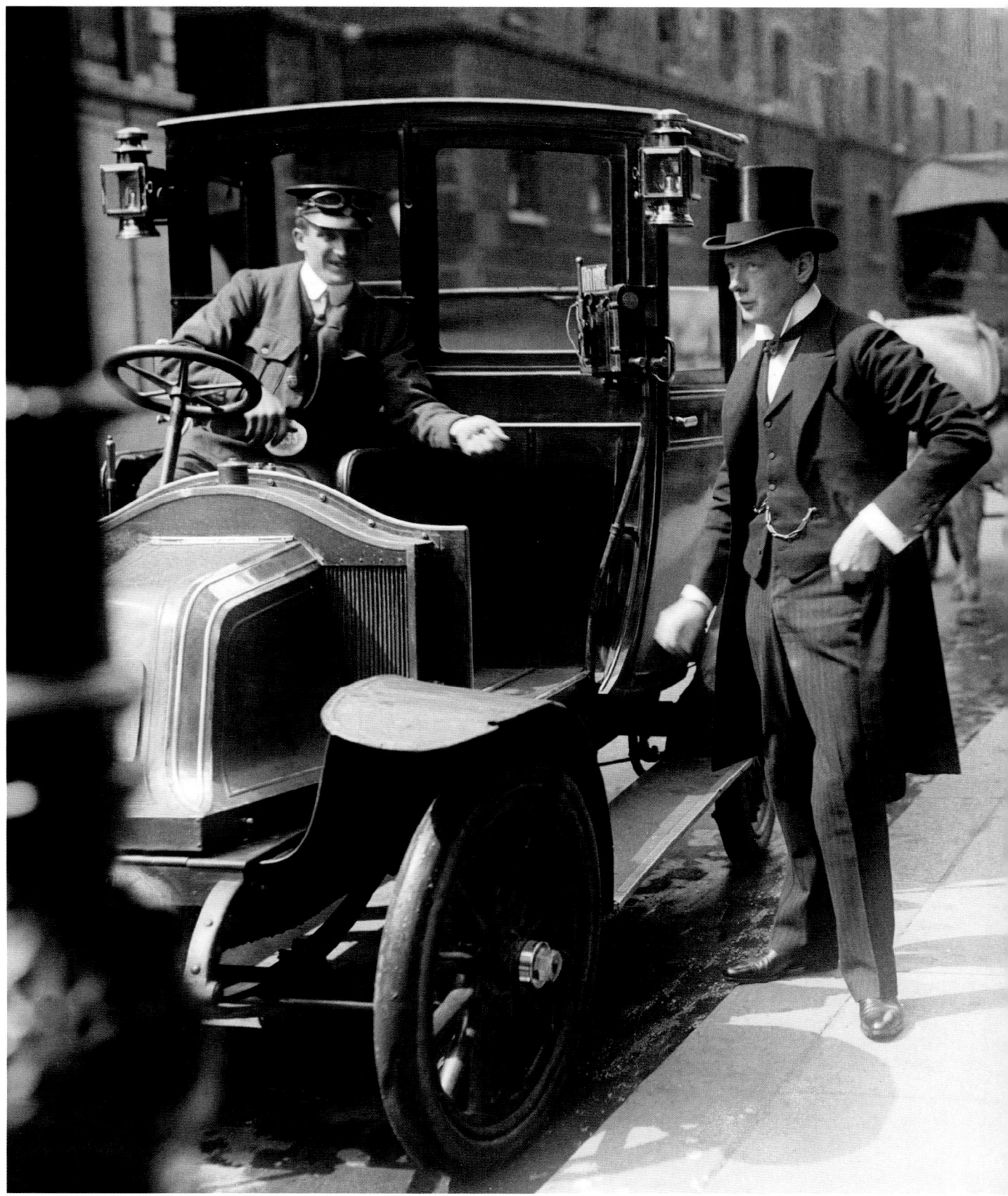

Right: The yacht *Mariska* sails past the Royal Navy's battleship HMS *Agamemnon* at Cowes, Isle of Wight. In 1918, the *Agamemnon* would have the distinction of being the ship on which the Turkish delegation signed the Armistice at the end of the First World War.

1908

Below right: Tsar Nicholas II's black-hulled, 5,557-ton yacht *Standart* (R) at Cowes. Measuring 401ft (122m) in length, the *Standart* was the largest privately-owned vessel in the world. After the Russian Revolution in 1917, the yacht was placed in dry dock until 1936, when she was converted for use as a minelayer. During the Second World War, she played a major role in the defence of Leningrad.

1908

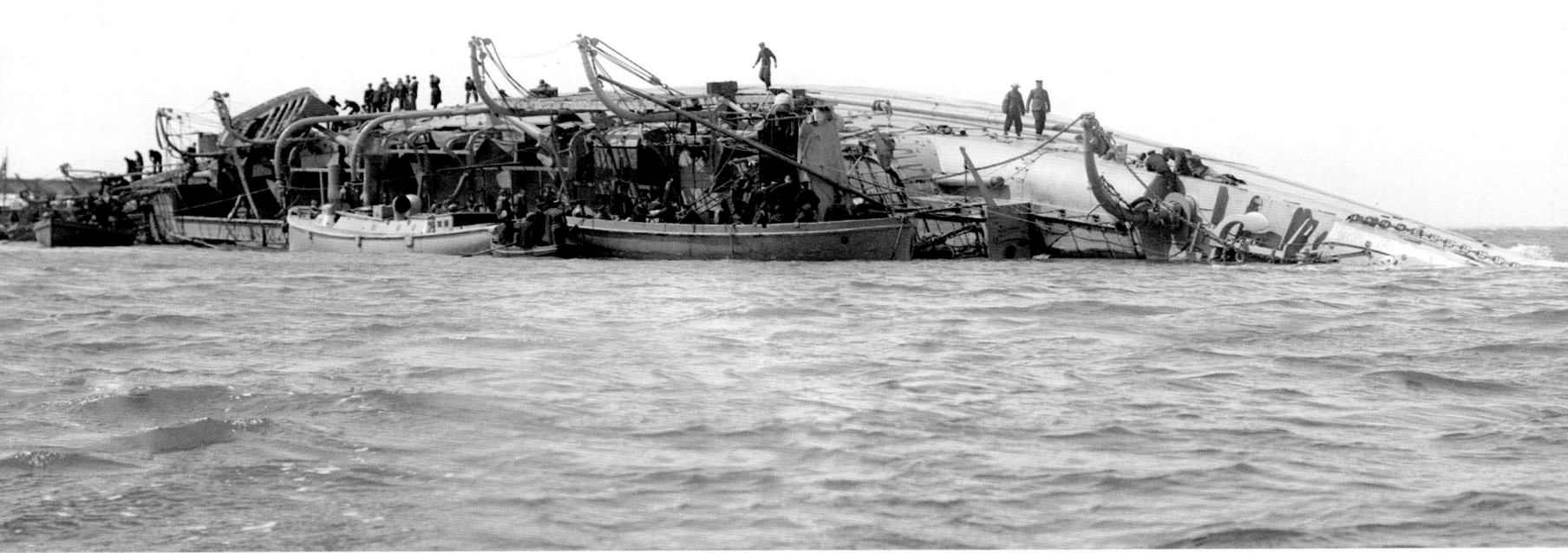

Above: HMS *Gladiator* in shallow water off the Isle of Wight. During a late snowstorm, the *Gladiator* was heading into Portsmouth Harbour when it was struck by the outbound American steamer SS *St Paul*. The passenger ship remained afloat and launched lifeboats, but the *Gladiator* foundered at once. Of the crew of 480, 128 were lost, only three bodies being recovered.

26th April, 1908

Right: George H. Chirgwin, British music hall entertainer, applying black-face make-up. Billed as 'The White Eyed Kaffir', Chirgwin had performed as a black-faced minstrel since childhood. His act was a mix of sentimental songs and wisecracking comedy, accentuated by an outlandish costume and make-up, comprising a tight black body suit, extremely tall hat and a white diamond painted around his right eye.

1908

Below: Wolverhampton Wanderers' FA Cup winning team: (back row, L–R) Rev Kenneth Hunt, Jackery Jones, Billy Wooldridge, Tommy Lunn, Ted Collins, Alf Bishop; (front row, L–R) Billy Harrison, Jack Shelton, George Hedley, Walter Radford, Jack Pedley.

April, 1908

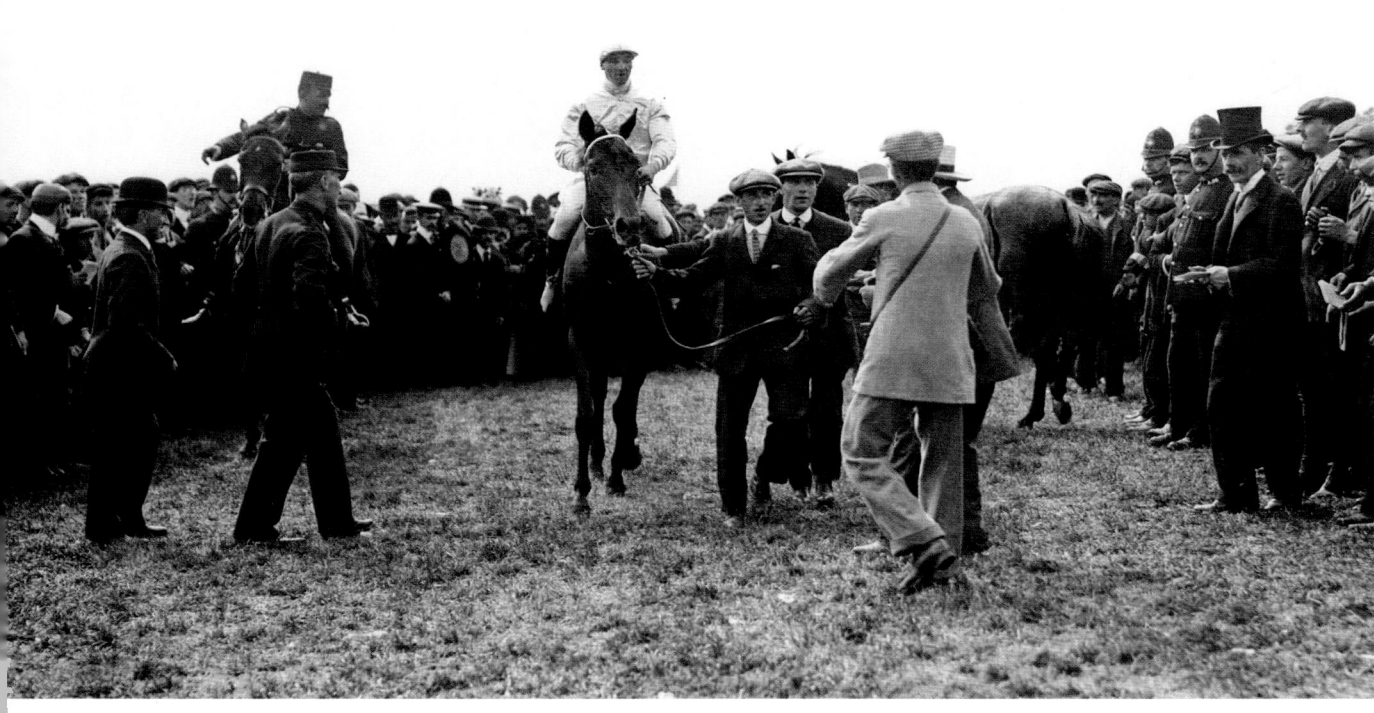

Left: London Olympics: The Great Britain team parades around the White City Stadium during the opening ceremony. The games would continue throughout the year until October.

27th April, 1908

Below left: Synorinetta, with jockey Billy Bullock, being led in after winning the Epsom Derby.

1st June, 1908

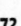

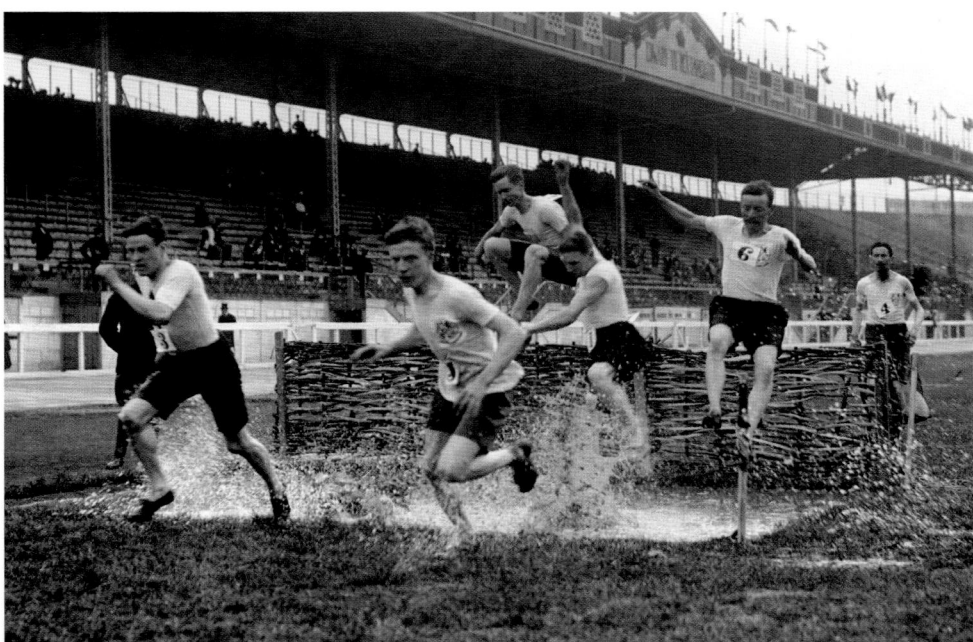

Above left: Competitors prepare for the start of the 100km cycle race at the 1908 Olympics in London.

1st July, 1908

Left: A Danish woman competes in the high jump. Very few women took part in the Olympics in those days. In 1908, there were 37, compared to 1, 971 men.

1st July, 1908

Above: London Olympics: the USA's gold medal winning team in the Team Military Rifle event. The USA came second in the medal tally with 23 golds, 12 silvers and 12 bronzes; Great Britain topped the table with 56 golds, 51 silvers and 39 bronzes.

11th July, 1908

Left: Athletes leap over the wattle fencing and plunge through the water jump during the men's 3,200m steeplechase event at the London Olympics.

18th July, 1908

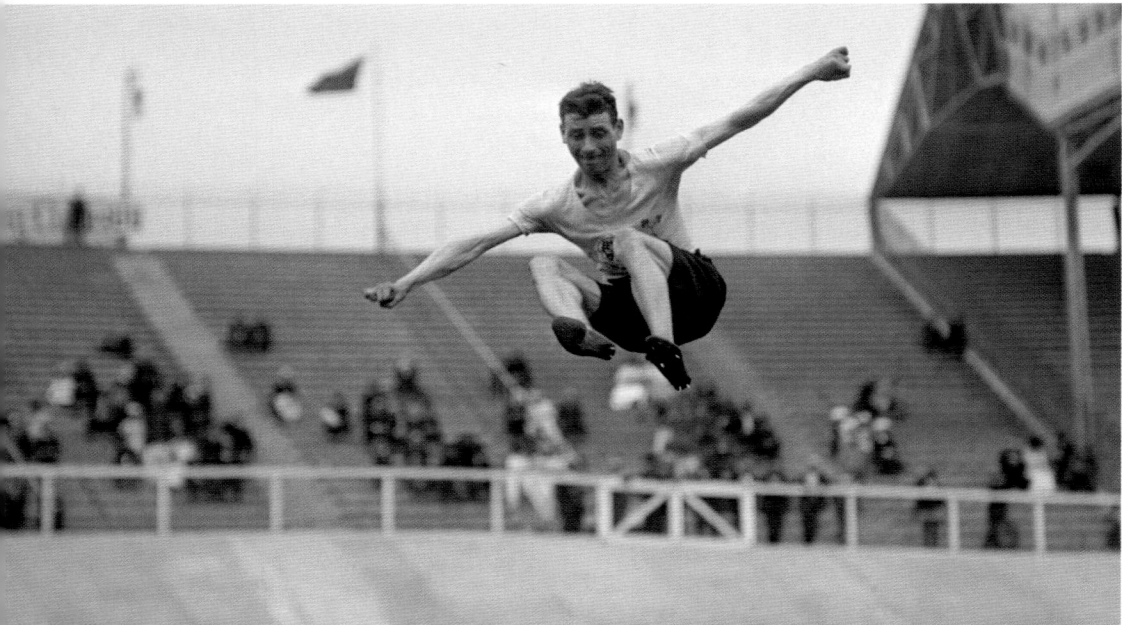

Above: Many events in the early Olympics are no longer featured. In 1908, they included tug of war. Great Britain was represented by the City of London Police team, who won the gold medal.

19th July, 1908

Left: Great Britain's Timothy Ahearne in action in the standing long jump heats.

20th July, 1908

Right: Cyclists monitor the team of Canadian runners as they pass through Windsor during the marathon event.

24th July, 1908

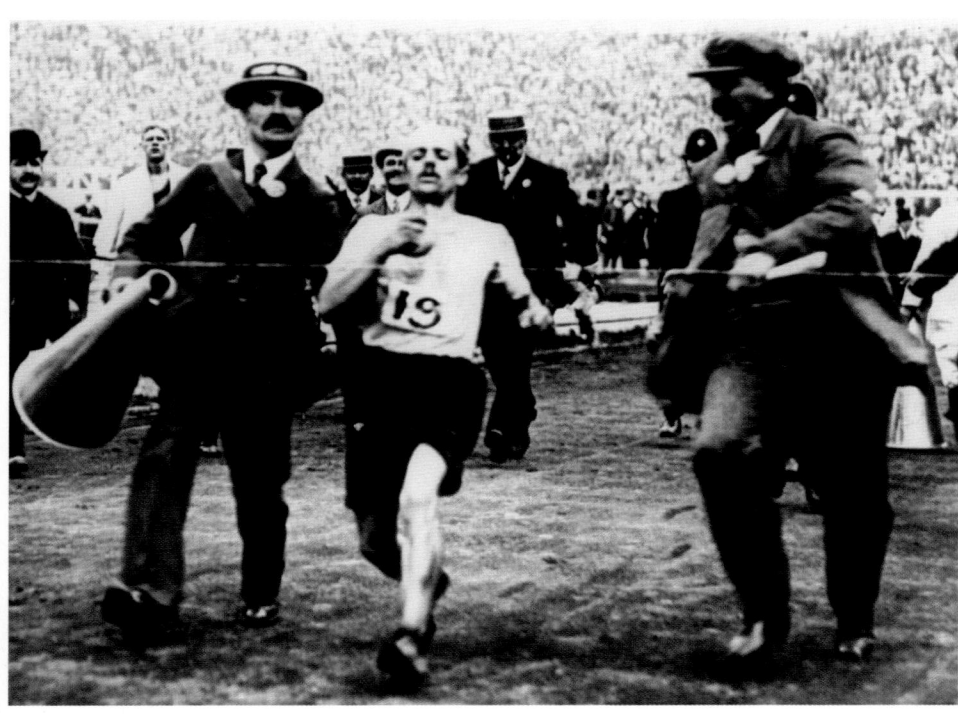

Above: London Olympics: Italy's
Pietri Dorando staggers across
the line to win the marathon. He
was helped by officials to cover the
last few hundred yards, however,
leading to his disqualification.

24th July, 1908

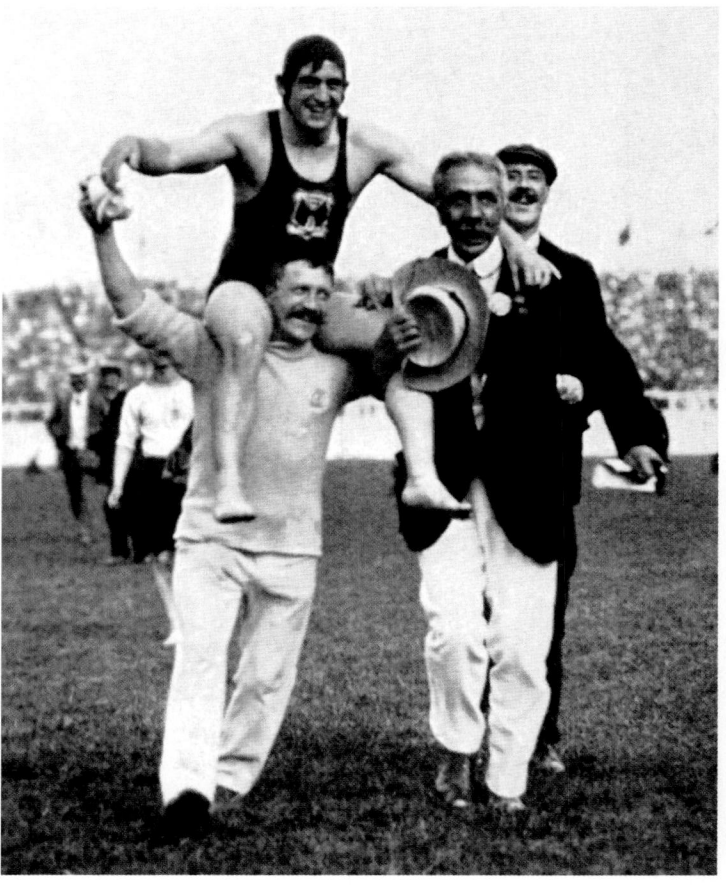

Above: Great Britain's Henry Taylor is carried shoulder-high around
the White City Stadium after swimming the final leg to win gold. He
gained three gold medals in the 1908 Olympics, a feat unequalled by
any British competitor for a hundred years.

24th July, 1908

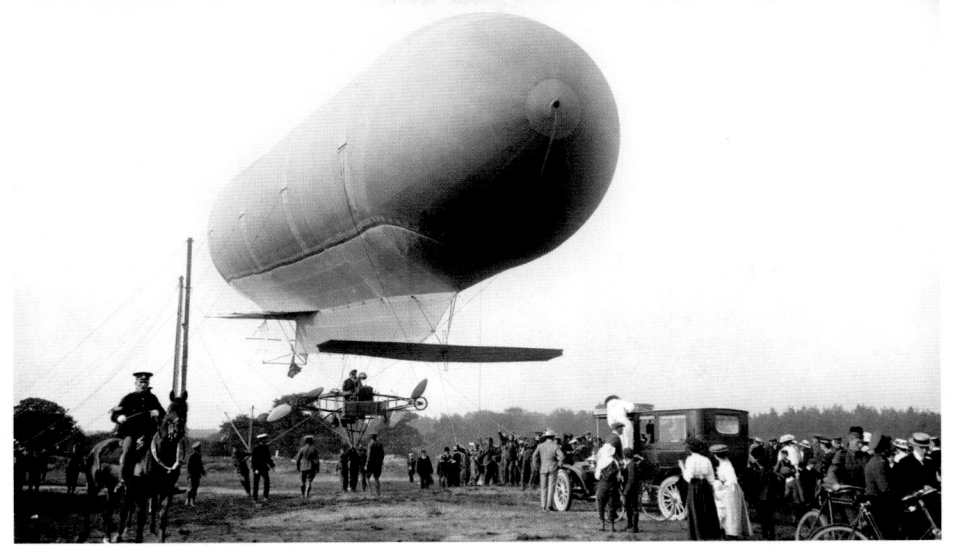

Left: Britain's second military airship, the *Nulli Secundus II*, takes to the air briefly. This was its second flight, which lasted only 15 minutes.

24th July, 1908

Below: During the 1908 London Olympics, rowing events were held at Henley-on-Thames, the UK being represented by the Leander Club, which beat Belgium to win gold in the final of the Coxed Eights.

31st July, 1908

Far left: Gas bags. Balloons are prepared for the Gordon Bennett Race in Berlin. At that time, the race was followed avidly by the newspapers, attracting the kind of attention that only the Olympic Games would receive today. Moreover, balloons were producing far more impressive performances than the recently developed aeroplane, in terms of flight duration, altitude and distance. Britain was represented in the race by Griffith Brewer and Frank K. McClean. The former was an experienced balloonist, while the latter would go on to play a major role in the Royal Aero Club. They lost, however, to the Swiss team of Theodor Schaeck and Emil Messner, who remained aloft for 73 hours, a record that stood until 1995.

11th October, 1908

Left: American aviator and pioneer of manned flight, Samuel Cody, seated in British Army Aeroplane No 1 before testing at Farnborough.

16th October, 1908

Below: Cody airborne in British Army Aeroplane No 1 during the first British powered flight. The flight lasted 27 seconds and covered a distance of 1,390ft (424m) over Farnborough Common.

16th October, 1908

Right: Artist Tom Mostyn. Born in Liverpool in 1864, Mostyn studied at the Manchester Academy of Fine Arts and was showing at the Royal Academy by the age of 29.

1909

Below: Jules Gautier, the manacled swimmer, about to undertake a record swim with hands and feet manacled. For a wager of £100, he swam the University Boat Race course, from Putney to Mortlake, on the River Thames while towing this boat, covering the distance in 1 hour, 30 minutes, 12 seconds.

1909

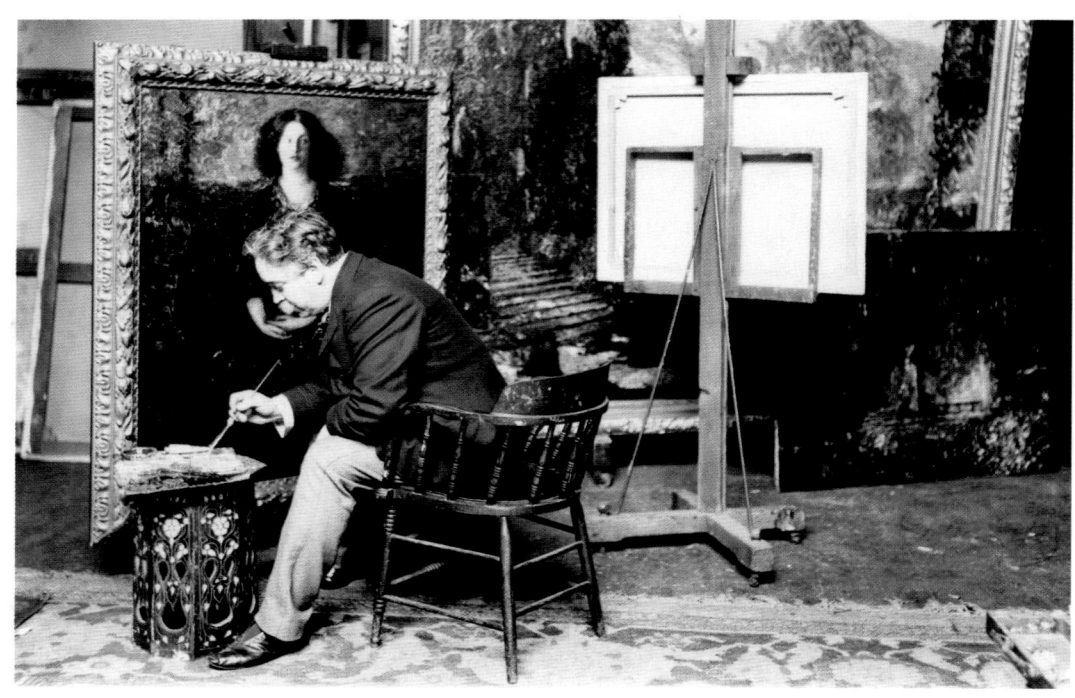

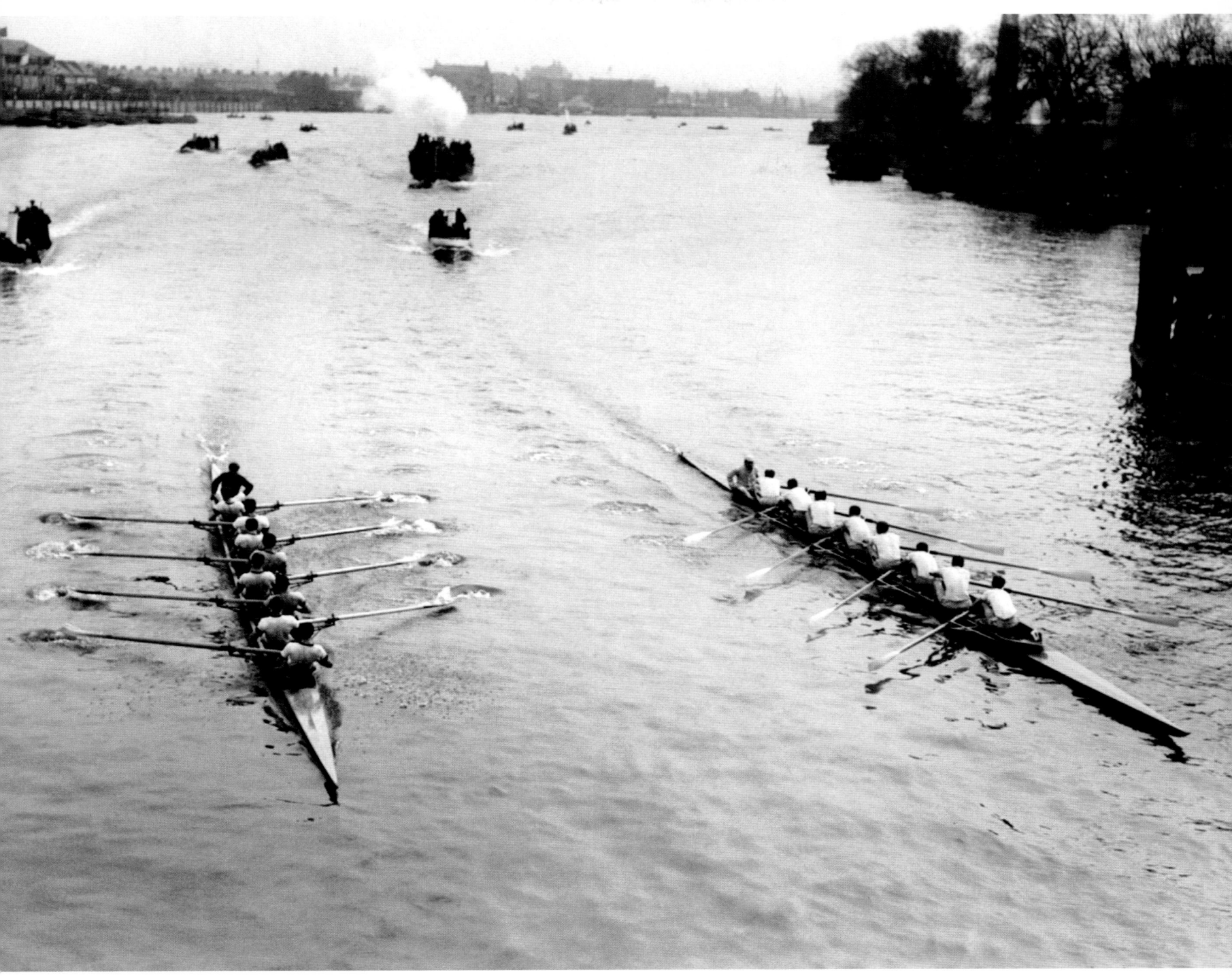

Above: Crews from Oxford and
Cambridge universities take part
in the annual Boat Race. Oxford (L)
would win in a time of 19 minutes,
5 seconds.

1909

Above: Clad in traditional smocks, this group of hunt beaters takes a break to enjoy their lunch. The occasion was the visit of King Edward VII and the Prince of Wales to Hall Barn, Beaconsfield, country home of Lord Burnham.

1909

Right: Mary, Princess of Wales leaving the Phoenix tin mine, high on Bodmin Moor, during a three-day tour of Cornwall with the Prince of Wales (the future King George V). The Princess named and officially started what would be the last large pumping engine designed, built and erected in Cornwall.

10th June, 1909

NO ADMITTANCE

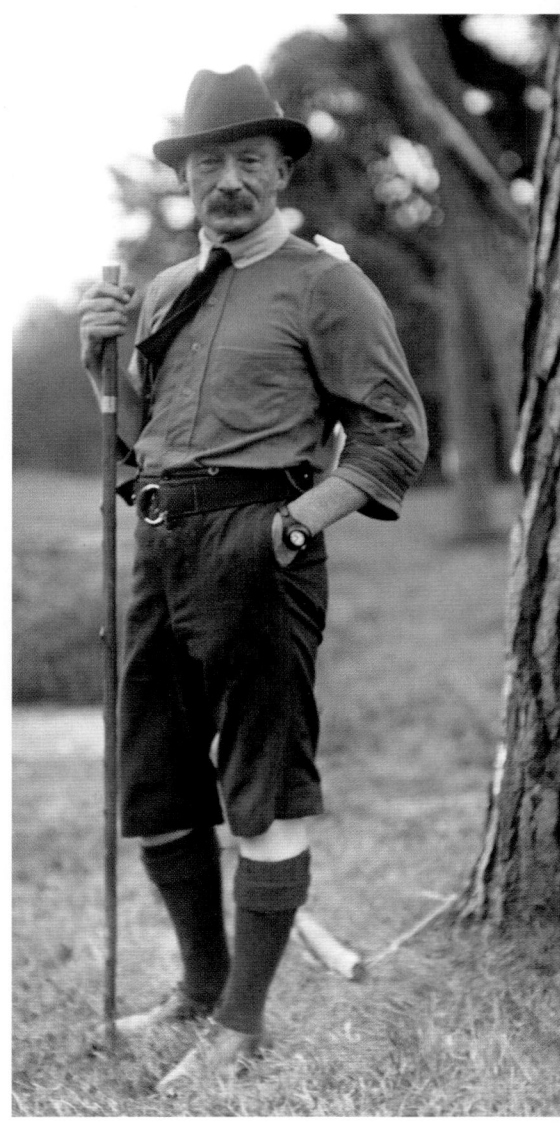

Above: Lieutenant General and Inspector General of Cavalry Robert Baden-Powell. An experienced soldier who had served with distinction in South Africa, Baden-Powell is famous for creating the Scout movement. He died in 1941, having spent the last years of his life in Kenya.

30th June, 1909

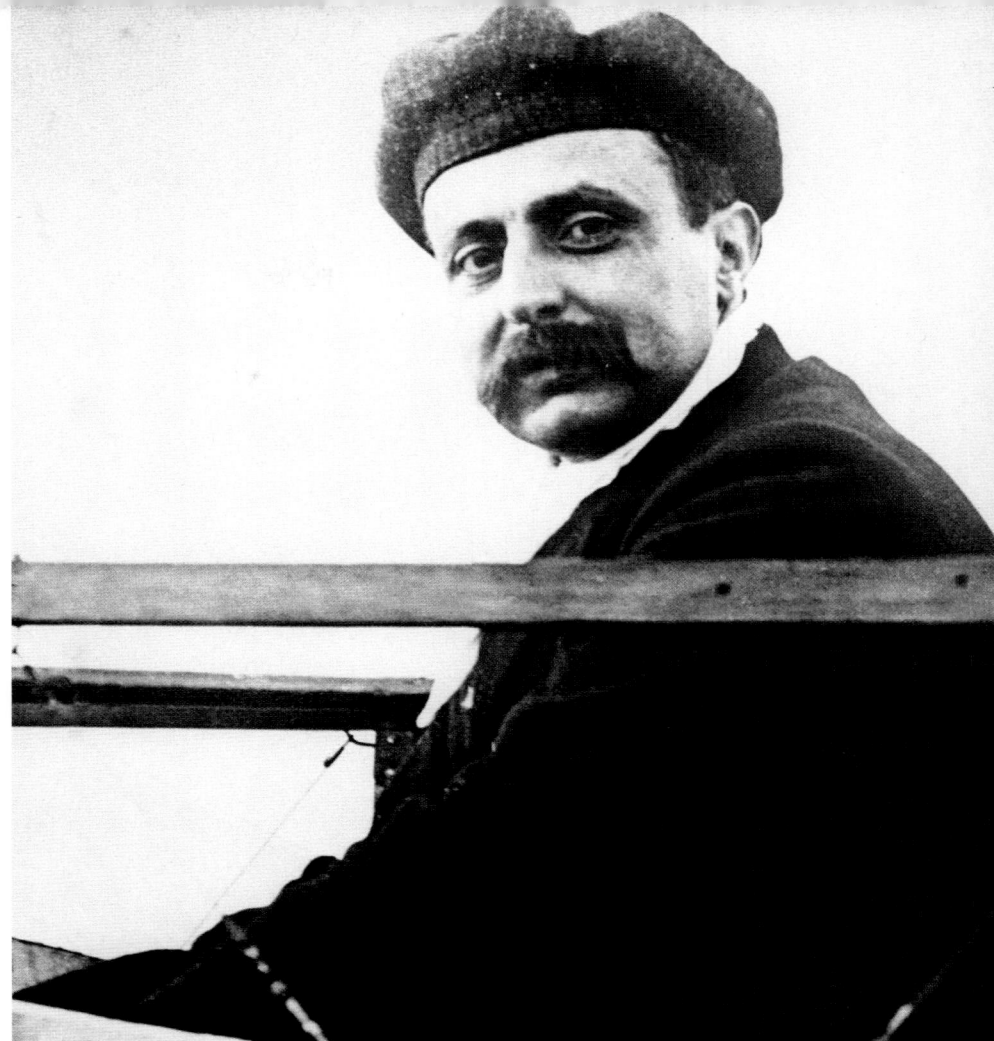

Above: Louis Blériot in his Blériot XI
aeroplane after making the first
powered flight across the English
Channel, overshadowing longer
flights already made over land by
the Wright brothers and others. For
the feat, he received a prize of
£1,000 from newspaper proprietor
Lord Northcliffe. H.G. Wells wrote,
*"England is no longer, from a
military point of view, an
inaccessible island."*

25th July, 1909

Left: People enjoying the sun on
the cliffs at Folkestone in Kent.

1st July, 1909

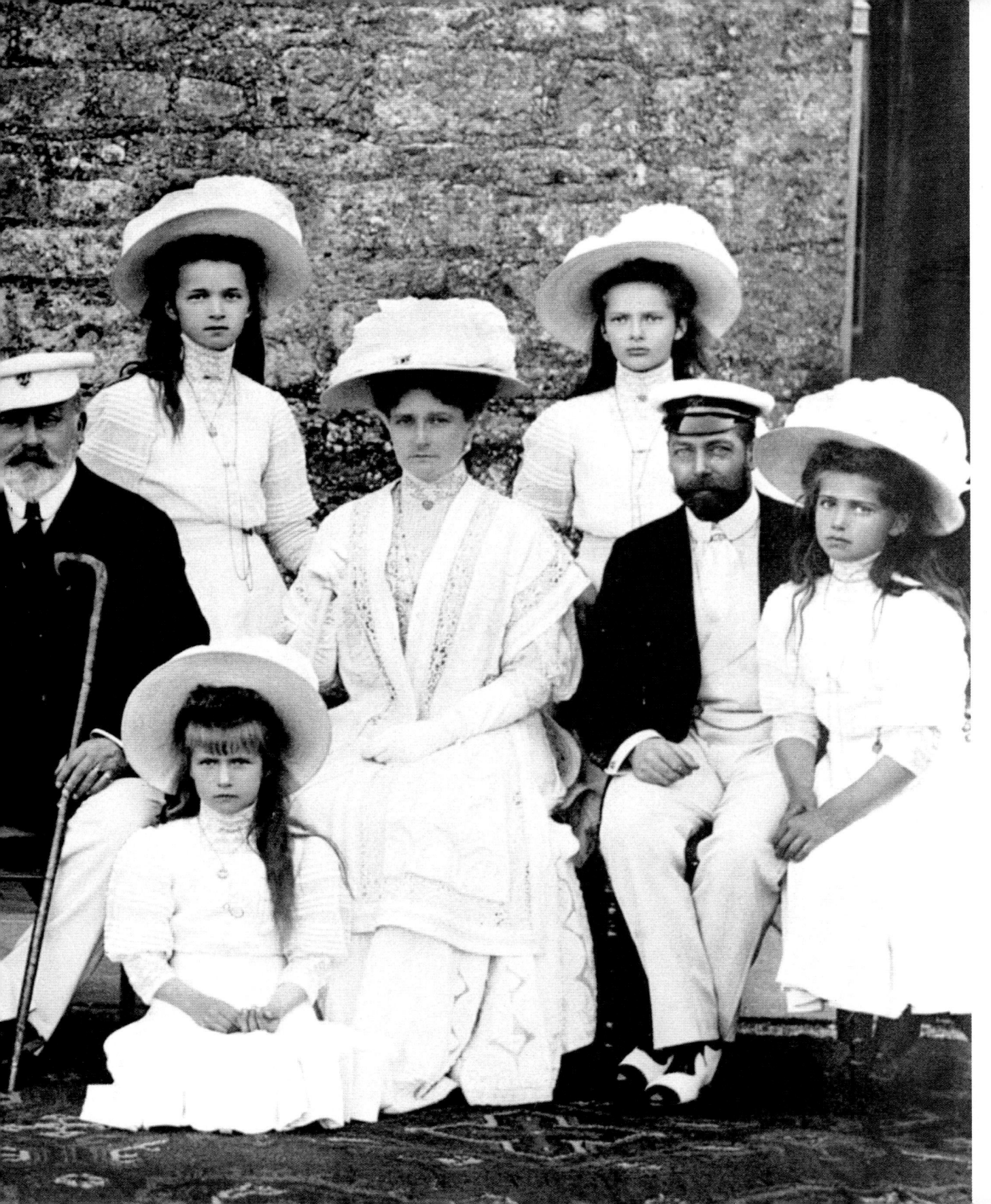

Left: A poignant Royal Family portrait shows (L–R) Queen Alexandra, Princess Mary (standing), the Prince of Wales, King Edward VII, and the Tsarina and Tsar of Russia, surrounded by their children. The Romanovs would be executed following the Russian Revolution in 1917.

4th August, 1909

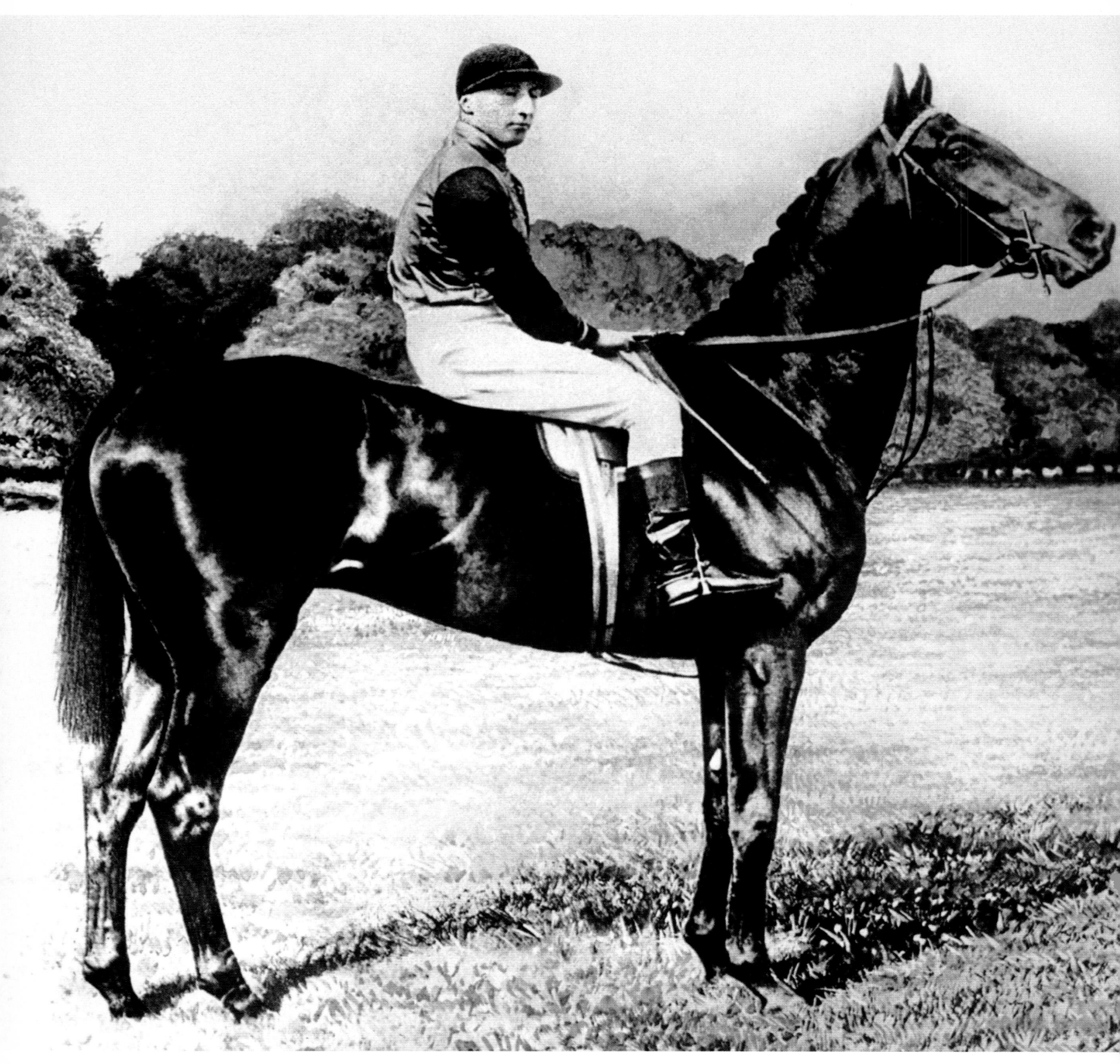

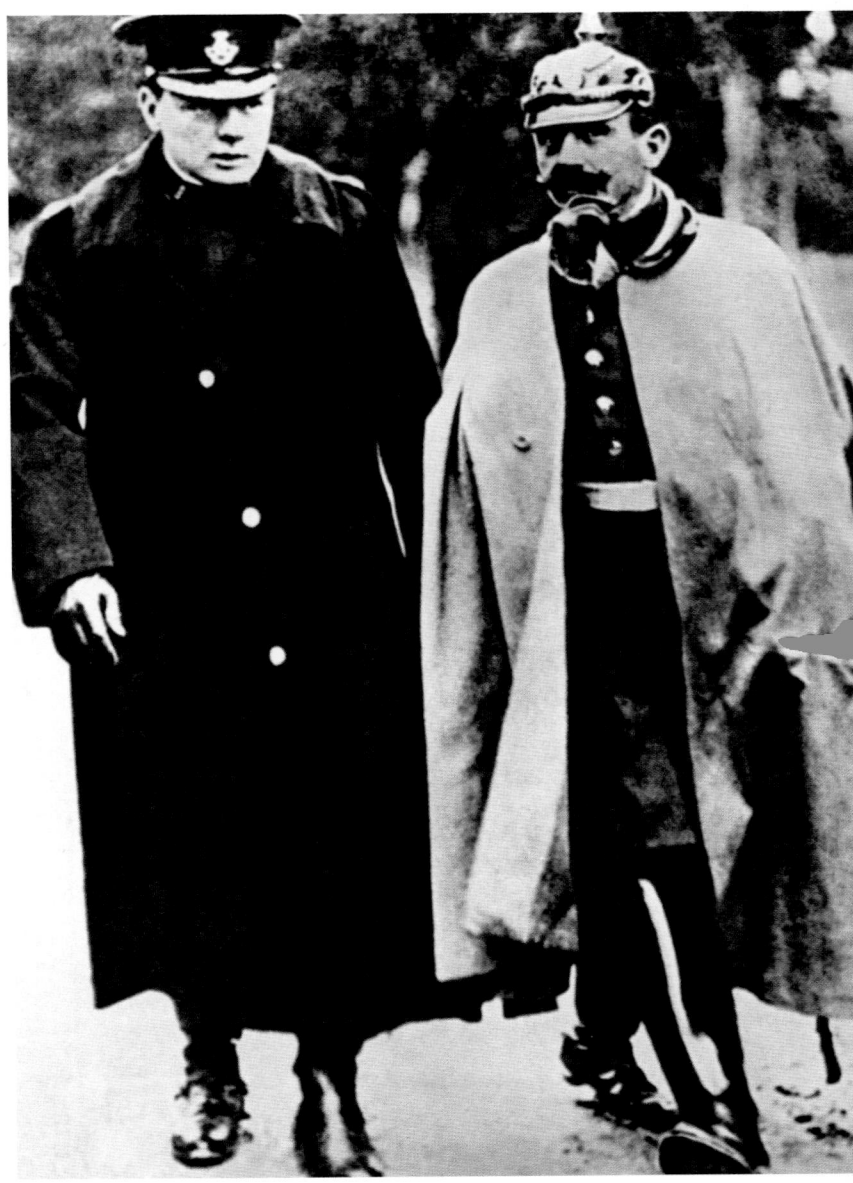

Left: King Edward VII with his horse Minoru, the 1909 Derby Stakes winner.

1st September, 1909

Right: Winston Churchill and the German Emperor, Kaiser Wilhelm II. The latter was demonized by the British during the First World War, being known popularly as 'Kaiser Bill'.

2nd October, 1909

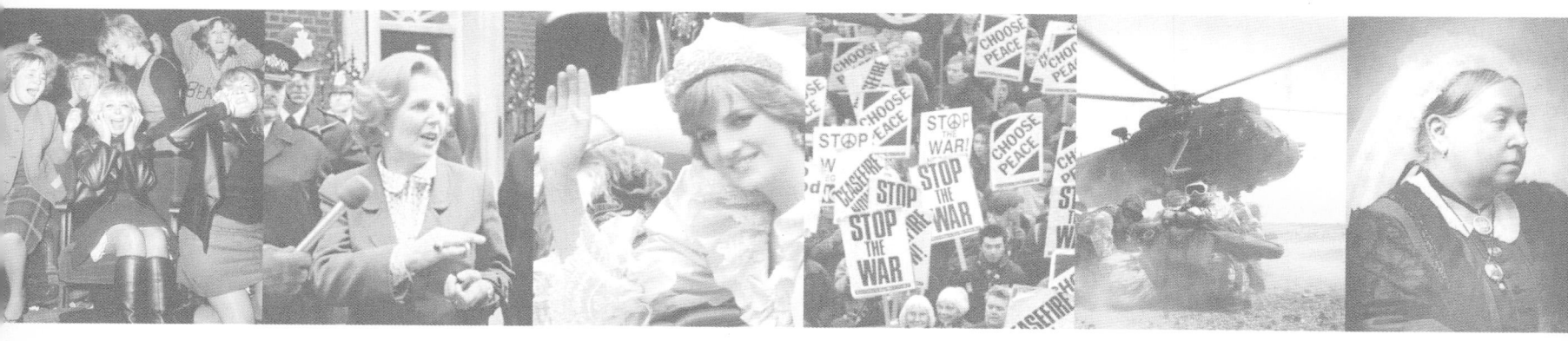

1910s

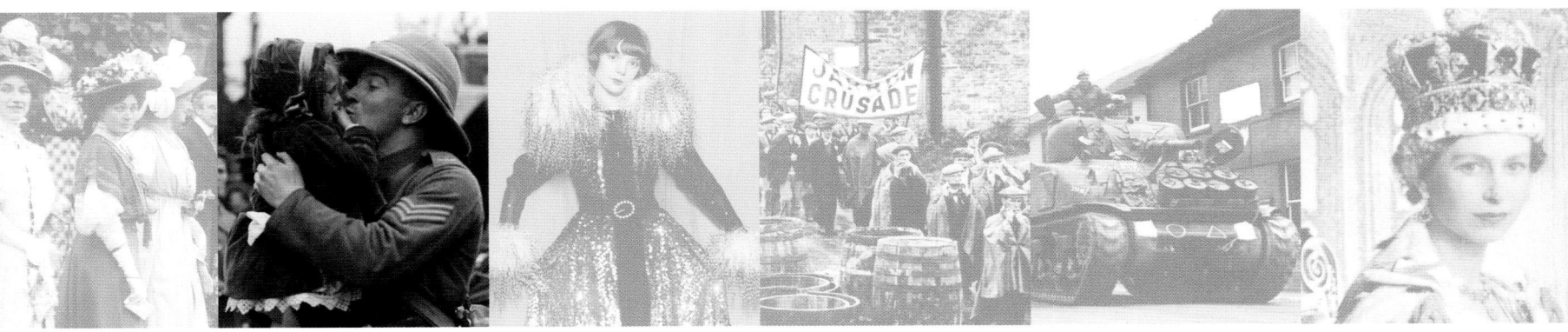

The decade between 1st January, 1910 and 31st December, 1919 encompasses a time of deep change in British society. Naturally, the First World War — not, of course, the 'War to End All Wars', as was thought, but an apocalyptic episode nonetheless — dominates those years and is considered to be responsible for the end of the servant culture in Britain. But was it? Even before the war tore a generation of young men from the nation, leaving those who were spared to question the old order, there was conflict between ordinary Britons and their 'masters'. A new industrial unrest became apparent on a large scale in the strikes at the beginning of the decade. Women were prepared to die in their struggle to achieve suffrage, while in Ireland there was an armed uprising against British rule, surely the most overt statement possible of dissatisfaction.

There can be no doubt that those in power must have watched with increasing unease as the revolution in Russia began to gain pace, and its Royal Family — closely related to Britain's own — was overthrown and executed. War or no war, it seems, social upheaval was inevitable.

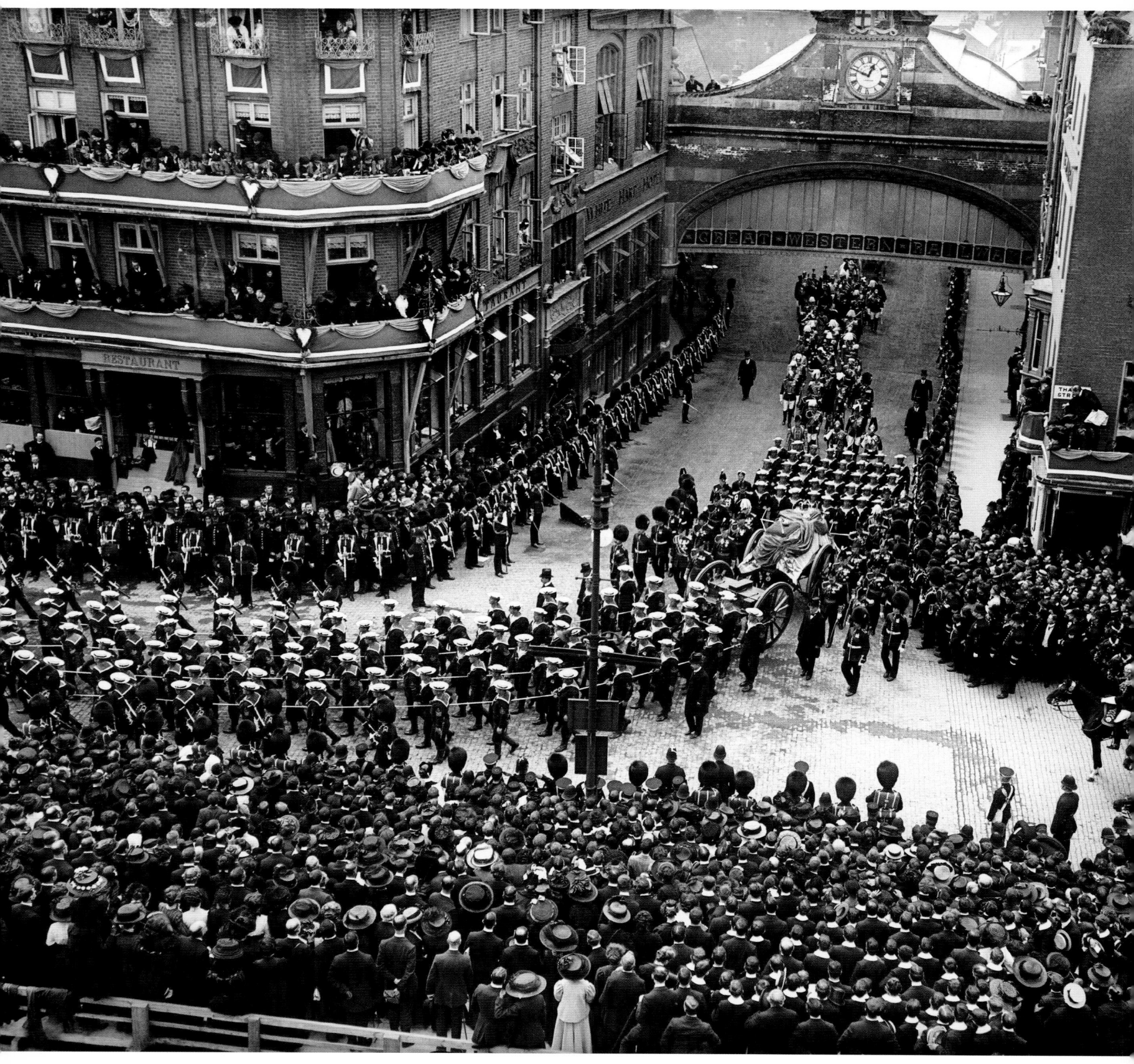

Left: The funeral cortege of King Edward VII arrives at Windsor, Berkshire for the King's burial.

20th May, 1910

Right: Dr Hawley Crippen with Ethel Neave, his alleged accomplice, during their trial for murder. Crippen was hanged in Pentonville Prison, London, after being convicted of murdering his wife and hiding her remains in the cellar of his London home in 1910. The couple tried to escape to Canada, but were caught after Henry Kendall, the captain of the SS *Montrose*, recognized Crippen and alerted Scotland Yard by radio.

30th September, 1910

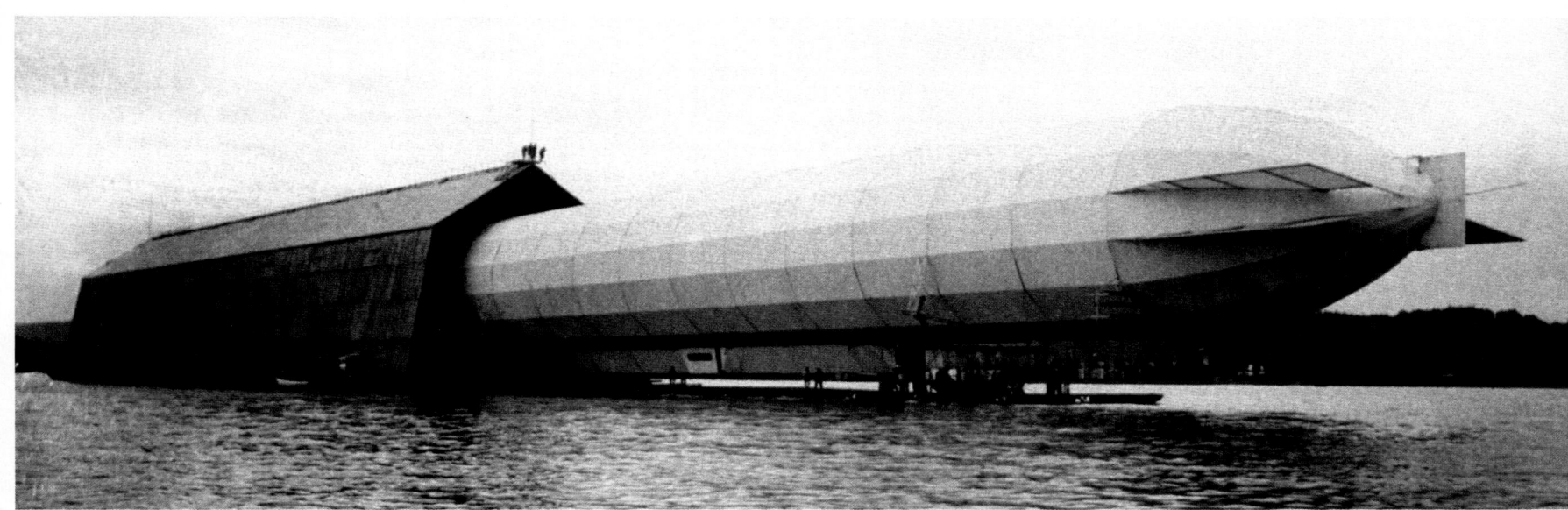

Above: In the early 20th century, Germany led the world in the development of the rigid airship, thanks to the efforts of Count Ferdinand von Zeppelin, whose designs achieved such success that the name 'zeppelin' became a generic term for the machines. The world's first commercial airline, Deutsche Luftschiffahrts-AG, operated services with zeppelins prior to the First World War, and Germany made extensive use of them to bomb London and other major cities in Britain during the war. Here, the LZ-3, the first successful zeppelin, enters its floating hangar on Lake Constance in southern Germany. A floating hangar was chosen because it could be aligned with the wind, easing the process of launching and retrieving the zeppelin.

10th October, 1910

Above: A face in the crowd. George Bernard Shaw (C, beard), Irish dramatist and critic, at a public meeting in London's Trafalgar Square. He was an active socialist and Fabian, and his progressive ideas informed much of his work.

1910

Right: Boy Scouts listen intently to their Scout Leader as he instructs them in the art of taking a compass bearing. The Scout movement had been formed only three years earlier by Robert Baden-Powell, a lieutenant general in the British Army. Campaign hats and wooden staves have long since disappeared from their equipment.

1910

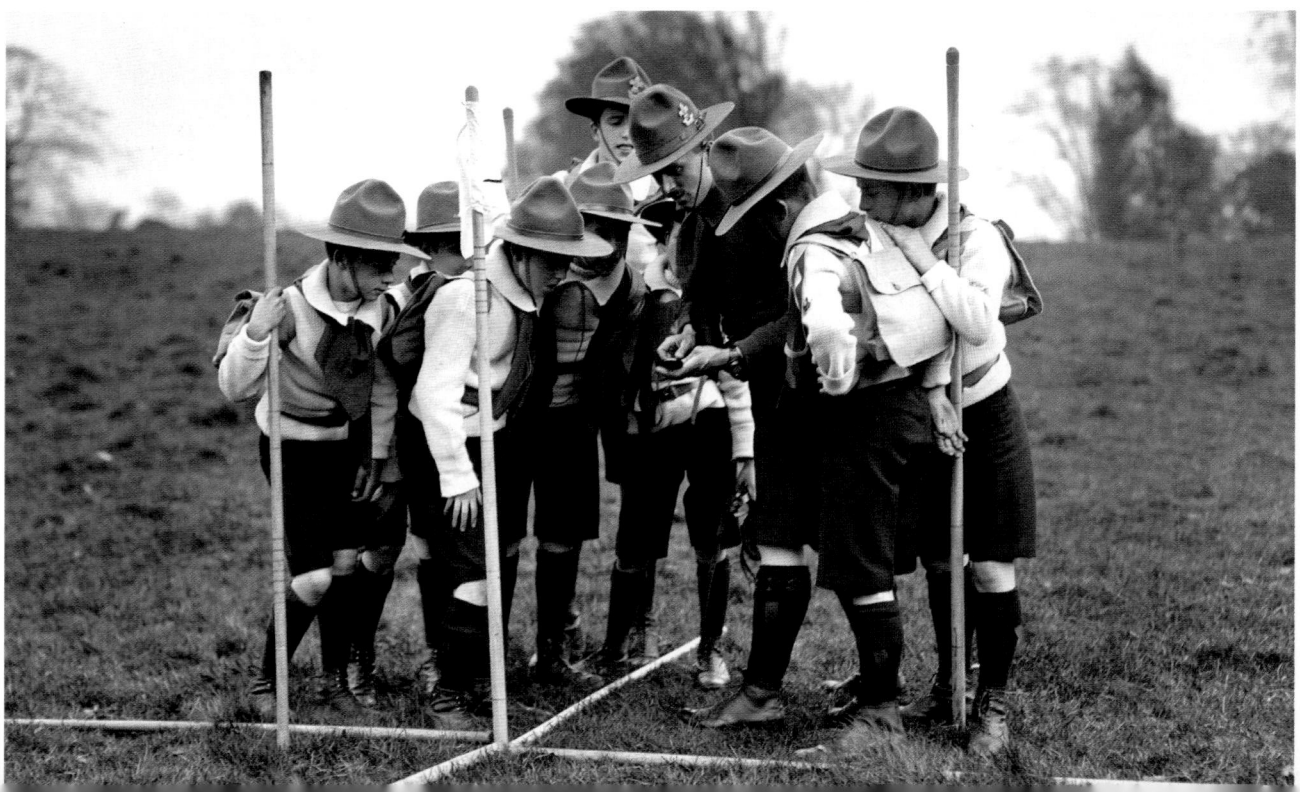

Right: An early cost-cutting exercise. A camel is put to economic use mowing the lawns at Regent's Park Zoo.

1911

Below: Deadman's Dock, London. Also known as Dodman's Dock, the wharf was given its name because of the shipbuilder Dudman and Company, which used to operate there. It was sold to the Brighton and South Coast Railway in 1850, and subsequently passed to the Southern Railway and then British Rail. Today, it is the site of the Surrey Quays shopping centre on the Isle of Dogs.

1911

96

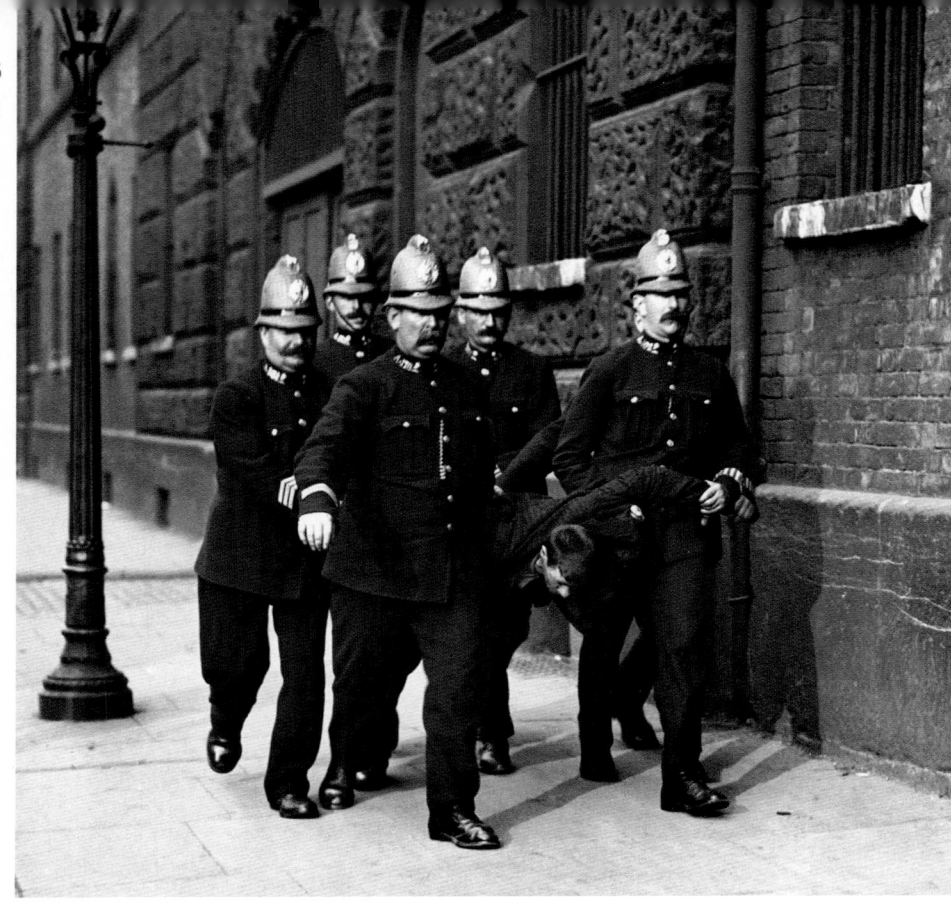

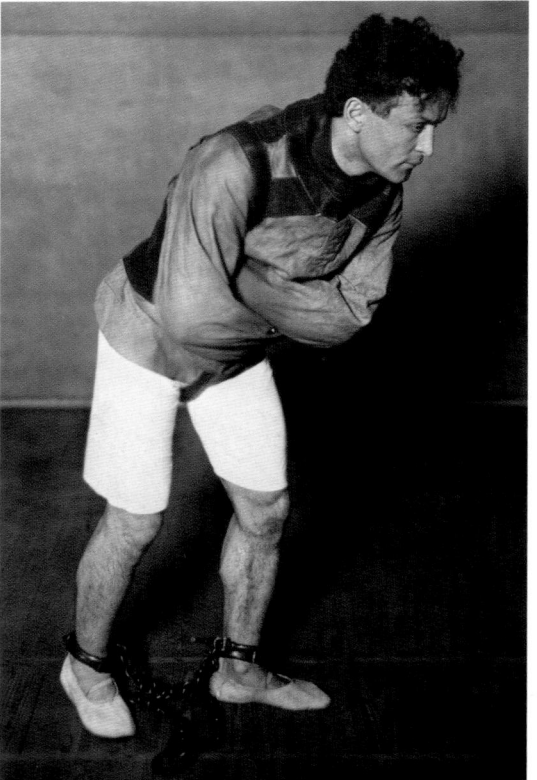

Above: Police frog-march a prisoner in Liverpool.

1911

Right: Winston Churchill (L, top hat) during the Siege of Sidney Street, East London. The siege came about when a gang of Latvian revolutionaries, who previously had shot two policemen, were traced to a house in Sidney Street. Armed police and soldiers surrounded the house, which caught fire, killing those inside.

3rd January, 1911

Left: Legendary escapologist Harry Houdini, whose acts brought him great acclaim. He appeared in Britain on several occasions, even storing an aeroplane in the country so that he could fly from city to city during a music hall tour.

1911

Right: French actress Sarah Bernhardt in *Theodora* at the Coliseum Theatre, London. Popularly known as 'the Divine Sarah', Bernhardt made her reputation on the stages of Europe during the 1870s. In the early 20th century, she became a pioneer silent-movie actress. In 1905, she had injured her leg on stage, but it had never healed properly and by 1915 gangrene had set in. The leg was amputated, but she continued her career without the aid of a prosthetic.

June, 1911

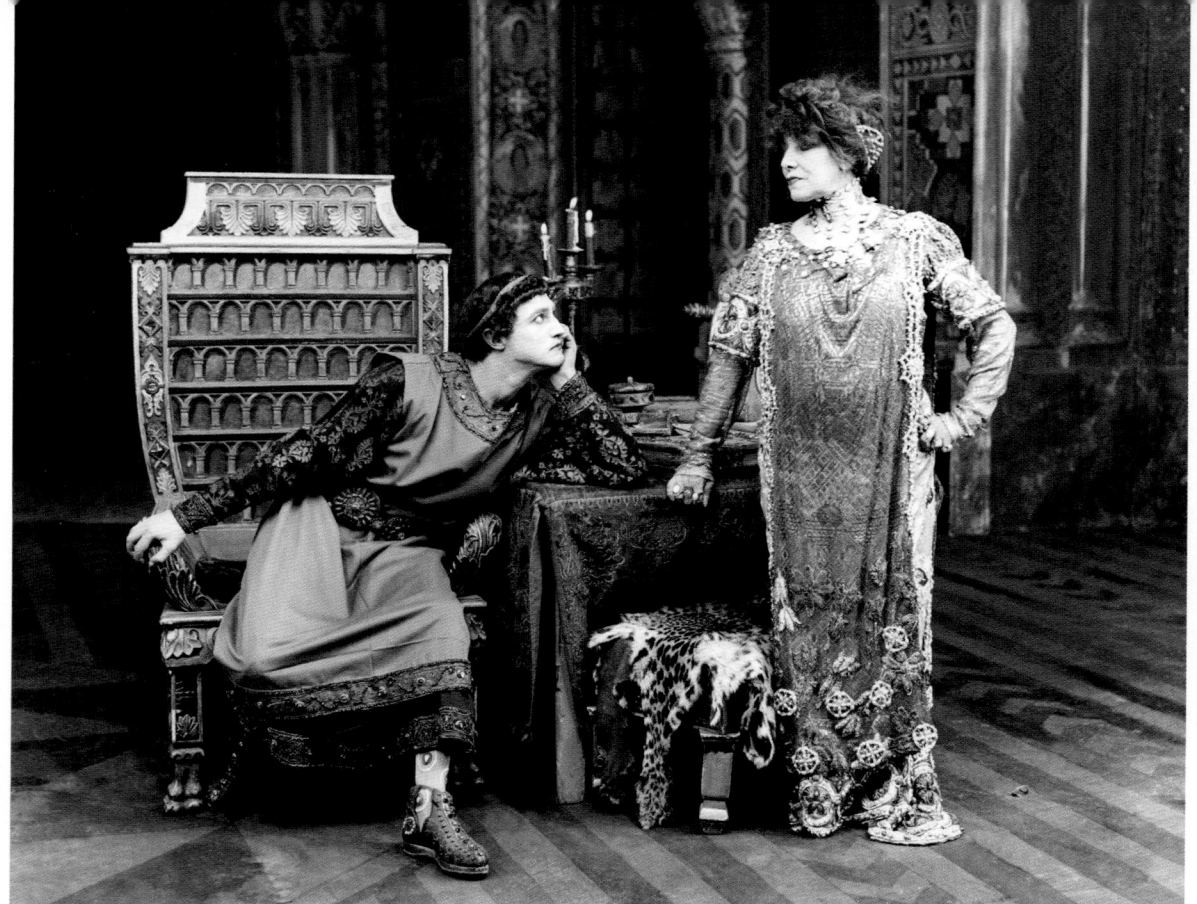

Above: Italian radio pioneer Guglielmo Marconi, who developed wireless telegraphy and successfully transmitted signals across the Atlantic.

1911

Right: Pearly royalty at Peckham Derby Show. The custom of wearing clothes decorated with pearl buttons had started in the 19th century and was part of a charitable tradition associated with working-class Londoners.

June, 1911

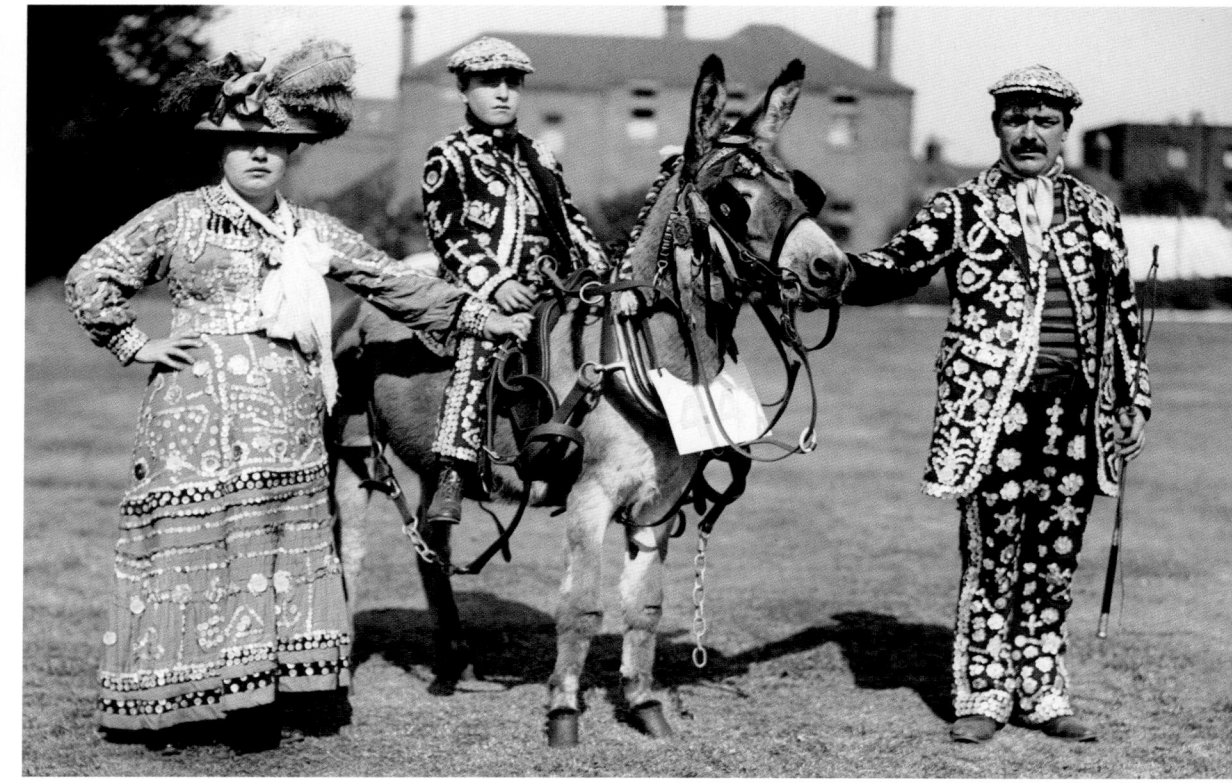

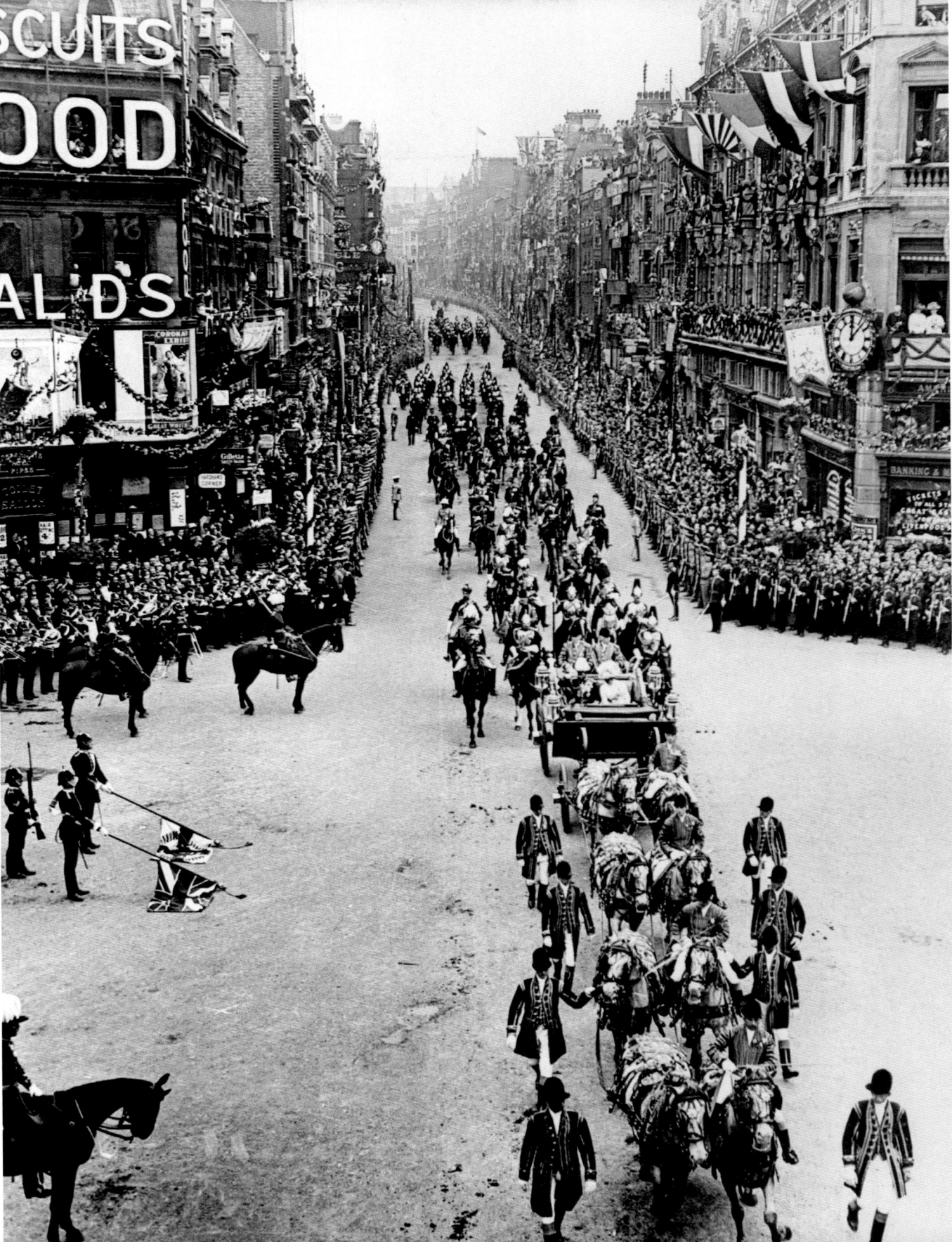

Right: The coronation procession of King George V passes down Fleet Street. To celebrate the coronation of the new monarch, a Festival of Empire was held at the Crystal Palace in south London. The festival included an exhibition of products from the countries of the empire displayed in three-quarter-scale replicas of their parliament buildings; a pageant dramatizing the history of London, Britain and the Empire; and an inter-Empire sports championship.

22nd June, 1911

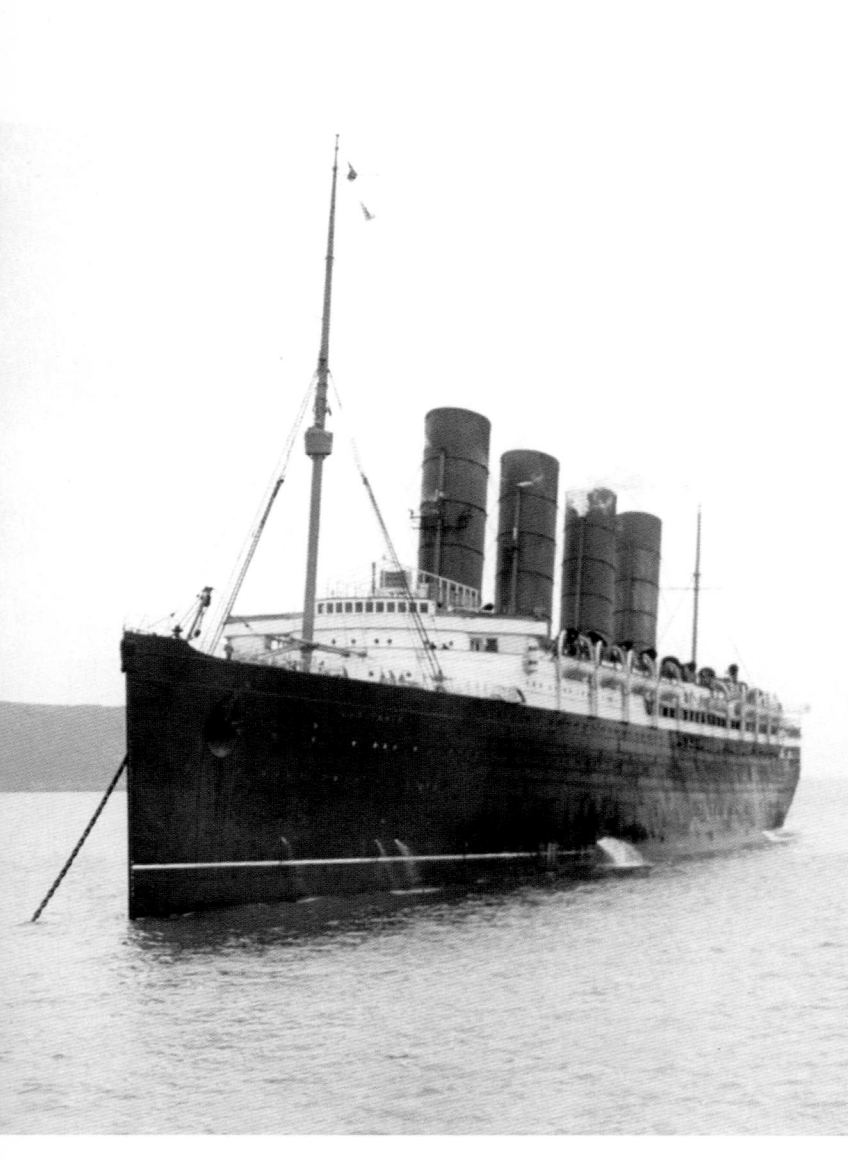

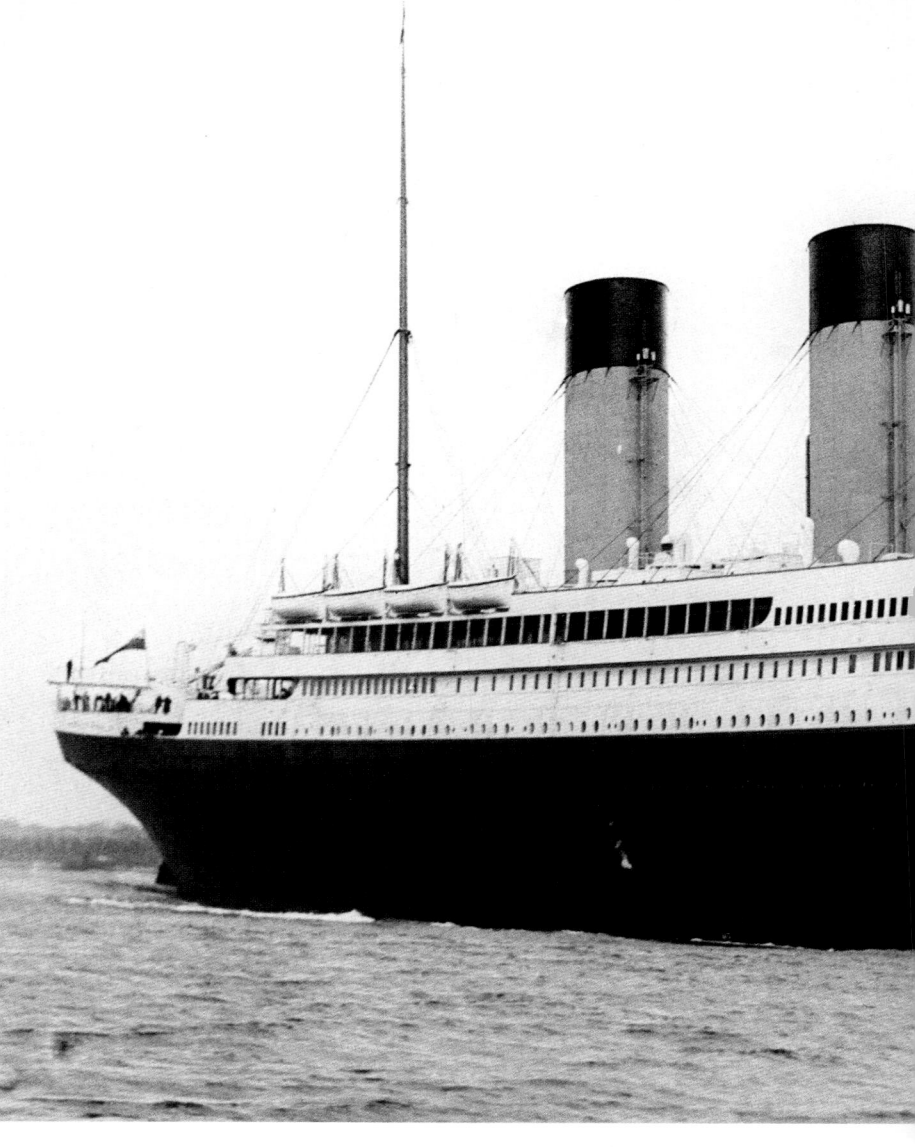

Above: The transatlantic liner
Lusitania moored in the Mersey,
at Liverpool. Her sinking by the
German U-boat U-20, 12 miles off
the coast of Ireland in 1915, and
the subsequent loss of life among
American passengers, is thought to
have prompted the United States
to enter the First World War on the
Allied side.

1911

Above: The 'unsinkable' transatlantic liner RMS *Titanic*. Belonging to the White Star Line, the ship sank off Newfoundland on her maiden voyage to the USA after striking an iceberg in April 1912; 1,513 people lost their lives.

1912

Right: *Titanic* First Officer William McMaster Murdoch. Portrayed as a cowardly murderer in the 1997 movie, he is actually considered to be a hero of the disaster by historians.

1911

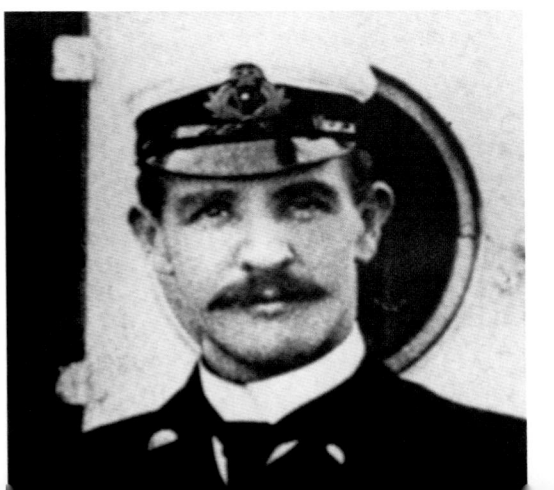

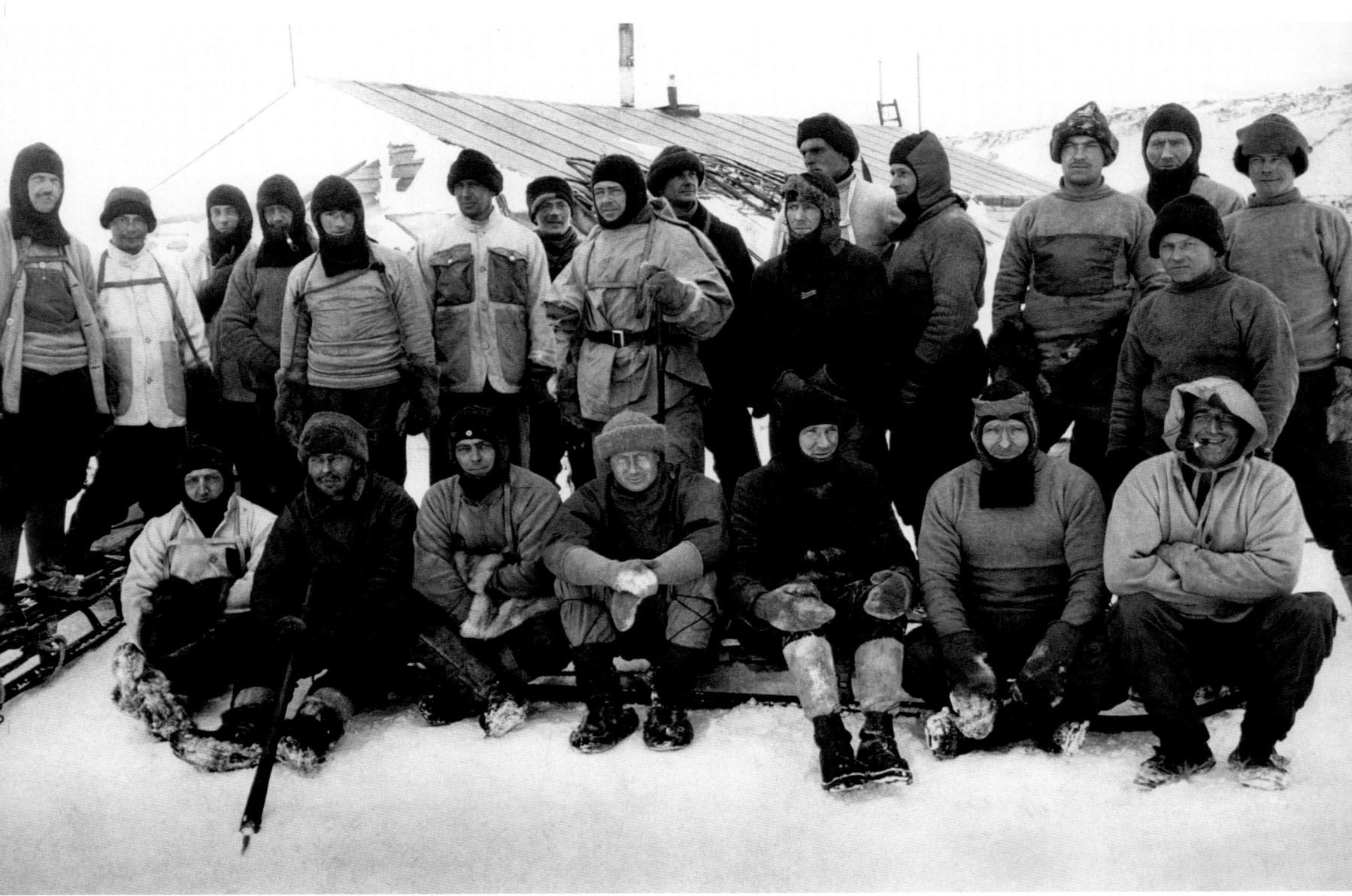

Above: Captain Robert Falcon Scott RN
(standing C, wearing balaclava) and members of
the ill-fated British Antarctic Expedition.

1912

Left: Cecil Meares and Lawrence Oates in the
stable at Scott's base camp. Oates would go with
Scott to the Pole and would sacrifice himself for
the sake of his companions on the return journey
by walking off into a blizzard with the words:
"I am just going outside and may be some time."

1912

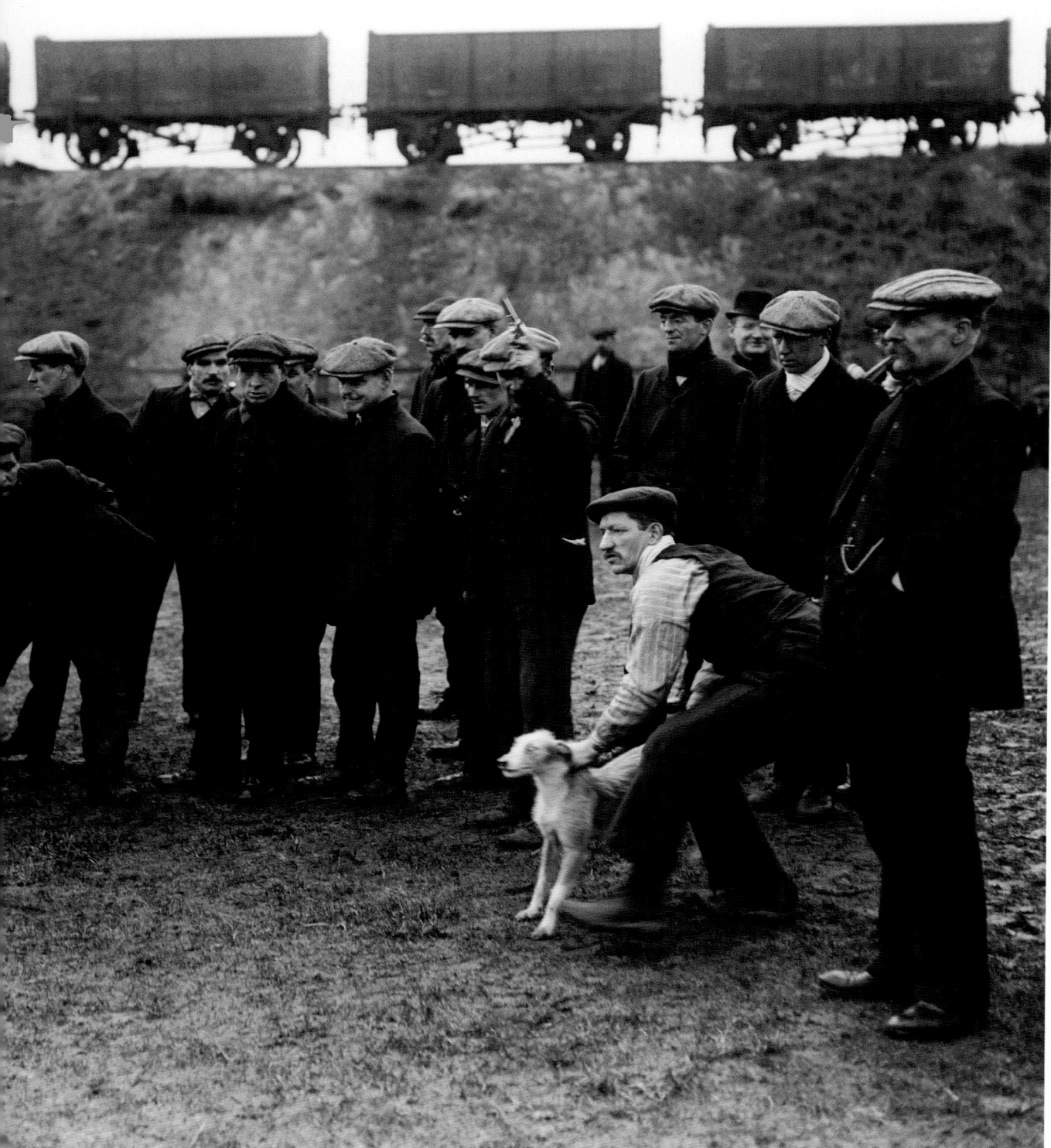

Left: A group of miners racing their pet whippets during a coal strike in Northumberland. Empty coal trucks stand idle in the background.

1912

Right: A strike meeting at Tower Hill in London during the Great Transport Strike. The years leading up to the First World War saw increasing industrial unrest in Britain, with dockers, transport workers and miners all pressing for increased wages. The outbreak of war brought an end to the troubles.

1912

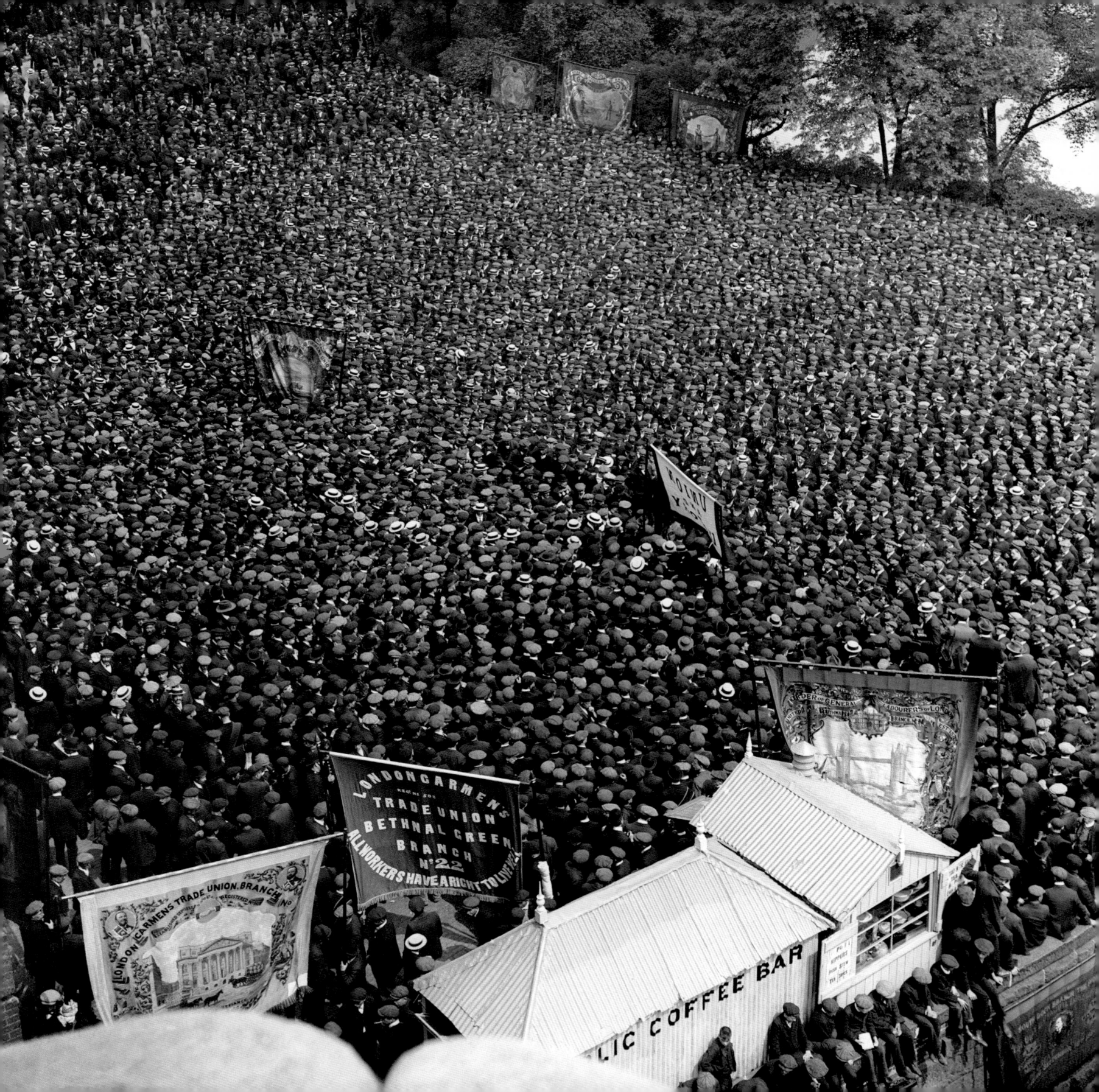

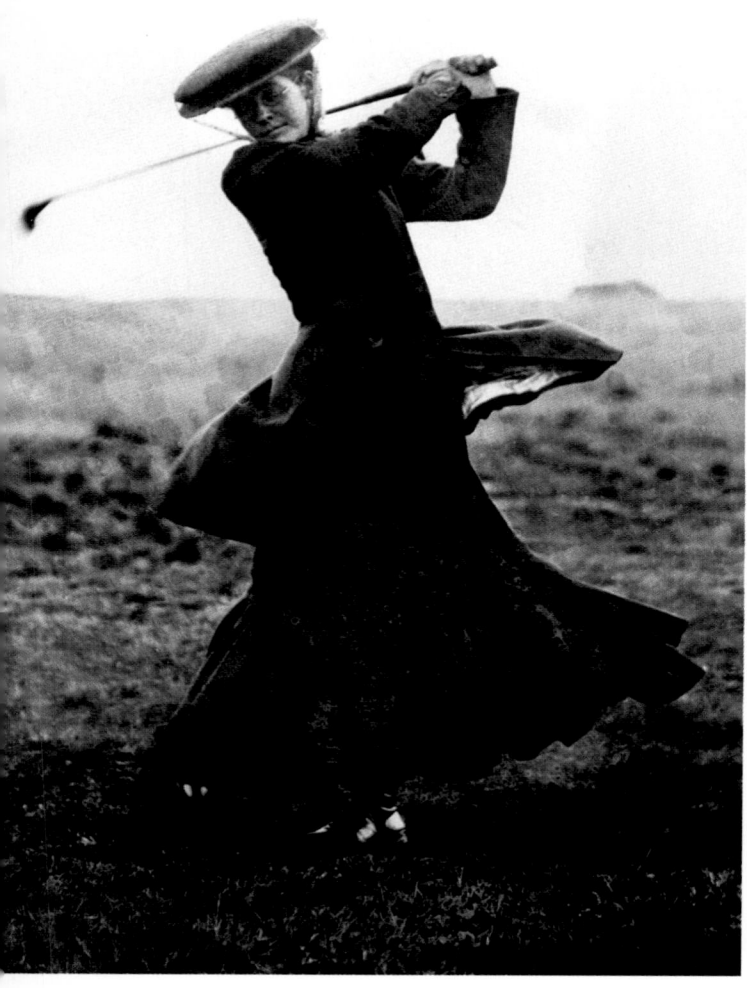

Above: Golfer Mrs Wilcock drives off from the tee. The voluminous fashions of the time did not lend themselves to many sports.

1912

Right: A trackless tram, an early form of trolley bus, with a conventional tram on the East Ham Tramways in London.

1912

Above: King George V on a tiger shoot in India in 1912, following the festivities of the Delhi Durbar, a ceremony held in December 1911, during which the newly-crowned King and Queen Mary were presented to an assembly of Indian princes and dignitaries as the Emperor and Empress of India. The King was a keen marksman and shot 21 tigers during his time in India.

1st February, 1912

Right: Renowned Russian ballerina Anna Pavlova with her cat. Pavlova is regarded as one of the finest classical ballet dancers in history.

June, 1912

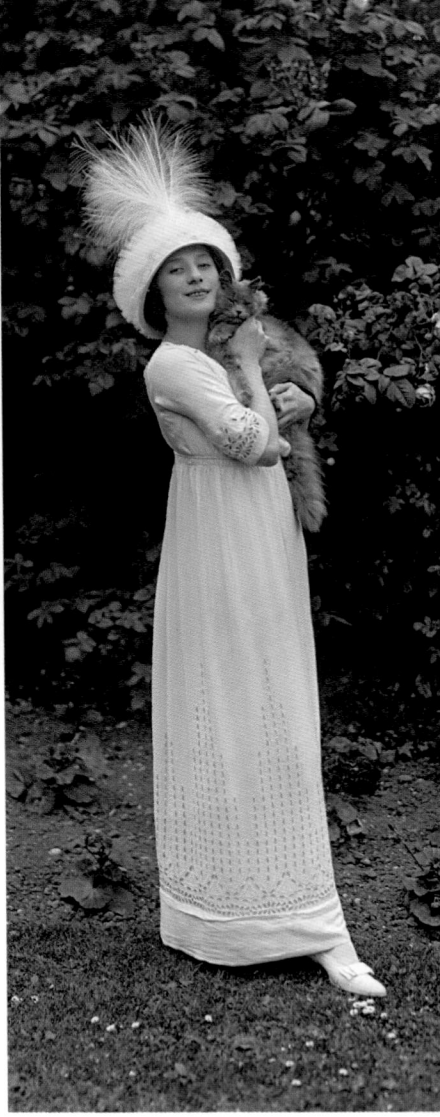

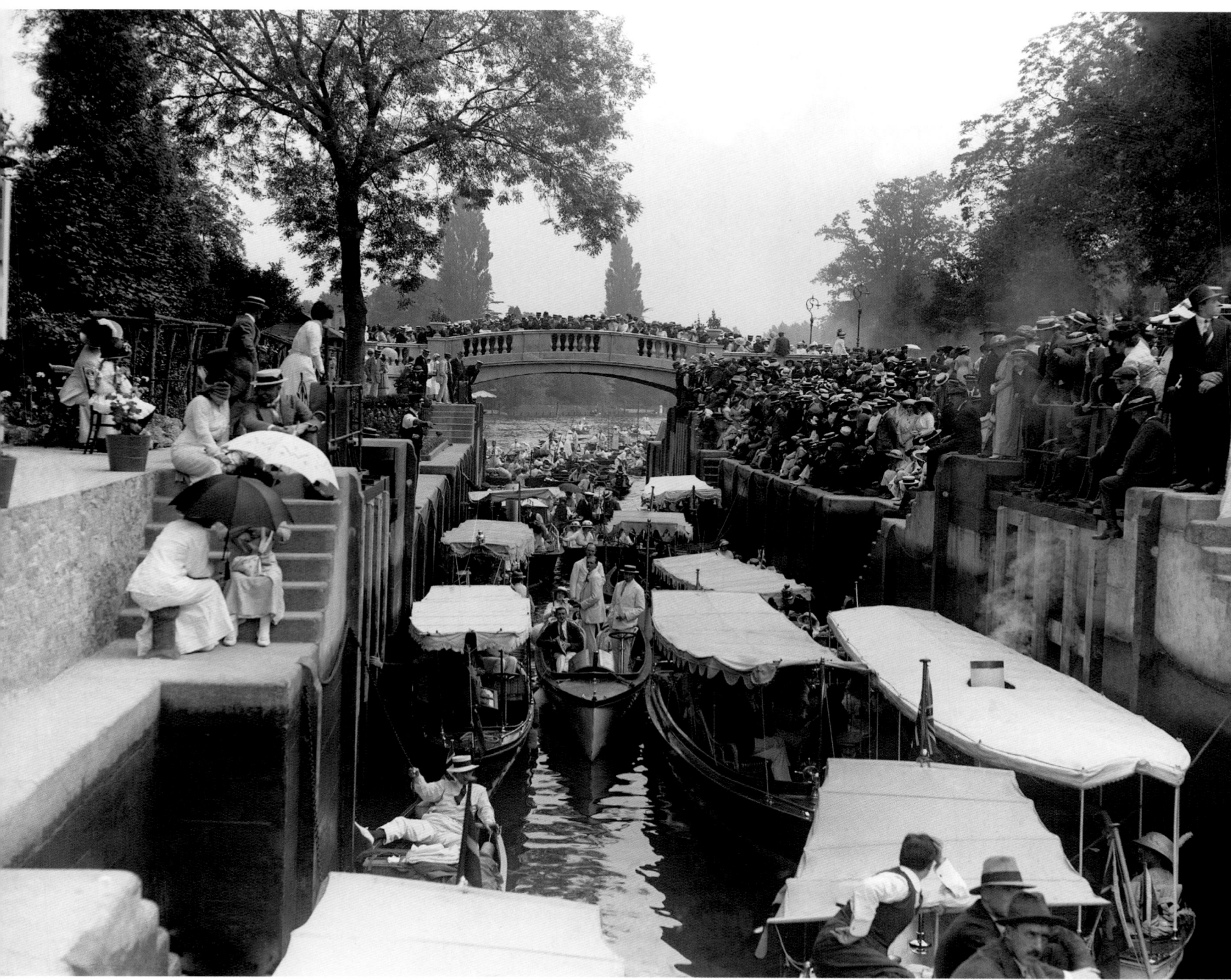

Above: Boulter's Lock on the River Thames on Ascot Sunday, where crowds would
gather to watch the rich and famous pass through, often on their way to Cliveden.

1913

109

Above: Tea time at Ranelagh
Gardens in Chelsea, London. The
extensive green pleasure ground,
with its shaded walks, lies adjacent
to Chelsea Hospital and is the site
of the annual Chelsea Flower Show.

1913

Above left: Dancers Petit and Petite
demonstrate the tango at the
London Opera House. The dance
had originated in Buenos Aires,
Argentina, becoming popular in
Europe in the early 20th century.

1913

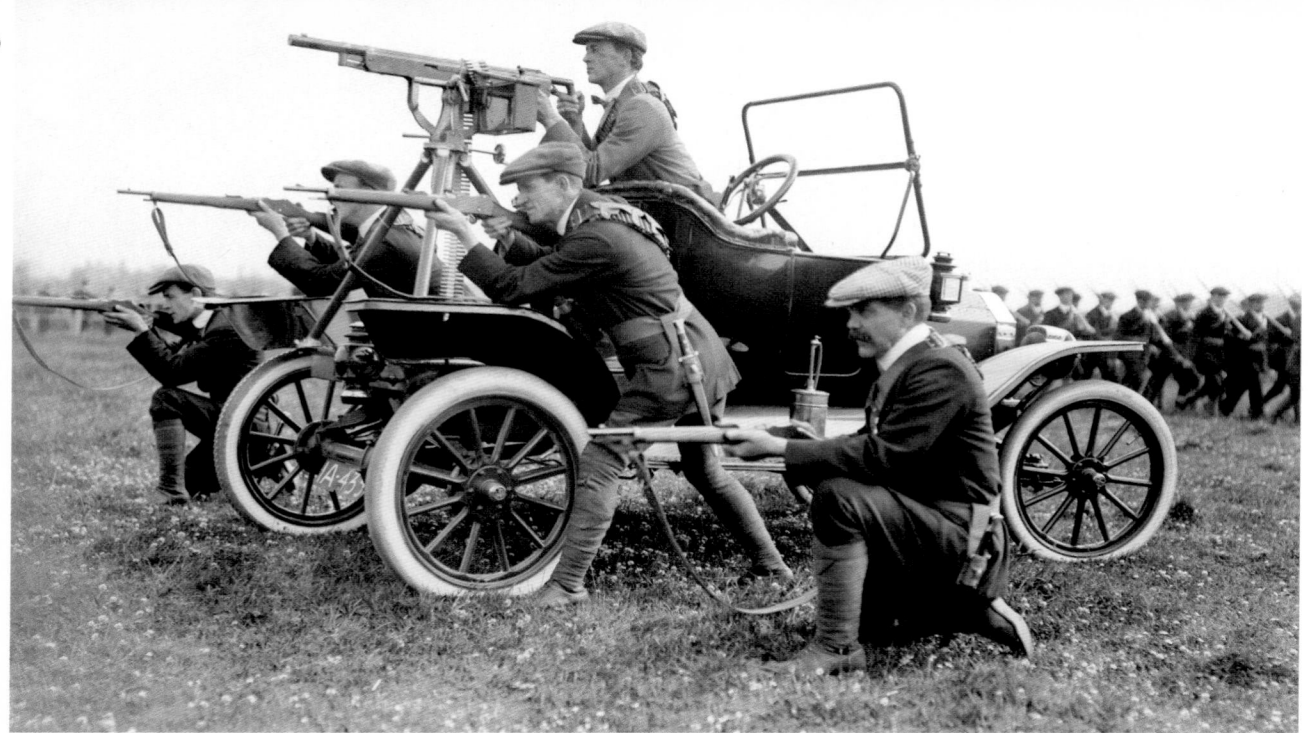

Right: As the remainder of the horses gallop by, Emily Davison lies unconcious beneath Anmer, her skull fractured. Herbert Jones has been thrown from the horse. He suffered mild concussion and a broken rib.

4th June, 1913

Above: Firepower. Protestant Ulstermen, members of the Ulster Volunteers, demonstrate their Boer War-era British Army weaponry. More than 100,000 men volunteered for the organization, which was formed to resist the establishment of Home Rule in Ireland, a demand of republicans.

1913

Right: The King's horse, Anmer, ridden by Herbert Jones, taking part in the parade prior to The Derby. During the race, Emily Davison, a suffragette activist, ran at the horse and was knocked down. She died later from the injuries she sustained. The jockey was also injured, but eventually he recovered.

4th June, 1913

Below right: The funeral procession of suffragette Emily Davison passes through Piccadilly Circus in London. Opinions differ as to whether the activist actually had intended to commit suicide. It seems more likely that her purpose was to divert the King's horse or stop it, and that her death was the result of a tragic accident. The jockey, Herbert Jones, was *"haunted"* by her face for many years after, and at Emmeline Pankhurst's funeral he laid a wreath as a tribute to both Mrs Pankhurst and Emily Davison.

14th June, 1913

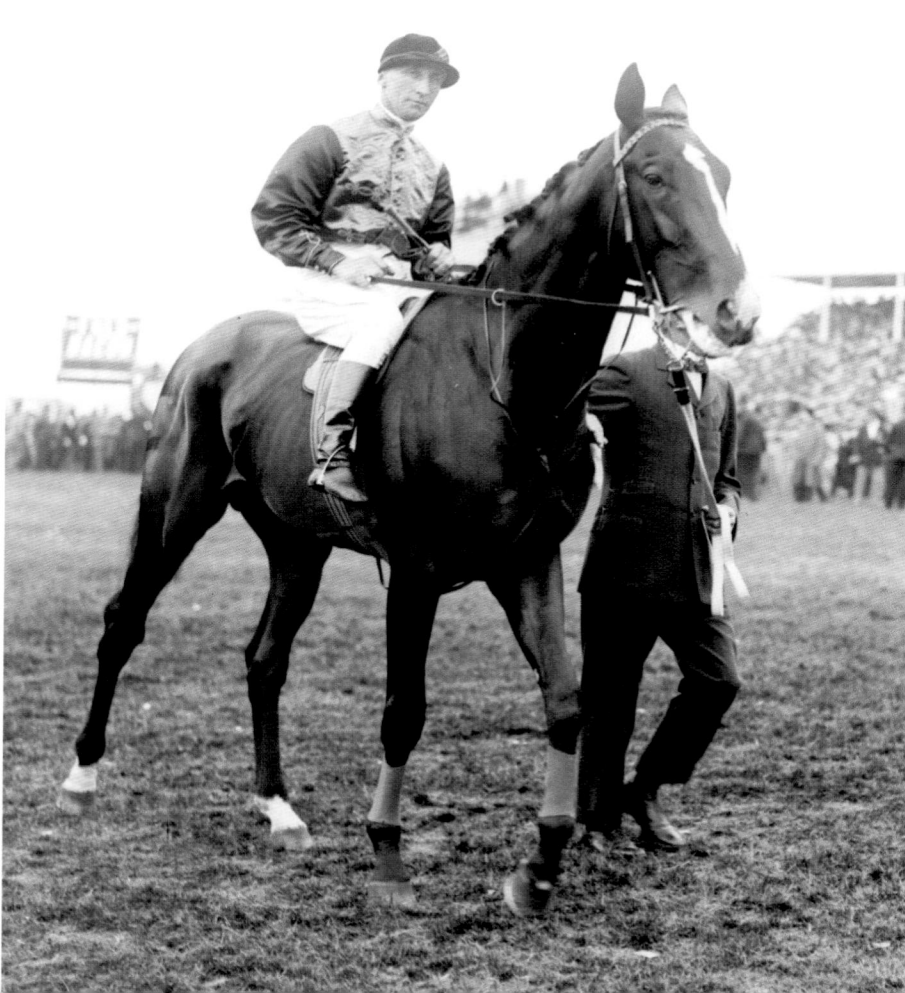

Above: Royal Navy Volunteer
Reservists, apparently cheerful
at the prospect, are called back
to active service following the
outbreak of war with Germany.

1st August, 1914

Right: With so many men having
joined the forces, women were
employed to do 'men's' work, such
as collecting tickets at London's
Victoria railway station.

4th September, 1914

Above: Dispatch riders of the British
Expeditionary Force (BEF), on Douglas
348cc motorcycles, are given directions
by a French sentry in northern France.
Their machines retain civilian paint
schemes. The First World War was the
first example of a truly mechanized
conflict, with motor vehicles of all types
having a major effect on events.

1st October, 1914

Right: A sergeant of the 3rd (Prince of
Wales') Dragoon Guards bids a fond
farewell to his family before leaving for
duty overseas.

31st October, 1914

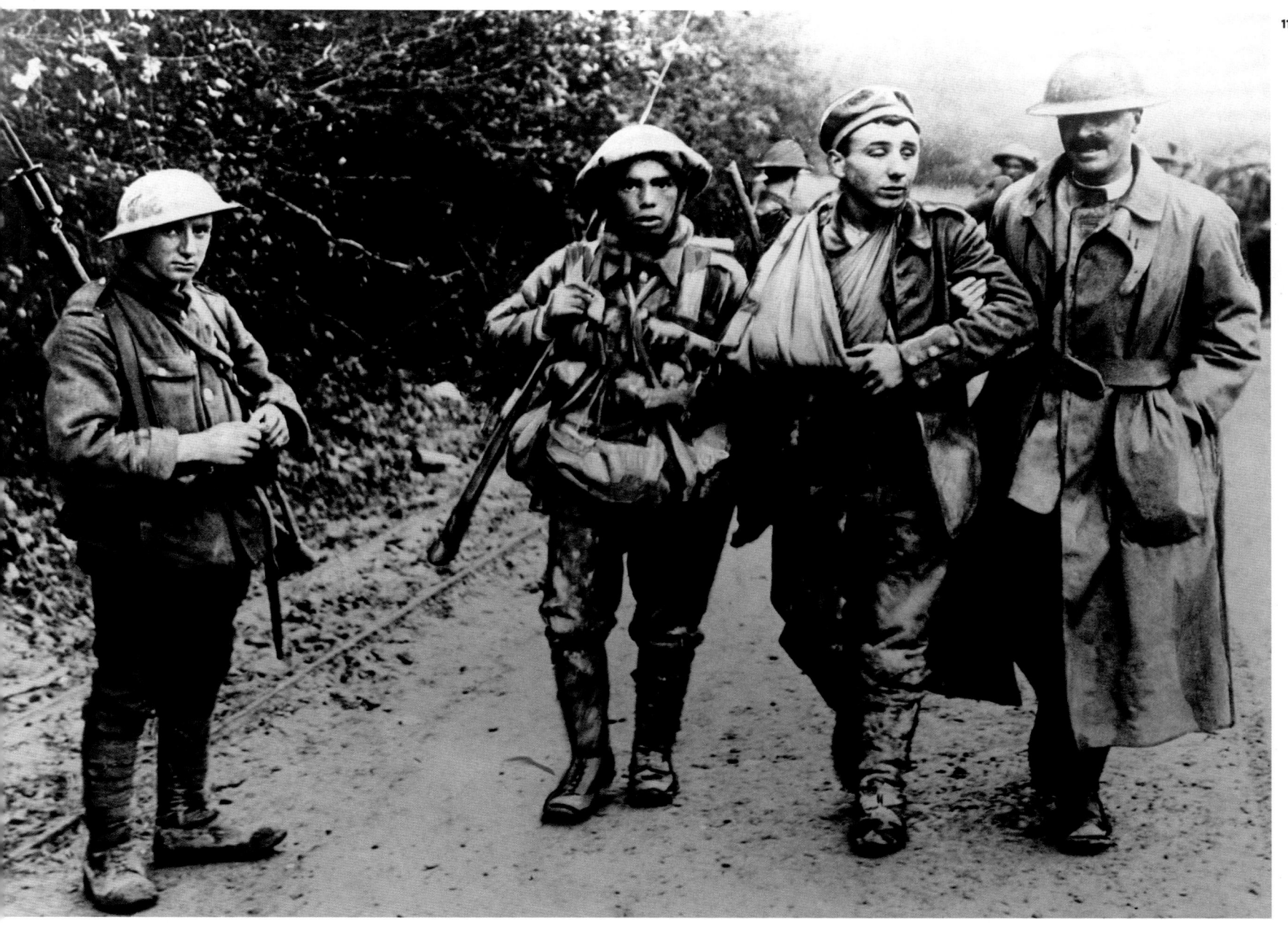

Above: A British Army chaplain gives a helping hand to an injured German prisoner of war. In general, PoWs of all nationalities were treated well during the First World War, often better than in the Second World War. The International Red Cross and neutral nations kept a close eye on their conditions.

3rd January, 1915

116

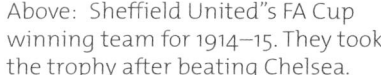

Above: Sheffield United"s FA Cup winning team for 1914–15. They took the trophy after beating Chelsea.

May, 1915

Above right: French actress Yvonne Arnaud looks doubtful about the joys of riding a llama during her visit to London Zoo; the llama seems miffed too.

1915

Above: Vesta Tilly, leading music hall star and the most famous male impersonator of her day. Her popularity reached its peak during the First World War, when she developed her act to encourage military recruitment. Among the songs she sang were *The Army of Today's All Right* and *Jolly Good Luck to the Girl who Loves a Soldier*. Sometimes men were asked to join the Army on stage during the show.

1915

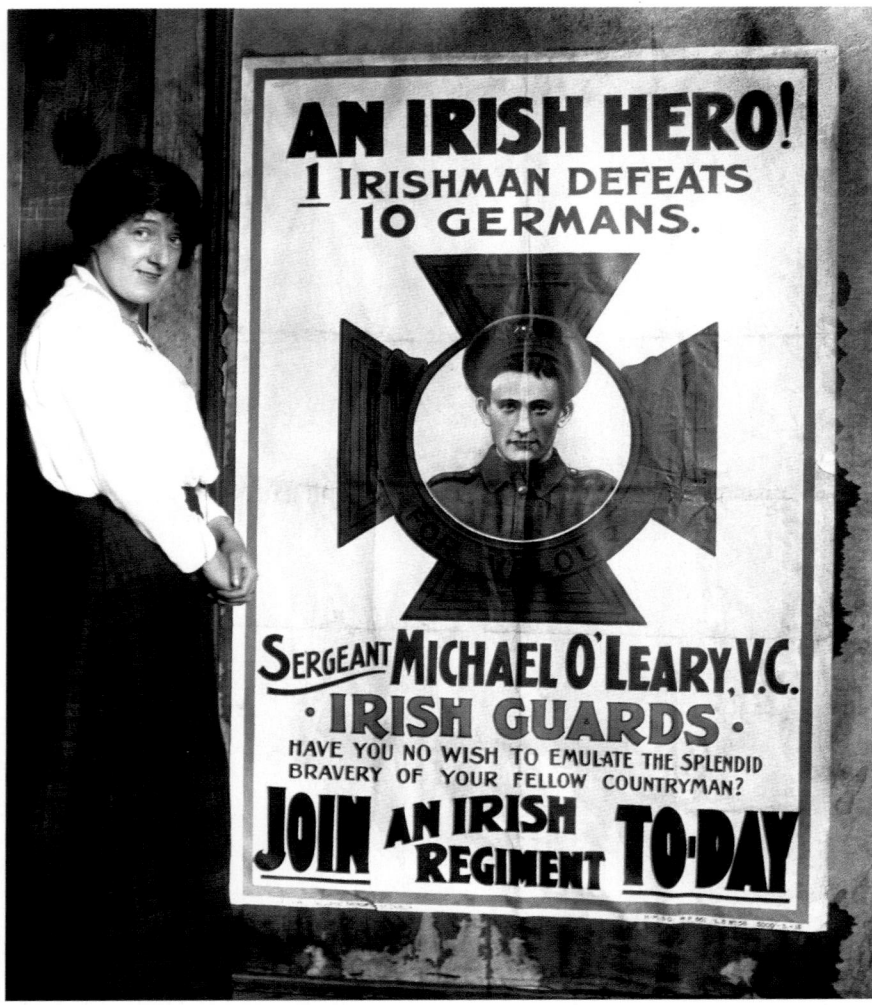

Left: A poster featuring Victoria Cross recipient Sergeant Michael O'Leary of the Irish Guards is used in an effort to boost Irish volunteer numbers during the First World War. O'Leary survived the conflict and served in the Second World War, rising to the rank of major.

1915

Below left: Renowned author Rudyard Kipling (second L) appeals for recruits in the seaside town of Southport. On Kipling's right is the Mayor of Southport in volunteer uniform. A few months after this photo was taken, Kipling's only son, Jack, was recorded as missing, believed killed, at the Battle of Loos in September.

13th May, 1915

Right: Anti-German sentiments ran high in Britain, leading to the persecution of those with German-sounding names. Here, a mob attacks Schoenfeld's tobacconists in Poplar, London.

13th May, 1915

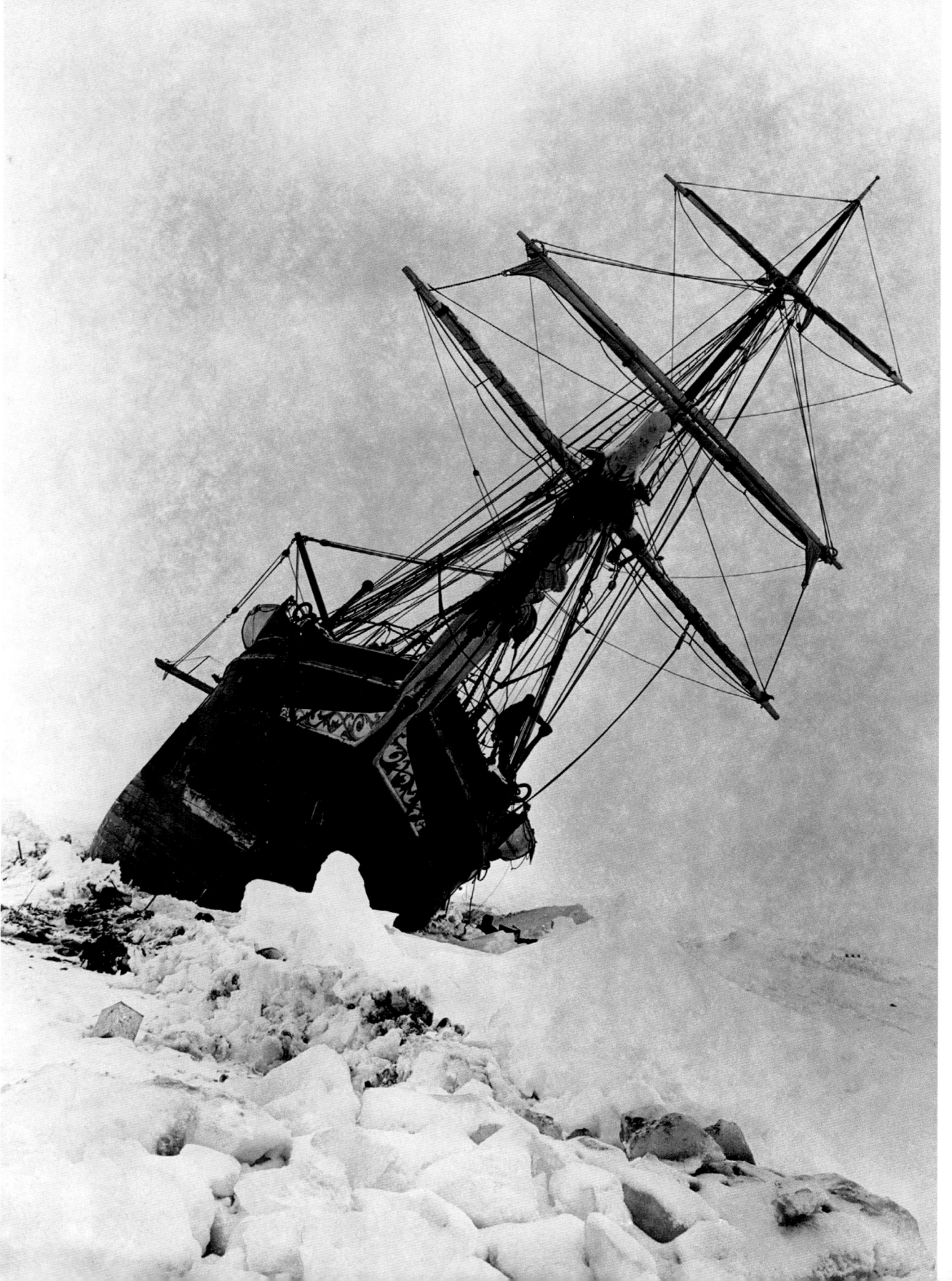

Left: Sir Ernest Shackleton set out for the Antactic again in 1914, intent on crossing the continent from sea to sea via the Pole. His ship, the *Endurance*, became trapped in the ice, however, and eventually was crushed between two immense ice floes, sinking on 21st November, 1915. The crew dragged and sailed the ship's boats across miles of difficult pack ice and open water until, exhausted, they reached the inhospitable and uninhabited Elephant Island. Stranded far from any shipping routes, Shackleton set out again with five of the men in an open boat. After 15 days of sailing through stormy, icy waters, they reached the whaling settlement on South Georgia and were able to organize a ship to rescue the remainder of the expedition.

27th October, 1915

Right: A soldier bids farewell to a fallen comrade near the appropriately named Cape Helles, on the Gallipoli Peninsula in Turkey. Tens of thousands of Turkish troops, nearly 11,000 Australians and New Zealanders, and 21,000 British soldiers perished during the Gallipoli campaign.

1st November, 1915

Overleaf: Canadian soldiers eat a midday meal next to their sandbagged position amid the mud of the Western Front.

1916

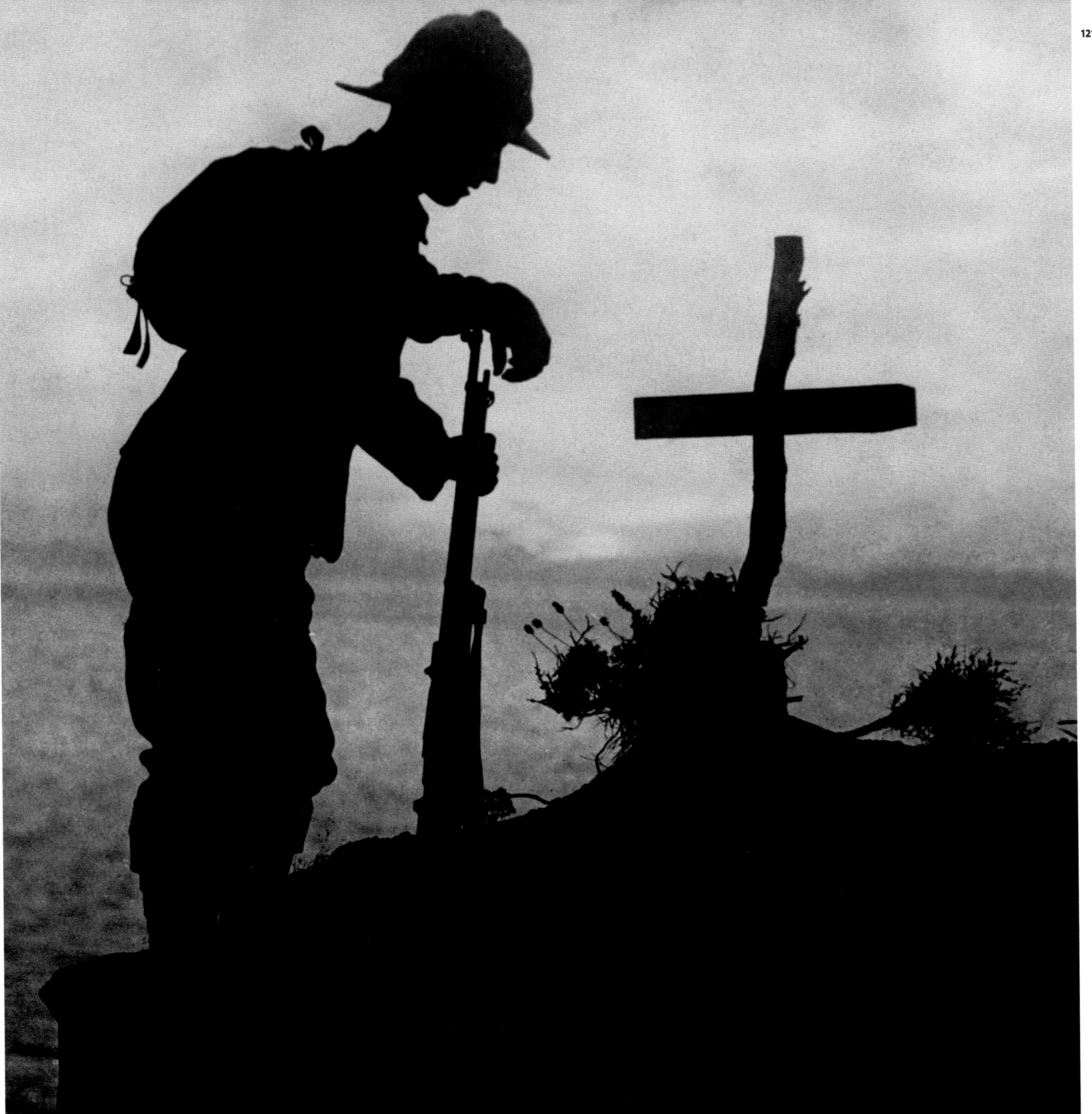

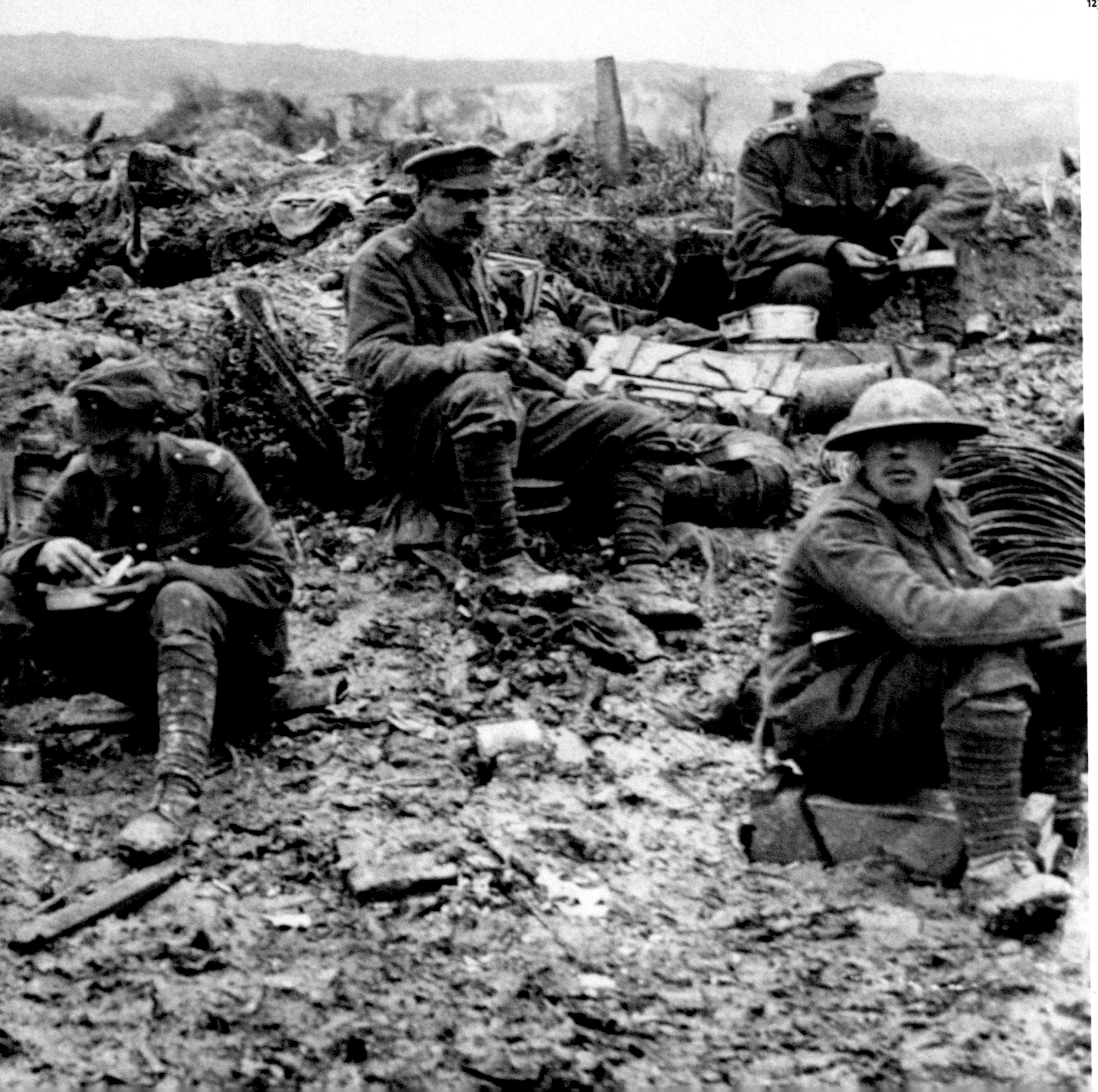

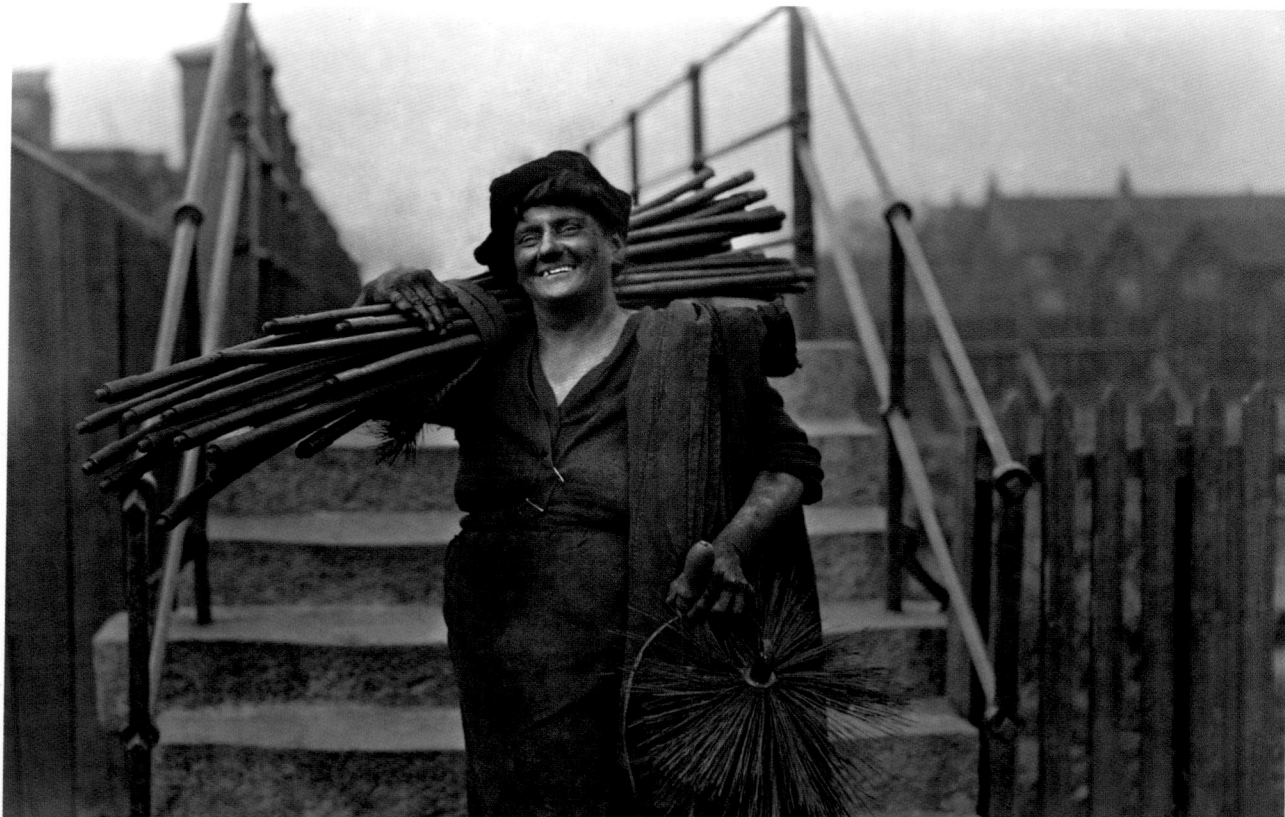

Left: The female crew of a Renault ambulance changes a front wheel. Between 1914 and 1918, more than 38,000 women worked as auxiliary nurses, cooks and ambulance drivers in Britain and on the Western Front.

1916

Below left: With her husband away fighting during the First World War, former stage star May Nelson carries the tools of her new trade, having taken on her spouse's peacetime occupation as a chimney sweep.

1916

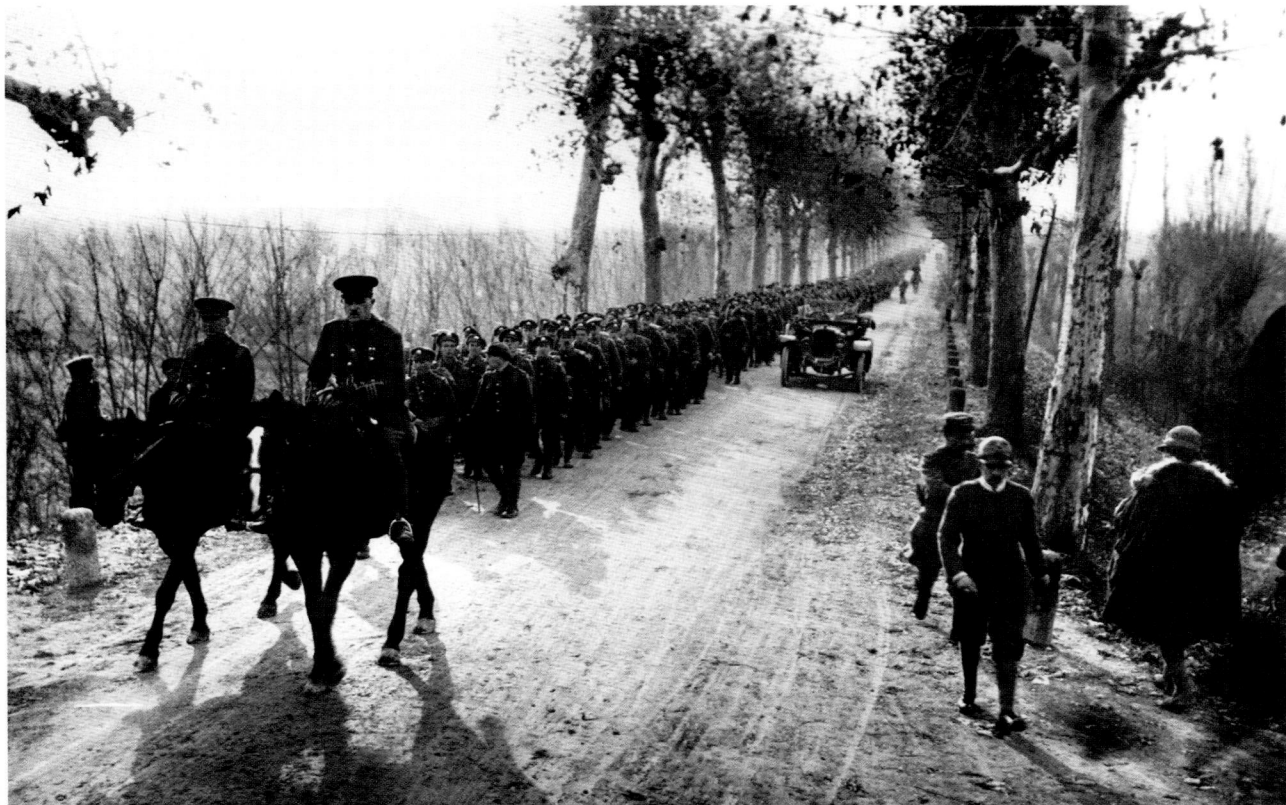

Above: A British military ambulance, drawn by mules, carries wounded from the trenches to a field hospital at Abu Roman during fighting against Ottoman forces in Mesopotamia, which posed a serious threat to the Persian oil fields that supplied the Royal Navy.

1916

Left: A column of soldiers of the Gloucester Regiment stretches back as far as the eye can see as they march through Piave on the way to the front at Asiago in Italy.

1st April, 1916

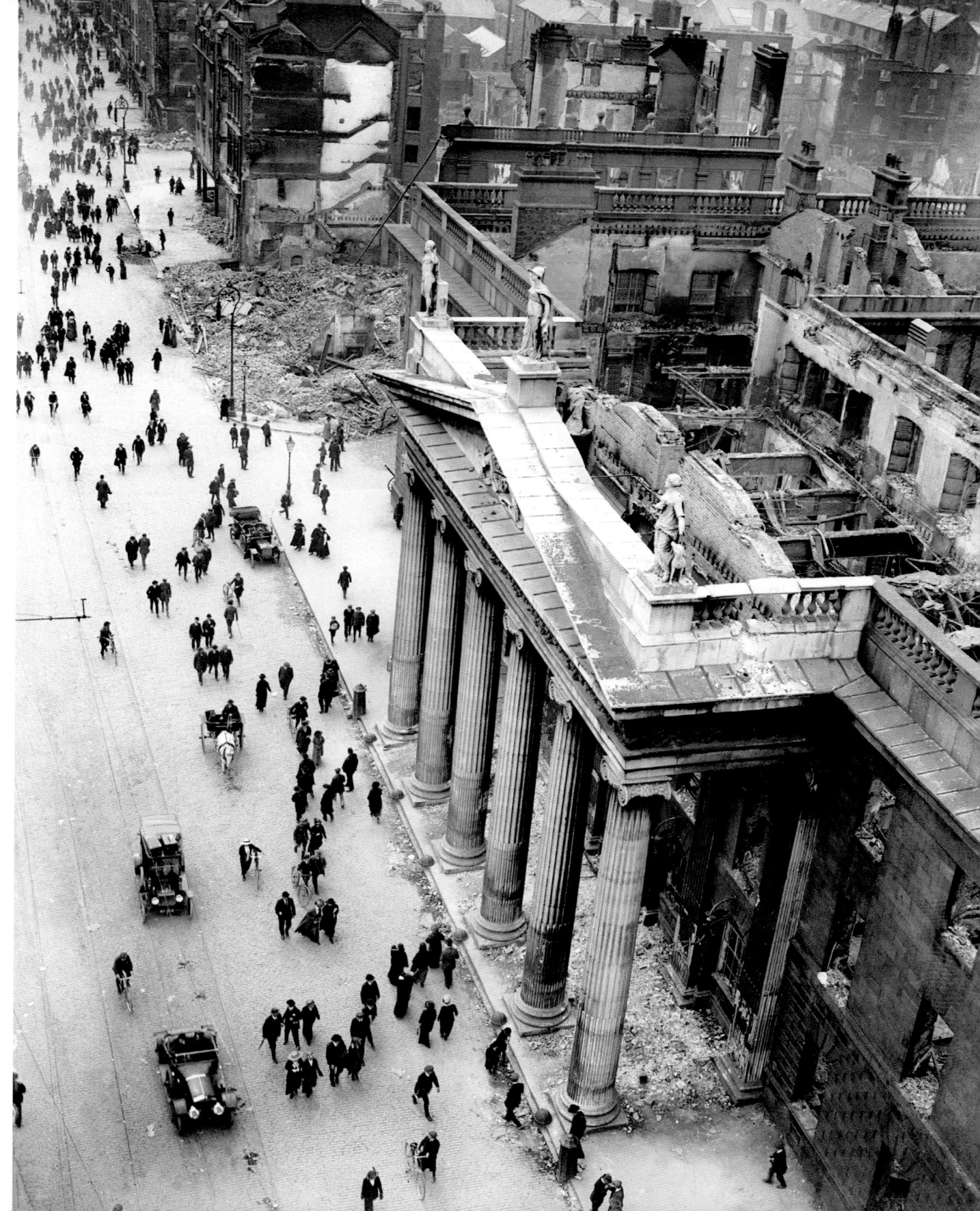

Right: The aftermath of the Easter Rising in Dublin. The ruined shell of the General Post Office is seen from the top of Nelson's Column. Rebels, proclaiming an Irish Republic, had seized control of the building, among several other key locations, on 24th April. After seven days of bloody fighting, the rebellion was suppressed by the British authorities and the leaders brought to trial, after which they were executed.

11th May, 1916

Right: An improvised armoured personnel carrier used to transport troops during and after the Easter Rising in Dublin. For protection, a steam locomotive boiler casing has been mounted on the back of a truck with an armoured cab, providing cramped accommodation for several men.

11th May, 1916

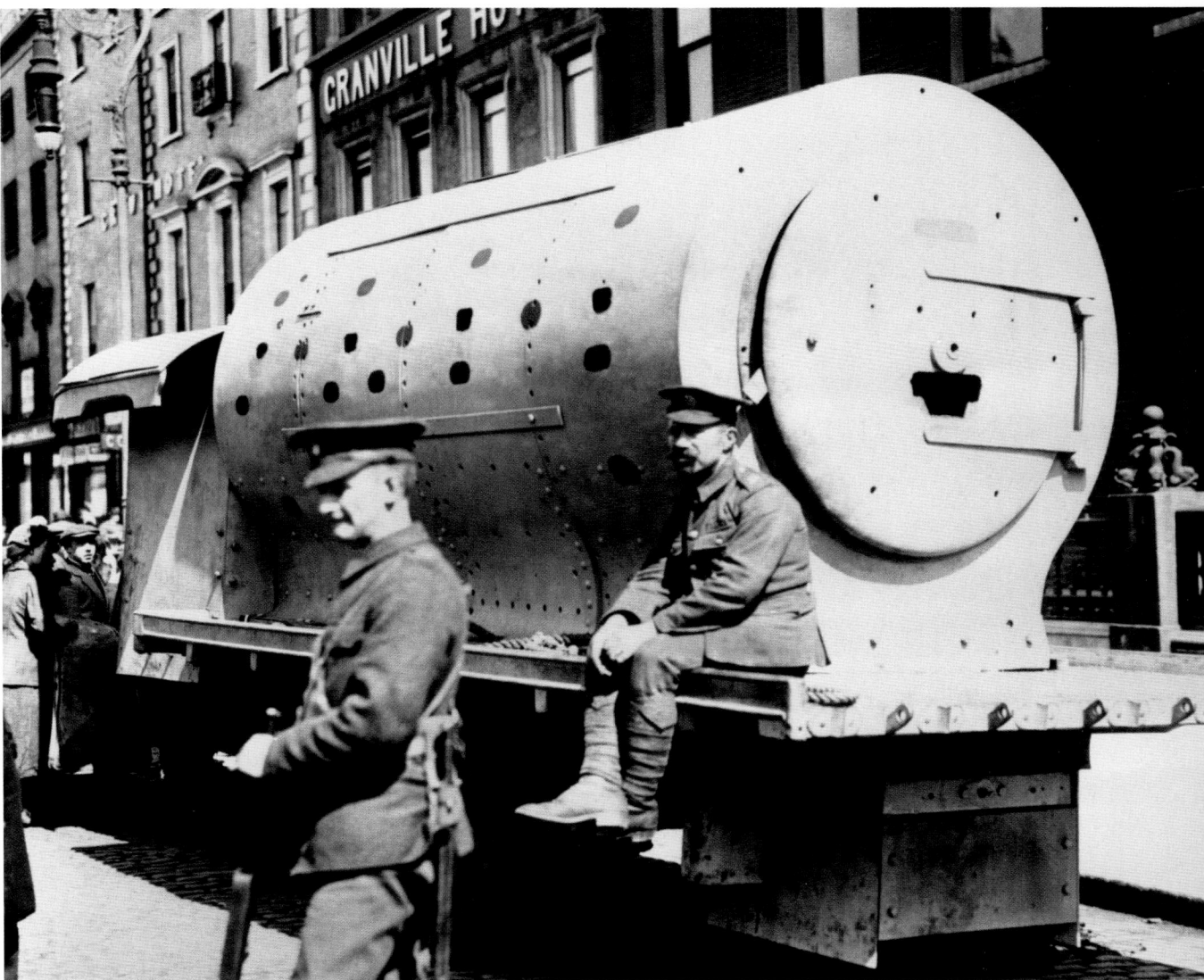

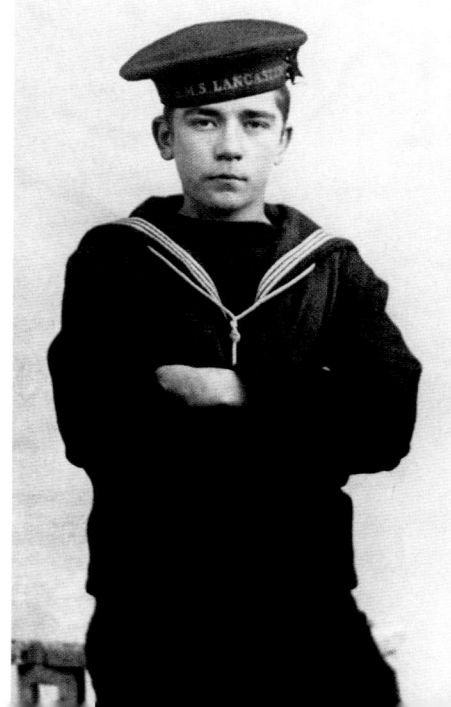

Above: Vice Admiral Beatty's flagship, the battlecruiser HMS *Lion*, comes under fire during the Battle of Jutland. The battle was the largest sea conflict of the First World War and the only occasion during that war when there was a full-scale clash of battleships.

31st May, 1916

Right: Aged just 16, John Travers Cornwell was a member of a gun crew aboard HMS *Chester* during the Battle of Jutland. Despite severe wounds and the deaths of the majority of the gun crew, 'Boy Jack' remained at his post awaiting orders. Later, he would die from his wounds, but he was posthumously awarded the Victoria Cross.

1916

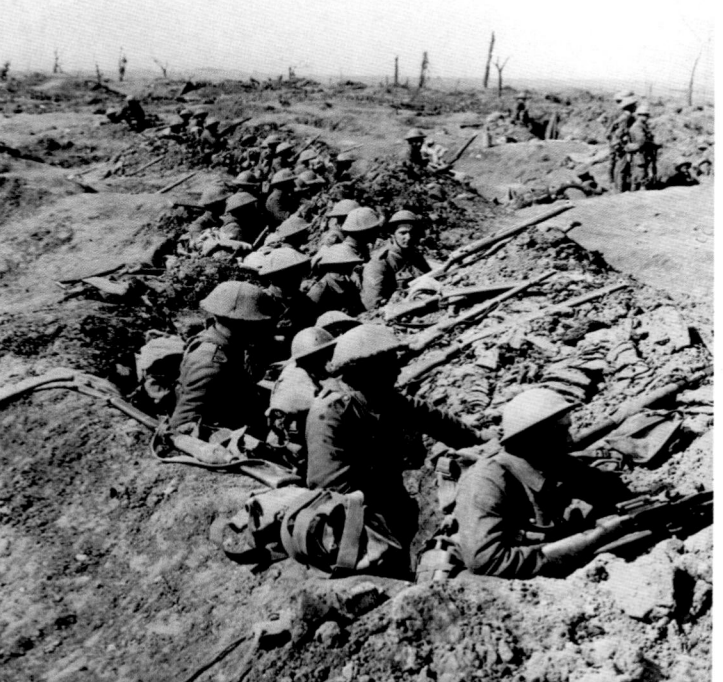

Above: A British artilleryman pulls the lanyard to fire an 8in howitzer. These massive weapons could fire shells over a distance of 12,300 yards (about seven miles/11km). Their main purpose was to neutralize enemy artillery, and to destroy strongpoints, ammunition dumps, roads and railway lines.

31st May, 1916

Left: British Infantrymen wait in their trench for the order to advance, the desolation of 'no-man's land', with its shell craters and shattered stumps of trees, stretching before them.

31st May, 1916

Above: At the fourth attempt, Sir Ernest Shackleton succeeds in returning to Elephant Island. He had made a round trip of 750 miles (1,200km) to South Georgia in a small open boat to get help for the 22 men left stranded there.

30th August, 1916

Right: Women at work cleaning engines and rolling stock on the South Western Railway during the First World War. Their need to wear traditional men's work clothing with trousers would have an effect on women's fashion in the 1920s.

January, 1917

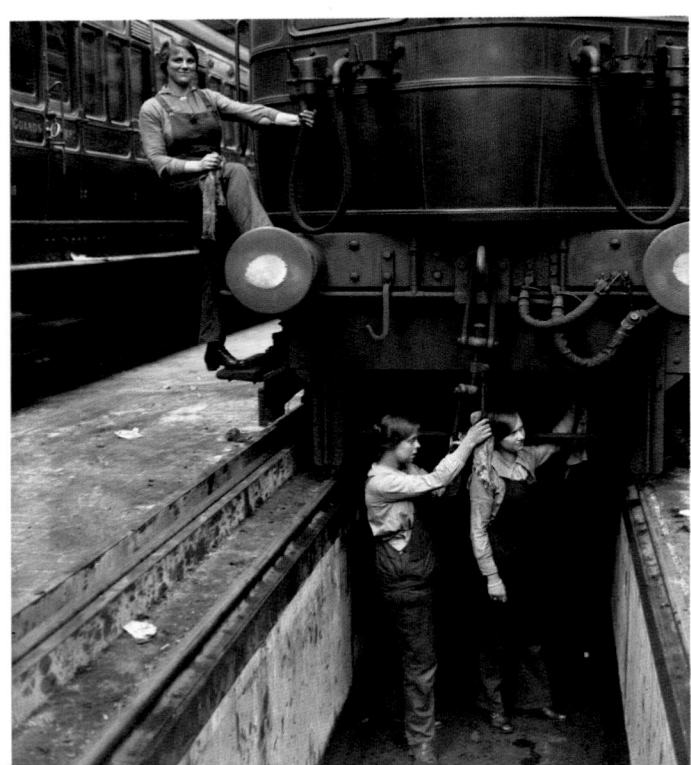

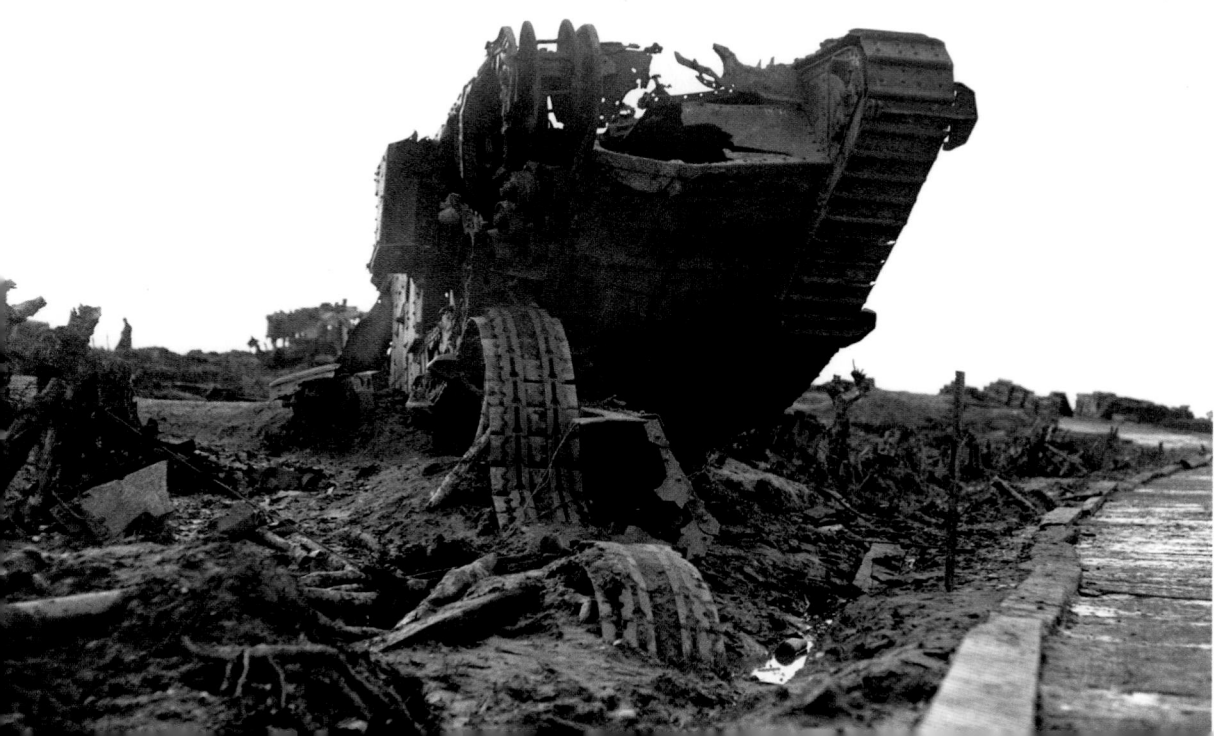

Above: Baron Manfred Freiherr von Richthofen, the 'Red Baron', seated in the cockpit of his Albatross DV fighter, with other pilots of his squadron, Jagdstaffel III. Richthofen was credited with downing 80 Allied aircraft before he was shot down in 1917 over the Somme, Northern France, during what was known by pilots on both sides as 'Bloody April'. Richthofen's brother, Lothar, is seated at the front (fur collar).

1st April, 1917

Left: A shattered British tank lies beside the Menin Road, near Ypres, Belgium. The road was used as a supply route by the British Army and was shelled intensively by German artillery. The first Allied tanks were sent into action in 1916 in an effort to break the stalemate of trench war. Although the early tanks were unreliable, ultimately they would prove to be powerful weapons.

25th September, 1917

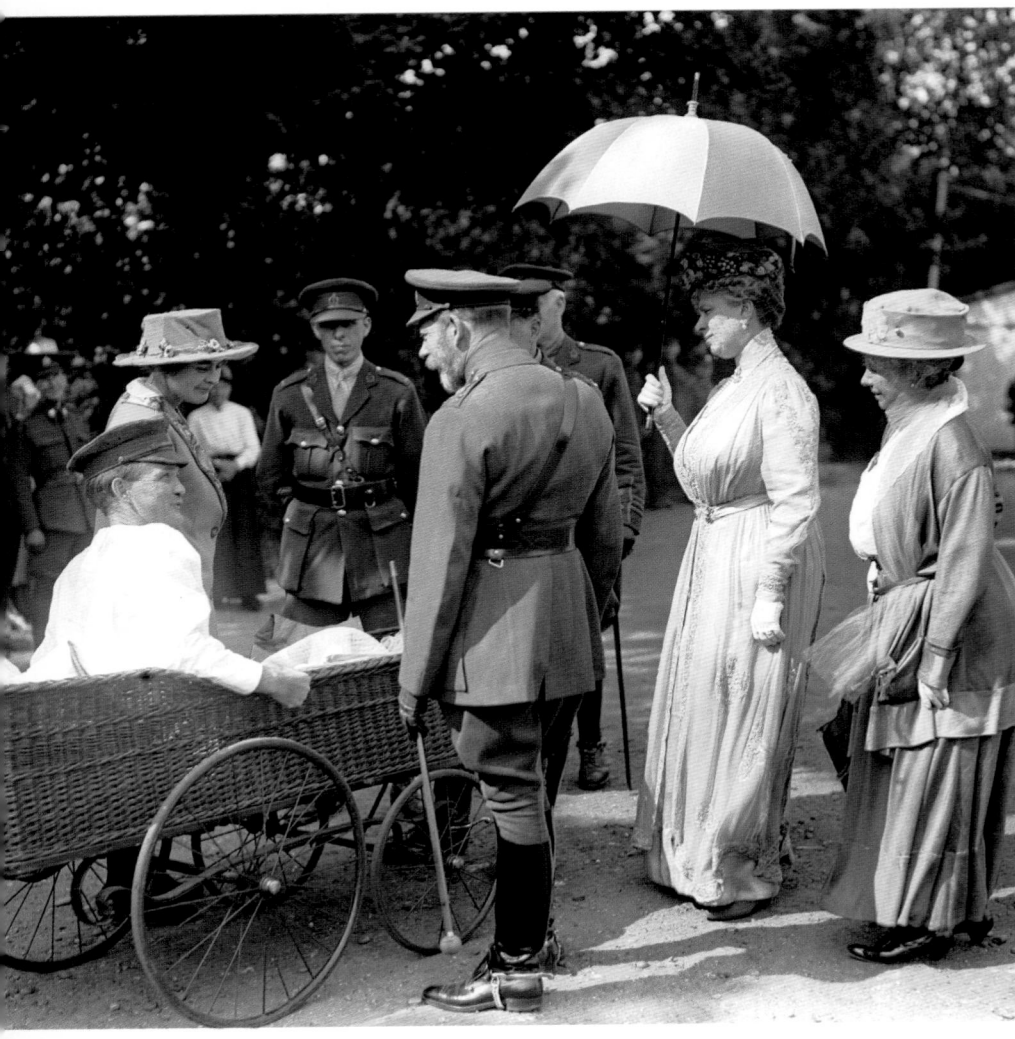

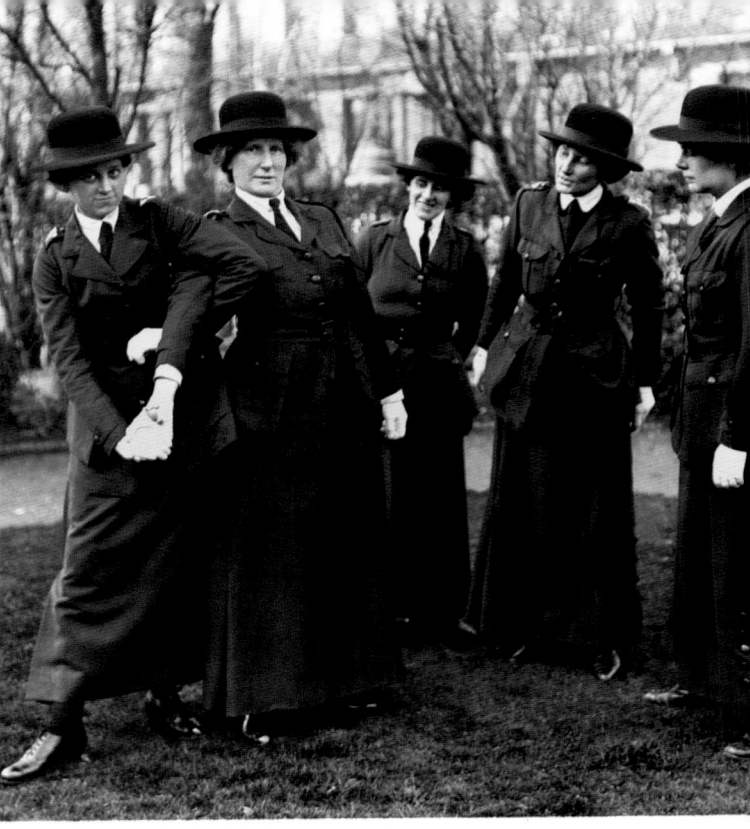

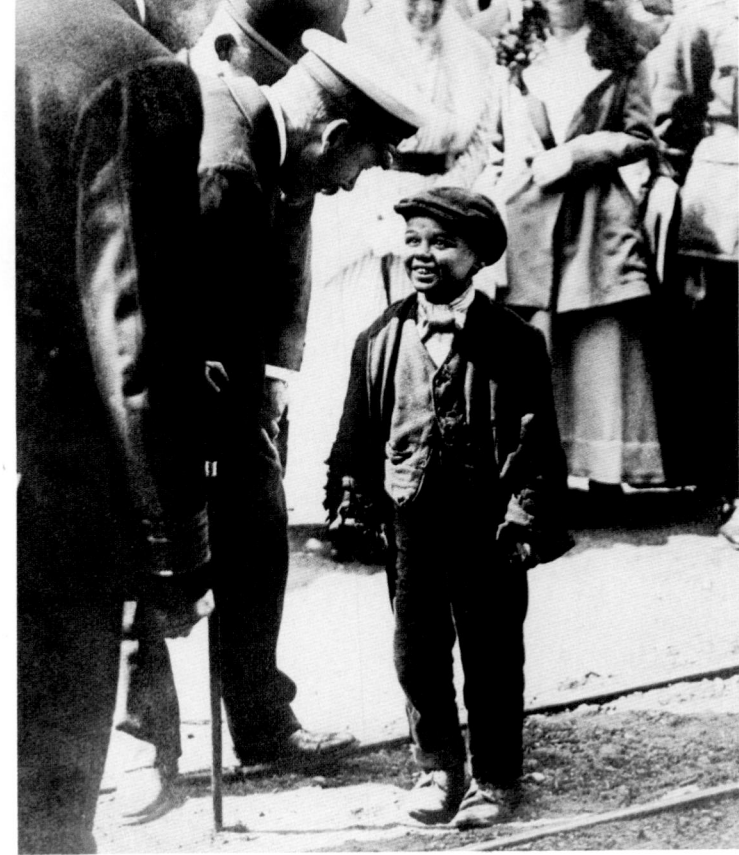

Above: King George V and Queen Mary chat with a recovering patient at a Canadian military hospital in England.

1918

Above right: Policewomen take part in a restraining exercise in Brighton, Sussex. Women enrolled in the police force during the First World War to fill gaps in the ranks left by large numbers of policemen who enlisted in the British armed forces.

1918

Right: King George V meets a young dockyard worker during a visit to a Sunderland shipyard. The employment of children was acceptable in the early 20th century.

1st August, 1918

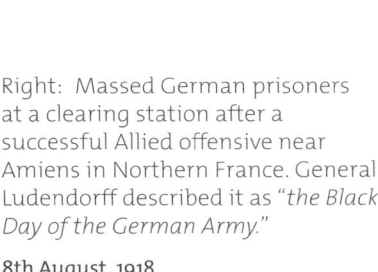

Right: Massed German prisoners at a clearing station after a successful Allied offensive near Amiens in Northern France. General Ludendorff described it as *"the Black Day of the German Army."*

8th August, 1918

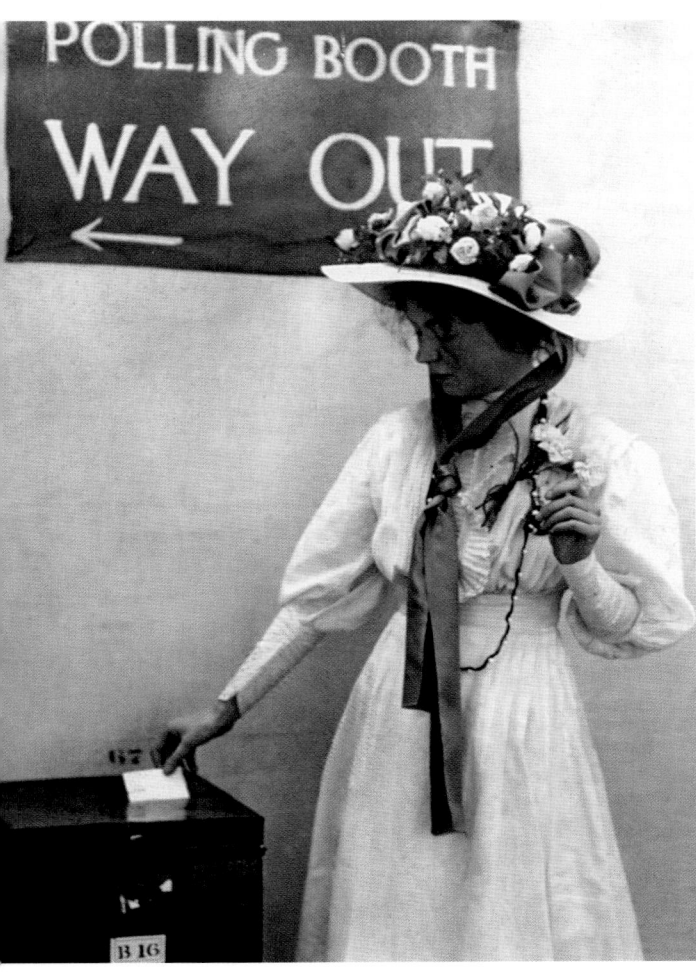

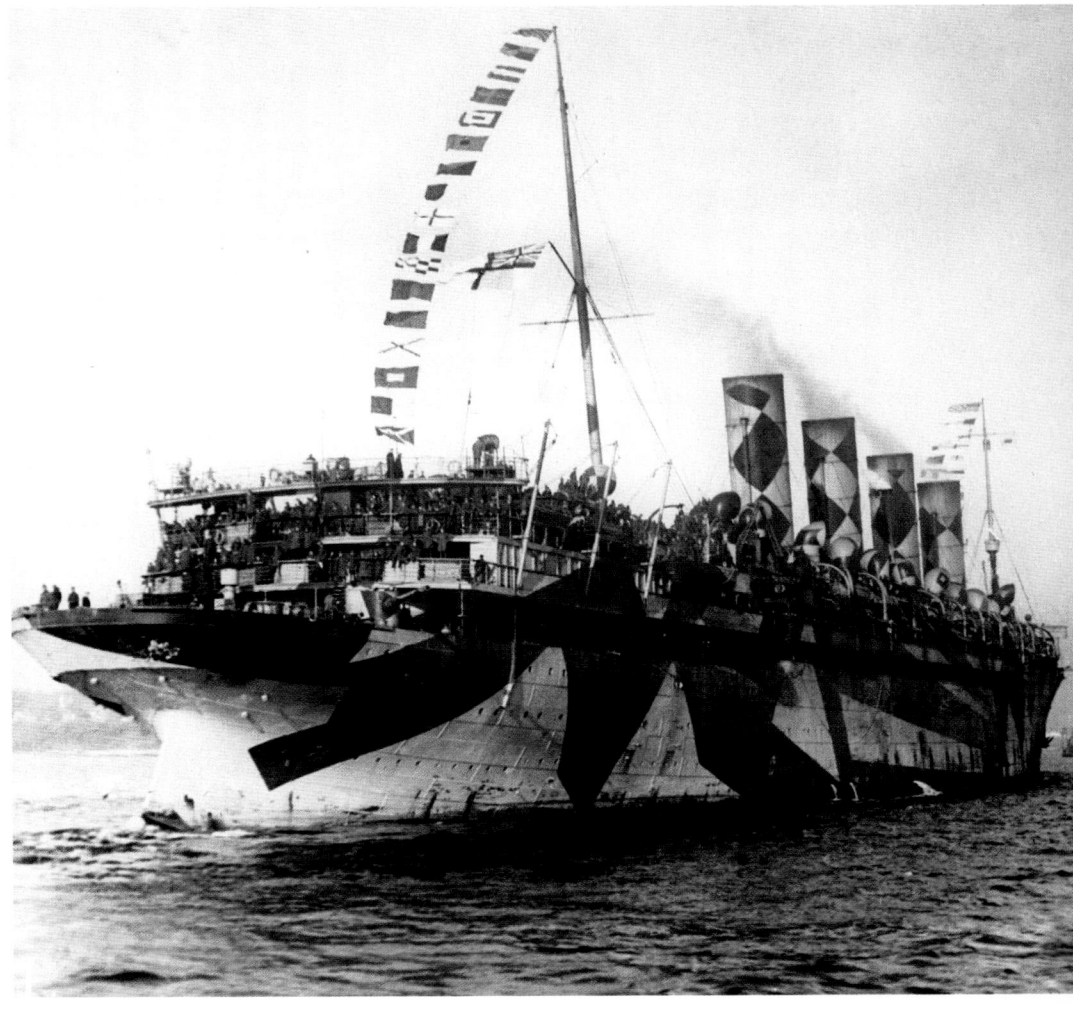

Below: The *Mauretania*, sister ship of the ill-fated *Lusitania*, arrives in New York with American soldiers returning from service in Europe. She still wears her wartime 'dazzle' camouflage, intended to confuse U-boats as to her position and length.

1919

Above: Suffragette Christabel Pankhurst exercises her newly-won right to vote in the General Election of December 1918. Under the terms of the Representation of the People Act, women over the age of 30 could now vote in elections and could also stand for Parliament on an equal footing to men. Pankhurst herself stood as the Women's Party candidate in Smethwick, Staffordshire, where she won 47.8 per cent of the vote, losing by only 778 votes to her sole opponent, the Labour Party's John Davison.

14th December, 1918

Left: German U-boat U-48, one of 39 submarines to surrender to the Royal Navy at the Essex port of Harwich in 1918. During the First World War, Germany produced 360 U-boats, of which around half were lost.

21st November, 1918

Above: Testing a bell at the Whitechapel Bell Foundry in London's East End, the oldest continuous business in the world.

1919

Above right: Just kidding around. Charlie Chaplin (L) and English boxer Ted 'Kid' Lewis engage in a friendly match. World welterweight champion Lewis, credited with being the first fighter to use a mouthpiece, enjoyed celebrity status, and Chaplin was godfather to his son.

January, 1919

Right: Slum dwellings in London. It would be many decades before such conditions were swept away.

May, 1919

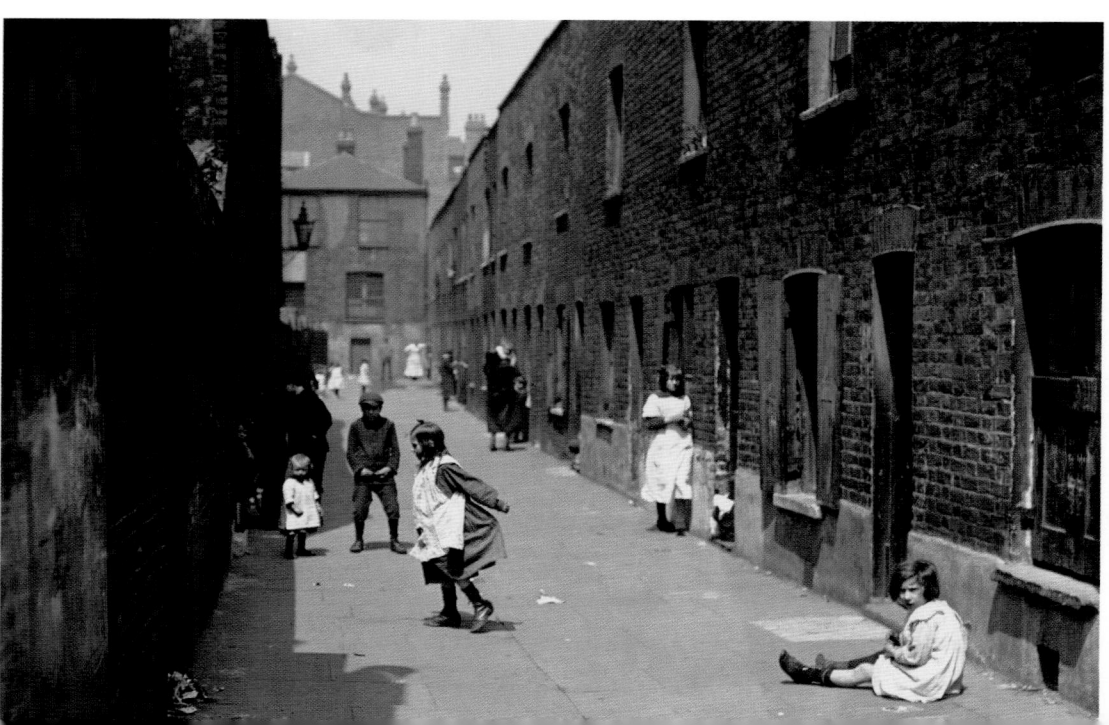

Left: The coffin of Edith Cavell lands at Dover's Promenade Pier for reburial on Life's Green, at the east end of Norwich Cathedral. Cavell, an English nurse who was matron of a clinic in Brussels, Belgium, had been executed in 1915 by the German military authorities for harbouring Allied soldiers and helping them escape during the First World War.

May, 1919

Below: The peace treaty is signed by representatives of Germany and the Allies at the Palace of Versailles, Paris, bringing an official end to the First World War.

28th June, 1919

Above: The British airship NS11 flying over
the Old Bailey in London. The NS11 was a
non-rigid airship, known as a 'blimp' in the
USA, and was one of a series developed by
the Royal Naval Air Service for long-range
submarine patrols and convoy escort. The
machine crashed with the loss of its crew
off the Norfolk coast on 15th July, 1919. It
was thought that a lightning strike had
caused the hydrogen gas to explode.

1919

Right: British aviators Arthur Whitton
Brown (L) and John Alcock. Their
transatlantic flight covered 1,890 miles
(3,042km) in just over 16 hours.
Subsequently, both men received
knighthoods.

23rd August, 1919

Above: The modified Vickers Vimy IV bomber in which John Alcock and Captain Arthur Whitton Brown made the first non-stop transatlantic flight, from Newfoundland to Ireland. To keep the engines running, Brown frequently had to climb out on the wings to clear the air intakes of ice.

23rd August, 1919

Right: American-born Viscountess Nancy Astor, Britain's first and only female MP until 1921, outside Plymouth Town Hall following her election to Parliament. She became the first woman in the House of Commons after Constance Markiewicz, who successfully stood as a candidate for Sinn Féin in the General Election of 1918, refused to take her seat in line with party policy.

30th November, 1919

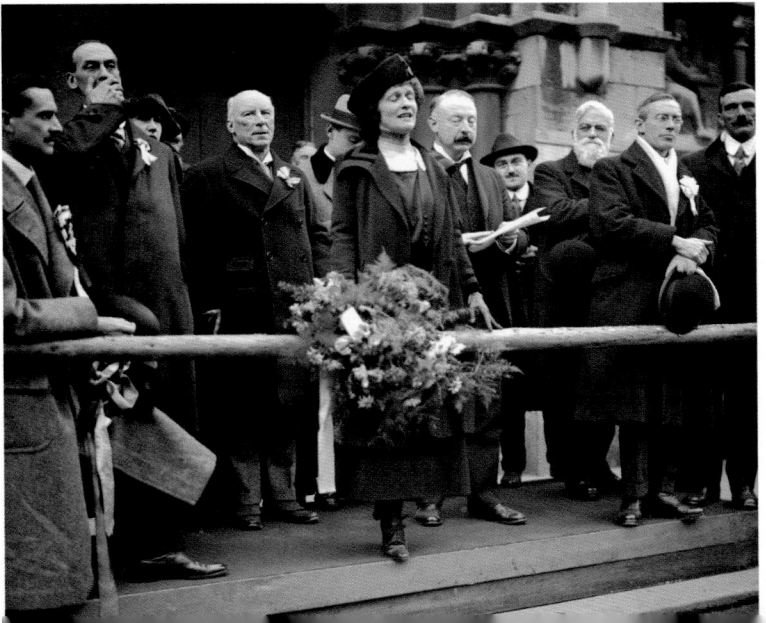

Overleaf: One year after the end of hostilities, as the clocks strike 11, workers and pedestrians pay their respects to those killed in the First World War with a two-minute silence. The tradition is carried out to this day at 11am on the 11th of November each year.

11th November, 1919

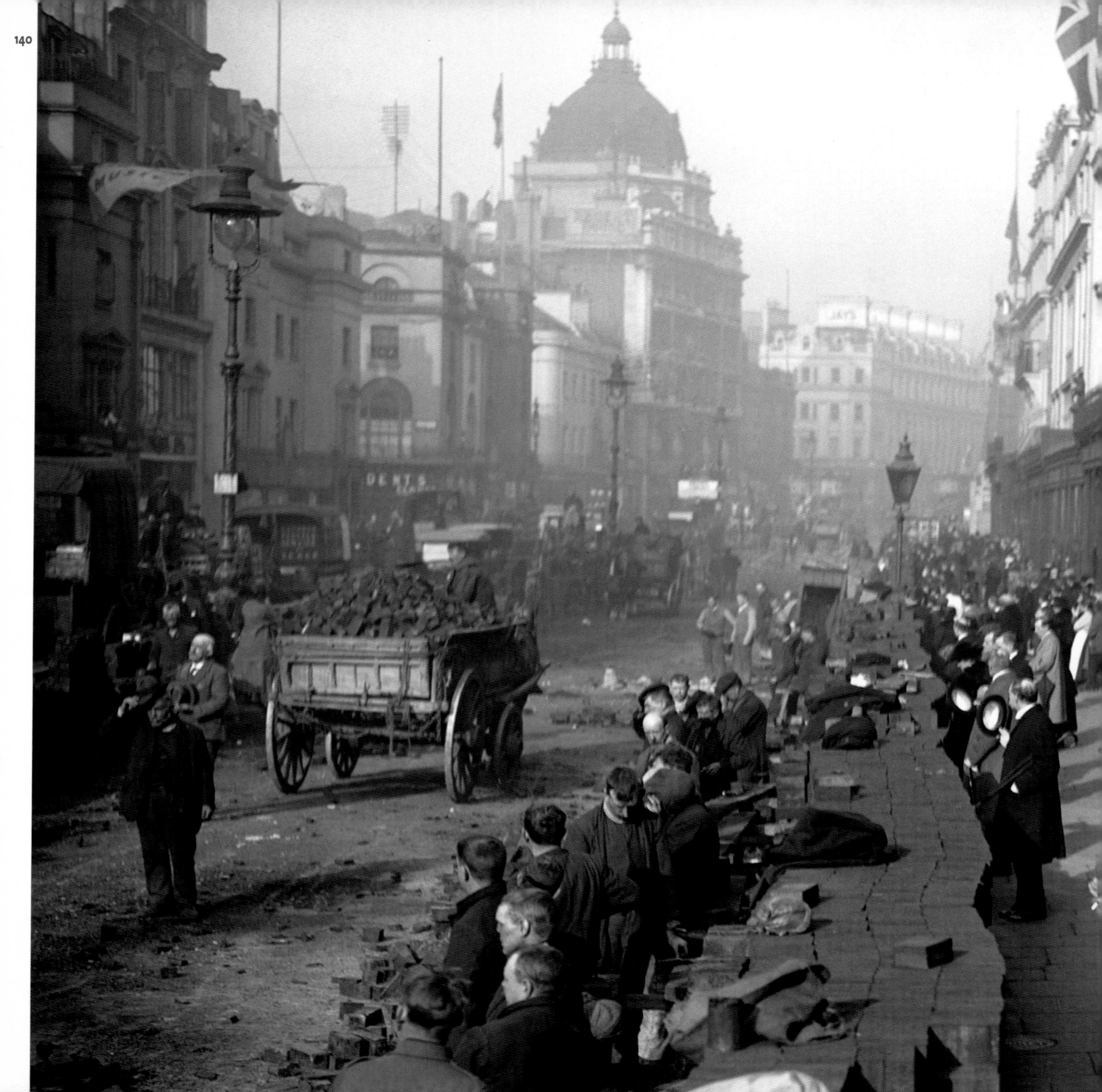

1920s

By rights, the 1920s should have been overshadowed by the terrible suffering and loss of life so recently borne in the First World War. Yet while memorials to those who died were prominent throughout the decade, the atmosphere was one of great energy, optimism, achievement and enjoyment – almost hedonism. Perhaps those who had survived were driven to savour life to the full. Records fell like skittles as fearless motor and aviation pioneers forced technological leaps and bounds to be made; sportsmen displayed ambition and idealism rather than professionalism – the *Chariots of Fire* Olympics fell in these years; and the doings of the arts and entertainment industries were on everyone's lips.

It was the first age of celebrity, in that peculiar modern sense. Sportsmen, aviators, racing drivers, royalty, actors, military officers and millionaires all merged as a glittering elite. Counts and high-born ladies raced motor cars at Brooklands, noblemen won medals at the Olympics, cabaret artistes won fortunes in the casinos, actresses married millionaires, and flyers crossed oceans in flimsy machines.

Given the horrors of the previous decade, who could blame them?

Right: Scottish lasses chase the herring, and the work, south to Scarborough, North Yorkshire. Here, three girls carry buckets of 'caller herring', which are about to be pickled in brine.

1920

Far right: Newly married movie stars Mary Pickford and Douglas Fairbanks arrive at Southampton to begin their European honeymoon. Pickford, known as 'America's Sweetheart', was one of silent film's most important performers and producers. Fairbanks was renowned for playing romantic heroes. The couple attracted vast crowds wherever they went and were often referred to as 'Hollywood royalty'.

21st June, 1920

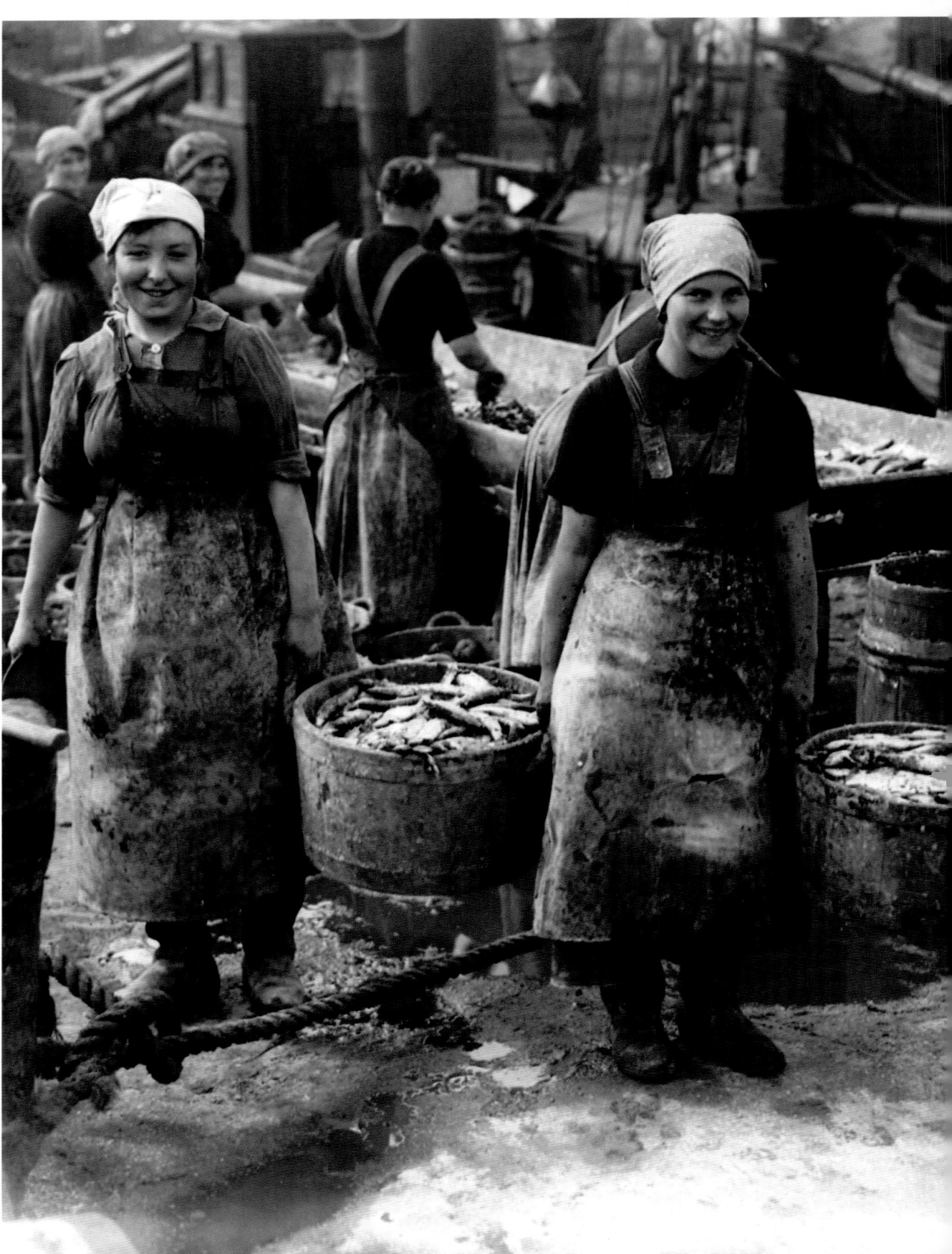

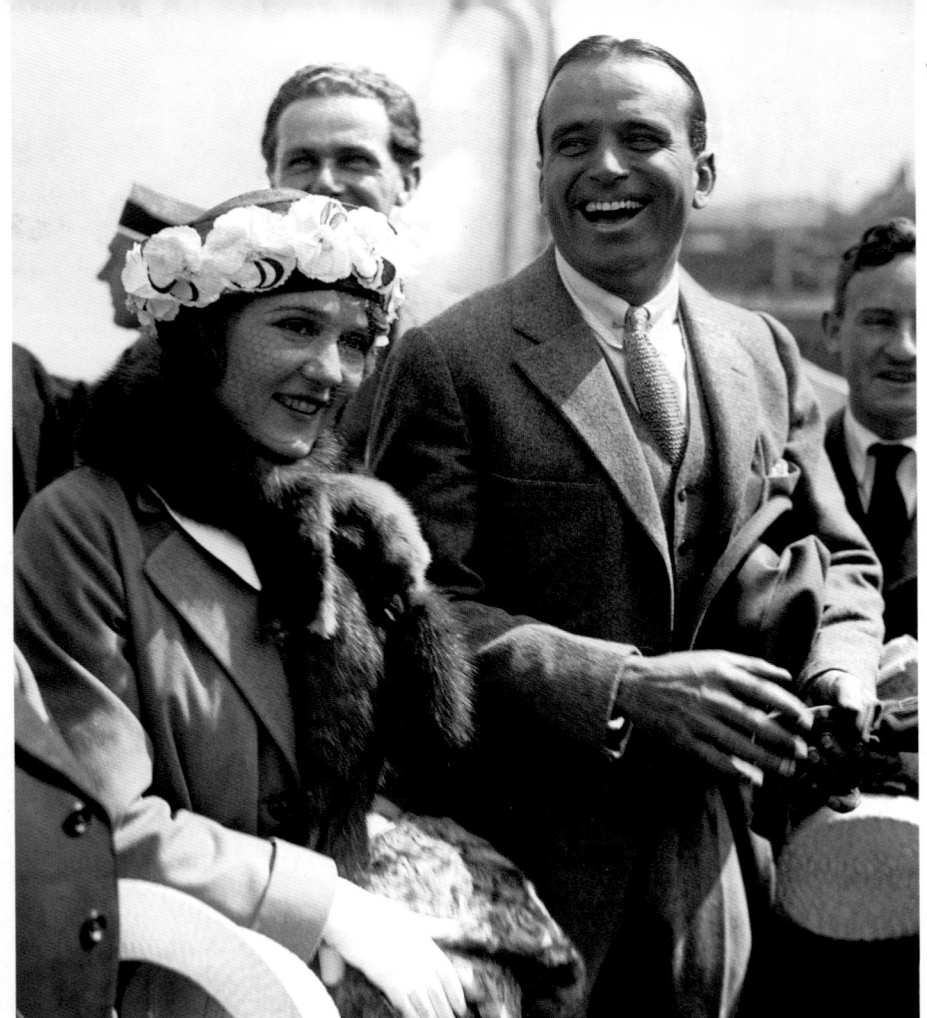

145

Right: French tennis players René Lacoste and Suzanne Lenglen in play at the International Tennis Party at Roehampton. Lacoste was one of four French players who dominated international tennis in the 1920s and 1930s. In 1933, he set up a company with André Gillier to produce his own style of tennis shirt, which bore an alligator logo. Nicknamed 'La Divine' (the divine one) by the French Press, Suzanne Lenglen won 31 championship titles between 1914 and 1926. A flamboyant trendsetter, she was the first female tennis celebrity and one of the first international female sports stars.

3rd July, 1920

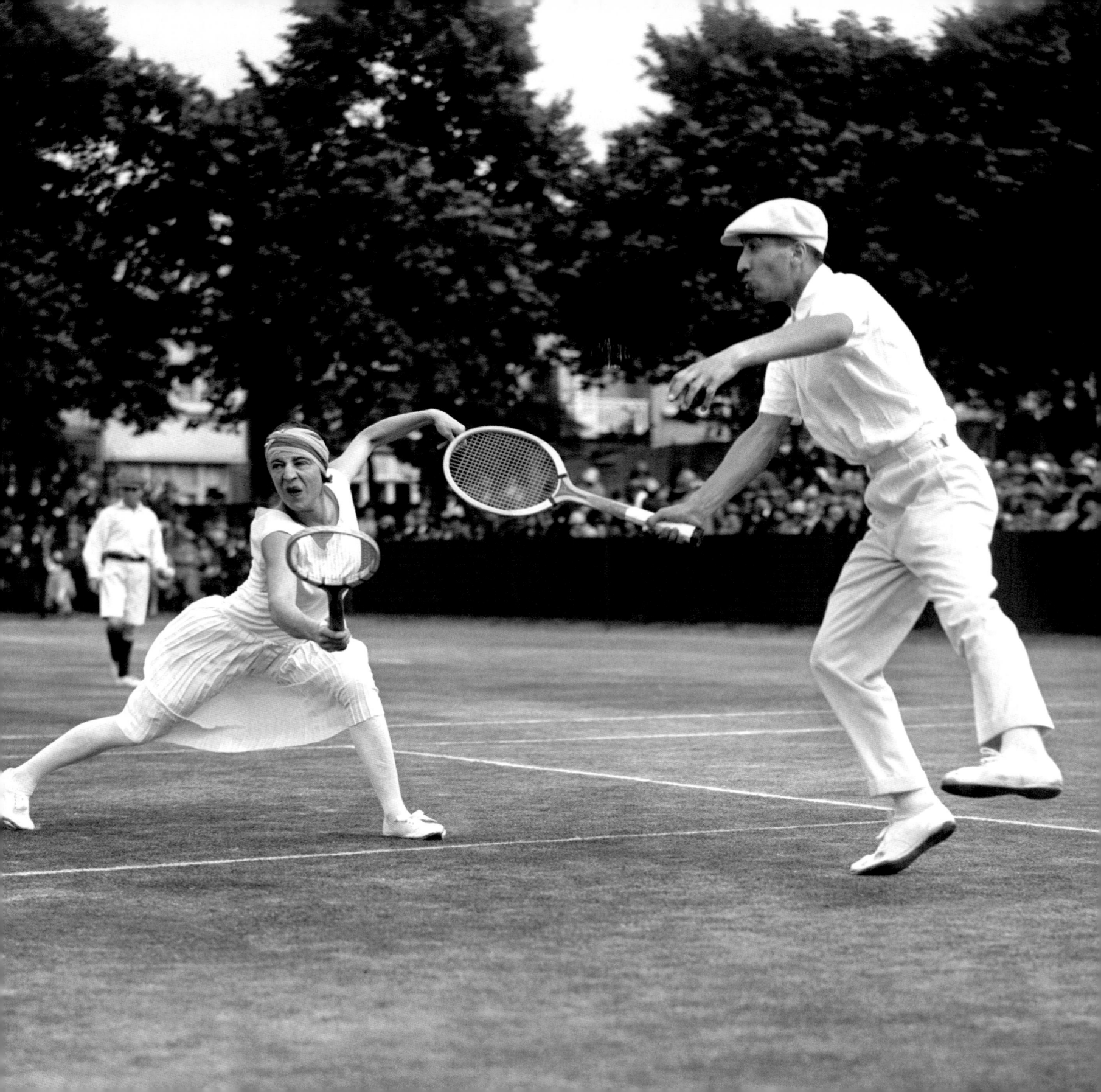

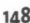

Above: A London & North Western Railway oil-fuelled steam locomotive pulls a passenger train out of Euston station, London. The LNWR existed between 1846 and 1922; during the late 19th century, it was the largest joint stock company in the world. It became a constituent part of the London, Midland & Scottish (LMS) railway in 1923.

1st September, 1920

Left: Police use a Ford Model T motor car to regulate slow-moving traffic in the East End of London.

12th October, 1920

Right: On Armistice Day, the nation buried the Unknown Warrior. It was here, where the Cenotaph stands now, that His Majesty King George V paid his tribute as he placed a wreath on the coffin, mounted on a gun carriage. Admiral Beatty can be seen in the line of naval officers (second L).

11th November, 1920

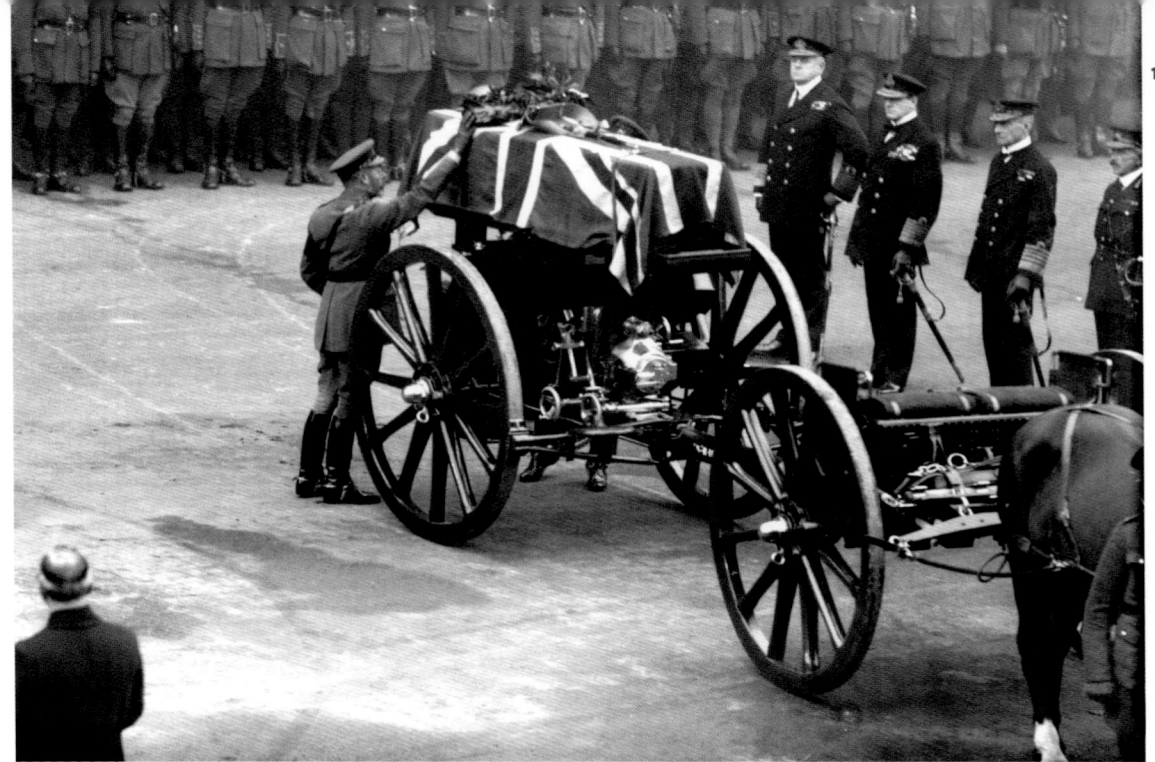

Left: An ice cream vendor and his customers on the streets of London. His barrow is patriotically decorated with portraits of King George V and Queen Mary.

3rd January, 1921

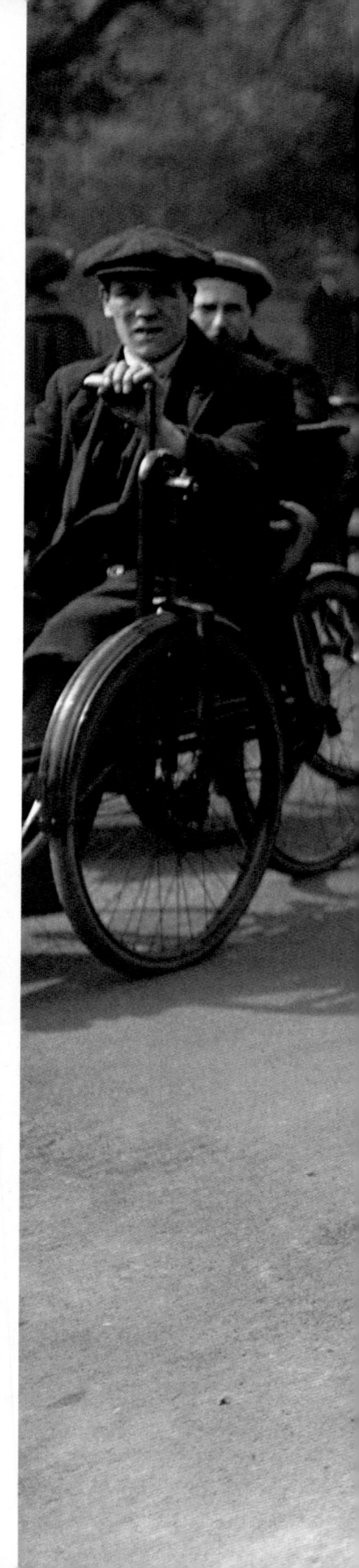

Above: The 600hp Chitty Bang Bang, Count Zborowski's huge racer, and the 8hp GN Cyclecar afford a striking contrast at the Brooklands circuit. Four 'Chittys' were built during the 1920s, achieving success on the track and fame off it. They inspired the book, film and stage musical *Chitty Chitty Bang Bang*.

26th March, 1921

Right: A Defence Force sentry at Somerset House in London, during the strike crisis of 1921. Defence Force members were taken from the Territorial Army, but did not wear uniform, as the TA could not be used to suppress civil disturbances.

1st April, 1921

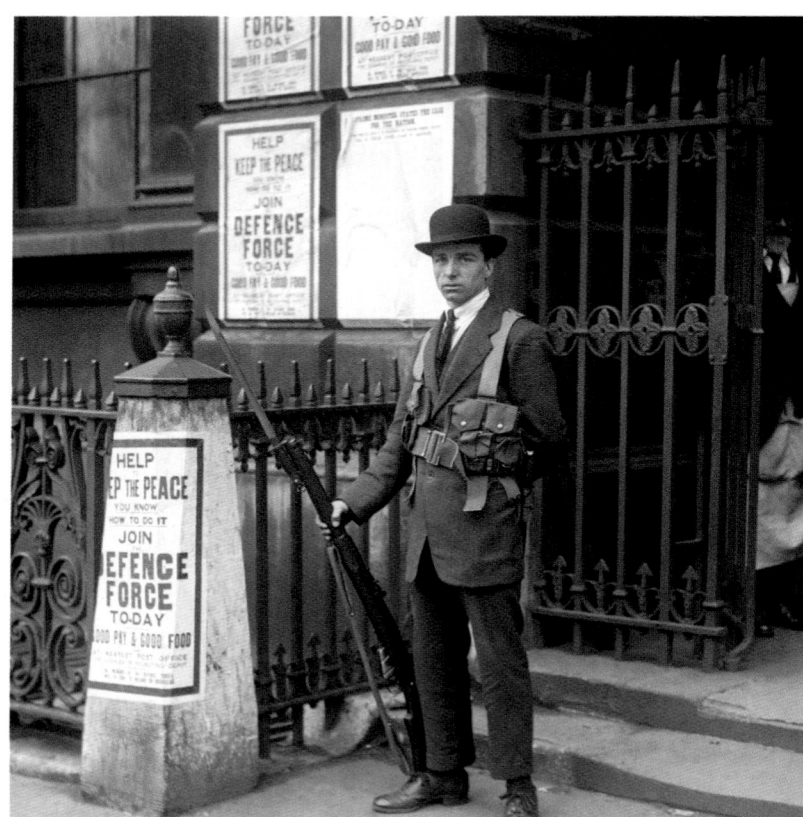

Far right: Lady Warrender out for a drive in the park with her friend Audrey James at the wheel of a cyclecar.

14th April, 1921

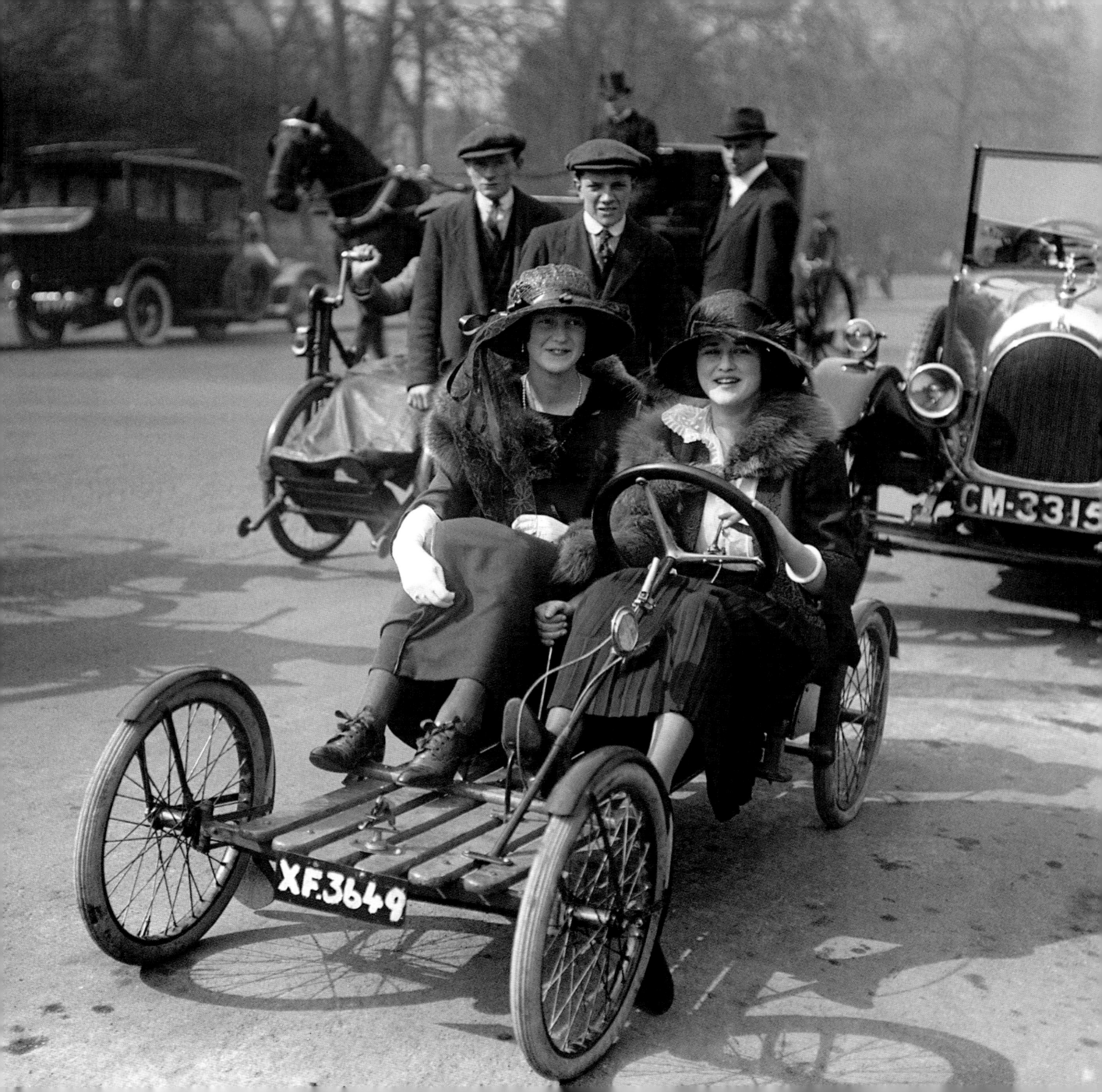

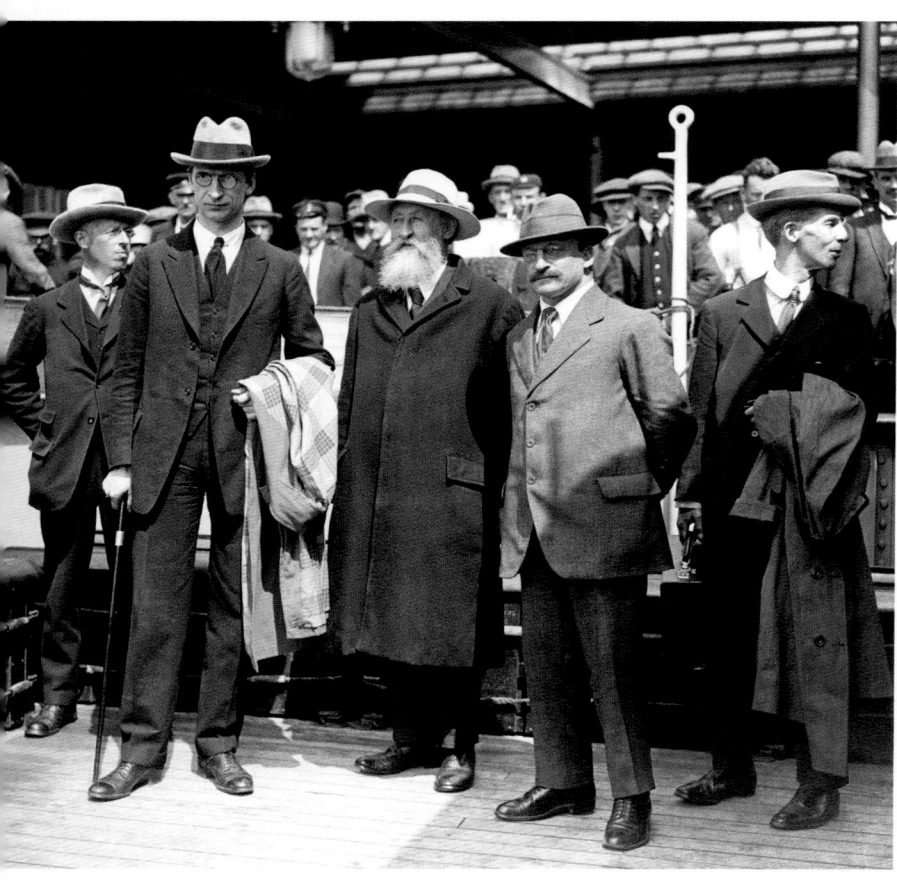

Above: The British government finally reached an accord with the Irish revolutionary group Sinn Féin: Ireland would become a free state. Eamon De Valera and his party on the Irish boat at Holyhead: (L–R) R.C. Barton, Eamon De Valera, Count Plunkett, Arthur Griffiths and Austin Stack.

12th July, 1921

Right: American comic actress Harriet Hammond with Roscoe Conkling 'Fatty' Arbuckle on the set of *Should a Man Marry?* in London. A scandal hung over the American actor, comedian and director after a party on 5th September, during which bit-part actress Virginia Rappe became ill and died four days later. Arbuckle was accused of raping and accidentally killing her. After three manslaughter charges, he was acquitted, but the scandal marred his career.

20th September, 1921

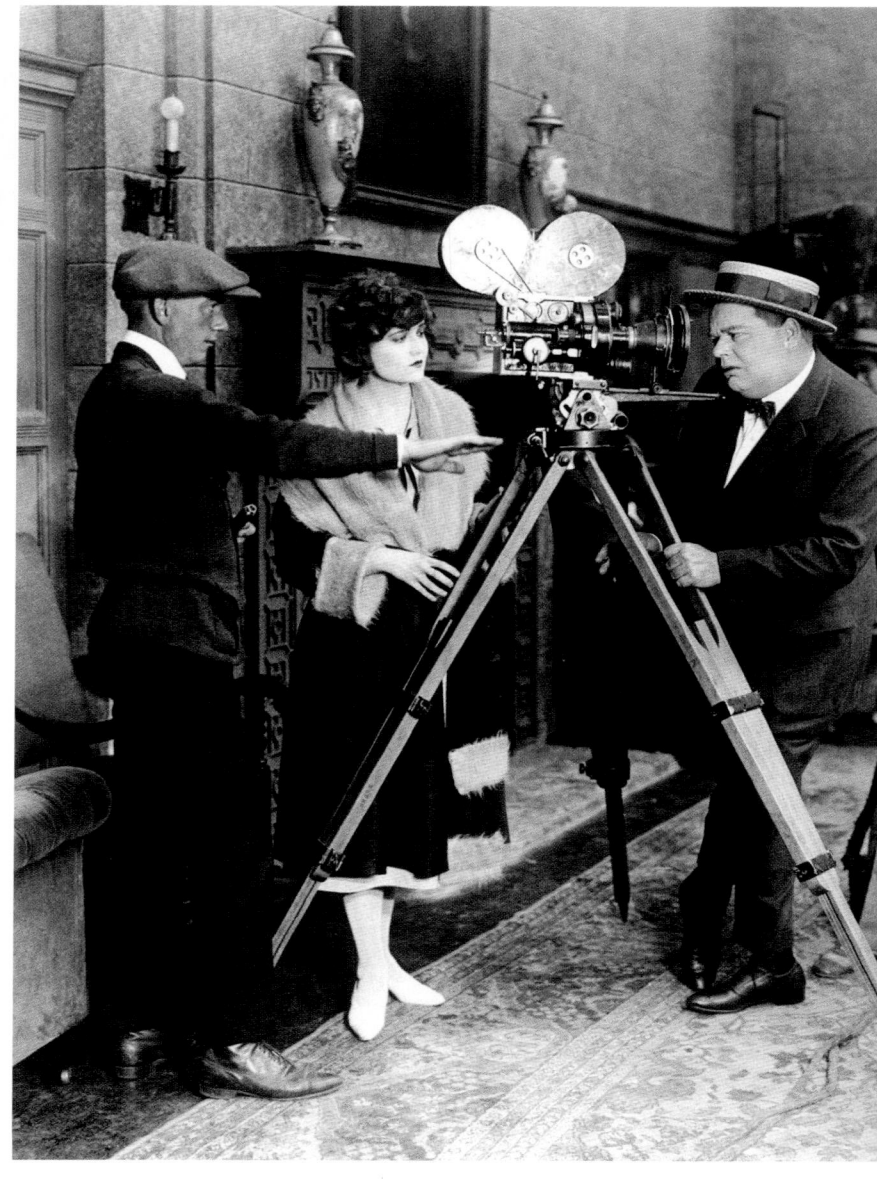

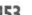

Above: The Prince of Wales, in Aden to visit British troops, is driven past locals and a banner asking him to *"Tell Daddy we are all happy under British rule"*. Daddy was King George V.

12th November, 1921

Right: Sir J.M. Barrie (with stick), the eminent playwright best known for *Peter Pan*, enjoys a late-night beverage at the Charing Cross coffee stall in London.

2nd December, 1921

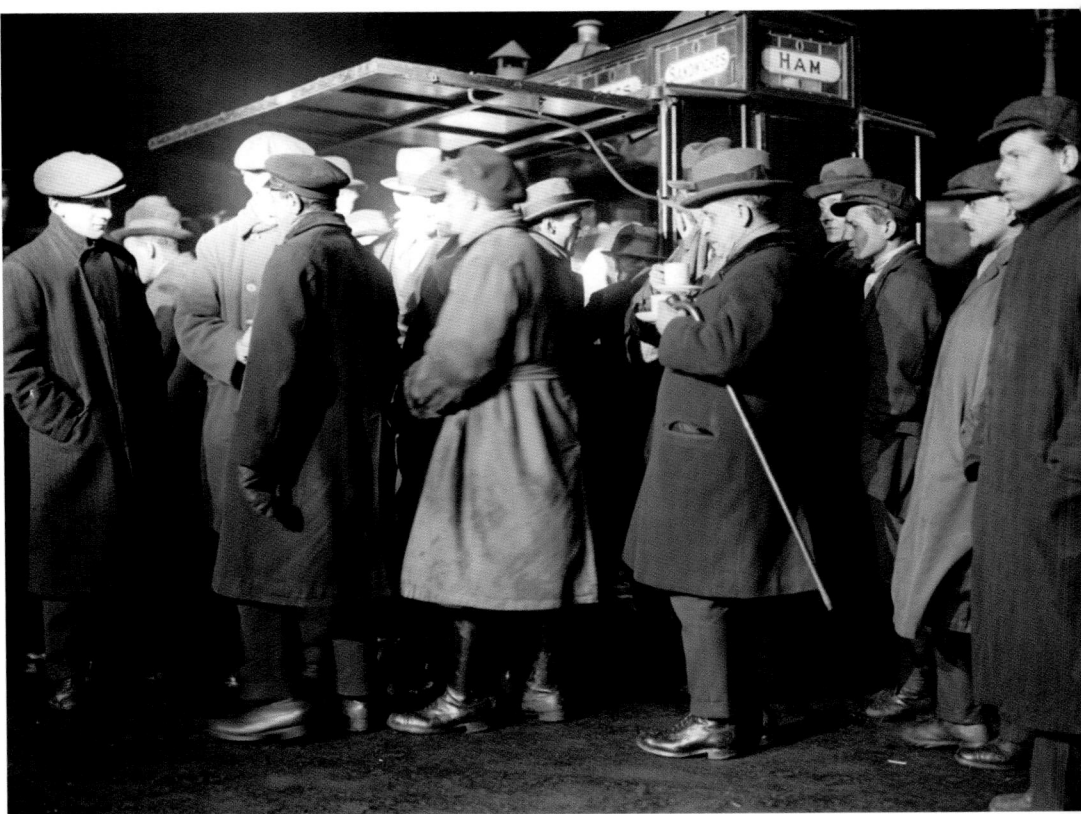

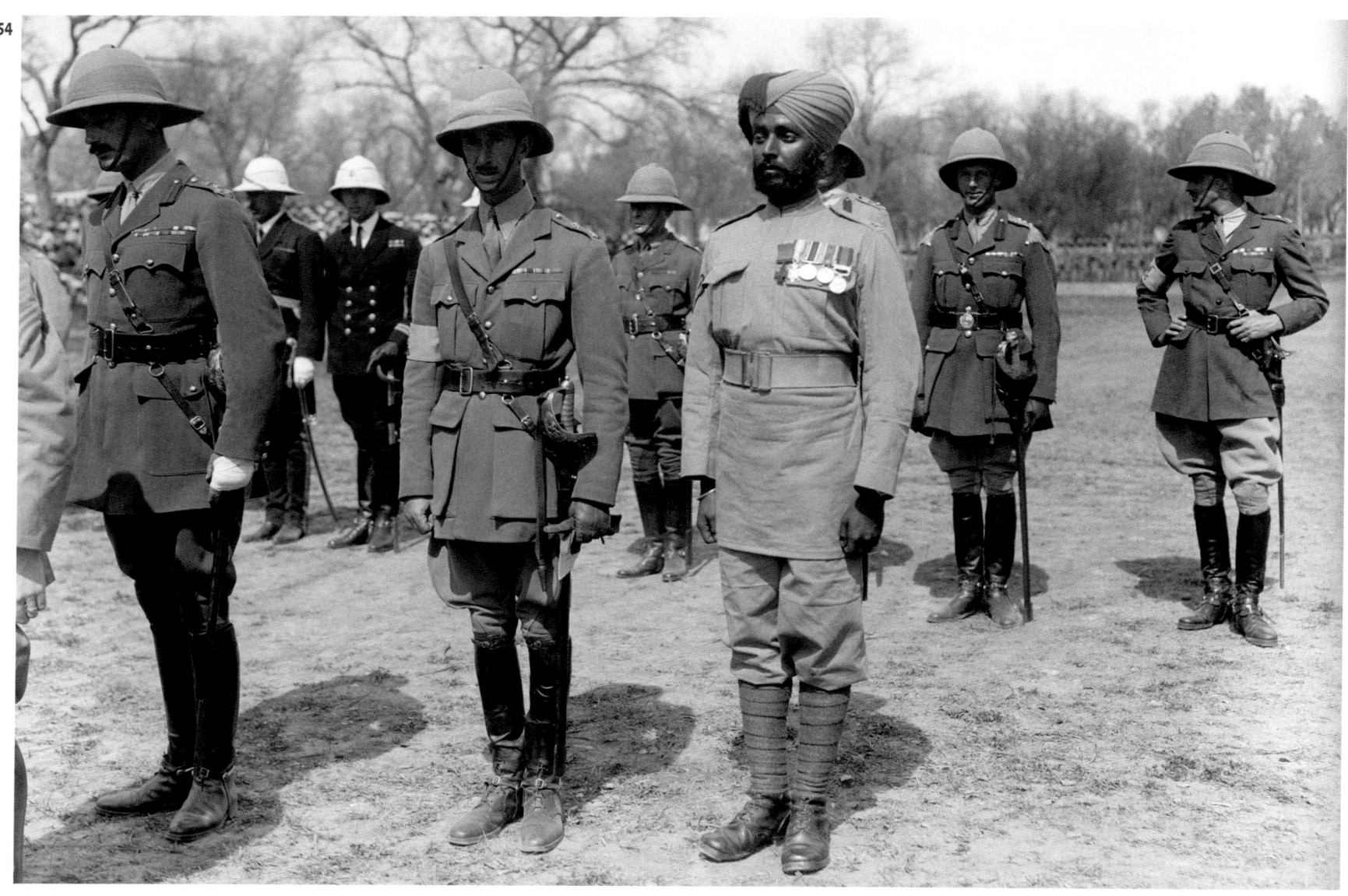

Above: Sepoy Ishar Singh of the 28th Punjab Regiment becomes the first Sikh
soldier to receive the Victoria Cross, the British Empire's highest military honour.
He was cited for conspicuous bravery in Waziristan, then a political hotspot near
the Afghan border.

10th March, 1922

Above: Spoils of war. The new ocean liner *Majestic*, the largest ship in the world. Built in Germany, originally for the Hamburg-America Line, as the *Bismarck*, she was ceded to Britain under the terms of the Treaty of Versailles after the First World War. She was not completed until 1922, however, after which she was operated jointly by the White Star Line and Cunard.

10th April, 1922

Right: Fancy dress. The Prince of Wales (C) and two companions in traditional Japanese costume while on board HMS *Renown* sailing from Hong Kong to Japan.

20th April, 1922

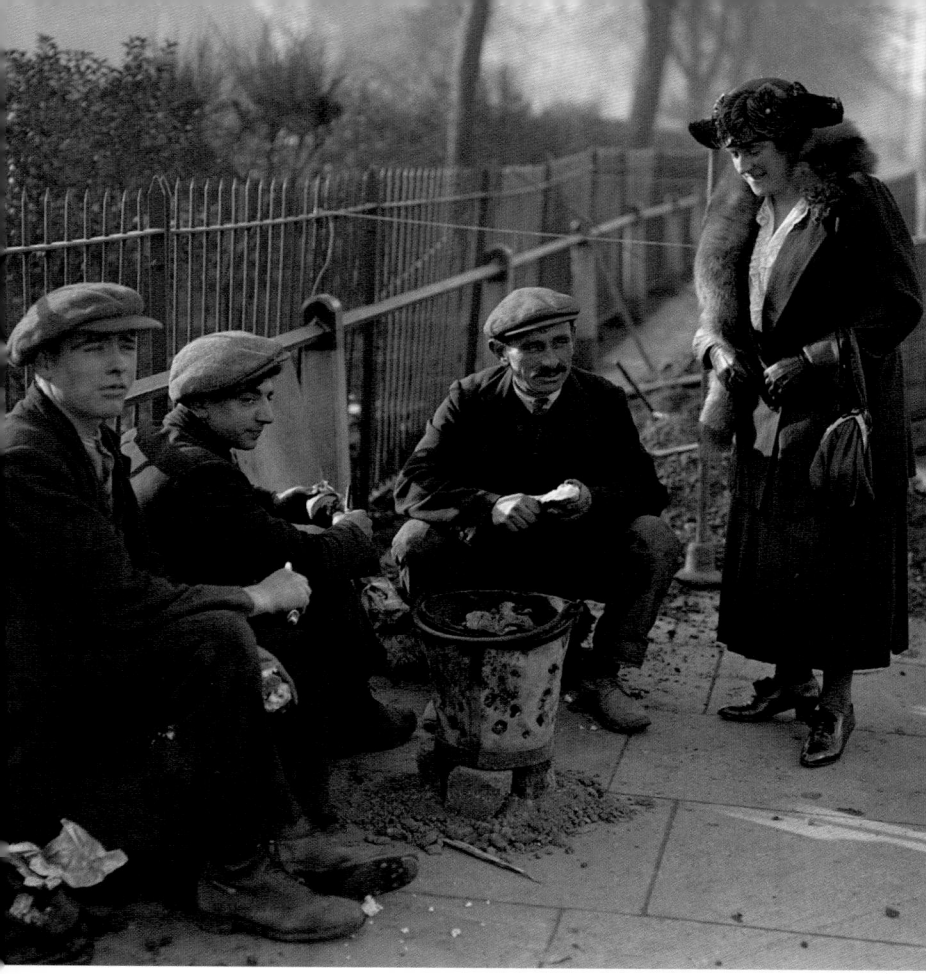

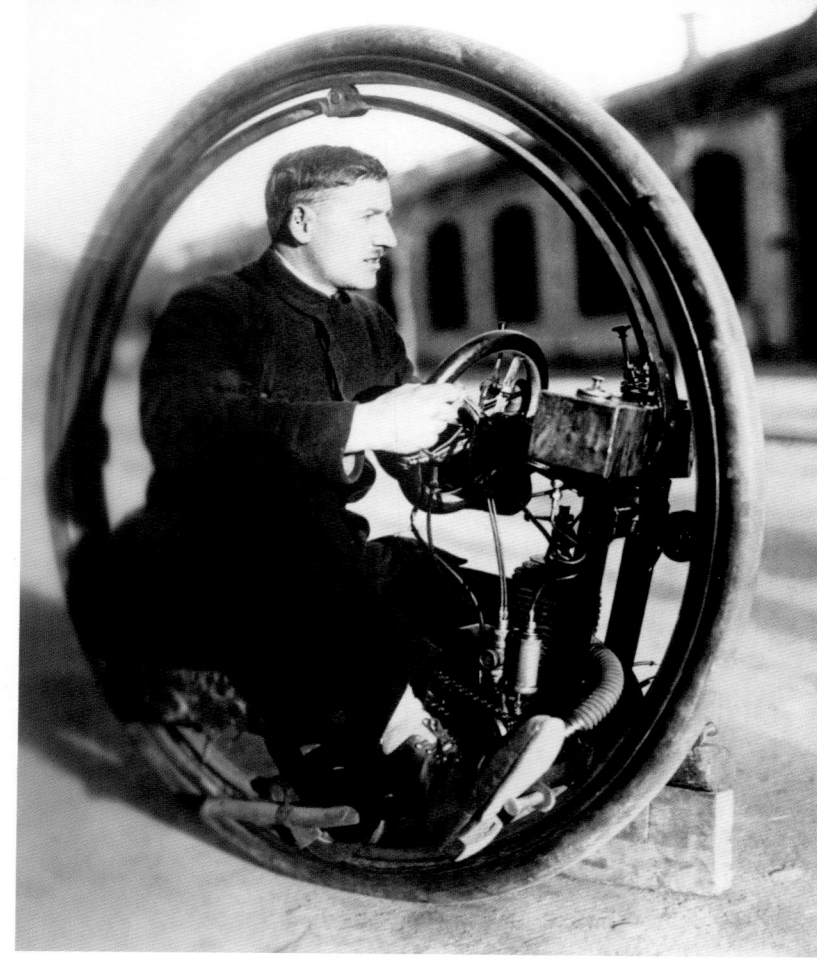

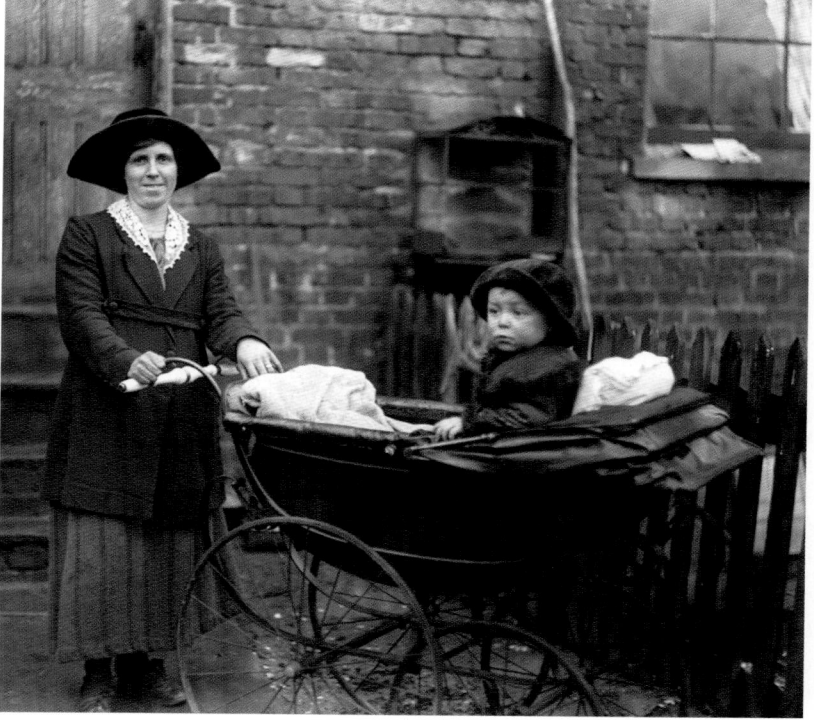

Above: Mrs Grant Morden canvasses for votes on behalf of her husband, the Conservative candidate in the Brentford and Chiswick by-election. Her words appear to be falling on deaf ears.

9th November, 1922

Above right: Signor Davide Cislaghi with his one-wheel motorcycle called the Monowheel, which was capable of speeds of up to 40mph (64km/h). He would go on to patent the machine in Britain in 1927, and although it proved a success in trials, it never caught on.

January, 1923

Right: Mrs Rose Firmarger and her baby, of Erith, Kent, have started training for the mothers' perambulator walking race to Brighton. Their training course is a gruelling 30-mile (48km) route from Erith to Farnborough via Bromley, Lewisham and Greenwich.

24th February, 1923

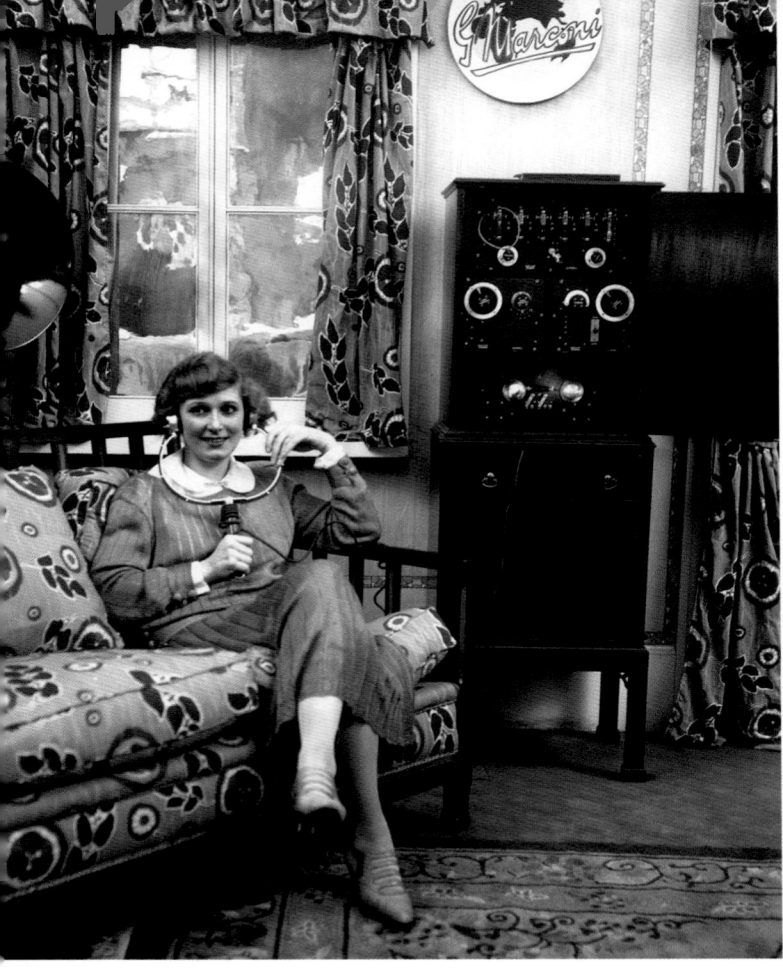

Left: Heather Thatcher, an actress in the musical comedy *The Cabaret Girl*, demonstrates the latest home wireless technology from Marconi.

10th March, 1923

Below left: An air of mystery. Sir Arthur and Lady Conan Doyle, with their two sons and daughter, at Waterloo Station, London, before setting out on a journey to the United States.

28th March, 1923

Above right: Sir Gerald du Maurier, at Cannon Hall, Hampstead, with his two daughters, Jeanne and Daphne (R). Daphne's subsequent fame as a novelist would eclipse that of her actor father.

1923

Right: The BBC had been formed in 1922 to regulate the new 'radio' that was proving so popular. Pictured are comedian George Robey and Alma Adair giving a wireless rehearsal from the Covent Garden Review *You'd be Surprised*.

1923

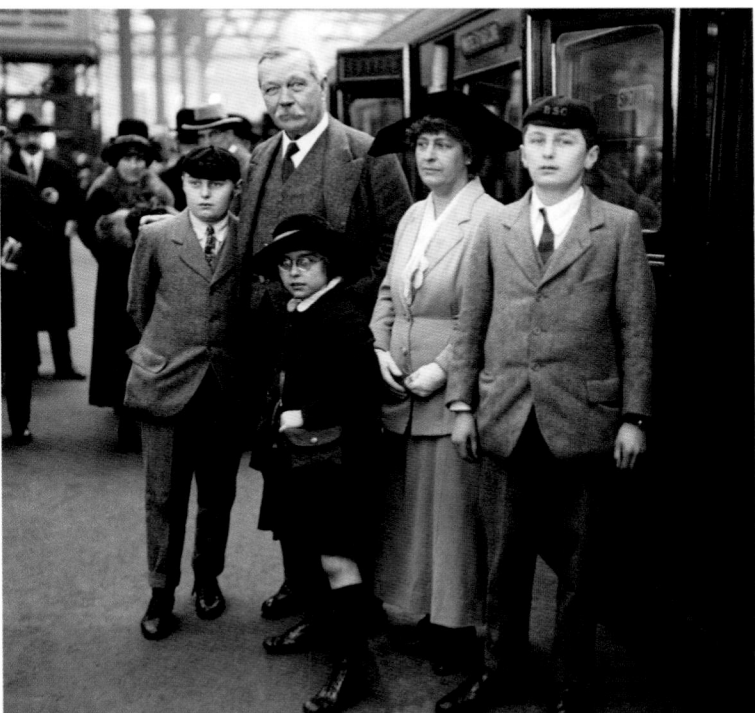

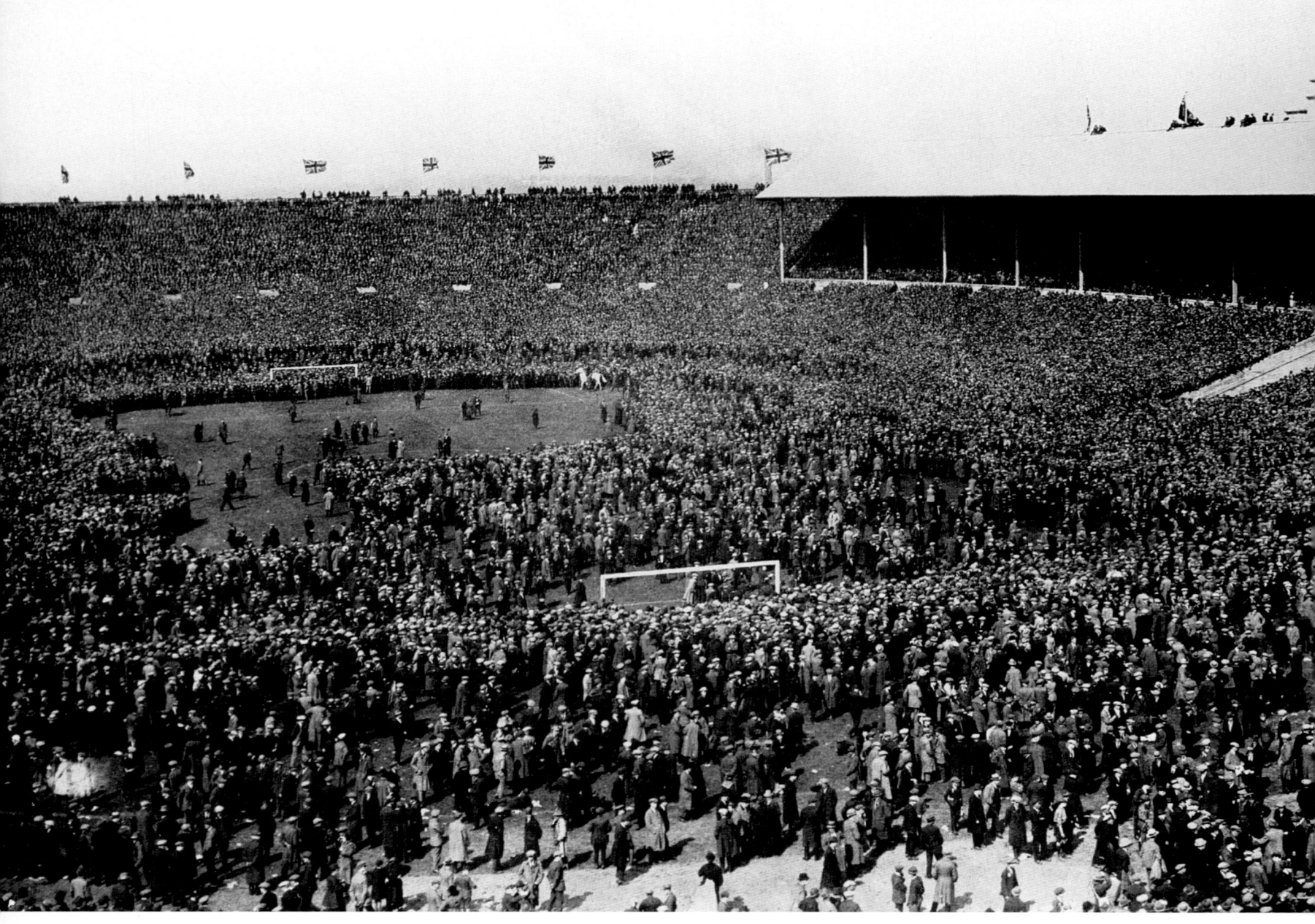

Above: The crowd swarms on to
the Wembley football pitch before
the first FA Cup Final to be played
at the Empire Stadium, only to be
quelled by PC George Scorey on Billy
the grey horse (C).

28th April, 1923

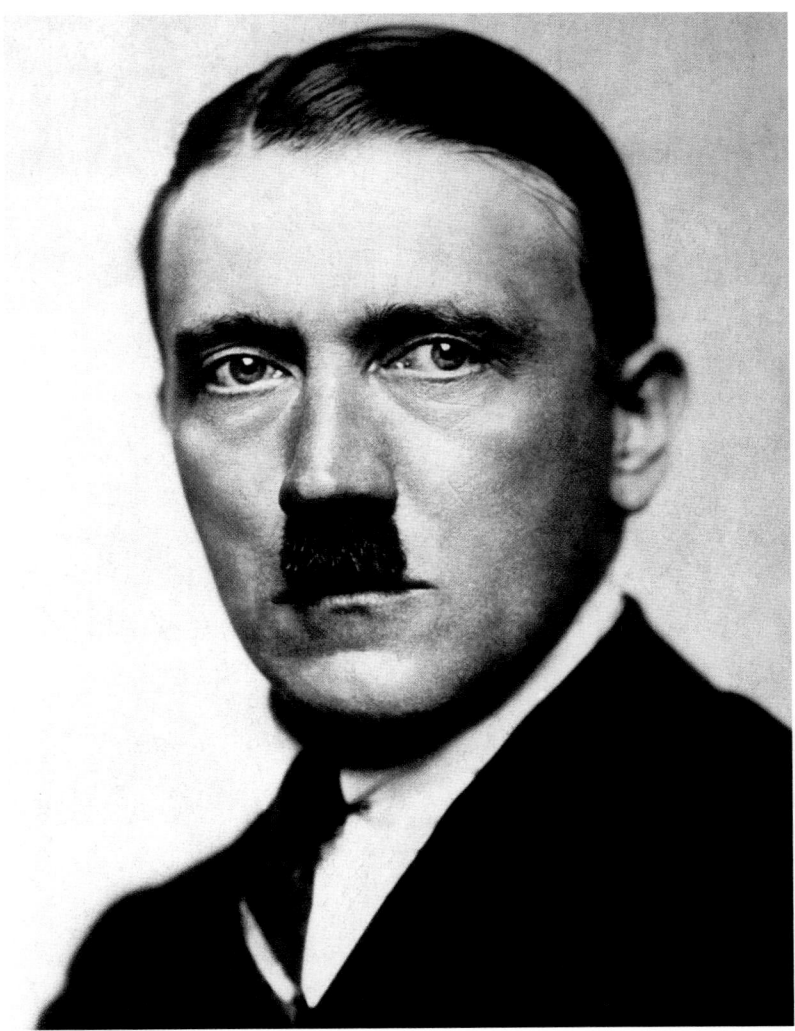

Above: A portrait of Adolf Hitler by Heinrich Hoffmann. The 1920s saw the rise of the National Socialist (Nazi) Party in Germany, led by Hitler, whose aims were German nationalist expansion and a war against the Jews, whom he saw as controlling Germany's enemies – Britain, France and the Soviet Union. His doctrine led ultimately to the Second World War and the Holocaust, in which 6,000,000 Jews were exterminated.

1923

Right: Hermann Göring, a highly decorated First World War German fighter pilot, was appointed by Hitler as head of the Nazi Party's paramilitary wing, the Sturmabteilung (SA). He would rise to become Hitler's nominated successor in the government that took Germany to war.

1923

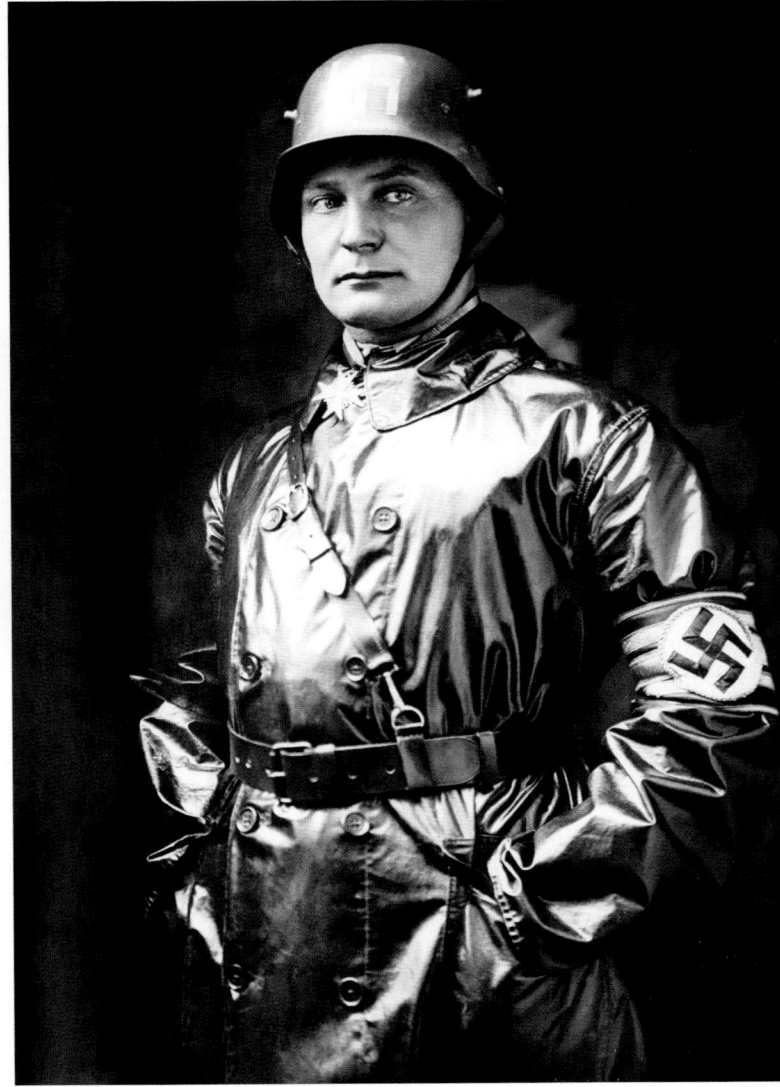

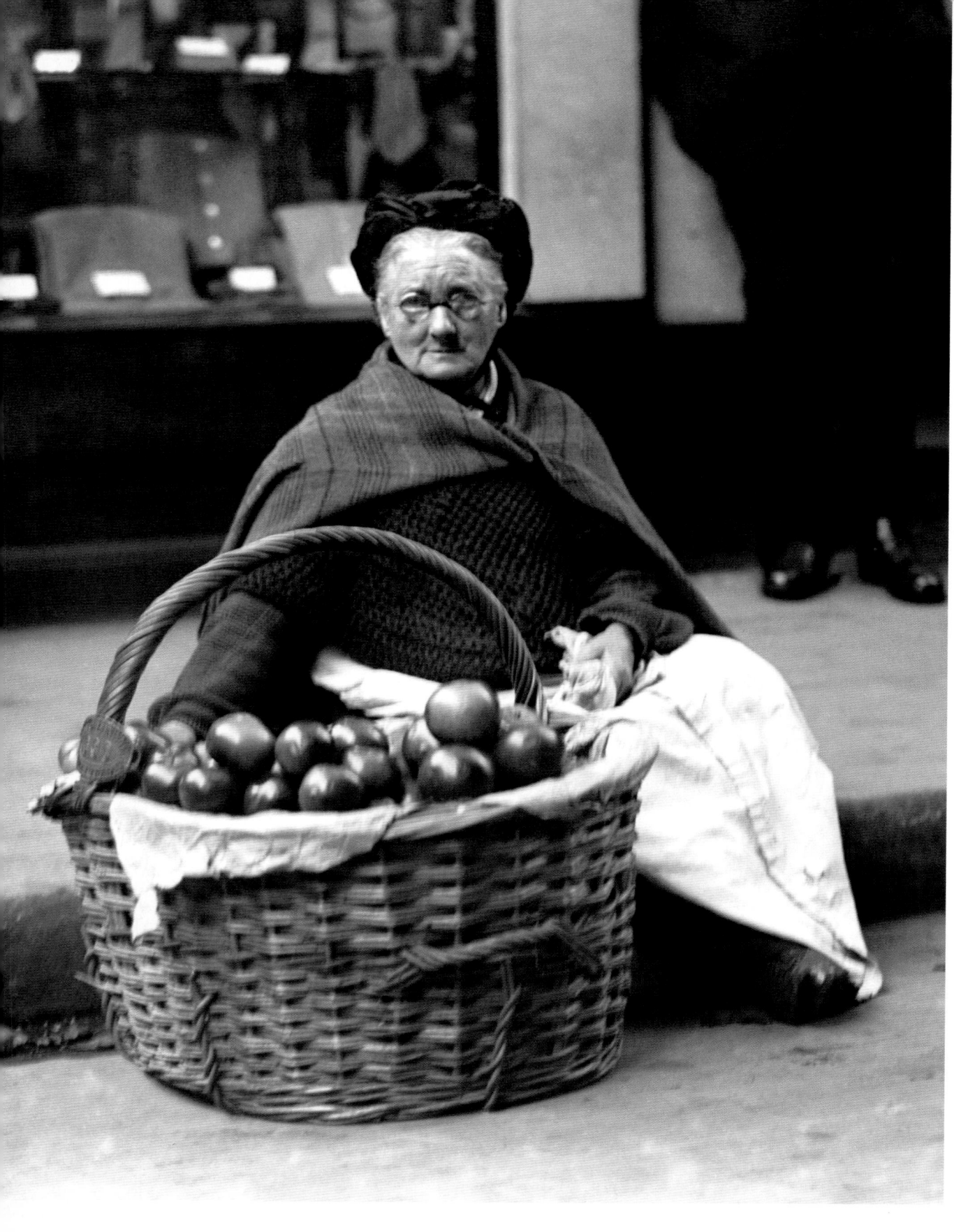

Left: Mrs Hunt, who sold apples for 40 years at the corner of Wood Street, Cheapside, in London. The licence that authorized her to trade in the street is attached to the handle of her basket.

25th October, 1923

Right: Coal miners take a break to eat their meal, watched by some of the pit ponies. The arduous work was not only the preserve of adult men, as can be seen from the young boy sitting on the left.

1924

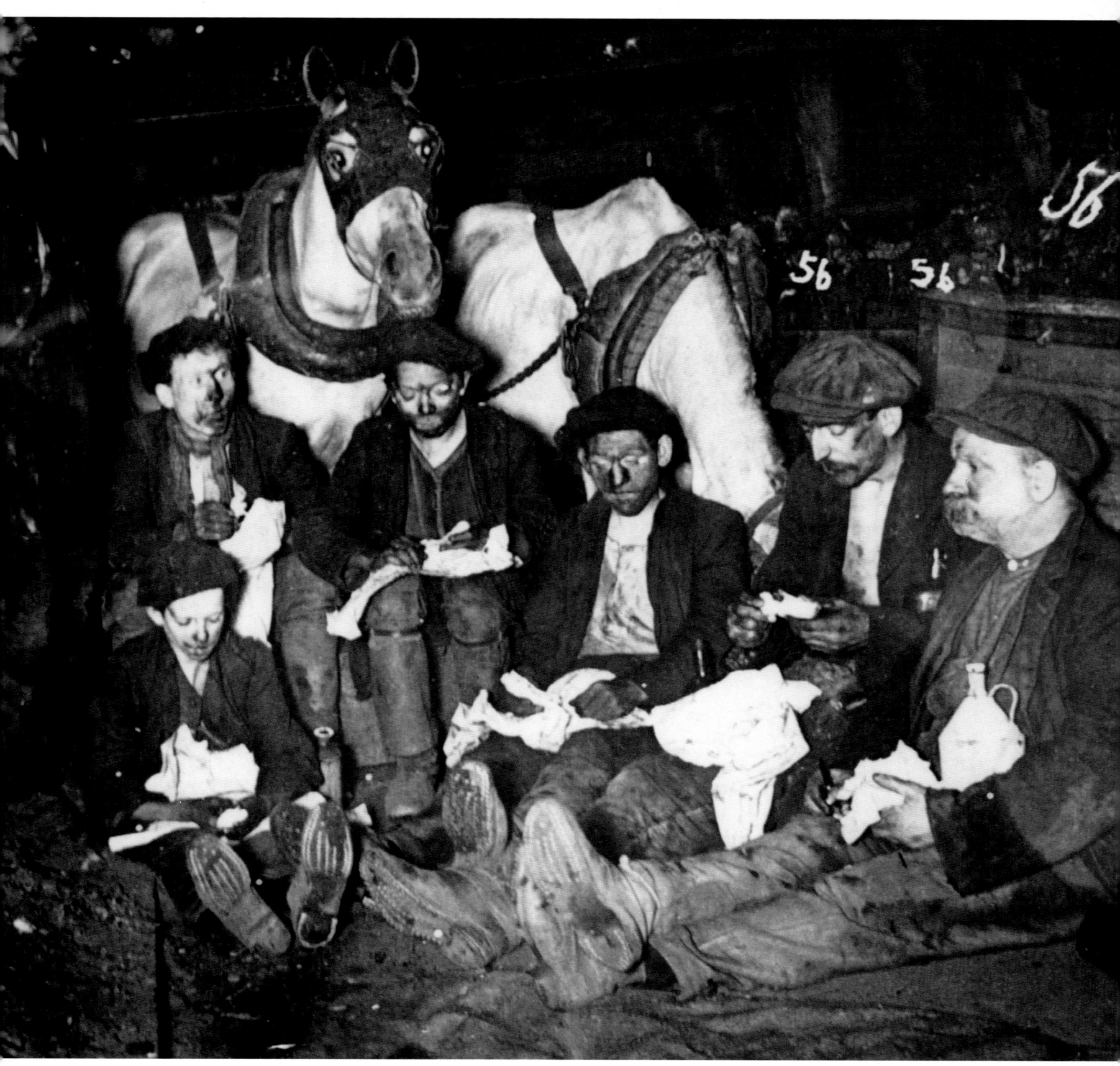

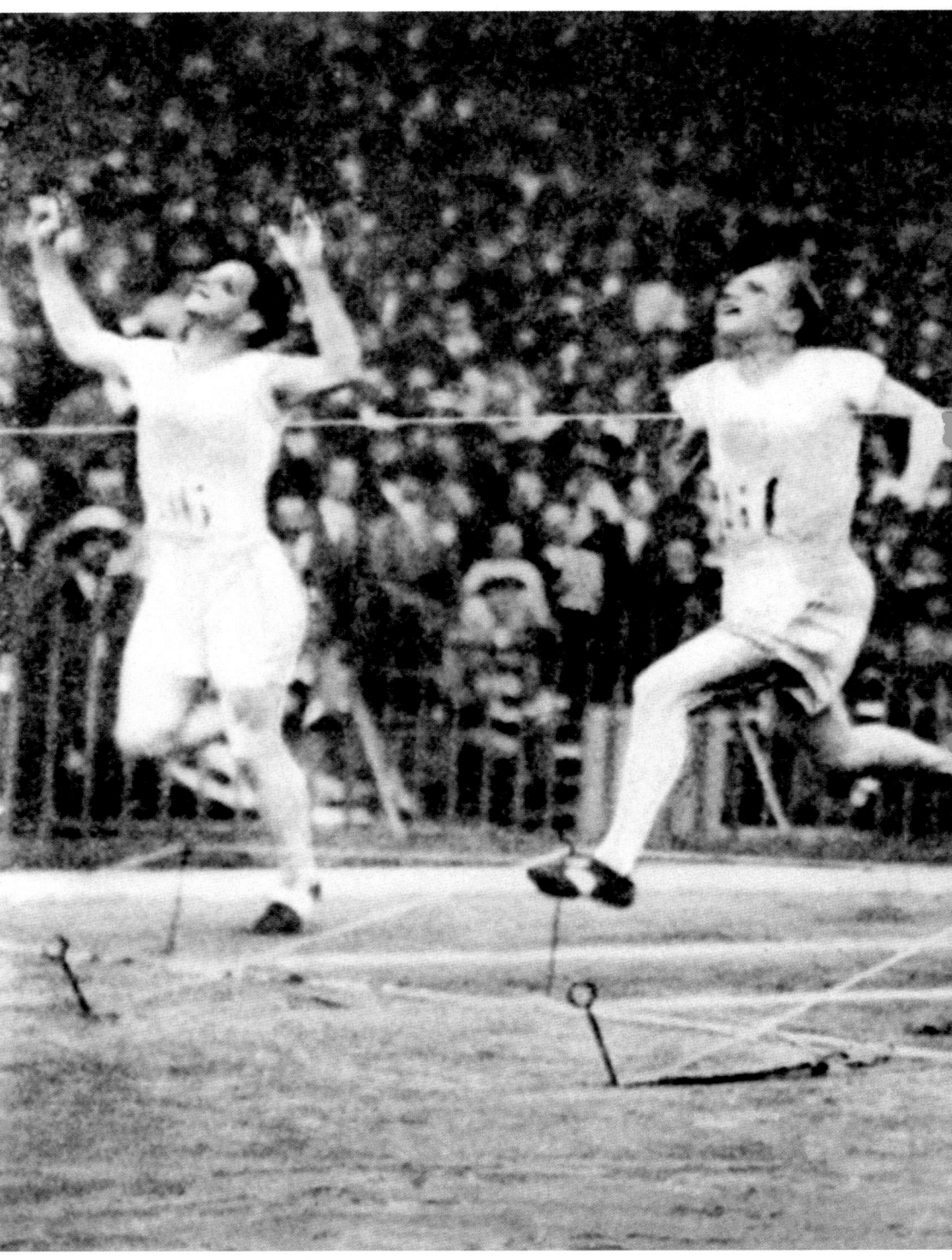

Right: Great Britain's Harold Abrahams (second R) wins his Olympic semi-final from the USA's Charles Paddock (second L). He went on to take gold in the 100m sprint, inspiring the 1981 movie *Chariots of Fire*.

16th July, 1924

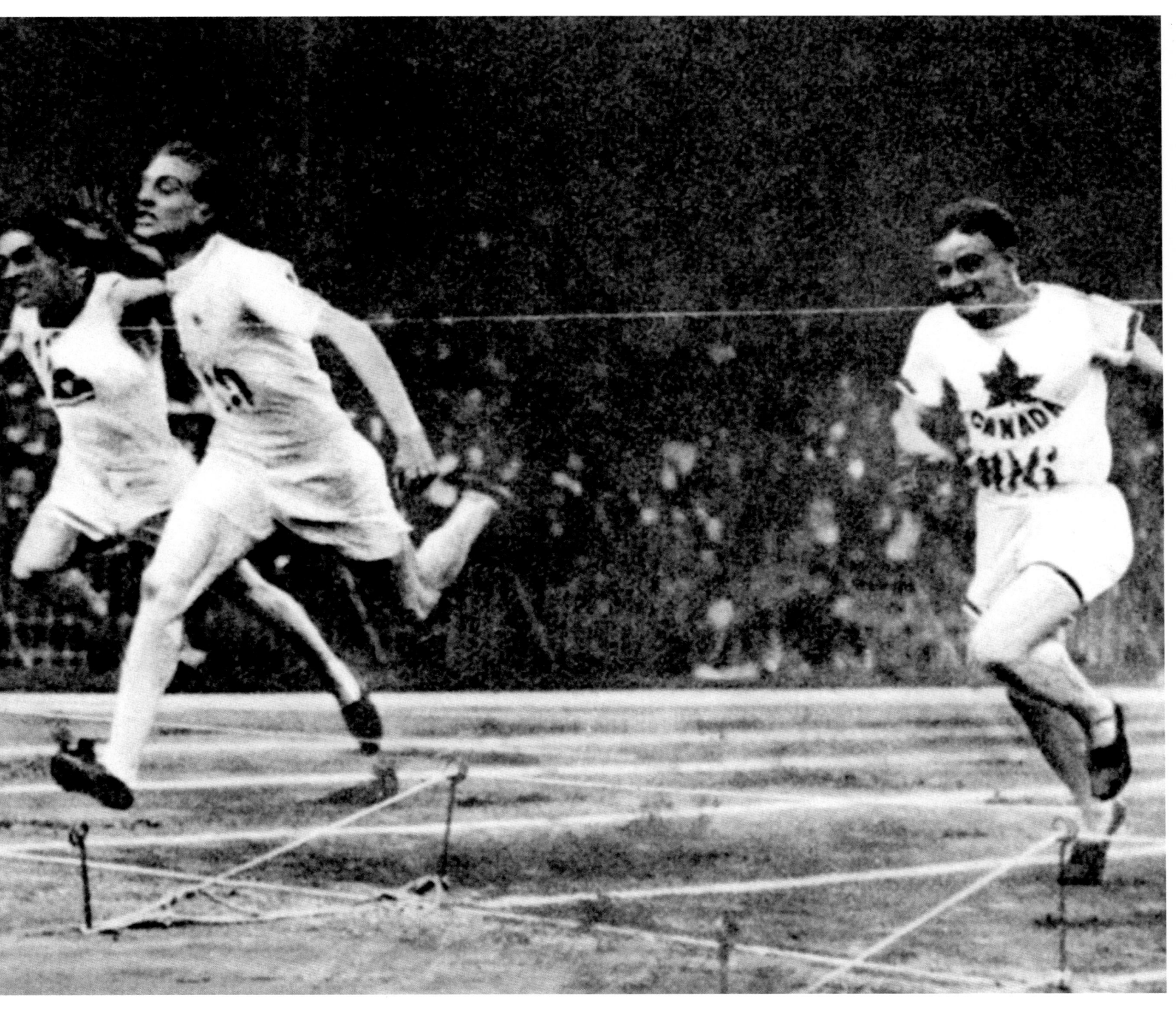

Right: The novel and artistic 'Jazz' coffee stall at the 'At Home' of the Arts League of Service at Robert Street, Adelphi, in London. British poet and critic Edith Sitwell and her brother, the writer Osbert Sitwell, are seen taking refreshment.

1924

Below right: Lady Diana Duff Cooper and companion at a garden party. In her youth, Lady Diana was considered the most beautiful woman in England. She was a nurse during the First World War; a magazine editor and newspaper columnist; a stage and film actress; and a society hostess. She was also the inspiration for characters in books by Evelyn Waugh and Nancy Mitford, among others.

24th July, 1924

Far right: King George V at the helm of his racing yacht, *Britannia*.

1st August, 1924

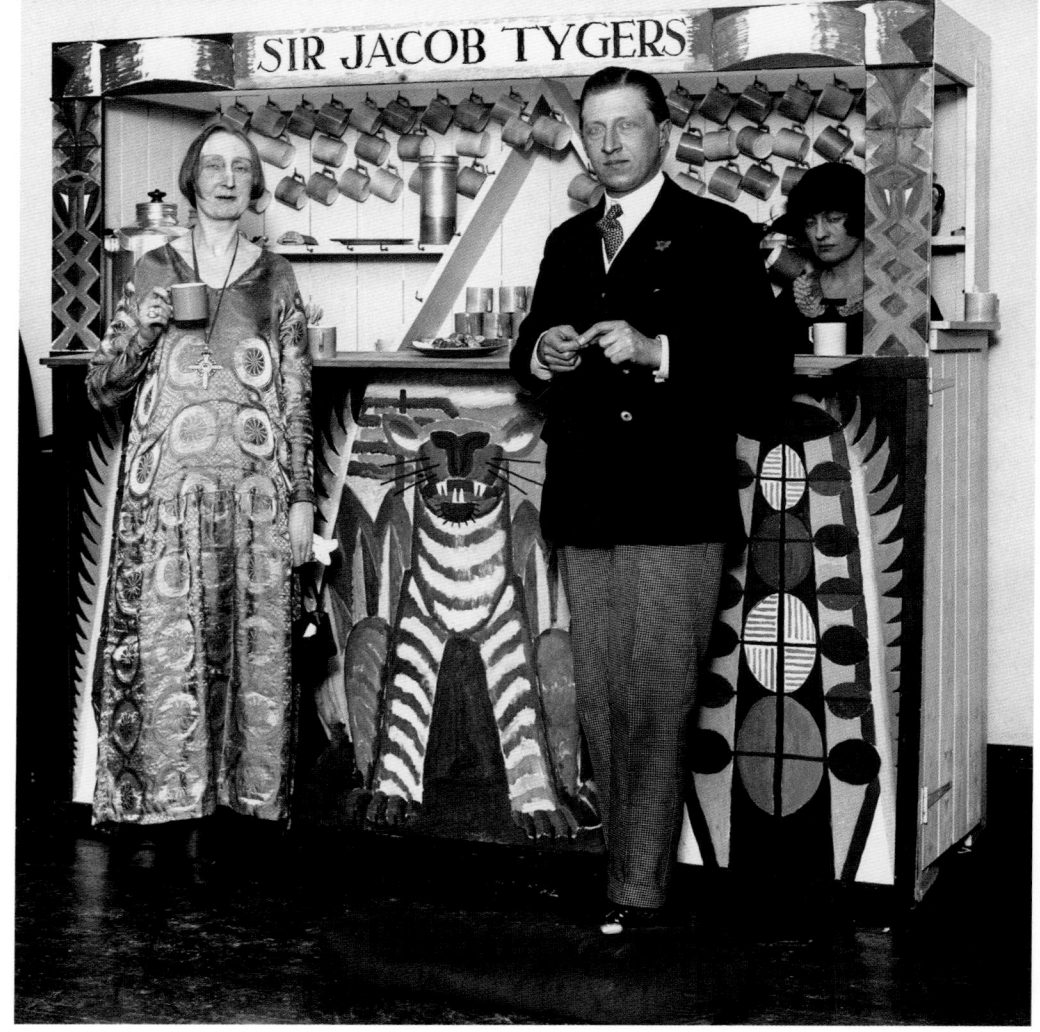

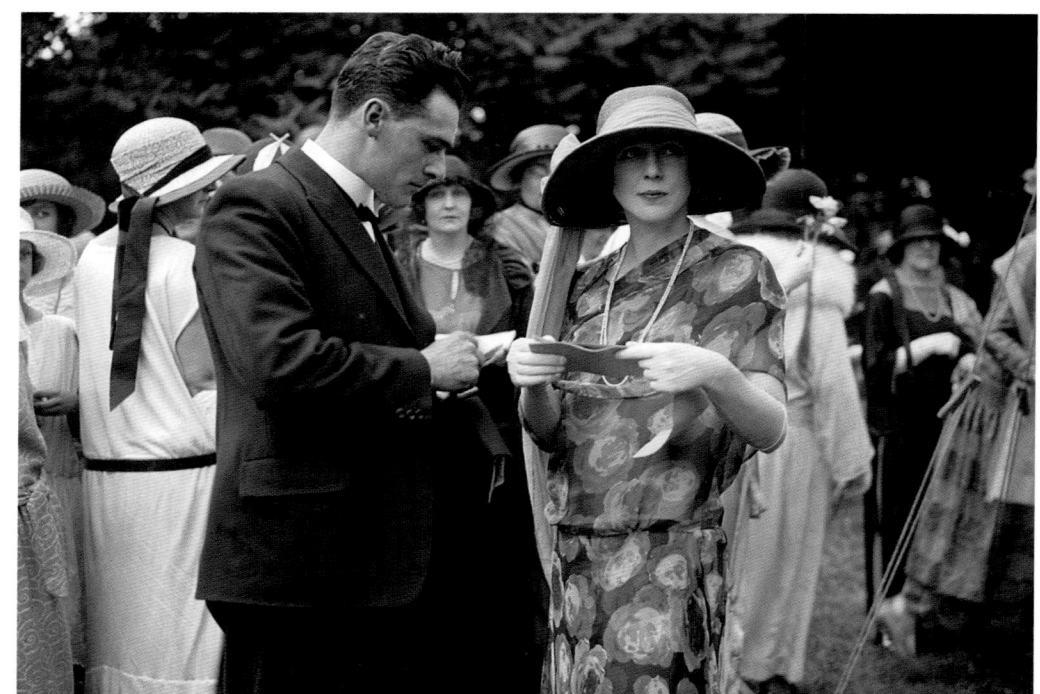

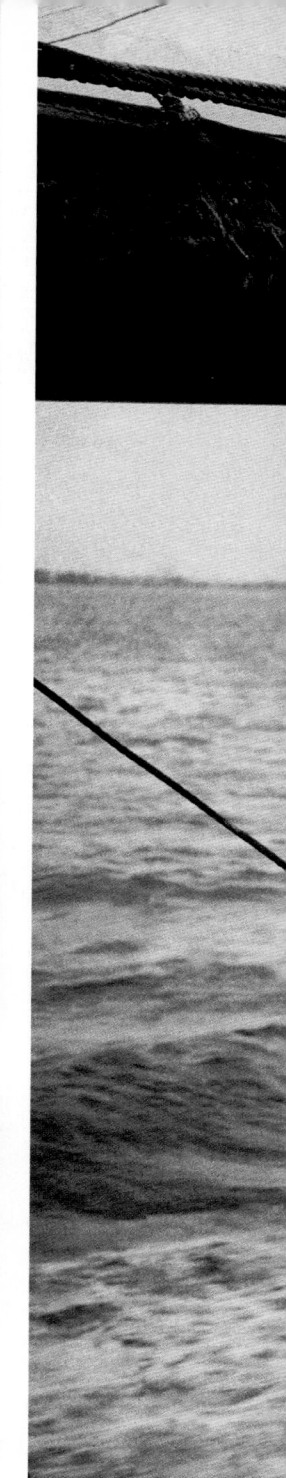

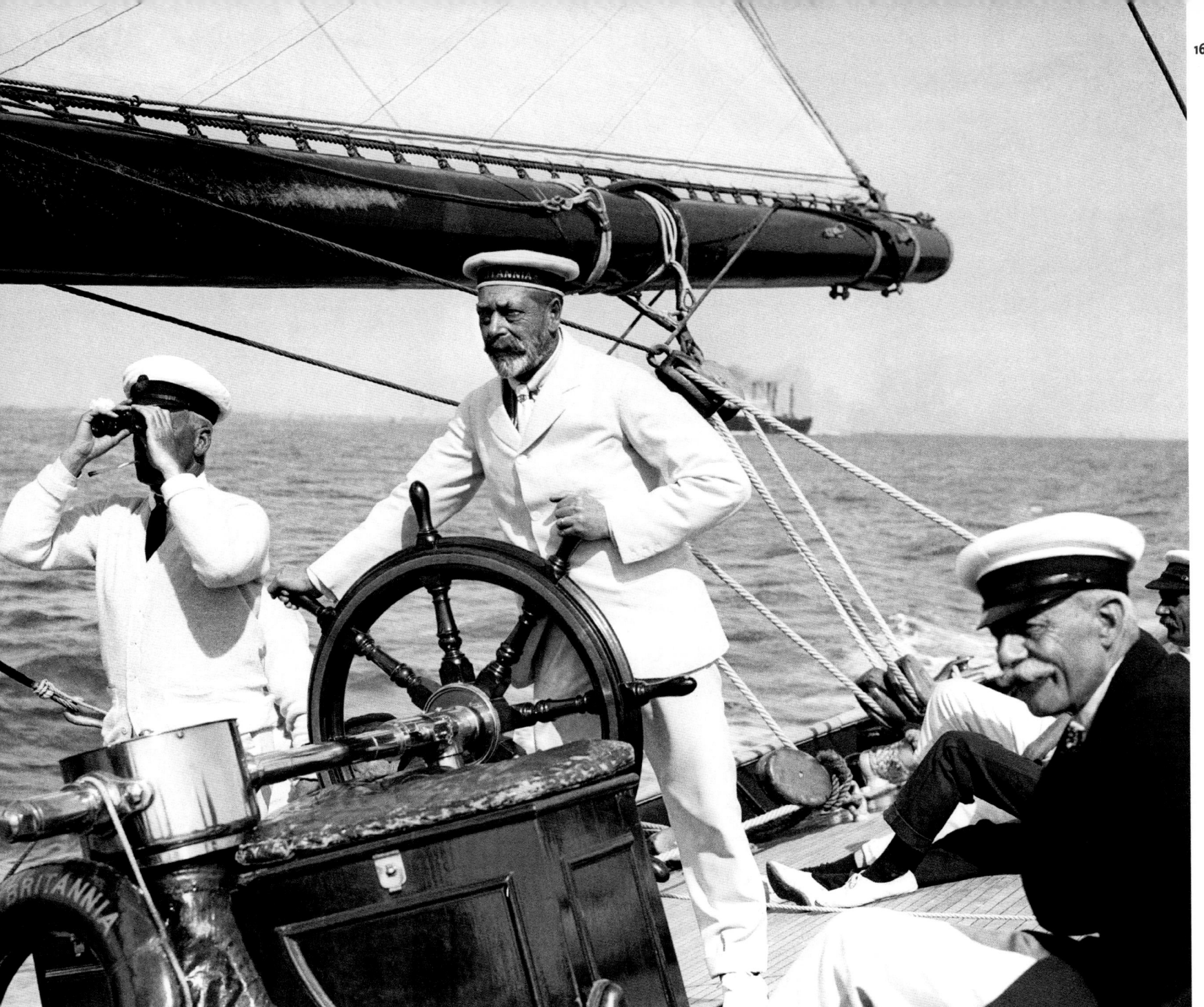

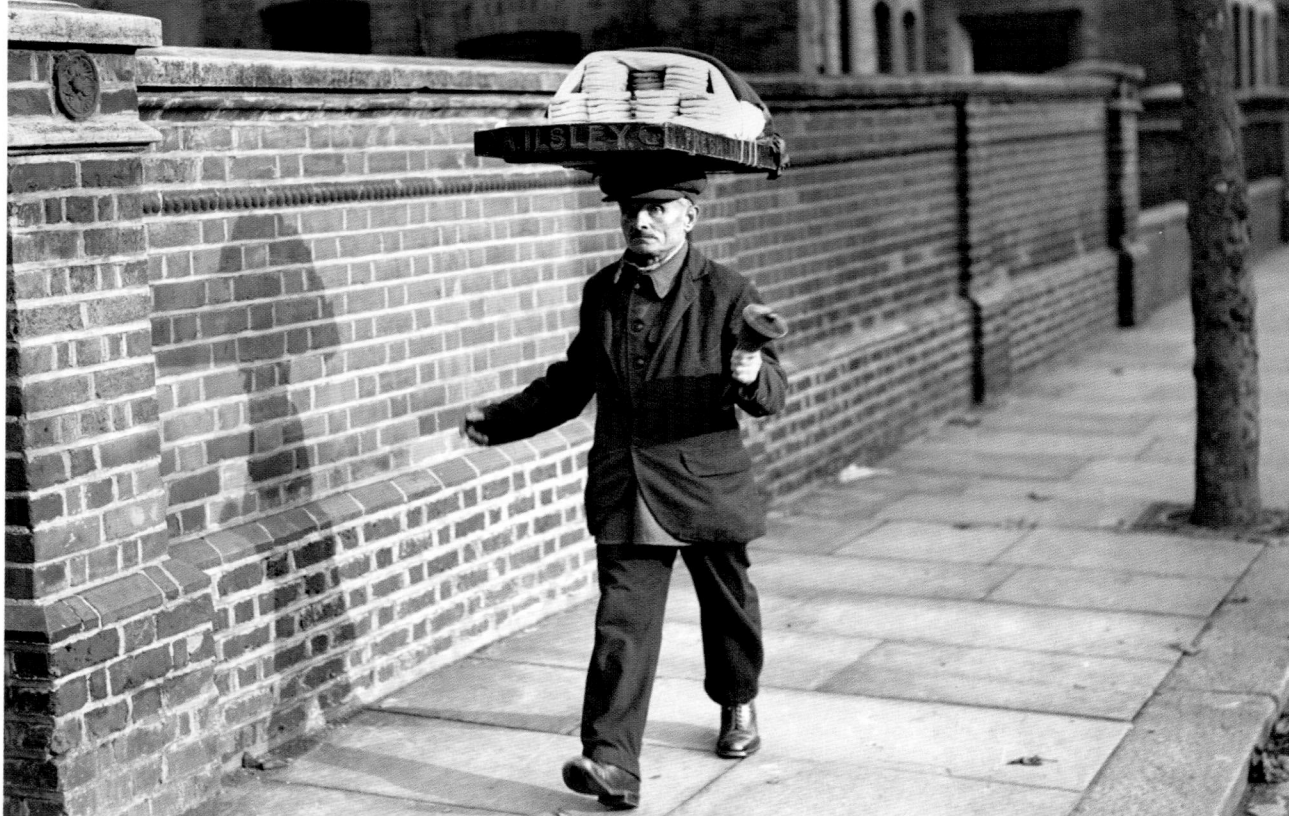

Left: Scouts parade with their Colours, passing through the vast crowd at the Boy Scouts Imperial Jamboree, Wembley Stadium.

3rd August, 1924

Below left: Balancing act. A muffin man, making deliveries to households and announcing his presence with a hand bell.

14th October, 1924

Right: Twin sisters Rosika (L) and Jansci Deutsch create the illusion of a mirror image. Known as the Dolly Sisters, the Hungarian-born performers were renowned stars of music hall and film in Europe and the USA. They were successful gamblers, too: in one season at Deauville, in France, they won $850,000, while in one evening at Cannes, Jansci won four million francs, which she promptly turned into a collection of jewellery. In the early 1920s, the sisters lived and performed in London, and were feted among high society. Edward, Prince of Wales (later Edward VIII) was particularly taken with Jansci and often would follow the sisters to the playgrounds of the rich and famous, such as Paris and Biarritz.

16th December, 1924

Far right: Surrey and England cricketer Jack Hobbs demonstrates the batting style that allowed him to score more runs and more centuries in first-class cricket than any other player in the history of the game.

1925

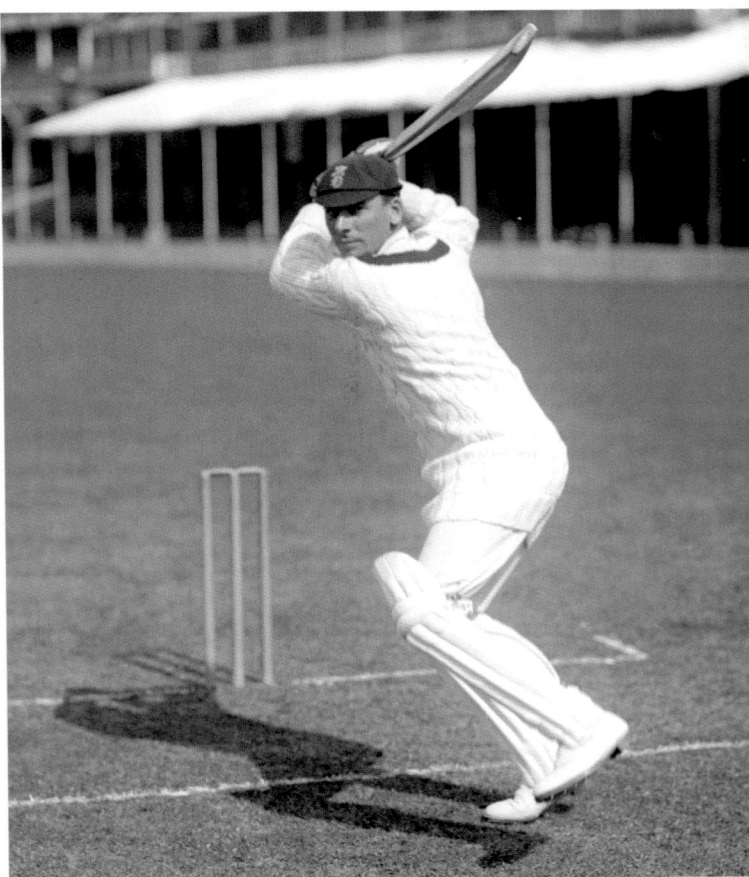

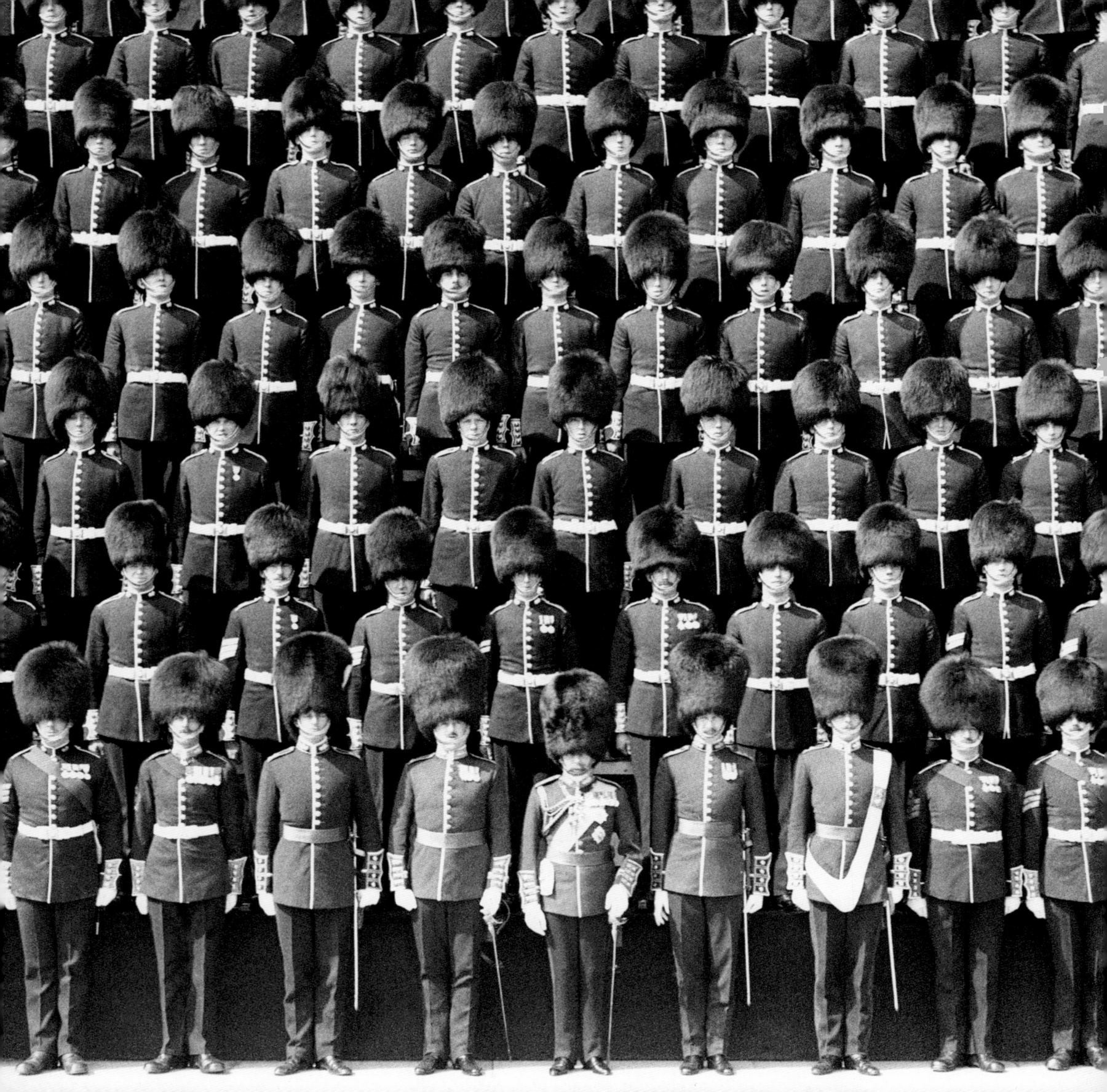

Above right: The start of the 200-Mile Race at Brooklands in Surrey. Brooklands had been opened in 1907 as the first purpose-built motor racing circuit in the world.

26th September, 1925

Left: King George V (front row, C) with a company of Grenadier Guards.

1st May, 1925

Right: British troops march through Cologne, Germany on their way to the railway station, ending the post-war occupation of the city.

2nd December, 1925

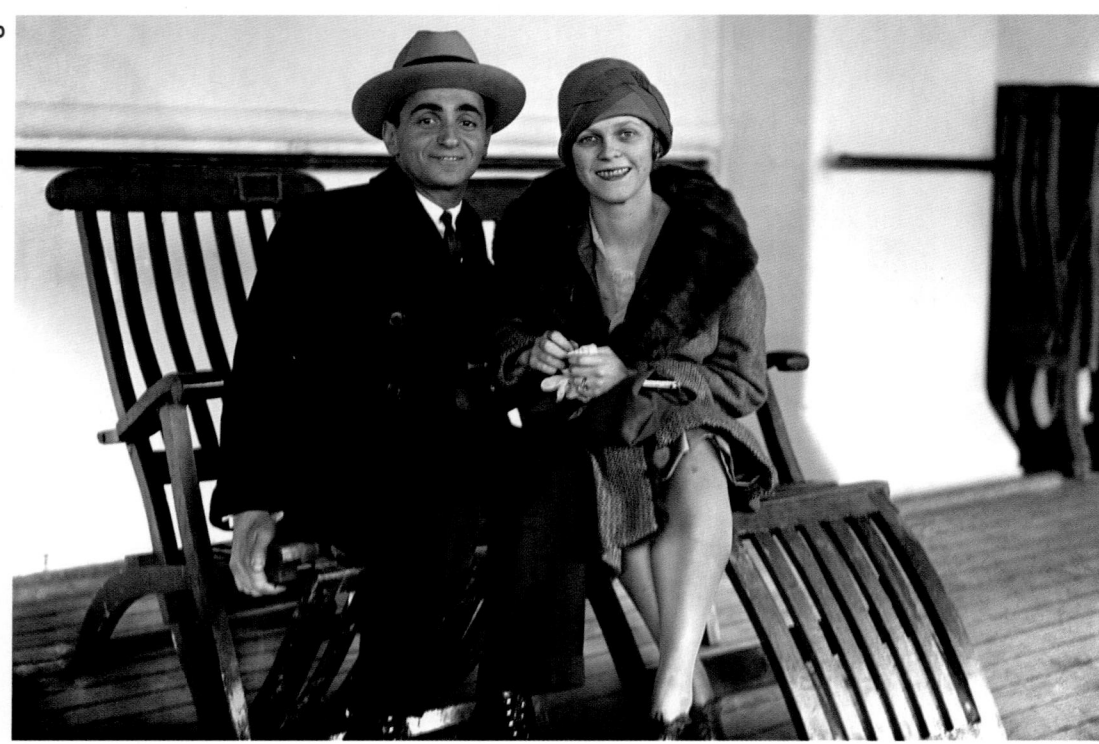

Above: Irving Berlin arrives in
Southampton with his wife, Ellin
Mackay. The marriage of widower
Berlin, an Orthodox Jew, and
Mackay, Roman Catholic heiress to
the Comstock Lode fortune, caused
a sensation in American society in
1925. However, the couple remained
devoted to each other for the 62
years of their marriage.

15th January, 1926

Right: Emily Lucas of Tunbridge
Wells, in Kent, with her 23rd child.

23rd March, 1926

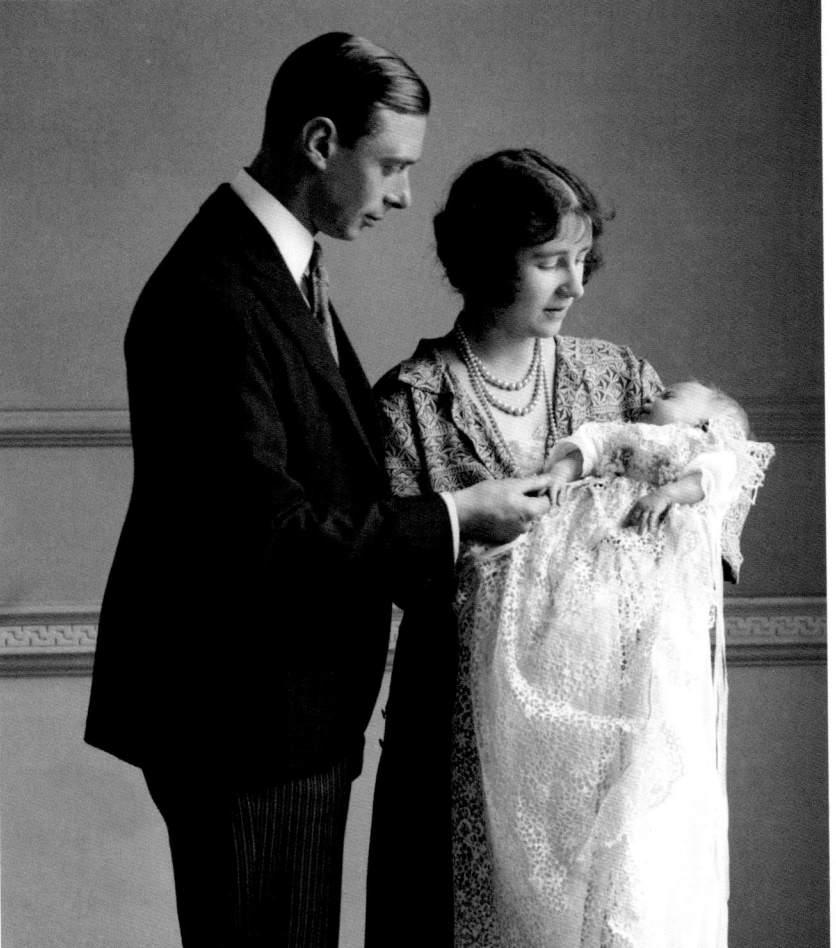

Above: Crowds flock to the Sussex seaside resort of Eastbourne to enjoy the Easter sunshine, although the coats and hats would suggest a chill in the air.

3rd April, 1926

Left: The Duke and Duchess of York (future King George VI and Queen Elizabeth) at the christening of their first child, Elizabeth, who would become Queen Elizabeth II.

1st May, 1926

Above: A food convoy with military escort during the General Strike, which ran from 3rd to 13th May, and brought Britain to a standstill. The strike had been called by the Trades Union Congress in an unsuccessful attempt to force the government to act to improve wages and conditions for coal miners.

10th May, 1926

Right: Police arrest a man during a disturbance at Hammersmith Broadway, London.

May, 1926

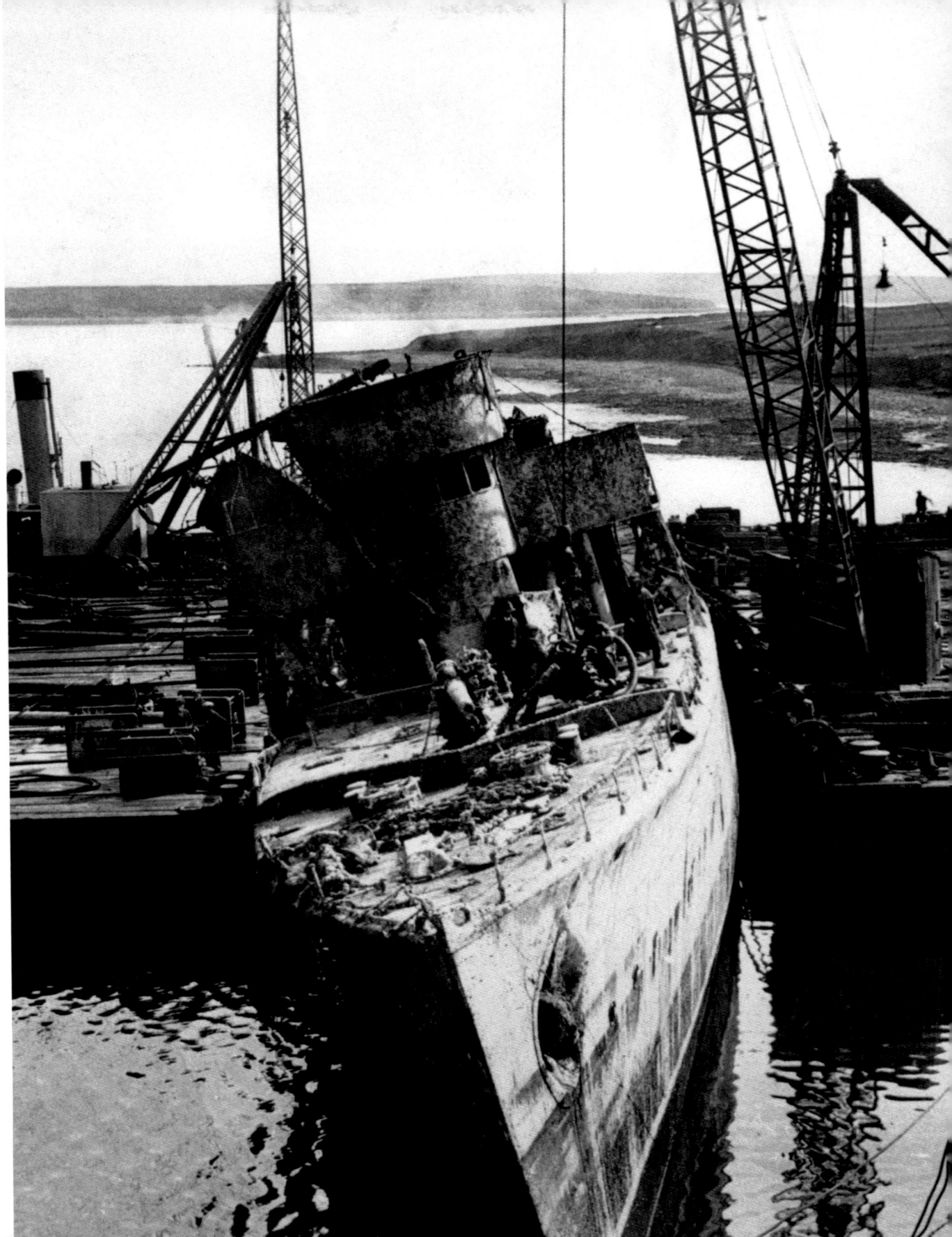

Right: A German destroyer is salvaged at Scapa Flow, in the Orkney Islands. Following the defeat of Germany during the First World War, 78 ships of the German Navy were interned in Scapa Flow pending a decision as to their fate. On 21st June, 1919, after most of the British fleet had sailed on manoeuvres, the German commander, Rear Admiral Ludwig von Reuter, ordered that his ships be scuttled to prevent them from being taken over by the British. Fifty-one ships were sunk without loss of life, but nine German sailors died when the British opened fire in an attempt to prevent the scuttling of another.

17th May, 1926

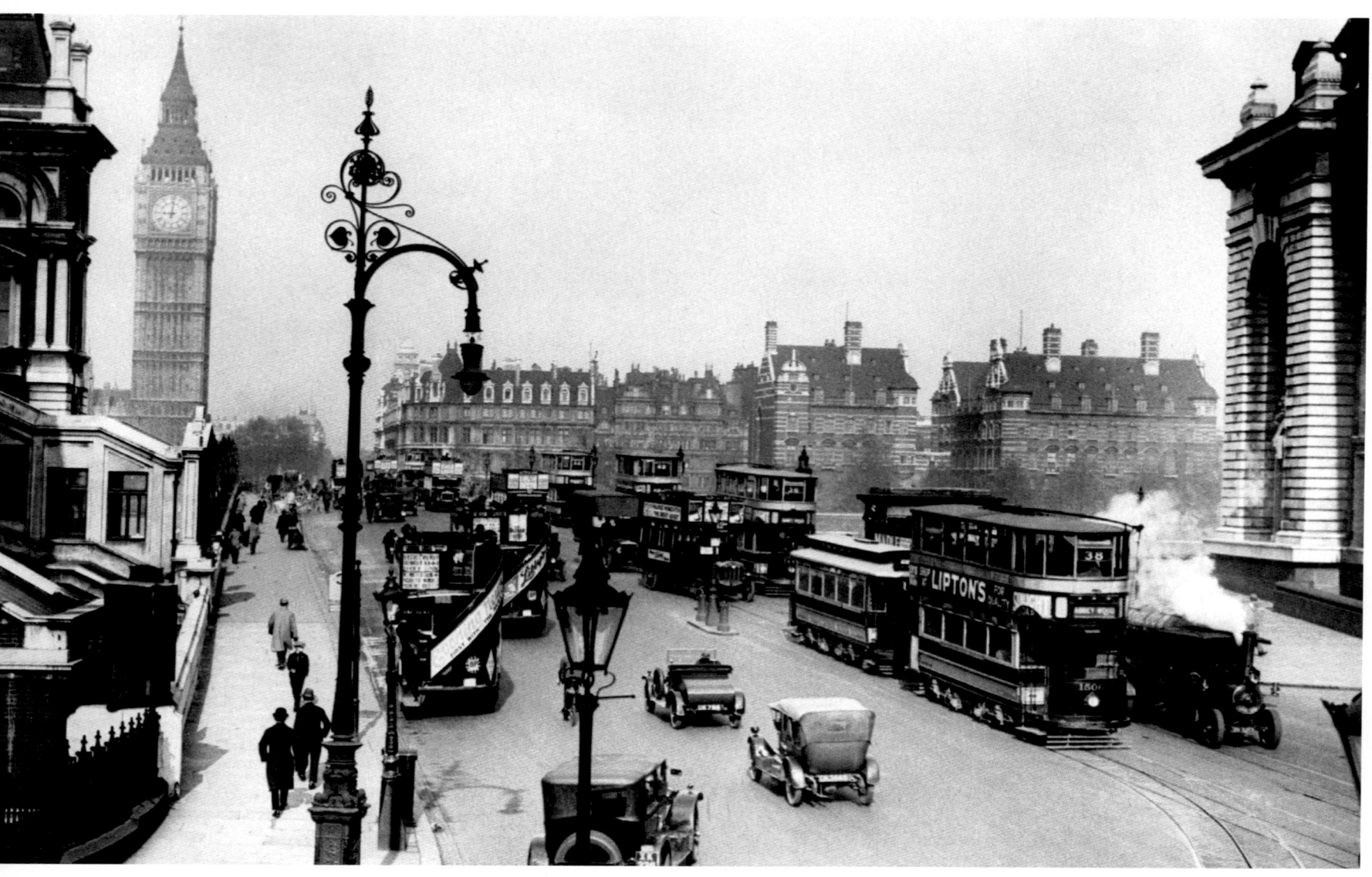

Above: Traffic returns to normal on Westminster Bridge in London following the General Strike. Trams and buses make up the bulk, leaving just enough room for the occasional private car and steam traction engine.

18th May, 1926

Right: A giant Armstrong Whitworth Argosy, named *The City of Birmingham* and belonging to Imperial Airways, arrives in Berlin, Germany. At the time, the Argosy was the world's largest commercial aircraft. It had three engines and could carry 18 passengers. Imperial Airways had removed two passenger seats, however, and replaced them with a bar operated by a steward.

27th August, 1926

Left: Men of Hirta, on the St Kilda archipelago in the Outer Hebrides, Scotland, whose inhabitants were short of stores owing to storms. Traditionally, the menfolk gathered in The Street after prayers for their daily 'parliament' to discuss the day's activities. After the First World War, most of the young men left the island and the population dropped to just 37 in 1928. Two years later, afflicted by influenza and crop failure, the island was evacuated.

3rd September, 1926

G-EBLO

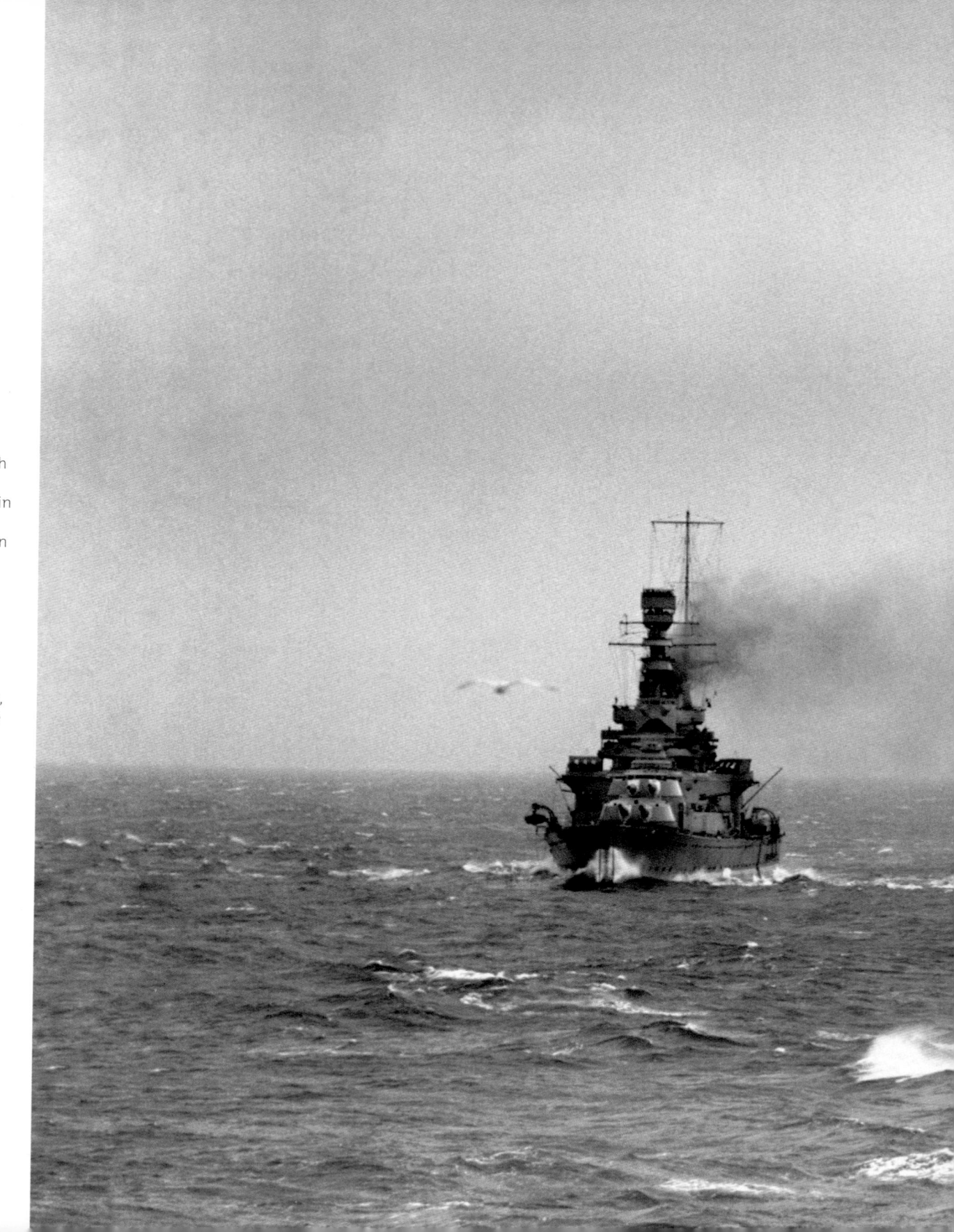

Right: The battlecruisers *Repulse* and *Renown* on manoeuvres with the Royal Navy's Atlantic Fleet. Both ships had been built during the First World War, being completed in 1916. They were considered high-maintenance ships, and were given the nicknames 'HMS *Repair*' and 'HMS *Refit*' respectively. During the interwar period, they were upgraded with additional armour and armaments, and took part in a number of actions during the Second World War. *Repulse*, along with the battleship *Prince of Wales*, was sunk by the Japanese Air Force on 10th December, 1941. *Renown* survived the war, eventually being scrapped in 1948.

30th October, 1926

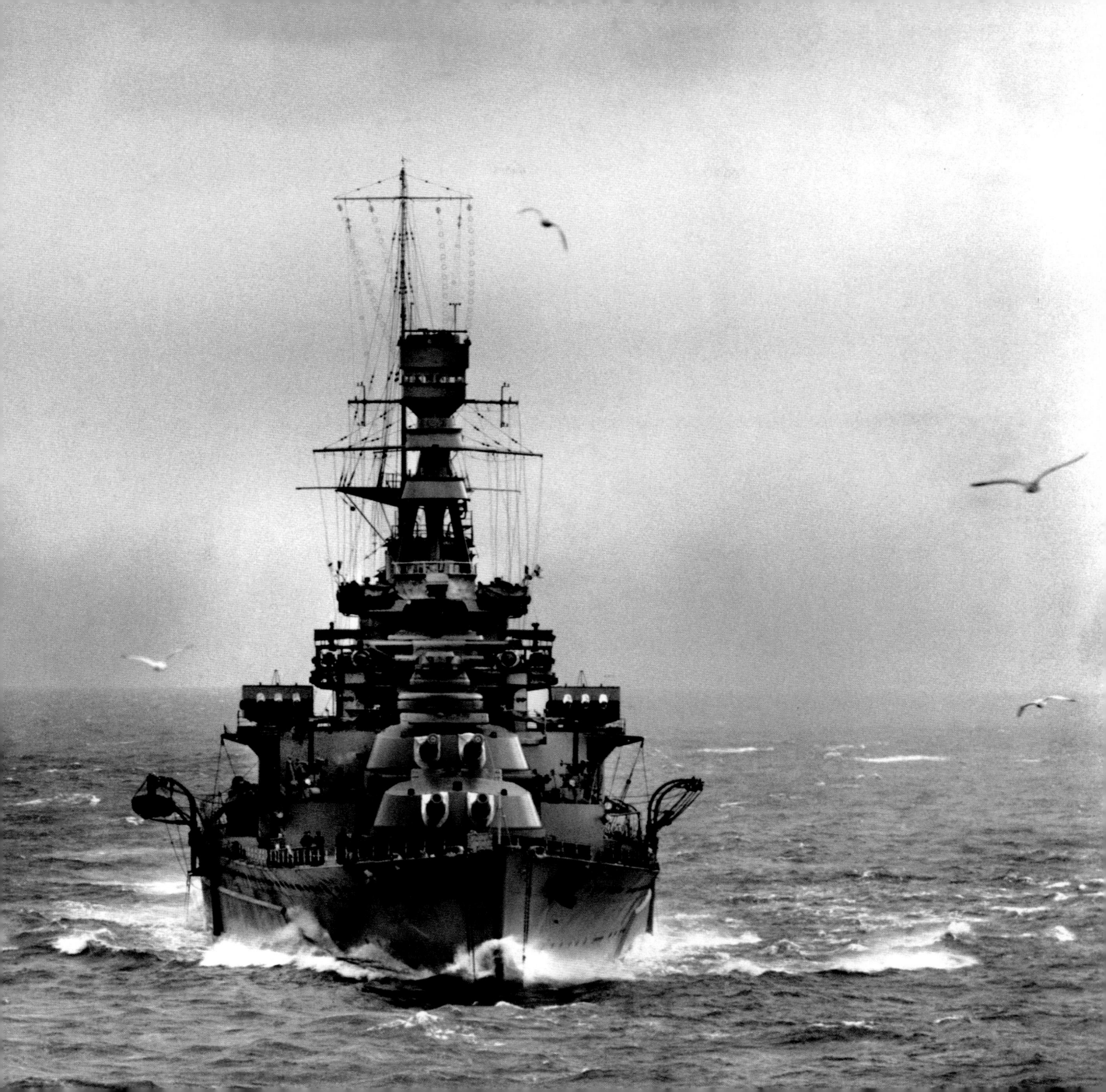

178

Left: The New Zealand Maoris perform their *haka* before the match with Harlequins.

30th October, 1926

Below: Major Henry Segrave in the Sunbeam 1,000hp *Mystery*, the car in which he would break the world land speed record in March at over 200mph (322km/h). The machine was fitted with two aircraft engines.

24th January, 1927

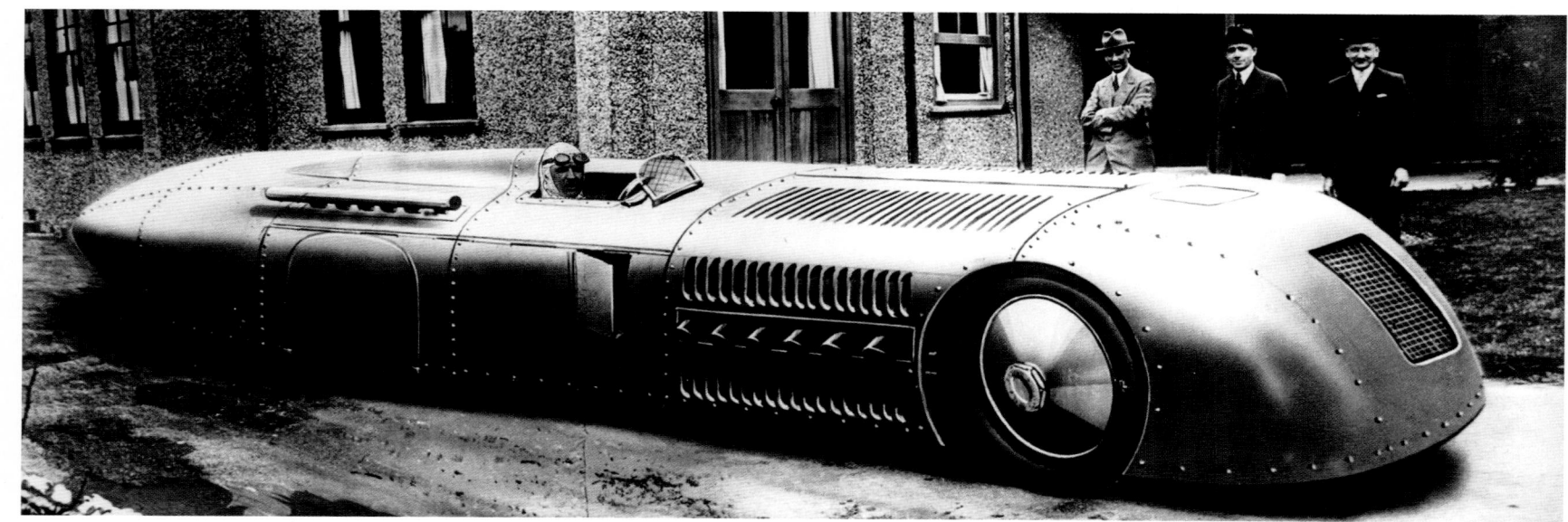

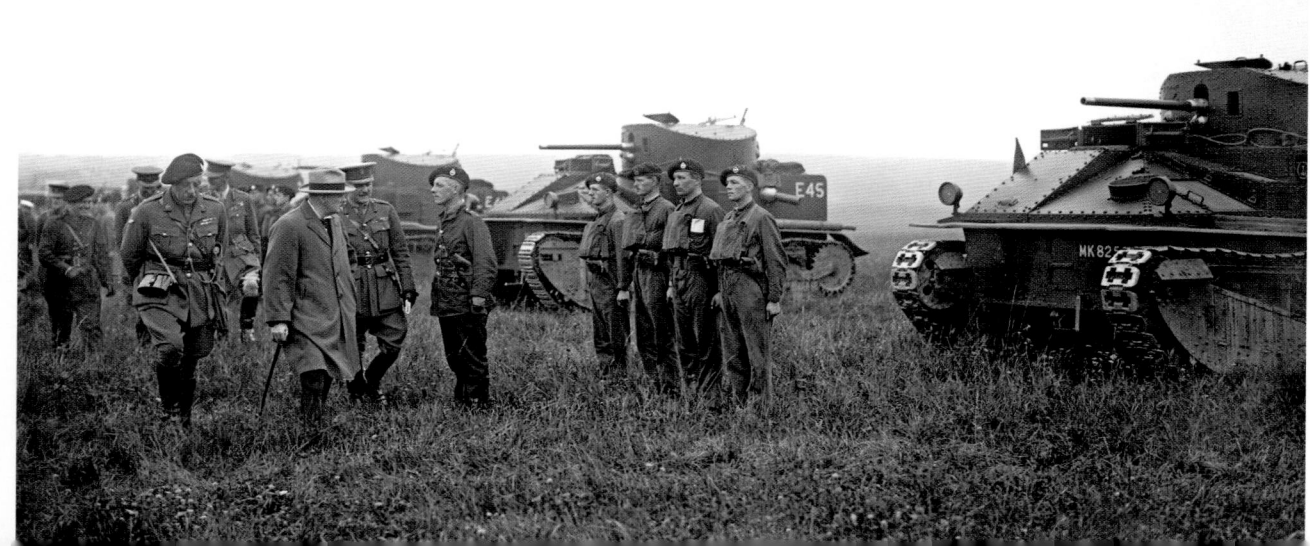

Left: The Chancellor of the Exchequer, Winston Churchill, inspects a mechanized unit of the British Army equipped with Vickers Medium Mark II tanks.

1927

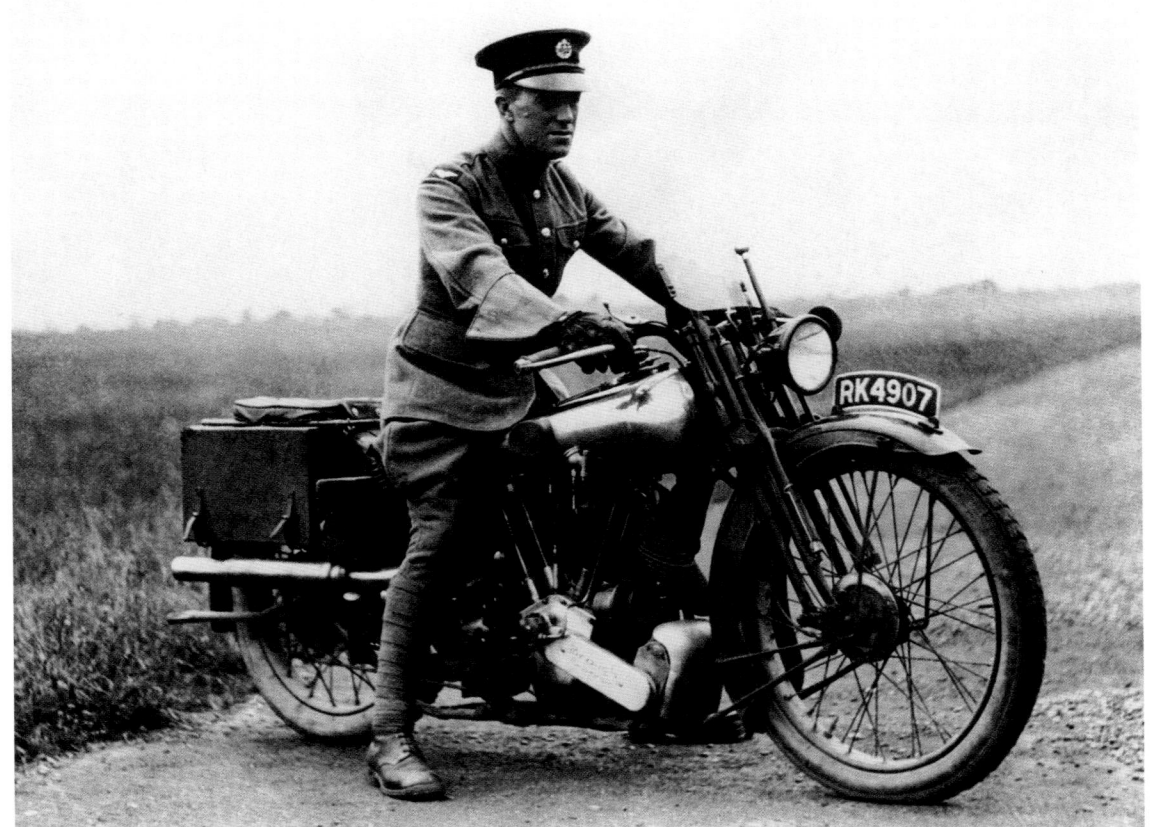

Right: A British armoured car patrols a street in Shanghai, China, during a tense period of nationalist-communist conflict. Shanghai had substantial foreign communities, since its position at the mouth of the Yangtze made it ideal as an international trading centre. Those communities employed their own troops for protection.

2nd February, 1927

Right: Royal Air Force Aircraftman Thomas Edward Shaw on his motorcycle, a Brough Superior SS100. Shaw was better known as Lieutenant Colonel T.E. Lawrence or 'Lawrence of Arabia'. He was a keen motorcyclist and owned a succession of Brough machines, on one of which he would be fatally injured in May 1935.

26th March, 1927

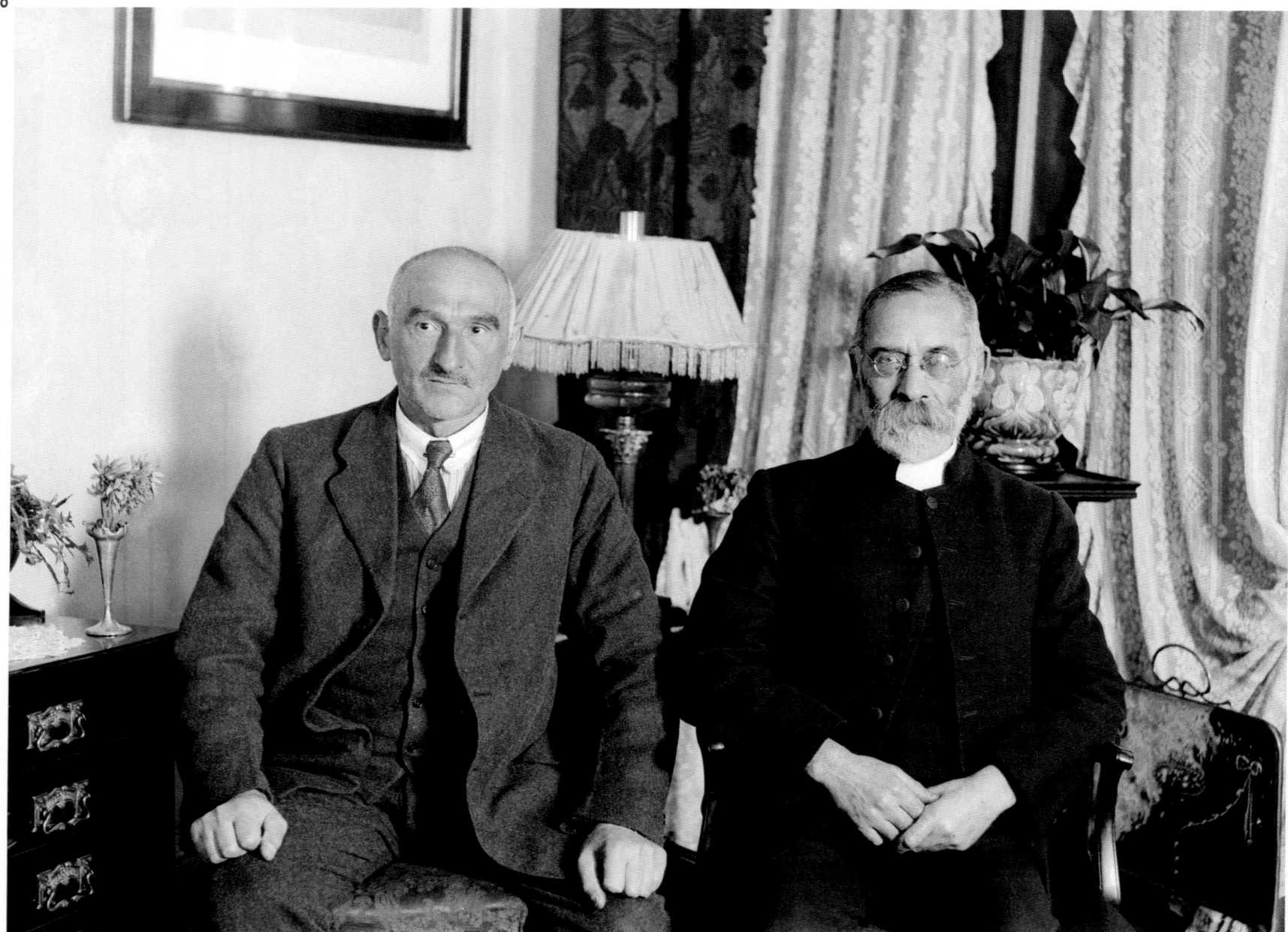

Above: Oscar Slater (L) and the Reverend E.P. Philips
after the former's release from Barlinnie Gaol, Glasgow.
Slater had been convicted in May 1909 of the murder
of 82-year-old Marion Gilchrist in Glasgow, despite an
excellent alibi. Supporters contacted Sir Arthur Conan
Doyle, the creator of the fictional detective Sherlock
Holmes, to ask for his assistance. Conan Doyle was able
to prove that Slater was innocent, but it took until 1927
for him to be released.

27th May, 1927

Above: Captain Charles Lindbergh's custom-built aircraft, the *Spirit of St Louis*, on its way to Southampton from Croydon Airport. Lindbergh had achieved a record breaking solo non-stop flight across the Atlantic from New York to Paris and was returning to the United States. At Southampton, he and his aircraft would join the USS *Memphis*, which would carry him to Washington, where President Calvin Coolidge would award him the Distinguished Flying Cross.

28th May, 1927

Right: Youthful American aviator Charles Lindbergh peers from the cramped confines of his aircraft. He had spent 33½ hours in the tiny cockpit during his transatlantic flight, several of them flying 'blind' in cloud. At Le Bourget airport in Paris, he had been met by a crowd of around 150,000.

28th May, 1927

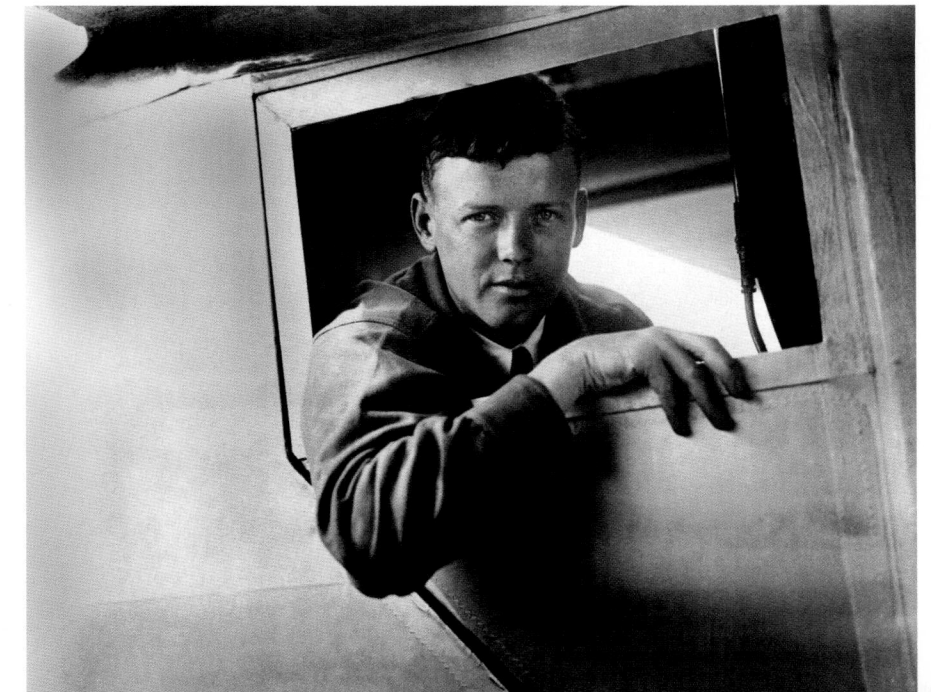

Above: Tennis players (L–R) Joan
Lycett, E. Colyer, Kathleen 'Kitty'
Godfree and Betty Nuthall model
the latest off-court fashions.

25th June, 1927

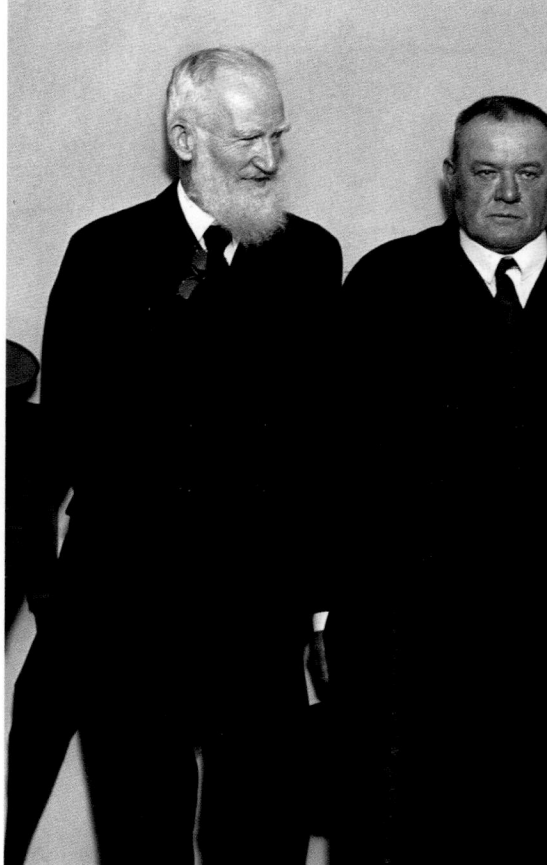

Above: Writers George Bernard Shaw, Hilaire
Belloc and G.K. Chesterton in a London debate.

29th October, 1927

Right: King Faisal of Iraq on his visit to Britain. Faisal had organized the Arab Revolt against the Ottoman Empire during the First World War, aided by Colonel T.E. Lawrence and the British Army. In 1920, he was proclaimed King of Greater Syria, but within months was expelled by the French after the Franco-Syrian War. In 1921, the British made him King of Iraq, where he achieved considerable success in improving education, building a powerful army and exploiting oil reserves.

1st December, 1927

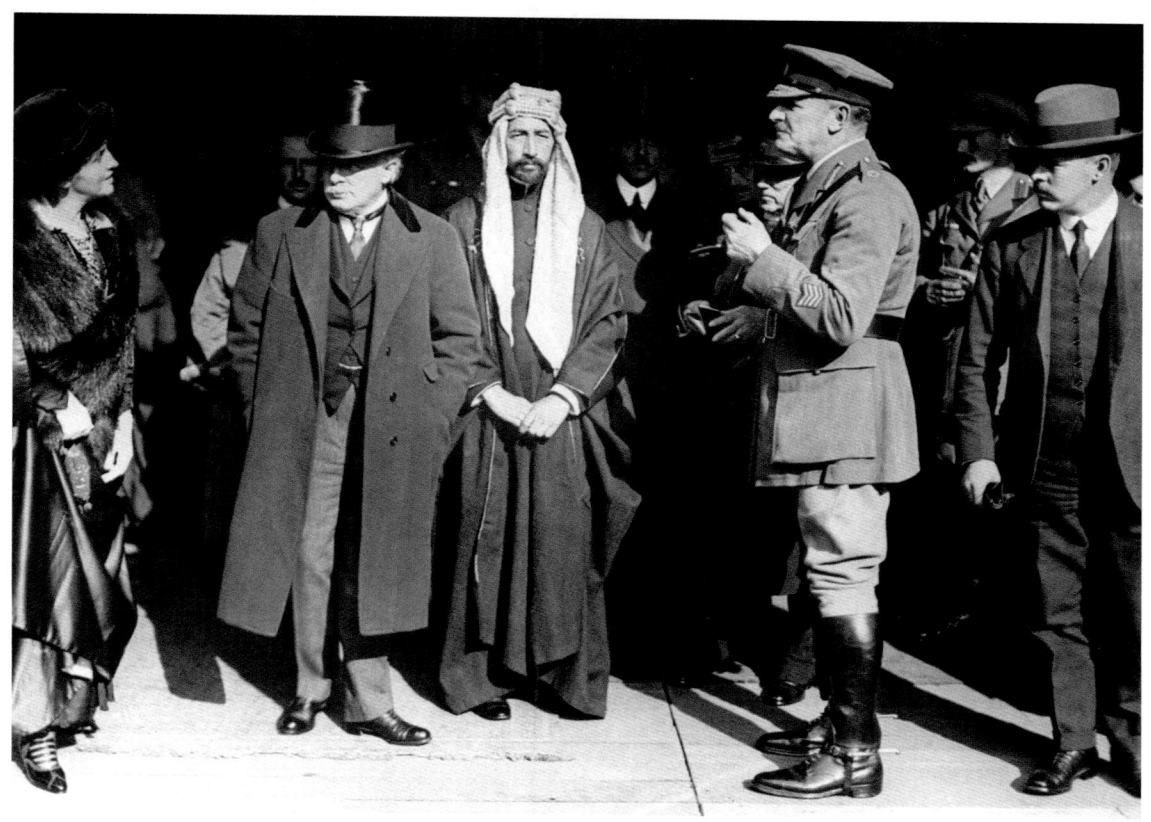

Right: A lost charabanc was discovered by a search party, buried in the snow between Godstone and Redhill, Surrey.

30th December, 1927

Left: Golfing champion Joyce Wethered, who is considered to be the greatest British female player of all time. She won the British Ladies' Amateur Golf Championship on four occasions: 1922, 1924, 1925 and 1929. She was also the English Ladies' champion for five years running, from 1920 to 1924.

10th March, 1929

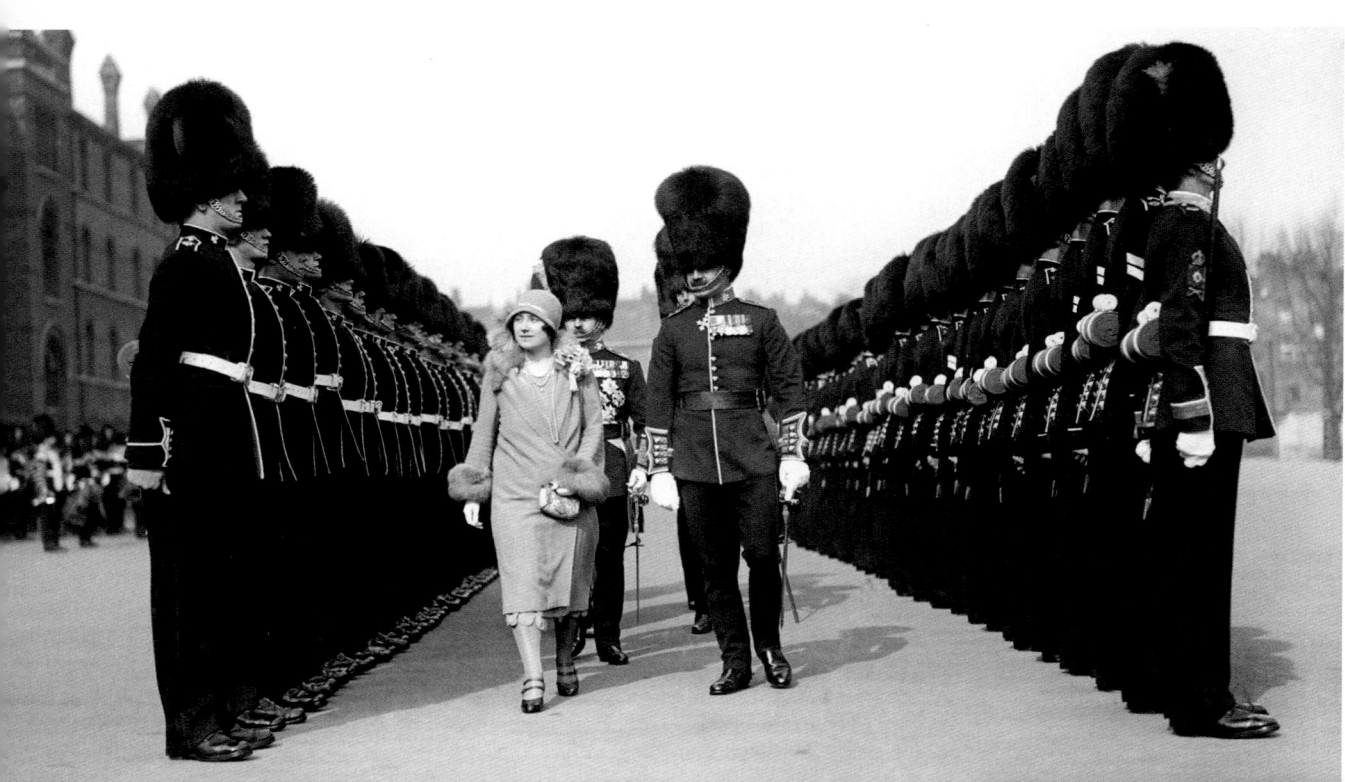

Left: Elizabeth, Duchess of York (later Queen Elizabeth, the Queen Mother) inspects the Irish Guards.

17th March, 1928

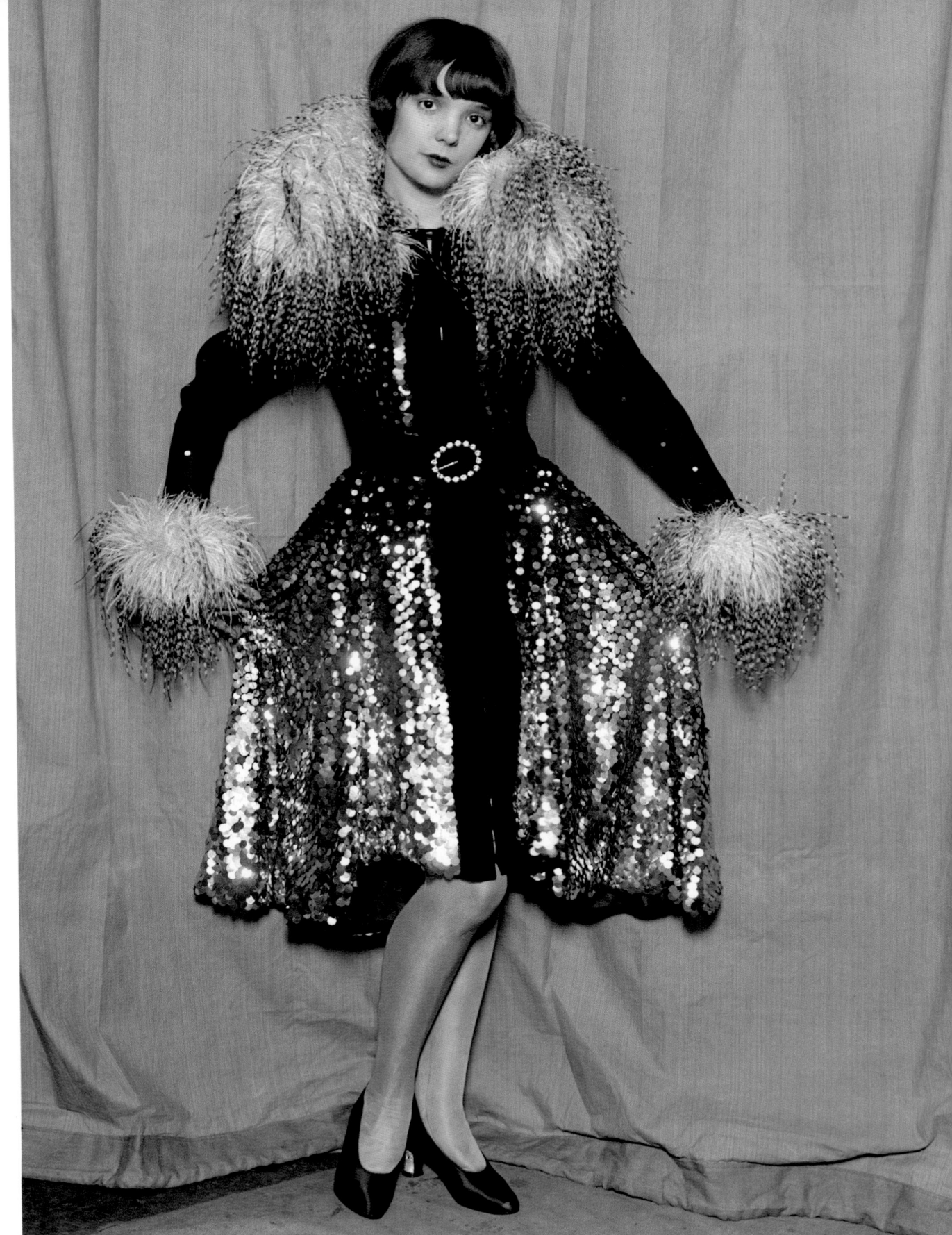

Right: Jessie Matthews, British stage and screen star of the late 1920s and 1930s. Matthews was a dancer and singer; among the songs she popularized were *A Room with a View* and *London Calling!* by Noël Coward, and *Let's Do It, Let's Fall in Love* by Cole Porter. The song *Over My Shoulder*, written for her 1934 movie *Evergreen*, became her personal theme tune. In the USA, she was known as the 'Dancing Divinity'. In Britain, however, she was given a less complimentary nickname after she was cited as 'the other woman' in divorce proceedings between actress Evelyn 'Boo' Laye and actor-director Sonnie Hale. Matthews' explicit letters to Hale were read out in court, prompting the judge to refer to her as odious, and the Press as the 'Diva of Debauchery'. Ironically, in later years, she would star in the BBC radio series *The Dales*, in which she played Mrs Dale, a paragon of middle-cass respectability.

24th March, 1928

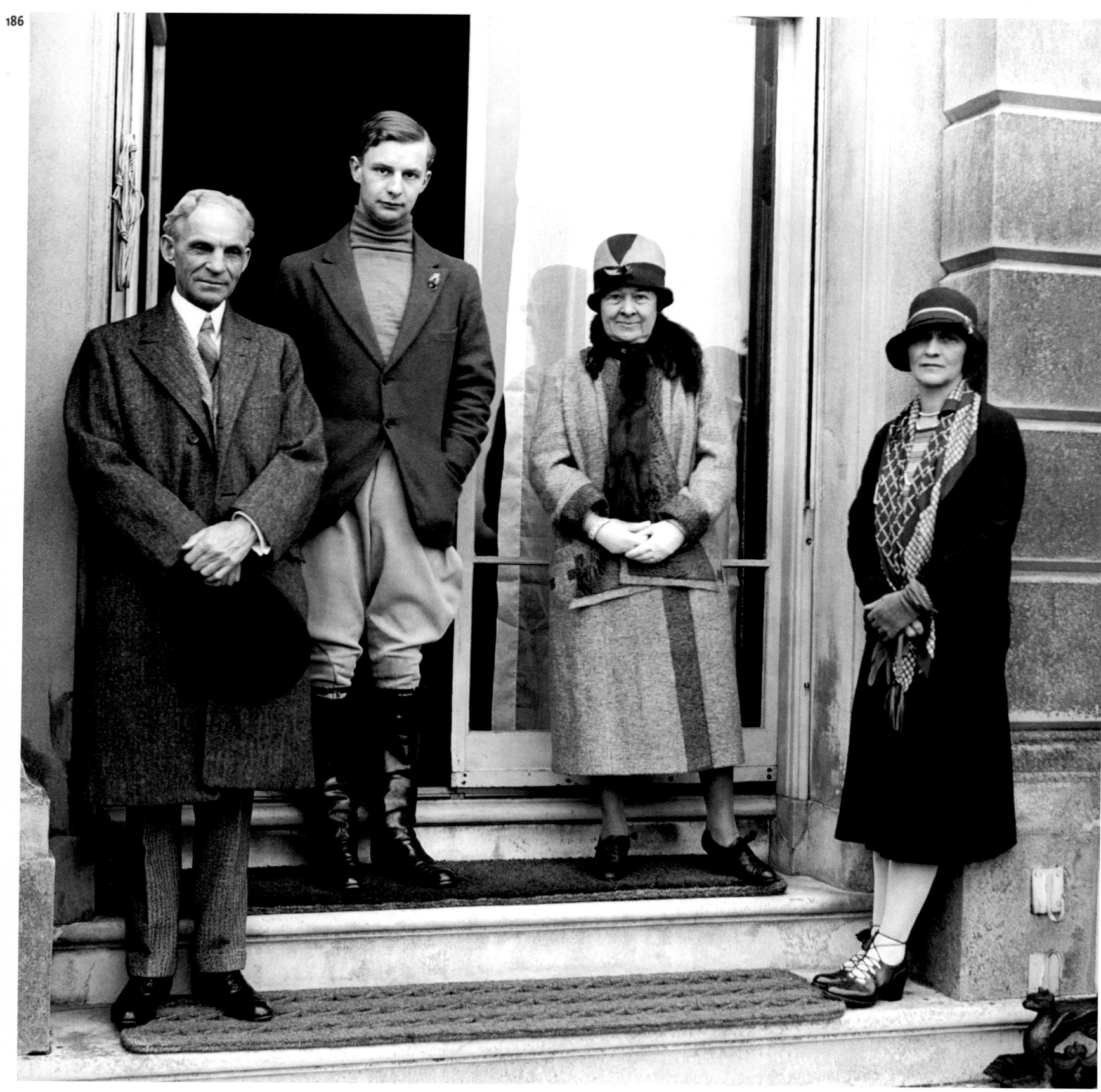

Above: Veterans of the King's African Rifles, a British colonial regiment raised from the various British possessions in East Africa, await inspection by the Prince of Wales.

1st June, 1928

Right: Chiefs and elders line the Prince of Wales' route in Nairobi during his official visit to Kenya.

1st June, 1928

Left: Henry Ford (L) and Mrs Ford (second R) on holiday in England, with the Honourable Waldorf Astor and Lady Nancy Astor at their Buckinghamshire mansion, Cliveden. The Astors were renowned for entertaining on a lavish scale; their guests included film stars, world leaders, writers and artists.

14th April, 1928

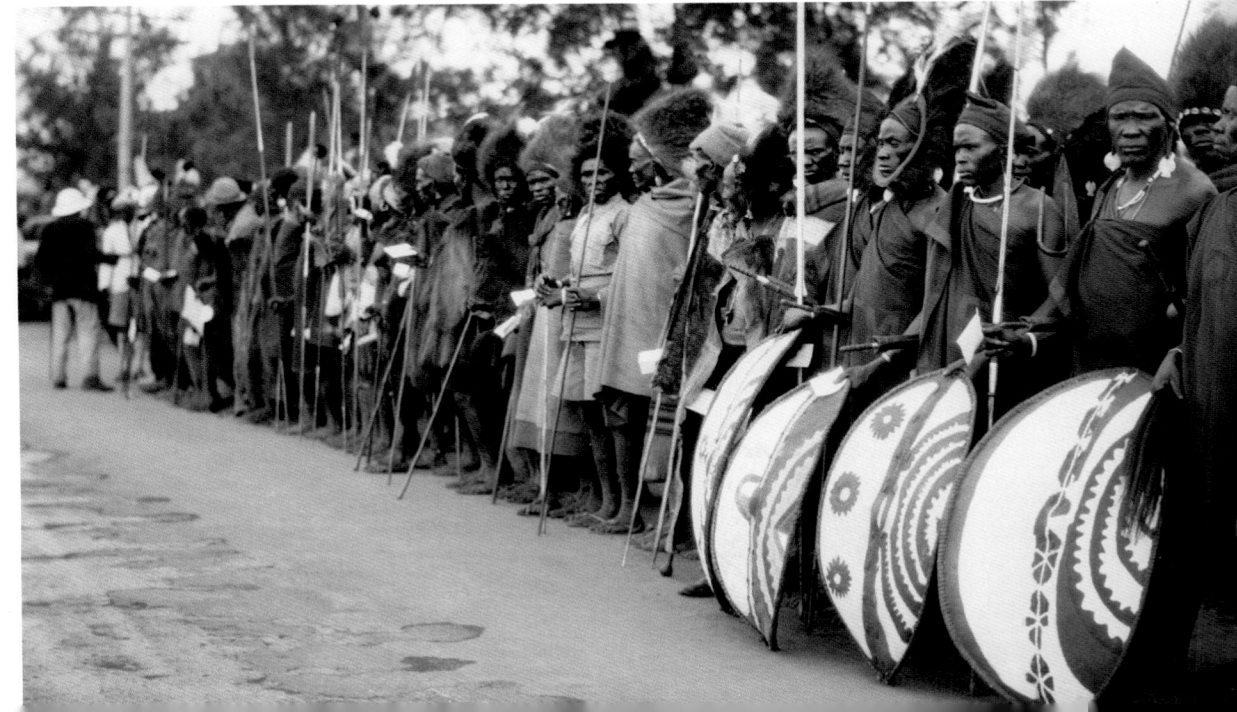

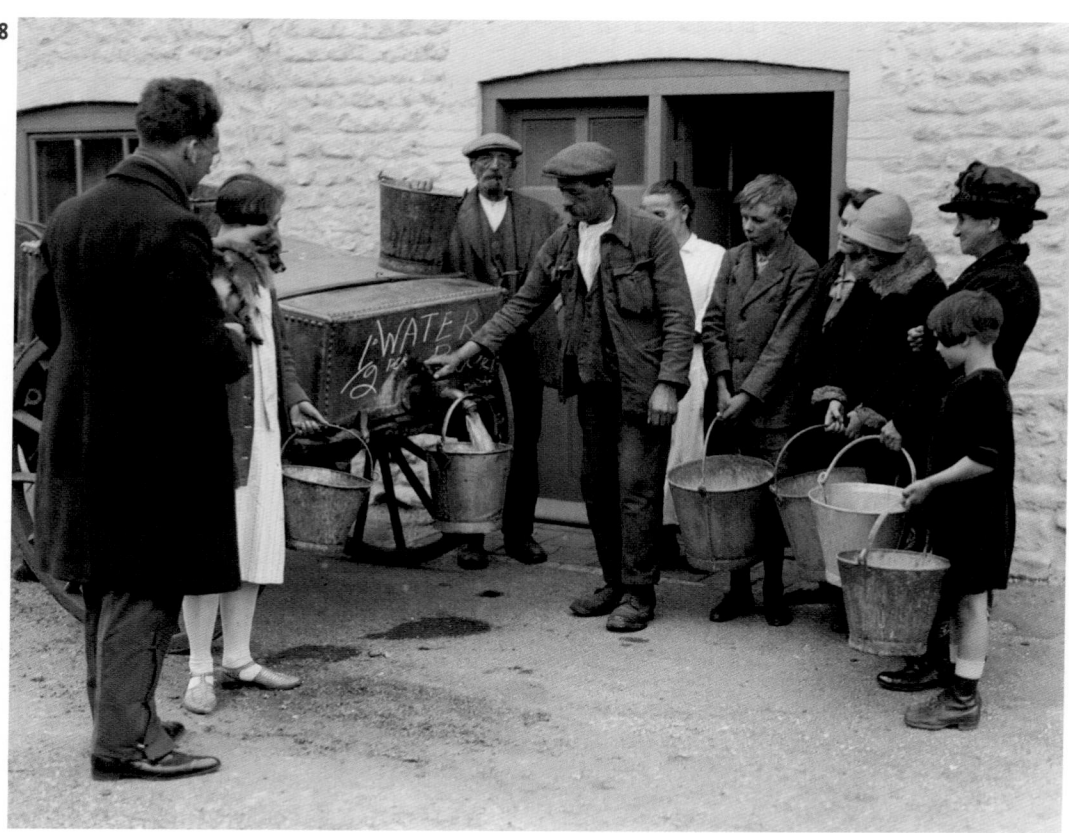

Left: The summer of 1928 saw a shortage of drinking water, a situation exploited by this entrepreneur, who is selling drinking water at a halfpenny per pail at Docking in Norfolk.

30th August, 1928

Below left: A mobile greengrocer enjoys a cigarette as he drives down the street with his 'shop'. Because of the high price and rarity of cars and small vans in the 1920s and 1930s, motorcycles, often fitted with sidecars, were pressed into service instead.

2nd February, 1929

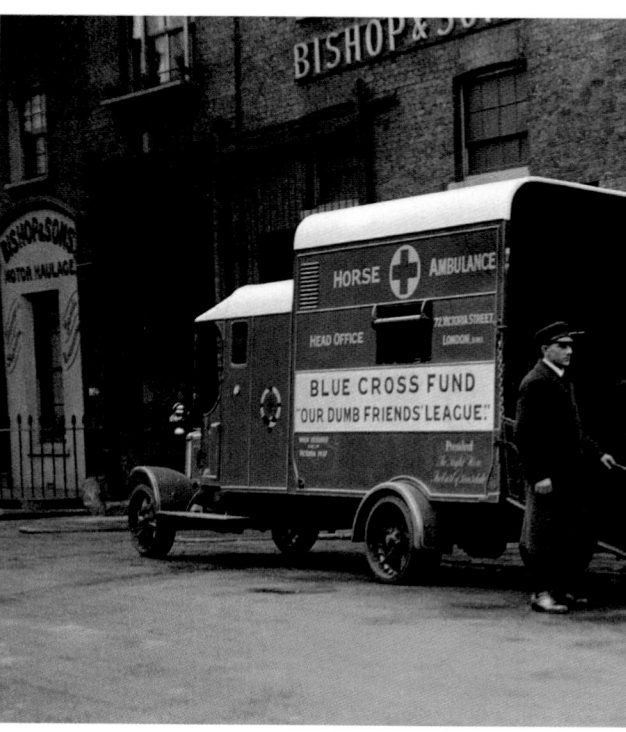

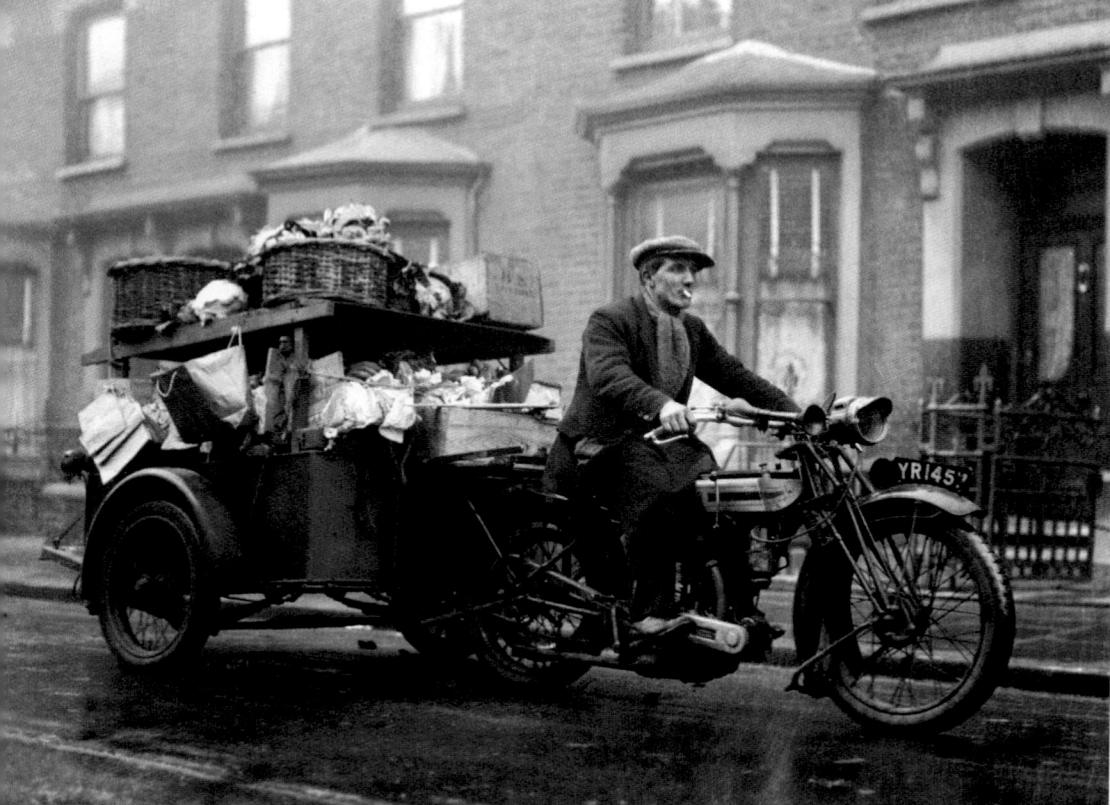

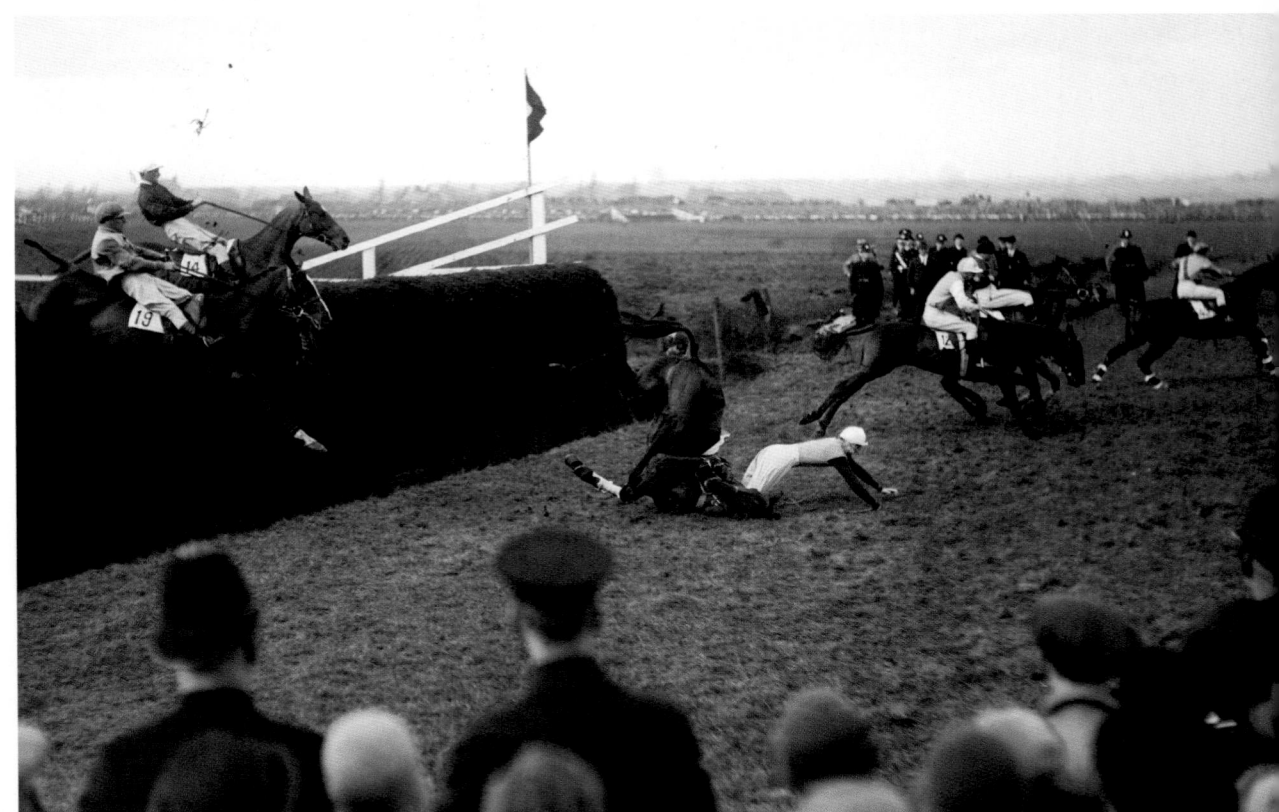

Above: A vet leads a lame horse into an ambulance belonging to the Blue Cross, a charity dedicated to animal welfare.

6th February, 1929

Above right: Some of the field bravely taking Becher's Brook, sixth obstacle in the Grand National at Aintree, only to tumble painfully on landing.

22nd March, 1929

Right: Fun in the sun by the river at Walton-on-Thames, Surrey.

1929

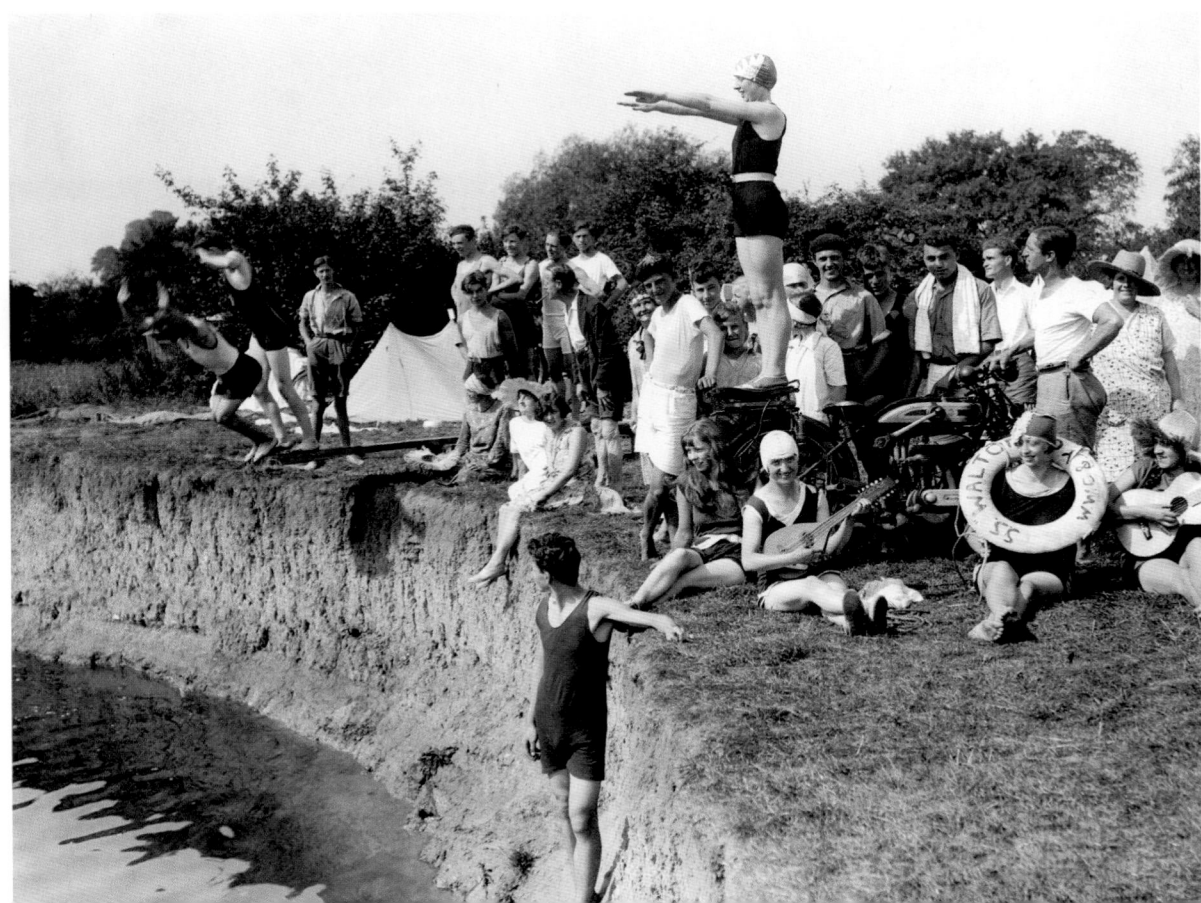

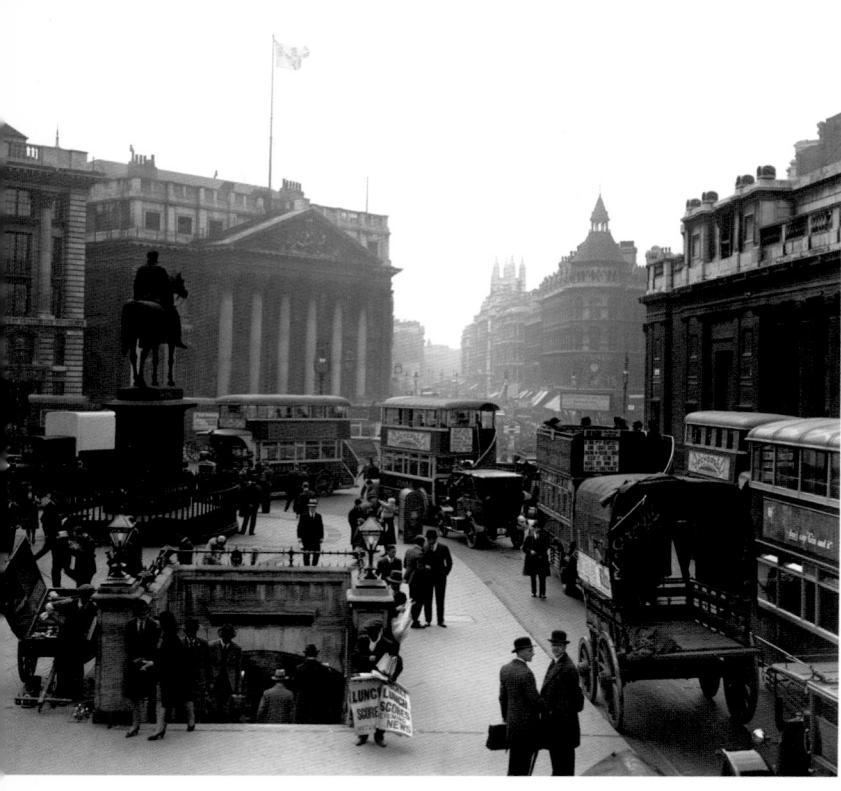

Left: Dense traffic in central London around Mansion House (C), the official residence of the Lord Mayor of London. Built between 1739 and 1752, it is notable for its Palladian-style portico with six Corinthian columns. The building contains its own court of law and 11 holding cells: 10 for men and one, the 'birdcage', for women. The famous suffragette Emmeline Pankhurst had been an inmate in the early 20th century.

1st May, 1929

Right: The Gaiety Theatre on Aldwych, at the eastern end of the Strand in the West End of London, was known for its successful musicals, notably the 1929 run of *Love Lies* by Stanley Lupino and Arthur Rigby, which starred Cyril Ritchard and Madge Elliot. The building was demolished in 1956 and replaced by an office development.

1929

Below: Two debutantes leave the American Women's Club for a presentation party at Buckingham Palace. To the left is a disabled ex-serviceman with his tray, a familiar sight after the First World War.

9th May, 1929

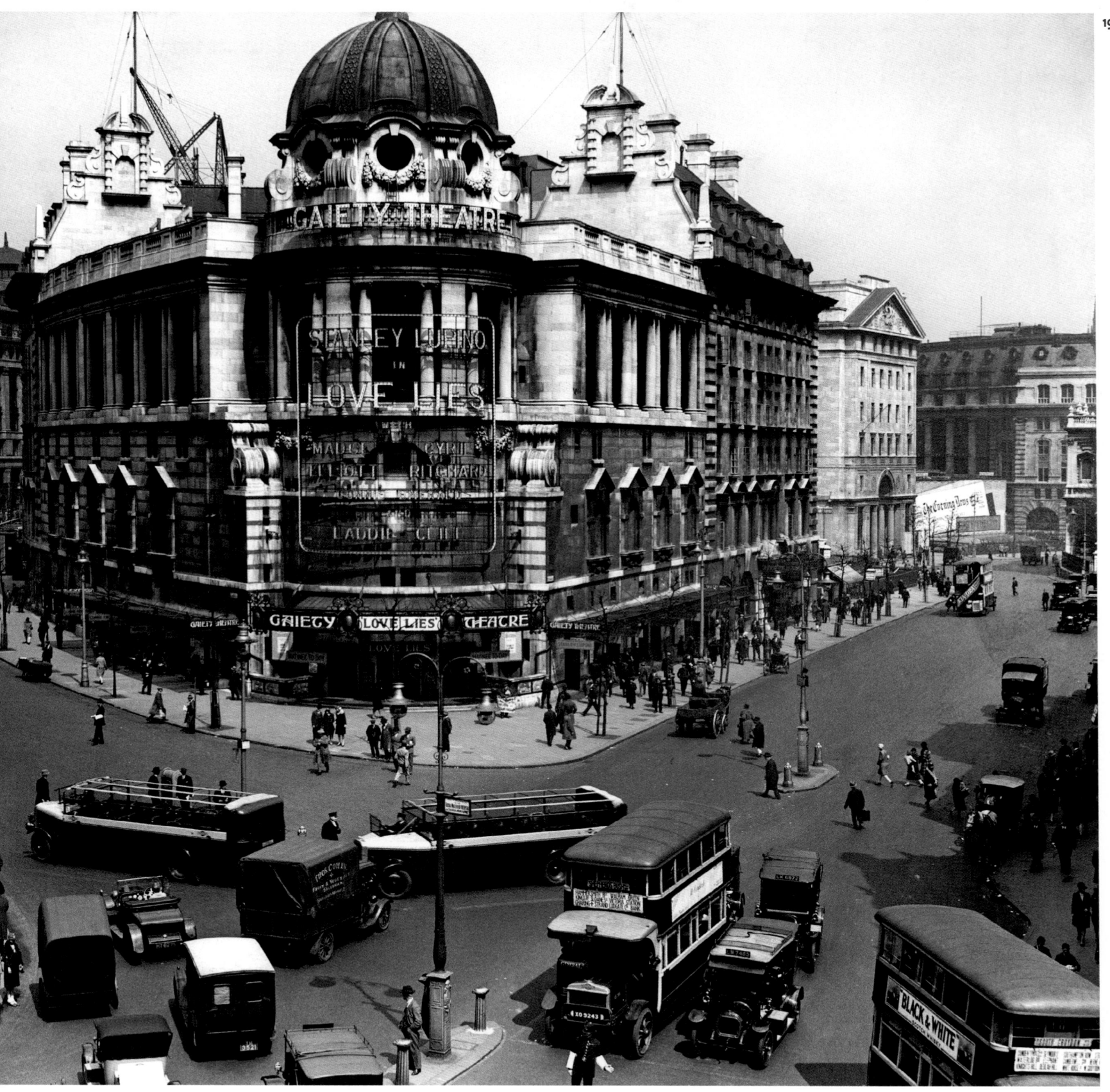

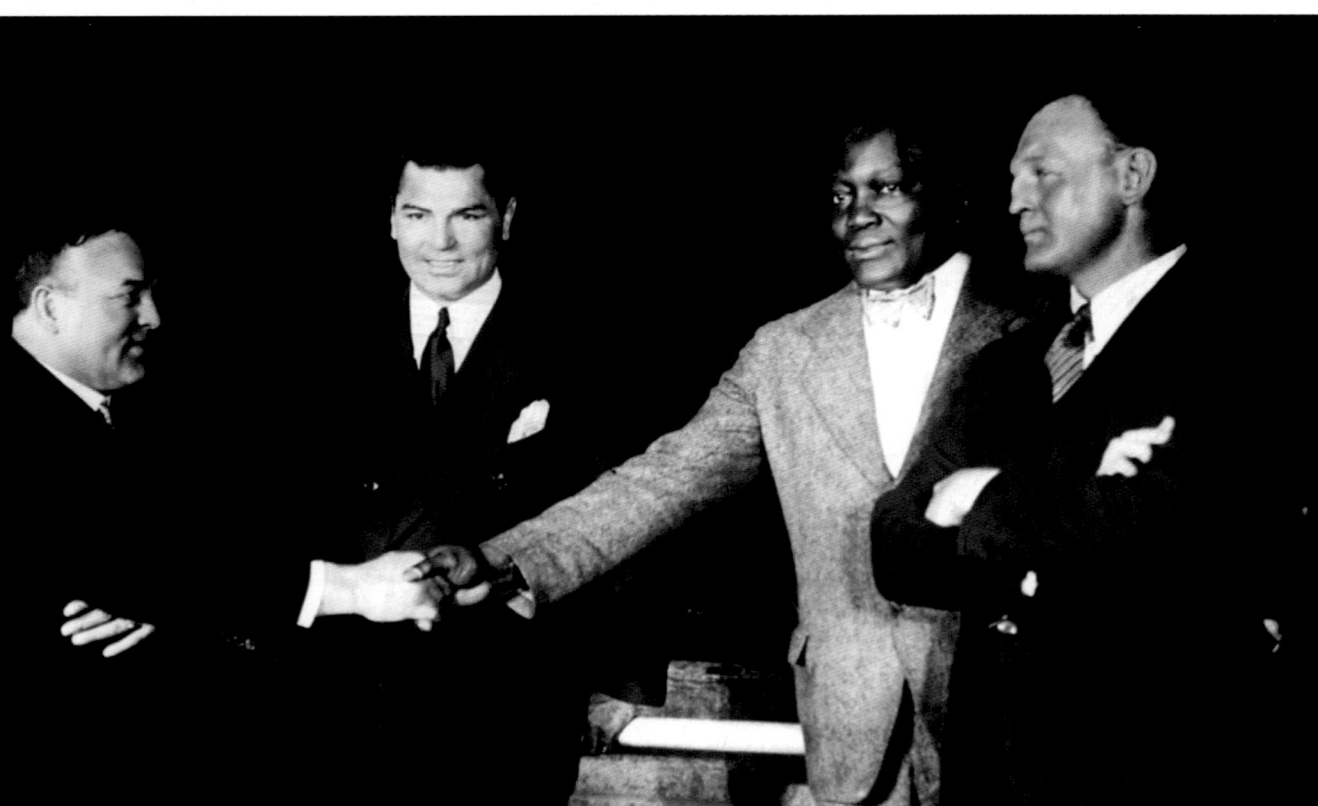

Left: Winston Churchill, resplendent in Tom Mix hat, near Del Monte, California, during his visit to the Monterey Peninsular.

29th October, 1929

Below left: Tommy Burns (L) shakes hands with Jack Johnson, the man who had wrested the world heavyweight boxing title from him in 1908, watched by Jack Dempsey (second L) and 'Young' Bob Fitzsimmons, son of the legendary British-born New Zealand boxer Robert James Fitzsimmons.

12th December, 1929

Right: The airship R100 nears the mooring mast at Cardington, Bedfordshire during its maiden voyage from the airship station at Howden in Yorkshire. Among those who had worked on the construction of the craft were designer Barnes Wallis (later to develop the 'bouncing bombs' used in the famous 'Dambusters' raid of World War Two) and mathematician Nevil Shute Norway, who is better known as Nevil Shute, author of *A Town Called Alice*.

12th December, 1929

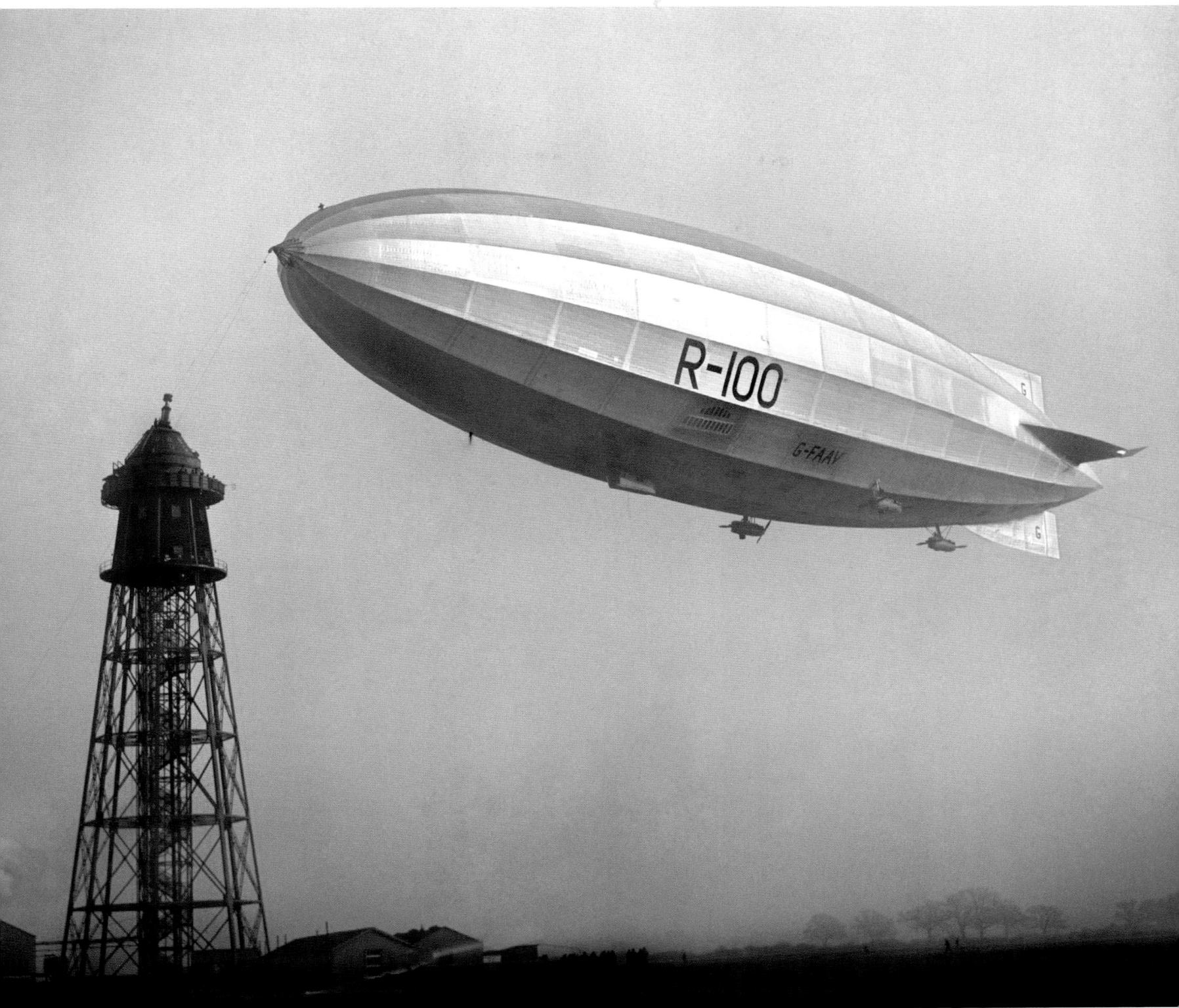

1930s

The 1930s saw Britain at its most unstable. Rapid industrial growth during the 1920s had been achieved through borrowing, leaving the economy over-extended and exposed when the Wall Street Crash sent shock waves around the world in 1929. Britain's exports were halved, unemployment soared, wage cuts were commonplace and the Depression took hold. The hardship that followed led to a profound deepening of social and political divisions, demonstrated by such mass protests as the Jarrow Hunger March. Three million Britons emigrated in search of a better life abroad, and fascism – firmly established in Italy, Germany and Spain – gained a foothold in Britain with Oswald Mosley's British Union of Fascists. Even the monarchy faltered when Edward VIII abdicated at the end of 1936.

Yet at the end of this chaotic decade, the British people were able to unite and face the terrible prospect of another world war with seeming ease. Far from being a divided and weakened society, Britain's domestic strength would be its salvation during the dark days that followed. The new King, George VI, and his likeable family captured the hearts of the people, and a leader who might have been born for the moment – Winston Churchill – stepped forward to inspire the nation.

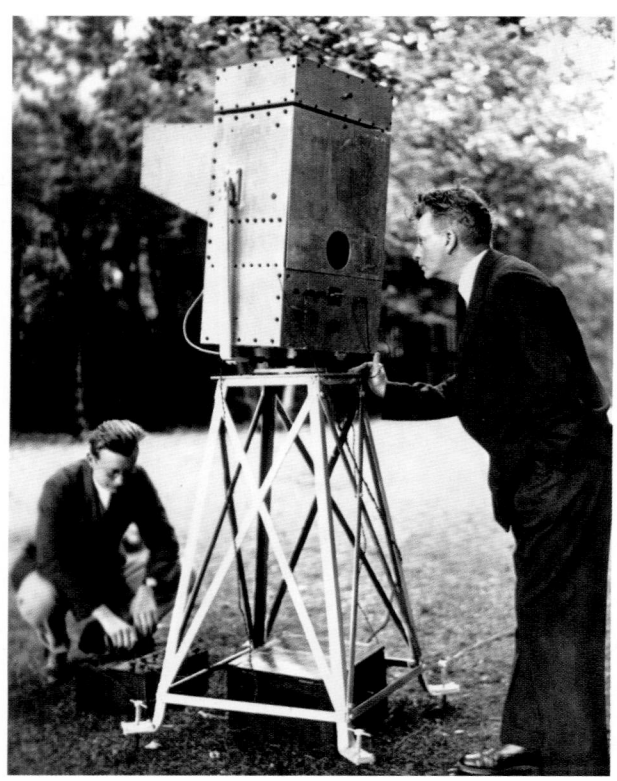

Above: John Logie Baird, inventor of the television, with his 'Noctovisor', a machine for seeing through fog, in the grounds of his home at Box Hill in Surrey. The device relied on the reflection of radio waves to form images.

1930

Above: Famous British aviatrix Amy Johnson with her de Havilland Gipsy Moth, named *Jason*, at the London Aeroplane Club, Stag Lane, north London. Having qualified as a pilot, Johnson went on to become the first woman to gain a ground engineer's licence. In May 1930, she would become the first woman to fly solo from England to Australia, going on to gain several other records and marry fellow long-distance aviator Jim Mollison. She would lose her life on 5th January, 1941, when the aircraft she was ferrying for the Air Transport Auxiliary crashed in the Thames Estuary.

10th January, 1930

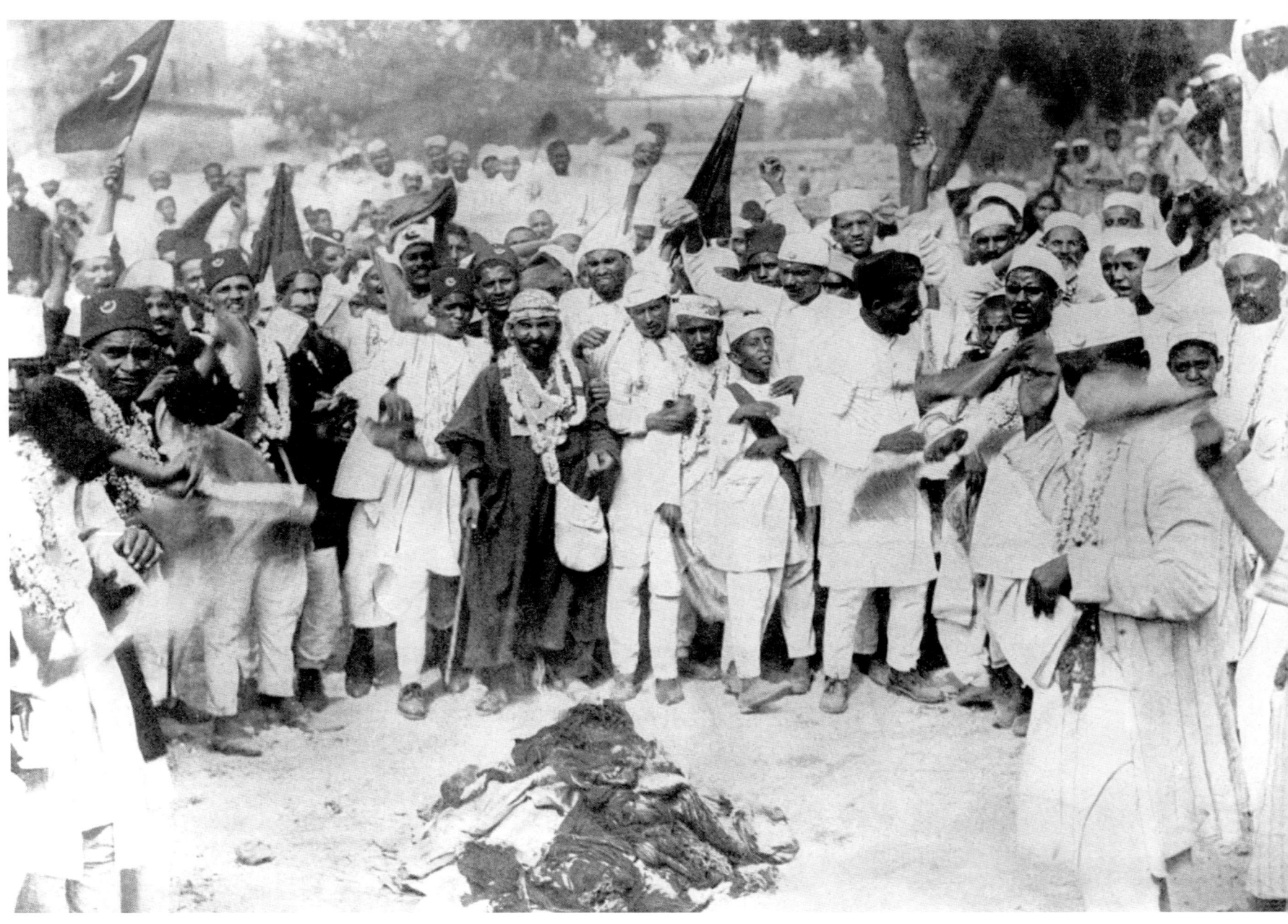

Above: Followers of Mahatma Gandhi burn cloth goods from Bradford and Manchester. By 1930, Indians were restless for independence, and Gandhi was heading a campaign of non-violent resistance to British rule. After leading a 250-mile (402km) march to the sea, he and thousands of others defied the British monopoly on the manufacture and supply of salt by making their own. Subsequently, the campaign would encompass a boycott of British cloth and the resignation of Indian officials working for the British. Although these acts were insufficient to force the British to relinquish control, they did put pressure on the government, and talks were opened with Gandhi. It would be many more years, however, before he would see his dream realized; self-rule was not granted to India until 1947.

7th March, 1930

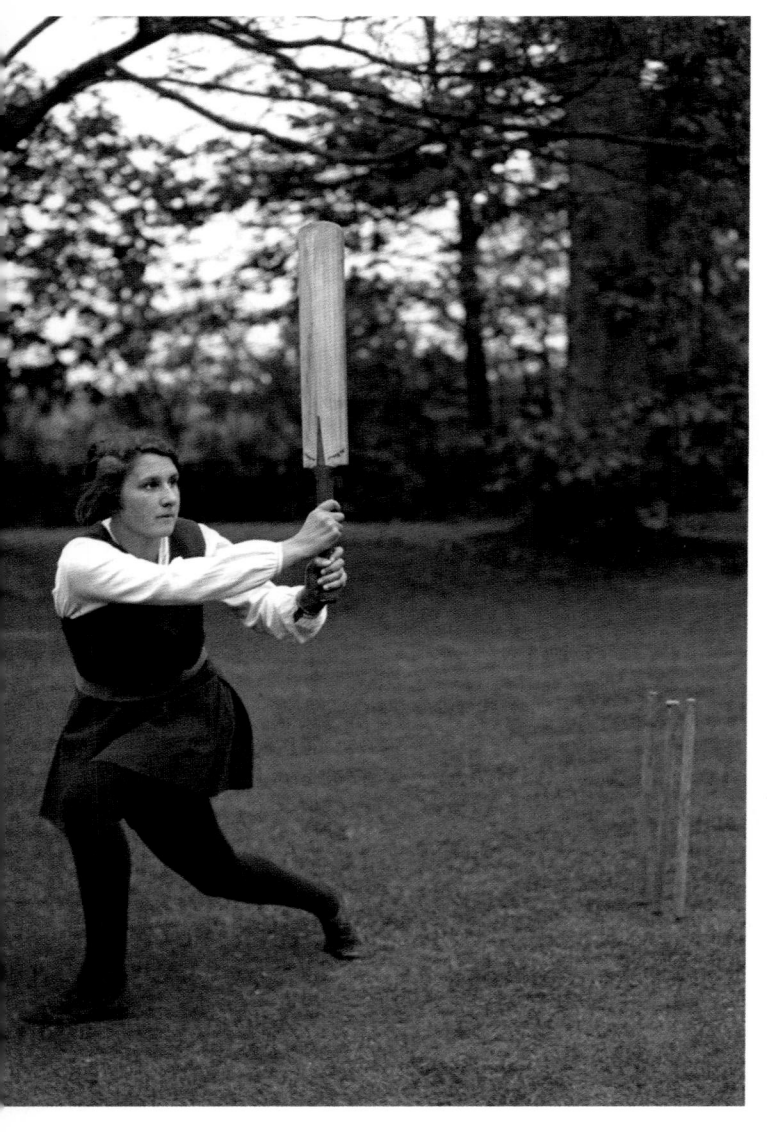

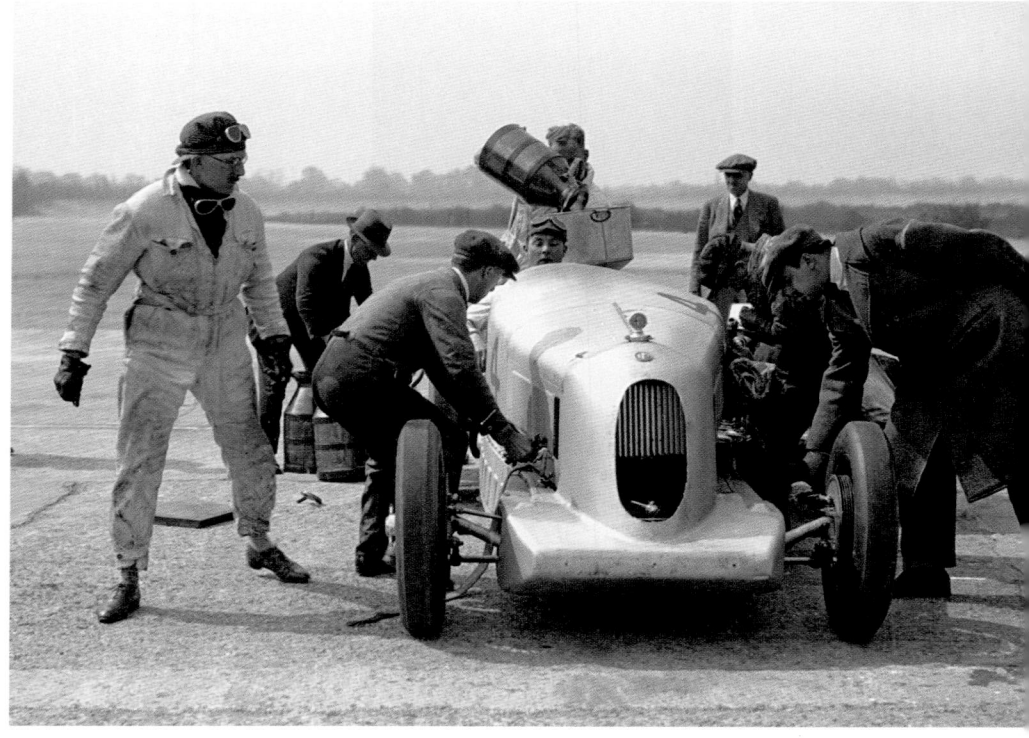

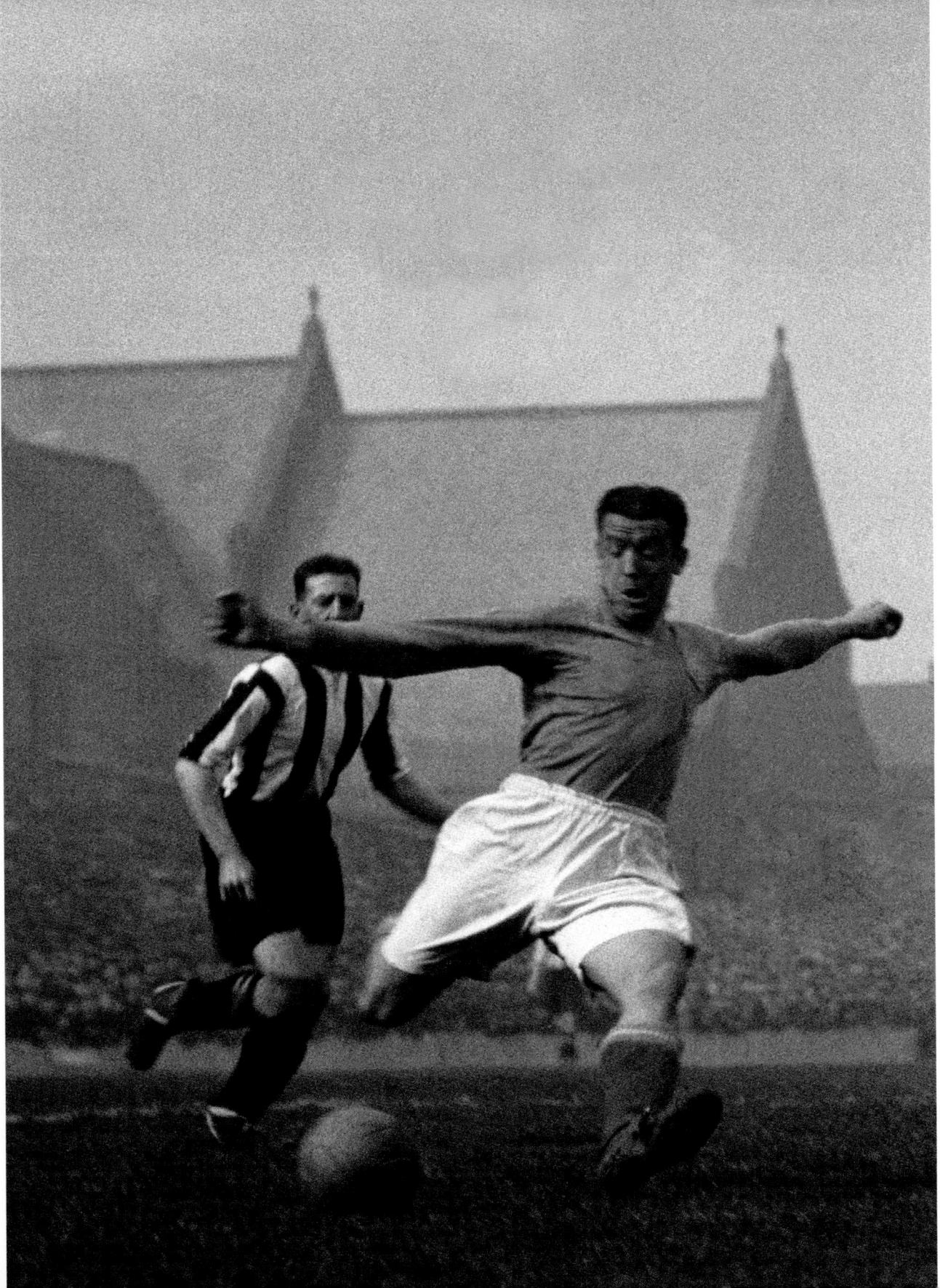

Facing page, left: Miss Mary Turner, the 18-year-old cricketer whose hurricane scoring caused a sensation, was regarded as the best batswoman in the country. She is seen during practice in the garden of her Surrey home.

11th May, 1930

Facing page, right: The Alfa Romeo of George Eyston (standing L) and his co-driver, R.C. Stewart, is prepared by mechanics before a record attempt. In addition to competing in motor races, Eyston was always on the look-out for records that he could break, and he was the first British driver to run a car at the Bonneville Salt Flats in Utah. He became well known for racing various models of supercharged MG.

18th July, 1930

Left: Bill 'Dixie' Dean of Everton, the most prolific goal scorer in English football history, shoots for goal at Goodison Park. About a third of the goals he scored were from headers.

20th October, 1930

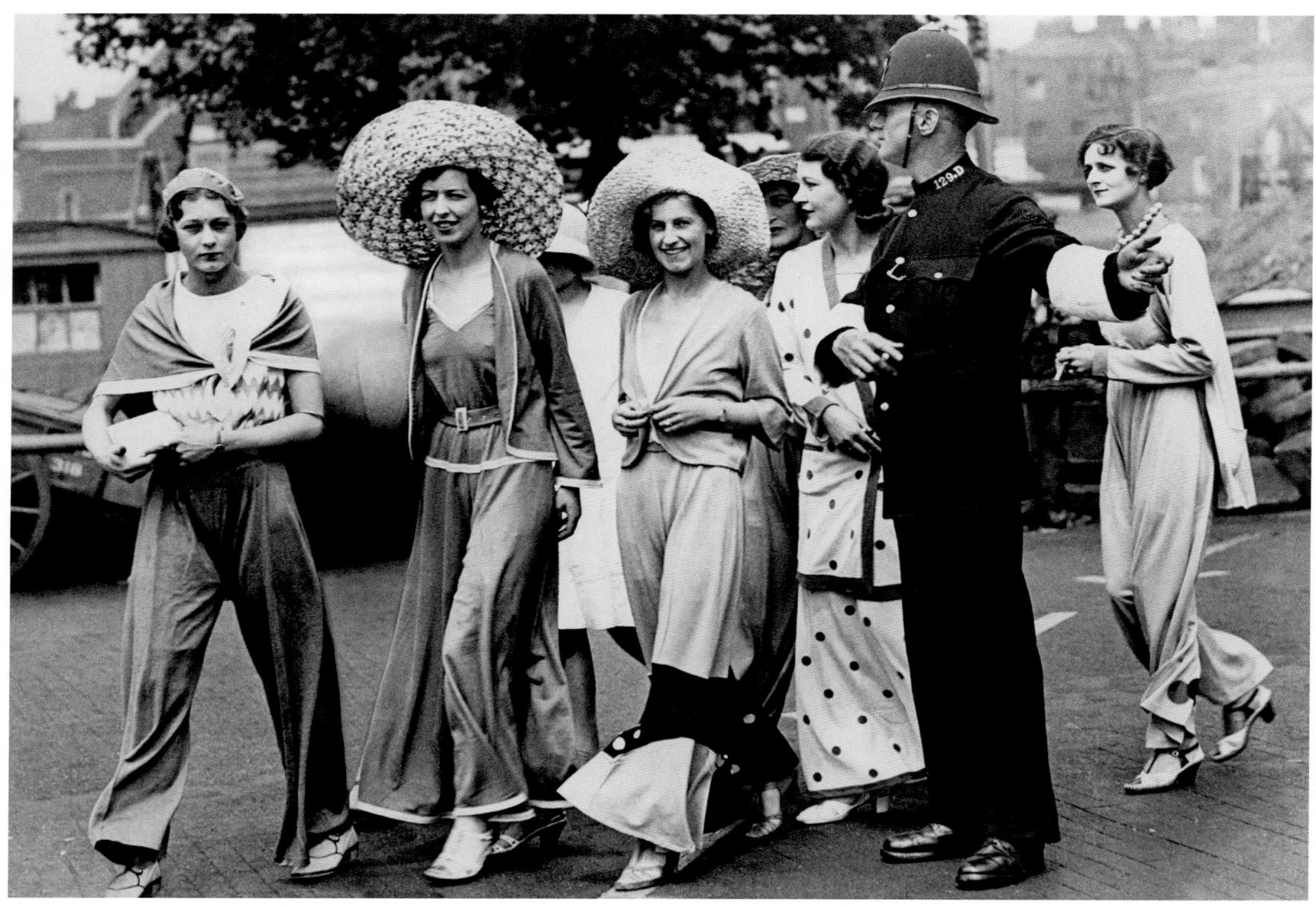

Above: Traffic stoppers. A policeman assists a group of fashionable young ladies
clad in the latest beach wear – 'beach pyjamas' – as they cross the road. Trousers
had become acceptable leisure wear for women during the 1920s, many having
worn them at work during the First World War. Beach pyjamas, often backless and
with flared legs, made their way to Britain from the Continent.

1930

Below: A man wearing wide-legged trousers known as Oxford Bags, so called because they were favoured by male students at Oxford University. The style evolved following a ban by the university in 1924 on the wearing of knee-length knickerbockers in lectures. The legs of Oxford Bags were so wide that they could easily be slipped on over the knickerbockers when required.

1930

Above: Mahatma Gandhi addresses a women's meeting in Bombay (now Mumbai) during a brief stay in the city. He played a major role in the struggle for home rule for India, leading a campaign of non-violent civil disobedience, for which he was arrested frequently. He is widely credited as the man who secured India's independence, which occurred on the stroke of midnight on 14th August, 1947, but he was not able to rejoice for long. Jubilant scenes across the country soon turned to horror, and thousands died as battles erupted between Muslims and Hindus in the two new countries of India and Pakistan, created through the partition of the religiously-divided sub-continent.

10th July, 1931

Left: The newly-built Broadcasting House for the BBC. Eric Gill's controversial statuary is still a work in progress; the major pieces, 'Prospero' and 'Ariel', are absent from above the front door. His scaffolding is set up to work on a smaller bas-relief (L).

13th August, 1931

Right: A farm worker operates a horsedrawn reaper-binder during the harvest above Teignmouth, South Devon.

14th August, 1931

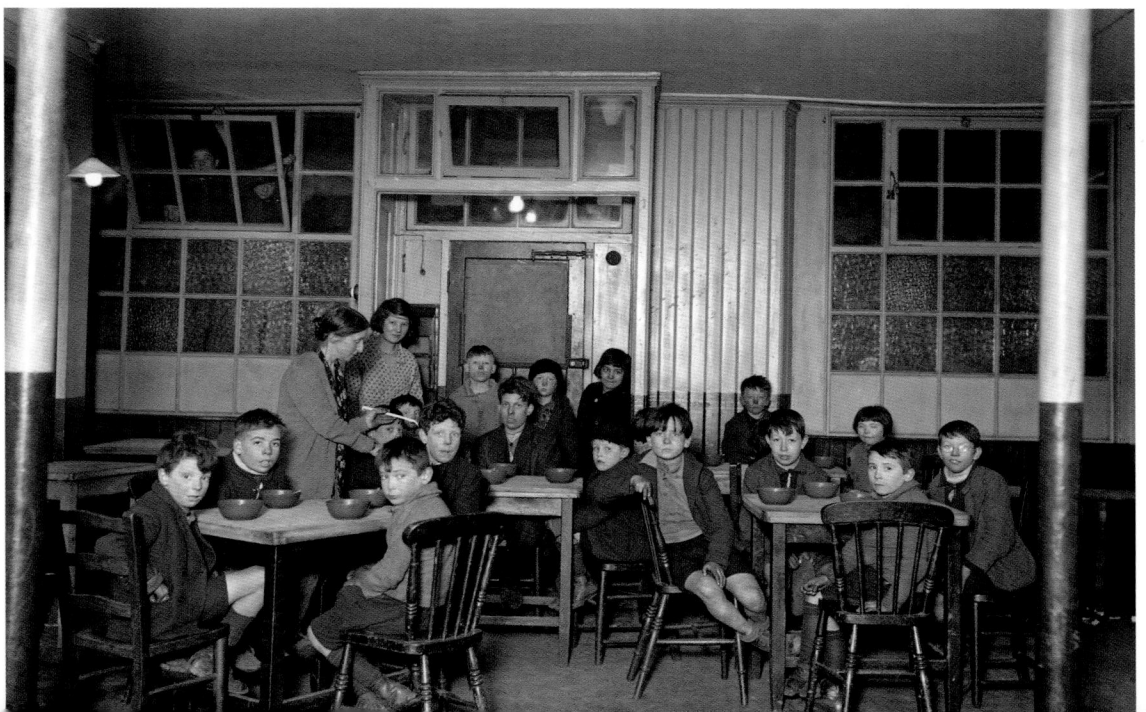

Left: No 10 Hyde Park Place, near Marble Arch. This tiny house, said to have been built for a lady's maid, consisted of a front door and one room only.

October, 1931

Right: In Canning Town, London, poor children are given soup, probably the only nourishing meal of the day.

1931

Above: Racing driver Elsie Wisdom
tunes her car's engine. While motor
racing has always been a male-
dominated pursuit, women played
an important role in the early days,
enjoying a higher profile in the
sport than women do today. In 1932,
Elsie, with co-driver Joan Richmond,
would win the prestigious
1,000-mile (1,600km) race at the
Brooklands track, the first women
ever to win a major international
car race.

1st October, 1931

Right: He went thataway! A three-
wheeled BSA police patrol car.

1st March, 1932

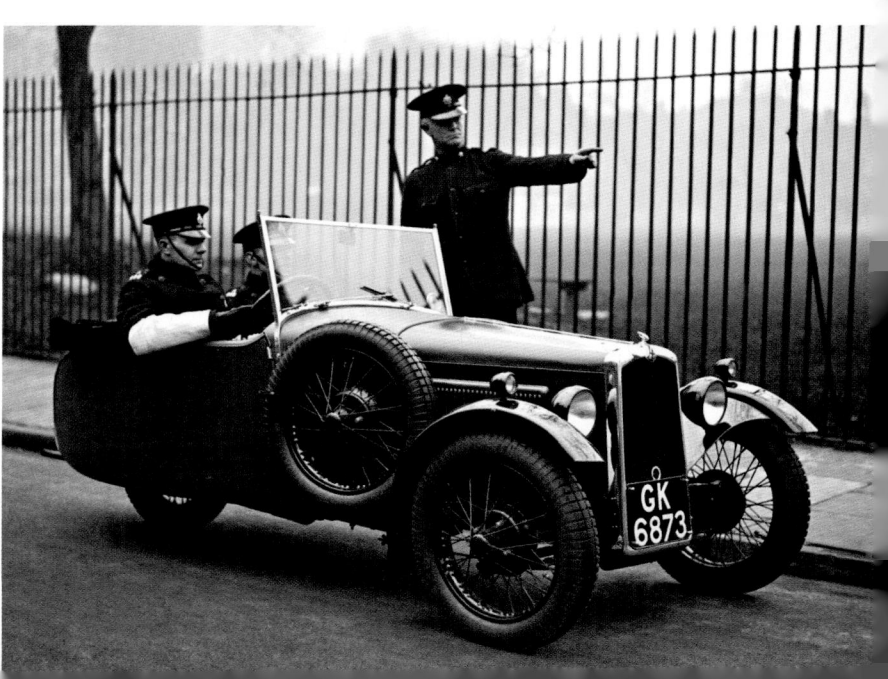

Right: Thick fogs, known as 'pea-soupers', were commonplace in London due to industrial air pollution and the use of coal fires for domestic heating. The young, elderly and infirm suffered respiratory ailments when conditions were at their worst.

1st March, 1932

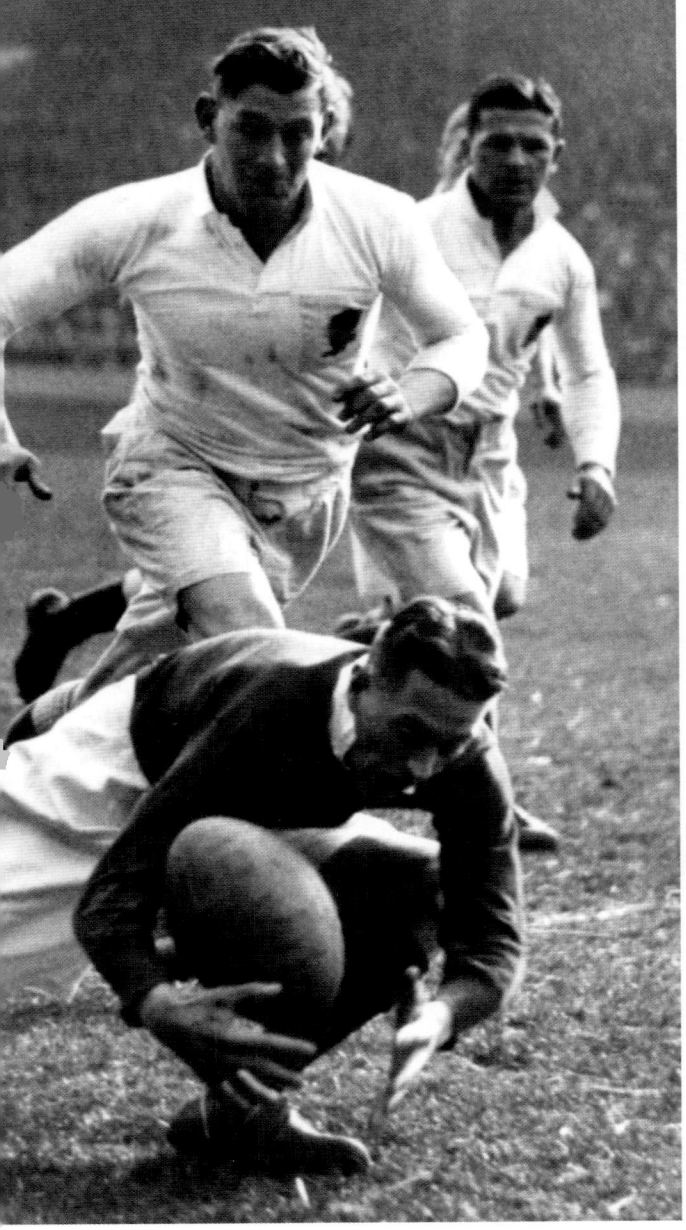

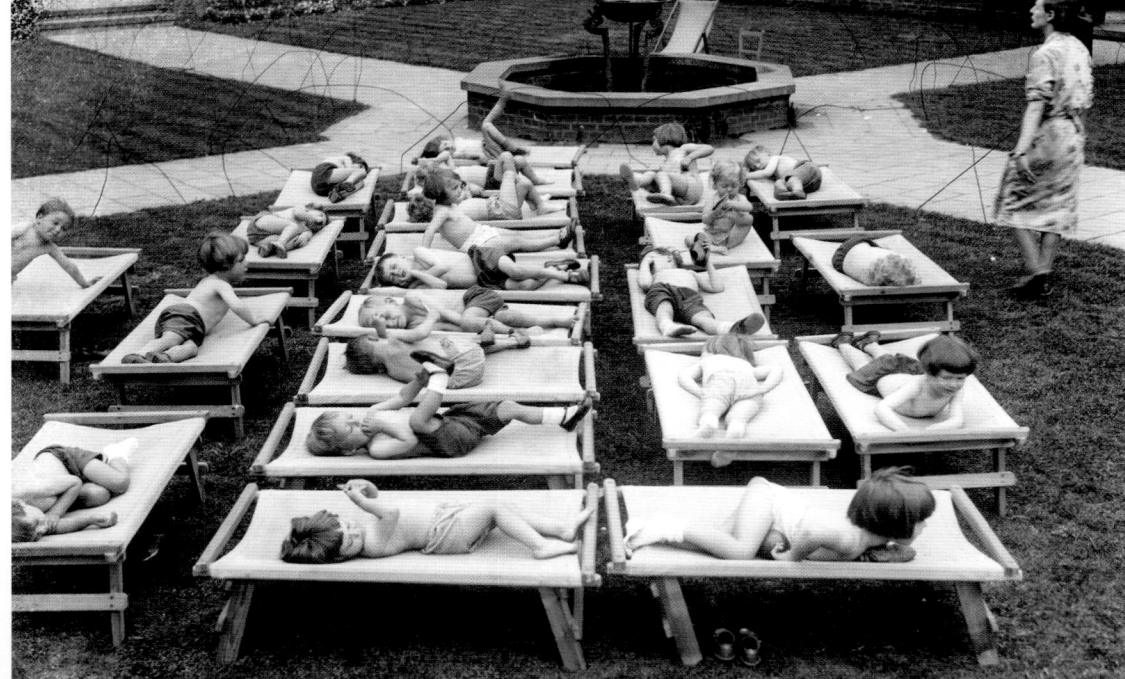

Above left: Folk dancing in the streets of Stratford-upon-Avon, after the Prince of Wales had opened the new Shakespeare Memorial Theatre.

23rd April, 1932

Above: Miss Margaret Whigham and Miss Holloway fashionably dressed to attend the Ascot races.

14th June, 1932

Left: Sunbathing in the grounds of a London day nursery. Heliotherapy – sunbathing for health – enjoyed considerable popularity in the 1930s and was regarded as a public health measure.

12th September, 1932

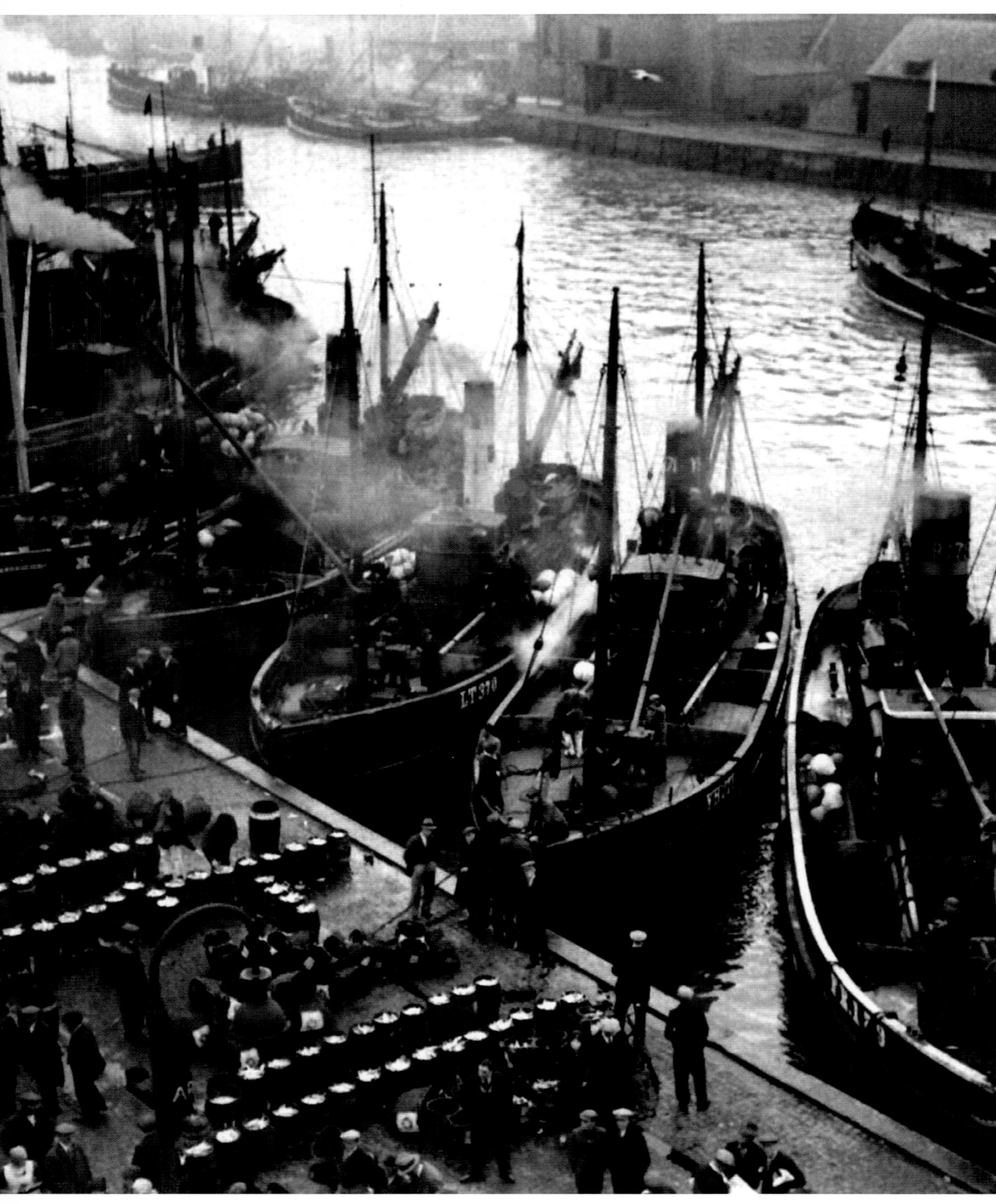

Left: The herring catch being landed at Great Yarmouth, Norfolk. The port was once home to Europe's largest herring fleet, comprising 1,000 boats, which could land 2,000 million fish in a season. By the 1930s, however, the industry was beginning to slump; the decline continued until the last herring drifters left the port in the 1970s.

12th October, 1932

Right: With unemployment in Britain at 2,750,000, the National Unemployed Workers' Movement organized a hunger march to London, formed from contingents from the depressed areas of the country, such as the South Wales valleys, Scotland and the North of England. The march terminated at Hyde Park in London, where a massive police presence provoked a violent response from the marchers, which continued for some days.

25th October, 1932

Right: Sir Malcolm Campbell with his new *Bluebird* car. Based on an earlier machine, it was powered by a Roll-Royce R V12 aero engine. At Daytona, Florida, in February 1933, the car set a record speed of 272mph (438km/h).

1933

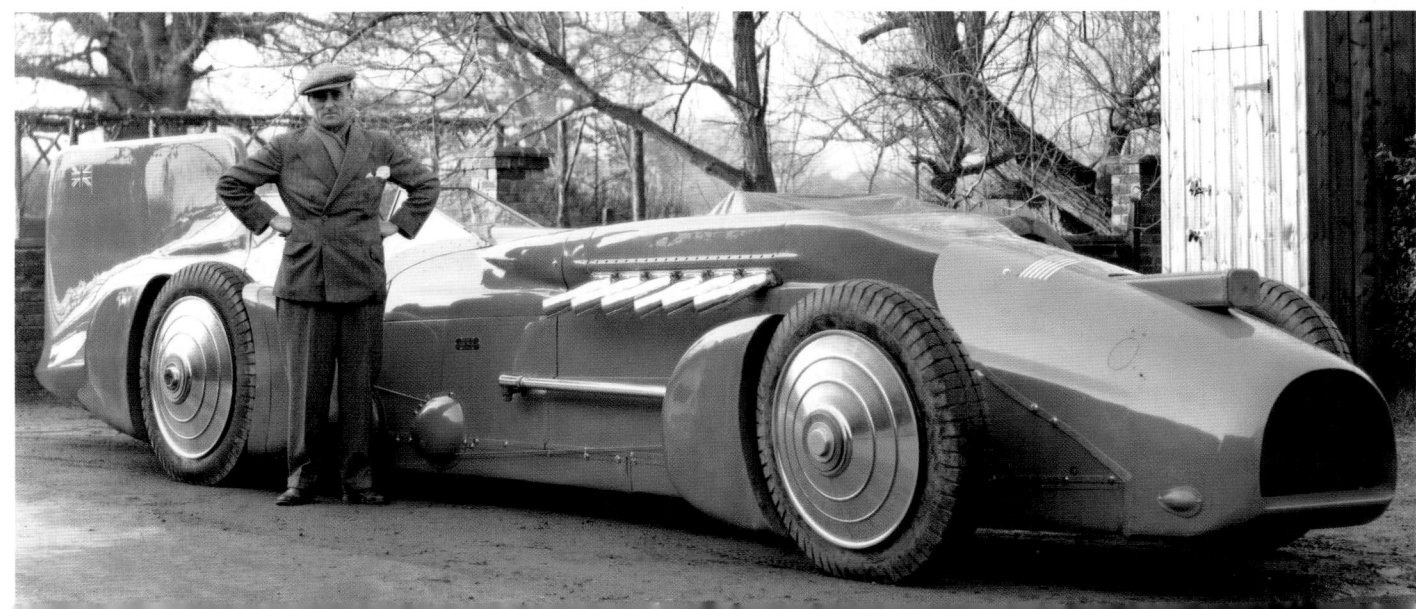

Left: Men work in precarious positions during the cleaning operation on the 'Lady of Justice', the 12ft (3.7m), gilded statue atop the Old Bailey, London.

6th January, 1933

Below: As a result of a wager, Mr Samson, who claims to be the strongest man in the world, resists the pulling power of a pair of shire horses at Croydon in Surrey.

24th June, 1933

Right: Feeling the heat. Children dressed for the great heatwave of 1933 meet a Grenadier Guardsman on duty outside Buckingham Palace, London.

4th July, 1933

Facing page: In London's East End, children play in a back yard among the washing and rabbit hutches.

10th March, 1934

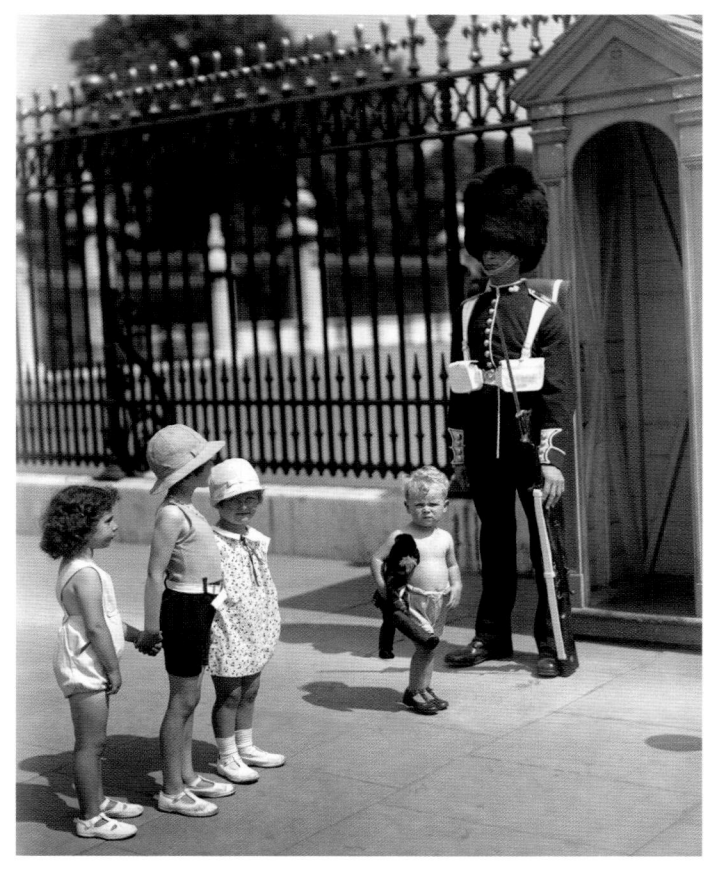

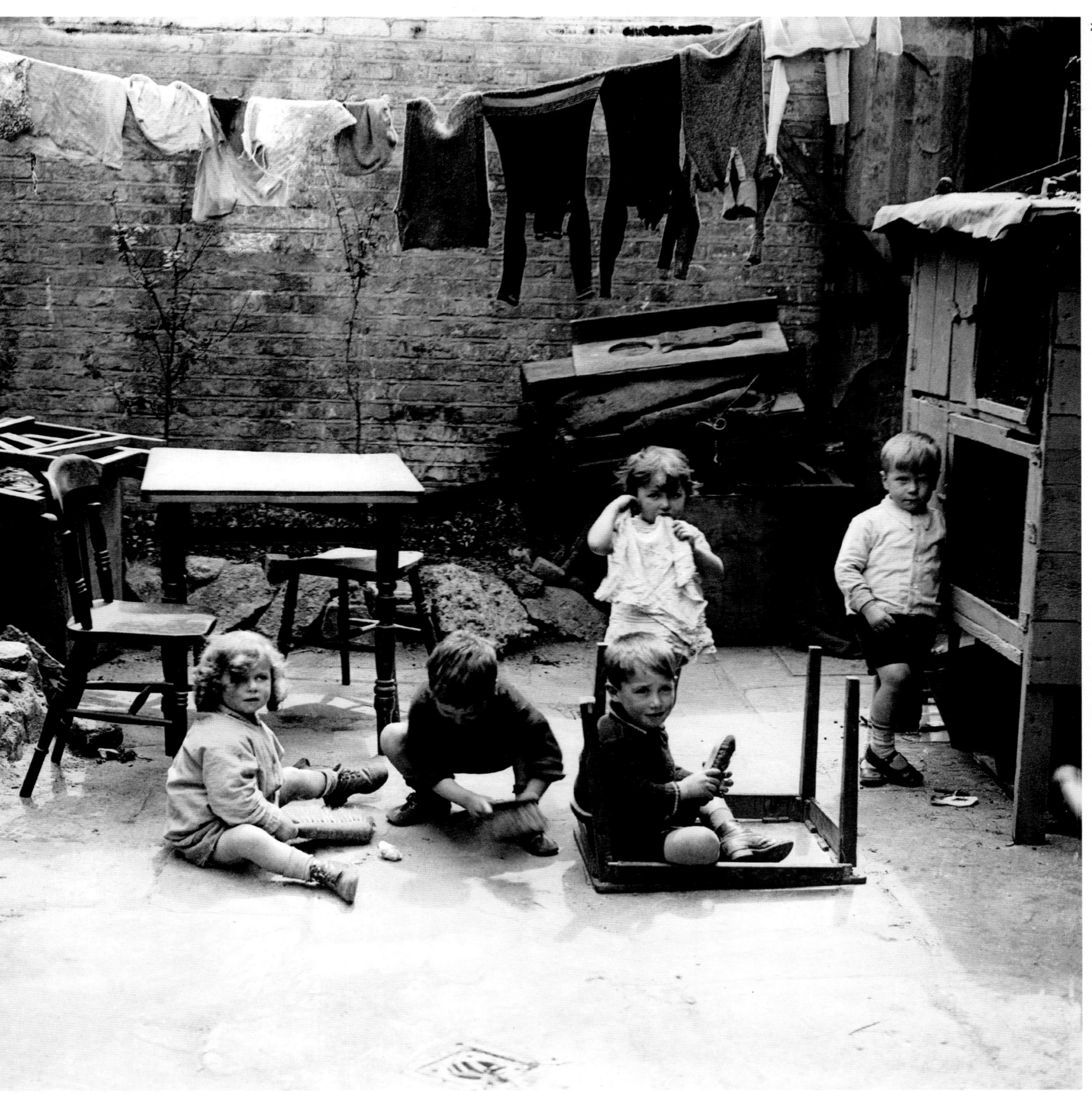

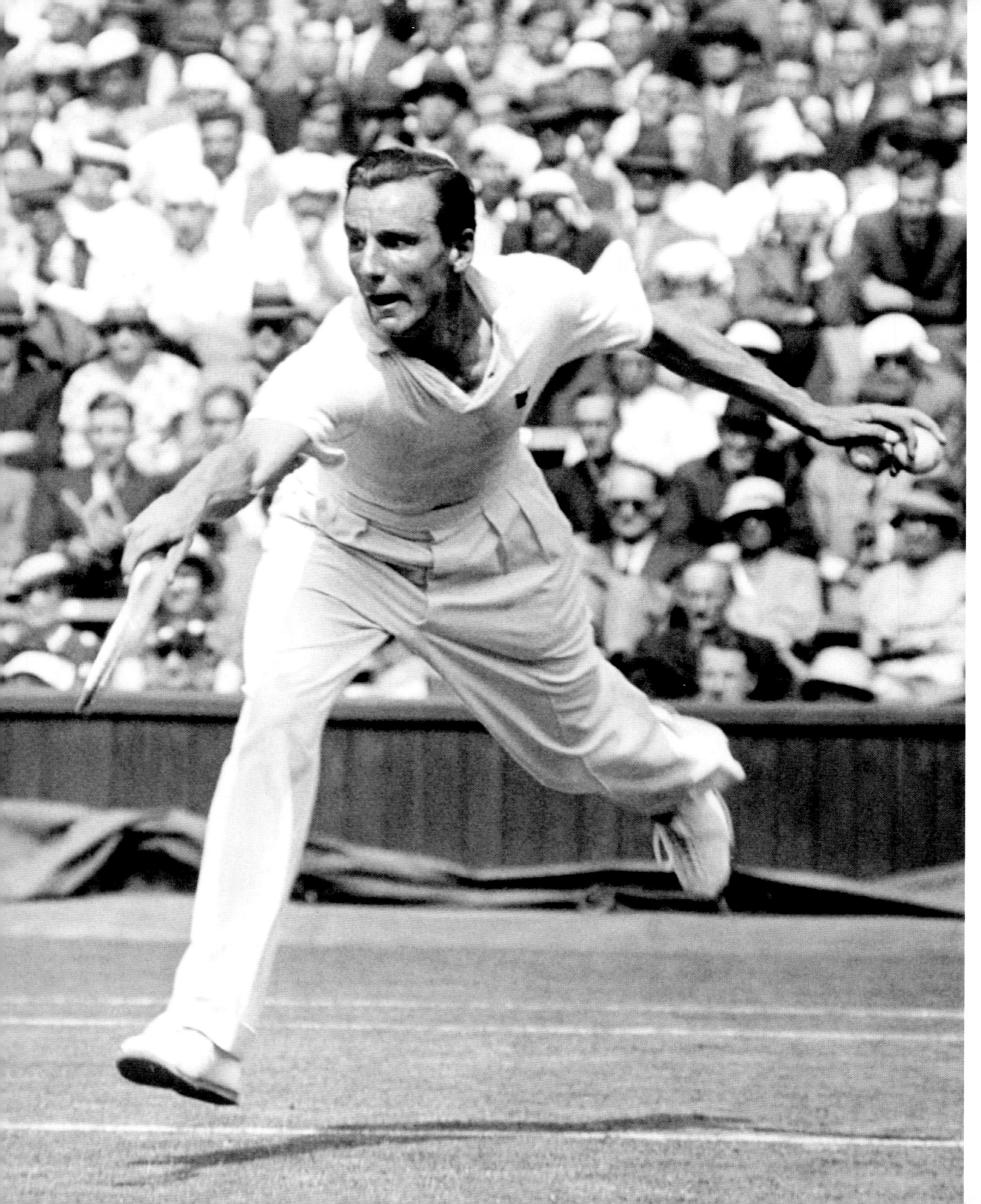

Left: Fred Perry lunges to play a backhand at Wimbledon. Born in Stockport, Cheshire, Perry was a player of both tennis and table tennis. He was the world's number-one tennis player for five years, four of them consecutive (from 1934 to 1938) and a three-time Wimbledon champion. He is one of only six players in history to have won all four Grand Slam events.

30th June, 1934

Right: Aviation
pioneer and aircraft
designer Thomas
Sopwith at the wheel
of his J-class yacht,
Endeavour, his wife
Phyllis behind him
with the stopwatch.
In 1934, Sopwith took
part in the America's
Cup race with
Endeavour and came
close to winning.

7th July, 1934

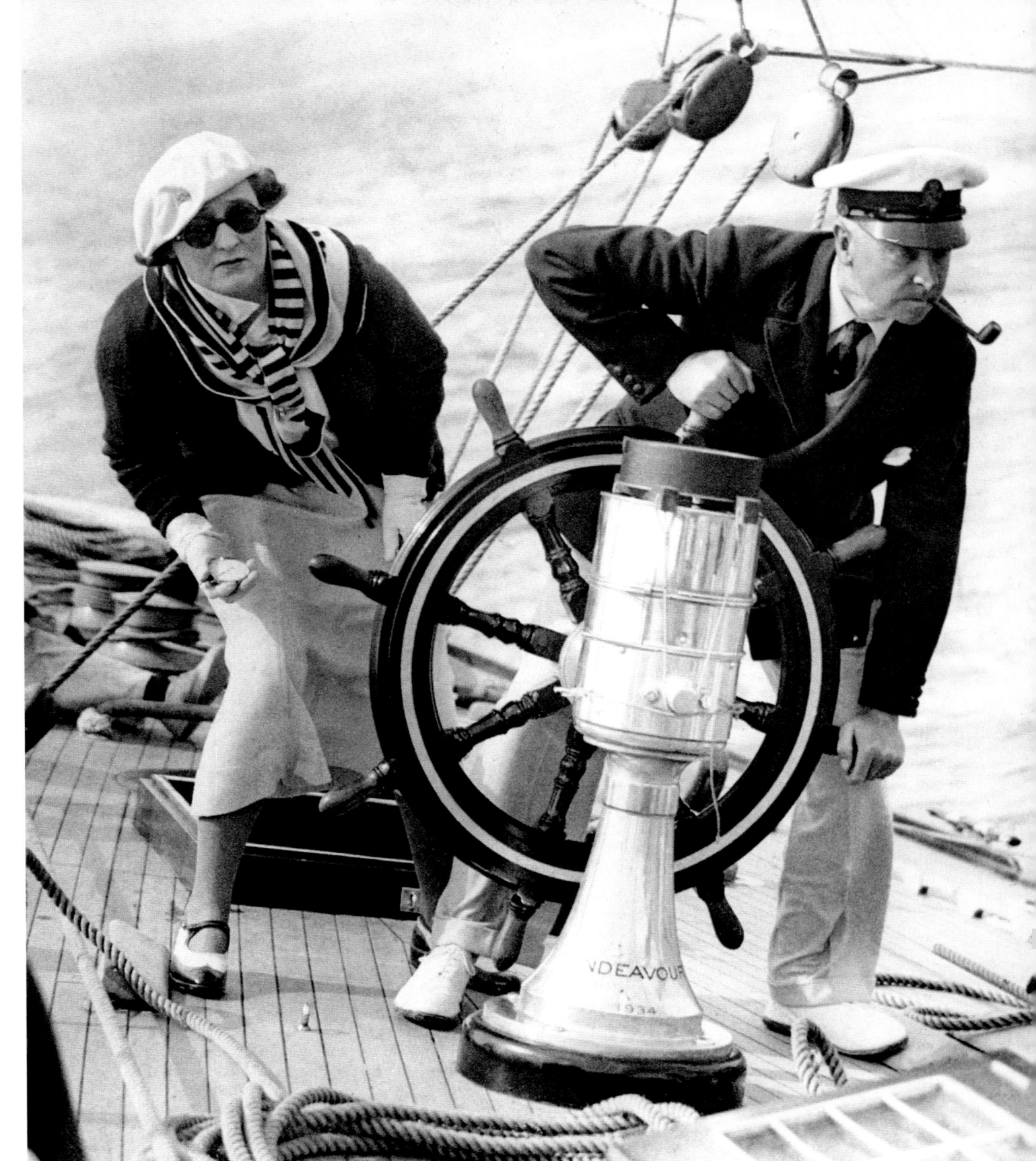

Above: Following a shift in attitudes toward female labour, brought about by the First World War, women continued to work in peacetime. Here, factory girls are persuaded to cheer and giggle for the camera.

21st December, 1934

Left: A man passes through an automatic turnstile at Stonehenge. The site had been given to the National Trust in 1928, and a programme had been instituted to return the surrounding land to agriculture, which involved the demolition of several nearby buildings.

6th January, 1935

Left: With the approach of the summer season, London's cricket equipment industry was gearing up for a busy time. At this factory in St John's Wood, lumps of willow are being transformed into bats, a process known as 'pod shaving'. A maker of cricket bats is known as a pod crafter, while experts are master pod crafters. Here, the willow blades are planed and shaped before the handles are spliced in place.

27th March, 1935

Below: British racing driver Victor Stafford's tiny streamlined racing car. Wedged into its cramped cockpit, Stafford hoped to break records at Brooklands.

10th April, 1935

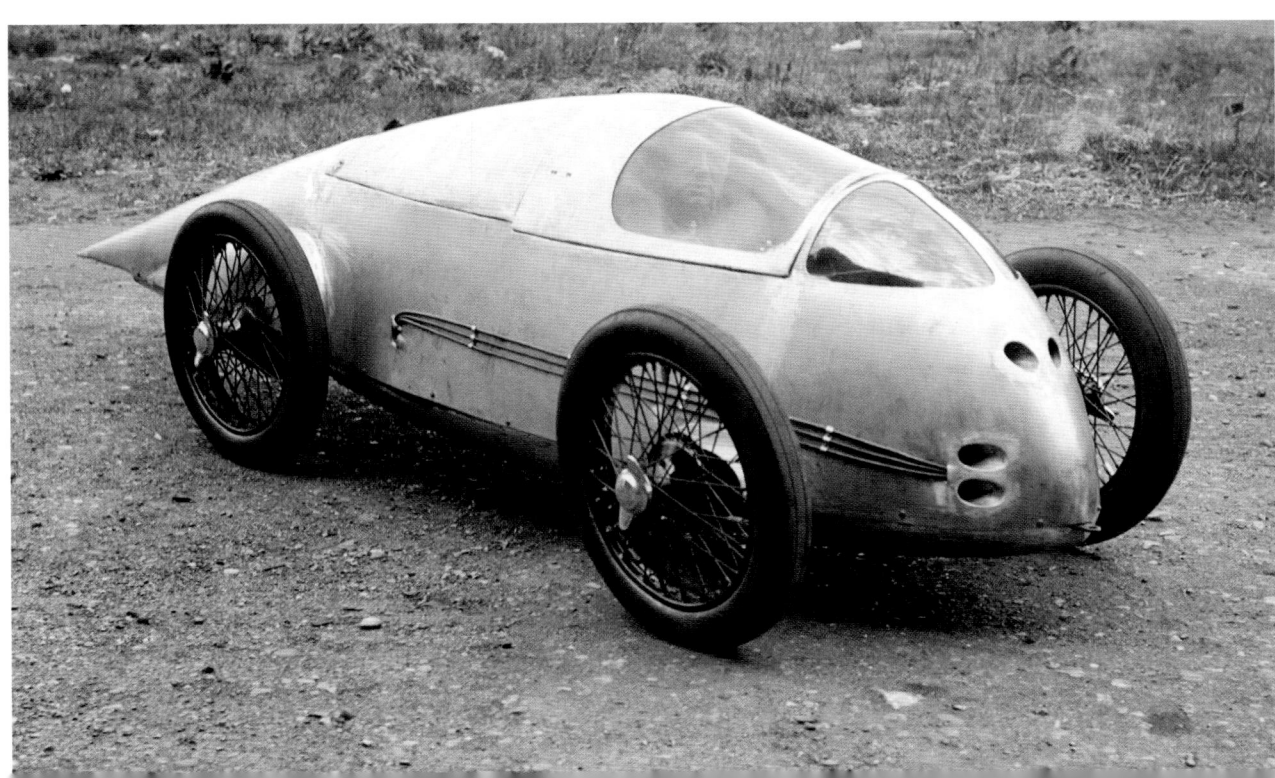

Above: The orthoptoscope, an apparatus designed to measure and cure squints (when the eyes are not parallel), at Moorfields Eye Hospital in London.

12th May, 1935

Left: British music hall composer and star Harry Champion 'tickles the ivories'. Born in Shoreditch, London as William Crump, Champion popularized a large number of songs, including *A Little Bit of Cucumber, Any Old Iron, Boiled Beef and Carrots, I'm Henery the Eighth, I Am, It's Cold Without My Trousers* and *What a Mouth*.

25th October, 1935

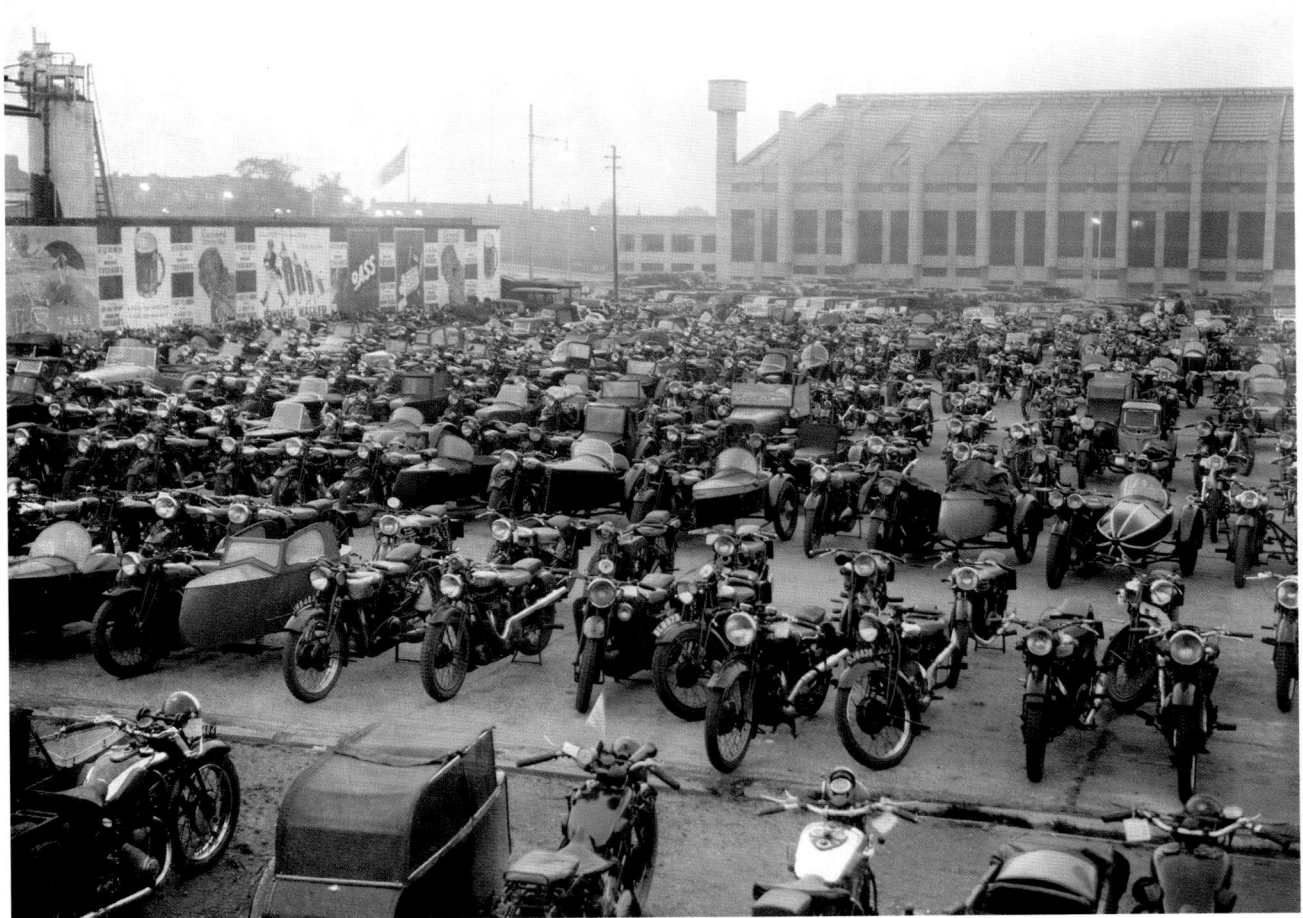

Above right: Hawker Fury fighters of the Royal Air Force's No 1 Squadron at Biggin Hill Aerodrome, Kent, where they were based for a 24-hour winter exercise extending from Clacton on the east coast all the way around to Beachy Head on the south coast. During the 1930s, No 1 Squadron was renowned for its aerobatic displays.

18th February, 1936

Right: Motorcycles provided an affordable means of personal transport for many during the 1930s, as demonstrated by this sea of machines parked outside Wembley Stadium

1936

Left: King Edward VIII makes his first radio broadcast to the world. Nine months later, on 11th December, he would broadcast again, but this time to announce his abdication. Determined to marry American divorcee Wallis Simpson, he chose to give up the throne when informed by Prime Minister Stanley Baldwin that the marriage would not be acceptable to the people and that it would provoke a constitutional crisis.

1st March, 1936

Left: Champion steel-bender George Challard trains his four-year-old son in the art of strongmanship by standing on his chest to toughen him up.

27th March, 1936

Right: Two traditional farm wagons laden with hay pass through a ford on the River Wye, on the border between England and Wales. Horses were still in common use in agriculture during the 1930s.

1936

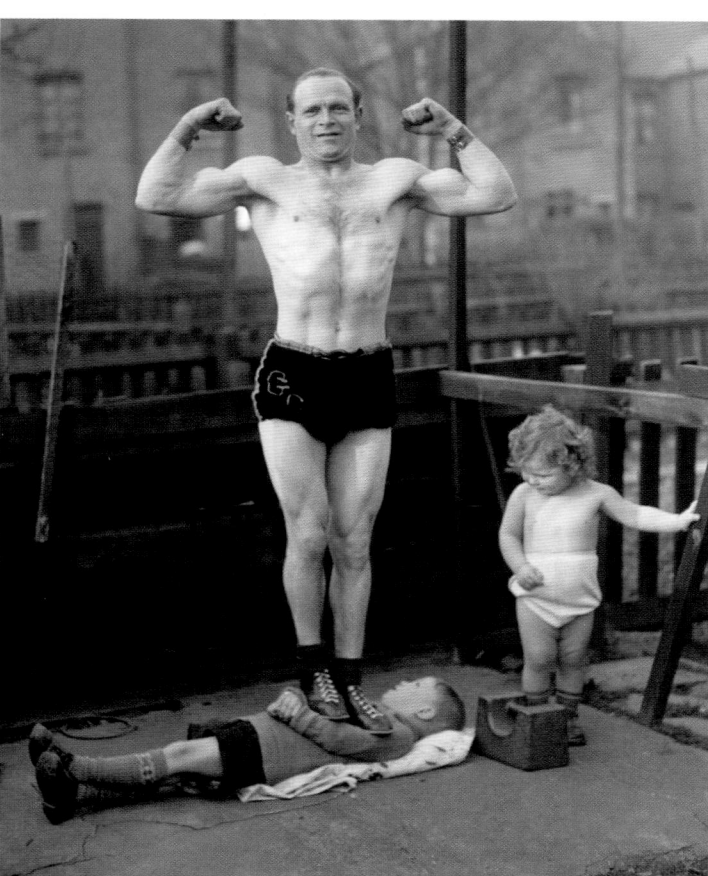

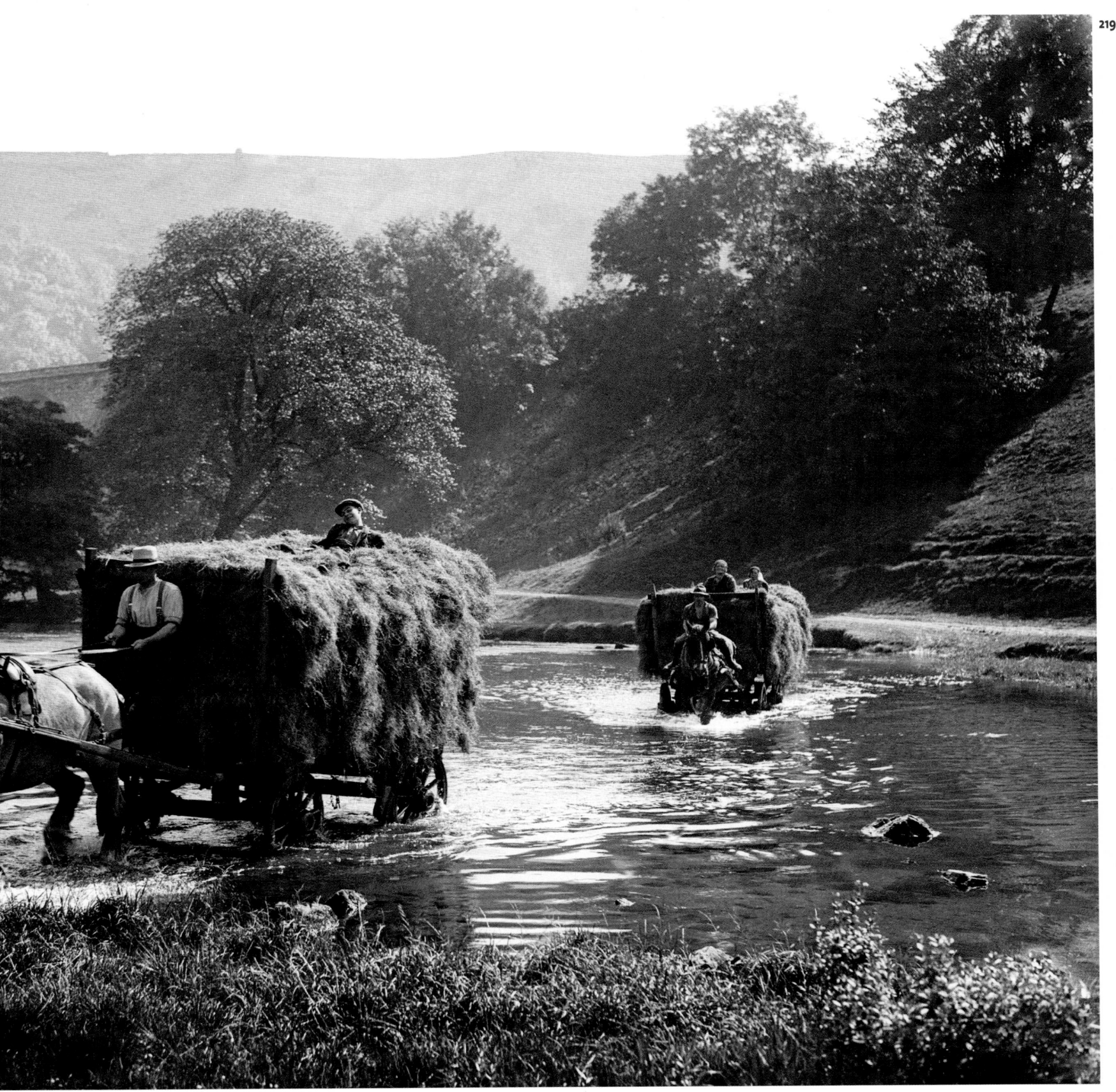

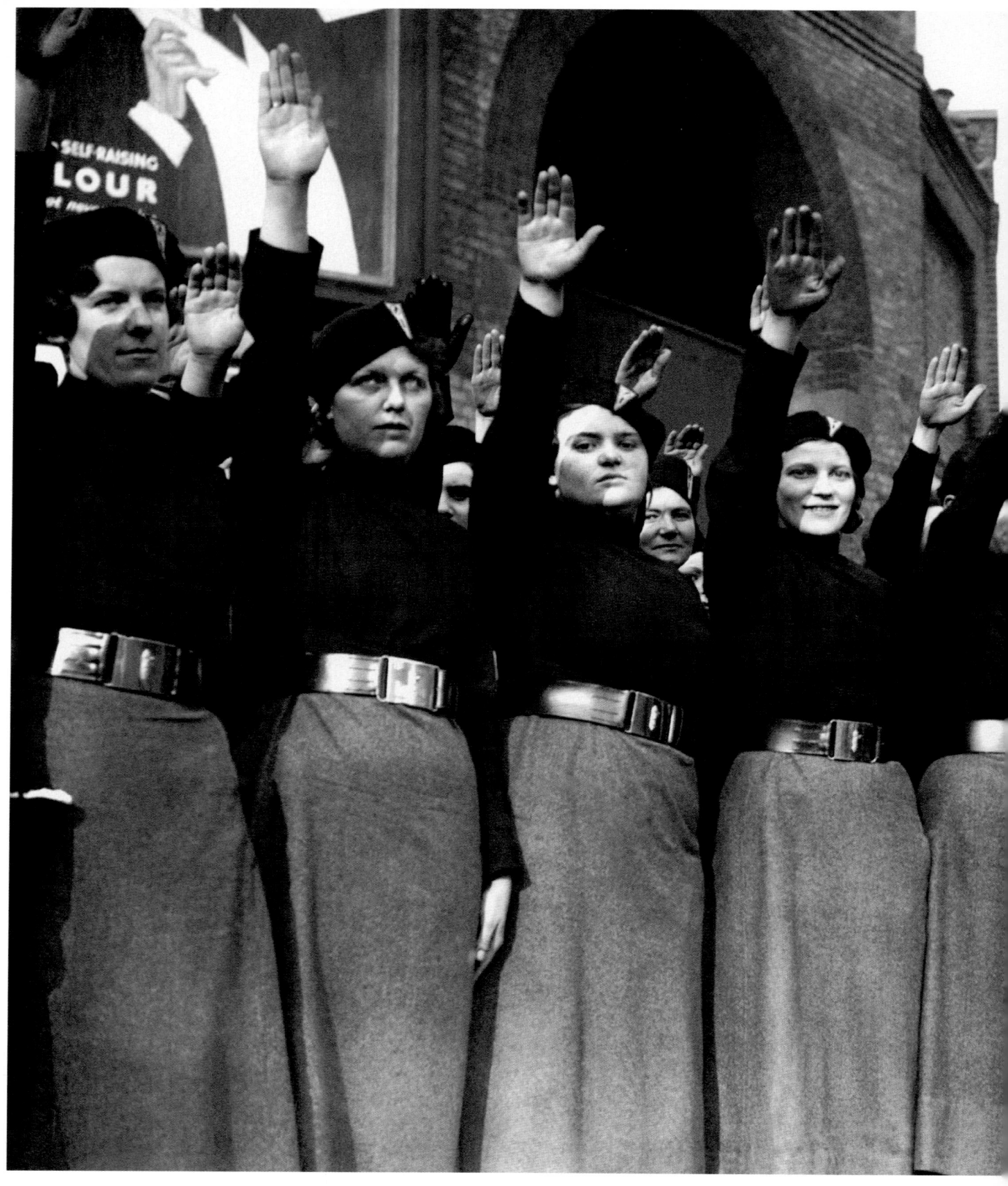

Above: Sir Oswald Mosley, the leader of the British Union of Fascists, known as the 'Blackshirts', addresses a meeting in the East End of London. Mosley was inspired by Italy's dictator, Benito Mussolini. His followers were often involved in violent controntations with communist and Jewish groups.

15th October, 1936

Left: Women members of the British Union of Fascists demonstrate the fascist salute outside their London headquarters.

5th October, 1936

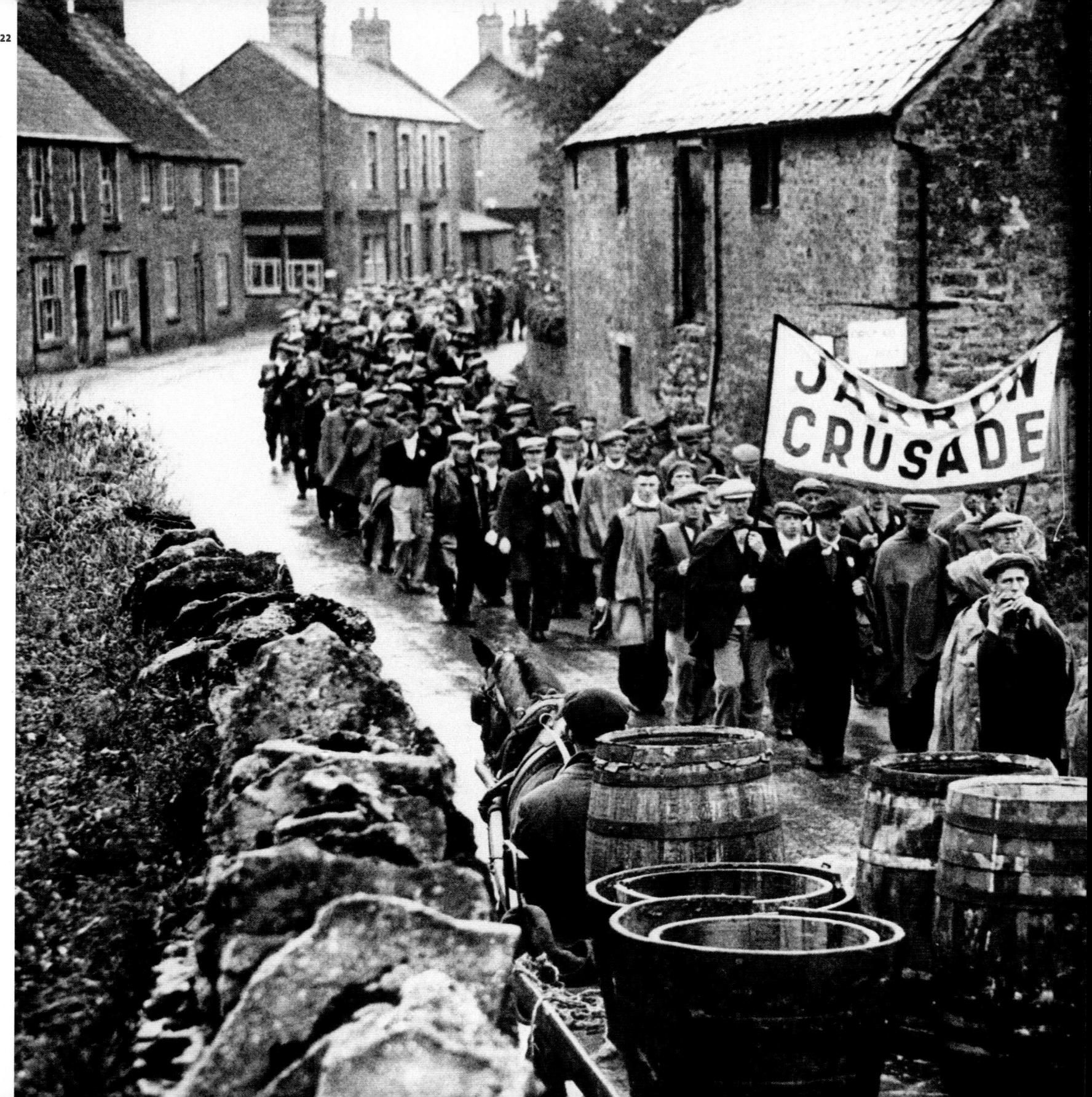

Left: The Jarrow marchers, led by a harmonica band, pass through Lavendon on their way to London to protest about unemployment and poverty in the north-east of England. They received little help, however, other than £1 each for the train fare home.

26th October, 1936

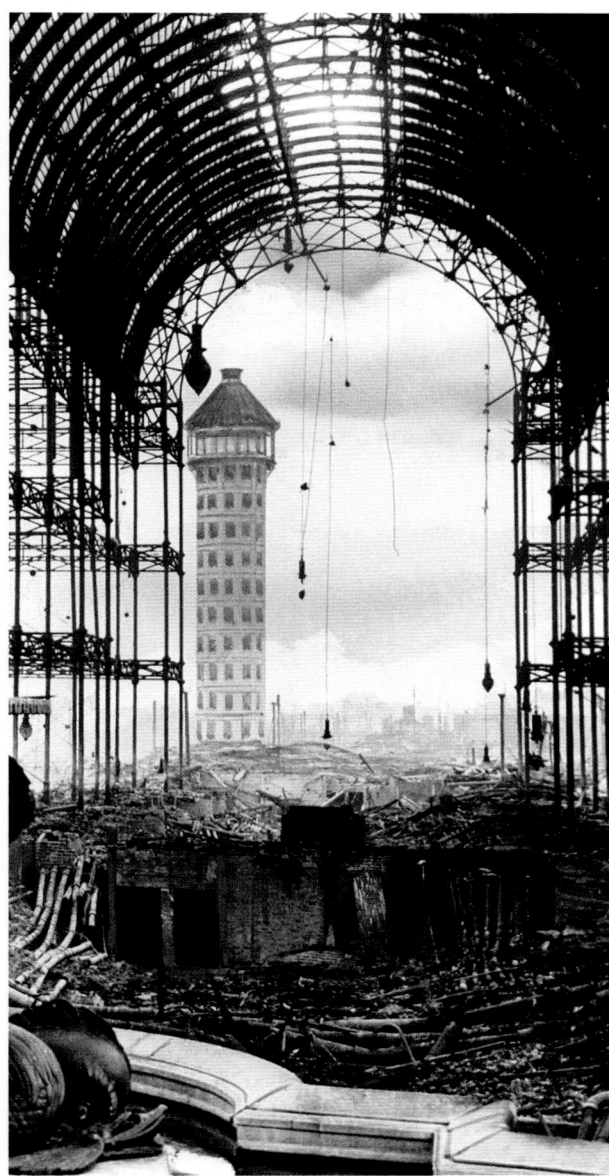

Above: The ruins of the Crystal Palace, London, after it had been burned down. The original cast-iron and glass building had been erected in Hyde Park to house the Great Exhibition of 1851. It was moved to Sydenham in south London after the exhibition, where it was used for concerts and exhibitions. The fire devastated the building, despite the efforts of over 400 firemen.

30th November, 1936

Right: The evening newspapers bring the shocking news that King Edward VIII has abdicated to be able to marry American divorcee Wallis Simpson. His reign of 325 days made him one of the shortest reigning monarchs in British history. In a radio broadcast, he explained that he felt unable to bear the burden of his duty as king *"without the help and support of the woman I love."* Subsequently, he was given the title Duke of Windsor, but he and the Duchess spent the remainder of their lives in exile.

10th December, 1936

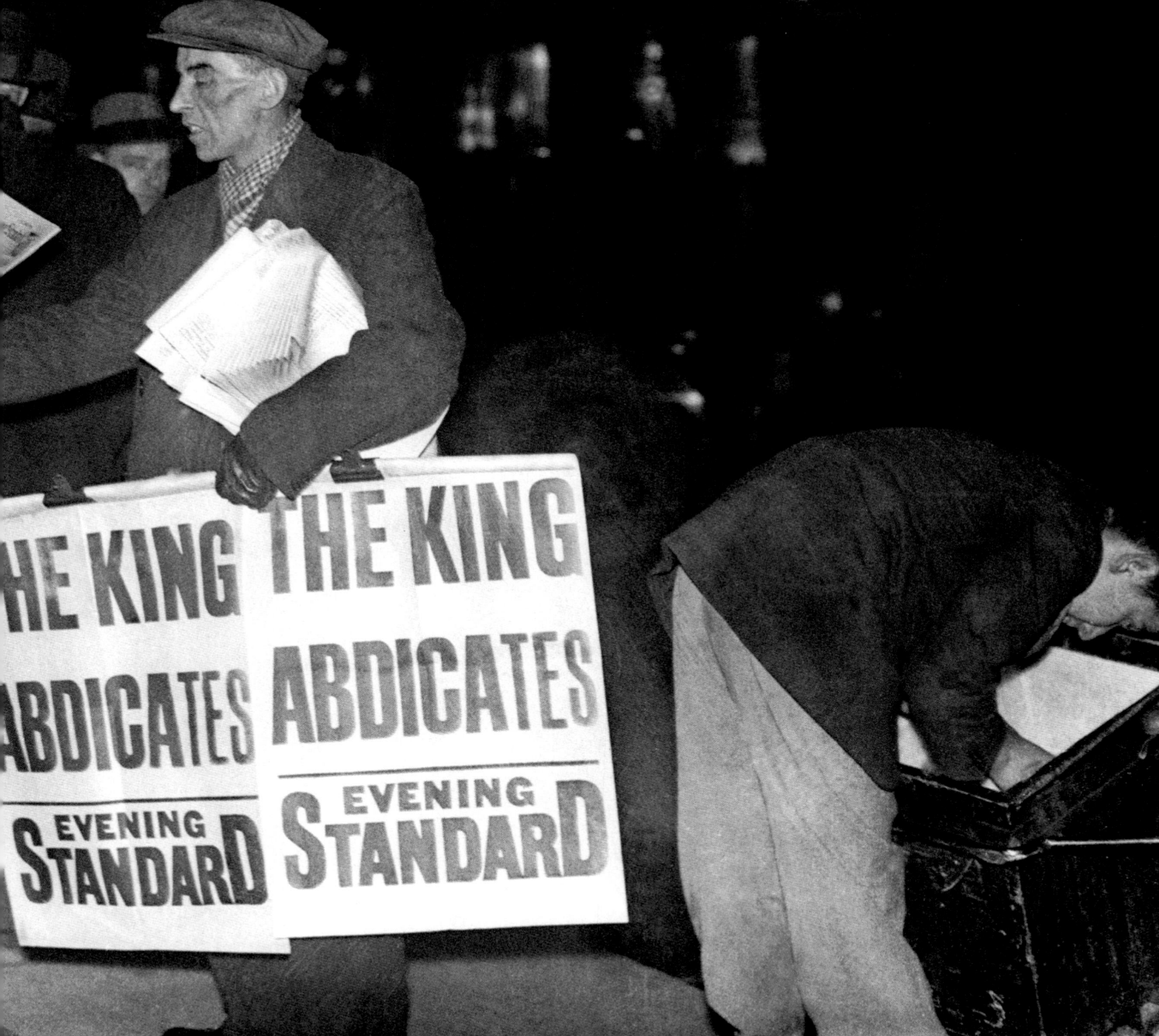

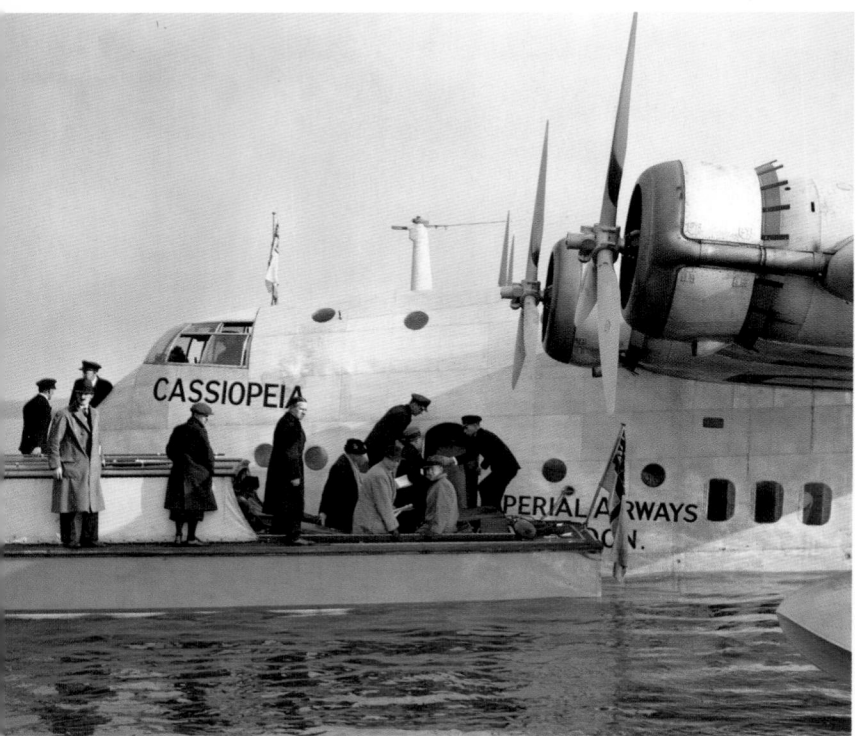

Above: Passengers are helped aboard *Cassiopeia*, a Short S23 Empire flying boat operated by Imperial Airways (later BOAC). The machine was about to set off on its maiden flight from Southampton to Alexandria in Egypt. The Empire series of flying boats was built to serve Imperial Airways' routes to the colonies in Africa and Australia. The S23 could carry 17 passengers and five crew. It was also operated by the Australian airline Qantas and Tasman Empire Airways of New Zealand.

26th January, 1937

Right: Following the abdication of Edward VIII, his brother, Prince Albert, assumed the throne as King George VI. In this official portrait, he is seen after the coronation with Queen Elizabeth and their daughters, Princess Elizabeth and Princess Margaret.

12 May, 1937

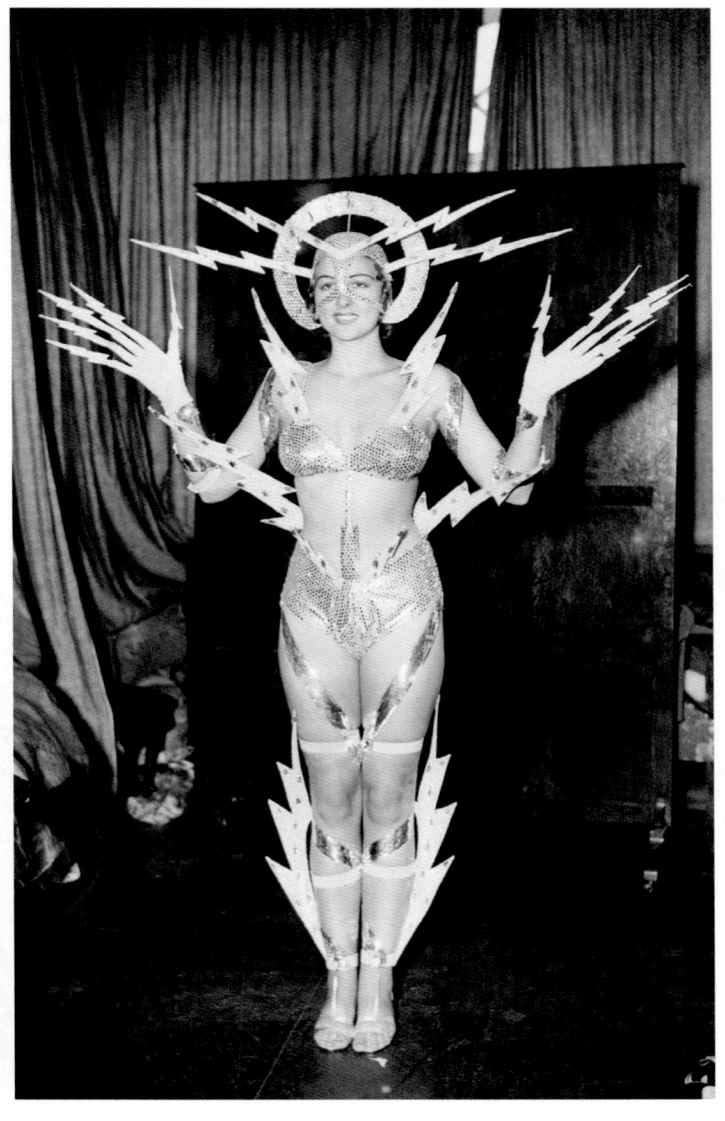

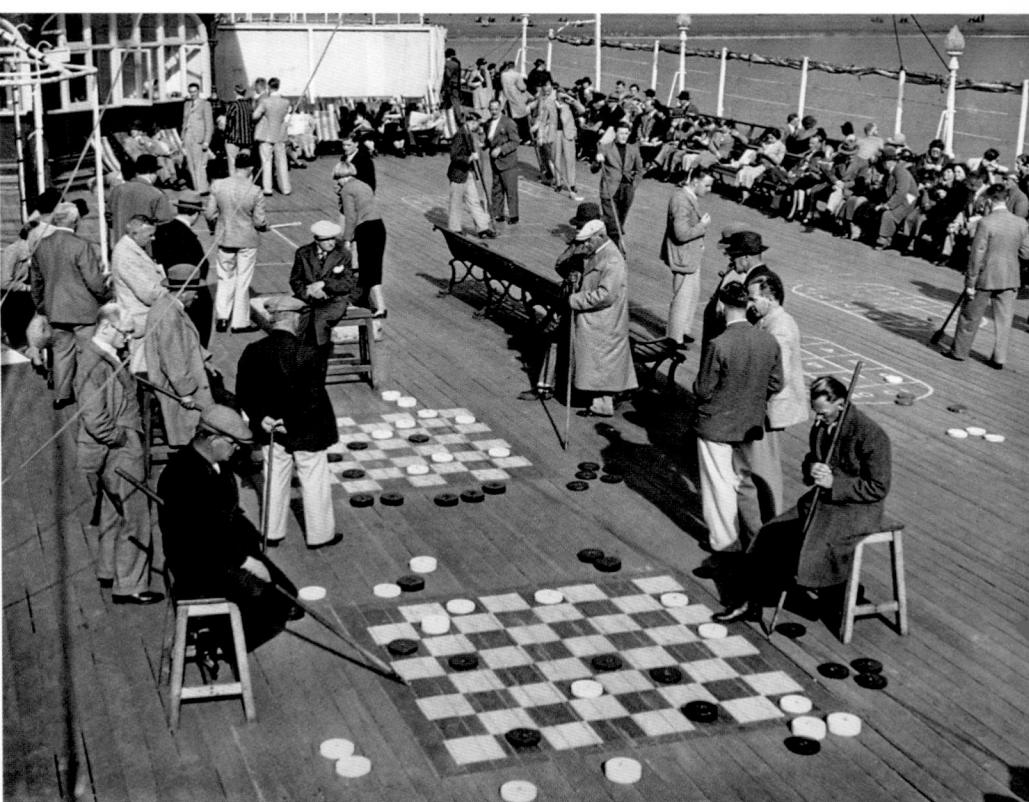

Above: The scene at Bournemouth where, drawn by brilliant sunshine and warm temperatures, crowds seek entertainment and relaxation on the pier.

1st October, 1937

Left: The Radio Queen, Miss Elmira Humphreys. The lightning flash emblem was commonly used during the 1930s to denote electrical energy.

22nd September, 1937

228

Right: The Duke and Duchess of Windsor meet the German Chancellor Adolf Hitler in Munich. It was thought that the pair had pro-Nazi and pro-fascist sympathies; certainly the Germans were dismayed at Edward's abdication, since they felt that his presence as king would have promoted a better relationship with Britain. During the Second World War, Winston Churchill sent the couple to the Bahamas, where he felt they could do the least damage to the British war effort. The Duke was installed as Governor, but he considered the Bahamas to be a third-class British colony and had a very low opinion of its inhabitants.

23rd October, 1937

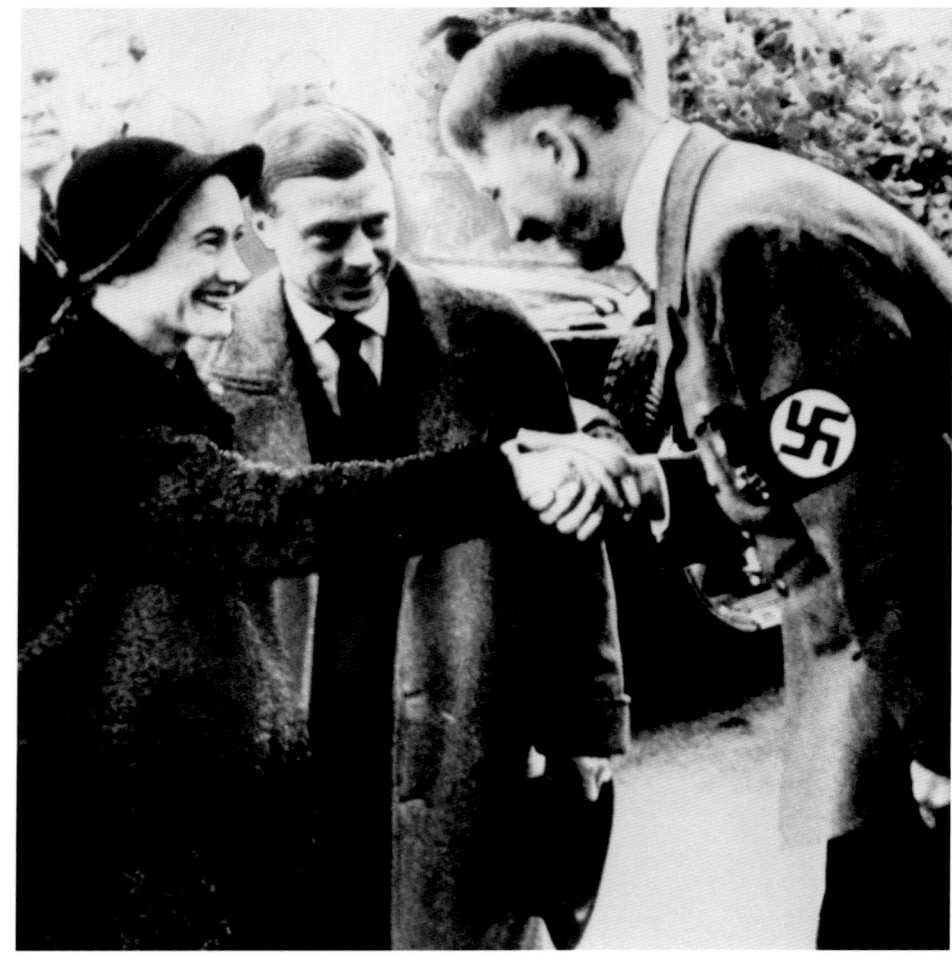

Right: The London, Midland & Scottish *Royal Tank Corps* No 5507, one of 52 Patriot-class passenger steam locomotives, stands alongside an LMS streamlined articulated diesel railcar. Diesels and electrification would spell the end for the steam locomotive on British railways.

26th October, 1937

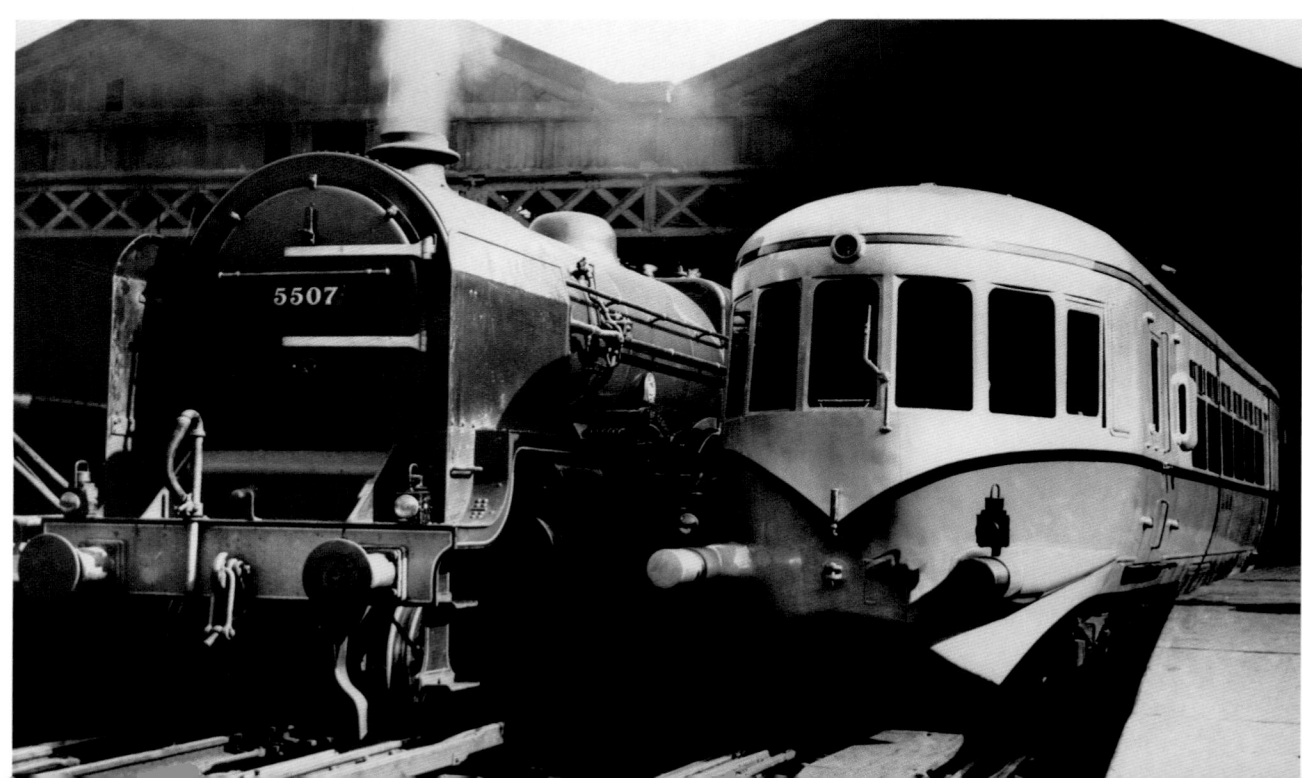

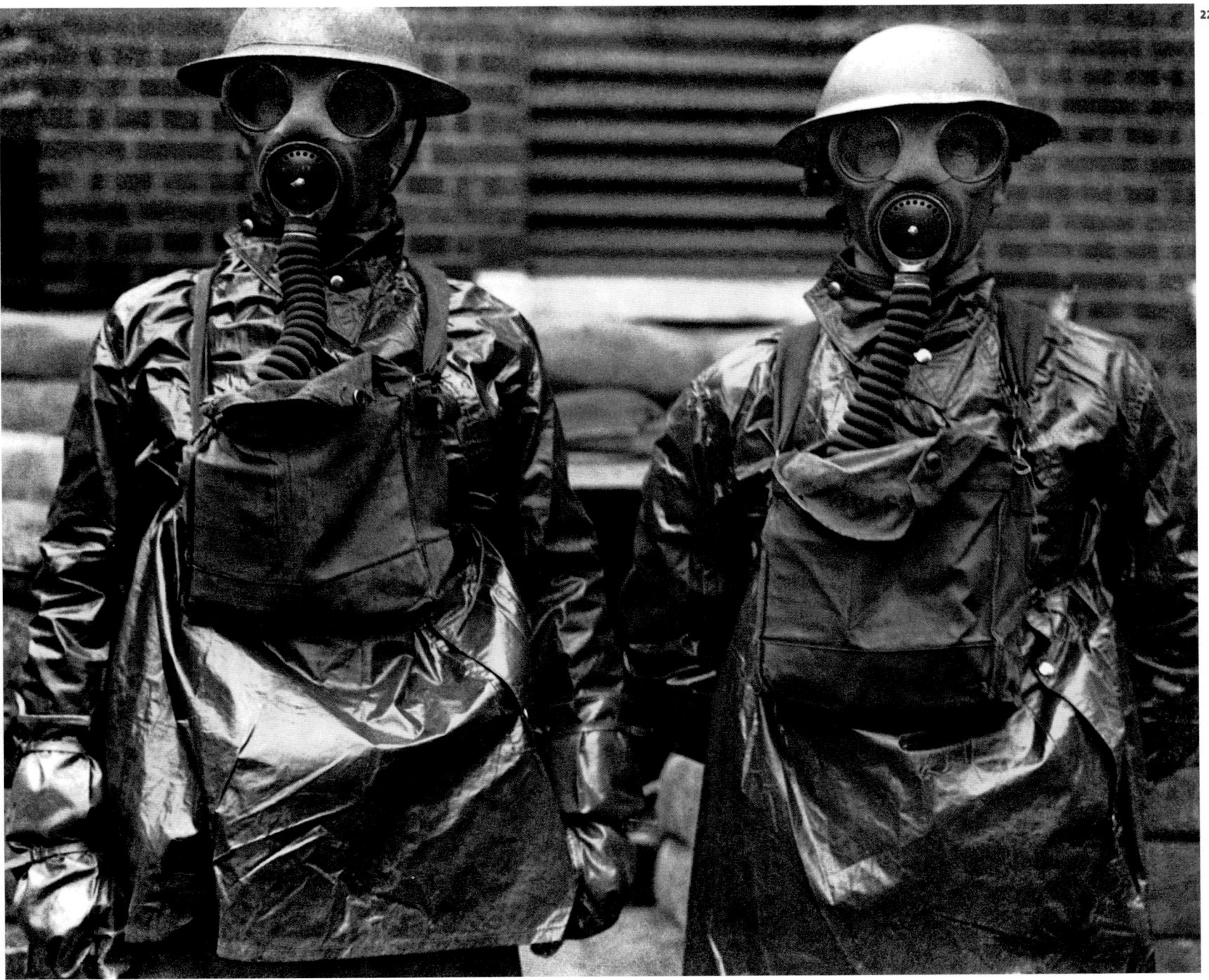

Above: Soldiers wear respirators and anti-gas coats (known as capes) during a 1938 air-raid drill as tensions on the Continent heighten. Following the use of gas as a weapon during the First World War, it was assumed that bombs containing gas would be dropped in a future war. To this end, all civilians in Britain were issued with respirators (gas masks). Troops were provided with anti-gas capes as well. These were intended to provide protection against liquid gas delivered as an air spray. Fortunately, gas was not used in combat by any protagonist during the Second World War.

4th February, 1938

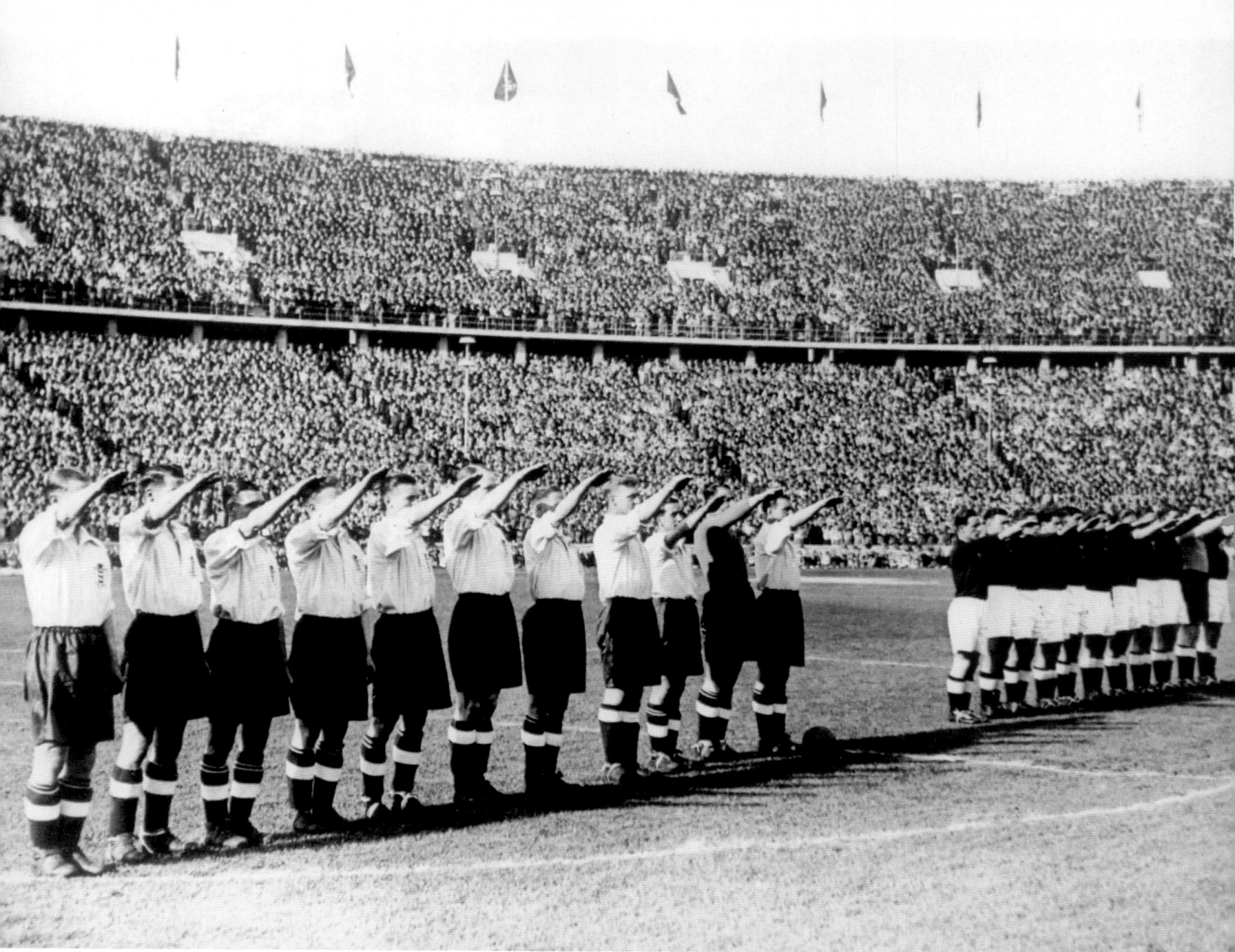

Above: The England team (L)
courteously joins the German team
in giving the Nazi salute before the
kick-off in an international friendly
match at the Olympic Stadium,
Berlin. England went on to win 6-3
in front of 120,000 spectators.

15th May, 1938

Above: Amateur racing driver John Cobb in the cockpit of his Railton-Mobil Special. Cobb was a director of a fur broking company, which allowed him to indulge his passion for speed. He held the outright lap record at the Brooklands track in a 24-litre Napier Railton at 143.44mph (230.84km/h). On 23rd August, 1939, he would drive this car to a record of 367.91mph (592.09km/h) at the Bonneville Salt Flats in Utah, then return in 1947 to raise the record to 394.19mph (634.39km/h). This would remain unbeaten until 1963.

2nd July, 1938

Right: Wearing a hat more suited to the tropics, a city gent receives a quick shoe shine from a bootblack at London's Charing Cross Station.

12th July, 1938

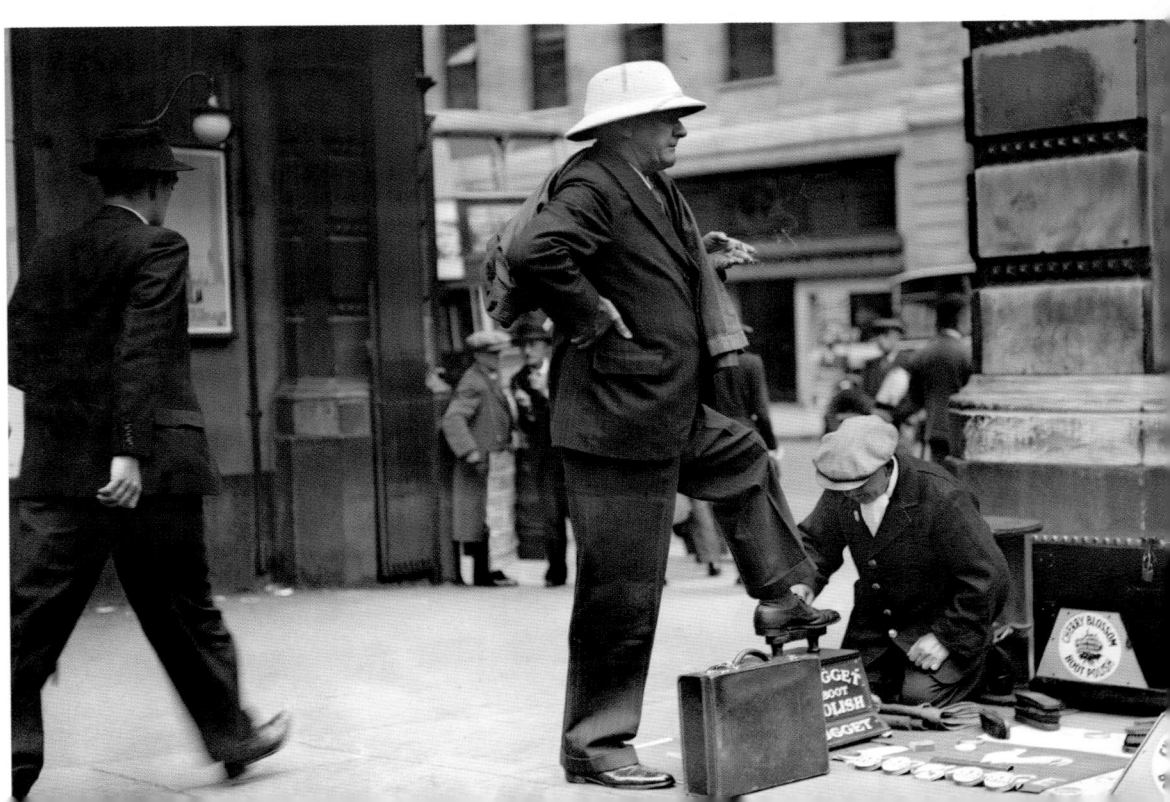

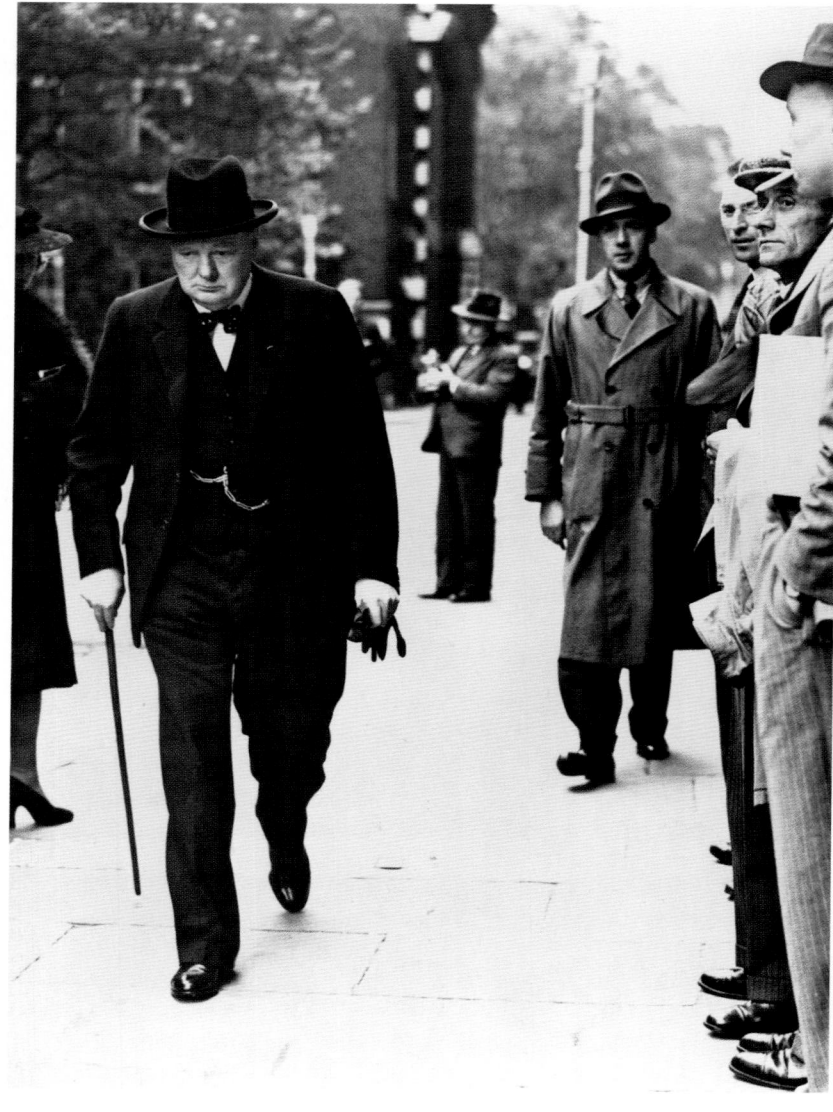

Above: A grim-faced Winston Churchill leaves 10 Downing Street after discussions with Prime Minister Neville Chamberlain over the Czech crisis, brought about by ethnic Germans living in the north and west of the country demanding autonomy for their region (prompted by Adolf Hitler).

10th September, 1938

Right: British Prime Minister Neville Chamberlain returns from talks with German Chancellor Adolf Hitler in Munich. He holds an agreement signed by the Führer, which he believes indicates Germany's desire never to go to war with Britain again. Chamberlain hails the talks as securing *"peace for our time"*, but Hitler would invade Poland on 1st September the following year, sparking the Second World War.

30th September, 1938

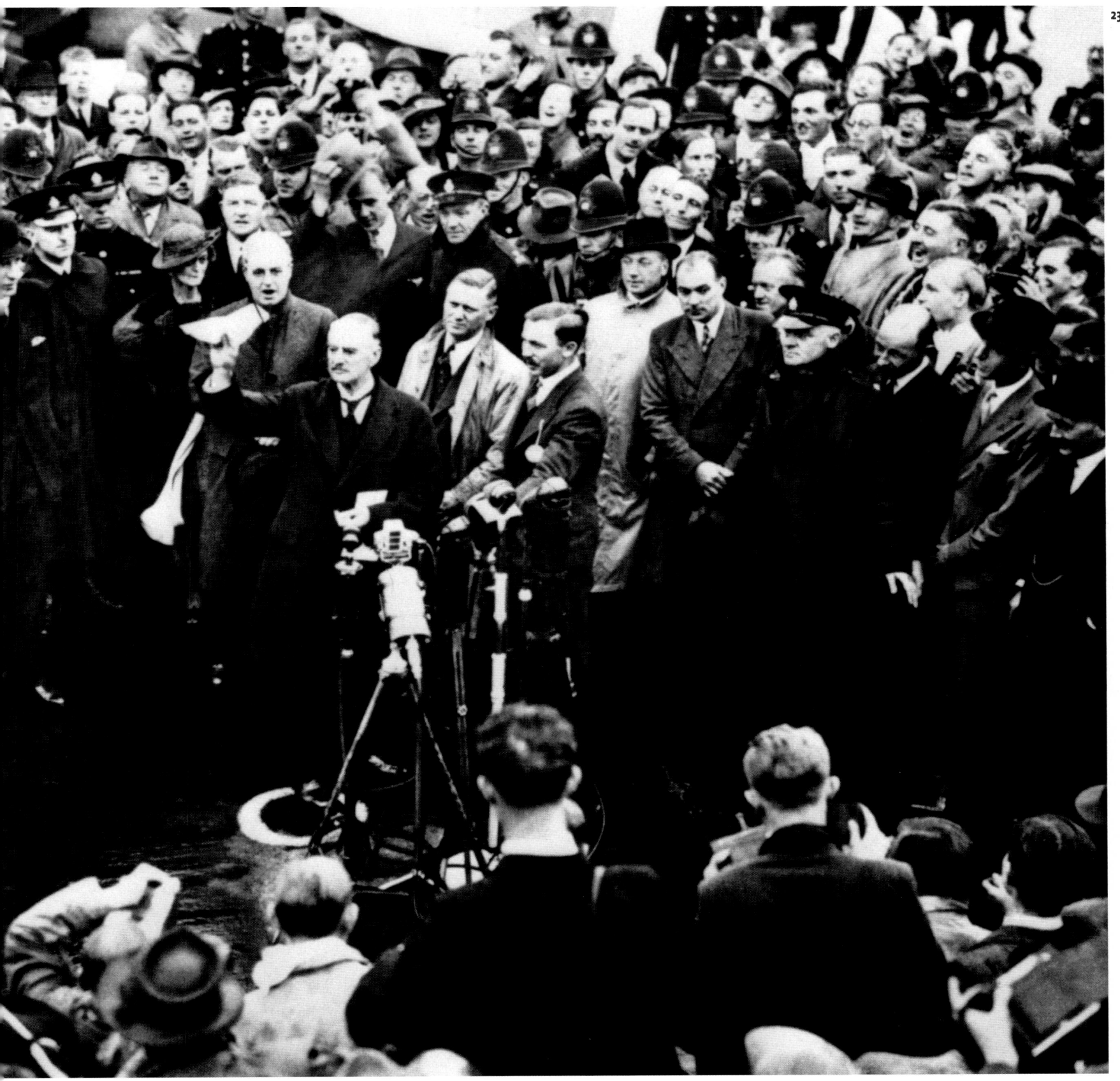

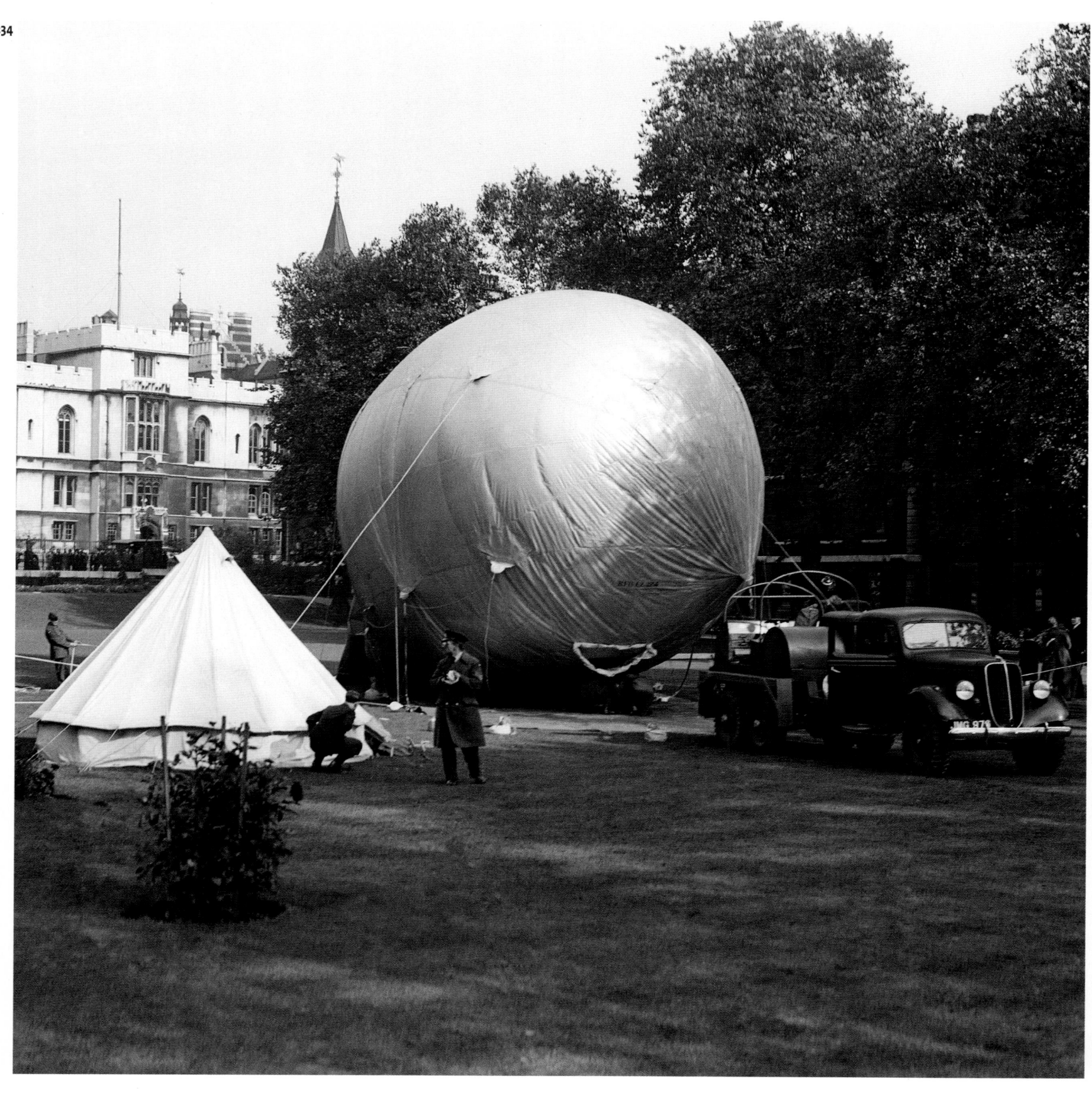

Left: As the prospect of war looms, a barrage balloon is prepared for launch. These balloons were used in large numbers during the Second World War to protect vulnerable targets from enemy air raids. They forced pilots to keep clear for fear of colliding with the mooring cables.

11th October, 1938

Right: When war was declared, it was thought that the country would be subjected immediately to air raids, so to make it difficult for enemy aircrews to identify their targets at night, a blackout was ordered. During the hours of darkness, it became illegal to show a light outdoors or allow light to shine from buildings. Getting about in total darkness was difficult, however, so many obstacles were painted white to make them a little easier to see.

1939

Left: The Royal Air Force's No
19 Squadron, based at Duxford,
Cambridgeshire, flying its new
Supermarine Spitfire fighters.
The squadron was the first to be
equipped with the Spitfire, and
these machines are very early Mk 1
examples, having two-blade fixed-
pitch propellers. Later examples of
the Mk 1 had three-blade variable-
pitch propellers that provided
improved performance.

1st May, 1939

Above: Vickers Wellington
bombers of the Royal Air Force on
exercise. The Wellington was used
extensively as a night bomber
during the early years of the Second
World War until superseded by
heavier four-engine machines
like the famous Lancaster.
Subsequently, many were used for
anti-submarine duties.

1st May, 1939

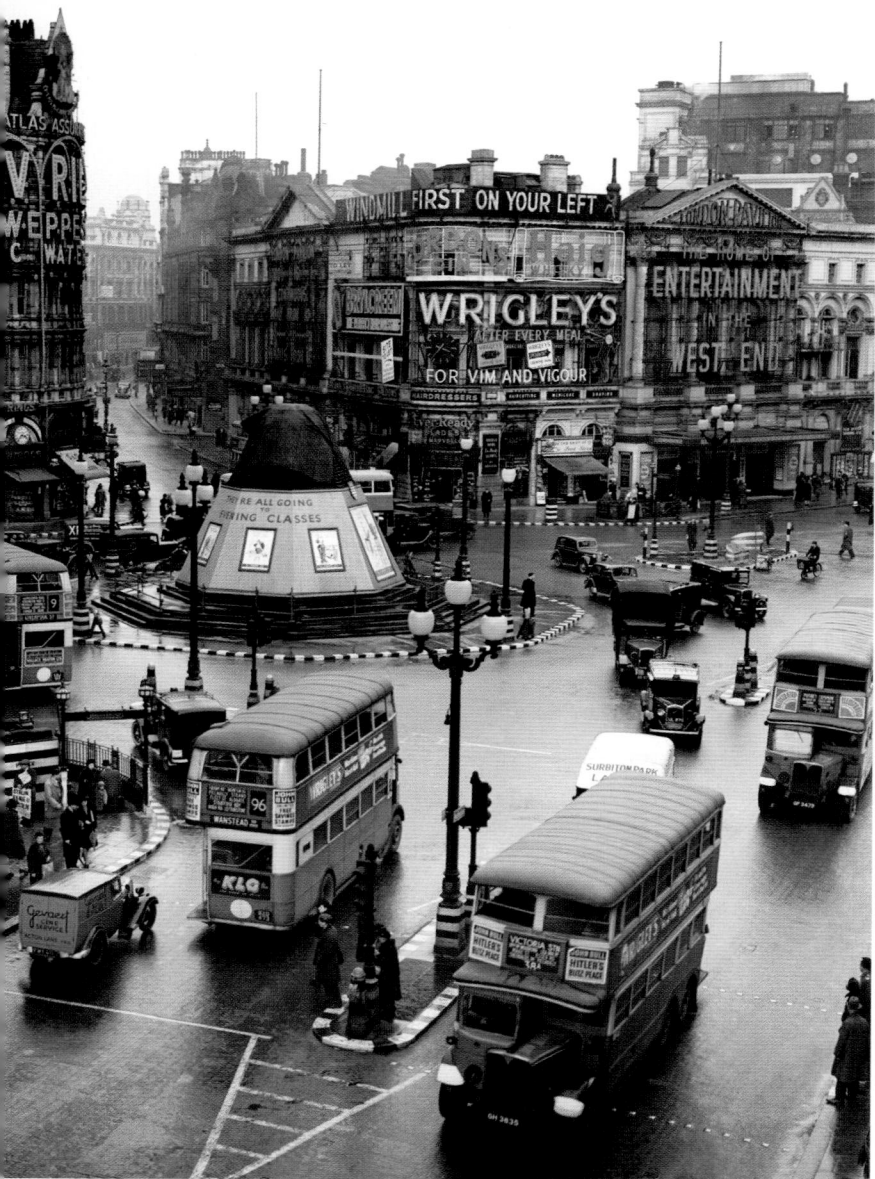

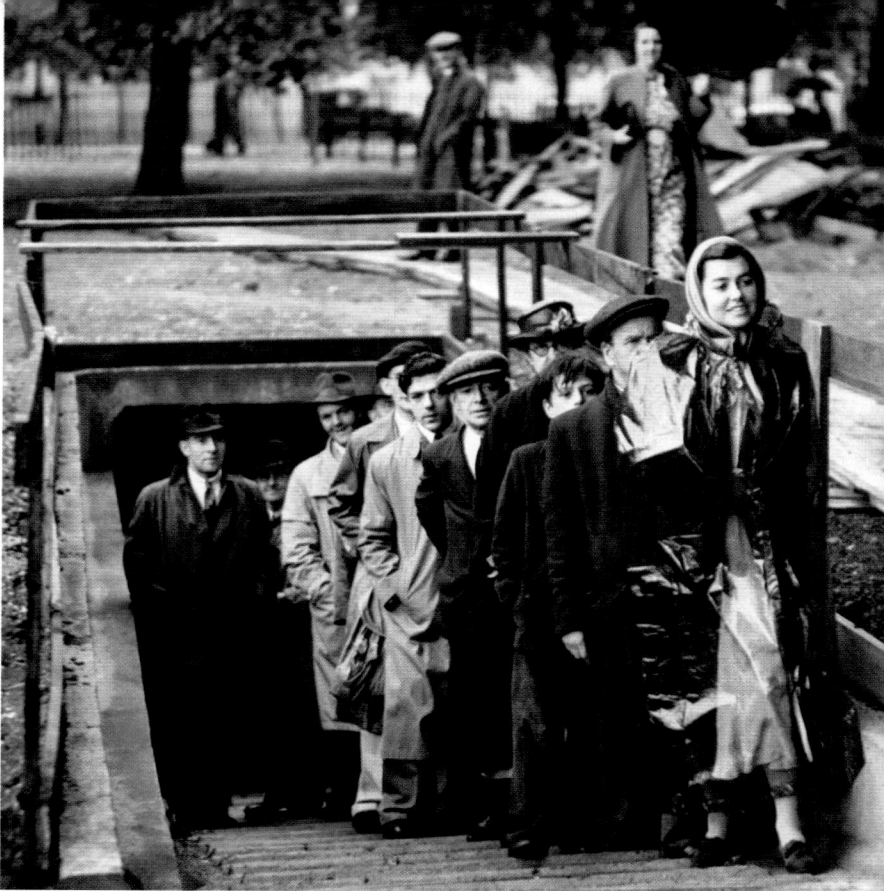

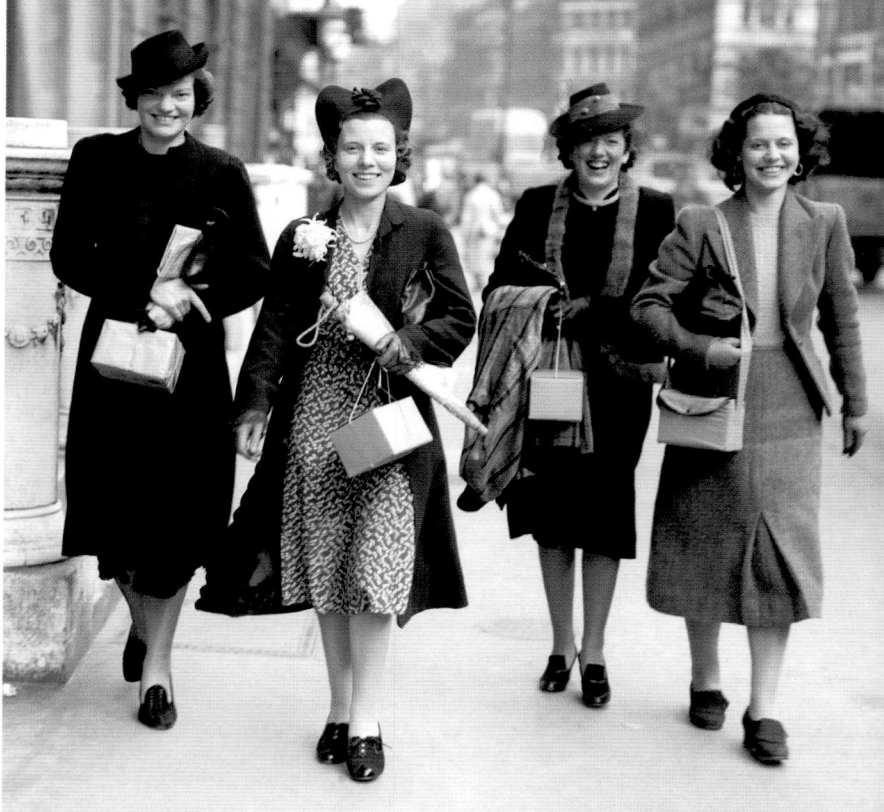

Above: London's Piccadilly Circus just before the start of the Second World War. The famous Shaftesbury Memorial with its winged statue (not actually Eros, but his brother, Anteros) has been given a protective covering prior to being removed for the duration of the conflict.

August, 1939

Above right: Civilians emerge from an air-raid shelter into a London Park. Members of the public used London Underground platforms as overnight shelters during the bombing of the city. In 1940, work began on a number of deep-level shelters below existing tube stations, designed to hold up to 8,000 people each.

August, 1939

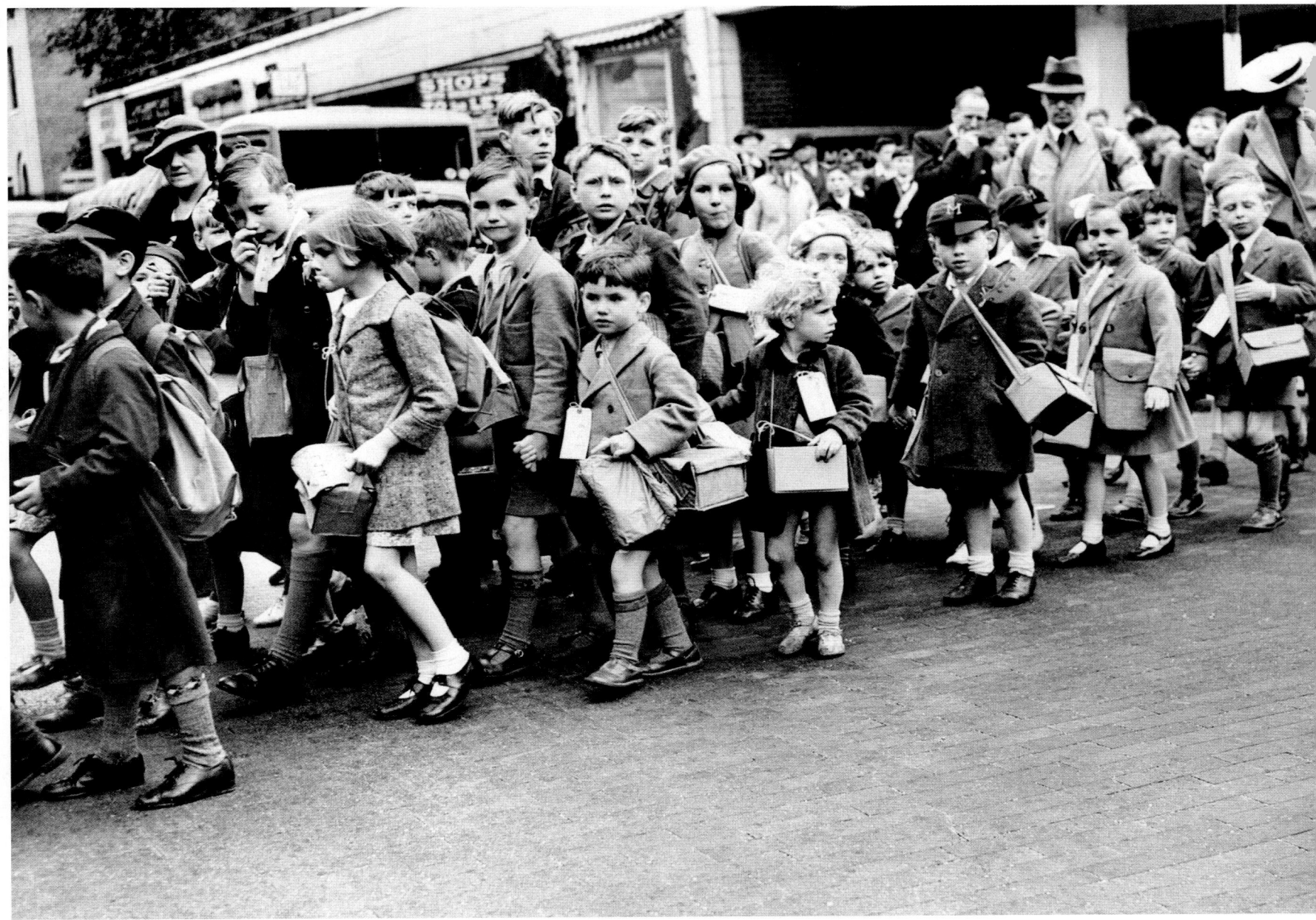

Above: Because of the fear that cities would be bombed, many children were evacuated to the country, where they would be billeted with local people, who were not always welcoming. Many found the entire experience very traumatic.

1st September, 1939

Left: Women on their way to work with their gas masks in cardboard containers. London began preparing for war in early 1939, air-raid, gas-mask and evacuation drills becoming parts of everyday life. Civilians were required to carry their gas masks with them at all times in case of a German gas attack.

August, 1939

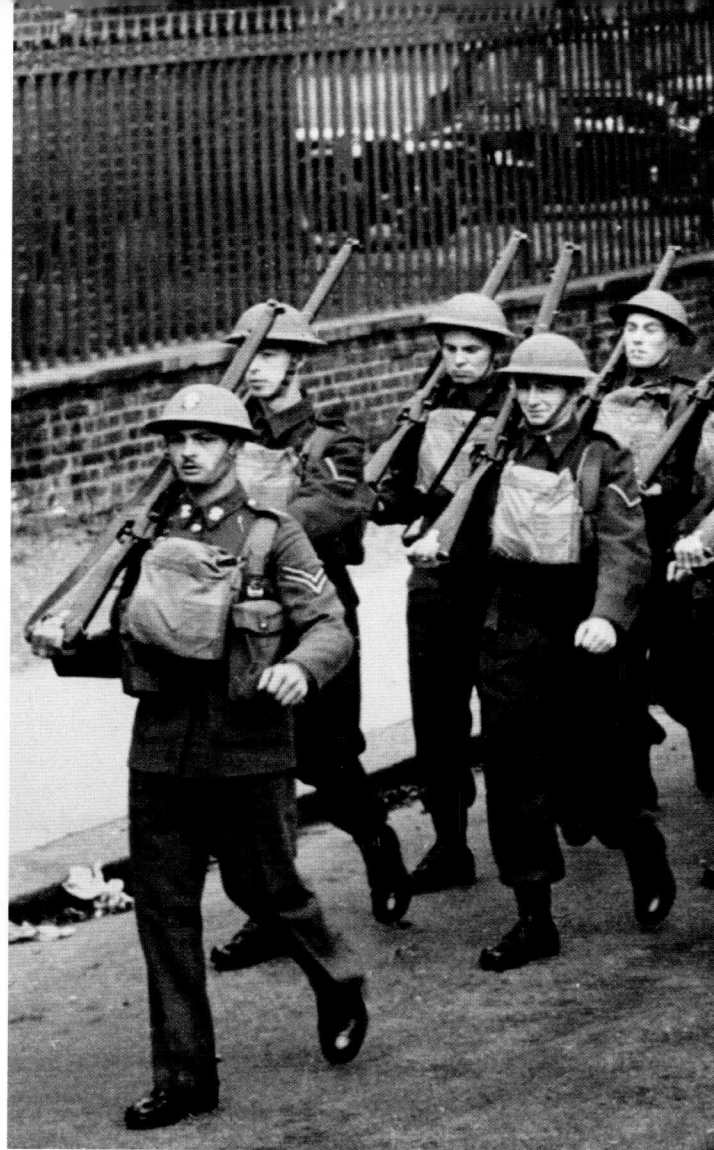

Above: Troops of the British Expeditionary Force march through London on their way to France.

15th September, 1939

Left: Soldiers demonstrate a Vickers machine gun and a range finder to onlookers in London's Trafalgar Square as part of a recruitment drive at the start of the Second World War. The huge poster at the foot of Nelson's Column leaves civilians in little doubt as to what their country expects of them.

5th September, 1939

Right: A milk bar sandbagged as a makeshift air-raid shelter. The only true safety from the bombing, however, was underground – the deeper, the better.

September, 1939

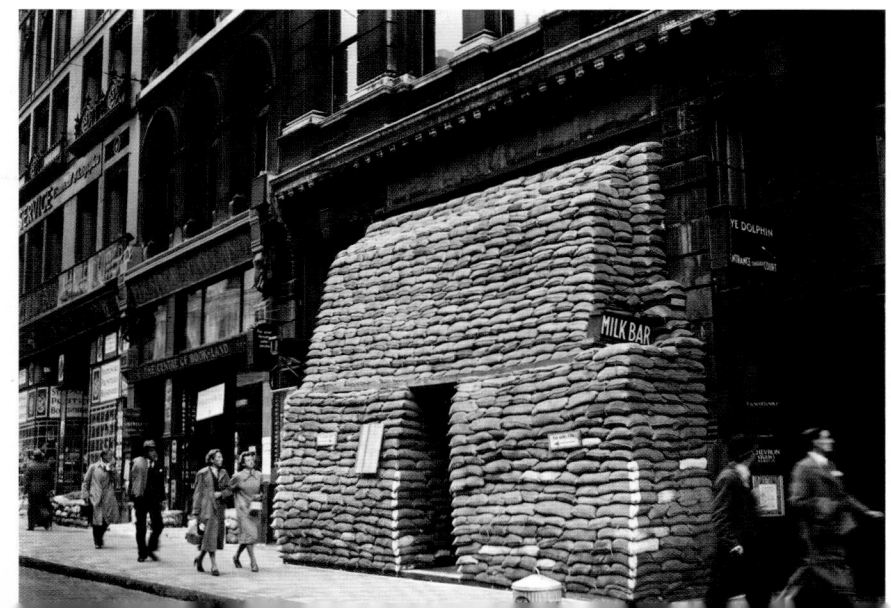

Above: A woman undergoing training at the Paddington Technical Institute in London. With large numbers of men on active service, women engineers were vital to industry.

4th October, 1939

Right: British troops enjoy an Entertainments National Service Association (ENSA) show. The likes of 'forces sweetheart' Vera Lynn, entertainer George Formby, and serving comics Harry Secombe and Spike Milligan played a vital morale-boosting role during the Second World War.

8th October, 1939

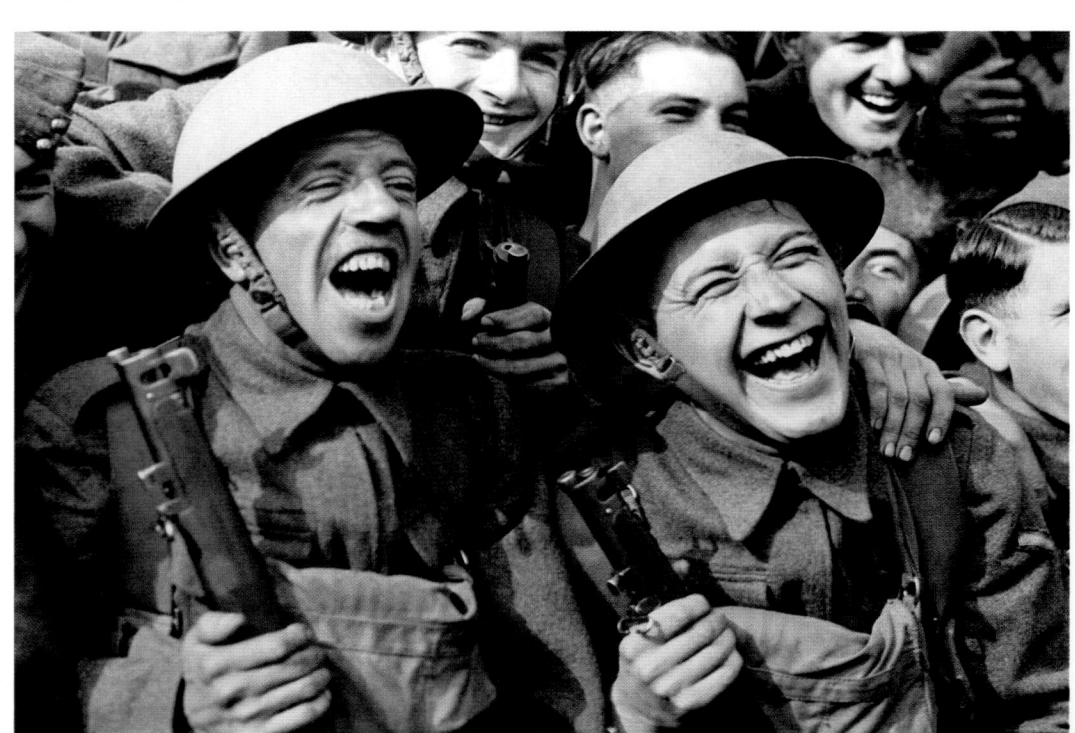

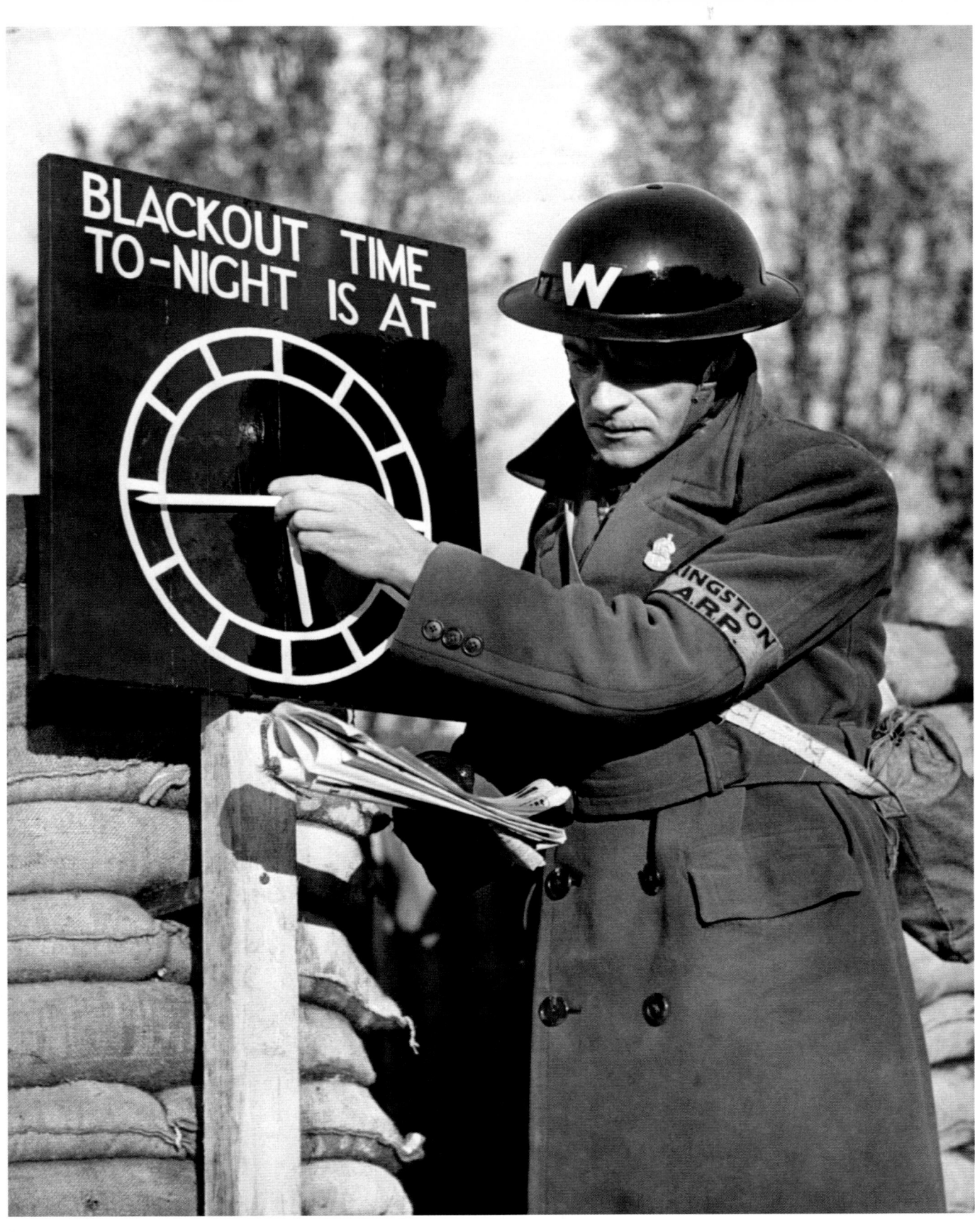

Left: An air-raid warden sets the blackout time indicator at an Air Raid Precautions (ARP) site near London. Keeping lighting to a minimum at night made it more difficult for German bombers to navigate over the country. Civilians employed close-fitting blackout blinds on windows and other measures to lessen the aerial threat. Even so, cries of "*Put that light out!*" became common from irate wardens.

1st November, 1939

Right: It's important to unwind, even in times of war. The various forms of athletic swing dance, such as the Lindy Hop, all of which were often simply referred to as the jitterbug, were popular during the 1930s and 1940s.

16th December, 1939

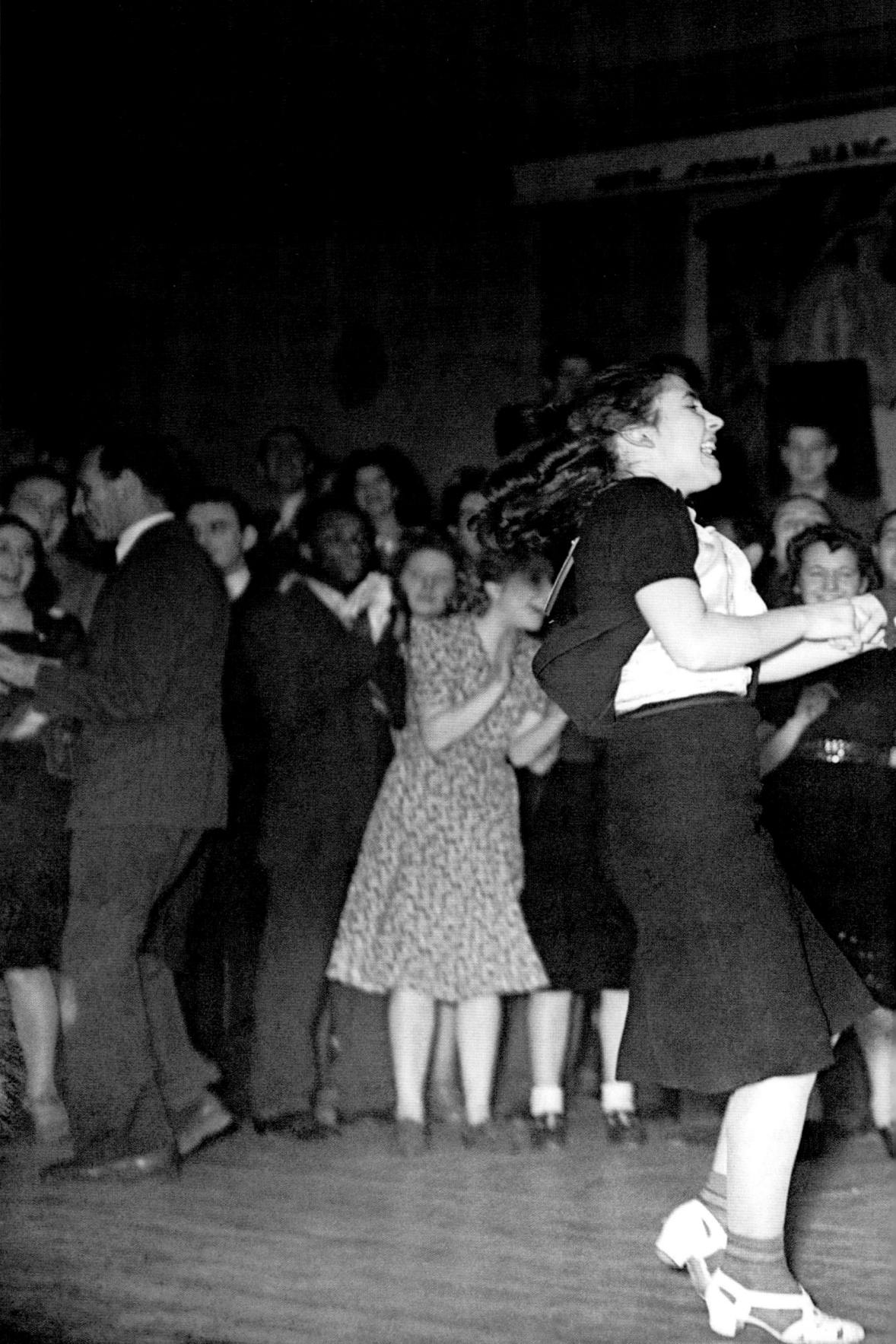

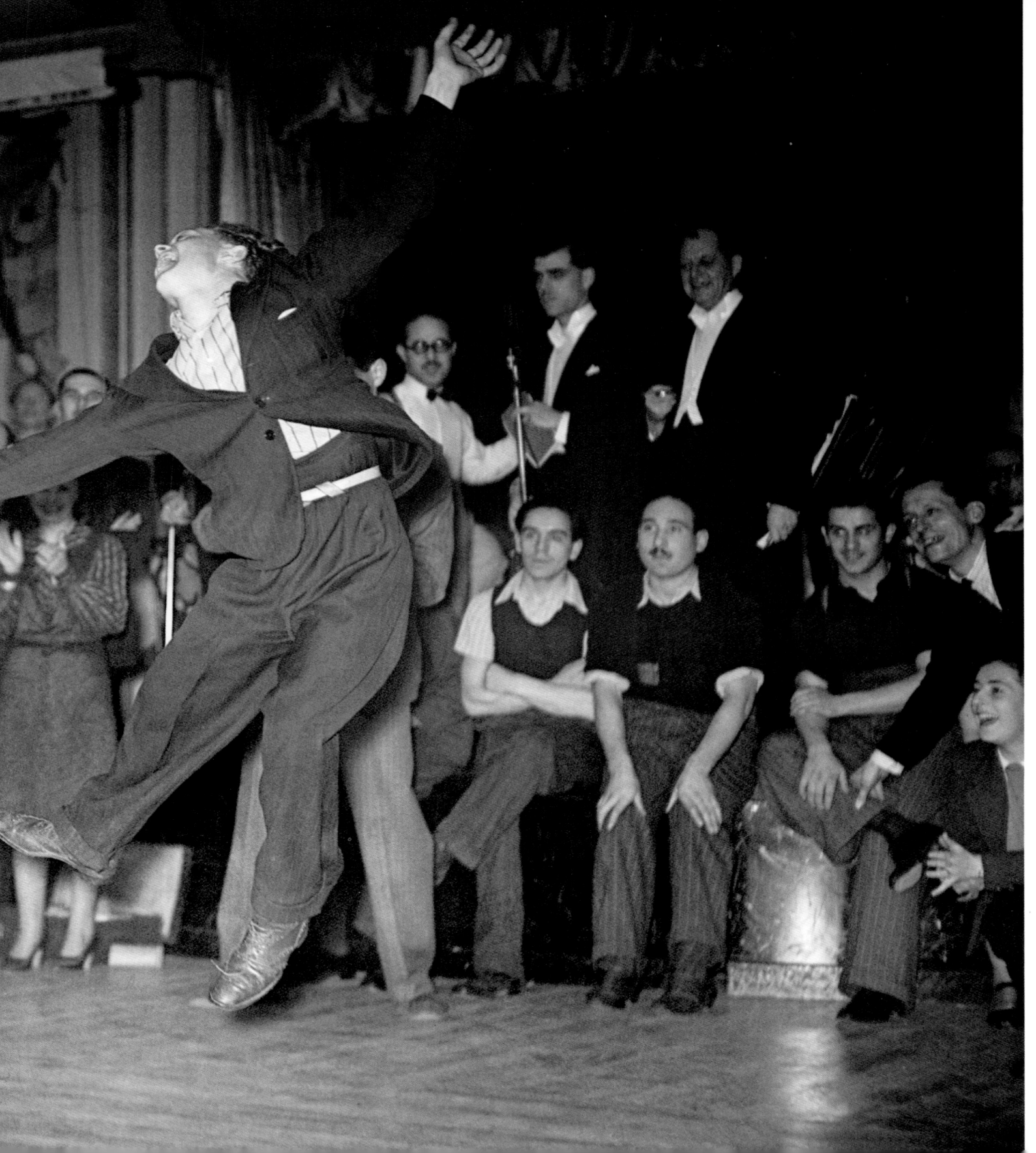

1940s

In the 1940s, Britain was taken to the brink of disaster before beginning a shaky journey to recovery. Unlike the First World War, the second global conflict was fought in British cities, towns and villages as well as on battlefields around the world – in the sky too, as the pivotal stage of the war known as the Battle of Britain raged in the summer of 1940, and the air war brought the front line to the population's doorstep. In no other British war have ordinary people participated so actively: they saw their homes destroyed, their children evacuated, their lives overturned.

While the second half of the decade is often characterized as an aftermath of that conflict, we see in the pictures of the time a sense of looking forward, not back. The marriage of the young Princess Elizabeth and the birth of her first child, Charles, meant that by the end of 1949, Britain had a new Royal Family in waiting. More ordinary women were also stepping forward: having moved into traditional male roles through wartime necessity, it seemed unlikely that they would settle back meekly into domesticity.

Something else had changed. A flickering bluish light in the corners of some parlours heralded a new age for news, entertainment and society. Its repercussions for everyone, regardless of standing, would be profound.

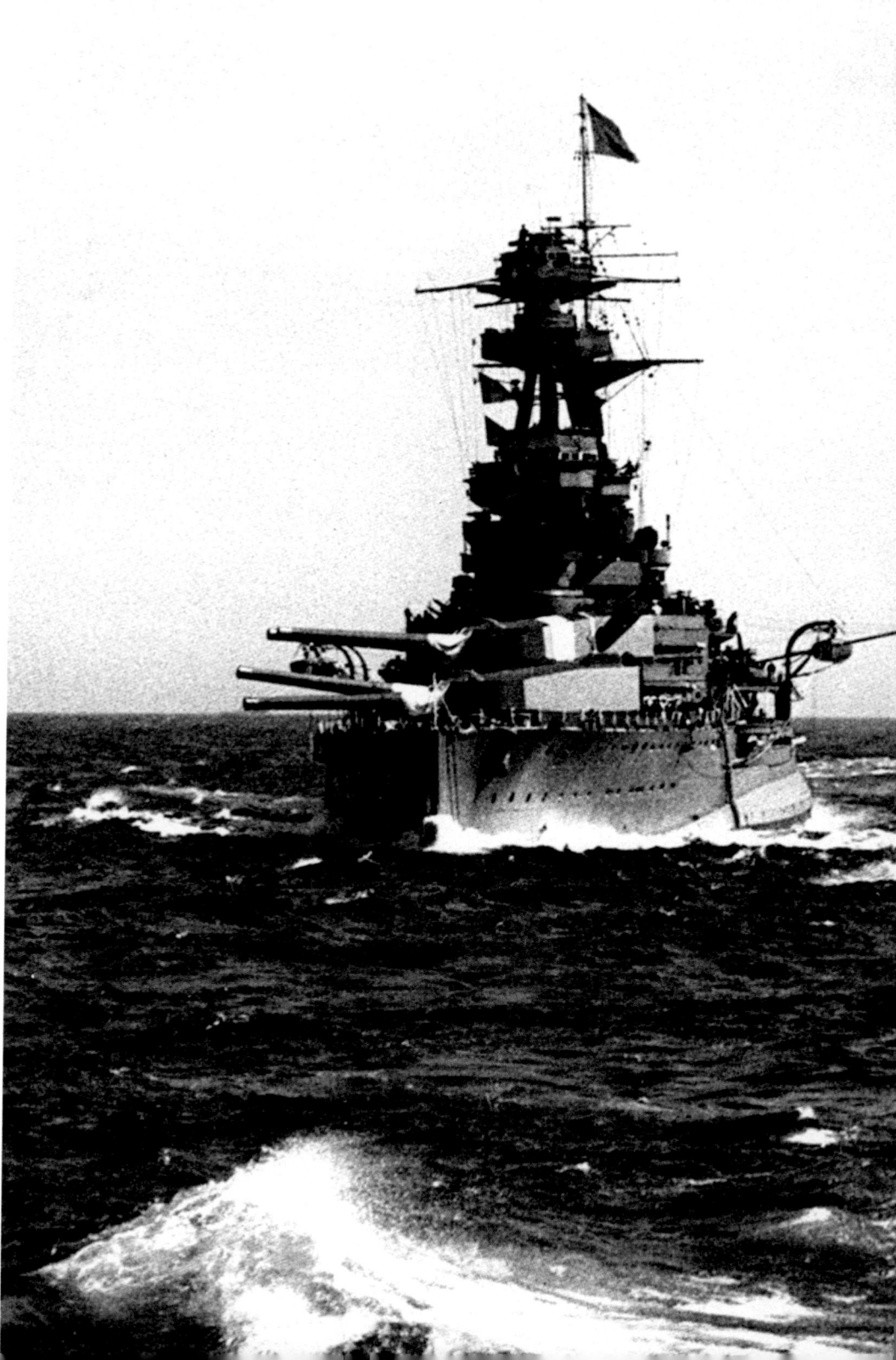

Right: A Royal Navy warship displays its considerable firepower. A battleship such as HMS *Valiant* had as many as eight 15in guns and 20 4.5in weapons. In 1940, the Royal Navy had 15 battleships and battlecruisers on its strength, as well as 7 aircraft carriers, 66 cruisers, 184 destroyers, 60 submarines and many other small surface craft.

1940

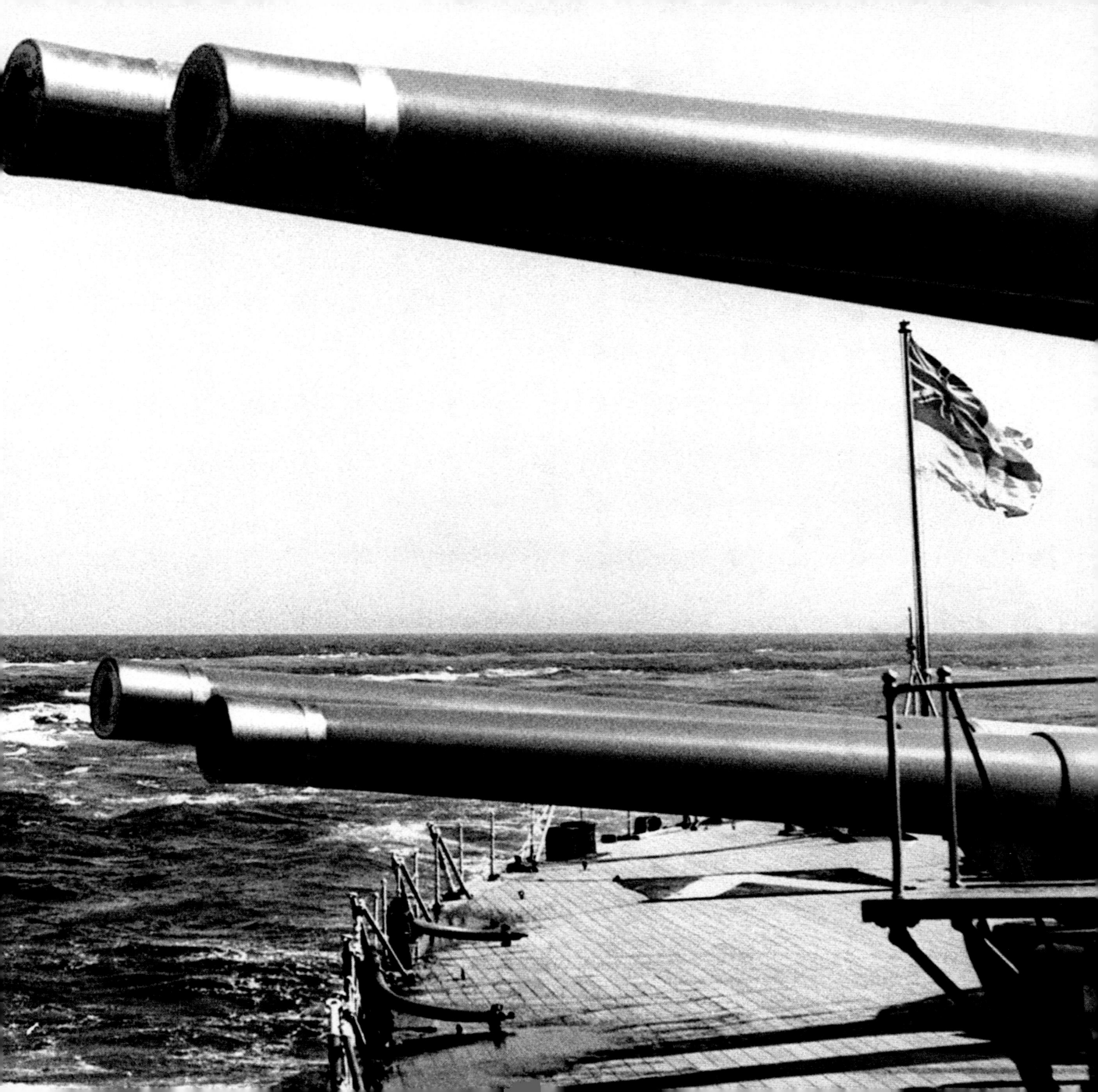

250

Right: A cow is painted with white stripes for camouflage purposes, or possibly so that it can be seen in the blackout. The exact reason may never be known.

24th February, 1940

Below: New recruits to a Local Defence Volunteers (LDV) detachment in London learn the basics of military drill on a factory roof. Only the man in the foreground carries a genuine weapon, albeit an antiquated rifle. The LDV was soon renamed as the Home Guard.

1st May, 1940

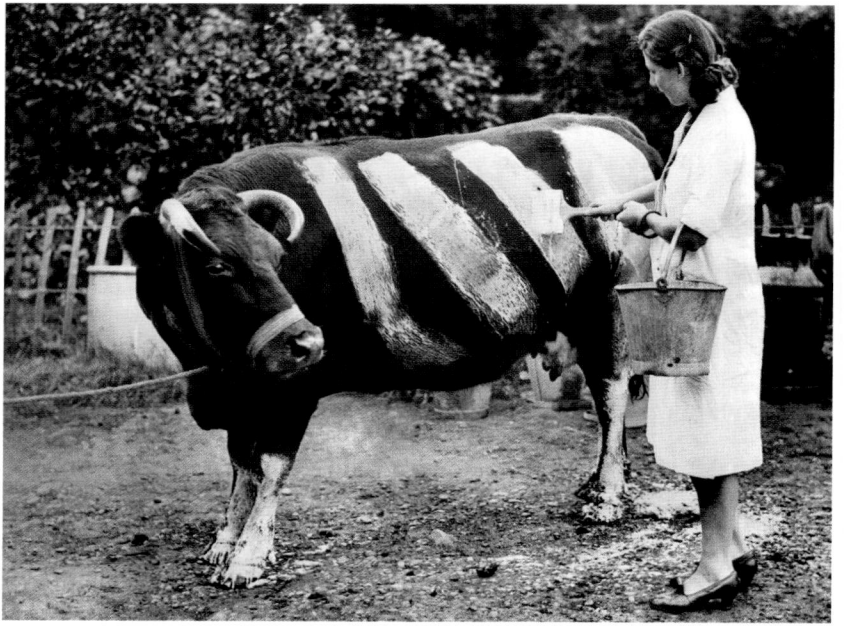

Right: RAF pilots of 609 Squadron, based in France with the British Expeditionary Force, relax with their pets beside a Spitfire.

31st May, 1940

Below right: Two RAF Hawker Hurricanes of 501 Squadron take off from Kenley Aerodrome in Surrey during the Battle of Britain. At the height of the battle, the pilots of Fighter Command could be 'scrambled' several times a day to meet incoming German raids. The aerial conflict raged throughout the summer of 1940, but eventually the RAF broke the German assault. Of their effort, Winston Churchill said, "*Never in the field of human conflict was so much owed by so many to so few.*"

20th July, 1940

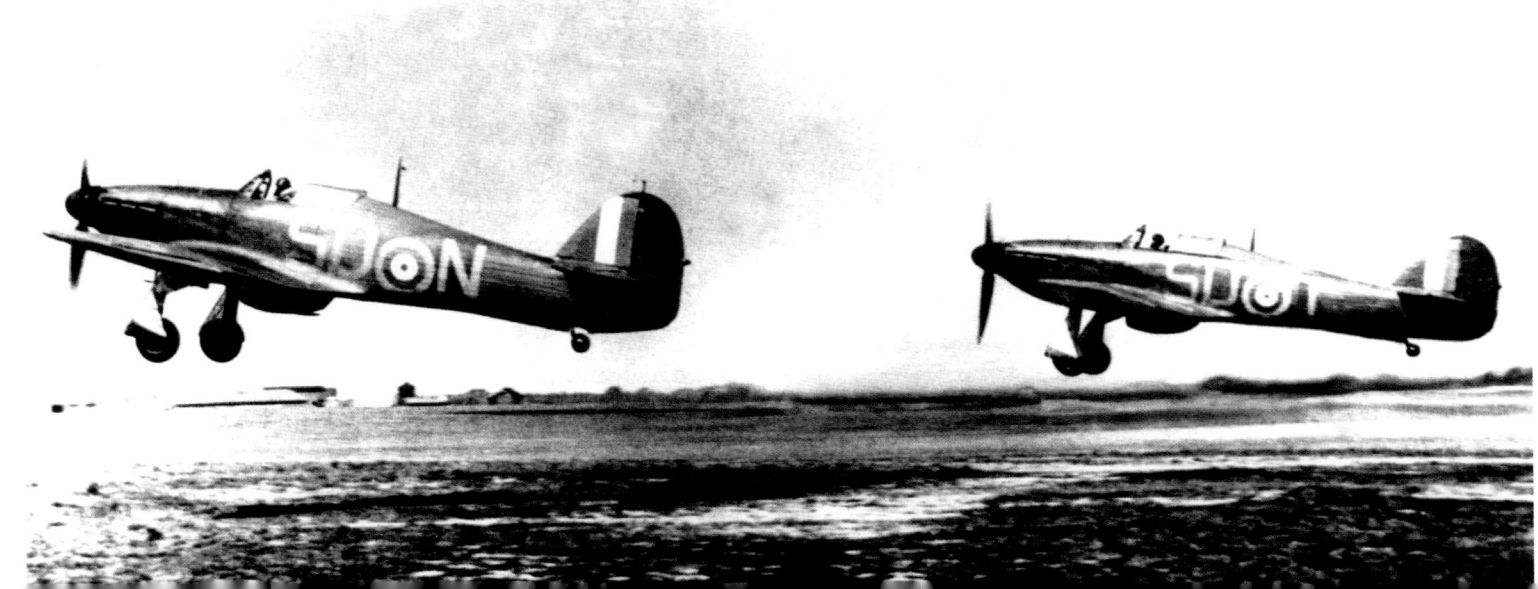

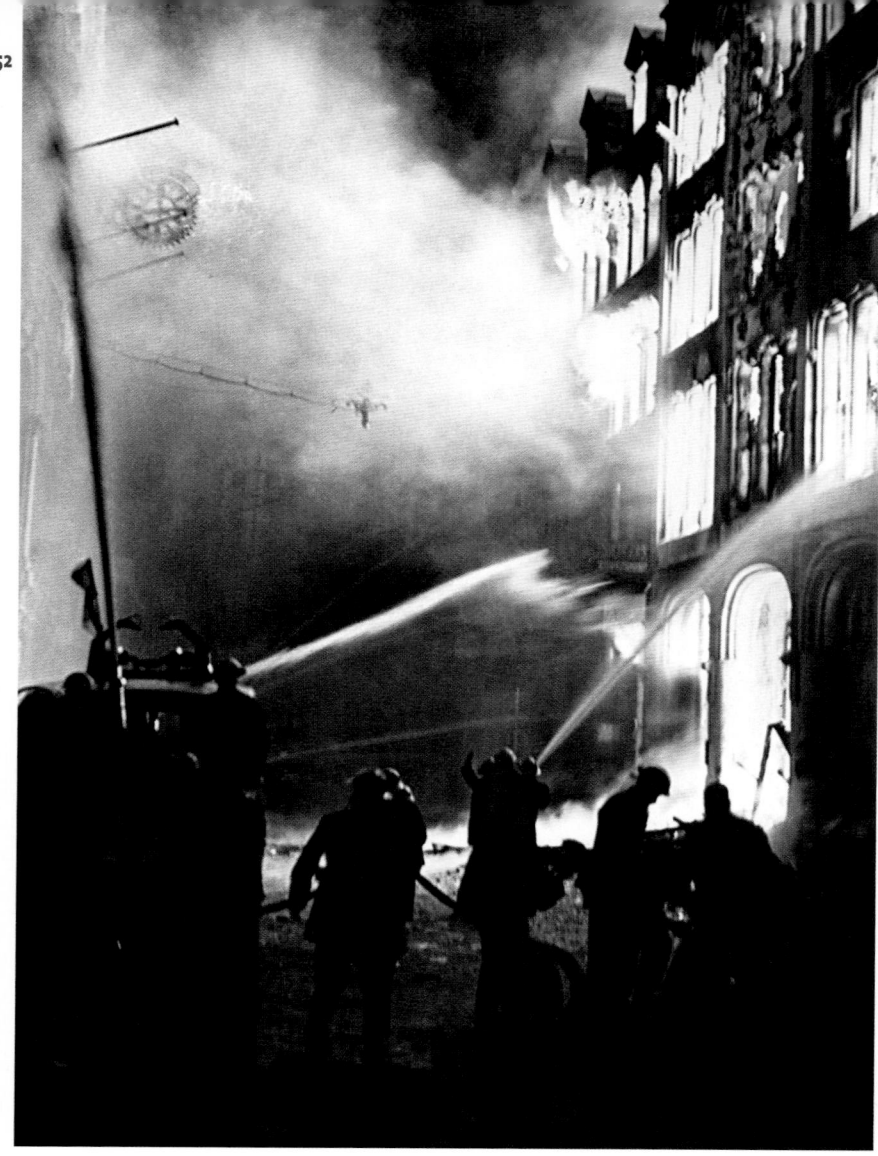

Above: On 24th August, 1940 central London was bombed for the first time. Incendiaries were dropped by the German Air Force, causing major fires in the City. Here, firemen attempt to tackle the blaze.

24th August, 1940

Right: After failing in their efforts to destroy the RAF's airfields, the Germans increased their bombing attacks on British cities, particularly London. This huge bomb crater in Balham, south London has almost swallowed a bus.

14th October, 1940

Left: For sixpence, the public is given a chance to inspect a German Air Force Messerschmitt Bf110 twin-engine machine belonging to a precision fighter-bomber unit. It had been brought down by anti-aircraft fire during an attack on RAF Hawkinge, near Folkestone in Kent. The aircraft was eventually shipped to the Vultee Aircraft Corporation in the USA for evaluation.

17th October, 1940

Right: Two Londoners peer from their Anderson shelter at the devastation around them. Named after Sir John Anderson, who was given special responsibility for air-raid precautions prior to the Second World War, these corrugated-iron buildings were provided free to householders whose incomes were below £250 per year. Those whose earnings were higher had to pay a price of £7. Many were converted to garden sheds after the war.

25th October, 1940

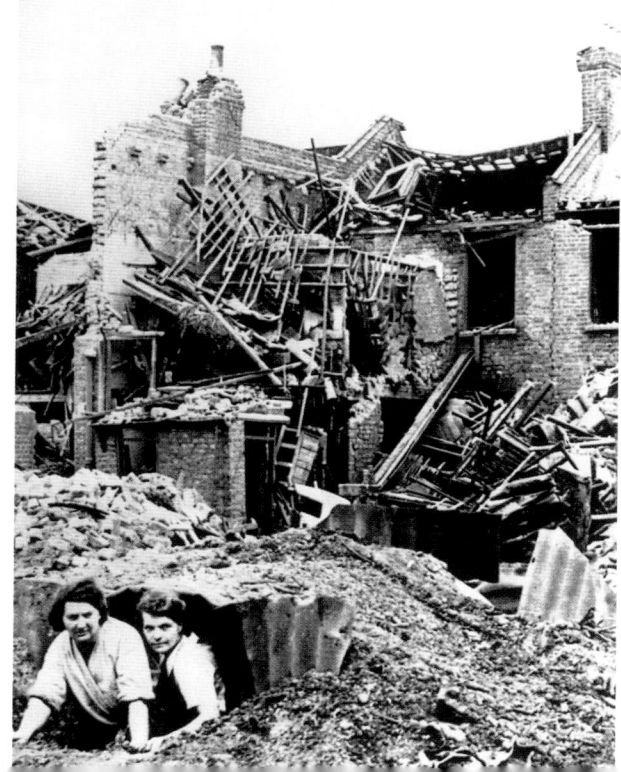

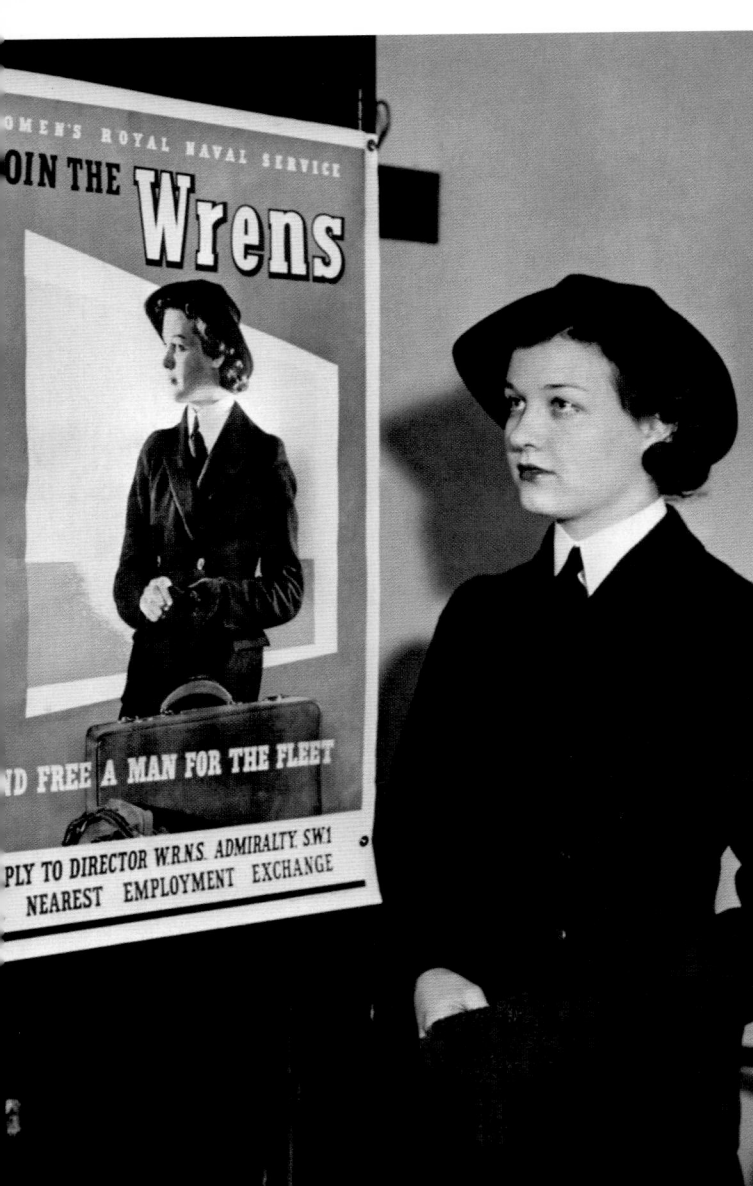

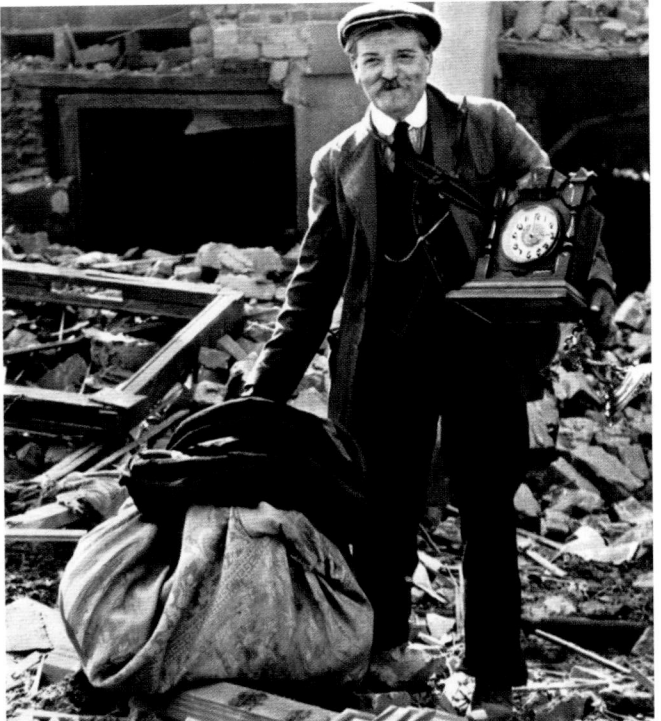

Left: Keep smiling through. Undaunted, a Londoner retrieves valuables from the remains of his home after a German bombing raid. Millions of incendiaries and an estimated 40,000 high-explosive bombs were dropped on the capital during the Blitz, which lasted from 7th September, 1940 to 10th May, 1941, damaging or destroying over a million properties.

1941

Above: Members of the Women's Royal Naval Service were known as 'Wrens'. In addition to taking on civilian work, women played vital roles in all three services, freeing men for front-line duty.

January, 1941

Right: Children practise wearing their gas masks at a school in Clerkenwell, north London. There was a mass evacuation of children from the cities in September 1939, following the declaration of war, because of the fear of imminent bombing raids, but the raids did not materialize for some considerable time. As a result, many children returned home – by January 1940, nearly 60 per cent were back with their families.

1941

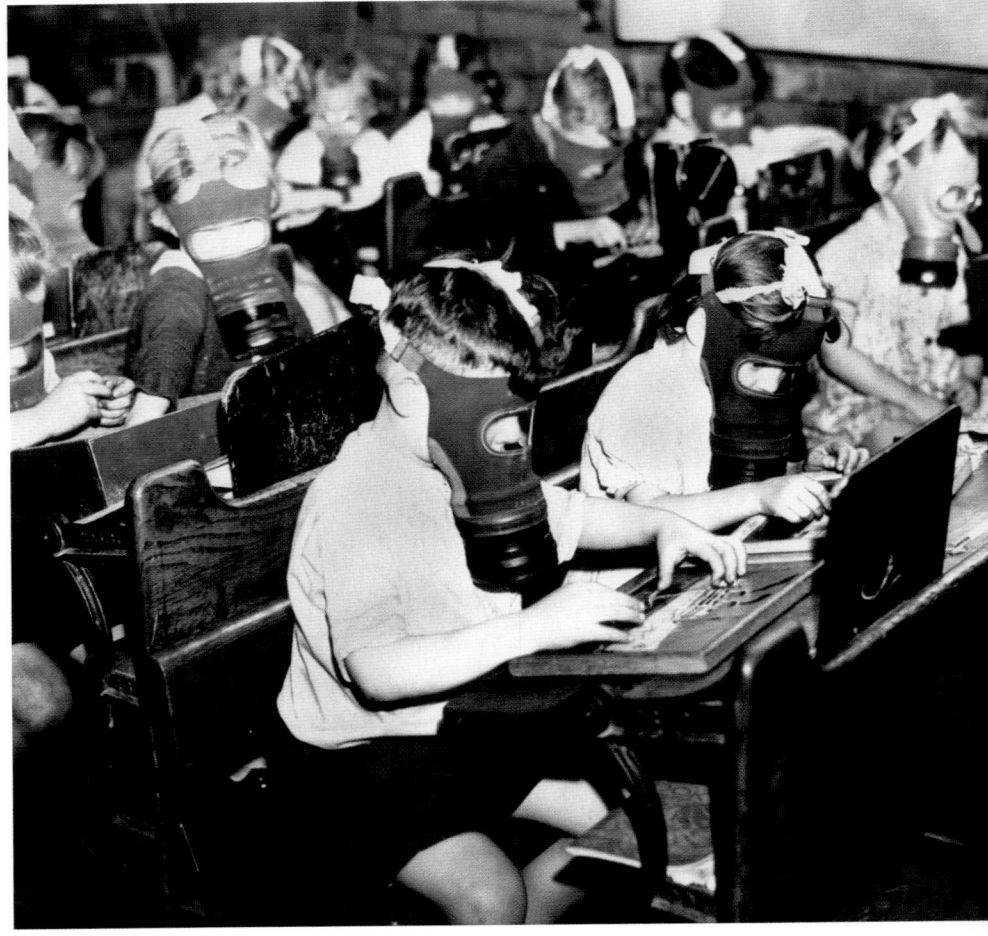

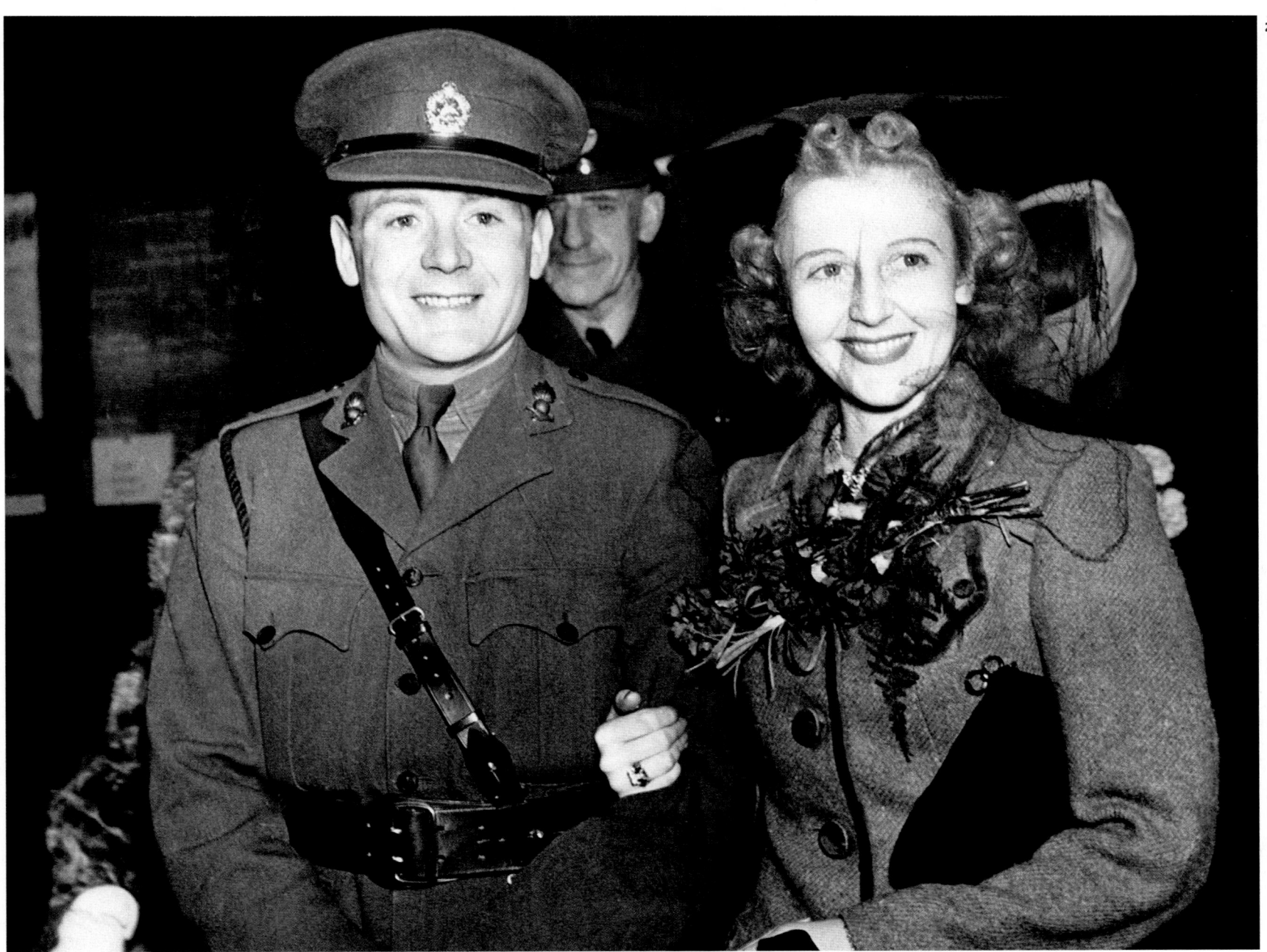

Above: Film star John Mills, then a second lieutenant, marries fellow actor Hayley
Bell in Marylebone, London. In 1942, Mills was given a medical discharge following
a stomach ulcer. He went on to star in several famous war movies, including *We
Dive at Dawn*, *This Happy Breed* and *Ice Cold in Alex*.

16th January, 1941

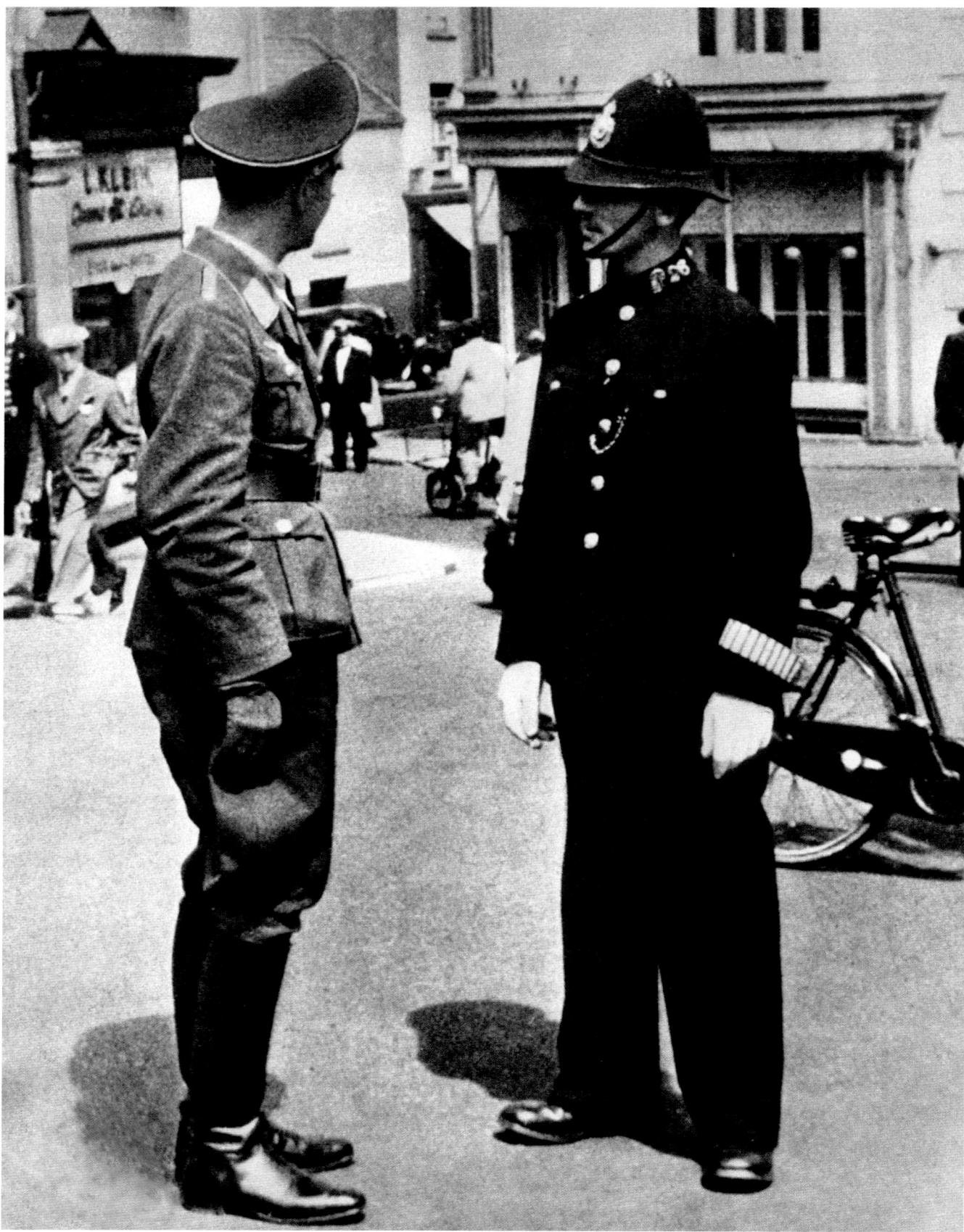

Right: Enemy occupation. A British police officer looks ill at ease as he is engaged in conversation by a member of the German Air Force in St Helier, Jersey. The Channel Islands were invaded by the Germans in June 1940 and remained under their control until 9th May, 1945. They were the only part of the British Isles to be occupied by Germany during the Second World War.

1st July, 1941

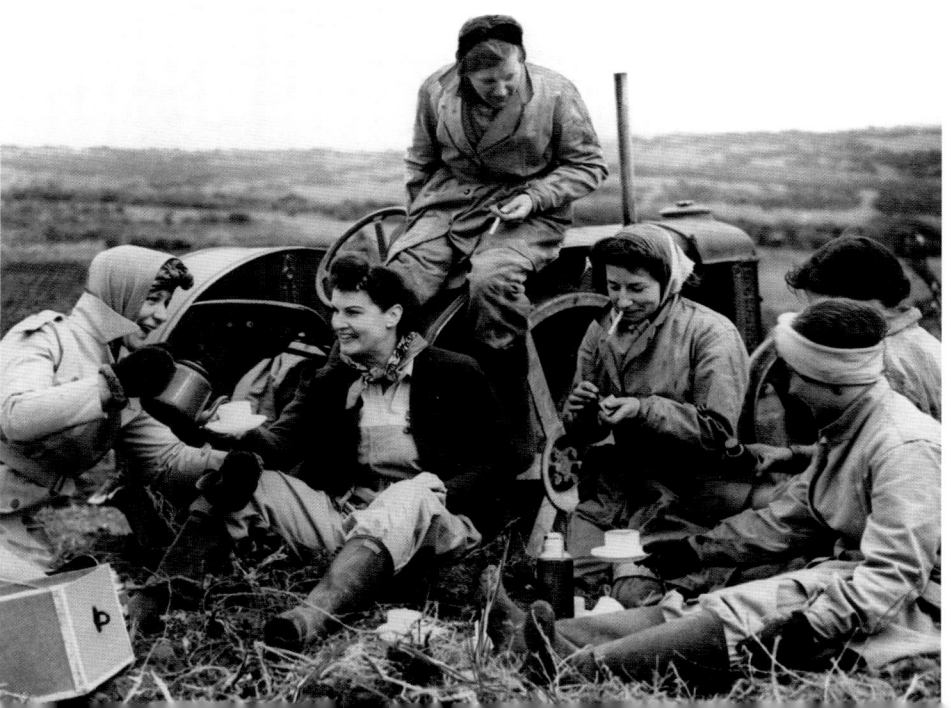

Above: Boys from a youth
club in Battersea, London help
with the harvest on a farm in
Buckinghamshire during the
Second World War.

1st September, 1941

Right: Land Girls relax with a cup
of tea and a cigarette at a farm in
Essex. With so many men away
in the services, and with huge
pressure on domestic farming
resources, at one point there were
80,000 members of the Women's
Land Army and 6,000 in the
Women's Timber Corps, also known
as the 'Lumberjills'.

1941

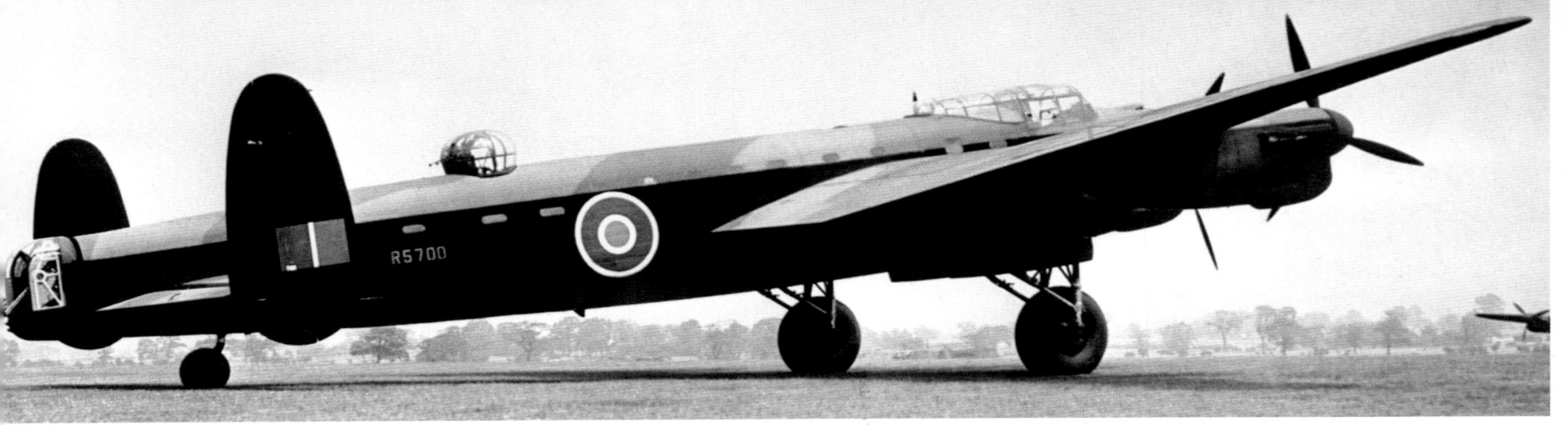

Above: An Avro Lancaster 1 of the
Royal Air Force's No 9 Squadron at
RAF Waddington, Lincolnshire in
early 1942. This particular machine,
serial number R5700, was reported
missing over Hanover, Germany on
23rd September, 1943. It had been
shot down and had crashed at Bad
Munderam-Deister, south-west of
the city. None of the crew survived.
They were buried in the local war
cemetery. The Lancaster was the
most successful of the RAF's four-
engine heavy bombers.

1942

Right: Women workers helping
to build Britain's first four-engine
bomber, the Short Stirling, which
played a major role in the Allies'
strategic bombing campaigns
between 1941 and 1943. It was
superseded by the Handley Page
Halifax and Avro Lancaster, being
switched to transport duties.

1942

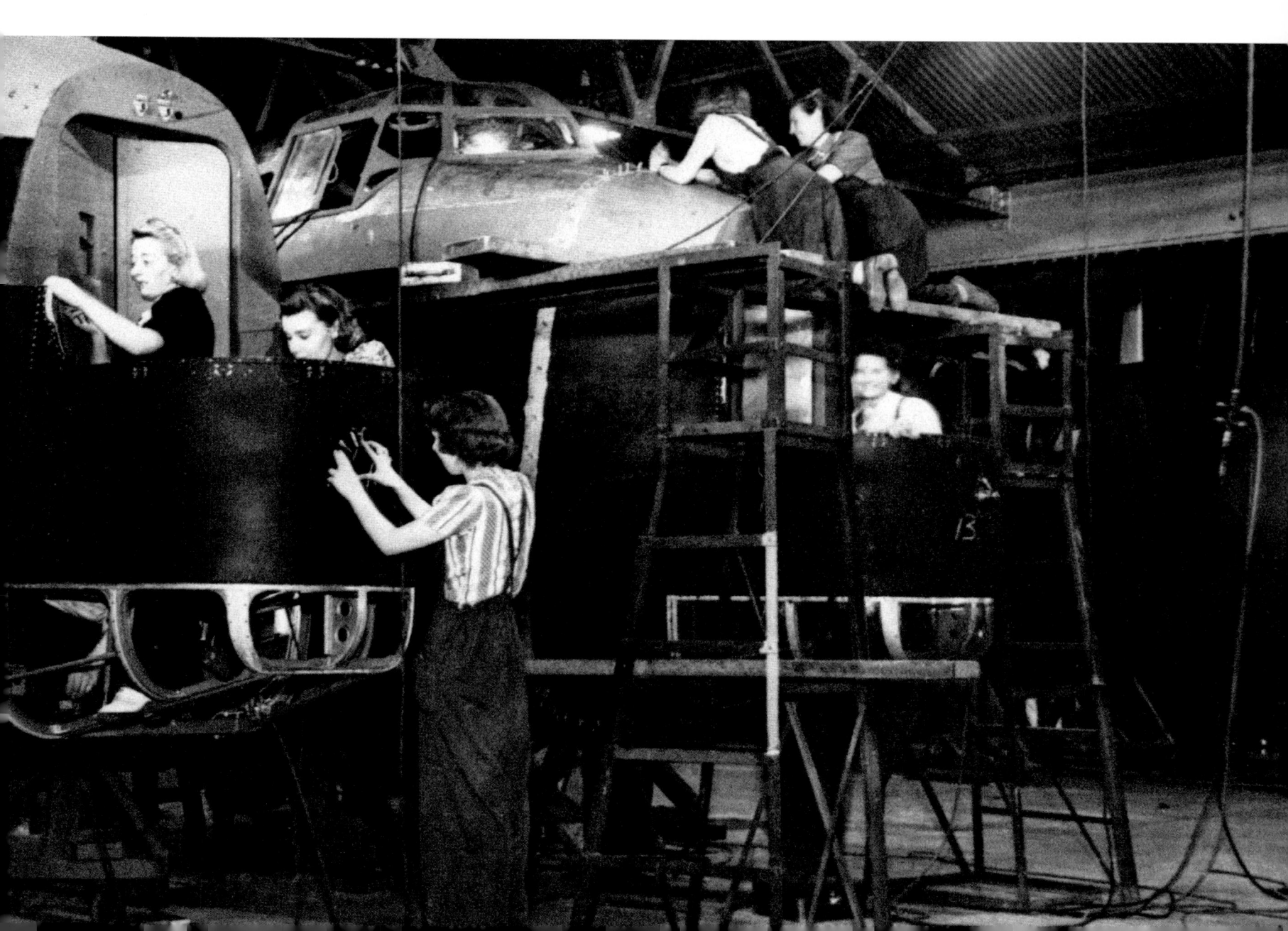

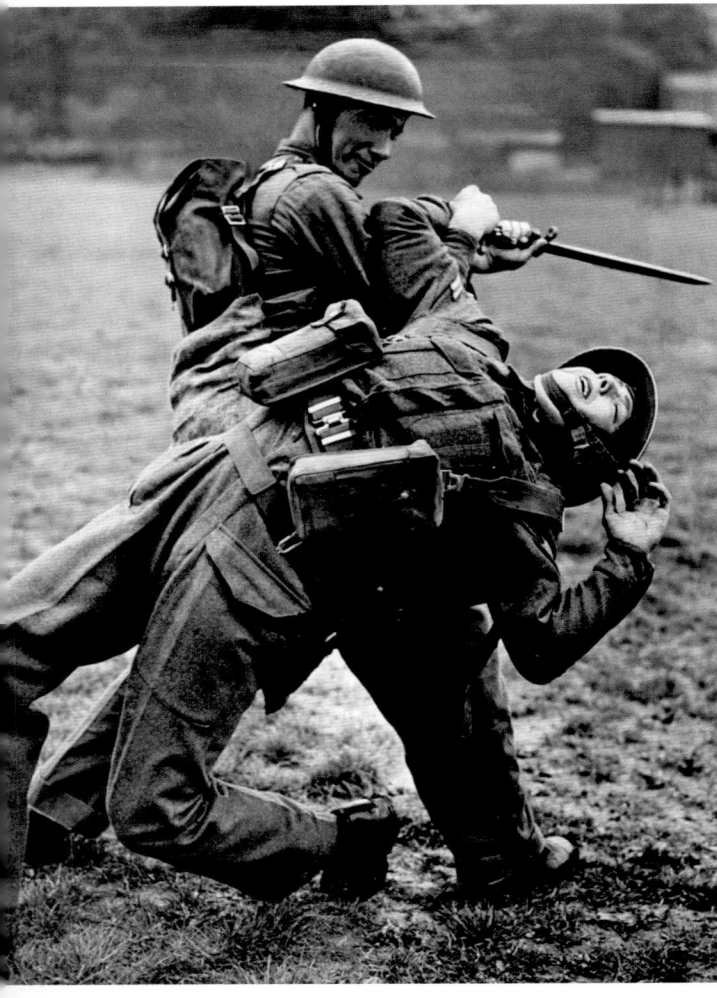

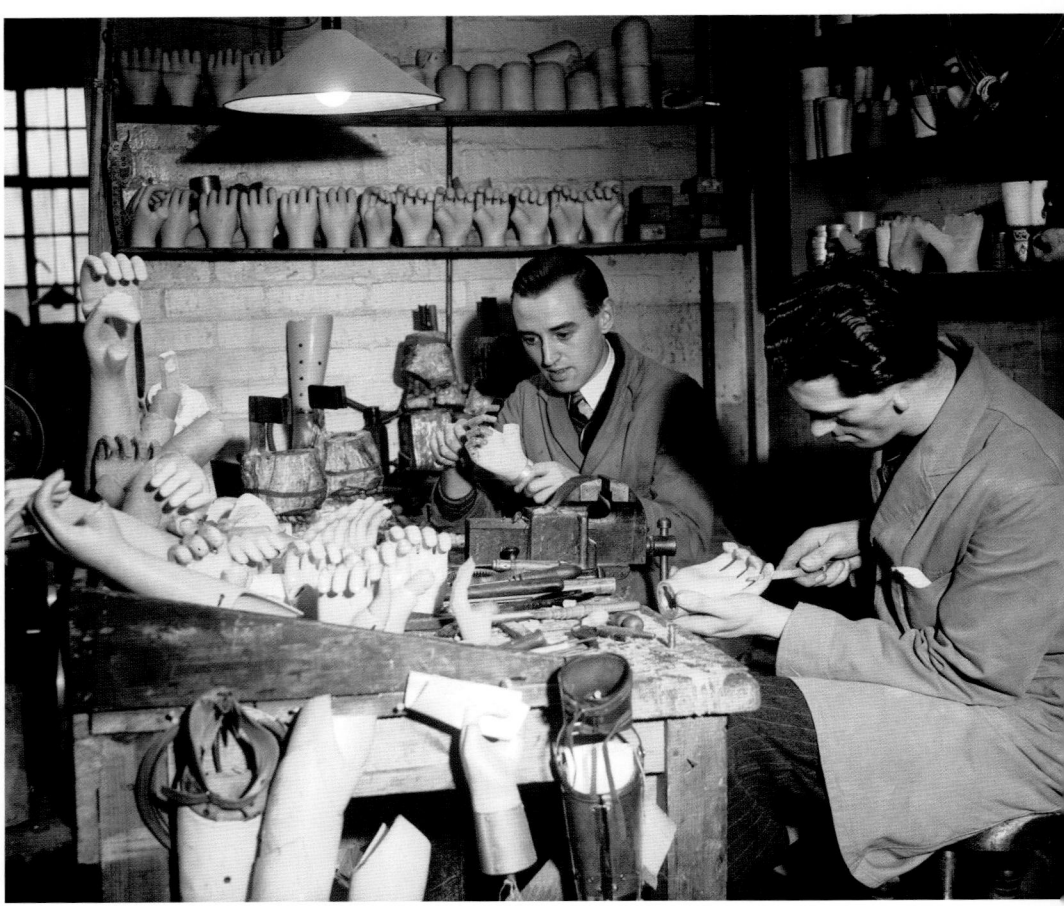

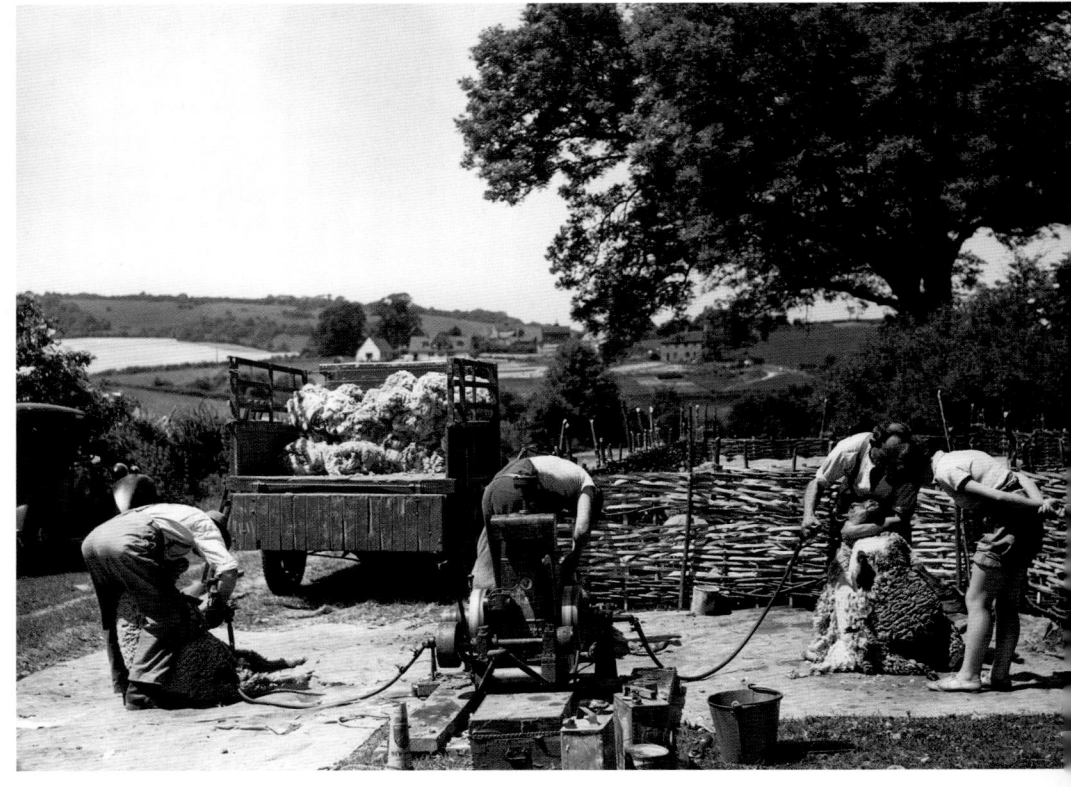

Above: Battle school. Two British soldiers give it their all during a lesson in hand-to-hand combat. One soldier attempts to disarm the other, who is holding a bayonet.

1942

Above right: Craftsmen working on prosthetics at Queen Mary's Hospital, Roehampton. During the Second World War, the specialist centre supplied and fitted artificial limbs for 20,000 military personnel and 2,000 civilians.

1st March, 1942

Right: A Land Girl is given a lesson in sheep shearing at Pyecombe, near Hassocks, Sussex.

22nd April, 1942

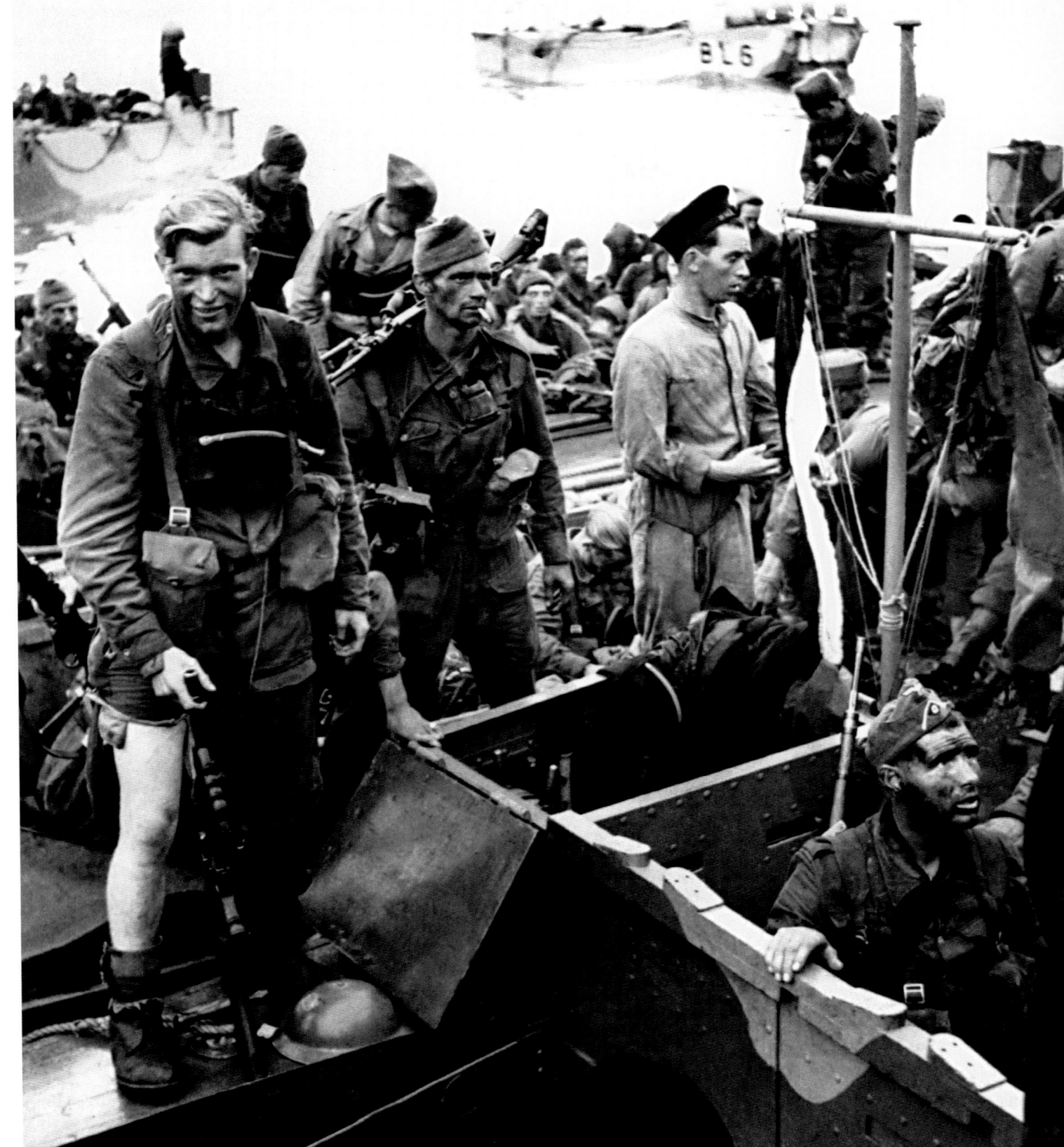

Right: Battle-weary Allied troops and their German prisoners are withdrawn from Dieppe during Operation Jubilee. More than 6,000 infantrymen set out to capture the German controlled French port, but the operation was a disaster – more than half of those involved were killed, wounded or captured.

19th August, 1942

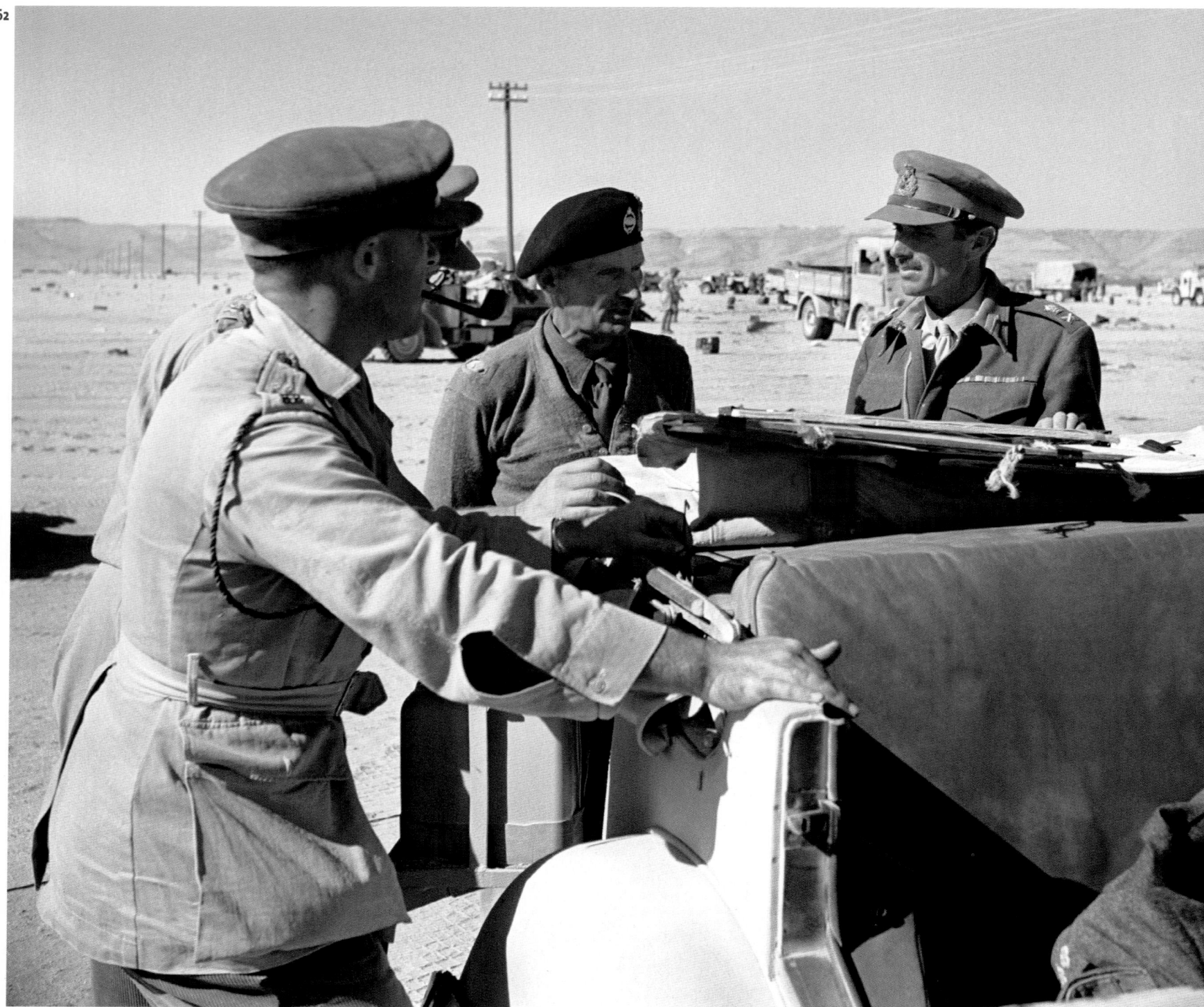

Above: Field Marshal Bernard Montgomery (C), commander of the British Eighth Army during the Western Desert campaign, briefs officers before the decisive Battle of El Alamein. It was the first major offensive against the Germans in which the Allies were victorious.

1st October, 1942

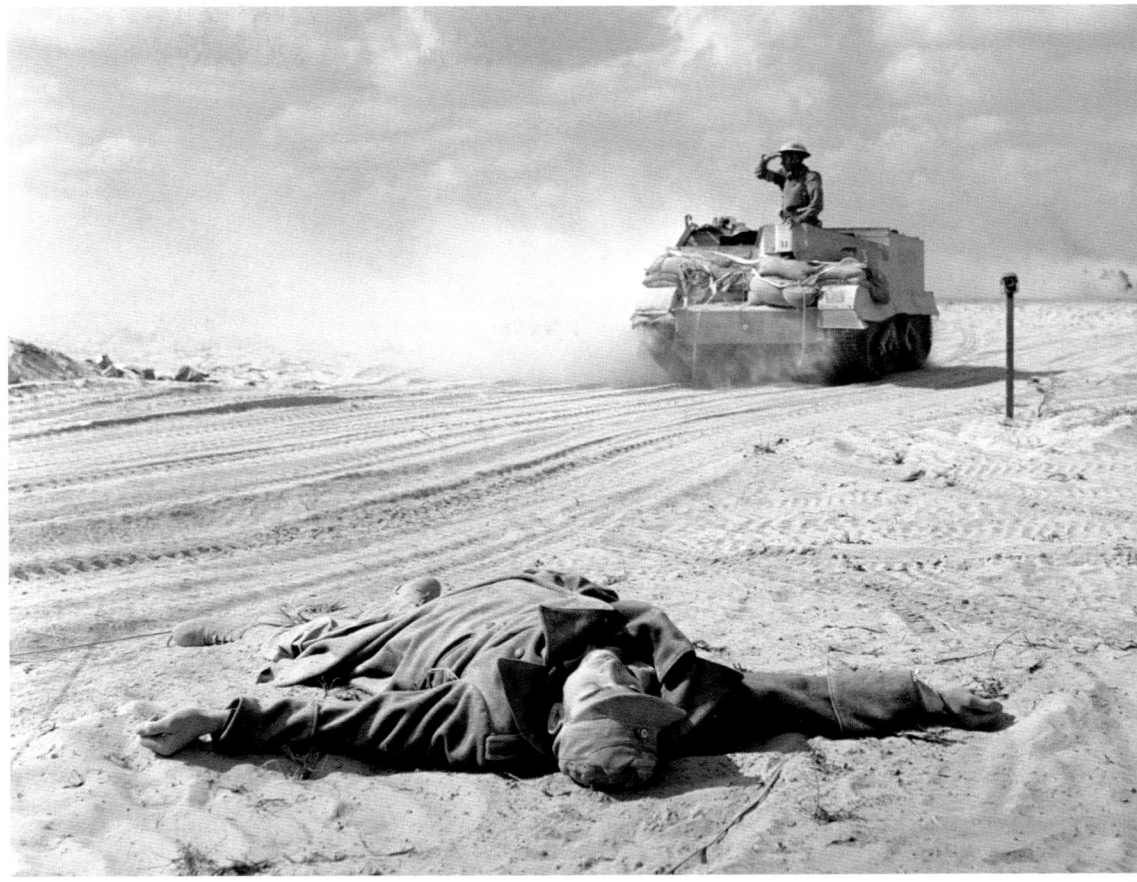

Above: Guy Gibson, 24, who would enter the pages of history as leader of the 'Dambusters' raid in May 1943, which destroyed two of Germany's most crucial dams with 'bouncing bombs'. He died on 19th September, 1944, when his plane crashed following a bombing mission.

26th October, 1942

Above right: A German soldier lies dead in the sand as a British Army bren gun carrier passes by, following the Battle of El Alamein. The victory proved a turning point in the fight for the Western Desert. British Prime Minister Winston Churchill said of the battle, *"This is not the end, it is not even the beginning of the end. But it is, perhaps, the end of the beginning."*

15th November, 1942

Right: An enemy supply train is left burning after an attack by long-range RAF fighters, south of Sidi Barrani in Egypt. Allied air supremacy was a vital ingredient in the destruction of the Axis forces in North Africa.

1943

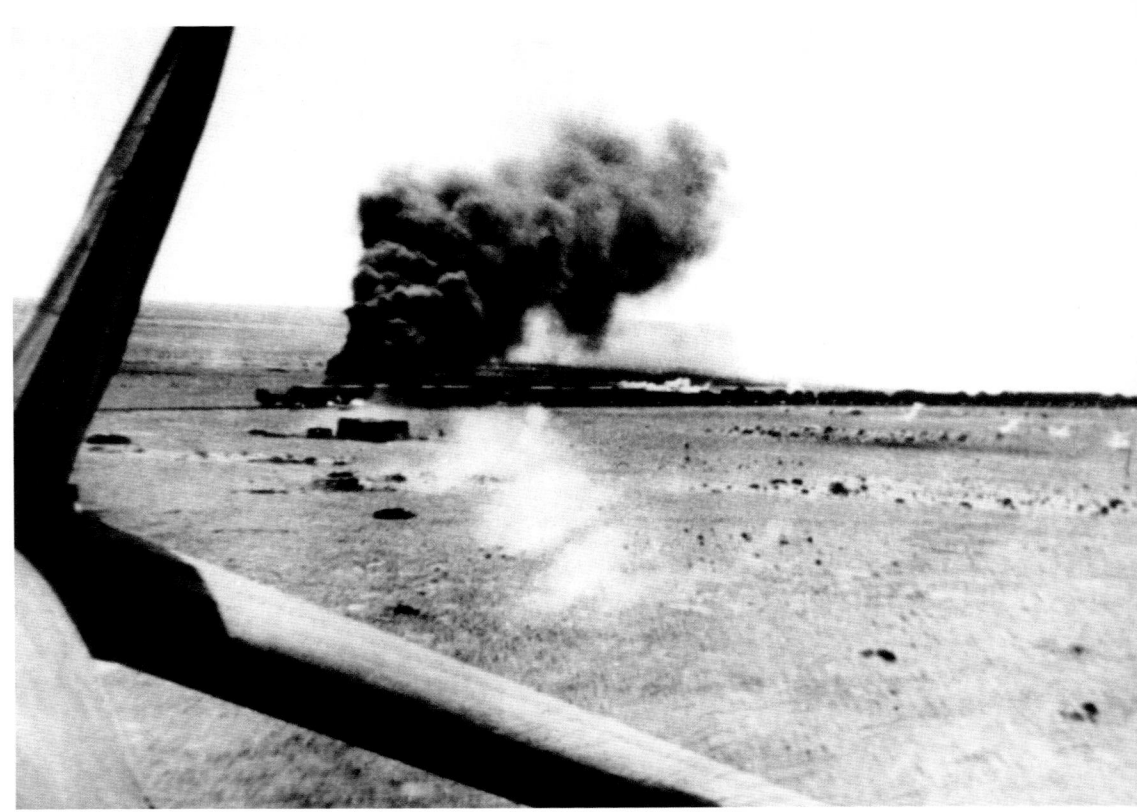

Far right: A British Army Sherman tank rumbles through a town on its way to a port on the south coast prior to the Normandy landings. The Sherman was an American-built tank supplied in large numbers to the British. Although it acquitted itself well in North Africa, it was at a disadvantage when it came up against the superior firepower and armour of the German Tiger and Panther tanks used in France, suffering substantial casualties. The wartime censor has obliterated a sign in the background as well as the tank's unit markings.

1st June, 1944

Above: General Orde Charles Wingate (wearing pith helmet), commander of the Chindits, briefs members of the USAAF's First Air Commando in Burma. The Chindits were a British India special force, consisting of long-range penetration groups who operated deep behind Japanese lines. Wingate was known for his eccentricities and could often be seen munching on a raw onion, which he wore around his neck in case he needed a snack.

1944

Right: British women provide refreshments for American troops from a convoy heading to the south coast of England during the build-up to D-Day, the Normandy landings. The invasion was the largest amphibious assault in history, over 175,000 troops being landed on the French coast in one day, 6th June, 1944.

1st June, 1944

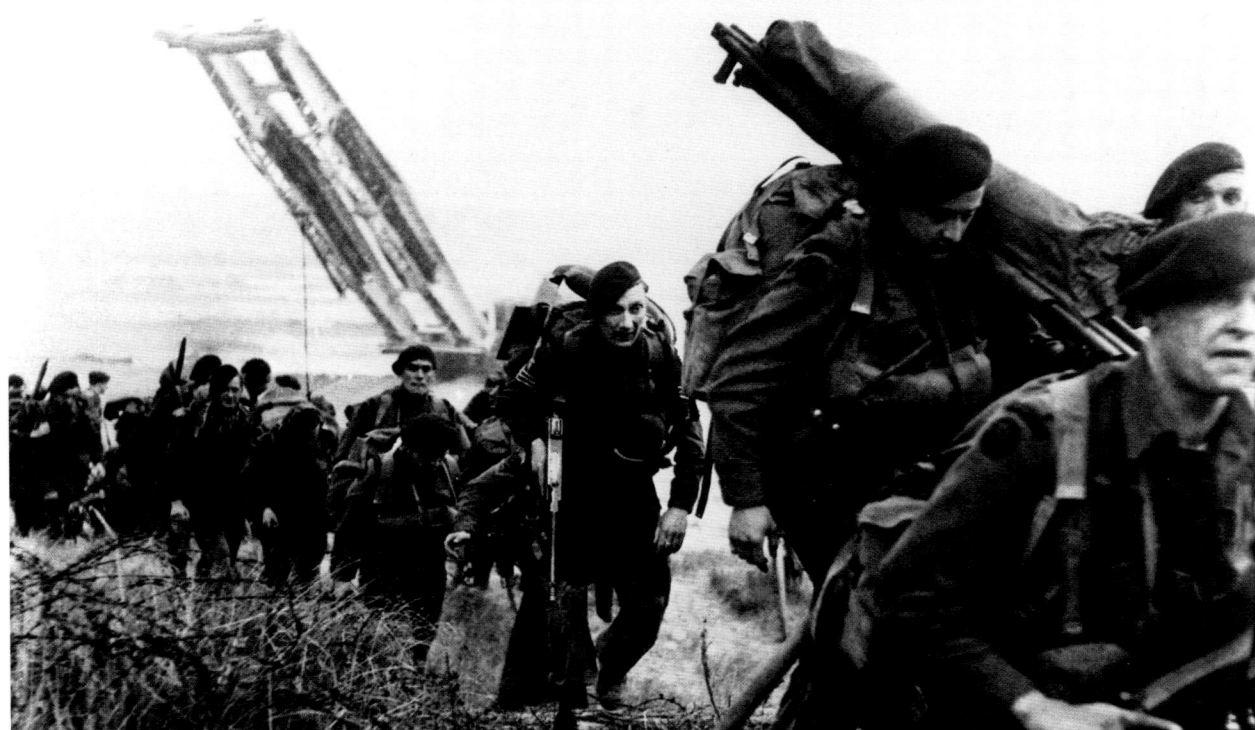

Right: Royal Marines of No 4
Commando, part of 1st Special Services
Brigade, advance inland from 'Sword'
beach, one of five sectors of a 50-mile
(80km) stretch of the French coast
allocated to the invasion. The brigade
was led ashore by a piper.

6th June, 1944

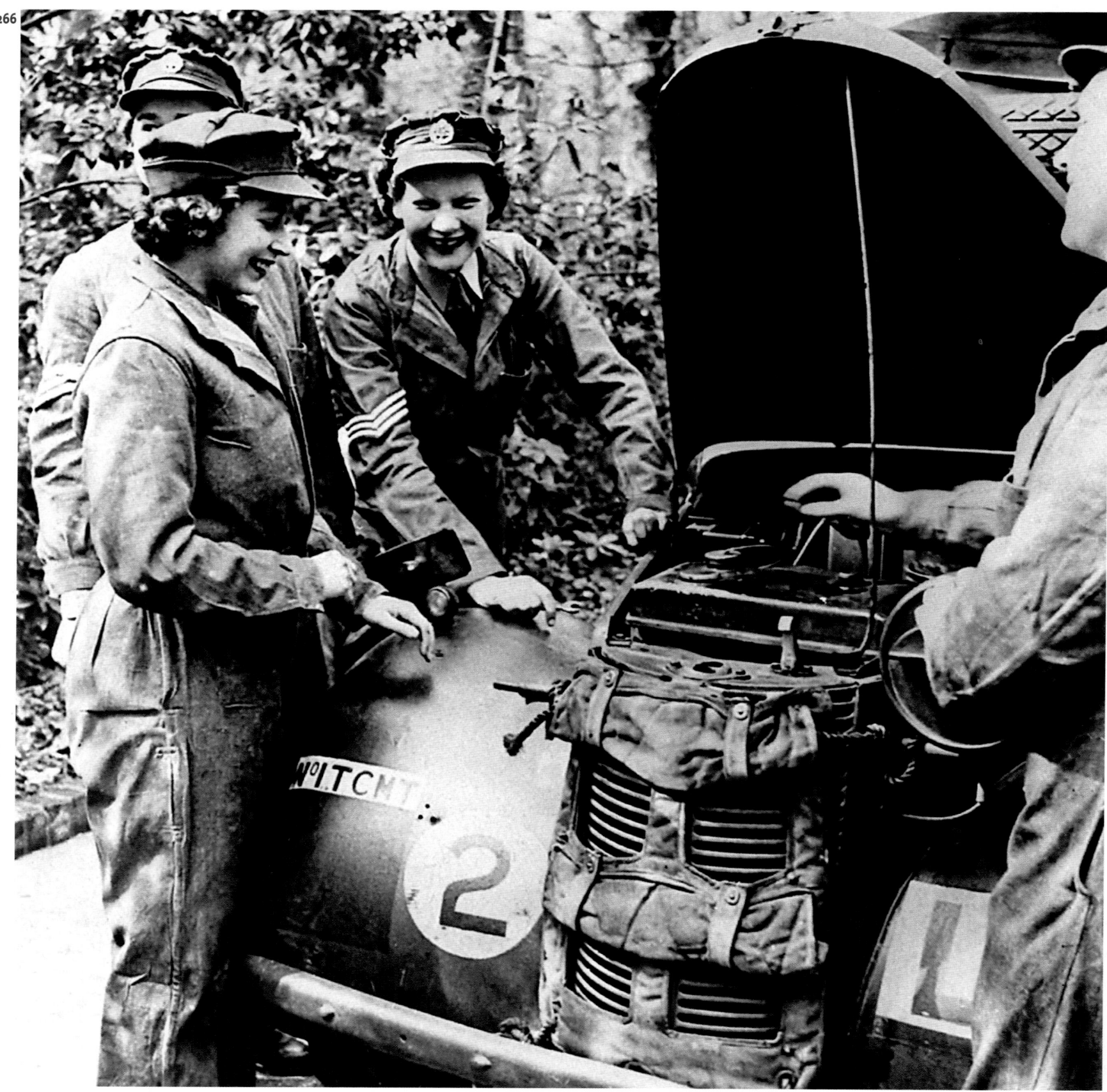

Above: The three Allied leaders, (L–R) Winston Churchill, Franklin D. Roosevelt and Josef Stalin, meet at Yalta in the Crimea to discuss the fate of Germany and the re-establishment of European nations after the Second World War. The leaders agreed that after Germany's unconditional surrender, it would be divided into four occupied zones, each controlled by one of the Allies: Britain, United States, Soviet Union and France. The future of Poland was also discussed, although Stalin reneged on the agreement to hold free elections, and the country remained in the grip of the Soviet Union until 1989.

4th February, 1945

Left: The future Queen, Princess Elizabeth, receives vehicle maintenance instruction on an Austin Ten while serving with the Mechanised Transport Training Corps at Camberley in Surrey.

1945

Right: German troops, watched by British and Canadian soldiers, load trucks with bodies following the liberation of the Bergen-Belsen concentration camp in north-west Germany. Around six million Jews were exterminated in such camps.

16th April, 1945

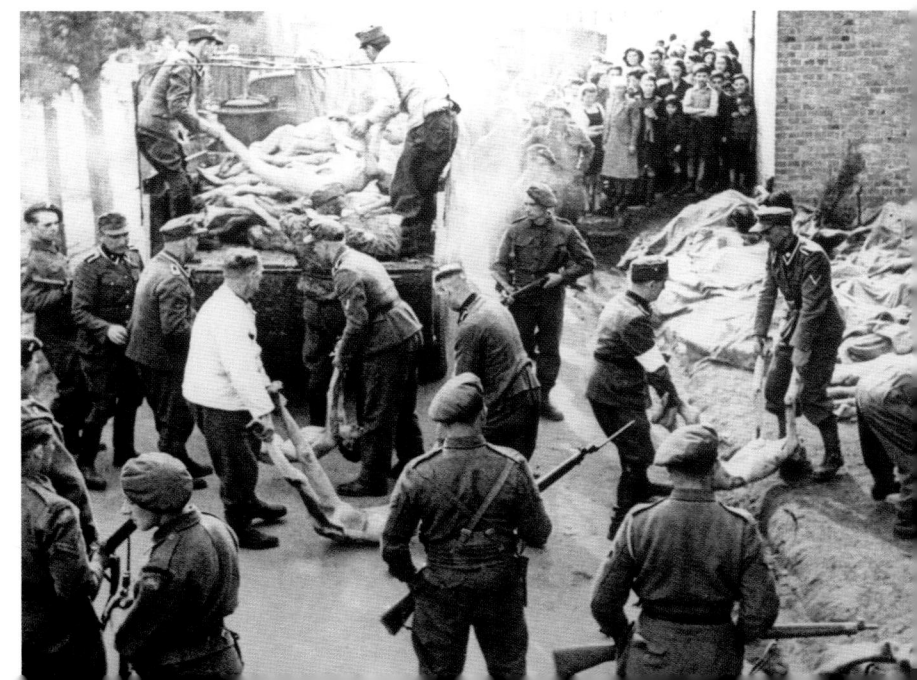

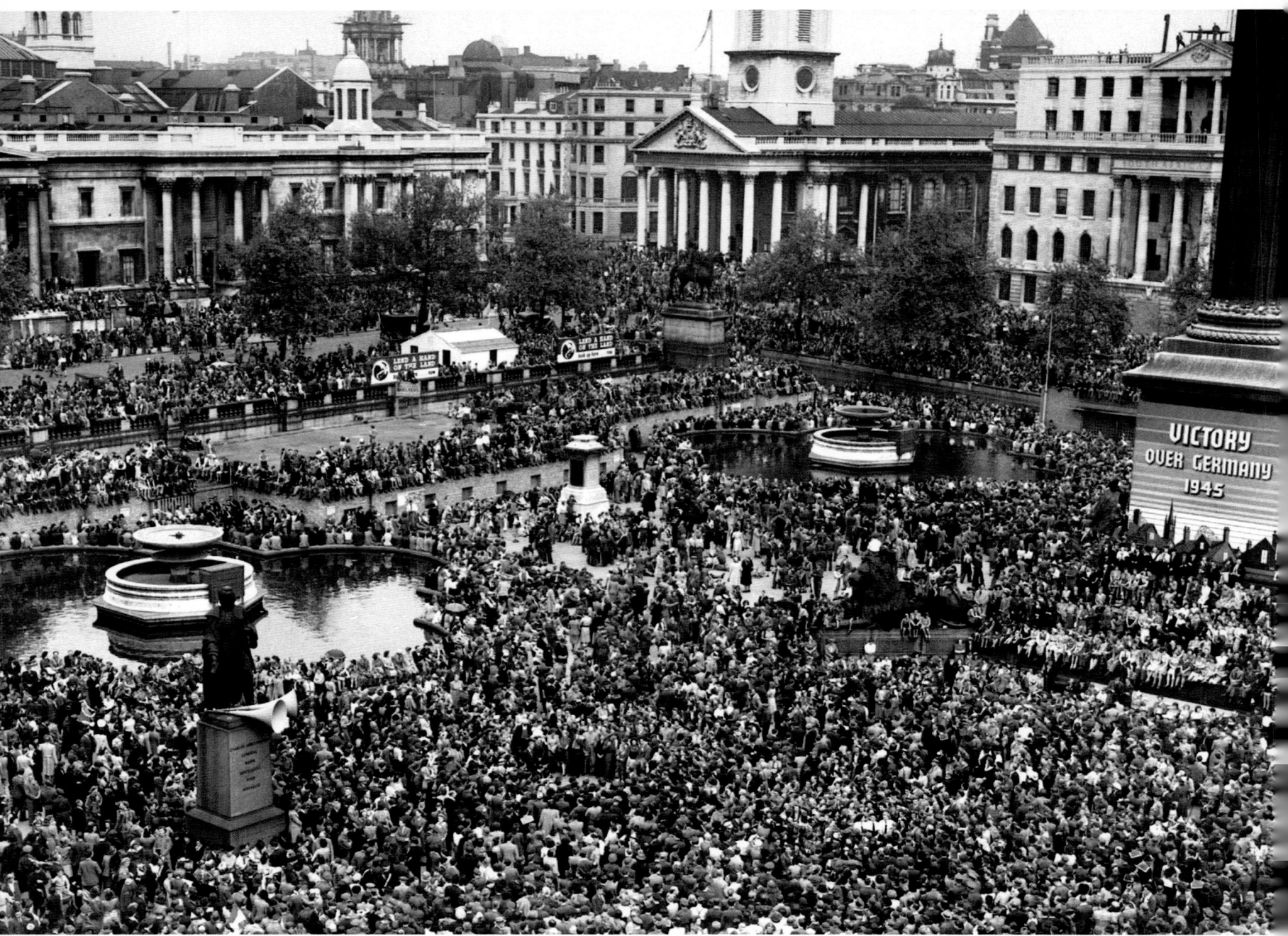

VICTORY
OVER GERMANY
1945

Above: Huge crowds gathered in Trafalgar Square in London, following the news that the war in Europe had come to an end. With Berlin being overrun by Russian troops, and American and British armies advancing rapidly from the west, German dictator Adolf Hitler had committed suicide on 30th April, 1945. Within days, his successor, Admiral Karl Dönitz, authorized Germany's surrender.

8th May, 1945

Right: Work begins to repair the damage done by the German bombing raids and rocket attacks. It would be many years before all the bomb sites were rebuilt.

June, 1945

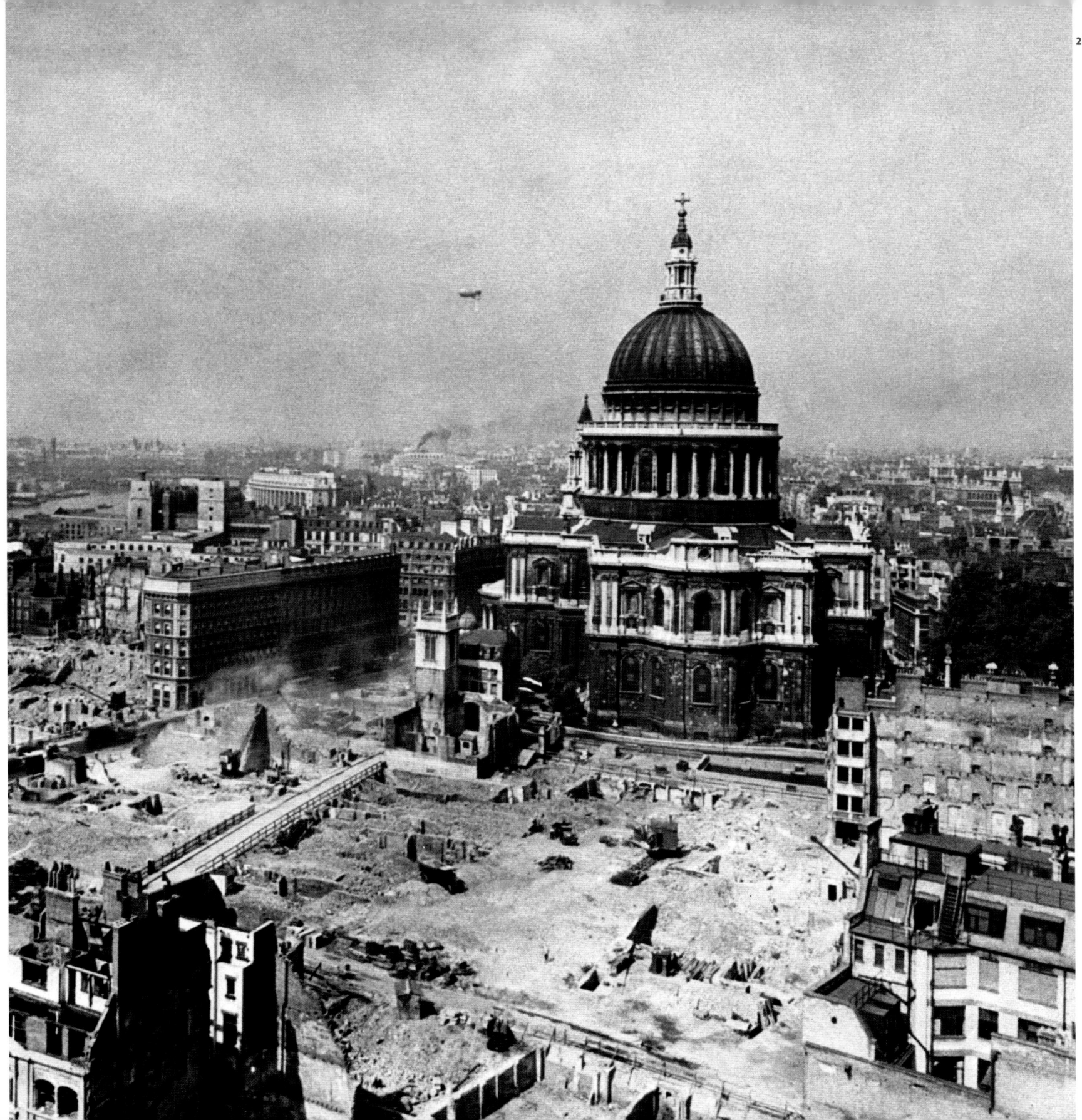

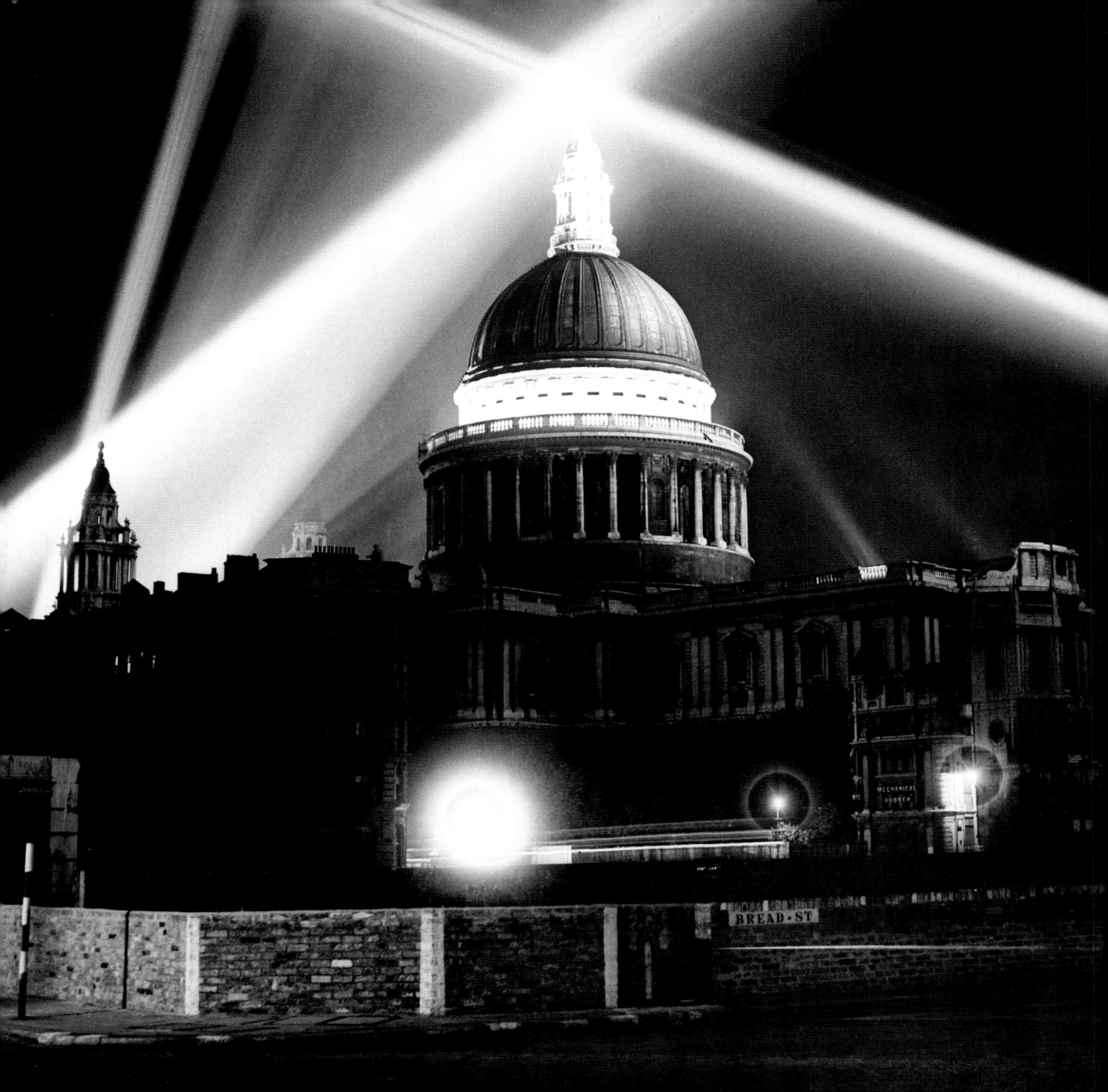

271

Above: Lord Louis Mountbatten, commander of the Allied forces in south-east Asia, presides as General Itagaki of the Japanese Imperial Army signs surrender documents in Singapore. Although the official terms of Japanese surrender had been signed in Tokyo on 2nd September, 1945, further ceremonies took place in Japanese-held territories after this date.

12th September, 1945

Left: Searchlights frame St Paul's Cathedral in spectacular fashion to celebrate the Japanese surrender on 14th August, 1945.

15th August, 1945

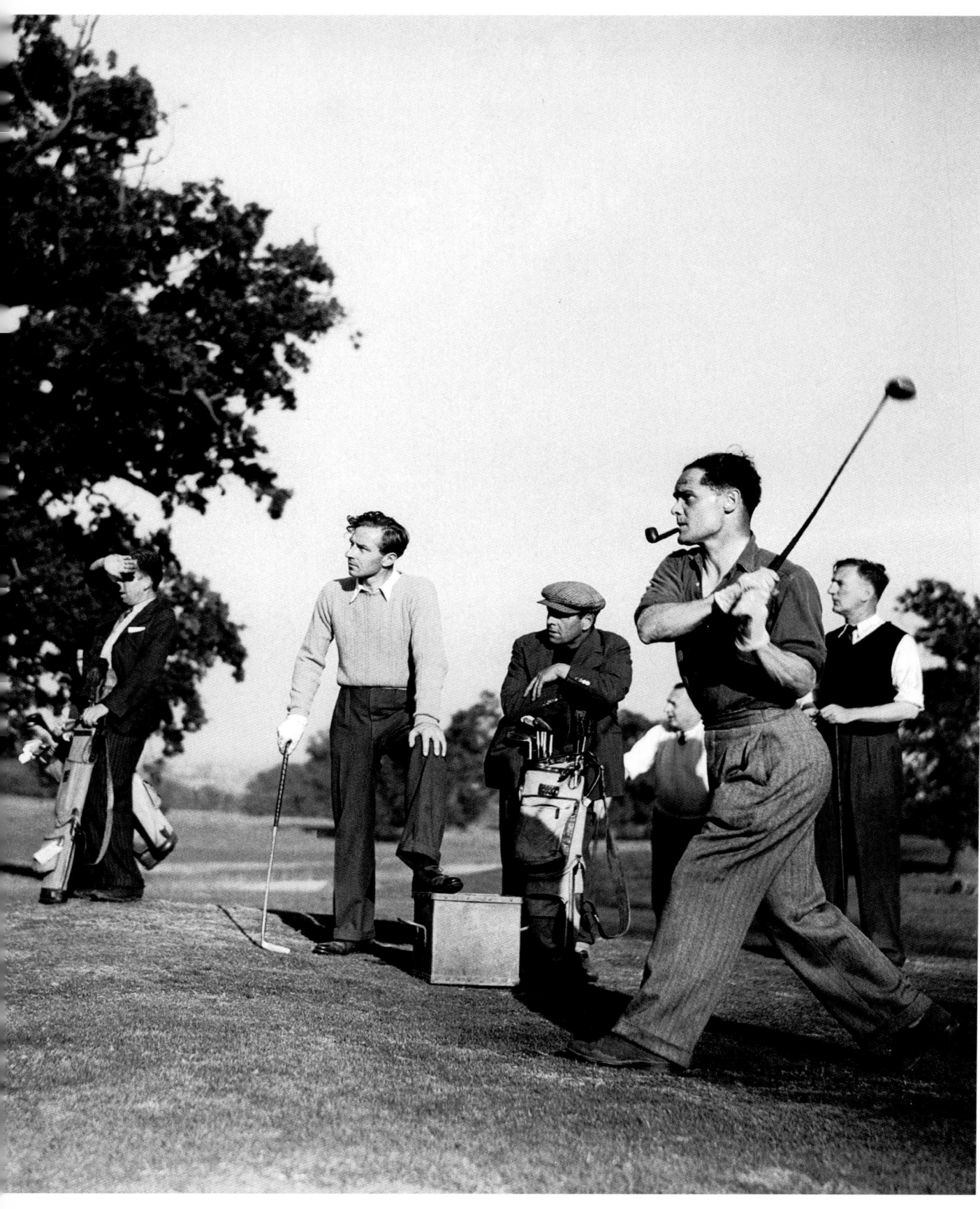

Left: Famous legless RAF fighter pilot Group Captain Douglas Bader (R) drives off, watched by his playing partner Wing Commander P.B. 'Laddie' Lucas (second L). Bader had lost both legs in a pre-war flying accident, but by sheer force of personality and flying skill had convinced the RAF to retain him as an operational pilot. After leading a squadron through the Battle of Britain, he had been shot down over France on 9th August, 1941 and had remained a prisoner of the Germans until 15th April, 1945. Upon release, his first request was for a Spitfire so that he could return to the war.

10th October, 1945

Right: Jockey Gordon Richards wins his 100th race of the season, the Castle Hill Plate at Windsor, on Sez You. Many consider Richards to be the greatest jockey ever. In 1953, he received a knighthood, becoming the only jockey ever to have received the honour.

12th October, 1945

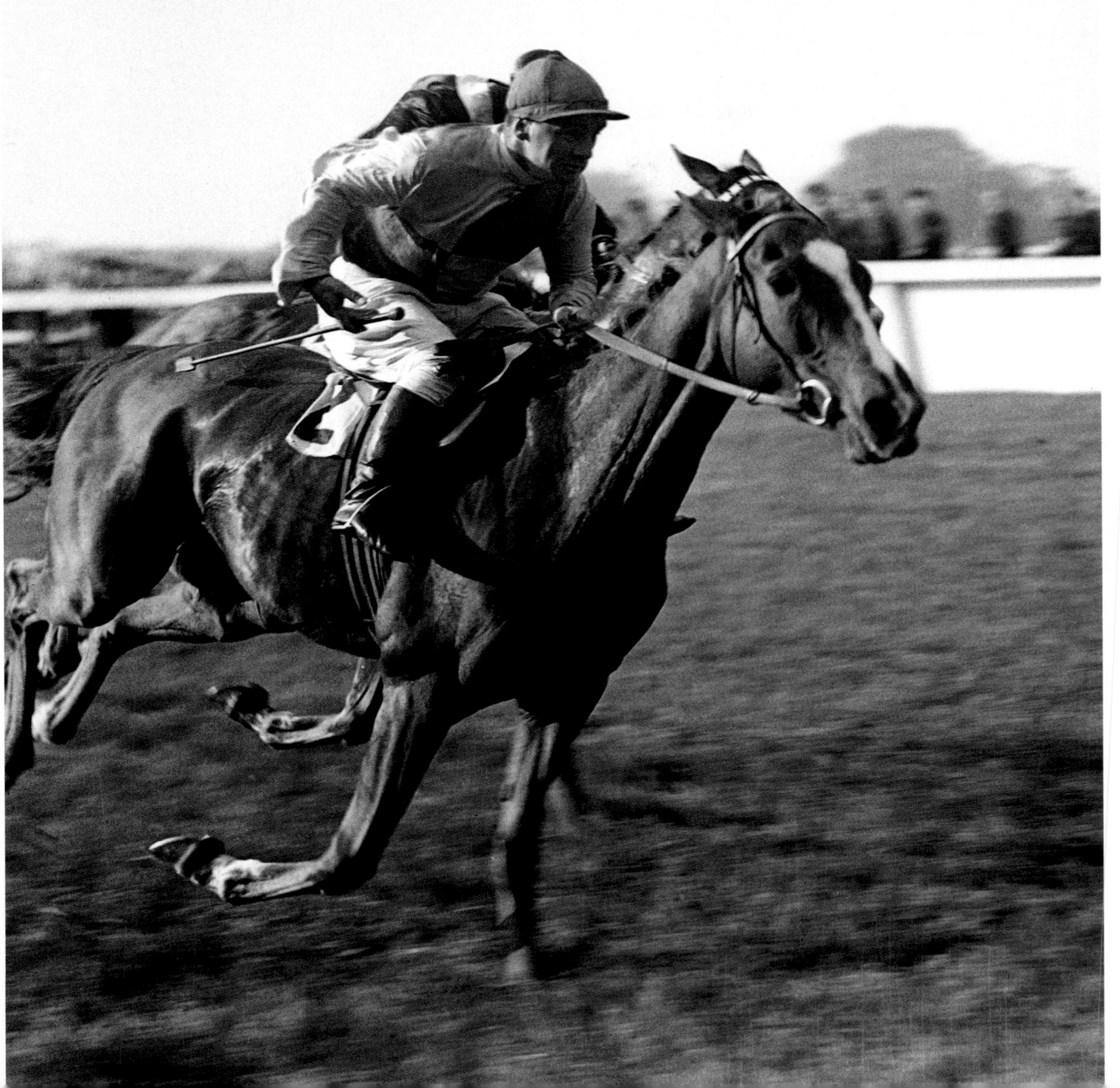

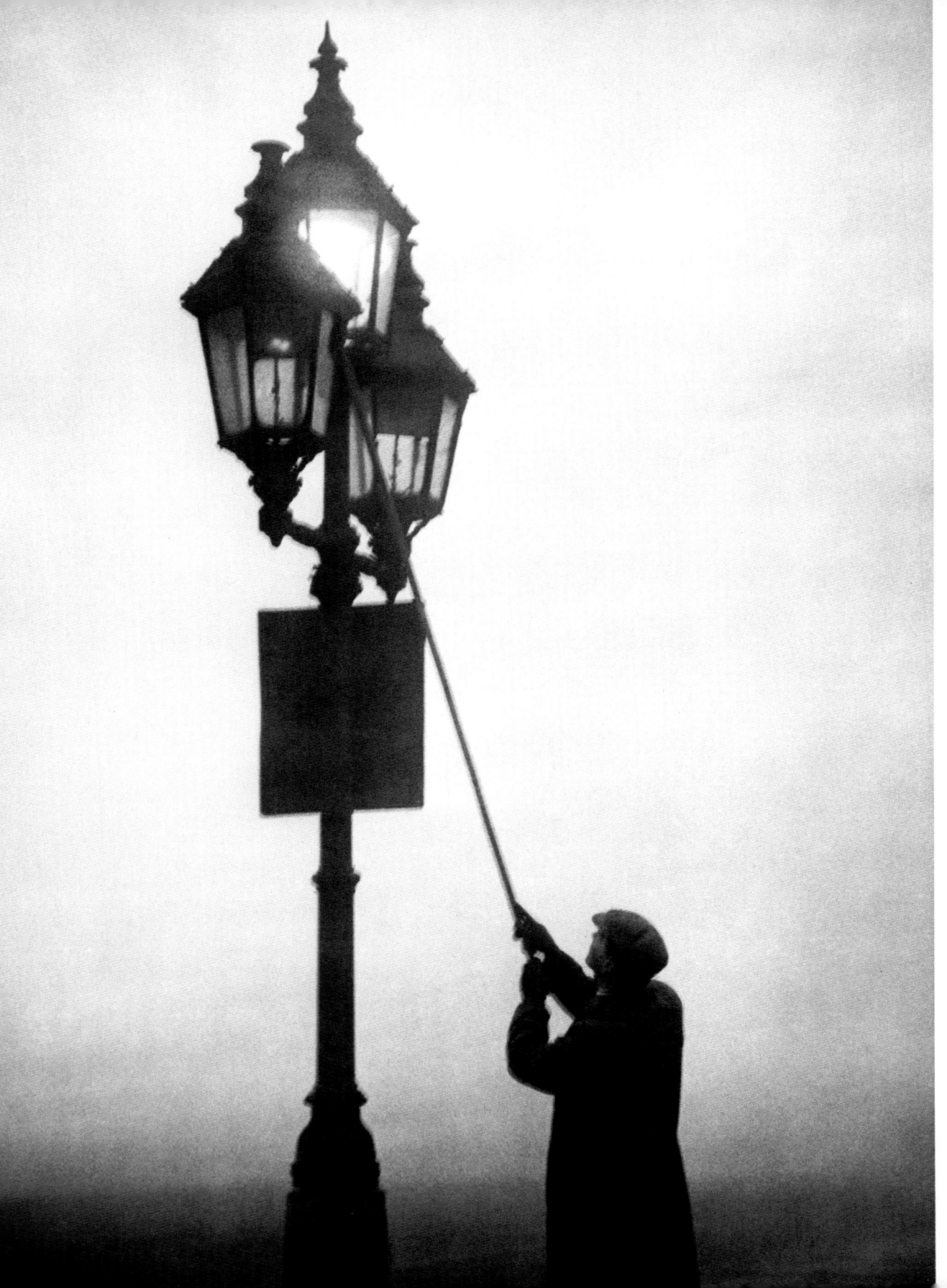

Left: A hangover from Victorian times, gas street lighting was still in common use in 1945. Here, a lamplighter turns on the lights during a 'pea-souper' fog.

31st December, 1945

Right: The biggest thing in post-war fashion, the New Look. This grey worsted coatdress is trimmed in navy and white spotted rayon, a semi-synthetic fibre that had recently come into common use.

23rd January, 1946

Above far right: Eighty feet (24m) below the surface, in part of the Piccadilly Circus Underground station known as 'Aladdin's Cave', national art treasures from the Tate Gallery and the London museums, stored at the outbreak of the Second World War, are retrieved to be put on display once more.

4th February, 1946

Far right: A convoy of Automobile Association Scouts (patrolmen), mounted on BSA motorcycle combinations, leaves an assembly point in the Midlands. At that time, the AA had 400 motorcycle patrols, whose job was to provide members with emergency roadside assistance. On passing a car displaying an AA member's badge, the Scout was required to salute smartly.

4th July, 1946

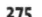

Right: The Gloster Meteor, known affectionately to its pilots as the 'Meatbox', was the first jet fighter to be commissioned by the Royal Air Force, and it saw action toward the end of the Second World War; it was the Allies' first operational jet. This example is a Mk 3.

4th July, 1946

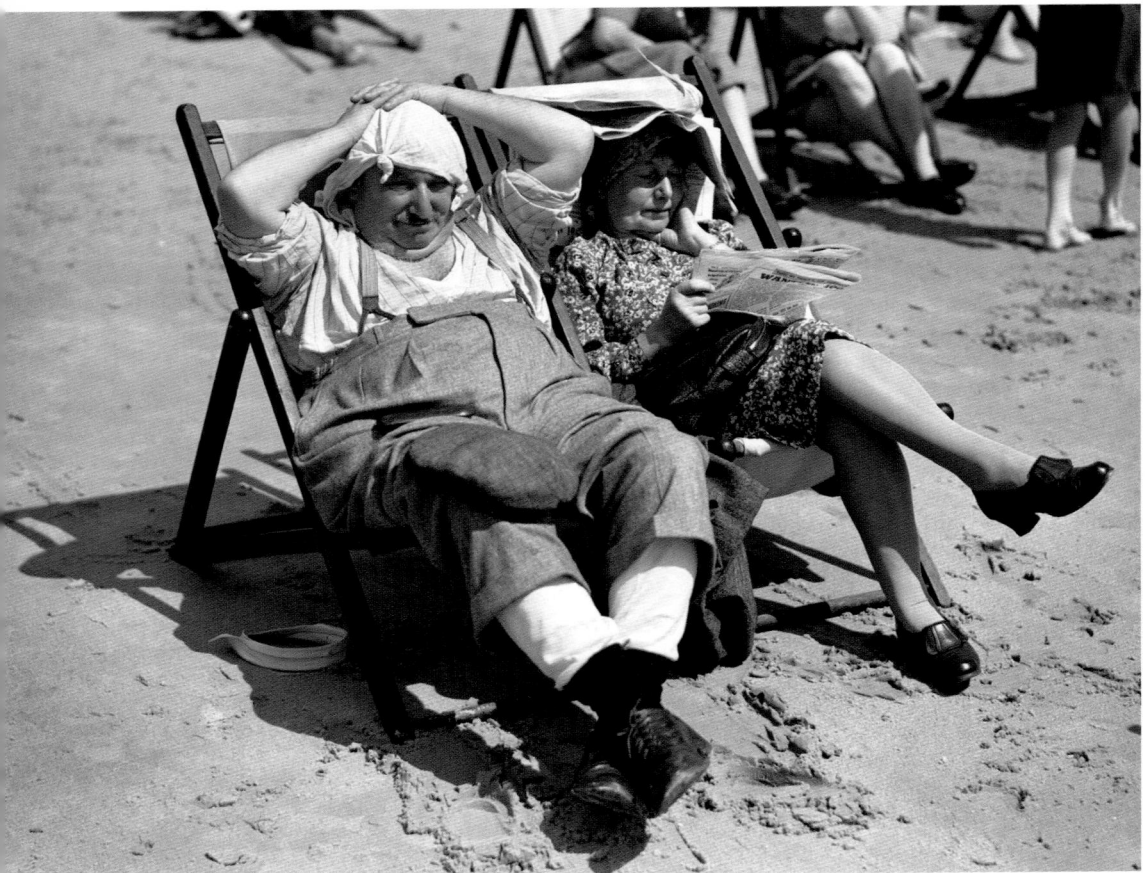

Above: A couple relax on Bournemouth's sunsoaked beach wearing traditional British headgear for protection against the elements: a newspaper and a knotted handkerchief.

12th July, 1946

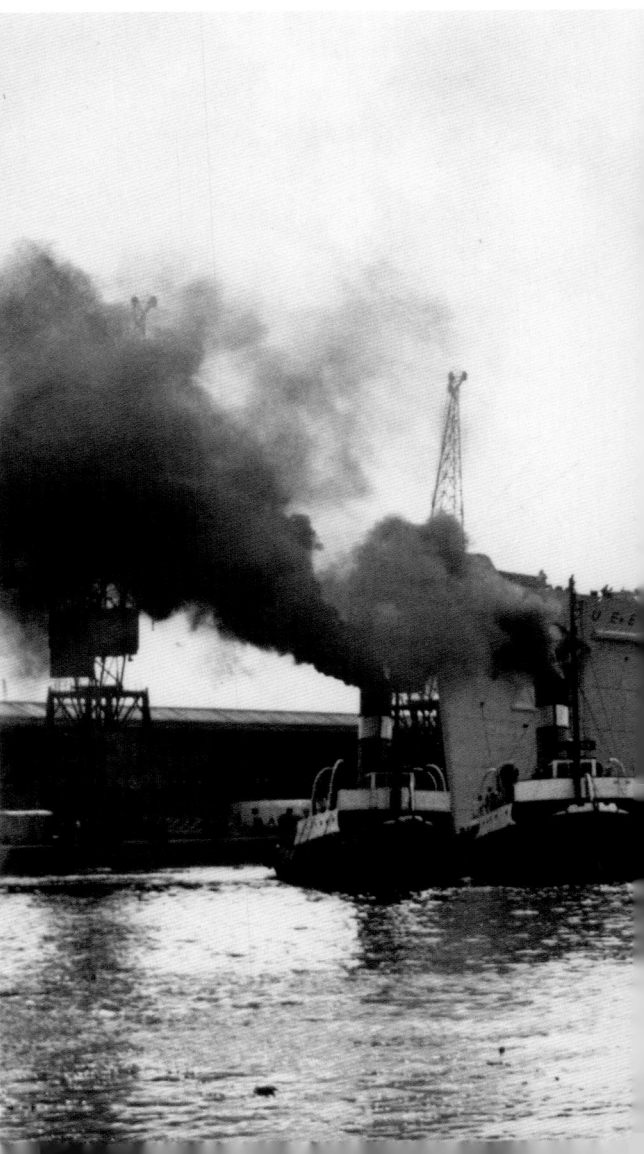

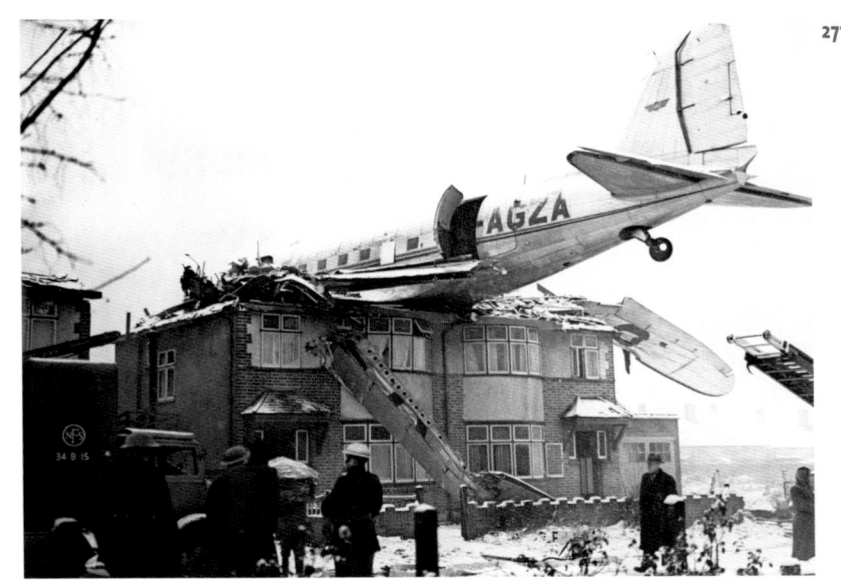

Right: Hitting the roof. A Douglas DC3 of Railway Air Services perches precariously on top of a house in the London suburb of Northolt, Middlesex after crashing on to the roof. The machine had just taken off from RAF Northolt, where its captain, William Johnson, subsequently known as 'Rooftops', had supervised its de-icing prior to take-off. Fresh snowfall on the wings destroyed their lift, however, preventing it from climbing away. The crew of four and one passenger escaped unhurt.

19th December, 1946

Below: The scene at Southampton as the Cunard-White Star liner *Queen Mary* is nosed by tugs out of her berth in the Ocean Dock before leaving for New York. On the quayside next to the *Aquitania*, workmen are busy repairing bomb damage. Both ships retain their wartime drab grey paint schemes.

27th August, 1946

278

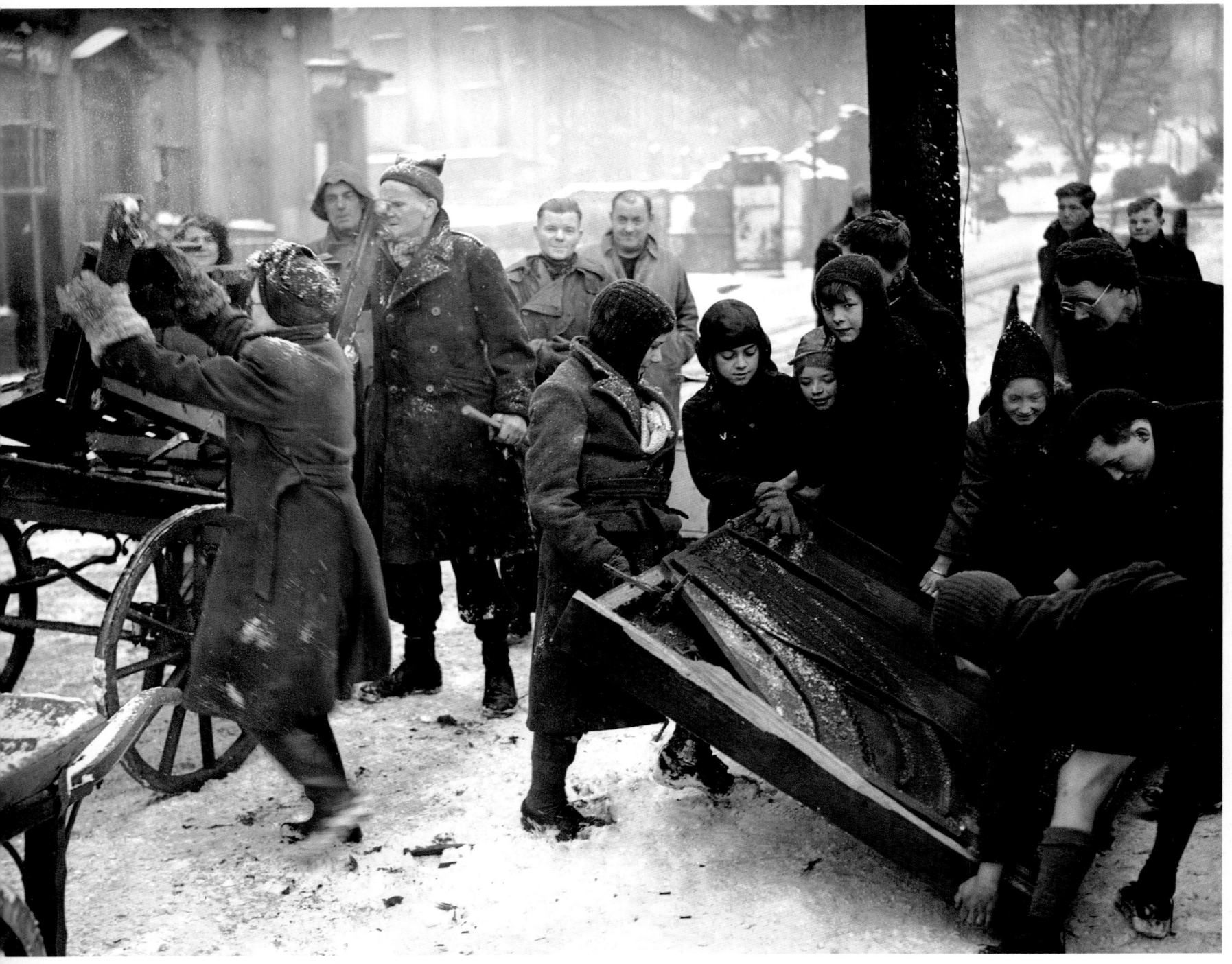

Above: The harsh winter of 1946–7 brought many hardships to a Britain struggling to recover from the Second World War. Heavy snowfall led to coal and food shortages. In Bristol, Mr Mickleburgh, a piano merchant, gave away pianos to be chopped up for firewood.

31st January, 1947

Left: During one of the coldest months on record, overnight temperatures at Kew Botanic Gardens climbed above freezing just twice in four weeks, and minus 20 degrees was recorded as far south as Essex. This was one of around only 25 occasions in history when the Thames froze over.

27th February, 1947

Below: Heroic efforts are made, in extremely dangerous conditions, to fill a breach in the north bank of the Little Ouse near Hockwold in Norfolk. Rapidly thawing snow combined with heavy rain brought extensive flooding to East Anglia: mobile canteens ferried up to 1,000 meals a day to those attempting to bolster weakened flood defences.

20th March, 1947

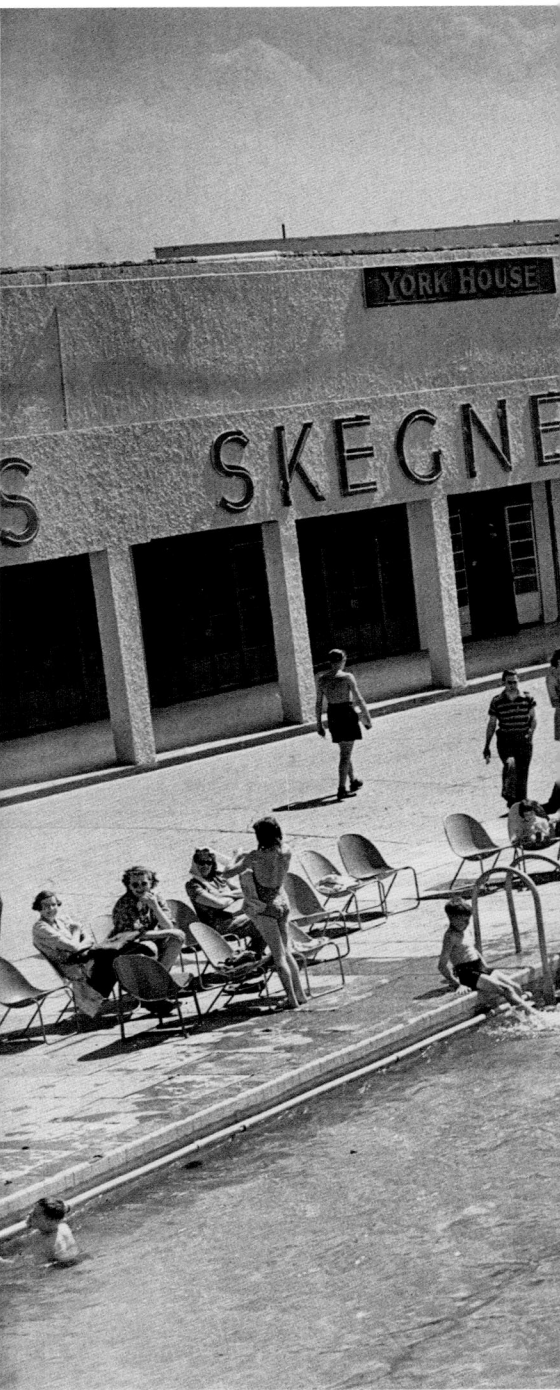

Left: A Butlin's Redcoat directs a guest to the bathing pool at the Skegness camp. Many famous entertainers began their showbusiness careers as Redcoats, including Des O'Connor and Sir Cliff Richard.

June, 1947

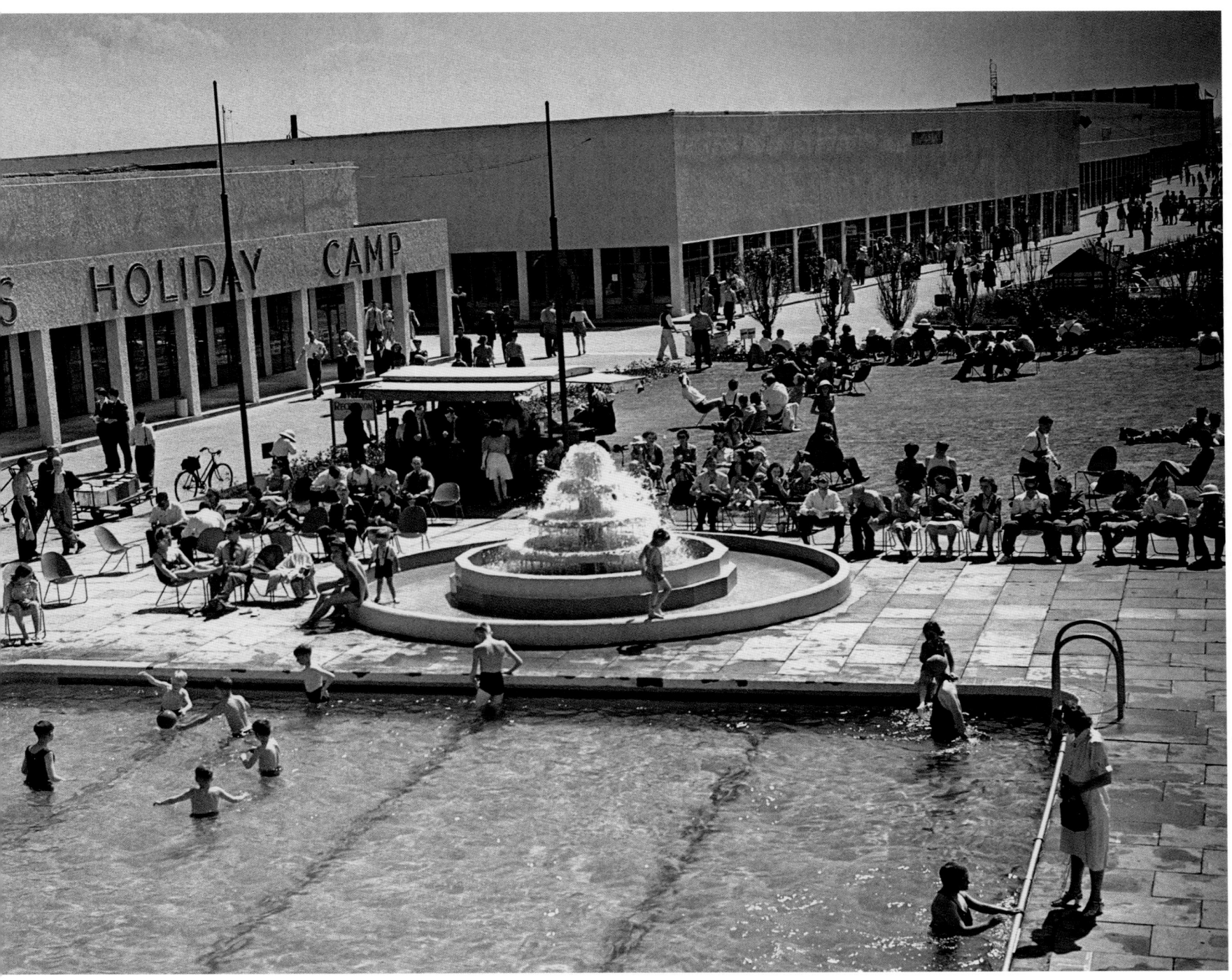

Above: Holidaymakers enjoy the new outdoor swimming pool at Butlin's holiday camp, Skegness, Lincolnshire. Postwar refurbishment had updated and improved the original complex, which had been opened by Billy Butlin in 1936, the precursor of a holiday camp empire. Butlin had been inspired to create the camps after miserable holiday experiences in his youth.

June, 1947

Above: A family of hop pickers on a Kent farm, down from London for the seasonal work and a 'holiday'. Their accommodation was spartan to say the least.

15th August 1947

Above left: Prime Minister Clement Attlee on the steps of 10 Downing Street. Many consider him to be the greatest prime minister of the 20th century.

6th August, 1947

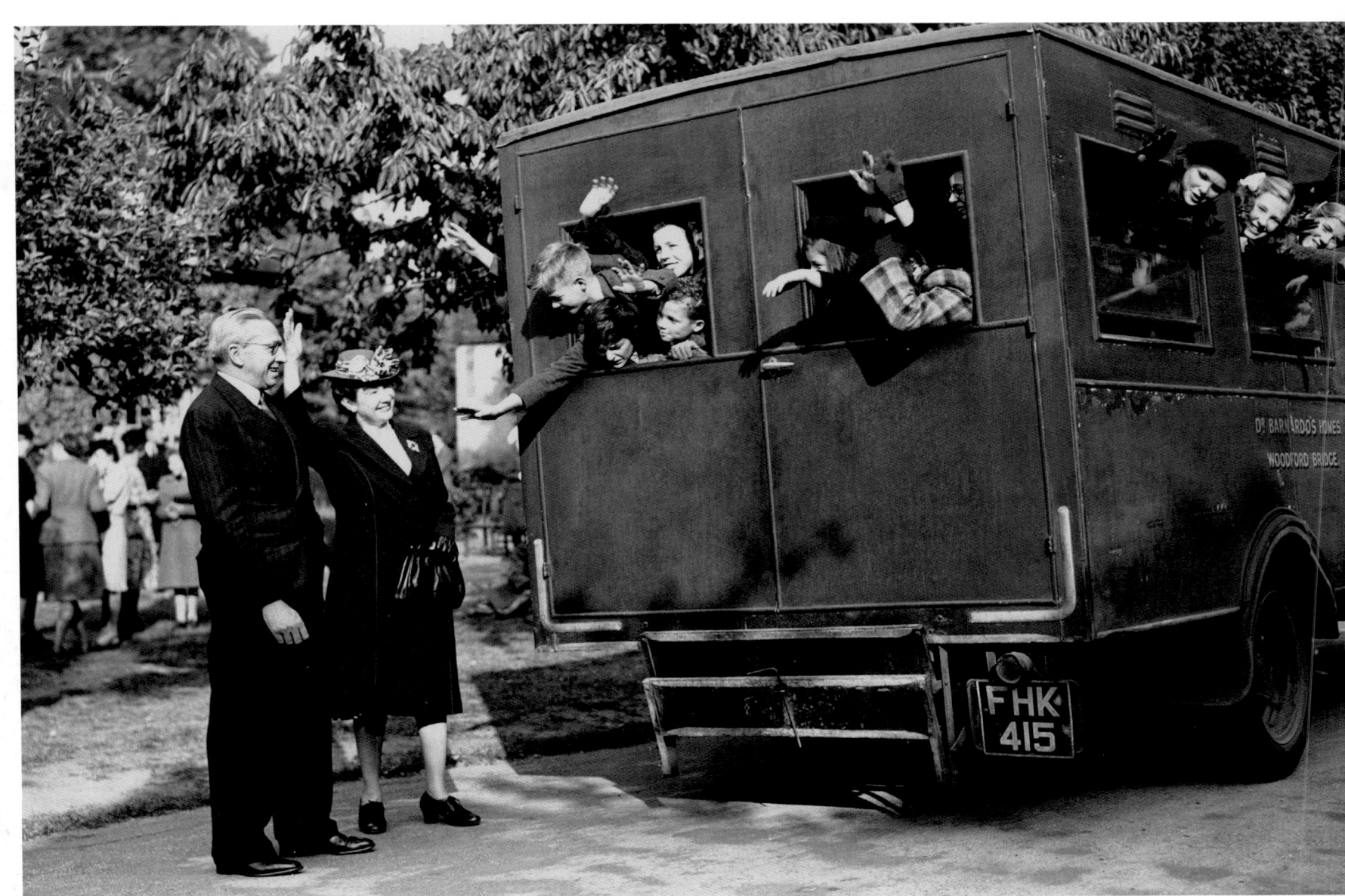

Above: Norman Mighell, Deputy High Commissioner for Australia, and Mrs Mighell give 40 Dr Barnado's children a send-off from their Woodford Bridge home as they leave for the SS *Ormonde* at Tilbury. The boys would go to a farming school in New South Wales, and the girls to a domestic service training home near Sydney. Although apparently happy at the prospect, many of the children who were forcibly 'exported' in this way found that poor conditions and harsh treatment awaited them.

7th October, 1947

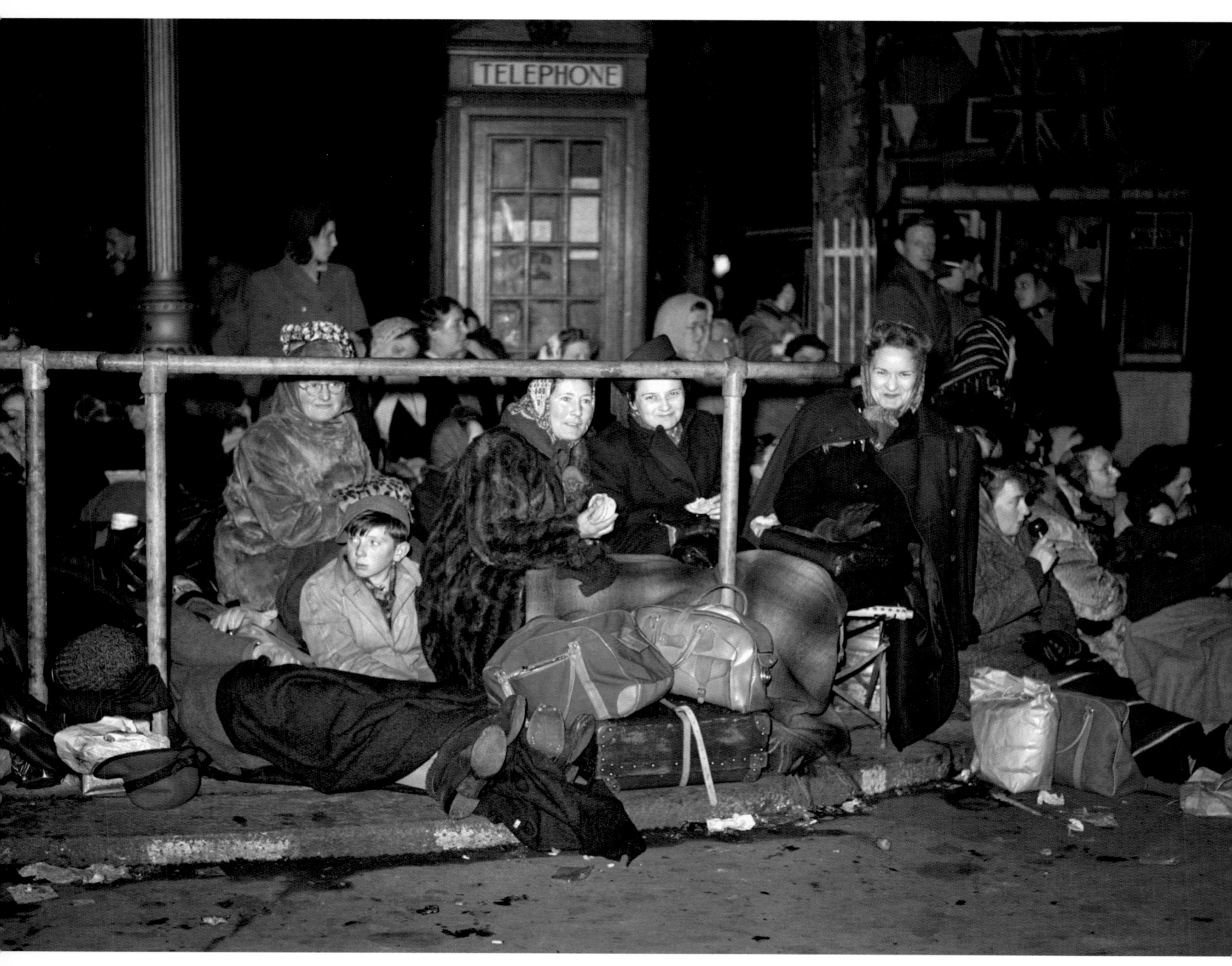

285

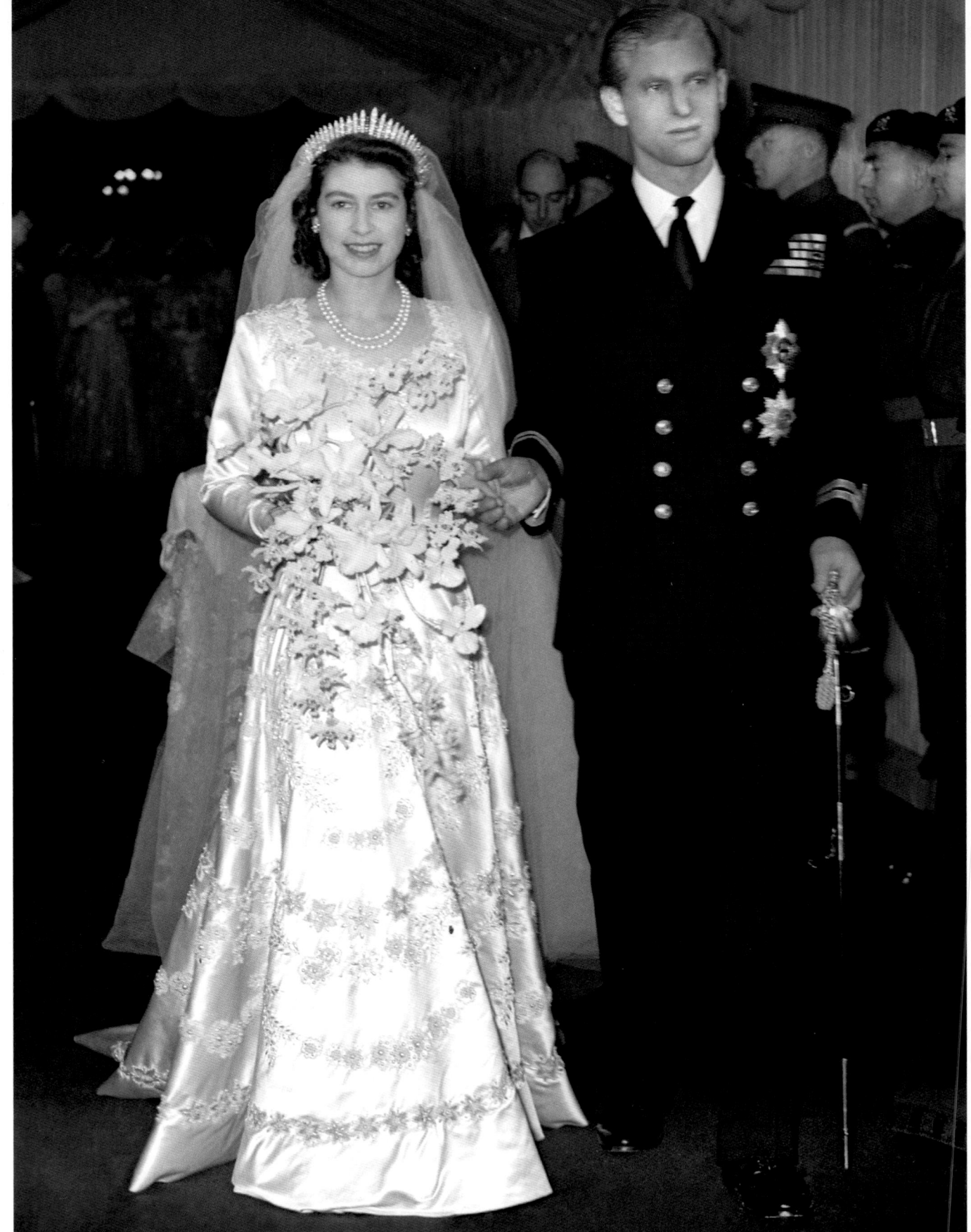

Left: Crowds camp out overnight on the streets of London to catch a glimpse of Princess Elizabeth and the Duke of Edinburgh during their wedding procession. With the country still recovering from the hardships of the war years, the wedding did much to bolster the spirits of the population. Some people were excluded from the celebrations, however, notably Prince Phillip's German relations, his three sisters, who had married high-ranking Germans, and the disgraced Duke of Windsor, formerly King Edward VIII.

19th November, 1947

Right: The Royal couple leave Westminster Abbey after the marriage ceremony. With rationing still in force in Britain, the Princess required clothing coupons to buy the material for her dress, which had been designed by Norman Hartnell.

20th November, 1947

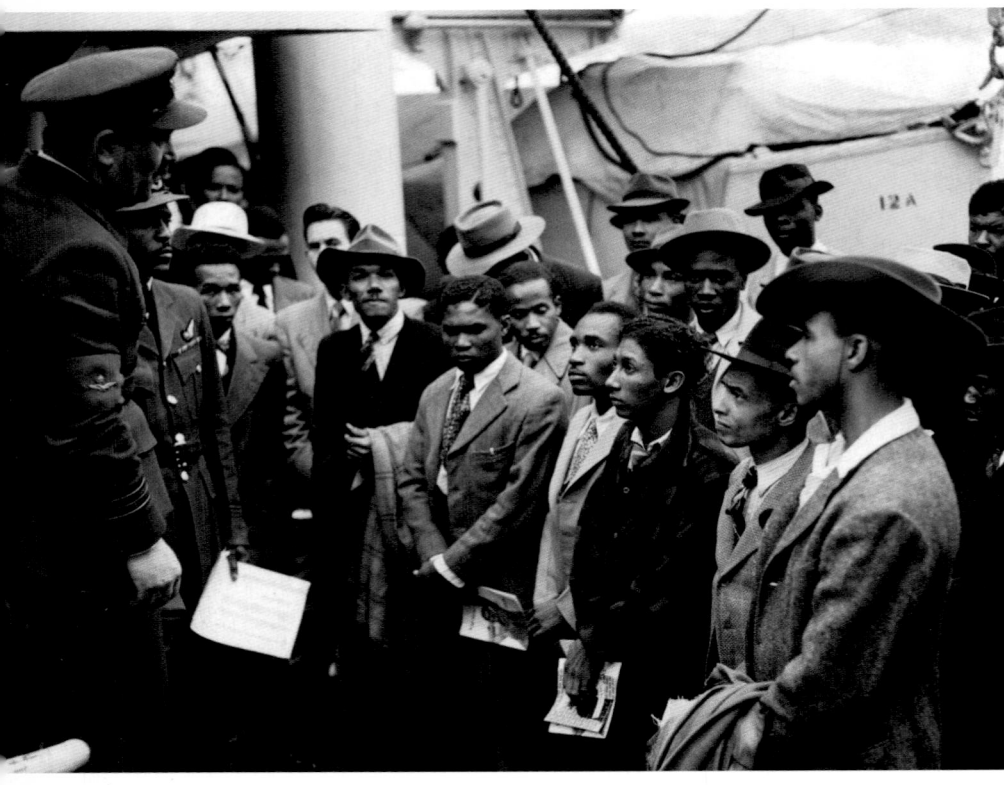

Left: Jamaican immigrants are met by RAF officers after the troopship *Empire Windrush* lands them at Tilbury. During the Second World War, many men and women from the Caribbean had joined Britain's armed forces, and in 1948 a number were on home leave. The *Empire Windrush* was returning to Britain from the Far East and had stopped in Jamaica to pick them up. At the same time, many of their former comrades took the opportunity to return with them to rejoin the RAF, while other adventurous young souls also seized the chance to see Britain. Although most had no intention of staying for more than a few years, the arrival of the migrants was the beginning of the multi-racial society we know today.

22nd June, 1948

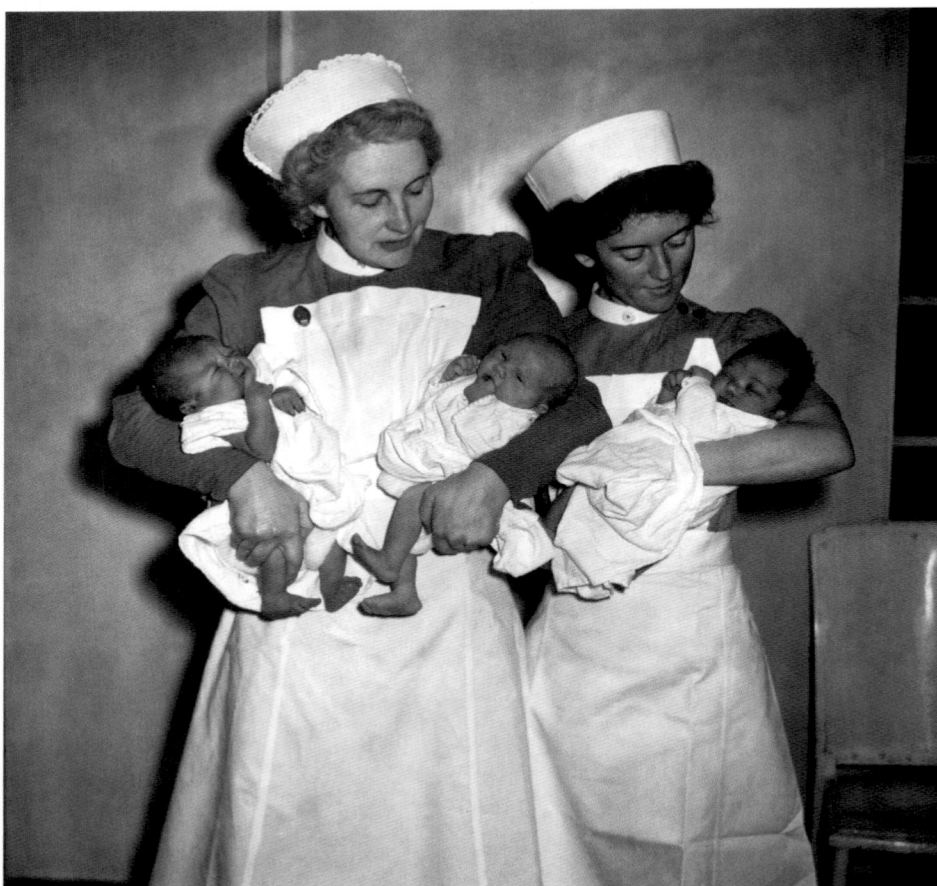

Left: The first babies to be born under the newly-established National Health Service (NHS), one of the major achievements of Clement Attlee's postwar Labour government.

5th July, 1948

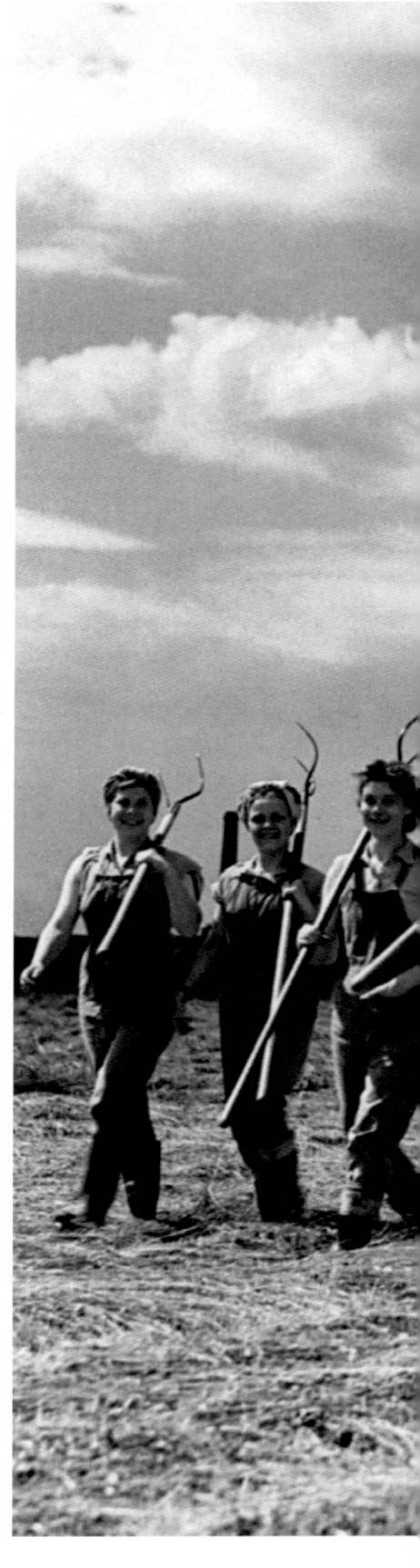

Right: Formed during the war, the Women's Land Army continued to provide agricultural workers to help on the land until disbanded in 1950. Here, trainees armed with pitchforks set out to turn hay in preparation for stacking.

9th July, 1948

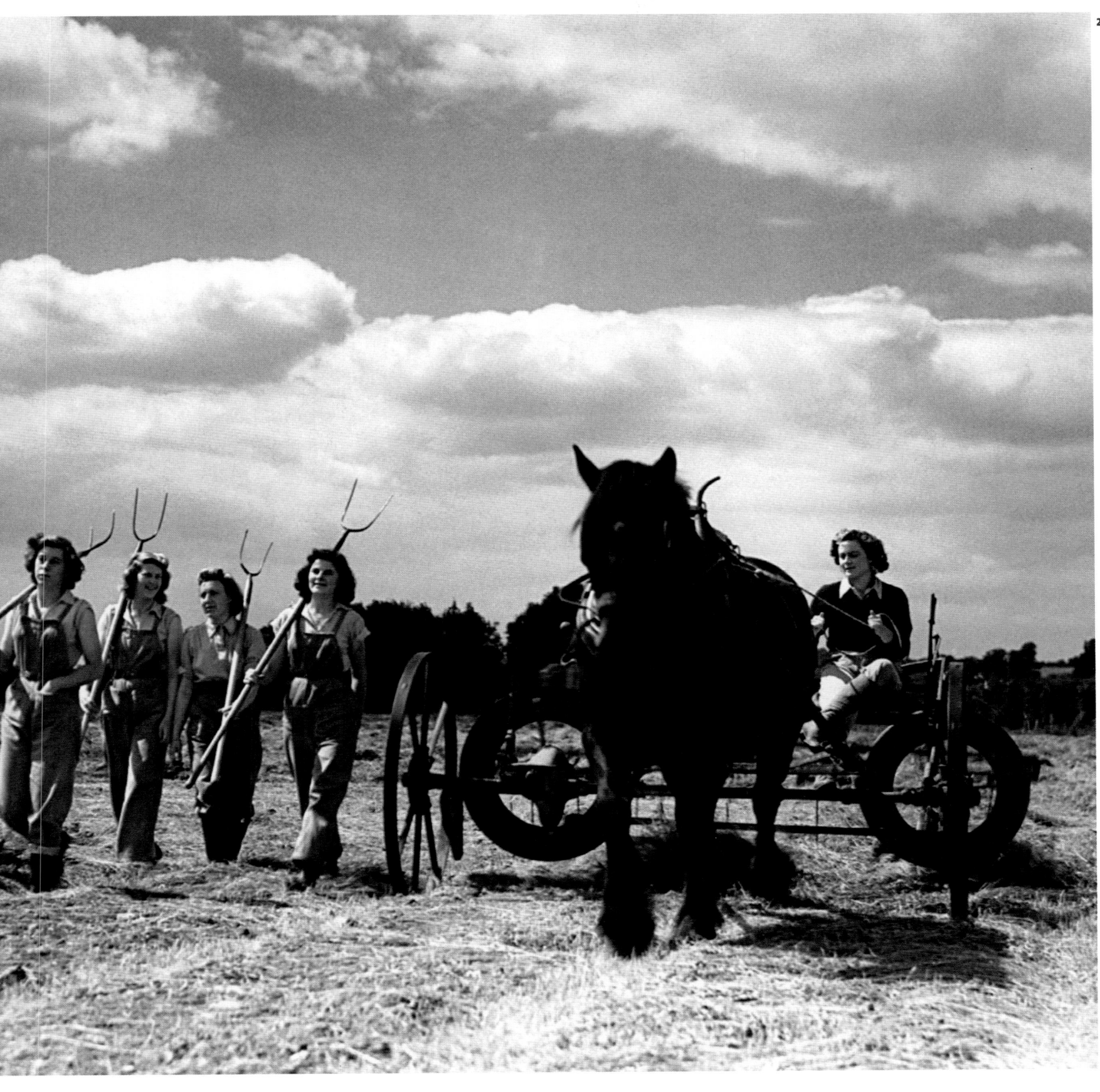

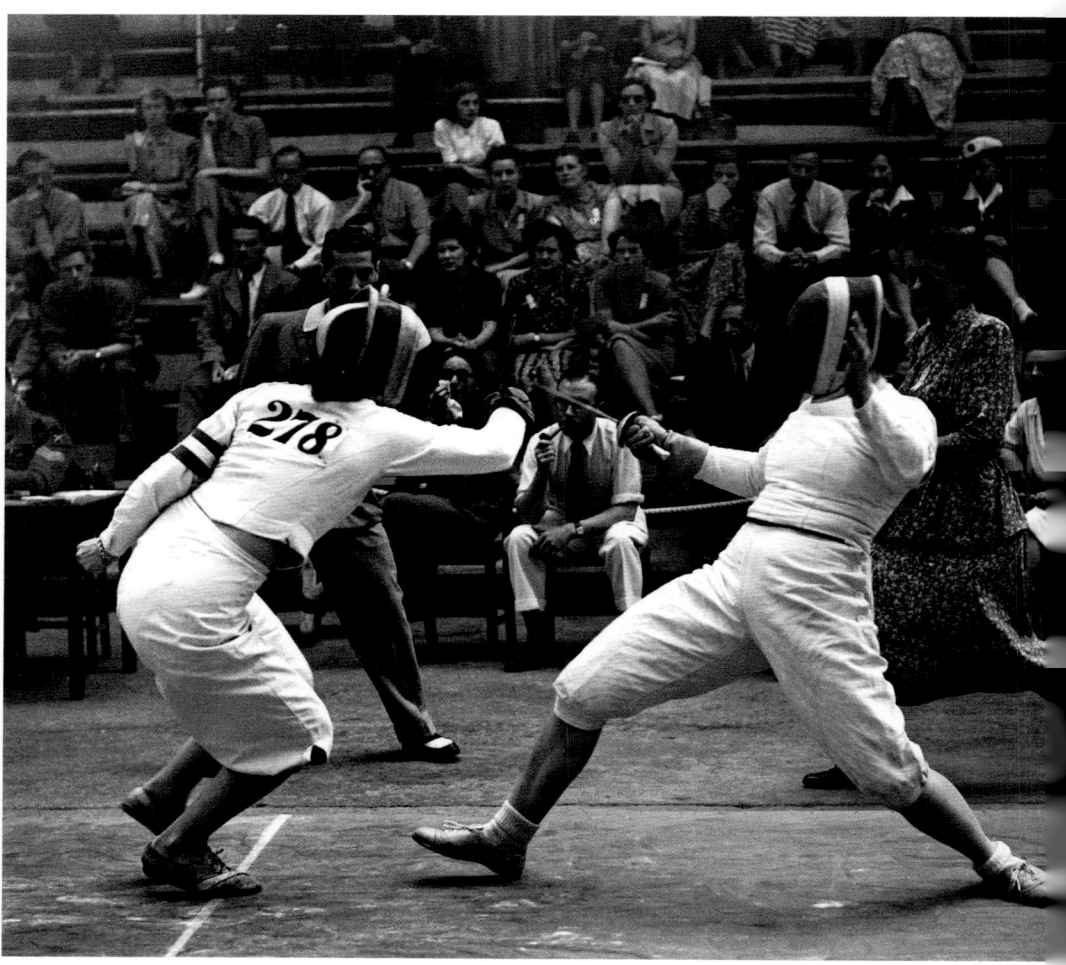

Above: Great Britain's Mary Glen-Haig (R) in action against Austria's F. Filz in the Foil semi-final. Although she went through to the final round, she did not gain a medal, placing eighth. She would compete in three more Olympics and win two gold medals at the Commonwealth Games.

2nd August, 1948

Left: Prince Adegboyega Folaranmi Adedoyin, originally from Nigeria, competes for Great Britain in the Long Jump at the London Olympics. He came fifth overall. He also took part in the High Jump, coming 12th.

31st July, 1948

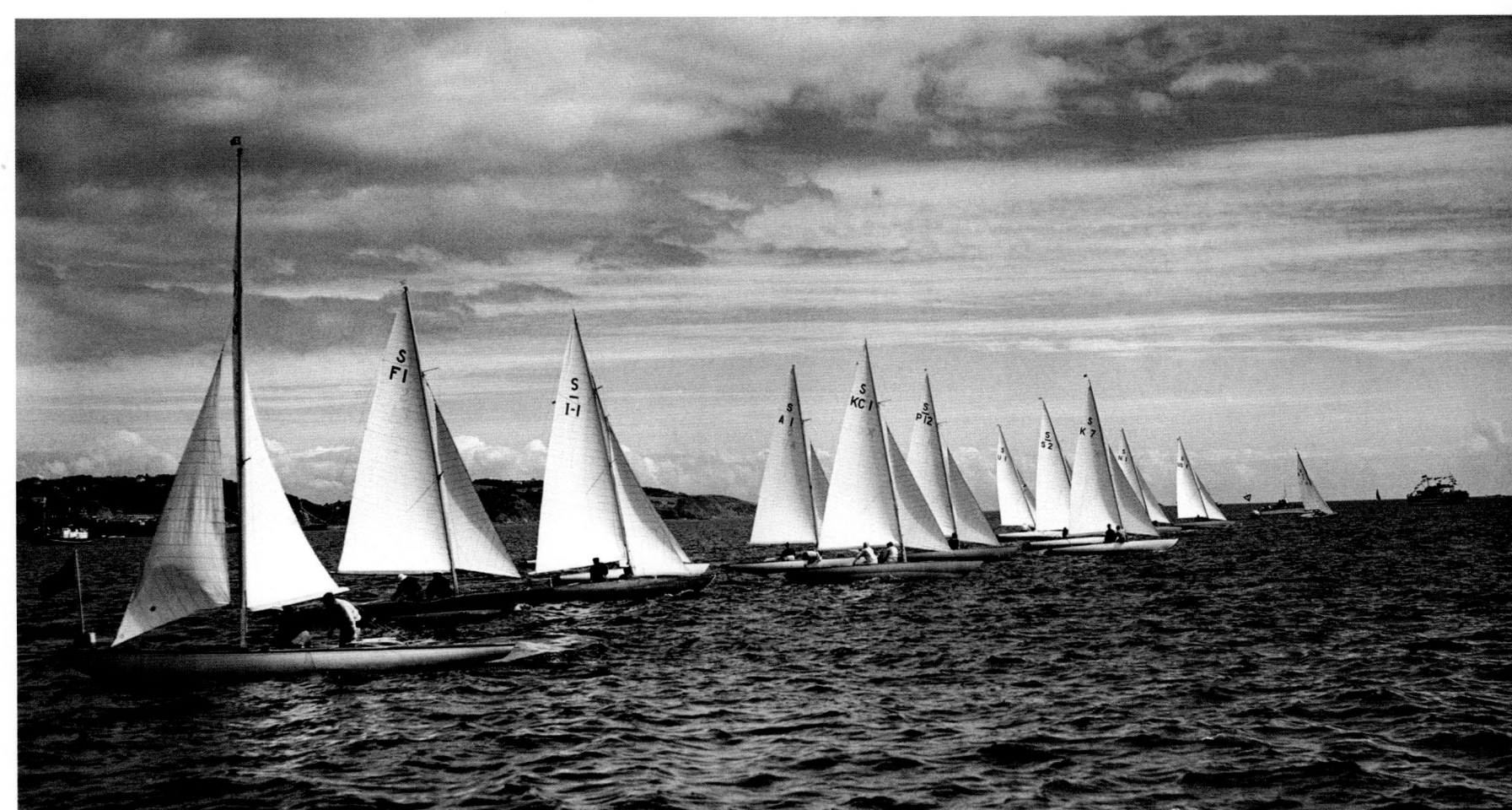

Above: Swallow Class yachts take part in a race at Torbay during the 1948 Olympic Games. Great Britain's entry, K7 *Swift* (fourth R), crewed by Stewart Morris and David Bond, was the gold medal winner in the event. Morris, who had served in the Royal Naval Volunteer Reserve during the Second World War, was British champion in both Swallow and Firefly classes.

3rd August, 1948

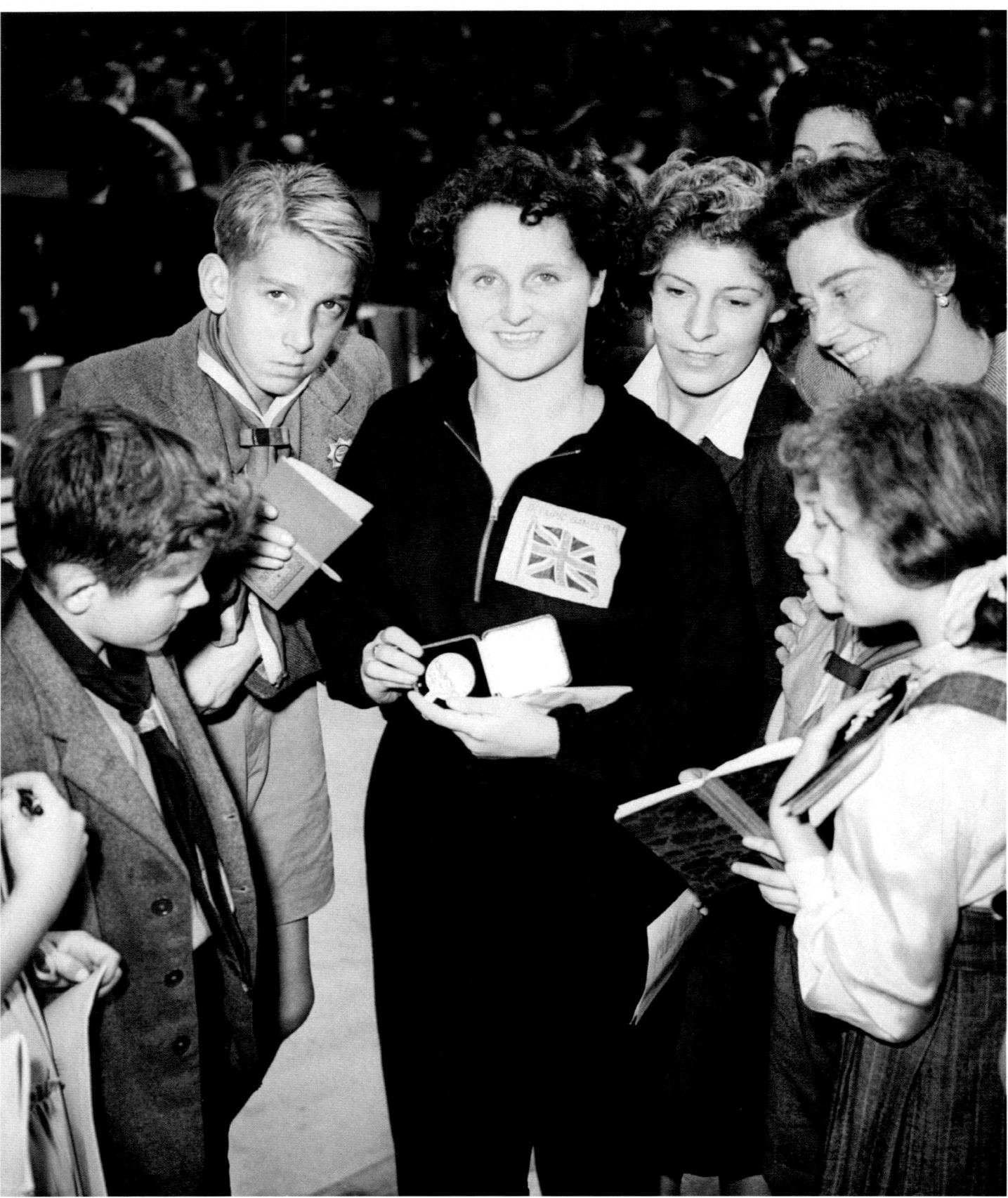

Left: Surrounded by young admirers, Scottish swimmer Catherine Gibson shows off the bronze medal she had won for Great Britain in the Women's 400m Freestyle final.

7th August, 1948

Above right: Great Britain's Harry Llewellyn on Foxhunter. Although the pair did not gain a medal at the 1948 Olympics, they would pick up a gold at the 1952 Olympic Games held in Helsinki.

7th August, 1948

Right: The Belgian women's gymnastic squad prepares with warm-up stretches.

12th August, 1948

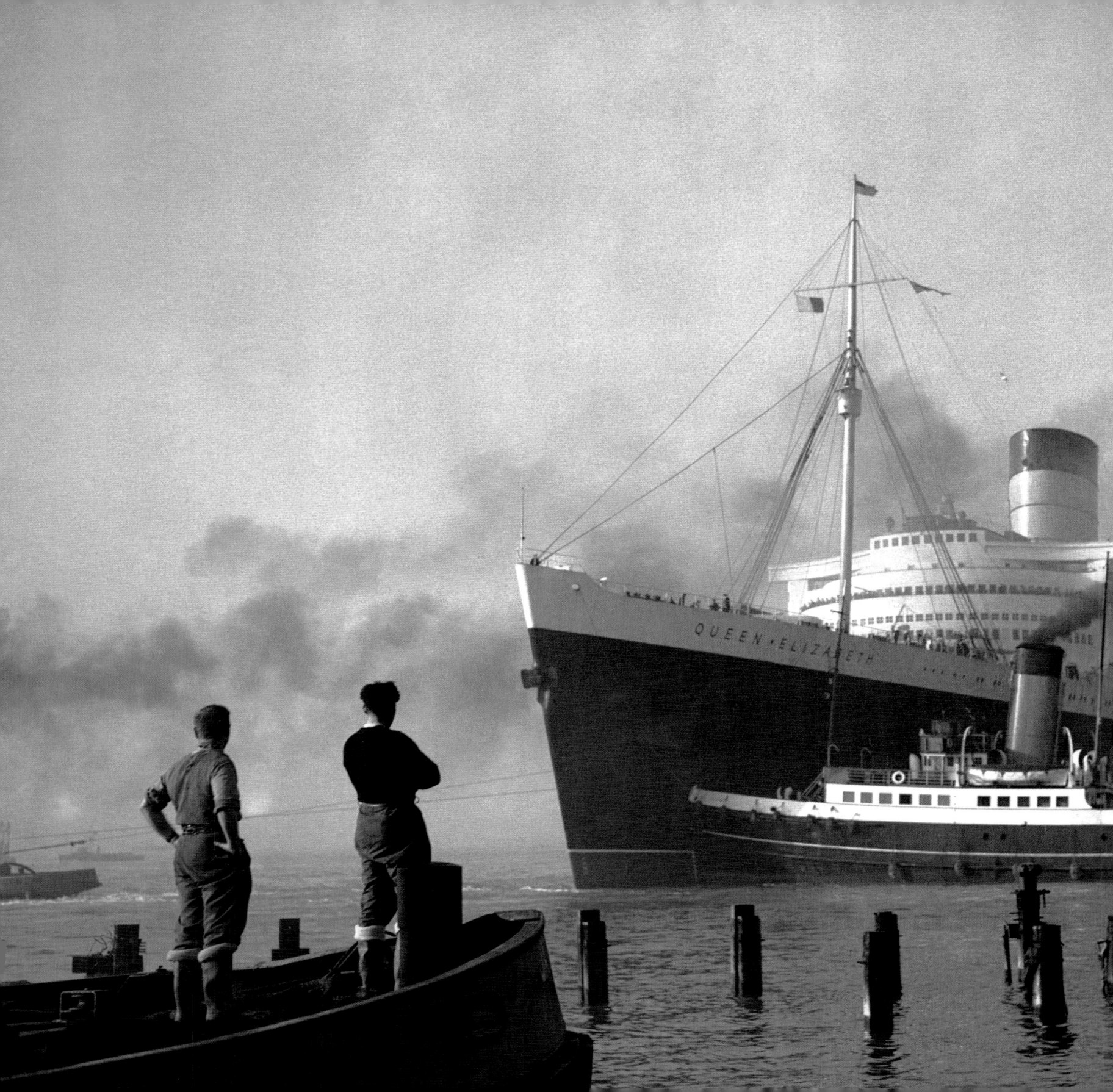

Top: The scene of the infamous Acid Bath Murders. At a ramshackle factory in Crawley, West Sussex, 39-year-old company director John George Haigh shot wealthy widow Olive Durand-Deacon and disposed of her body in sulphuric acid. While examining the human sludge remains, forensic investigators recovered three gallstones and part of her dentures.

2nd March, 1949

Above: John George Haigh at Horsham Courthouse, West Sussex, after being remanded for the murder of Olive Durand-Deacon. Police discovered that she was Haigh's sixth victim.

11th March, 1949

Left: The Cunard transatlantic liner RMS *Queen Elizabeth* sets sail from Southampton after being held up by a strike and then fog.

1st December, 1948

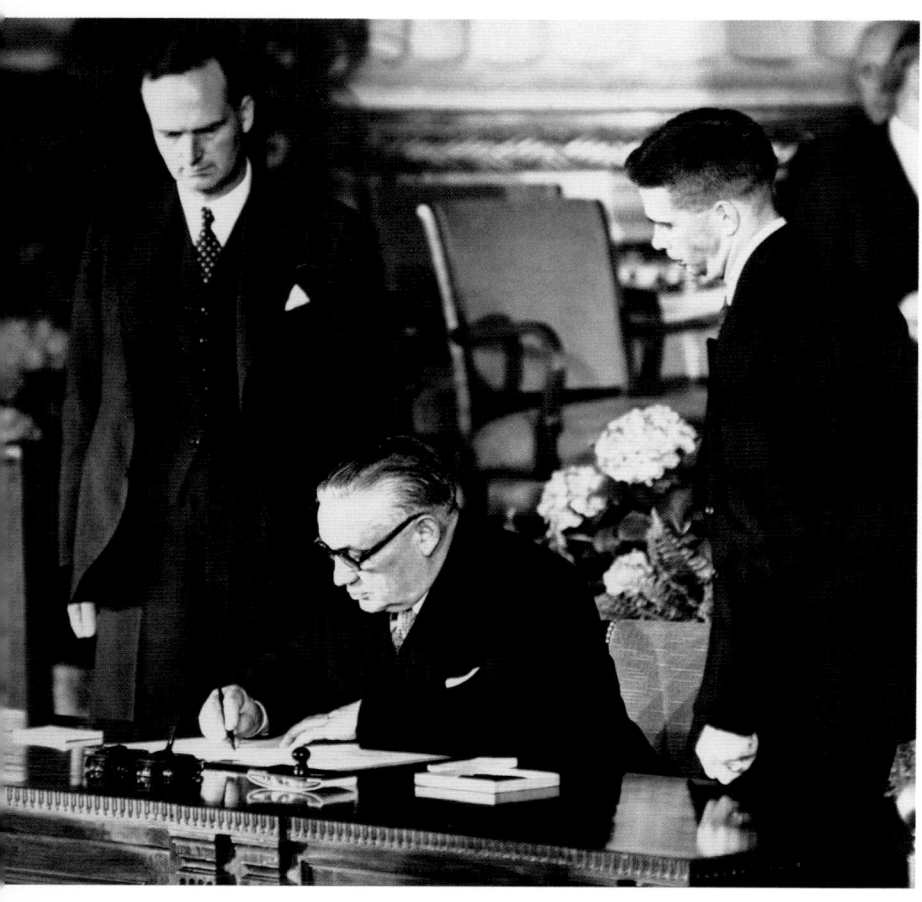

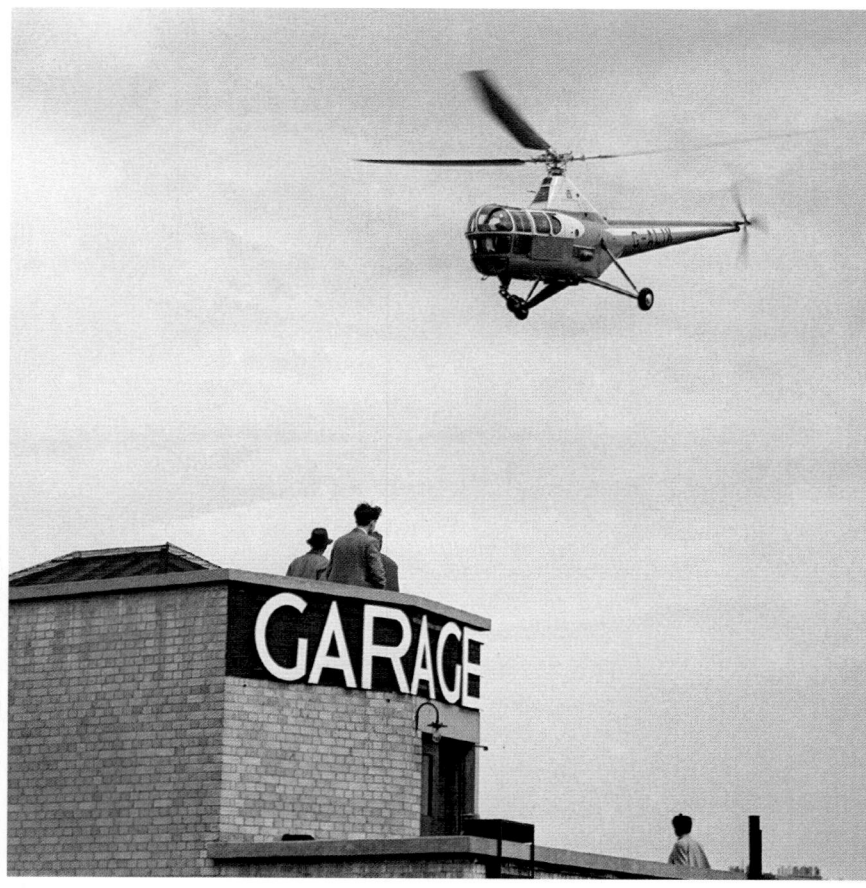

Above: A Westland WS-51 Dragonfly takes off from Olympia in London on the first helicopter passenger flight to Paris. The Dragonfly was a licence-built version of the American Sikorsky S-51. It was used by the Royal Navy for search-and-rescue work.

5th May, 1949

Above left: In Washington, DC, Foreign Secretary Ernest Bevin signs the North Atlantic Pact on behalf of the UK. Looking on is Sir Oliver Franks (L), British Ambassador to the United States. The pact brought into being the North Atlantic Treaty Organization (NATO). It was signed by 12 nations originally: Belgium, Canada, Denmark, France, Iceland, Italy, Luxembourg, the Netherlands, Norway, Portugal, the United Kingdom and the United States.

4th April, 1949

Left: Lethal legacy. During the Second World War, vast numbers of bombs were dropped on Britain by the German Air Force. Not all of them exploded, and many remained buried undergound for years until eventually unearthed by building excavations. These members of a Royal Engineers bomb disposal squad are defusing a 2,500lb (1,134kg) high-explosive bomb found in Dagenham, Essex.

21st May, 1949

Below: The Royal Navy's HMS *Amethyst* arrives safely at Hong Kong Naval Dockyard, having recently spent ten weeks trapped on the Yangtze River in China under bombardment from Communist artillery in what became known as the Yangtze Incident. Many of her crew, including the captain, were killed, while others were injured.

10th August, 1949

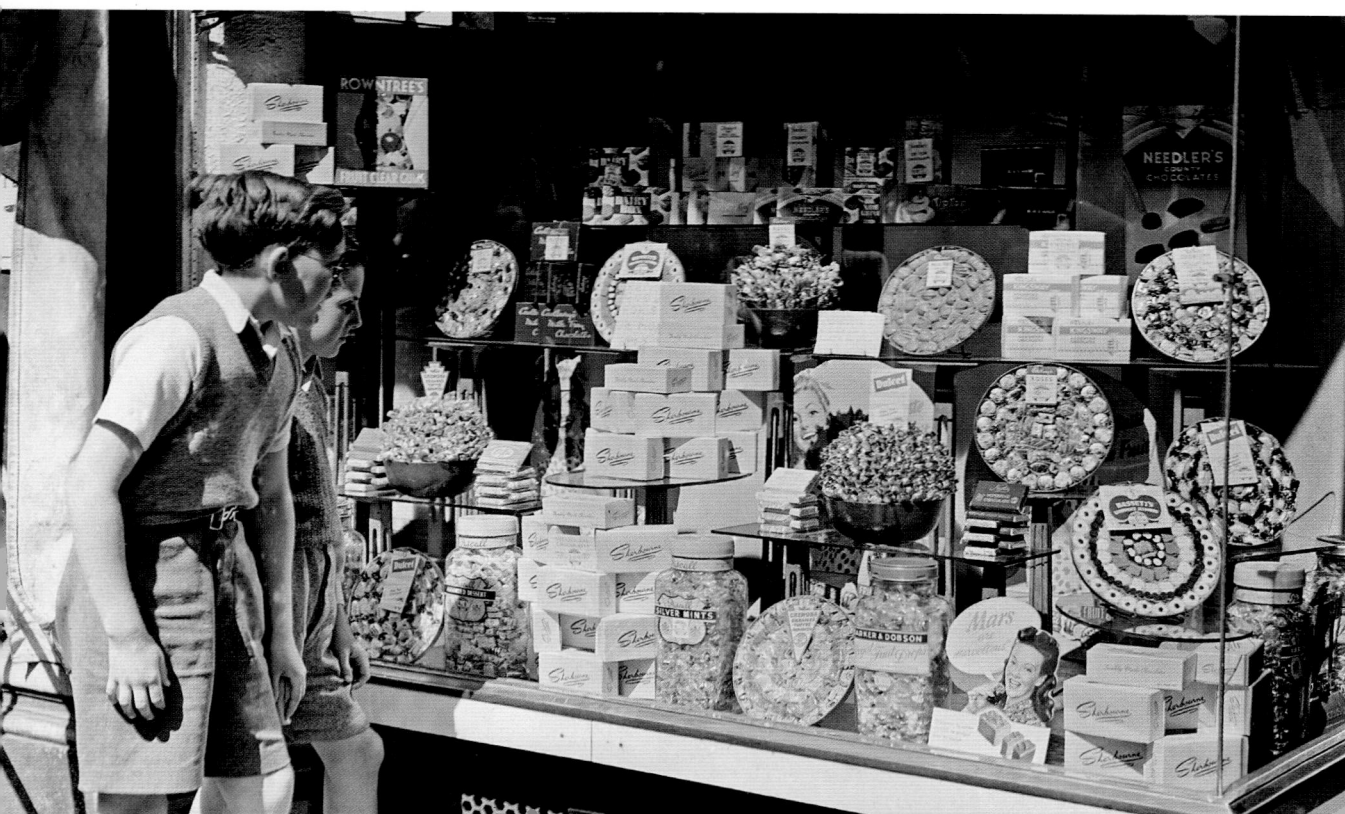

Left: A British Railways mobile booking office at Herne Bay, Kent offers cheap day tickets and third-class-only 'Holiday Run-about' tickets to other popular coastal resorts. British Railways had been formed in 1948 following the nationalization of the 'big four' private British rail companies. It remained in operation until the mid-1990s, when the rail system was gradually reprivatized.

11th August, 1949

Below left: Tempting treats. To the horror of British children, sweet rationing is reintroduced and will not end until 1953.

12th August, 1949

Right: Goggle box. A family at home watching television. Broadcasts had been suspended in Britain in 1939 following the outbreak of the Second World War, but they were resumed by the BBC on 7th June, 1946.

15th September, 1949

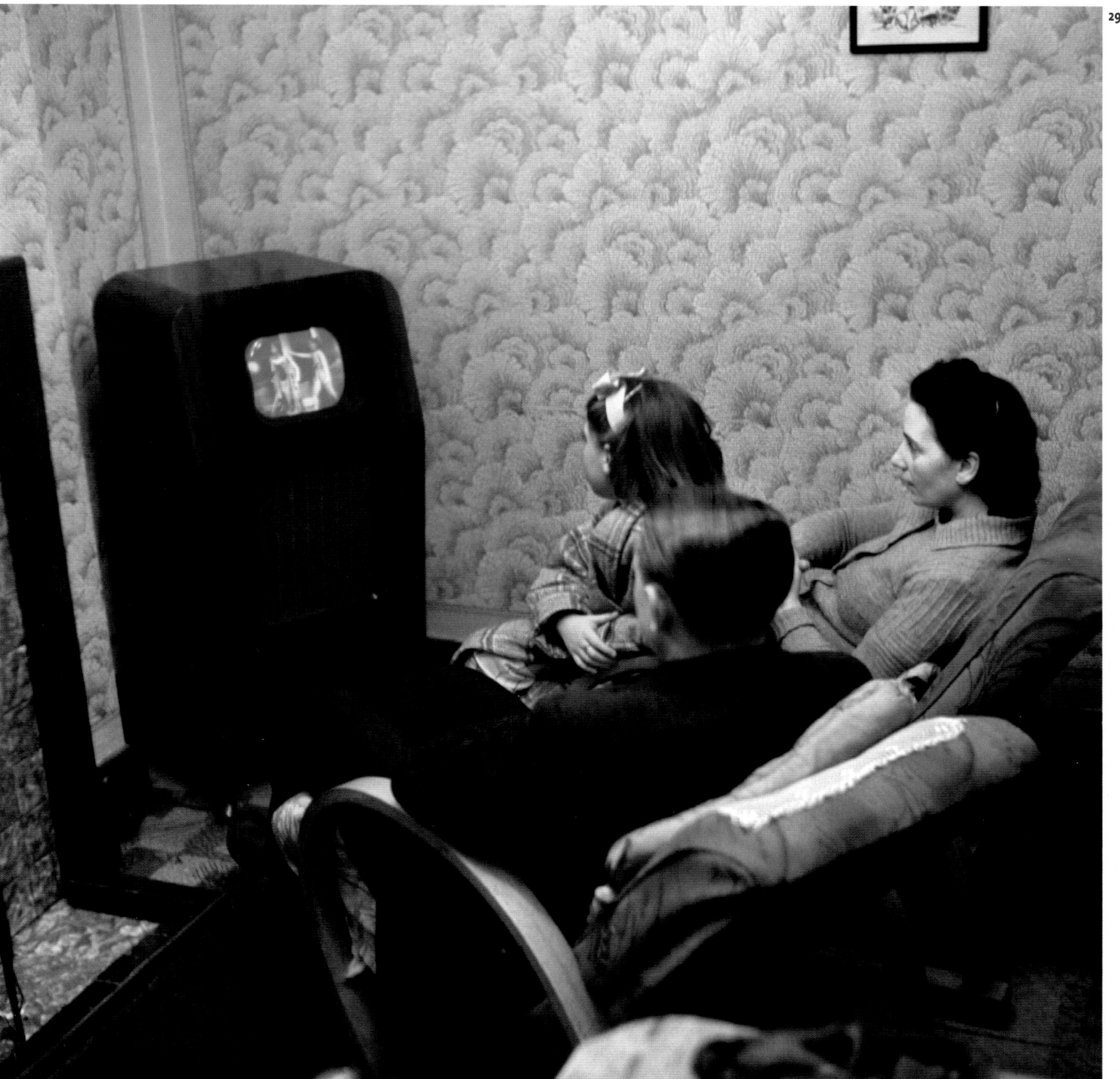

1950s

Standing at the mid-point of the 20th century, the 1950s was a period of contrasts. The world's first jet aircraft passenger service was introduced in 1952, yet milk was still delivered by horsedrawn carts, while the last working oxen in the country were still being used for ploughing in 1959. In London, the Festival of Britain of 1951 had its eyes fixed firmly on a modernistic horizon, but rationing of basic foods continued well into the decade. Inevitably, shadows of the previous decade's world war persisted, darkened by the conflicts in Korea and Suez, and civil unrest in the last outposts of empire.

The people who populate the following pages could not have known what the next decade held for them, but with our hindsight the signs are there to see: in the 1950s, teenagers emerge as a distinct social group with their own culture, no longer merely an awkward intermediate stage between childhood and adult life; the stirring of racial tensions begins to be felt as increasing numbers of migrants arrive from the Caribbean; and the medium of television takes its place as both recorder of and influence on life in Britain.

Thus the past and future meet gradually, mingling and gently colliding in a process of ceaseless change in the journey from what has been to what will be.

Left: Loaded with rockets and bombs destined for targets in Korea, this Douglas AD Skyraider is about to take off from a United States Navy carrier, which was part of a combined American-British task force. The Skyraider was a powerful and adaptable machine that specialized in close air support for ground troops. It also saw service in Vietnam during the late 1960s and 1970s.

10th July, 1950

Below left: Vera Lynn, known during the Second World War as the 'Forces Sweetheart', brings back memories for ex-servicemen during a garden party held by the Queen at Buckingham Palace, London.

3rd August, 1950

Right: The 1st Battalion Royal Northumberland Fusiliers raise a cheer as they set sail for Korea aboard the troopship *Empire Halladale* from Southampton. The conflict had broken out between the Republic of Korea (in the south), supported by the United Nations, and the Democratic People's Republic of Korea (the north), backed by China and the Soviet Union. It started in June 1950 and continued until July 1953. It became, in effect, a proxy war between the powers involved in the Cold War.

11th October, 1950

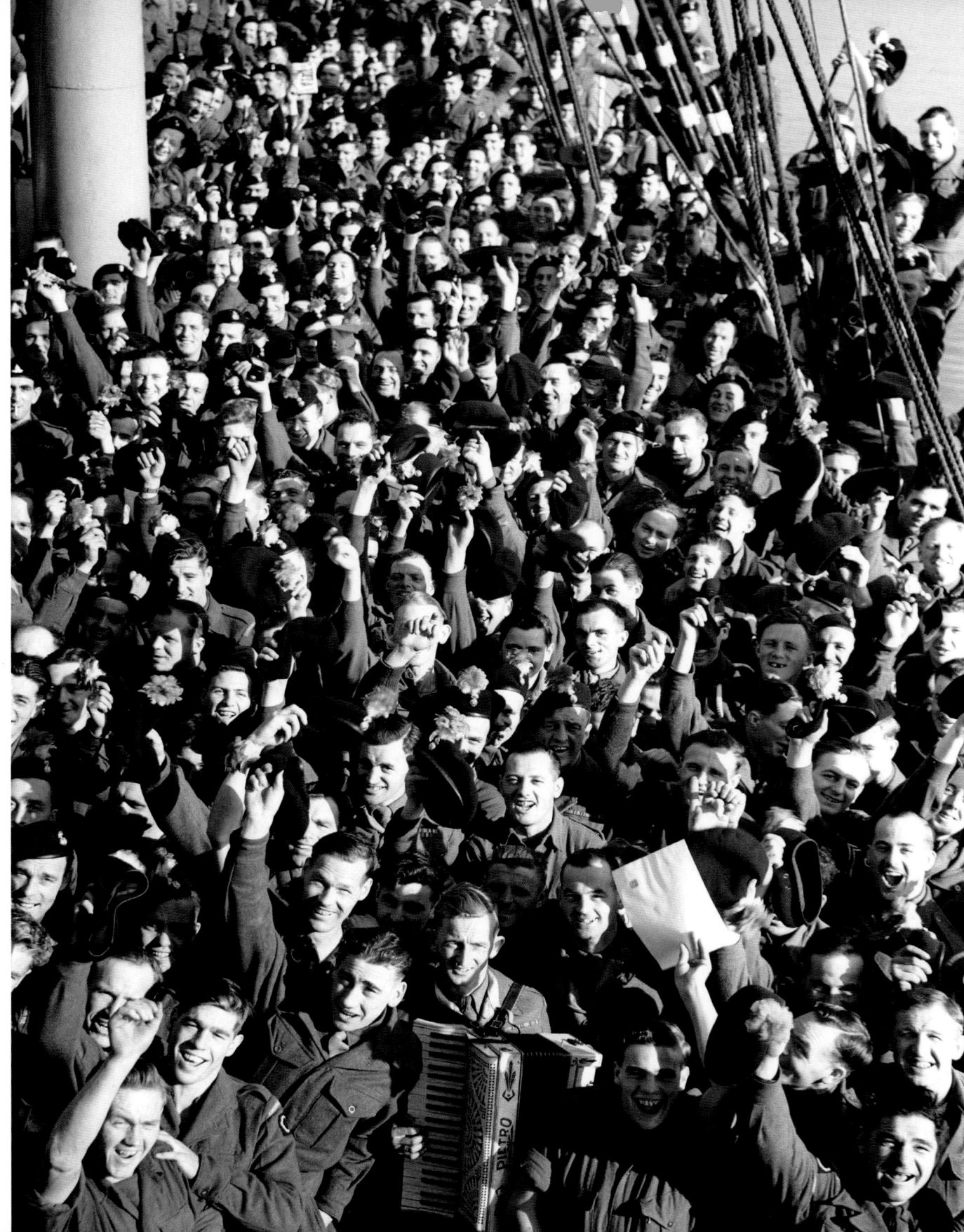

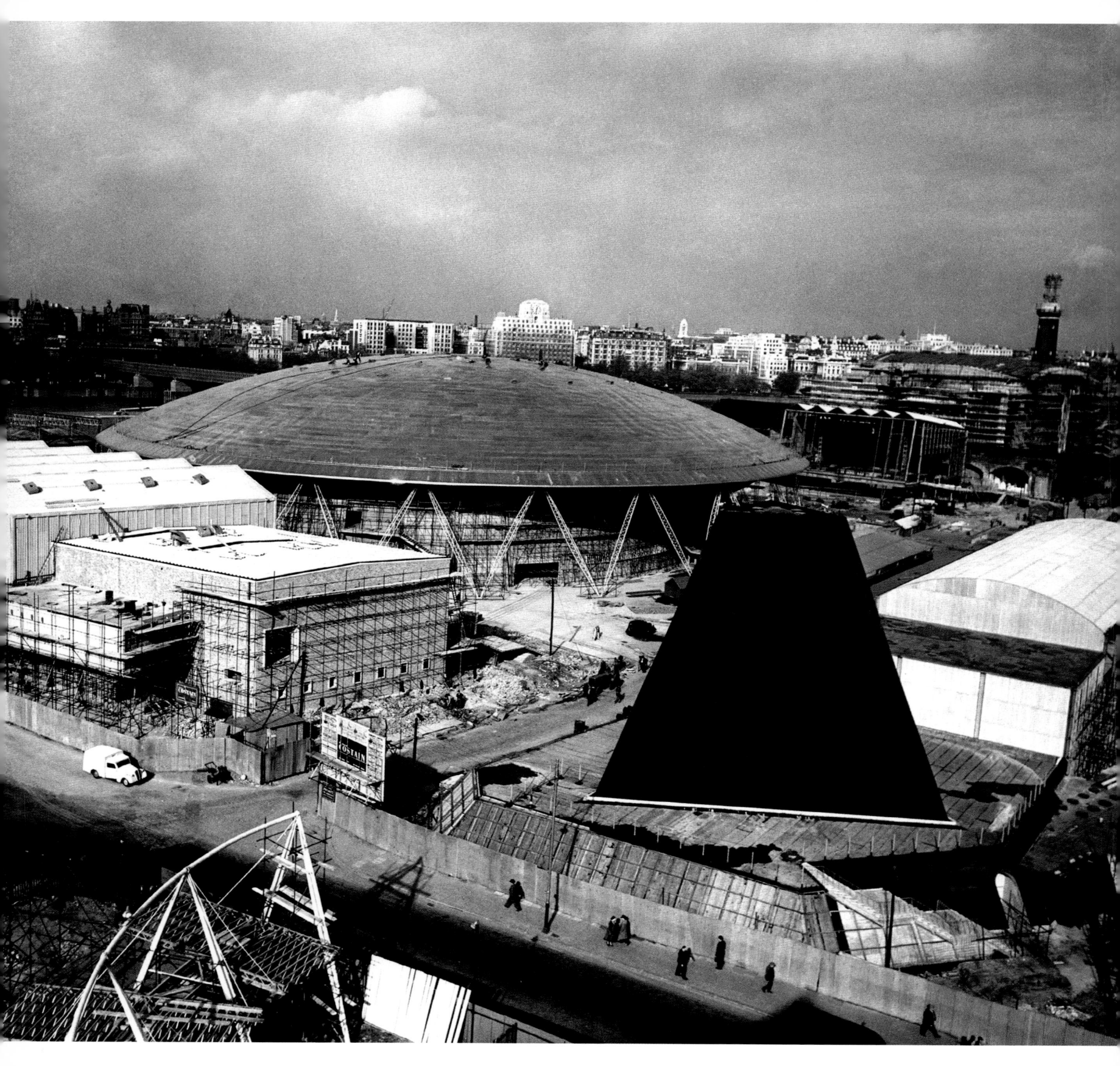

Left: Work progresses on the Festival of Britain site on the south bank of the River Thames in London. Dominating the site is the Dome of Discovery, while in the distance is the Shot Tower, the only original building left standing on the site. Used originally for the manufacture of shot balls through the freefall of molten lead, it was fitted with a radio telescope aimed at the moon. The festival opened in 1951.

12th October, 1950

Right: The number of women working in the Women's Land Army steadily decreased as men returned from the forces to reclaim their jobs, and the food shortage in Britain gradually eased. Eventually, the WLA was officially disbanded and 500 of its members, clad in their trademark uniform, marched from Wellington Barracks to Buckingham Palace for their farewell inspection by Queen Elizabeth (later the Queen Mother).

21st October, 1950

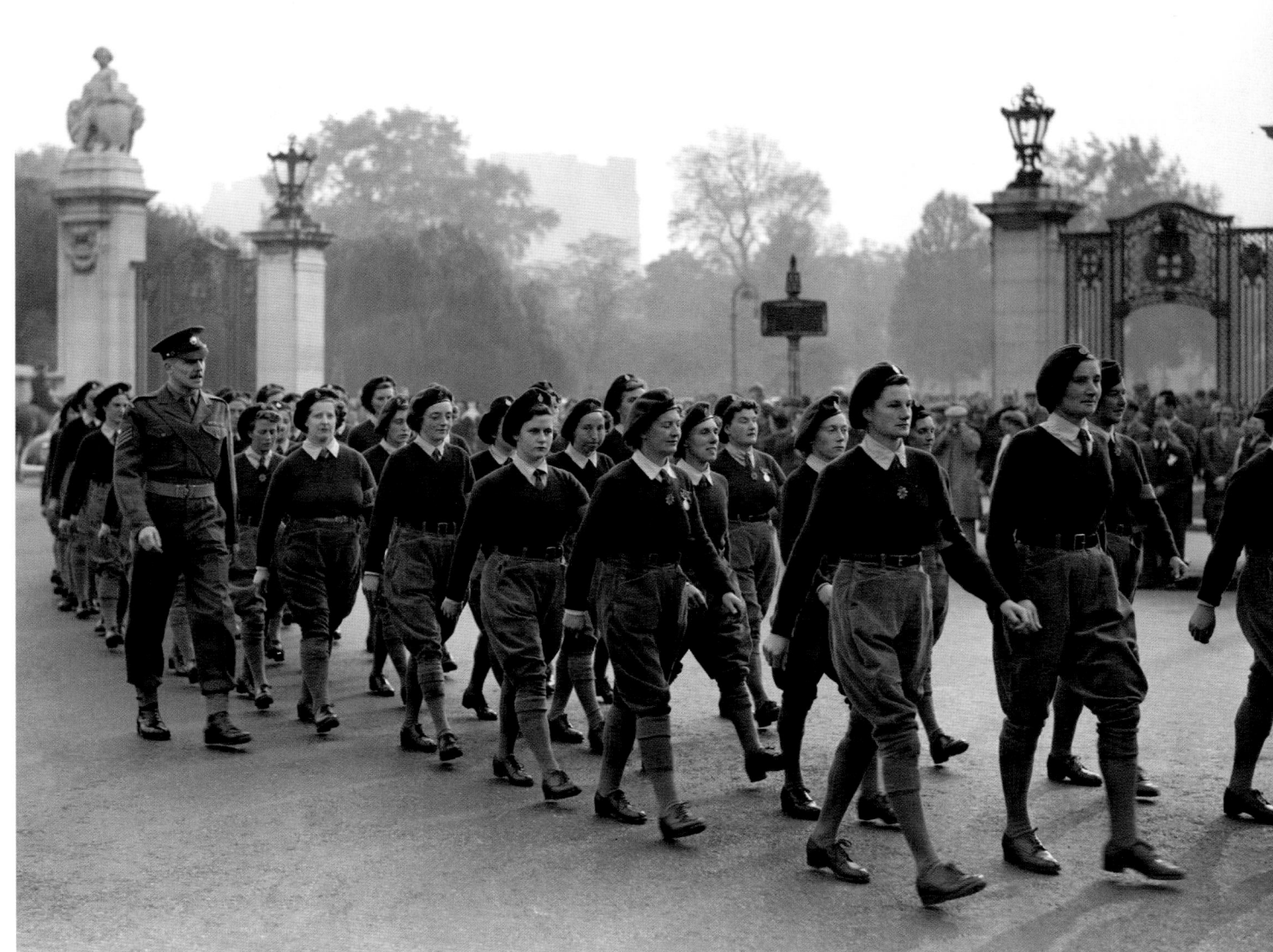

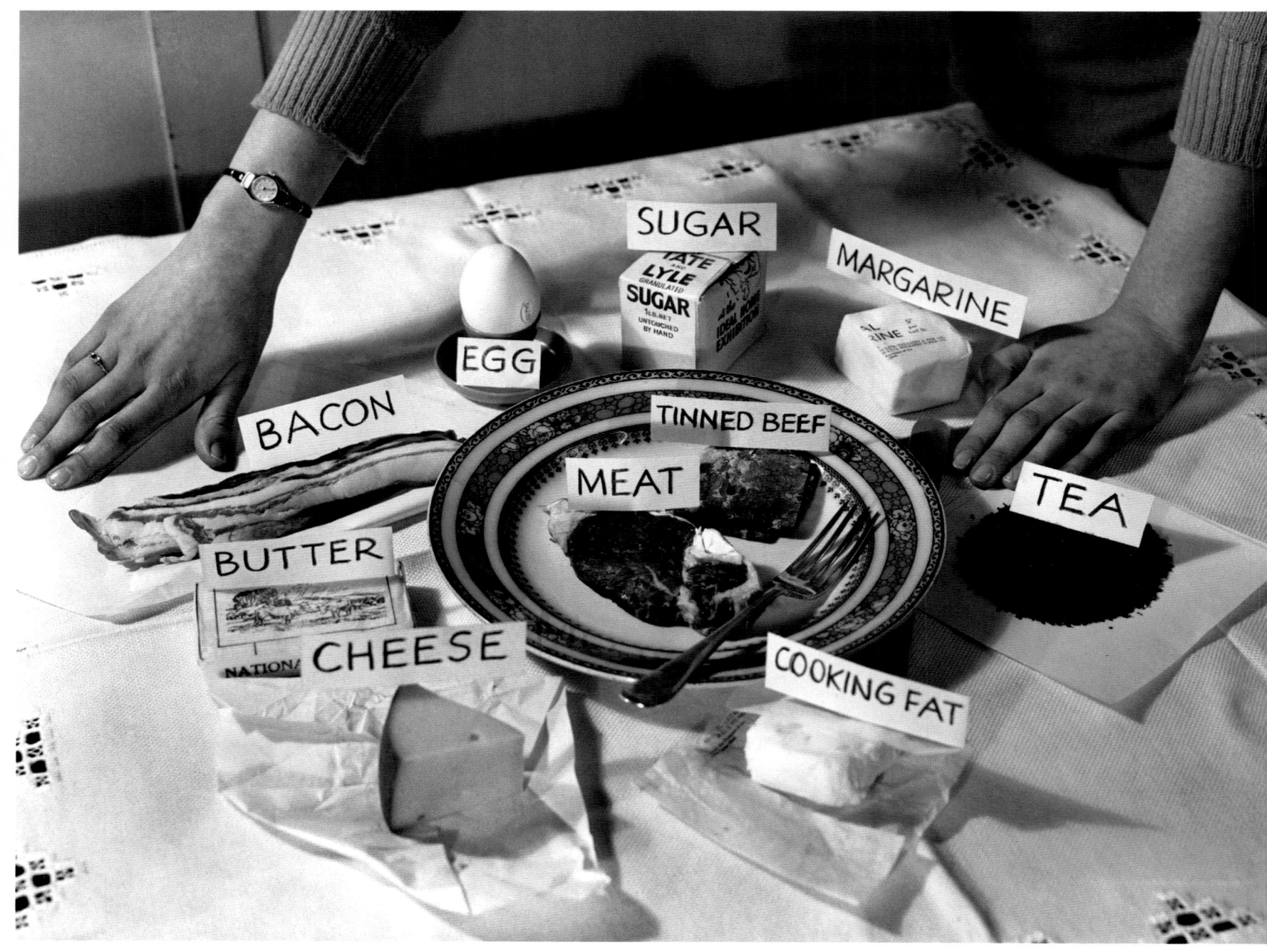

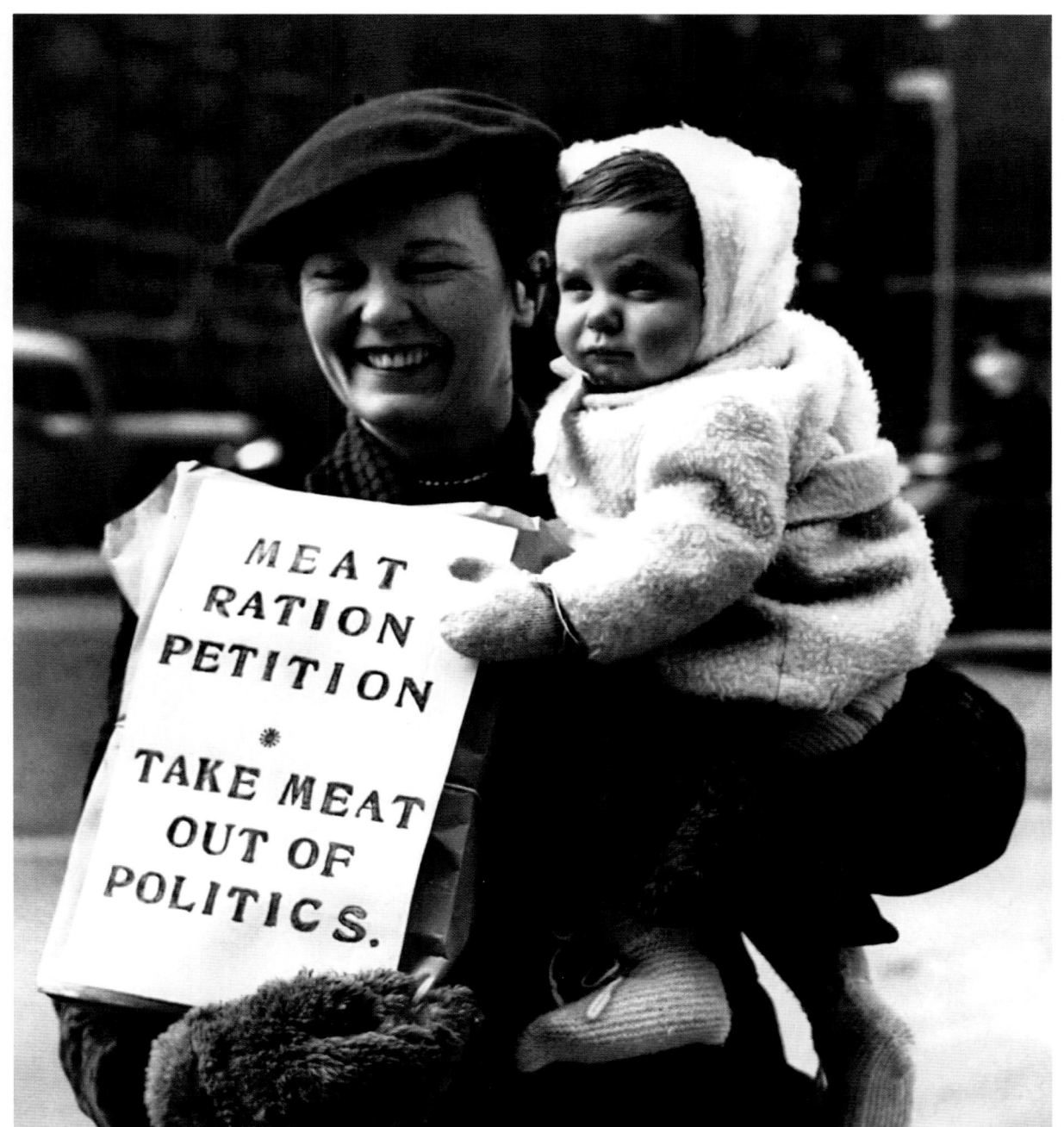

Far left: Food rationing continued into the 1950s, and in some cases became harsher than during the war years. This was due to a number of reasons, including the need to feed the population of areas of war-torn Europe under British control, and a lack of resources to expand food production and importation. One person's weekly portion of rationed foods is shown here.

10th February, 1951

Left: Actress Mary Clare led a group of women who presented a petition – signed by 166,000 – to the House of Commons, London, asking that meat rationing be ended. In fact, it remained in place until 1954.

20th March, 1951

Above: Described by the Labour Party's deputy leader Herbert Morrison as a *"tonic for the nation"*, the Festival of Britain was a series of exhibitions aimed at giving the population a sense of pride, and a feeling of recovery and progress after the grim wartime years of the 1940s. This Transport Pavilion was at the main site on London's South Bank. Hanging from the roof are two racing aircraft, a Supermarine S6 seaplane and a twin-engine de Havilland Comet, both successful pre-war machines.

16th April, 1951

Right: A nighttime view from Westminster Bridge, after the opening of the Festival of Britain by King George VI, showing the distinctive and apparently free-floating Skylon, the Royal Festival Hall and the Dome of Discovery. A popular joke at the time was that the Skylon, like the British economy, had no visible means of support.

4th May, 1951

Above: Guy Burgess, former British intelligence officer and double agent who fled to Russia with his friend and fellow spy Donald Maclean. For nearly five years, their whereabouts was a mystery until they revealed themselves in Moscow in 1956. The pair belonged to a group known as the 'Cambridge Five', all of whom had been recruited at Cambridge University. The other members of the group were Kim Philby, Anthony Blunt and John Cairncross.

1951

Left: Donald Maclean, a former British diplomat, was publicly exposed as a spy for the Soviet Union in 1951. He defected to Russia and remained there until he died in 1983. Maclean had passed secrets concerning atom bomb production to the Soviets during and after the Second World War.

1951

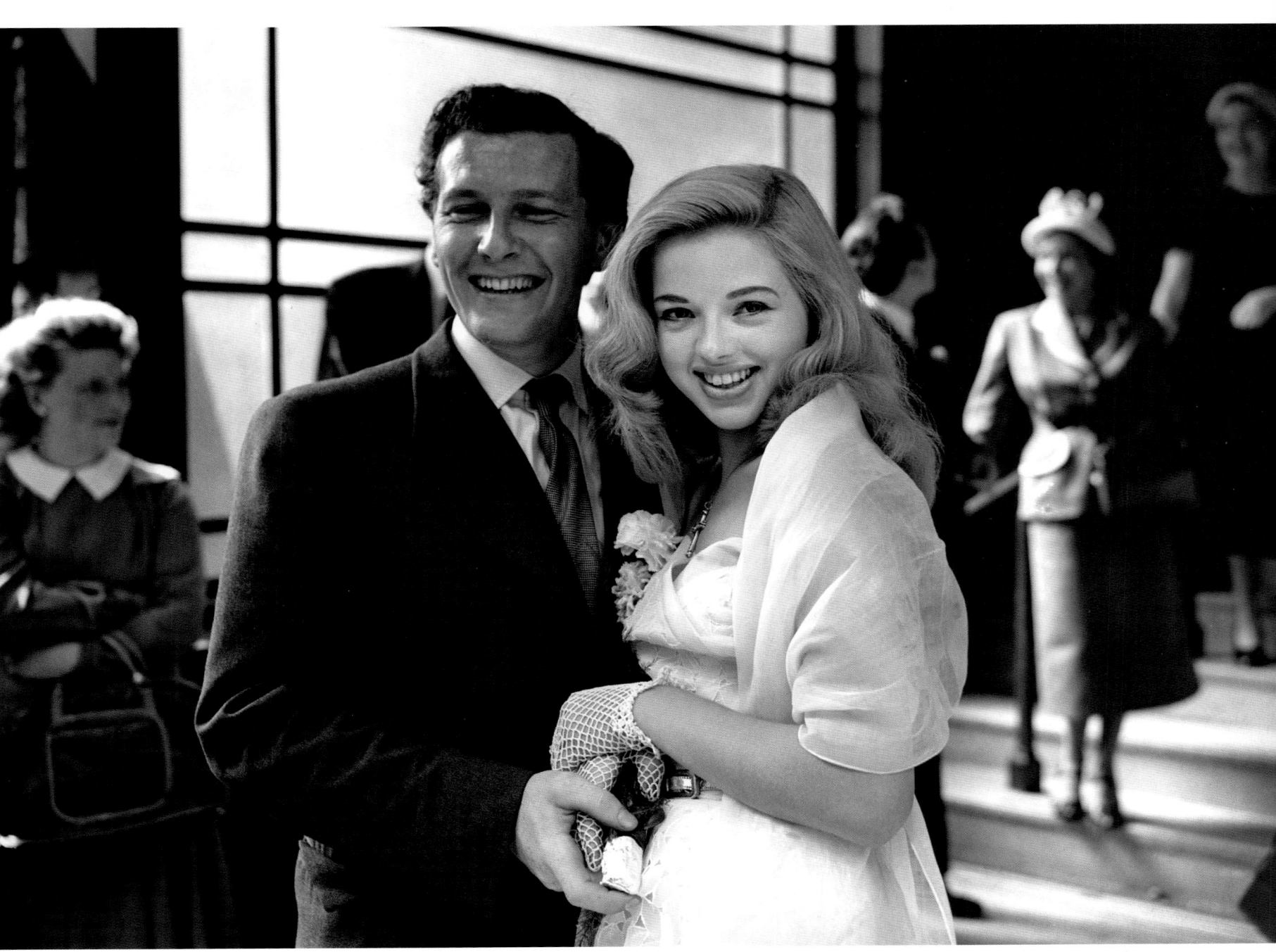

Above: Nineteen-year-old film actress Diana Dors and her new husband, Dennis Hamilton, 26-year-old representative of an engineering firm, leaving Caxton Hall registrar's office after their wedding. Dors was a skilled actress, but her looks condemned her to many lightweight roles.

3rd July, 1951

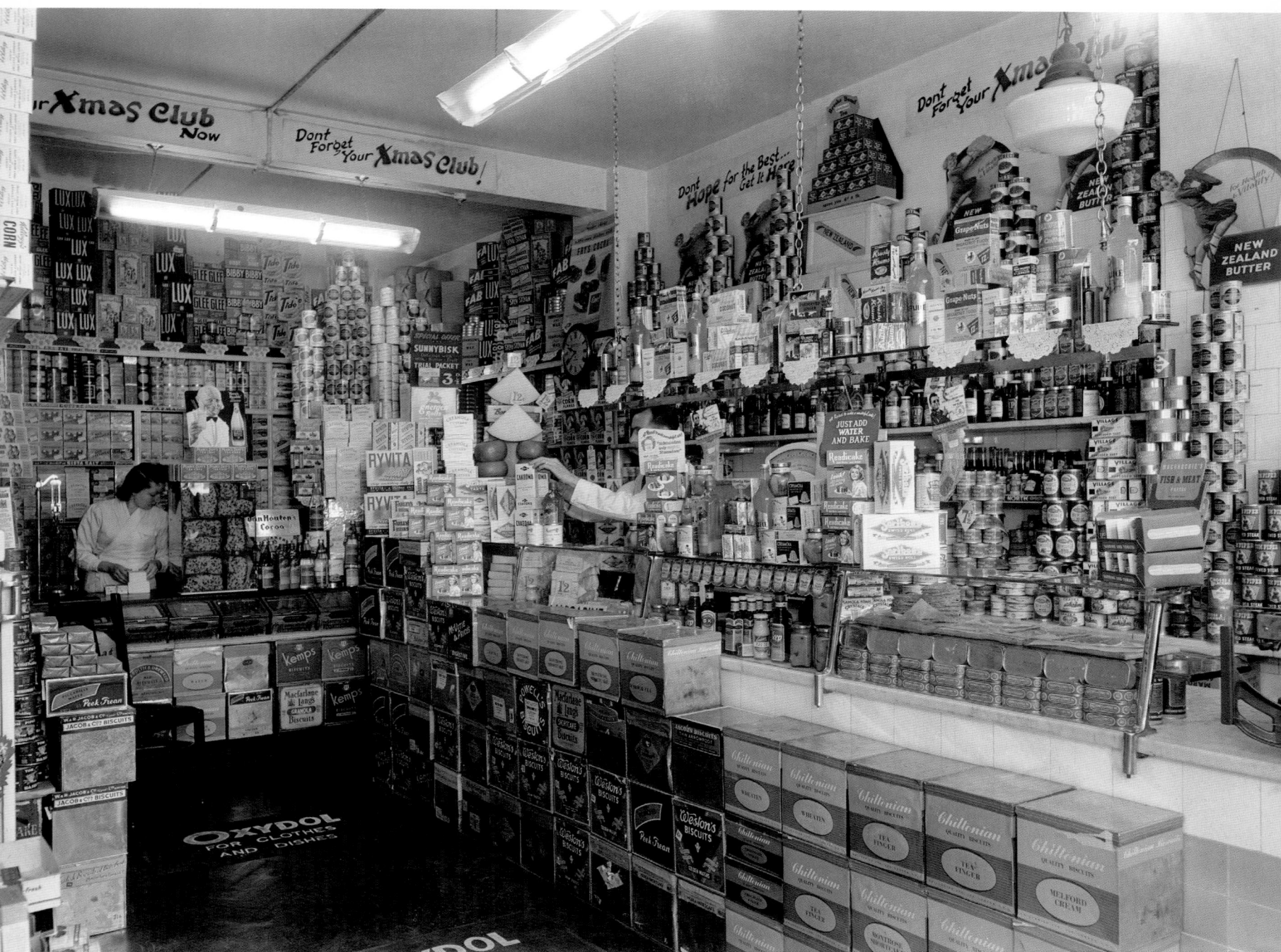

Above: The interior of a grocer's shop before the advent of the supermarket. Marks & Spencer opened its first self-service shop in 1948, Sainsbury's and Gateway (Somerfield) followed suit in 1950, while Tesco opened its first supermarket in 1954.

11th July, 1951

Below: An Express Dairy milk roundsman with horse and cart. Although motorized delivery was introduced in the 1940s with the Bush Pony three-wheeler electric float, the traditional methods were still used on some rounds well into the 1950s. In many cases, the horses were so familiar with the rounds that they would walk and stop where required without being commanded by the milkman.

13th July, 1951

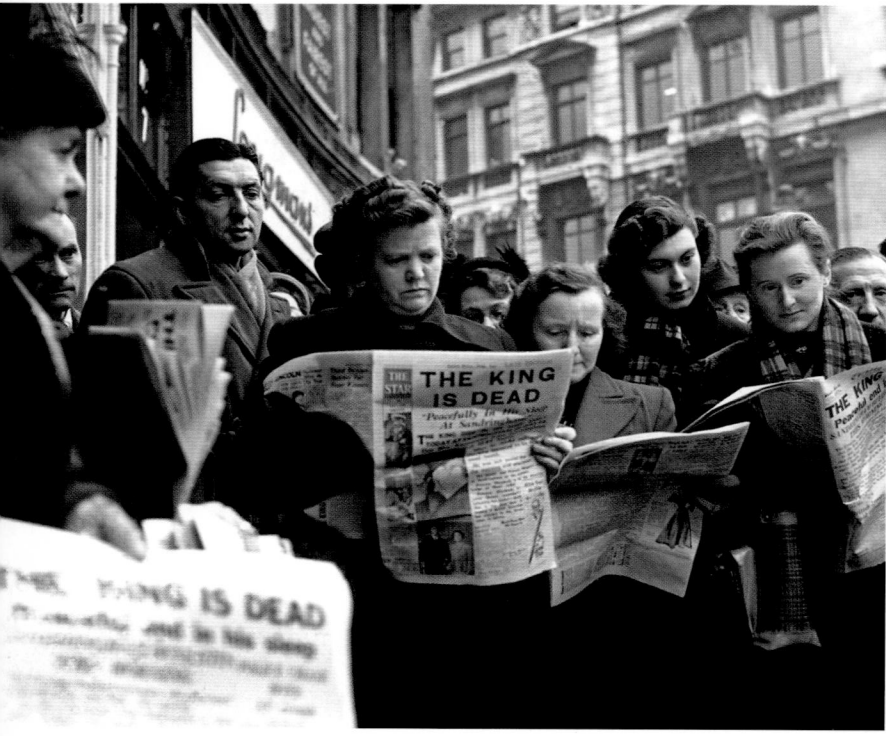

THE KING IS DEAD

THE KING IS DEAD
"Peacefully in his sleep"
At Sandringham

THE KING IS DEAD
Peacefully and in his sleep

Above: Lunchtime crowds at
Ludgate Circus in London read news
of the death of King George VI. The
stress of the wartime years had
taken a toll on the King's health,
on top of which he was a heavy
smoker and had developed lung
cancer. Increasingly, ill health had
prevented him from attending
official engagements, and his
daughter, Princess Elizabeth, had
been required to stand in for him.
He died from a coronary thrombosis
while asleep on 6th February, 1952.

6th February, 1952

Right: The coffin of King George VI
lies in state at Westminster Hall,
London. The funeral was held at St
George's Chapel, Windsor Castle,
where his remains lie alongside
those of his wife, Queen Elizabeth
The Queen Mother and his
daughter, Princess Margaret.

11th February, 1952

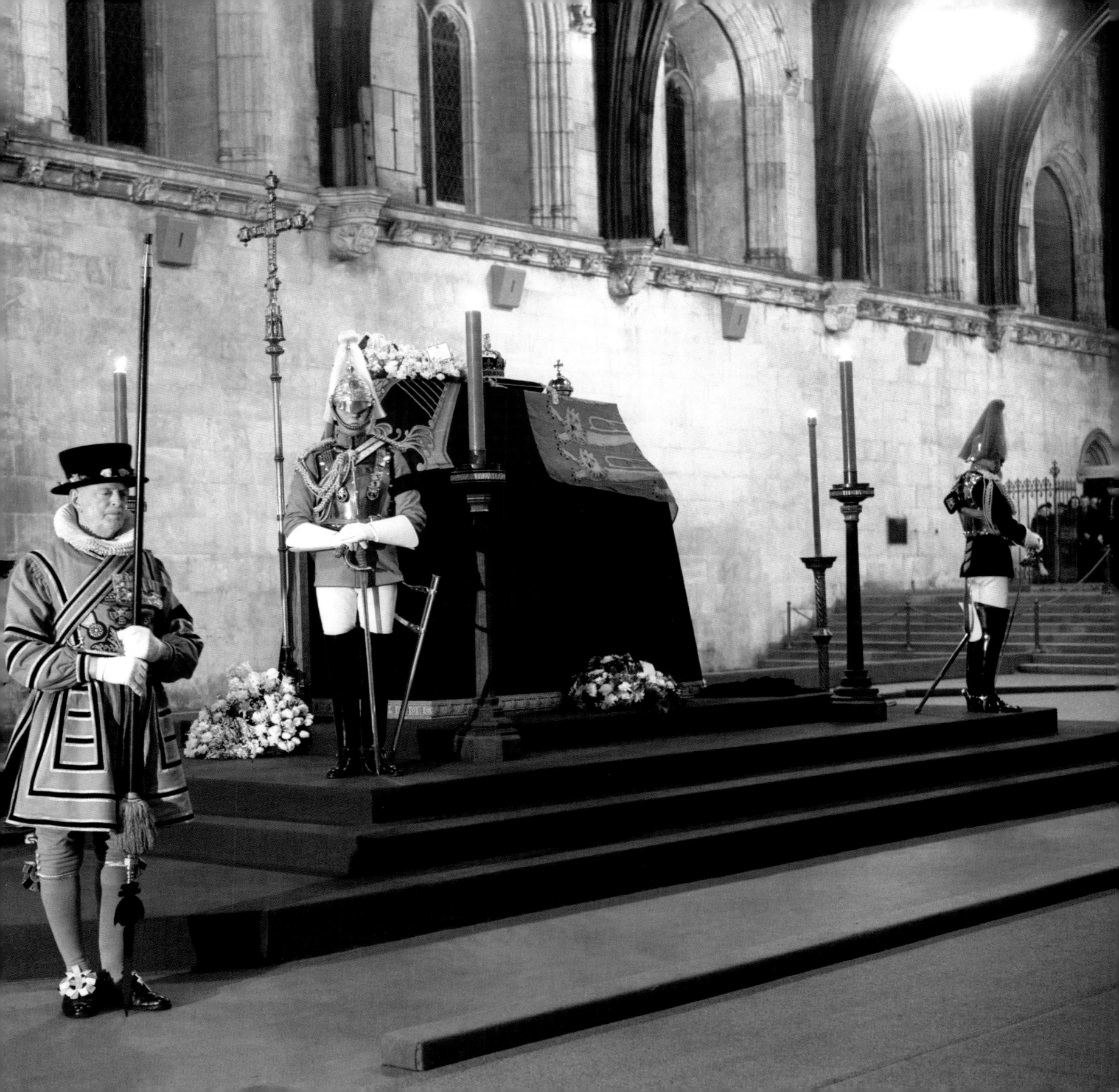

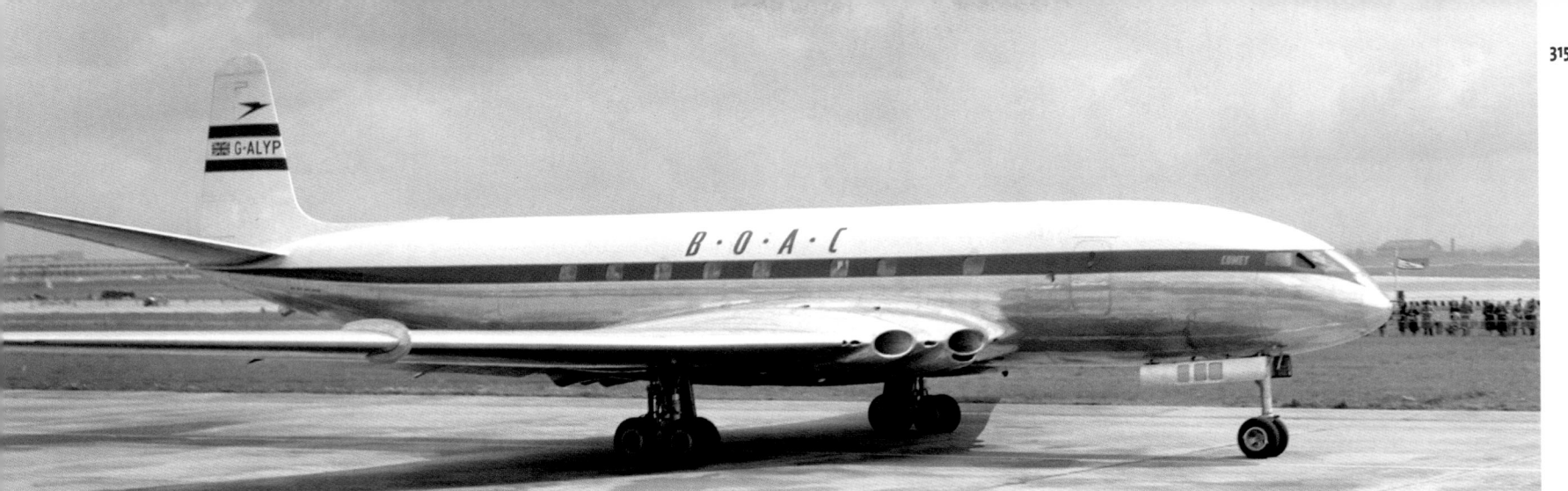

Above: The world's first regular jet airliner service was inaugurated on 2nd May, 1952 when a 36-seat de Havilland Comet of British Overseas Airways (BOAC) took off from London's Heathrow Airport on a flight to Johannesburg, South Africa. The Comet was the world's first commercial jet airliner, having first taken to the air in 1949.

2nd May, 1952

Above left: Oxford University's crew rows out into a blizzard at the start of the 1952 University Boat Race. They would just take the win that year.

29th March, 1952

Left: Bagging a bargain. Shoppers pick over the collectables at a stall in north London's Caledonian Market.

5th April, 1952

Right: End of an era. The summer of 1952 saw the end of the tram service in London. From then on, buses became the norm. Ironically, trams are considered to be more environmentally friendly today.

30th June, 1952

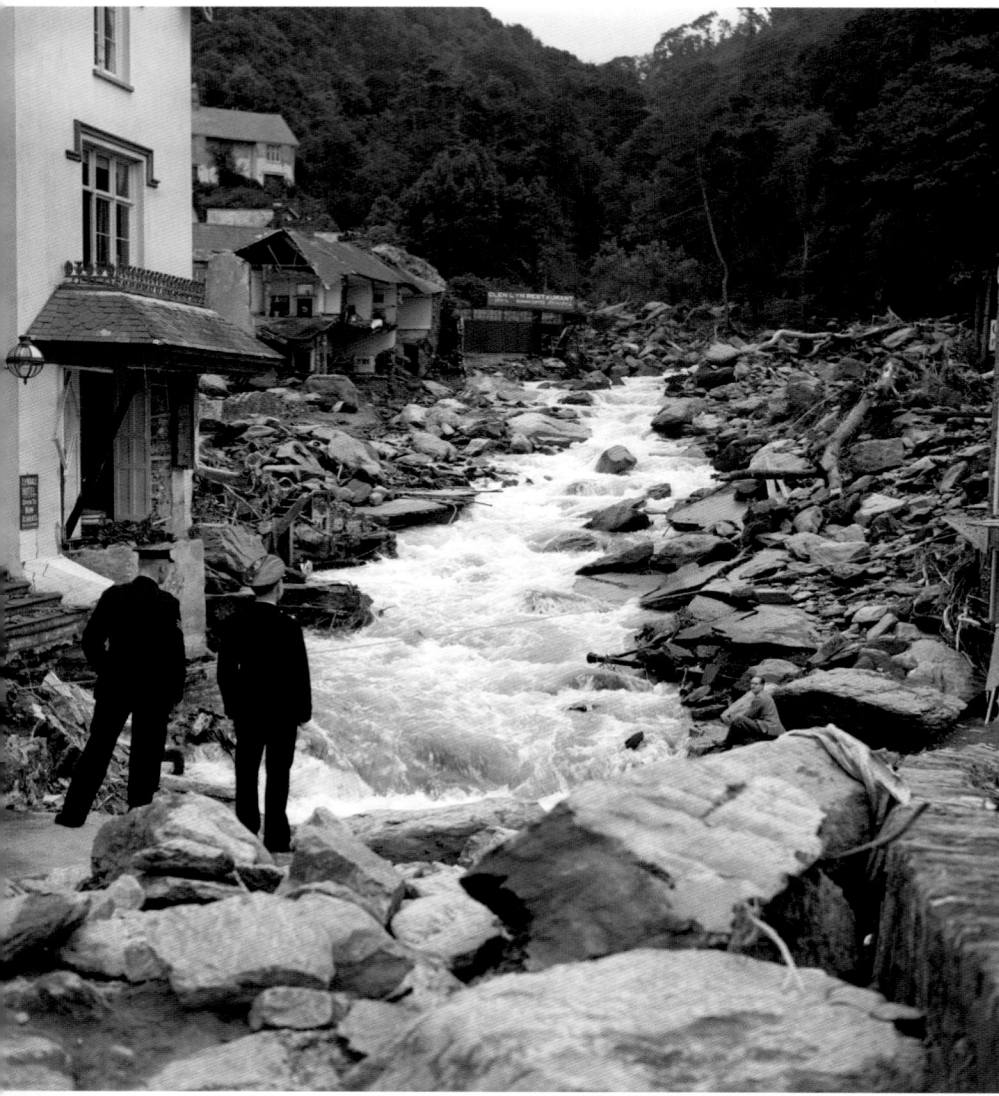

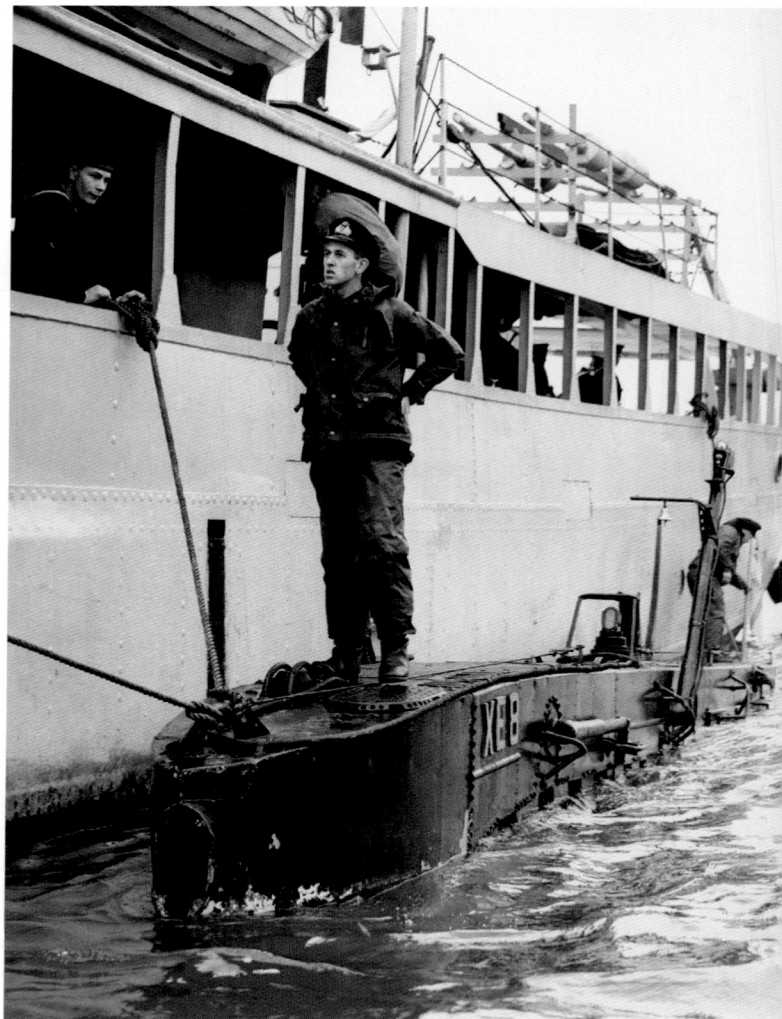

Above: The four-man midget submarine XE8 moored alongside its mother ship, the escort vessel HMS *Gateshead*, in the Pool of London. Craft of this type were used in the daring raid against the German battleship *Tirpitz* in September 1943, which put the ship out of action for over six months. Later in 1952, XE8 was sunk in the English Channel off Portland to act as a sonar target for anti-submarine training. The vessel was raised in 1973 and restored for the Imperial War Museum.

1st October, 1952

Above left: The Lynmouth Disaster. Two weeks of heavy rain had left Exmoor saturated when a 21-hour downpour – 11in (279mm) of rain, half of which fell in just five hours – swelled the East Lyn and West Lyn rivers. Draining through Lynmouth to the sea, their combined torrents became a wall of water that demolished homes, resulting in 34 deaths. Rumoured links with cloud-seeding trials were subsequently disproved.

17th August, 1952

Above: The scene of destruction following a triple train crash at Harrow and Wealdstone station, on the outskirts of London. An express sleeper train from Perth, Scotland had struck a local train standing in the station at more than 50mph (80.5km/h). Seconds later, a double-headed express en route from London Euston to Liverpool ploughed into the derailed coaches. One hundred and twelve people died, and 340 were injured in the accident.

8th October, 1952

Above: The expression of a man who likes good fare and knows how it should be prepared is worn by television's first celebrity chef, Philip Harben, as he concocts a gourmet's delight in a saucepan at the Alexandra Palace television studios, London.

13th October, 1952

Right: On 1st February, 1953, freak weather conditions funnelled a massive storm surge south through the North Sea toward the English Channel, causing widespread flooding along England's east coast. These servicemen are mending a breach in the sea wall at Canvey Island, in the Thames estuary, which was most overwhelmed by the floods. The Netherlands' dykes were also severely breached, causing over 1,800 deaths.

2nd February, 1953

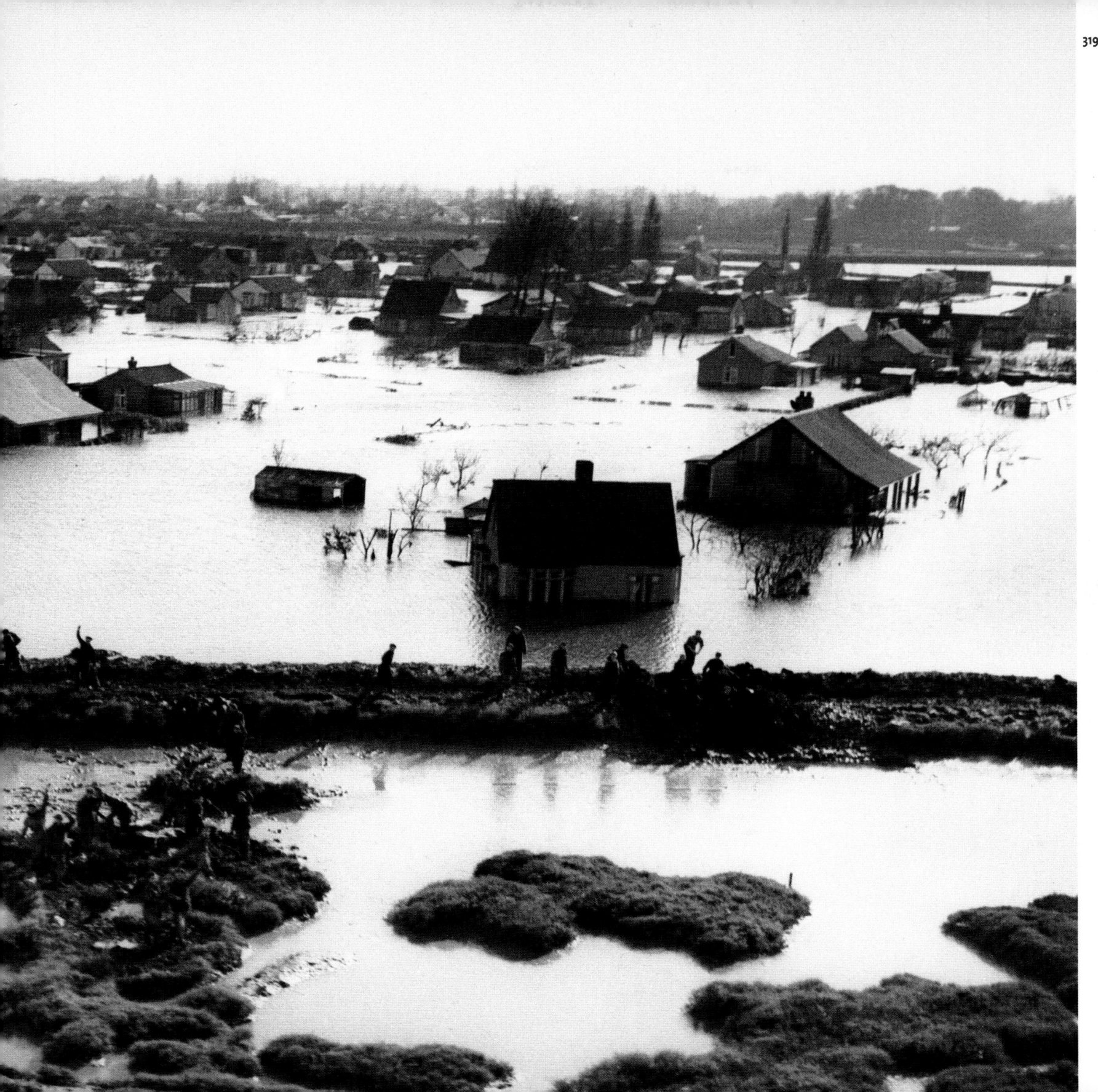

Below: Blackpool captain Harry Johnston (top L) holds the FA Cup aloft after his team came back from 3–1 down to win 4–3 against Bolton Wanderers, thanks to inspired performances by Stanley Matthews (top R), hat-trick hero Stan Mortensen (second R) and winning goal scorer Bill Perry (third L).

2nd May, 1953

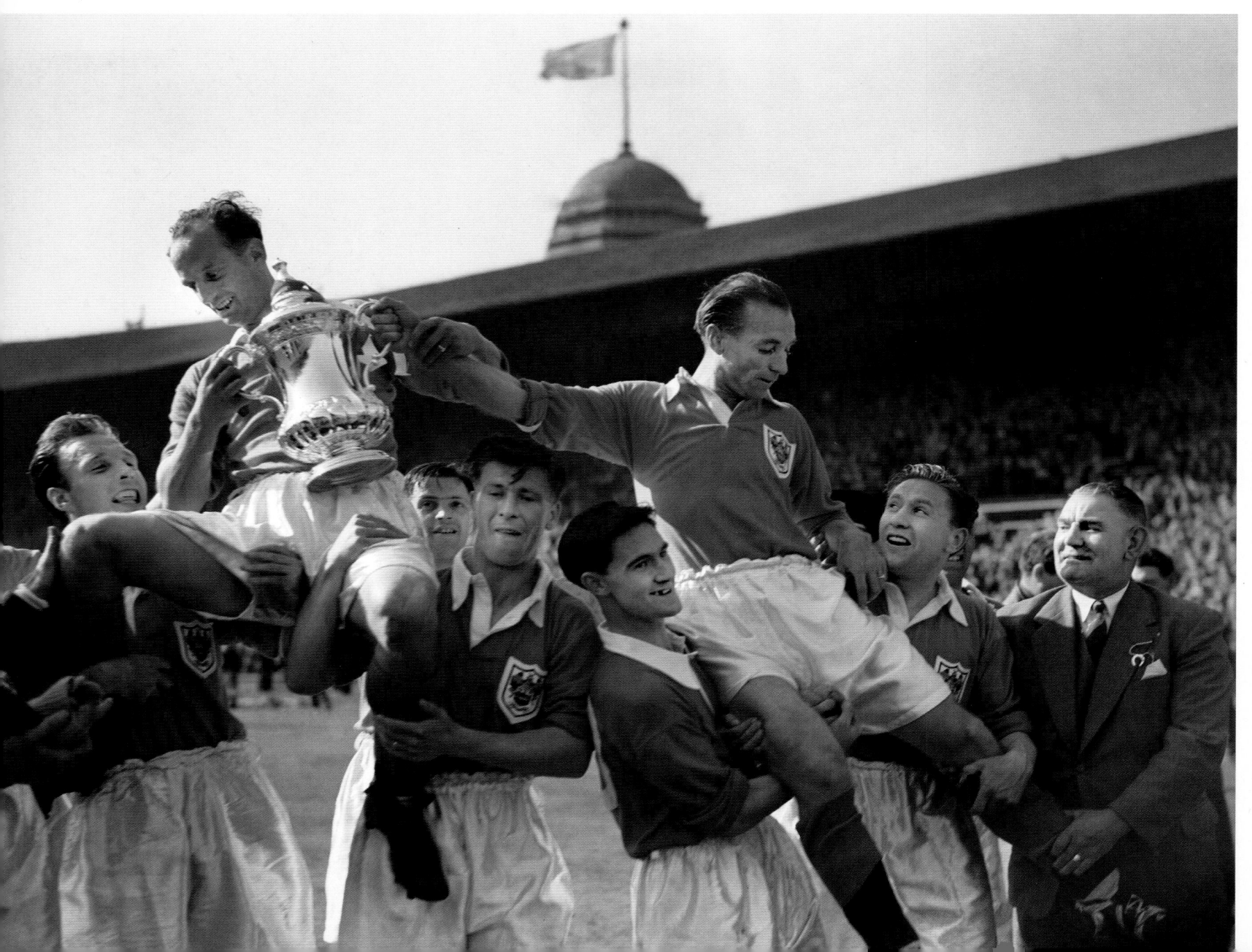

Right: Pilots of the RAF on temporary duty flying F-86 Sabre jets with the 51st Fighter-Interceptor Wing of the United States Air Force in Korea. F-86s were the mainstay of United Nations jet fighter operations against the North Koreans, but they frequently came up against MiG-15 jets flown by Soviet and Chinese pilots. These had a performance edge, but most Sabre pilots were experienced Second World War veterans who managed to neutralize the advantage.

4th May, 1953

Below: In 1952, an insurgency against British rule began in Kenya, known as the Mau Mau Revolt. Although British troops were brought in, most of the effort aimed at countering the revolt was borne by the Kenyan Police and the Kenyan Home Guard. Here, District Officer John Wordsworth hands a rifle to Home Guard member Francis Kiraku, whose father had been murdered by Mau Mau terrorists.

13th May, 1953

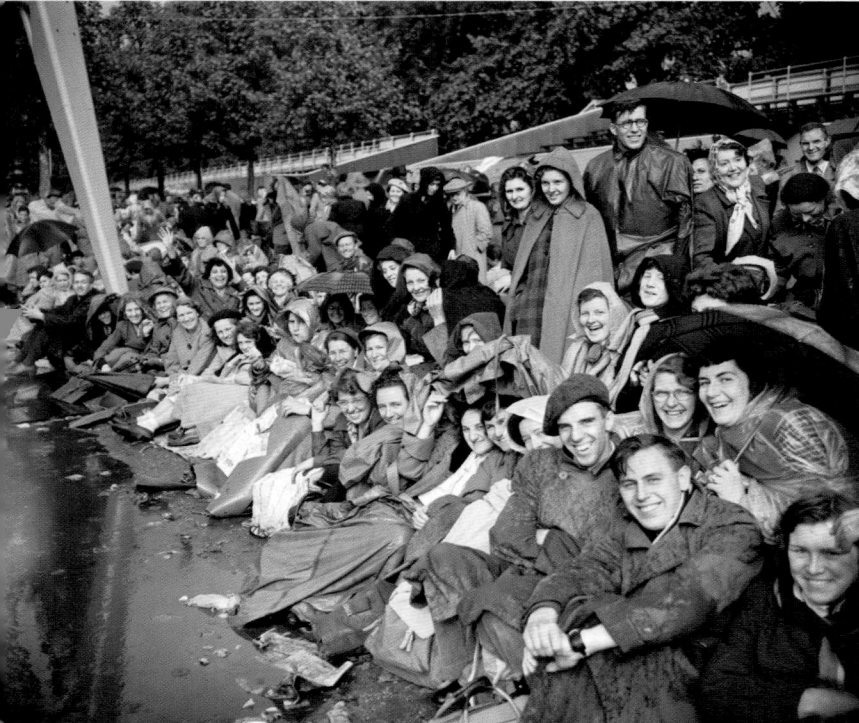

Above: Spirits undampened by rain, a large crowd lines London's Mall, waiting patiently for the Coronation Procession of Queen Elizabeth II.

1st June, 1953

Right: The Royal procession passes through Piccadilly Circus after the Coronation of Queen Elizabeth II.

2nd June, 1953

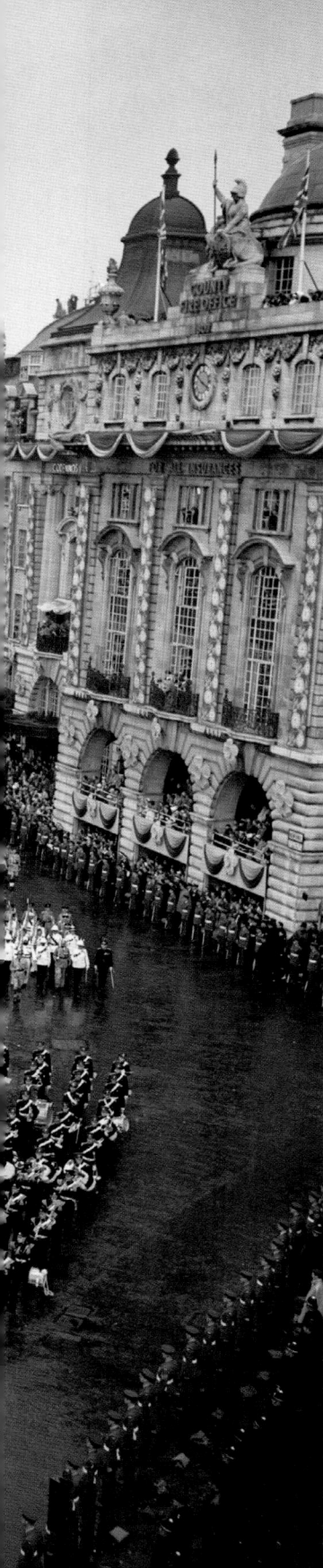

Above: Queen Elizabeth II wearing the Imperial State Crown and her Coronation robes following the ceremony at Westminster Abbey. She had acceded to the throne upon the death of her father, King George VI.

2nd June, 1953

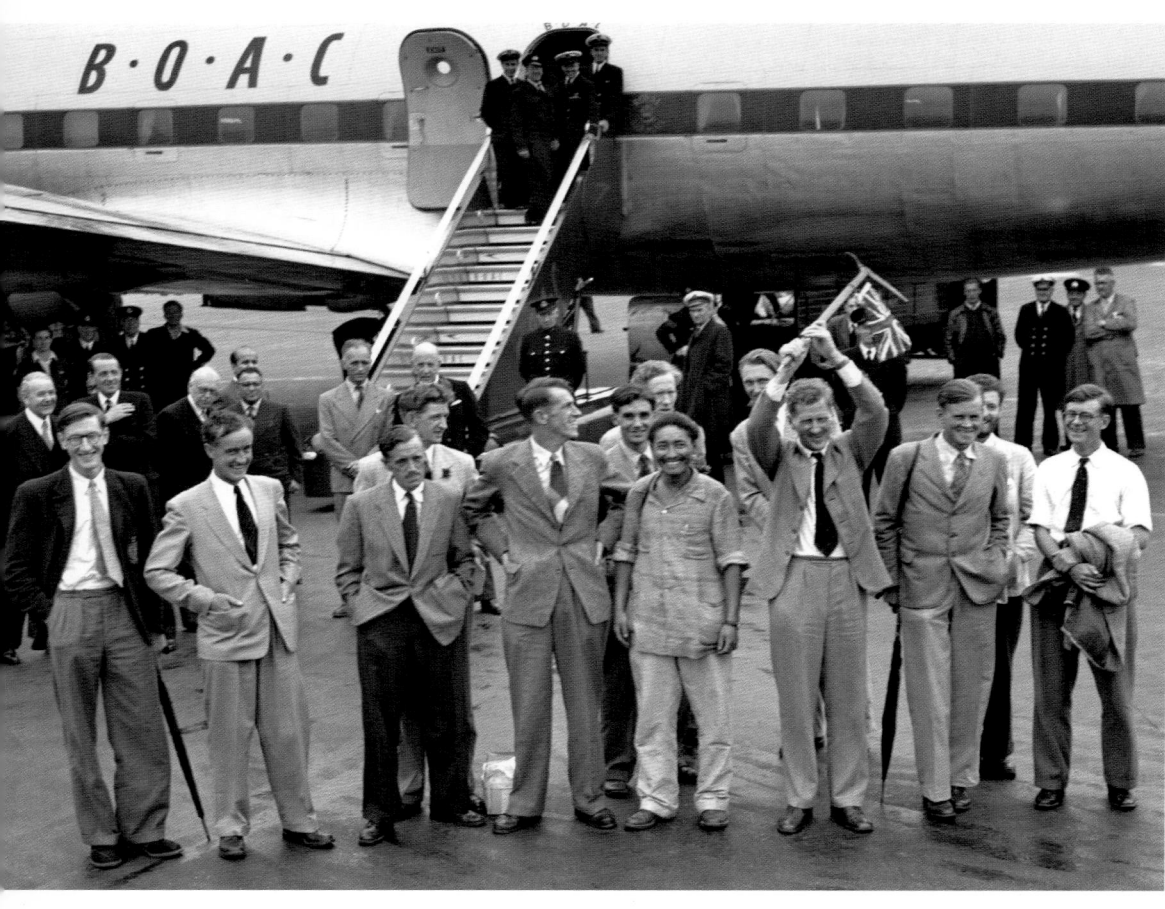

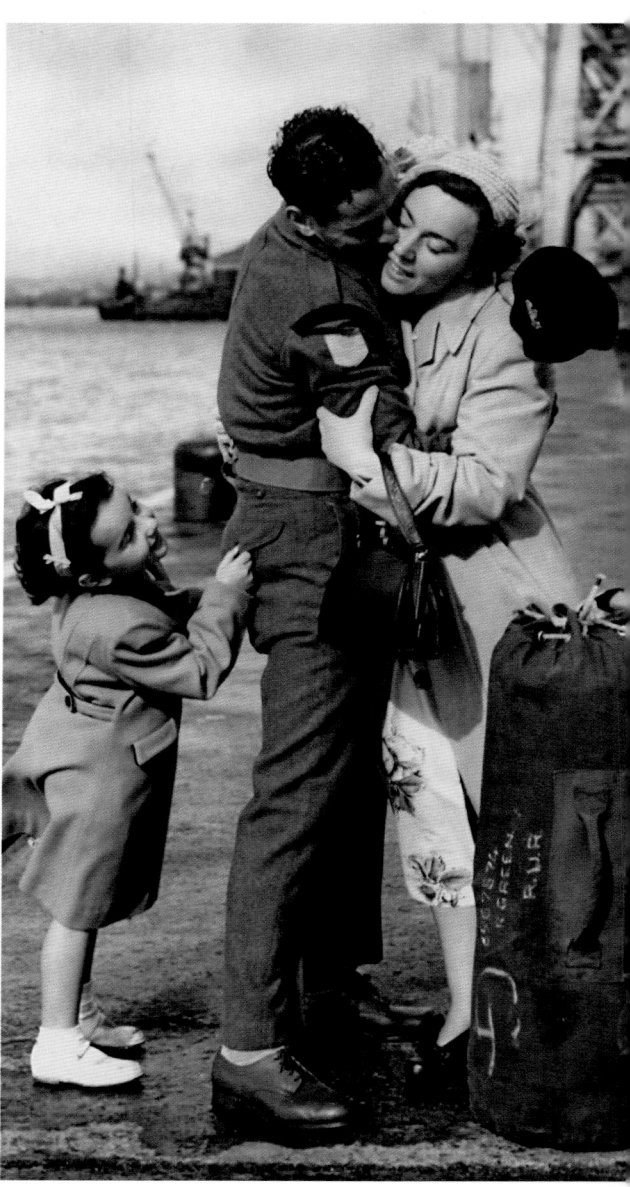

Far left: High climbers. A triumphant Everest party arrives at London's Heathrow Airport after conquering the highest mountain in the world. Front row (L–R): George Band, Major Charles Wylie, Alfred Gregory, Edmund Hillary, Sherpa Tenzing Norgay, Colonel John Hunt, Dr Charles Evans and Mike Westmacott. News of the party's success had reached London on the morning of Queen Elizabeth's Coronation.

3rd July, 1953

Left: Rifleman Ronald Green is reunited with his wife Kathleen and his daughter, also Kathleen, at Southampton docks after being held as a prisoner of war by the North Koreans. Protracted negotiations for an armistice began on 10th July, 1953, but a pact was not signed until 27th July.

16th July, 1953

Right: British boxer Randolph Turpin (L) and Frenchman Charles Humez during their fight at White City, London. The bout was for the vacant European Middleweight title, which Turpin won on points

6th August, 1953

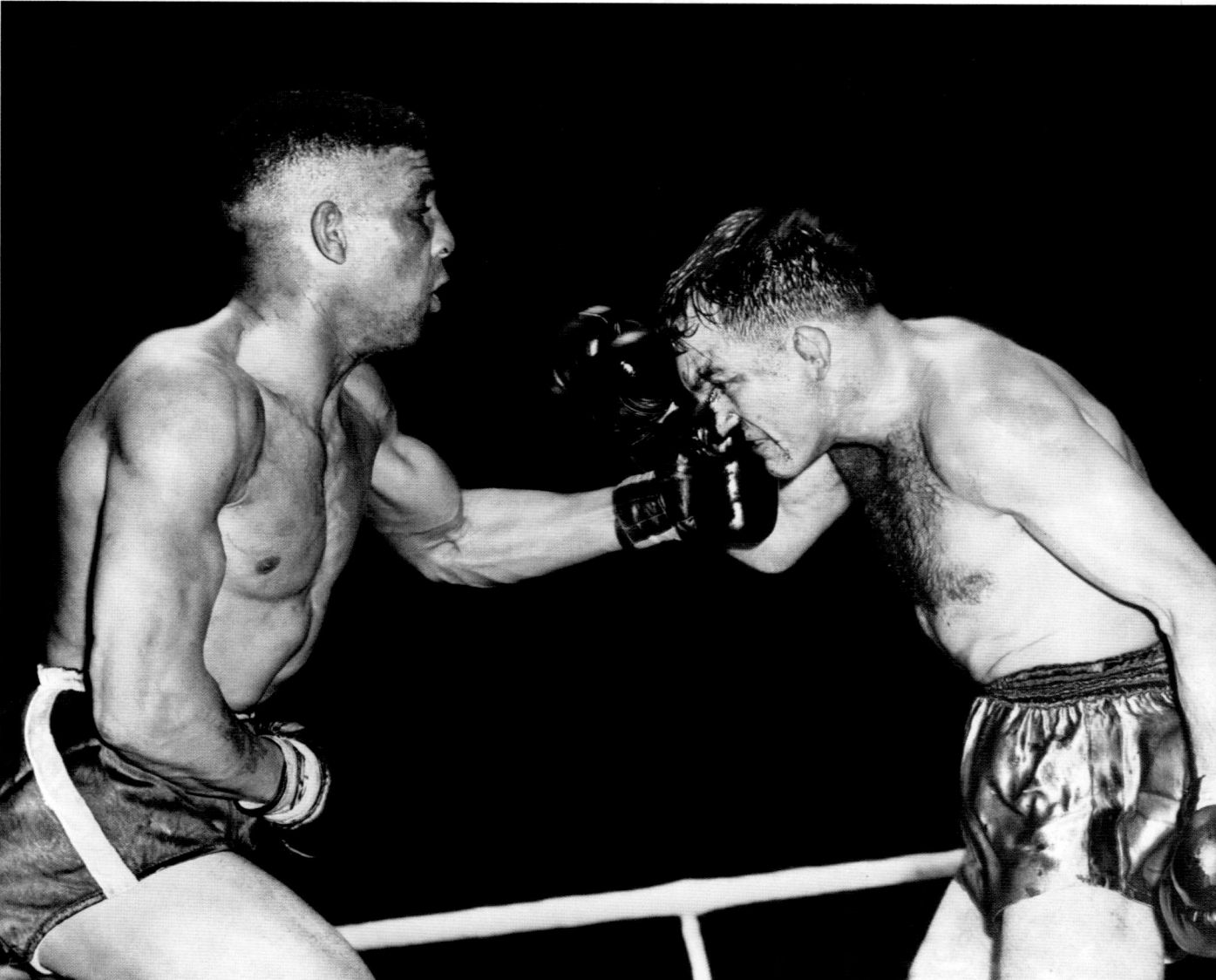

Left: Smog was a common occurrence in London in the early 1950s, due to poor-quality coal used for domestic heating, the presence of several coal-fired power stations and the increase in diesel-powered buses after the closure of the electric tram system. In December 1952, a prolonged period of severe smog led to the deaths of 12,000 people. Here, Sheila Glibbery is seen buying a smog mask for her journey home to Essex at a chemist's shop in Charing Cross.

17th November, 1953

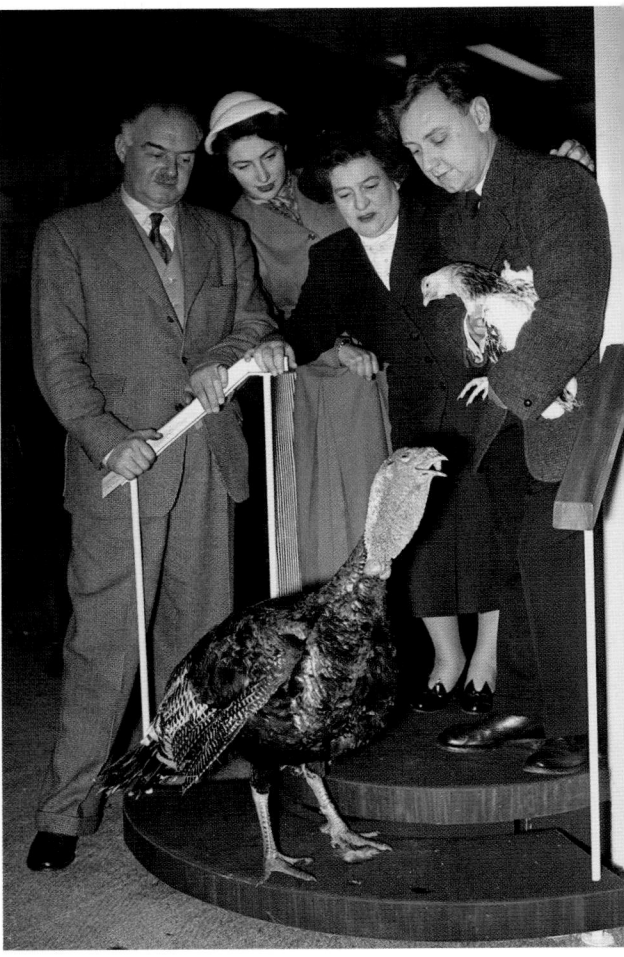

Above: Members of the cast of the BBC radio show *The Archers* with a turkey and chicken at the National Poultry Show: (L–R) Harry Oakes (Dan Archer), Lesley Saweard (Christine Archer), Gwen Berryman (Doris Archer) and Norman Painting (Phil Archer). Painting would remain with the show until his death, at 85, in October 2009.

10th December, 1953

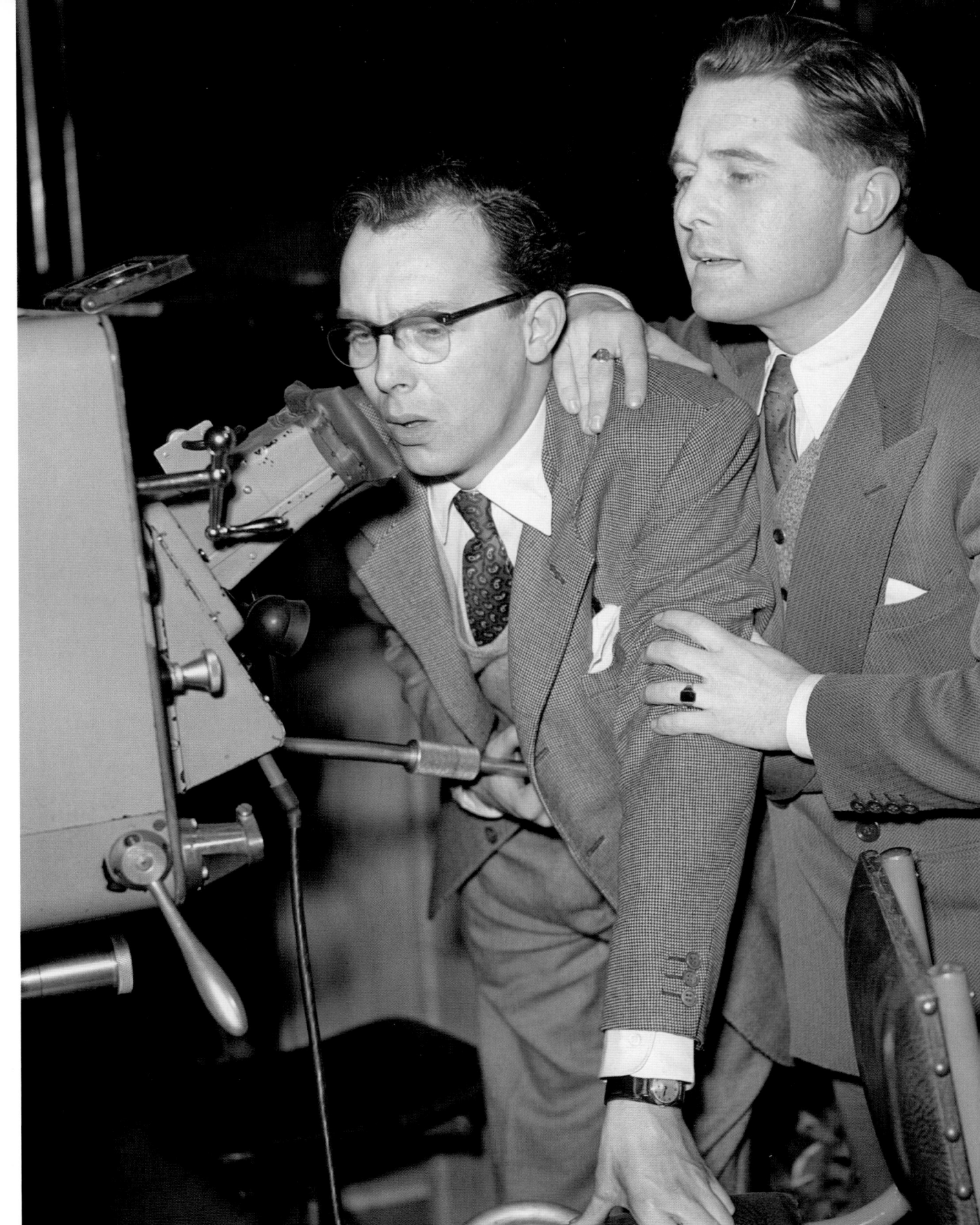

Right: Having just made the switch from radio, comedians Eric Morecambe (L) and Ernie Wise take a look at the view from the other side of the camera. Their show, *Running Wild*, was not well received, however, and was given damning criticism in the newspapers. One review included the definition: "*TV set – the box in which they buried Morecambe and Wise.*" It was a salutary lesson, and the pair paid much greater attention to their material in future. They would, of course, go on to achieve great success.

30th March, 1954

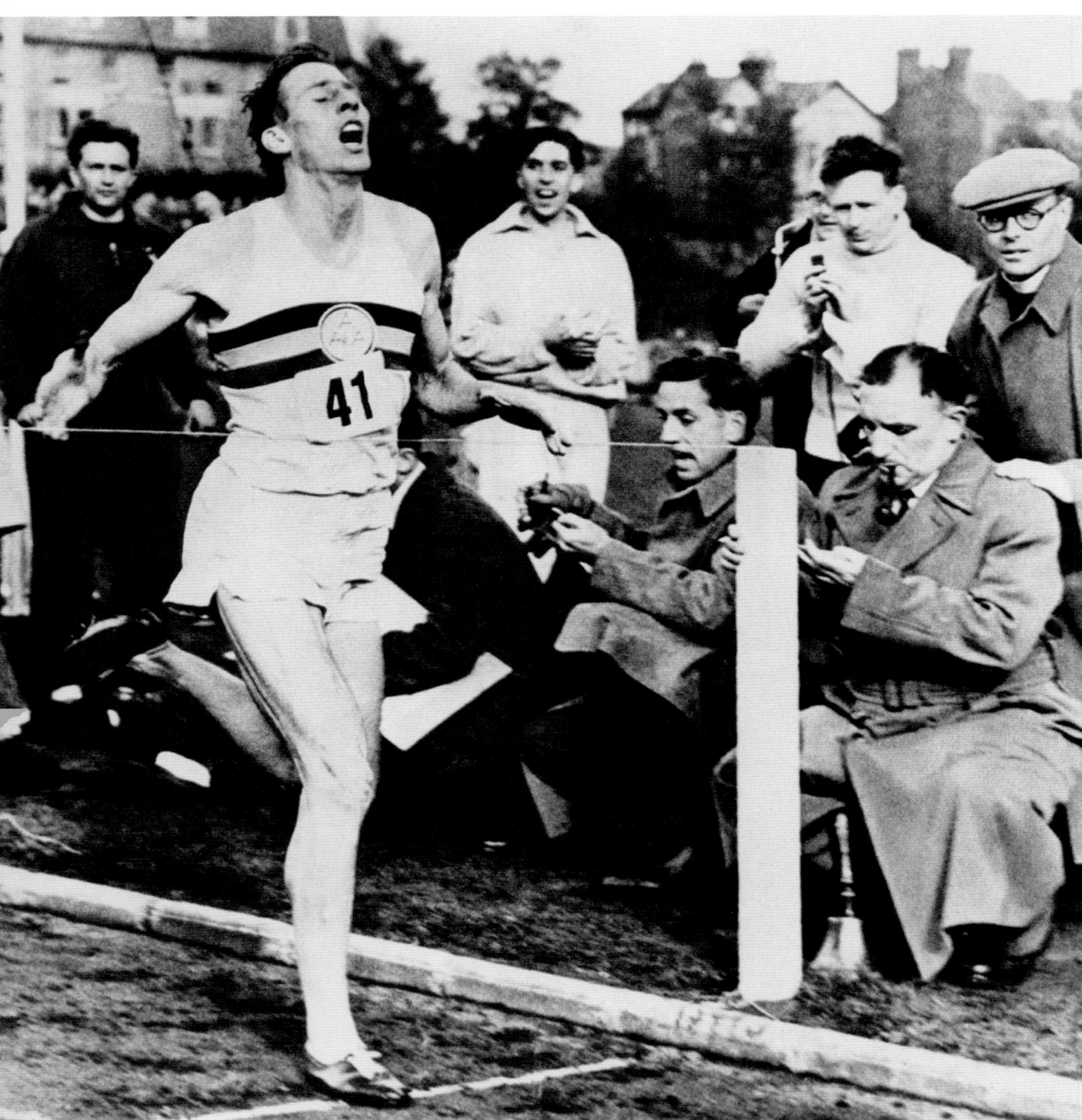

Left: Medical student Roger Bannister, 25 years old, breaks the tape at an athletics meeting in Oxford, and the world's first sub-four-minute mile has been run – in 3 minutes, 59.4 seconds.

6th May, 1954

Right: The *Golden Fleece*, an ex-LNER Class A4 streamlined 4-6-2 steam locomotive, hauls The Elizabethan express train from London King's Cross station to travel the 393 miles (632km) to Edinburgh in 6½ hours – at the time the fastest ever non-stop journey between the two cities, with an average speed of 60mph (96.5km/h), and the world's longest non-stop run.

28th June, 1954

Far right: John Levitt, 'Master Ardil-Terylene', and Lillian Grasson, 'Miss Nylon', at the first National School Age Clothing Fair, held at London's Royal Festival Hall. In those days, clothes for older teenagers mimicked those of their parents.

1st November, 1954

Right: The lad himself and pals. The cast of the BBC radio situation comedy *Hancock's Half Hour* during the broadcast of another episode: (L–R) Bill Kerr, Moira Lister, Tony Hancock and Sid James. Episodes of the series were chosen for broadcast after a nuclear attack to boost morale.

1st November, 1954

Far right: Heavy snow on Hampstead Heath, London made skiing a viable means of transport for residents.

14th January, 1955

330

Right: Ruth Ellis was the last woman to be hanged in Britain, on 13th July, 1955 for gunning down her boyfriend, David Blakely. Ellis' friend, Jacqueline Dyer, revealed during the trial that Blakely *"beat her unmercifully"*.

28th April, 1955

Below: John Surtees passes Kate's Cottage on his 500cc Manx Norton during the Isle of Man TT. That year, Norton's team boss, Joe Craig, had given Surtees his first factory sponsored ride. Kate's Cottage is one of the most iconic sights of the TT; originally it was known as The Keppel.

11th June, 1955

Below: Yorkshire's Fred Trueman (L) hits his second successive six of the over as Middlesex wicketkeeper Les Compton looks on. Trueman was also a fast bowler, one of the greatest in cricketing history, and was known popularly as 'Fiery Fred'. He was the first man to take 300 wickets and subsequently became an outspoken radio commentator. He died, aged 75, in 2006.

18th July, 1955

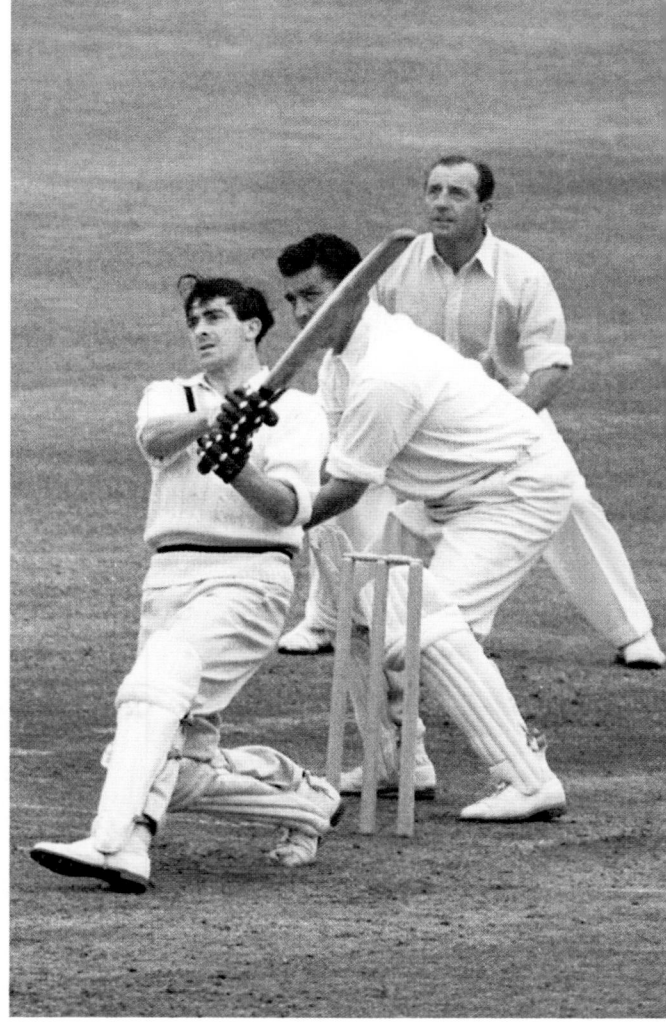

Left: A popular meeting place for London's young pop music fans was the 2i's Coffee Bar in Old Compton Street, Soho. Many future stars were discovered there, including Cliff Richard, Joe Brown and Tommy Steele.

6th November, 1955

Right: Kim Philby, KGB and NKVD spy. Philby was a senior British intelligence officer who had been recruited to the Soviet cause while at Cambridge University in the 1930s. He was one of a group of spies known as the 'Cambridge Five', the others being Donald MacLean, Guy Burgess, Anthony Blunt and John Cairncross. Philby defected to the Soviet Union in 1963.

8th November, 1955

332

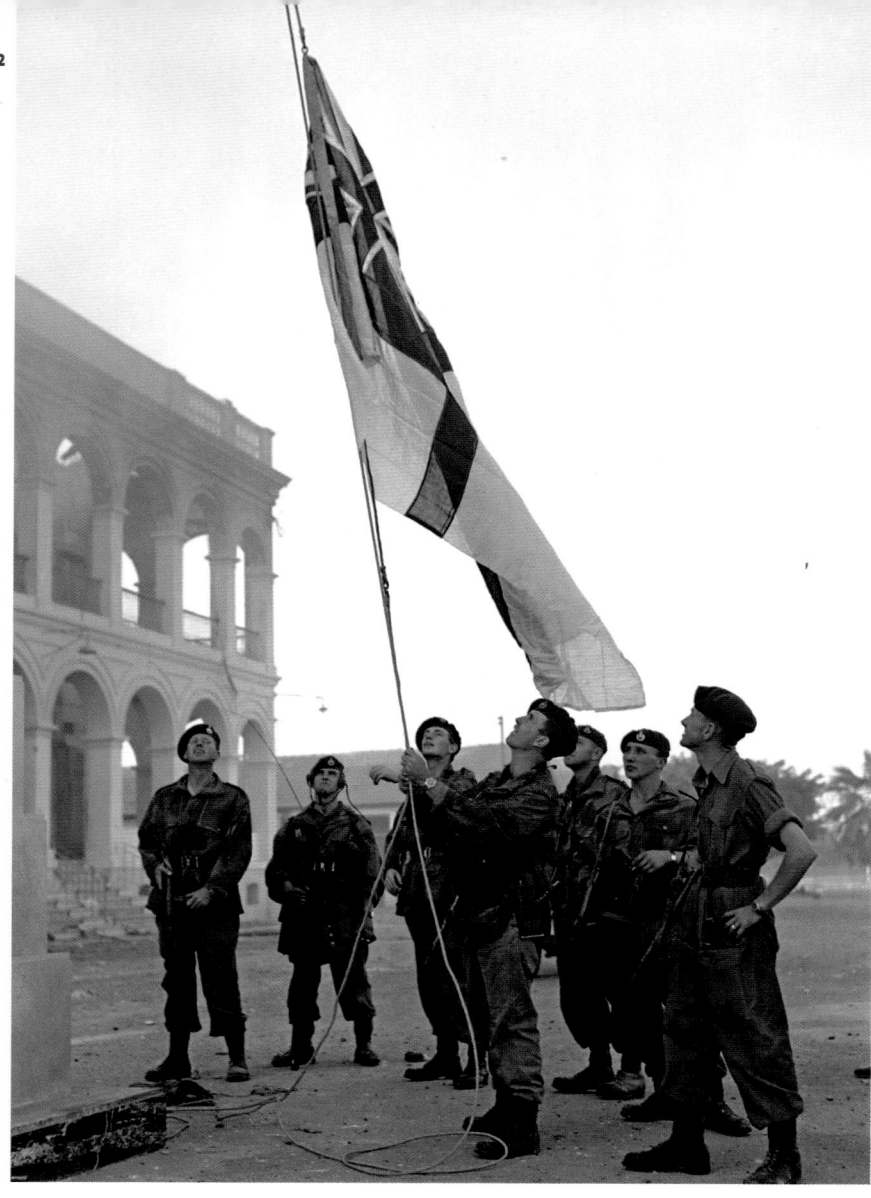

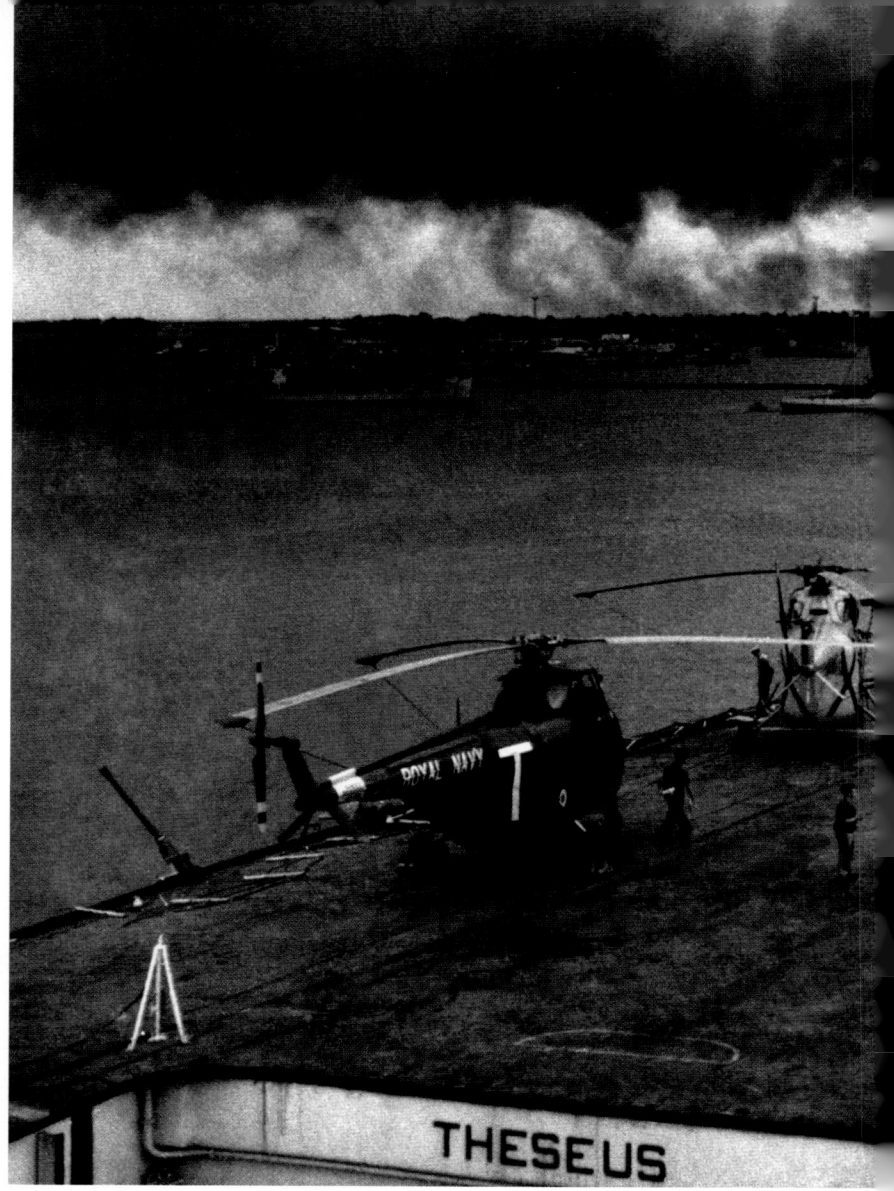

Above: British Royal Marine Commandos raise the White Ensign over Navy House, Port Said, Egypt, just 10 minutes after capturing the building in heavy fighting with Egyptian forces during the Suez Crisis. The crisis had come about following Egypt's decision to nationalize the Suez Canal on 26th July, 1956. In conjunction with France and Israel, Britain invaded the canal region.

8th November, 1956

Above right: Commandos await the call to arms on the flight deck of HMS *Theseus*, just off Port Said in Egypt. In the distance, smoke billows from blazing oil tanks. The assault on Port Said marked the first and biggest helicopter operation in the history of the British services.

12th November, 1956

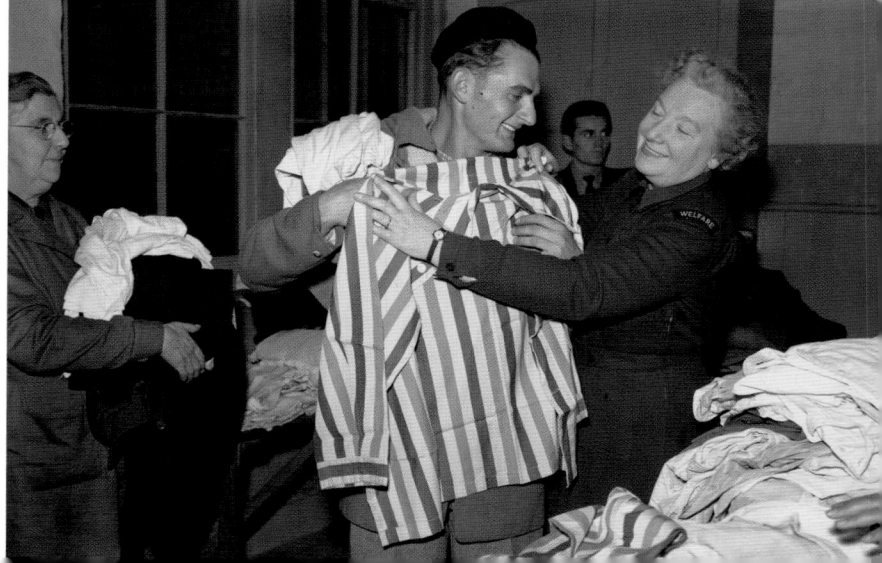

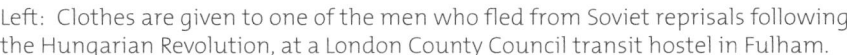

Left: Clothes are given to one of the men who fled from Soviet reprisals following the Hungarian Revolution, at a London County Council transit hostel in Fulham.

20th November, 1956

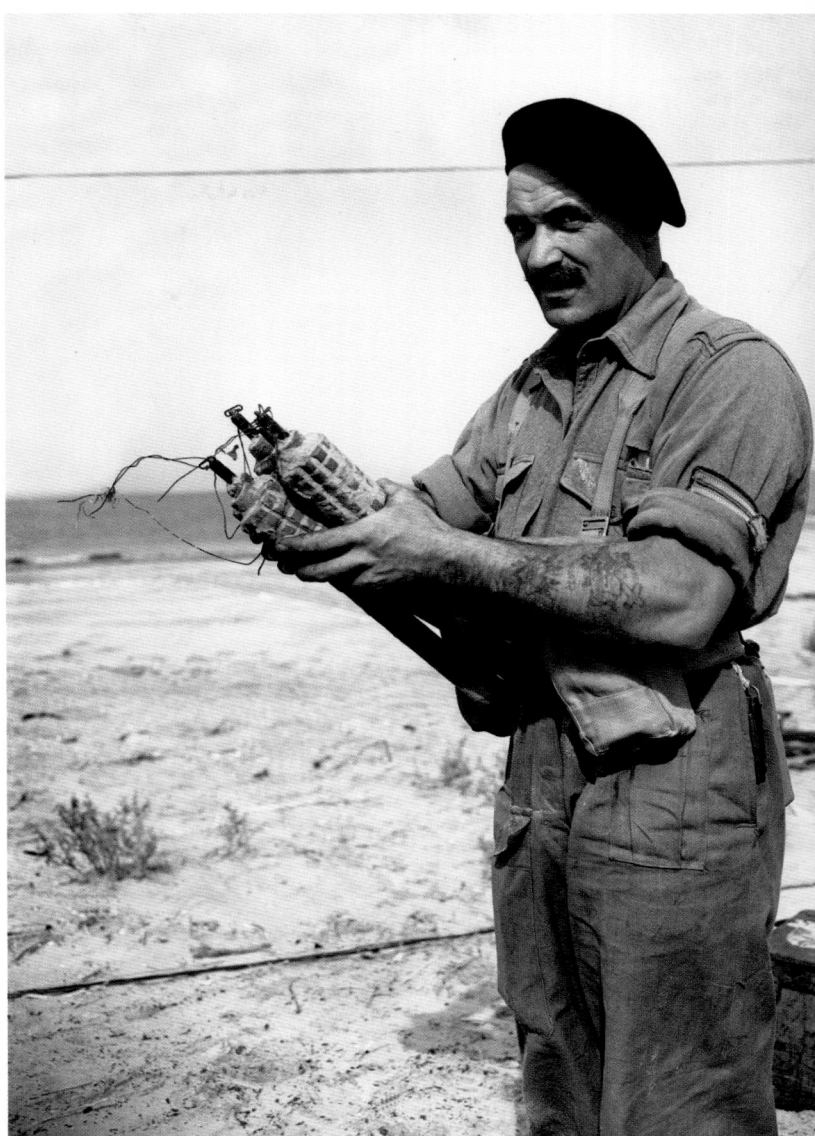

Above right: Sergeant Bill Kidd, a British Army bomb disposal technician, with a handful of recovered mines during the Suez Crisis.

1st December, 1956

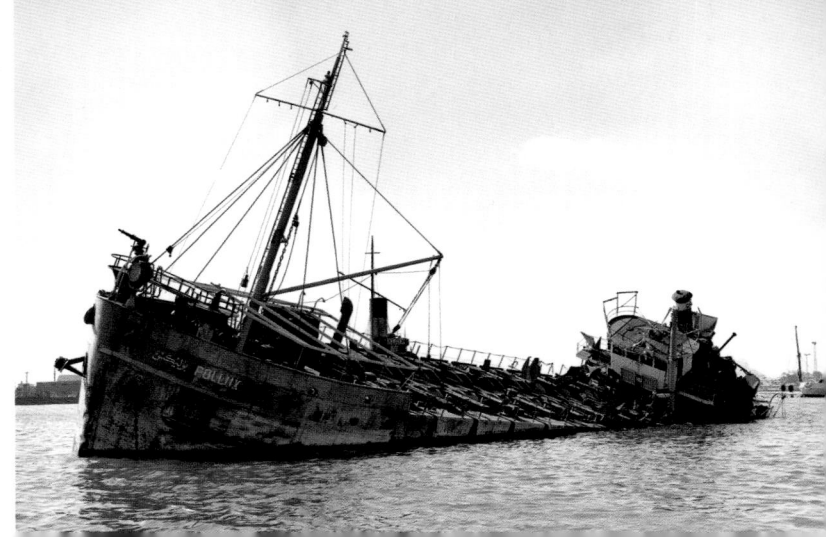

Right: The Egyptian owned ship MV *Pollux*, one of 40 vessels that were scuttled in the Suez Canal as blockships on the orders of Egyptian President Abdel Nasser in response to the Anglo-French invasion. The canal would remain closed to shipping until early 1957.

1st December, 1956

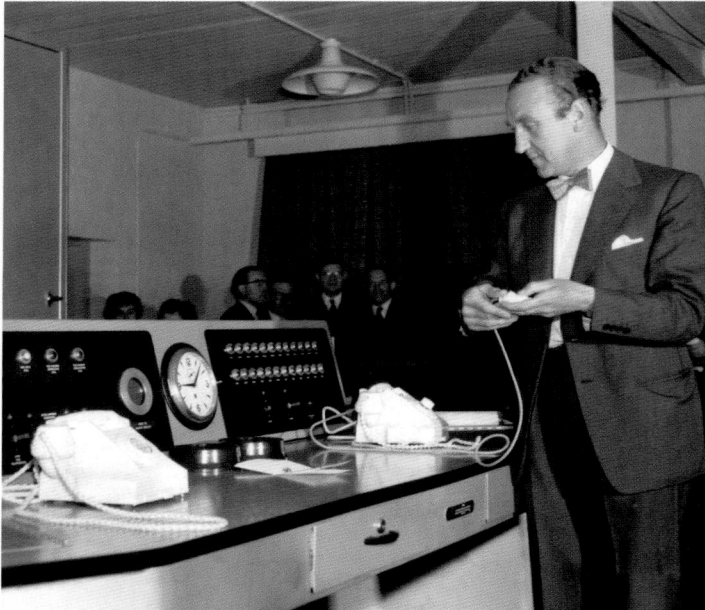

Above: Ernest Marples, the Postmaster-General, presses a button to start up ERNIE (Electronic Random Number Indicating Equipment) for the first Premium Savings Bonds draw, at Lytham St Annes, Lancashire.

1st June, 1957

Left: Twenty-year-old Shirley Bassey, then known as 'the Tigress of Tiger Bay', a week before she flew to the United States to fulfil engagements in Las Vegas. She had been discovered singing in working men's clubs in her home town of Cardiff.

10th January, 1957

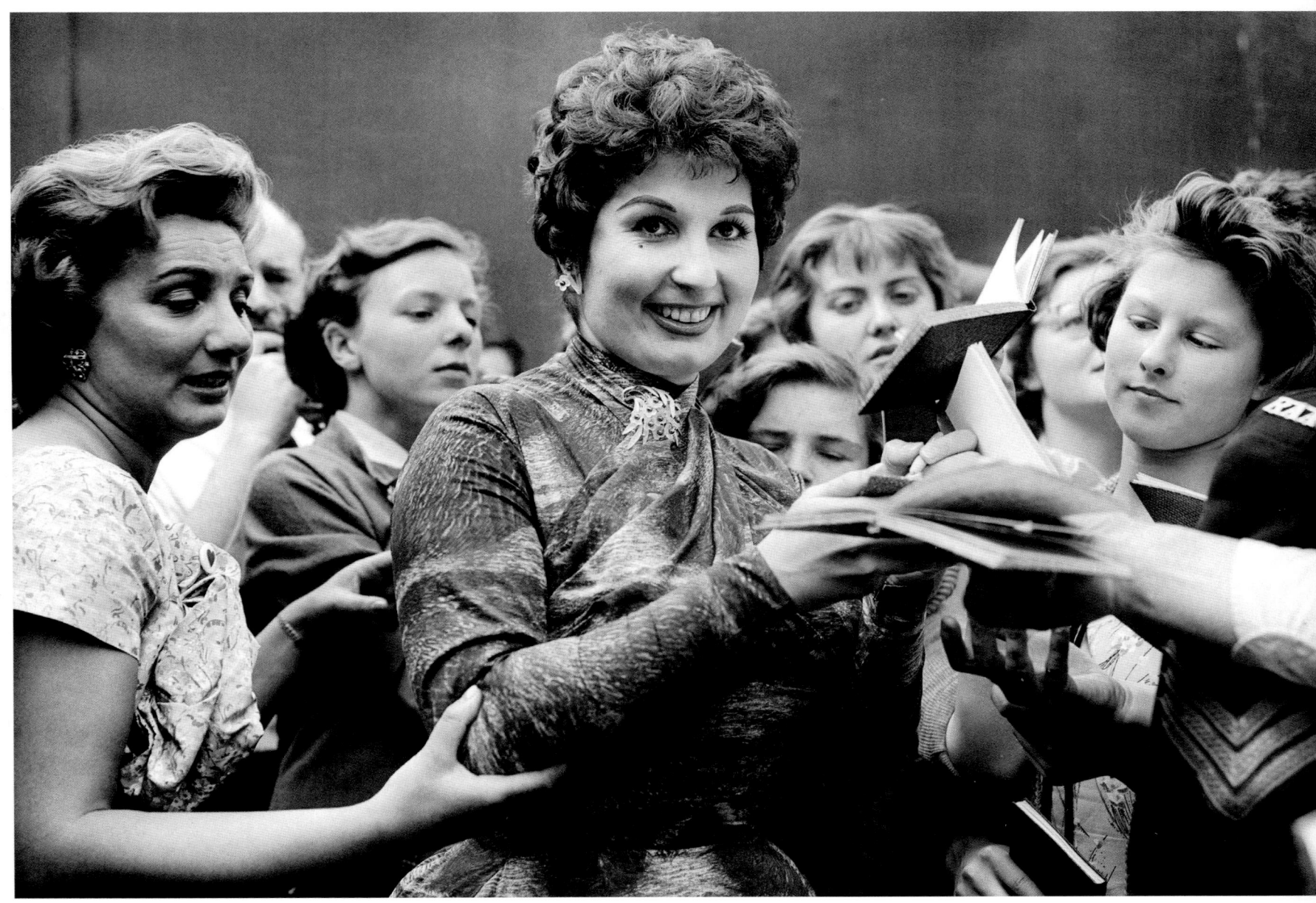

Above: Pop singer Alma Cogan is besieged by young fans seeking her autograph. Known as 'the girl with a giggle in her voice', Cogan was the highest paid female singer of her era.

1st June, 1957

Right: The Tiller Girls perform on the ITV stage at the National Radio and Television Exhibition, Earls Court, London. Famous for their high-kicking routines, the Tiller Girls had a history that went back to 1890, when the first troupe had been formed by John Tiller in Manchester. He had realized that if the dancers linked arms, they could dance with much greater precision.

25th August, 1957

Above far right: Jayne Mansfield, at the Carlton Theatre, Haymarket, London, for the premiere of her film *Oh! for a Man*. Mansfield was one of the blonde bombshells of the 1950s, her platinum blonde hair, hourglass figure and cleavage-revealing dresses making her a guaranteed box-office draw. She was the first mainstream star to appear nude in a Hollywood film with sound (*Promises, Promises*). Mansfield was killed in a car crash in 1967, at the age of 34.

26th September, 1957

Far right: Real gone! The McCormick Skiffle Group: (L–R) Billy McCormick, Frank Healy, Wesley McCausland, Edward McSherry, and James McCartney.

2nd November, 1957

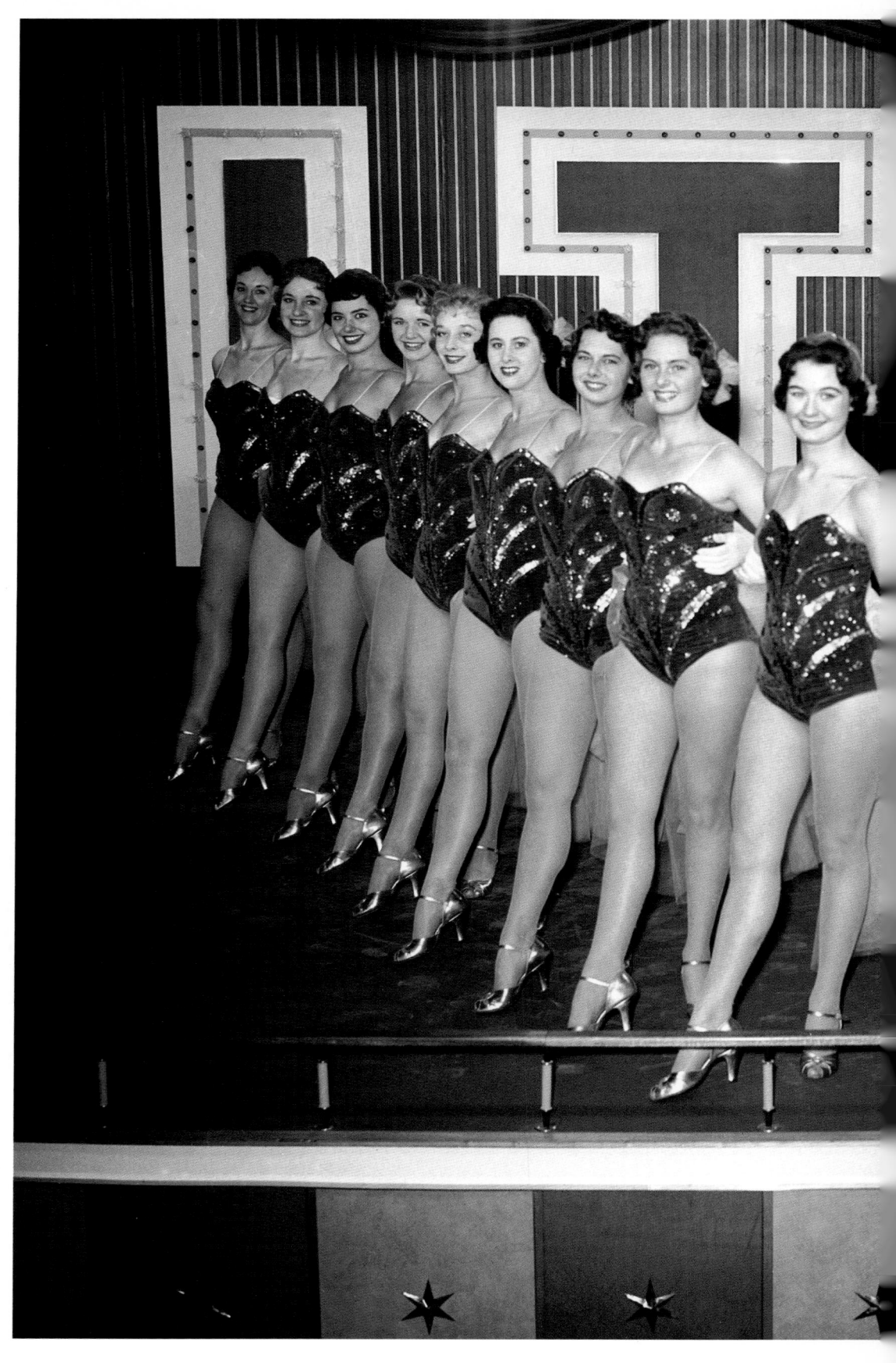

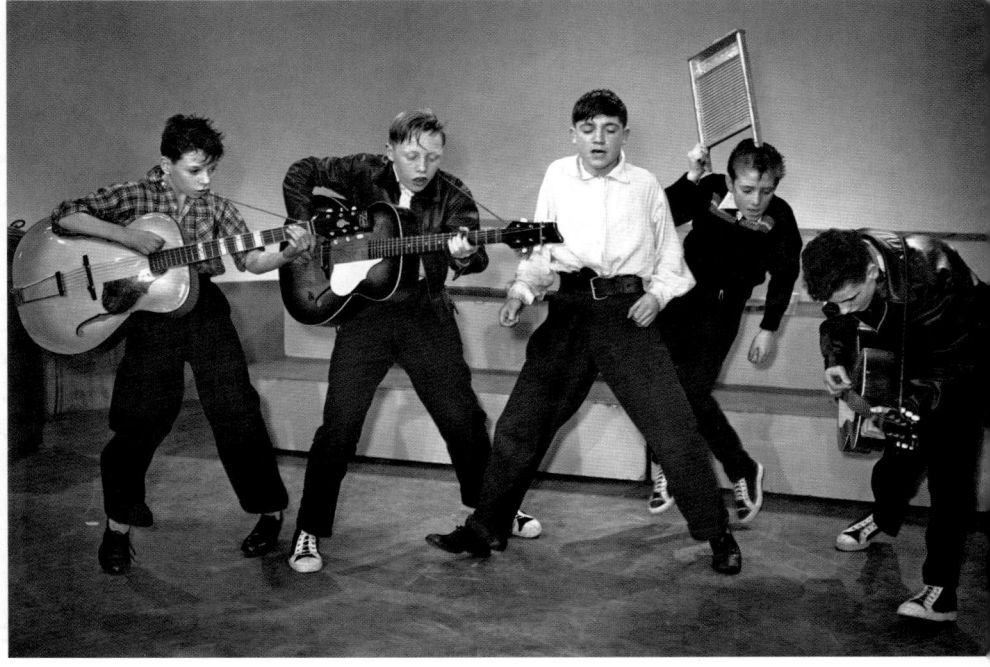

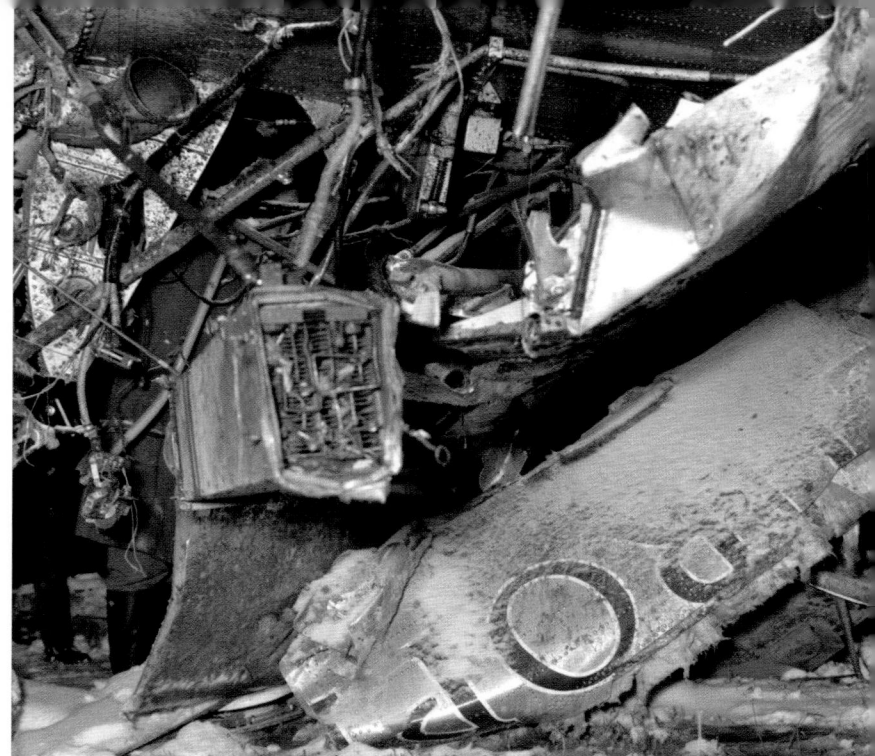

Far left: Winifred Atwell plays
aboard a BOAC Britannia airliner
between London and New York.
A recording of the half-hour
performance aboard the plane
was flown back from New York for
screening in Jack Hylton's *Monday
Show* on ITV. L–R: Hughie Green,
Rosalina Neri from Milan, Ronnie
Ronalde and Jack Hylton.

6th February, 1958

Left: The twisted wreckage of
the British European Airways
Airspeed Ambassador that was
carrying the Manchester United
football team back from a match
in Belgrade, Yugoslavia. After
refuelling in Munich, the machine
crashed as it tried to take off from
a snow-covered runway, killing
23 people, including eight of the
team's players.

6th February, 1958

Below left: The crowd at a rugby
match at Twickenham observes a
minute's silence in memory of the
Manchester United players who
had been killed in the Munich air
disaster two days before.

8th February, 1958

Right: Five Hawker Hunter jet
fighters of the Royal Air Force's
No 111 Squadron, which acted as
the RAF's aerobatic team, known
as the Black Arrows. Renowned
for their formation flying, 'Treble
One' Squadron achieved a record
in 1958 by flying a 22-jet formation
loop. Their legacy lives on today
in the RAF's Red Arrows team. The
Hunter served with the RAF for
many years, and also equipped 19
other airforces. The two blisters
below the cockpit of each aircraft
were added to collect ammunition
links when the guns were fired.
They were dubbed 'Sabrinas' by
the crews after the well-endowed
contemporary British film star.

5th May, 1958

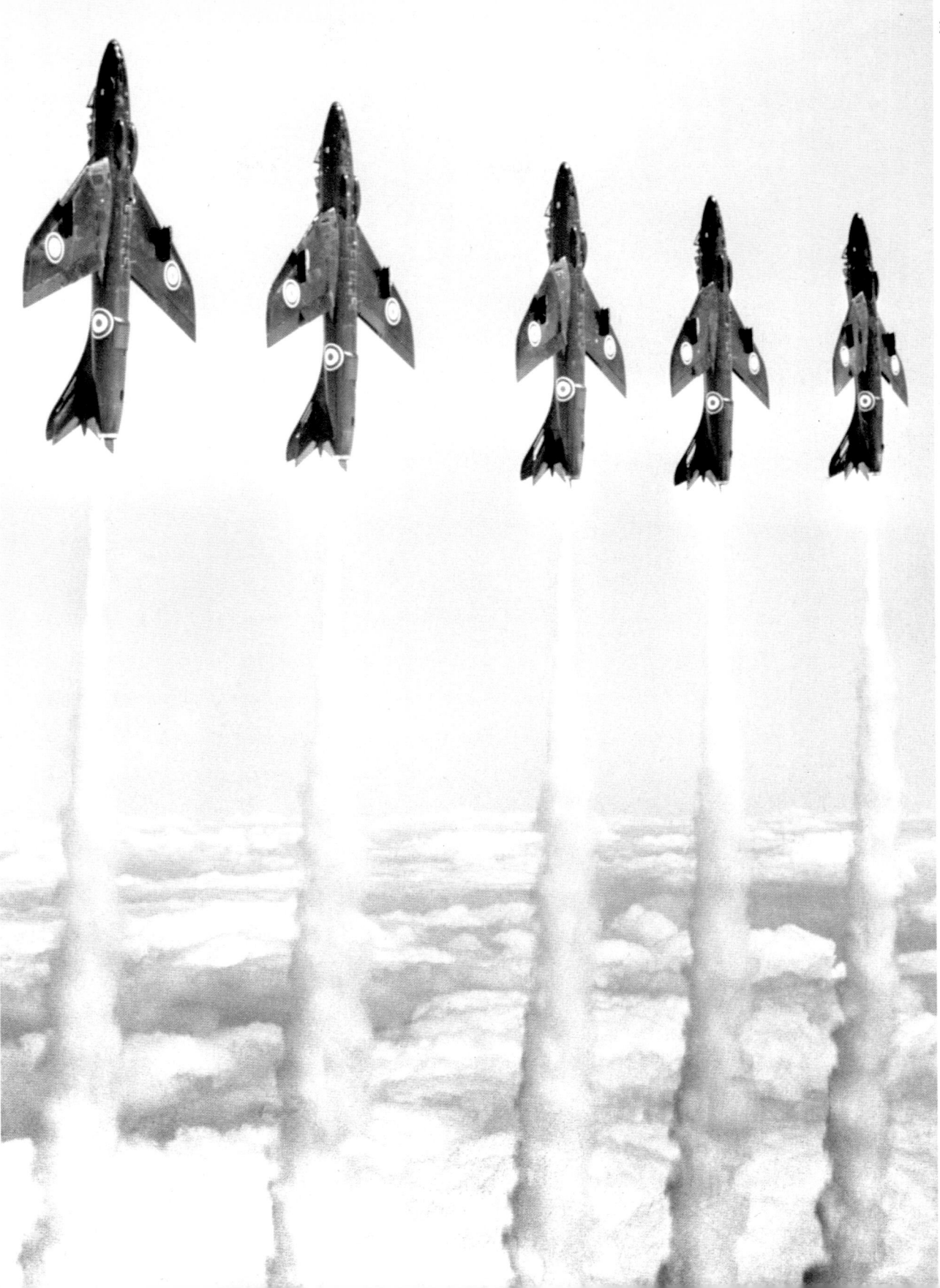

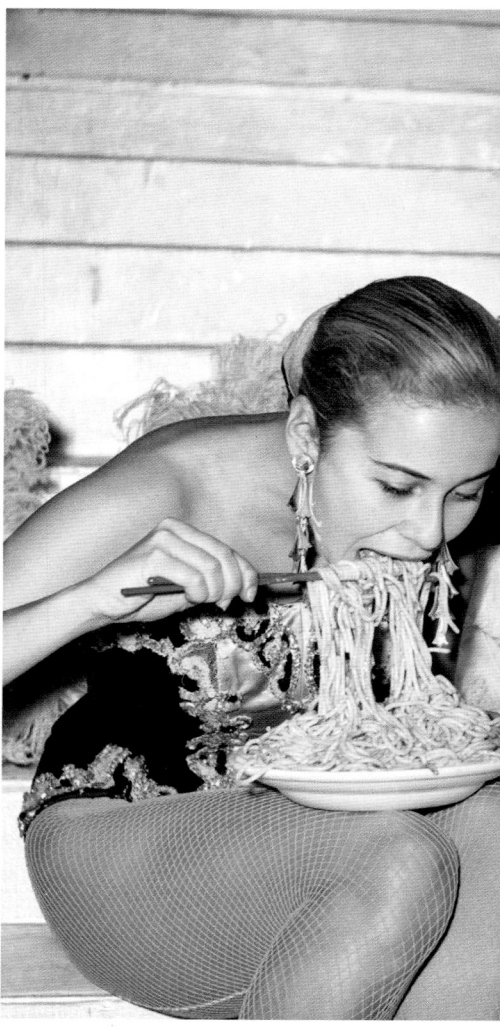

Above: *"You ring – we bring"*. Two
enterprising young women operate
a sandwich delivery service with
a Vespa scooter and sidecar. The
Vespa and its rival, the Lambretta,
were both made in Italy, and offered
a degree of stylishness that was not
quite matched by contemporary
British scooter manufacturers.

1st July, 1958

Right: One of the first parking
defaulters is booked in Grosvenor
Square by traffic warden Mr W.
Matthews, when Britain's first
parking meter experiment came
into operation in Mayfair, London.

10th July, 1958

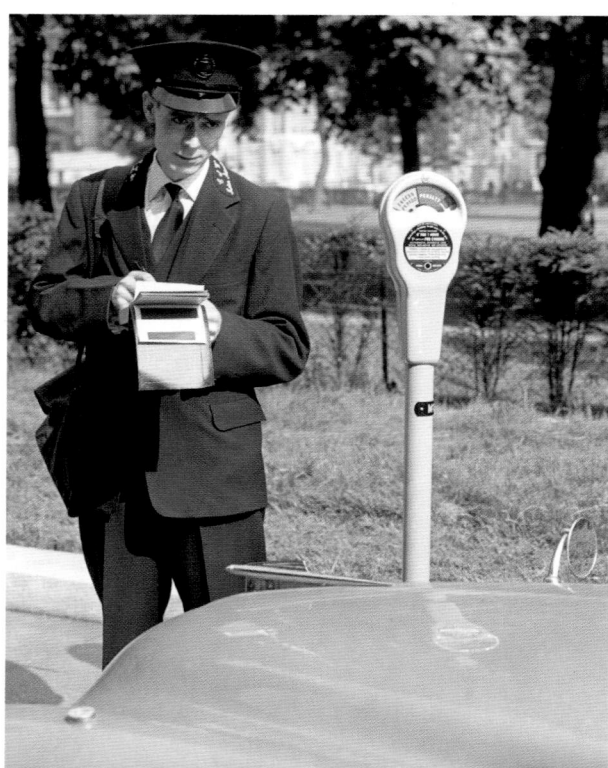

Below: What a mouthful! L–R: Showgirls Kathryn Keeton, Mariella Capes and Hazel Gardner at the Soho Fair spaghetti eating contest.

10th July, 1958

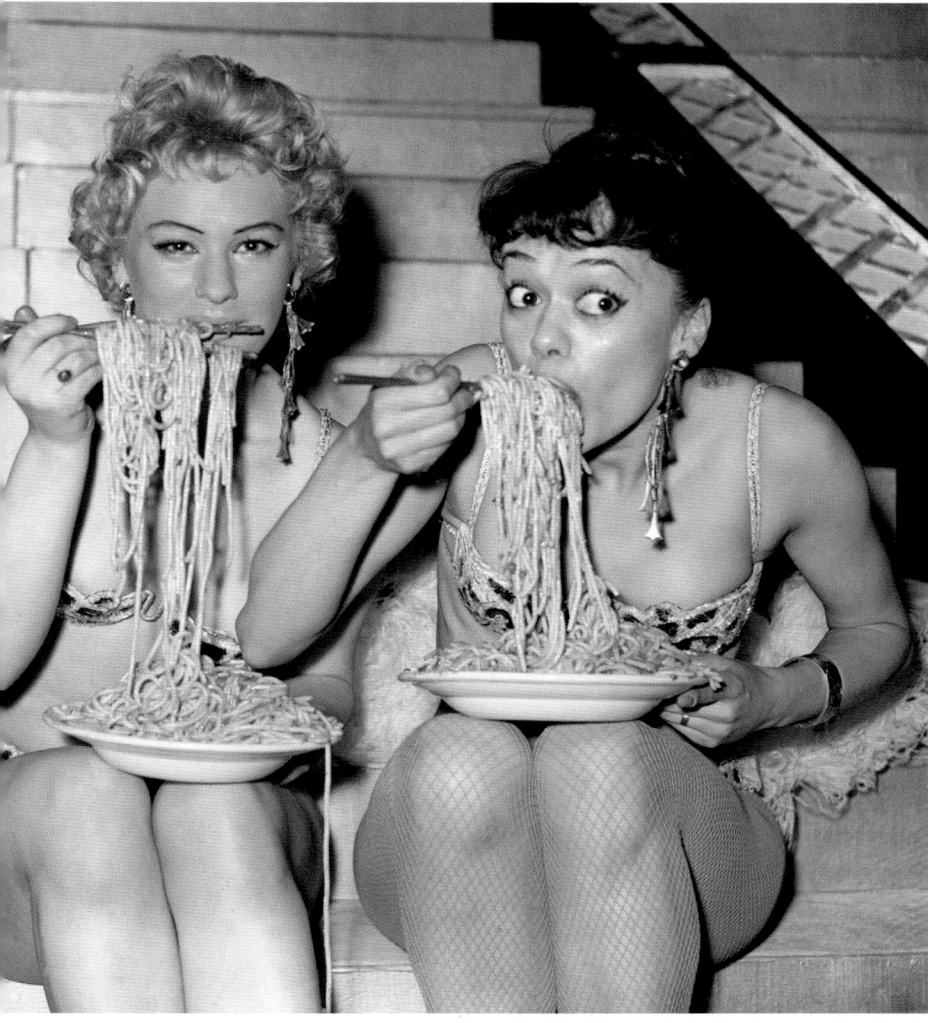

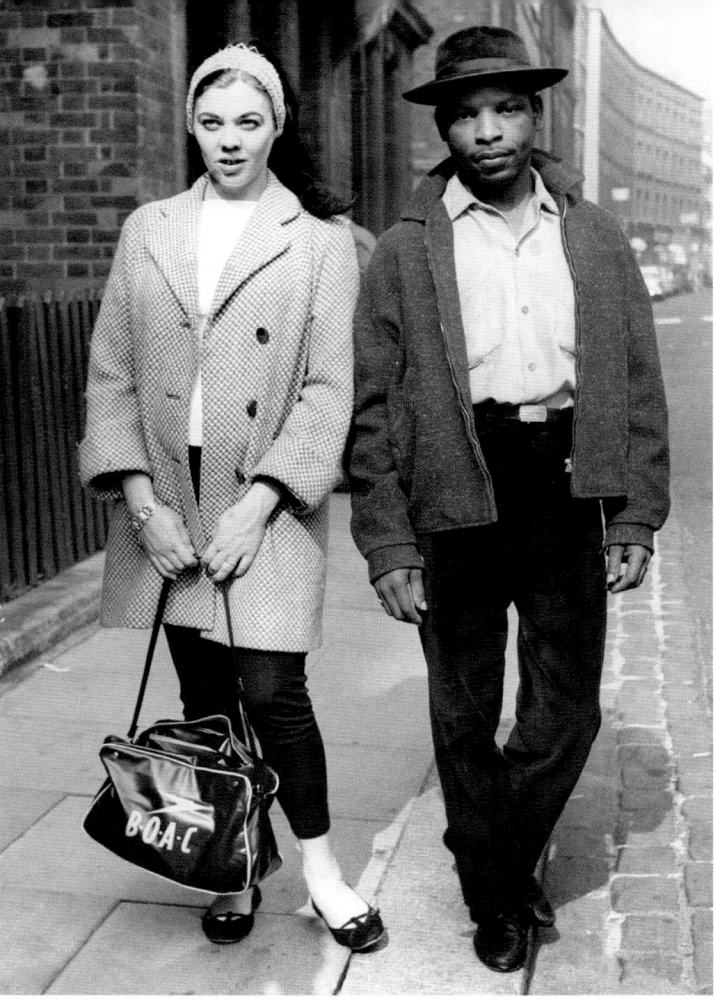

Above right: A West Indian man and his white girlfriend walk through the streets of Notting Hill Gate, London, despite the threat from right-wing thugs following race riots in the area.

2nd September, 1958

Right: A bruised, but smiling, Henry Cooper (L), who upset the world boxing rankings with his win over highly rated American Zora Folley at the Empire Pool, Wembley, reads messages of congratulation at his Bellingham, Kent home the next day. With him are his mother and identical twin brother, George (who also boxed, as Jim Cooper). Henry was eager for a match with American world champion Floyd Patterson.

15th October, 1958

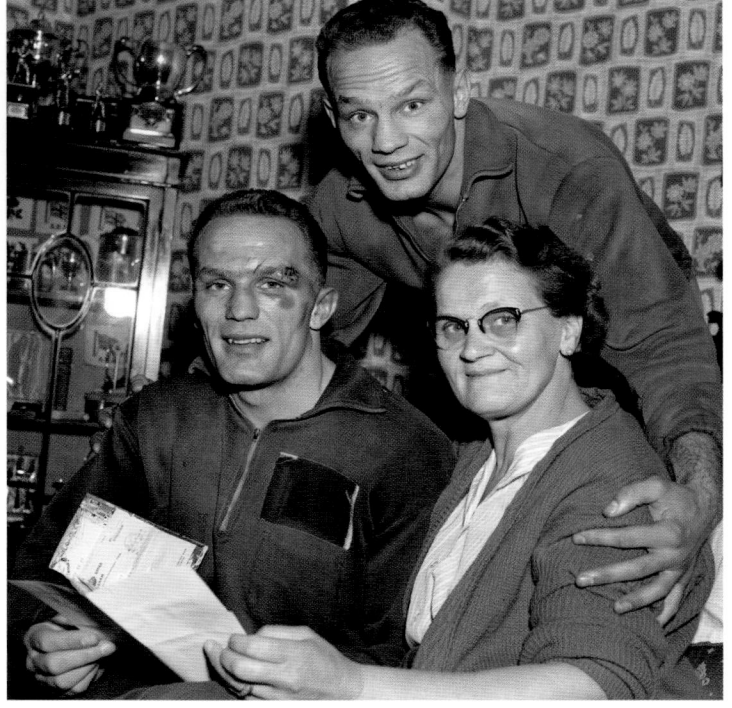

Right: Ted Smith, stockman on the Earl of Bathurst's estate, Cirencester Park in Gloucestershire, with Jim and Joey, the last two working oxen in Britain.

1st March, 1959

Below: Seventeen-year-old Barbara Rawlinson, of Islington, north London, is horrified by the many dials and controls of the Fairey Multi-Purpose Electronic Analogue Computer at the Electronic Computer Exhibition, Olympia, London.

28th November, 1958

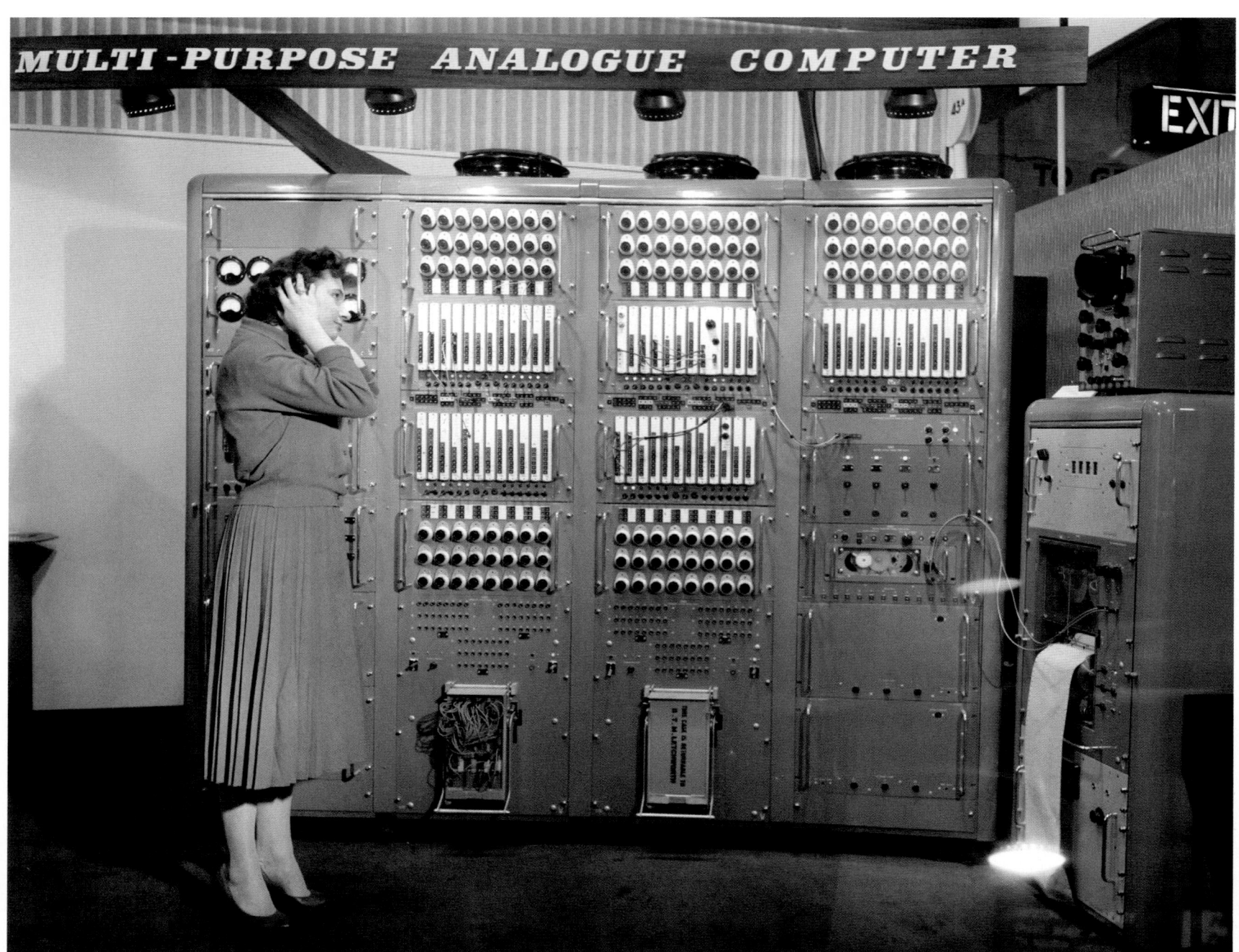

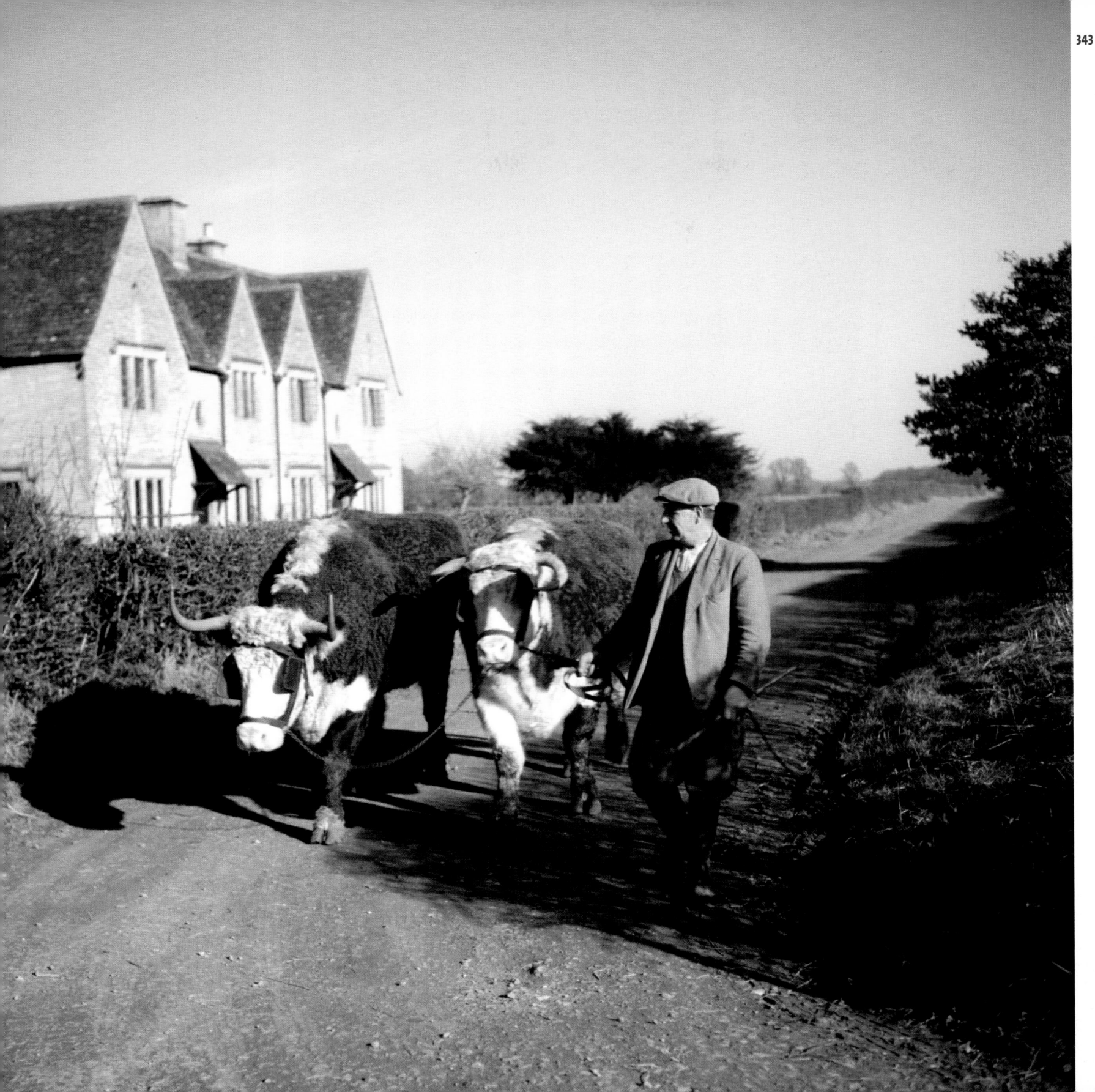

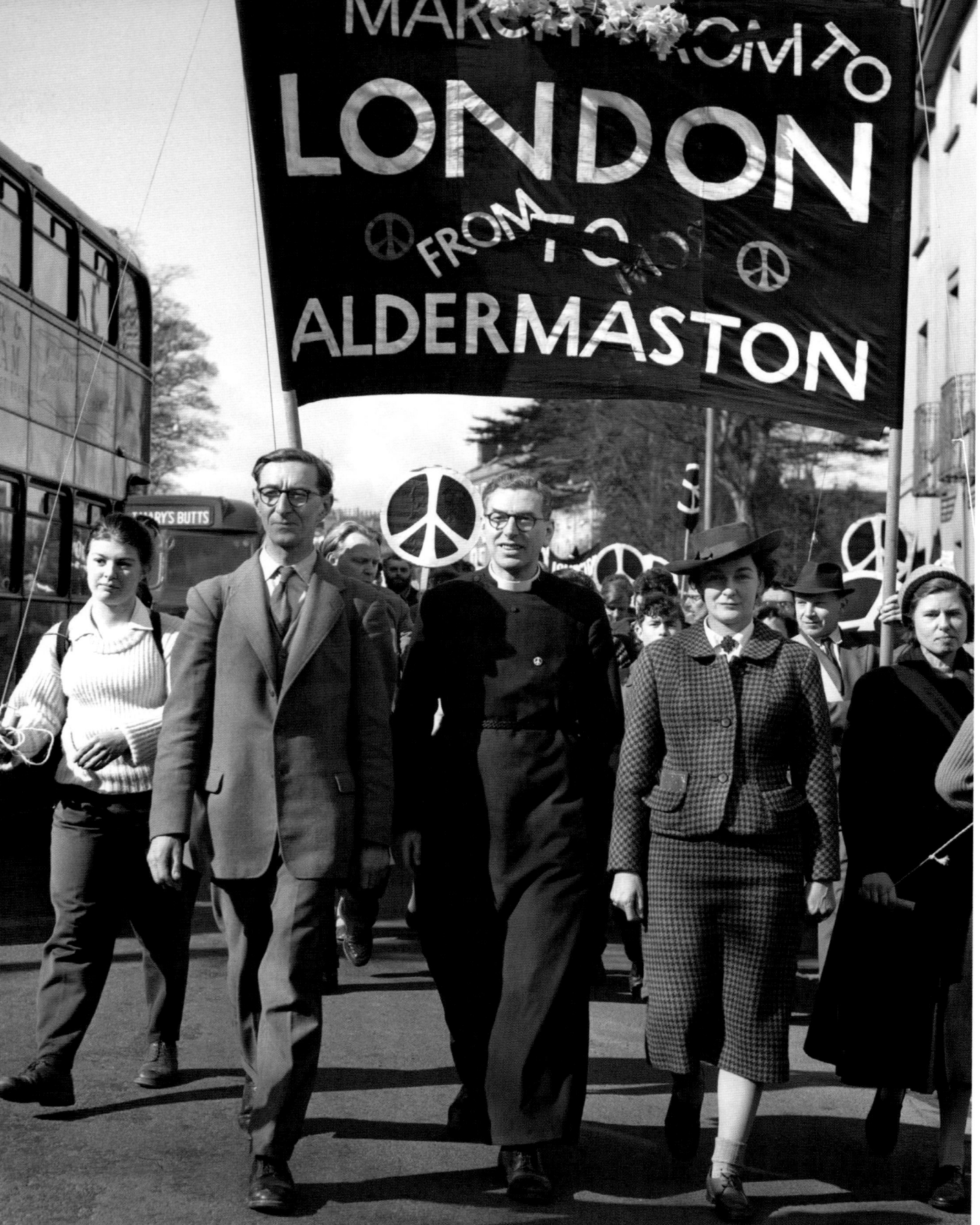

MARCH FROM TO LONDON FROM TO ALDERMASTON

Left: Canon Lewis John Collins (C) and Jacquetta Hawkes (second R), writer and wife of novelist J.B. Priestley, head a column of anti H-bomb demonstrators as they march from Aldermarston to London. Organized by the Campaign for Nuclear Disarmament (CND), the 52-mile (84km) march took place annually at Easter during the 1950s and 1960s, although the first (in 1958) had reversed the route, from London to the Atomic Weapons Research Establishment at Aldermarston. At its height, the 'Ban the Bomb' march attracted tens of thousands of protestors. CND was formed in 1957, and its distinctive logo has become a universal peace symbol. Designed by Gerald Holtom, it is based on the semaphore signals for 'N' and 'D' (Nuclear Disarmament).

28th March, 1959

Above right: Brigitte Bardot at a London Hotel during a photocall after arriving from Paris to start location shooting for her film *Babette Goes to War*.

9th April, 1959

Right: The Royal Navy's aircraft carrier HMS *Eagle*, one of the two largest British aircraft carriers ever built (the other was her sister ship *Ark Royal*). She remained in service until 1972.

29th May, 1959

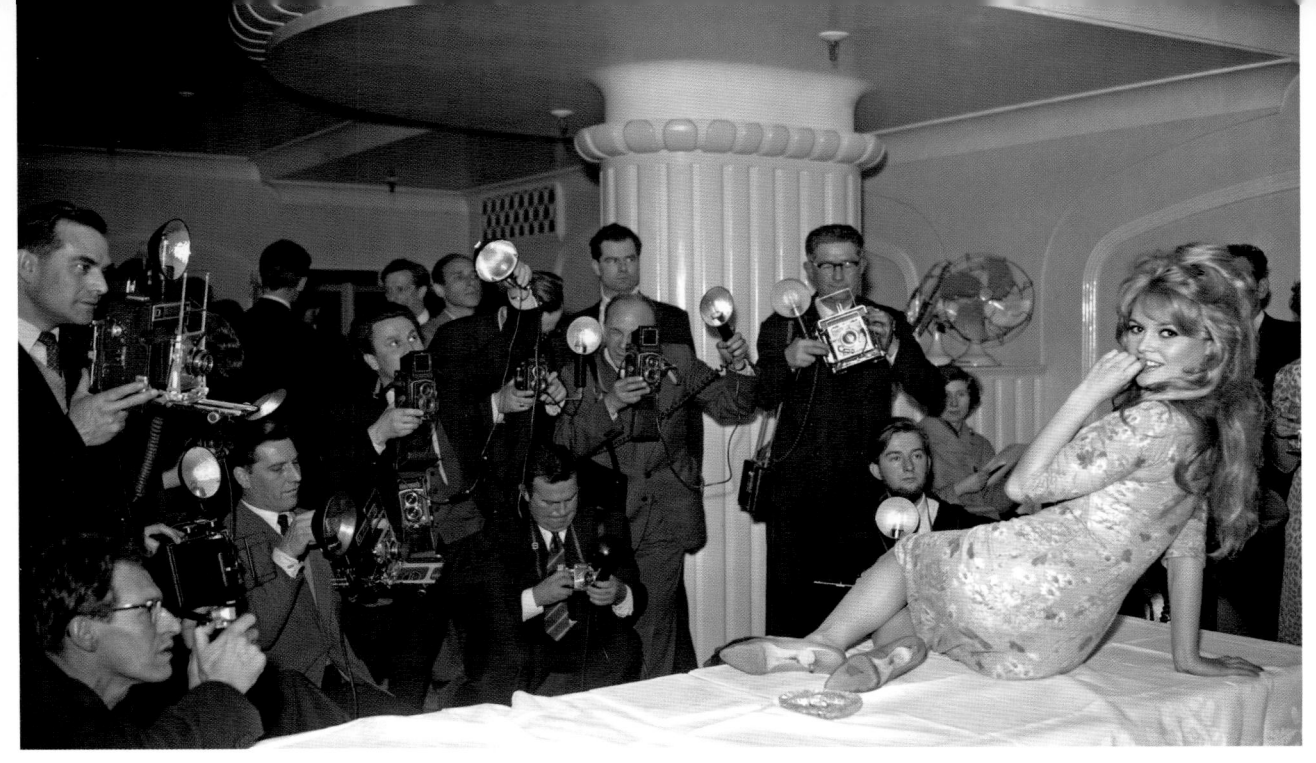

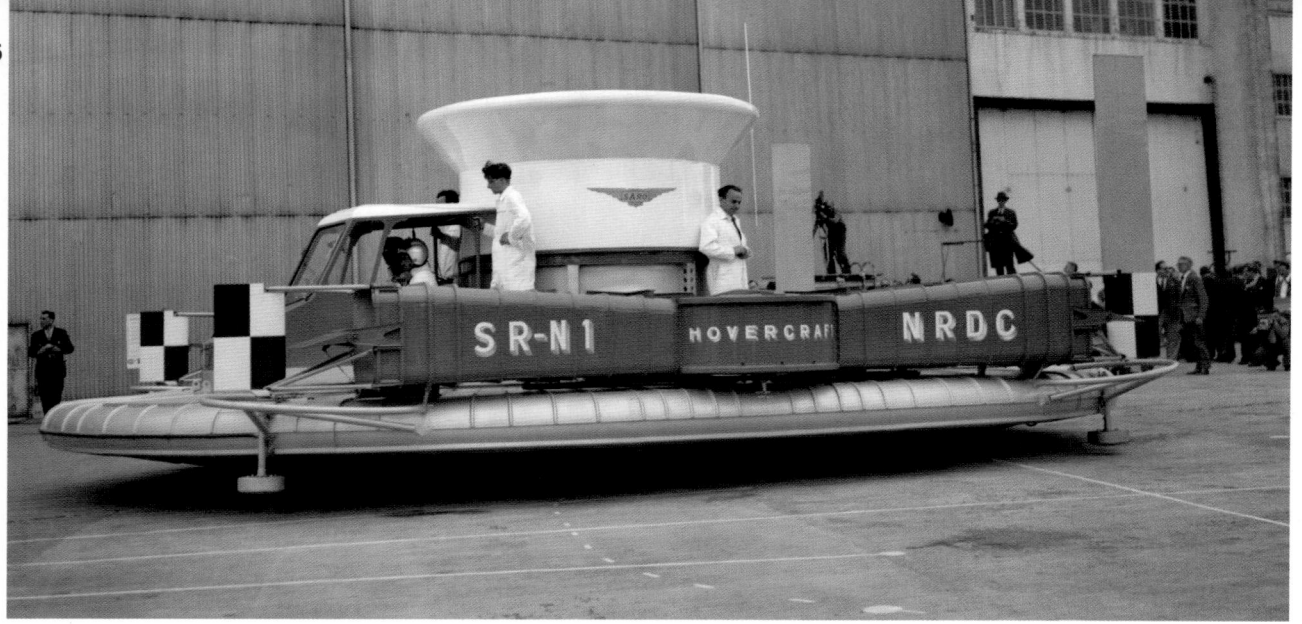

Left: The all-British prototype SR-N1 hovercraft, designed by Christopher Cockerell and built by Saunders Roe, is demonstrated at Cowes on the Isle of Wight.

11th June, 1959

Below left: The revolutionary Mini was launched by the British Motor Corporation in 1959. It was a unique concept with a transverse mounted engine, front wheel drive and four seats in a compact package. It went on to achieve great popularity and competition success.

28th August, 1959

Right: Security? What security? US President Dwight Eisenhower (standing) waves to the crowds on Fleet Street as he is driven to St Paul's Cathedral with British Prime Minister Harold Macmillan (seated in back seat). Unlike present-day processions of national leaders, there is no armoured limousine, no secret service personnel, no gun toting policemen, no crowd barriers set well back, just an open Rolls-Royce and a couple of motorcycle outriders. President Kennedy's assassination in 1963 would change all that.

31st August, 1959

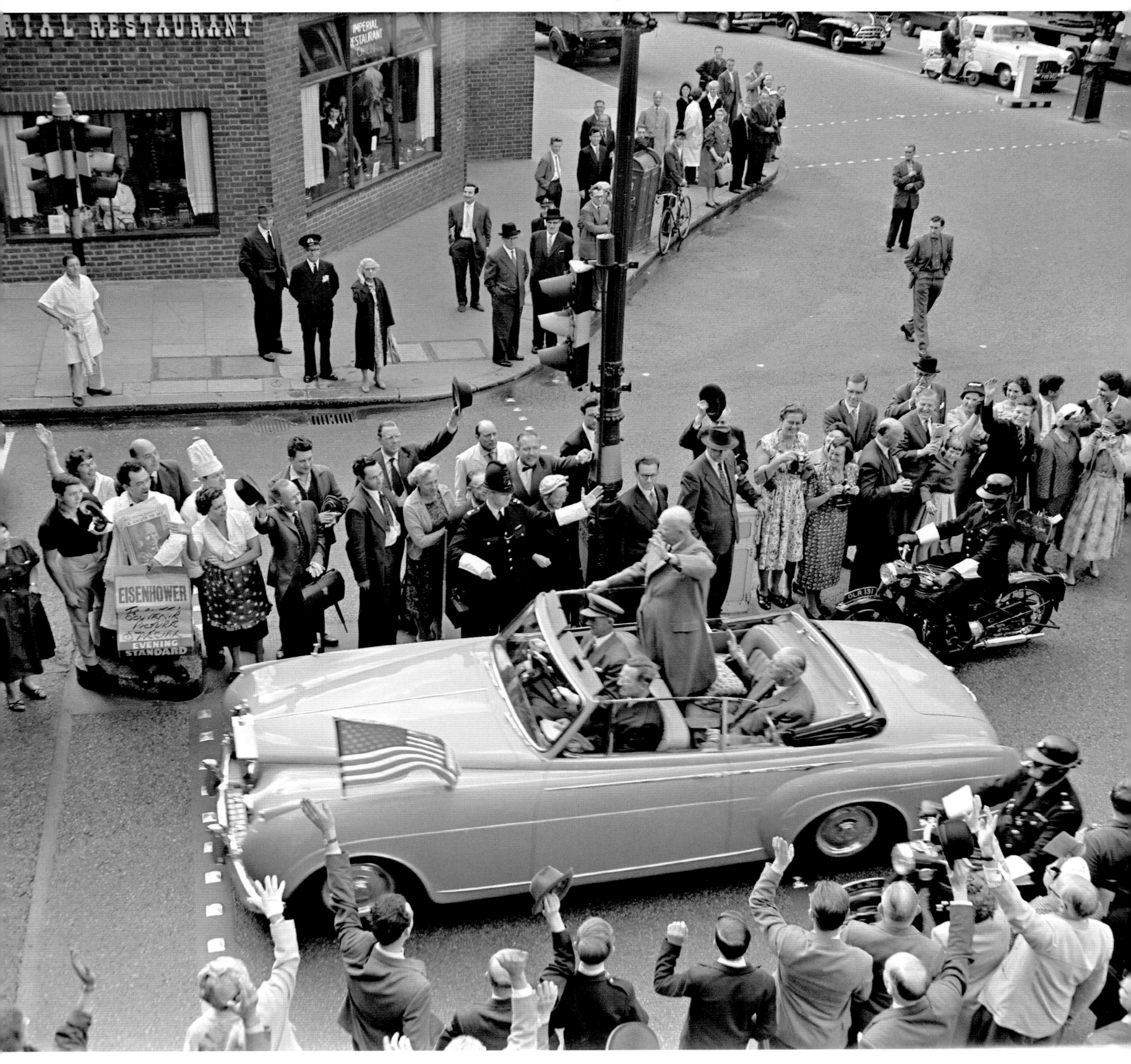

Above: The first cars speed along Britain's first full-length motorway, the M1 between London and Leeds. With no hard shoulders or central crash barriers – and very little traffic – it was very different to the motorways of today. The idea of motorways was so new that a television advertising campaign was thought necessary to educate drivers in how to use them. With a voice-over by popular television actor Jack Warner (famous for playing policeman Dixon of Dock Green), they admonished drivers not to attempt U-turns across the central reservation or stop to picnic on the verge.

2nd November, 1959

Right: Sir Winston Churchill and Lady Churchill at home on the occasion of the statesman's 85th birthday. At the time, he was still an MP and did not stand down until 1964, although his majority had dropped in the 1959 General Election by over 1,000.

30th November, 1959

Below: Dr Barnes Wallis, who had collaborated on the R100 airship and the Vickers Wellington bomber, and had developed the 'bouncing' bombs used by the Royal Air Force in the 'Dambusters' raid, contemplates his latest scheme, the supersonic Swallow variable-geometry aircraft. A number of models were built to test Wallis' theories, but defence cuts brought an end to further development, although the Americans used his variable-geometry ideas on the General Dynamics F-111 bomber.

30th December, 1959

1960s

The 1960s was unquestionably the most iconic decade of the 20th century. The fashions, music, arts and personalities that emerged during that time continue to influence Britain more strongly than those of any other period. Given this, photographs from the era portray a world that was more drab than we might imagine, but below the surface everything was changing. This can be seen most clearly in the faces of the young people – and young people would come to dominate the news of the time – which wear expressions of challenge and confidence not seen before. This was a generation born after the Second World War, who were experiencing greater affluence and leisure than either their parents' or grandparents' generations; perhaps this explains the decade's explosion of creativity and individualism that fuels Britain still.

Just as senior government minister John Profumo fell before Christine Keeler and Mandy Rice-Davies, so the old order fell before the advance of the new. On the beaches of the south coast, in the universities, on the Isle of Wight, the future had already arrived.

Above: BR Standard Class 9F
No 92220 *Evening Star*, a 2-10-0
locomotive, steams slowly out of
Swindon Locomotive Works after
the naming ceremony. The last
steam locomotive to be built by
British Railways as a result of its
dieselization and electrification
policy, the engine is now preserved
as an exhibit at the National
Railway Museum, York.

18th March, 1960

Right: Seventeen-year-old Martin
Davies, troop leader of the 25th
Warrington Group Scouts, strides
proudly out of Windsor Castle past
a guard on duty, after becoming
the first member of the Scout
movement to gain the Duke of
Edinburgh's Gold Award.

24th April, 1960

Right: Princess Margaret and
Anthony Armstrong-Jones after their
wedding ceremony at Westminster
Abbey. Armstrong-Jones, a
professional photographer, was
gifted the title of Earl of Snowdon
as a result of the marriage to ensure
that any child born to the Princess
would have a title. Although they
remained married for 18 years,
their relationship broke down very
quickly for a variety of reasons,
among them the fact that both
were promiscuous, particularly
Armstrong-Jones, and that both
needed to be the centre of attention.

6th May, 1960

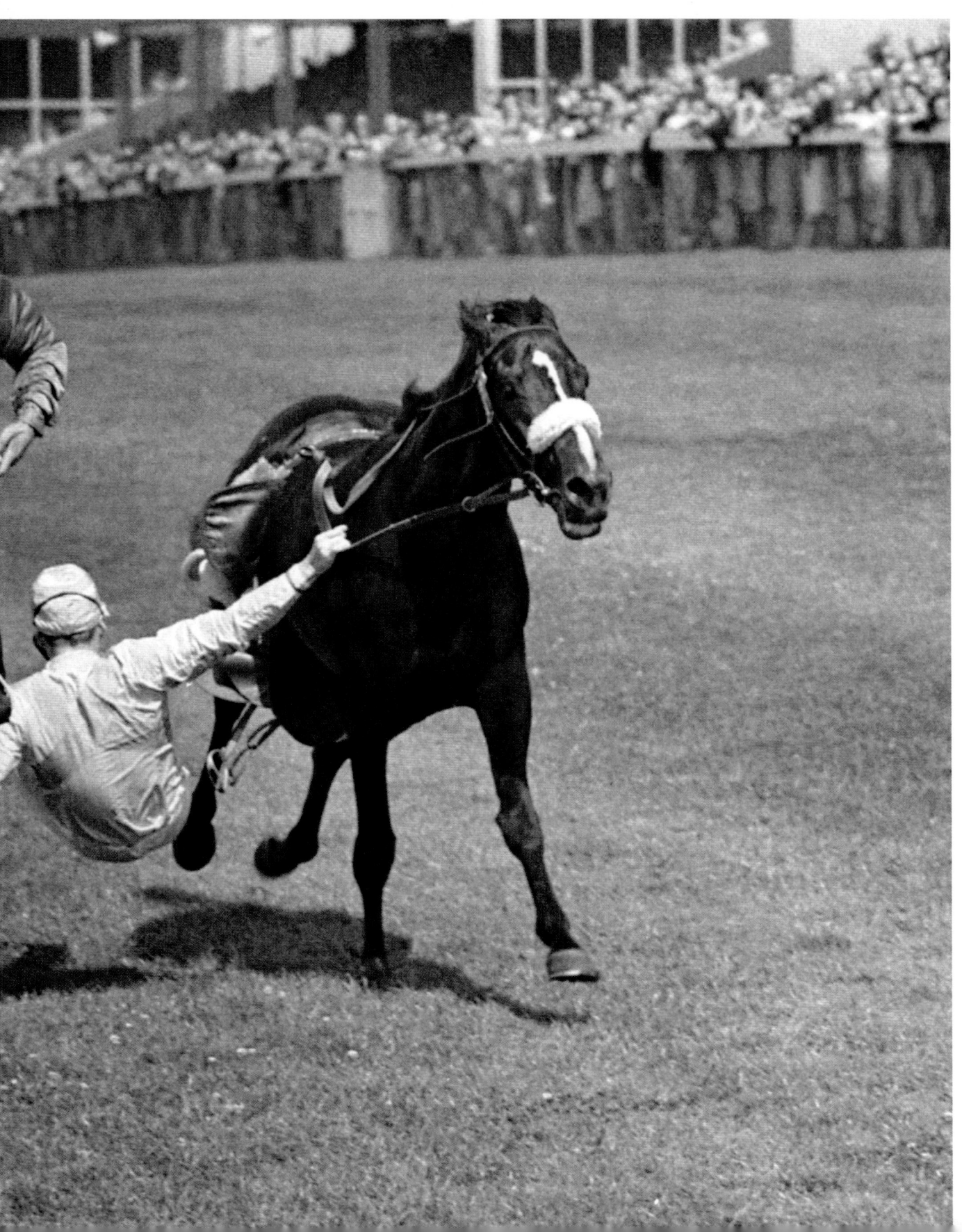

Left: Lester Piggott tries desperately to hang on to Barbary Pirate, after being unseated on the final straight at Brighton. Considered by many to be the best English flat jockey of all time, Piggott amassed 4,493 wins, including nine Derbys, during his career. After retiring from riding, he became a successful trainer, but tax evasion earned him a prison sentence in 1987 and subsequently the loss of his OBE. He returned to riding upon his release in 1990 and continued to win, finally retiring for good in 1995.

18th August, 1960

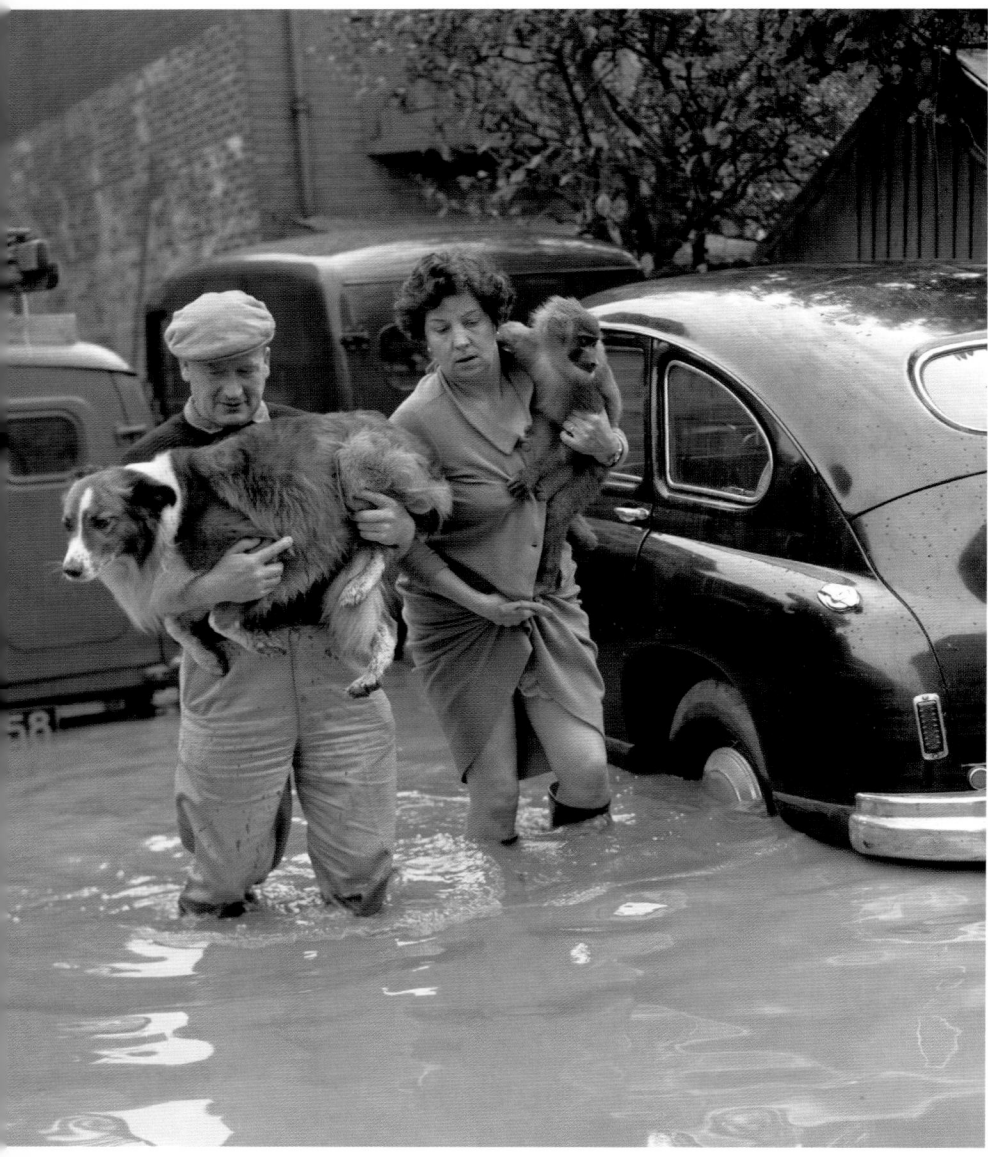

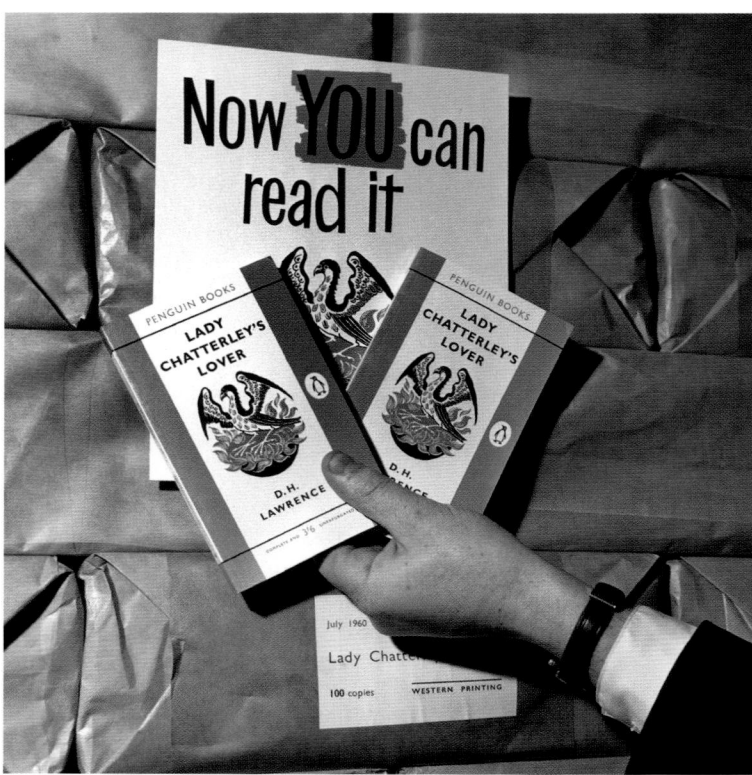

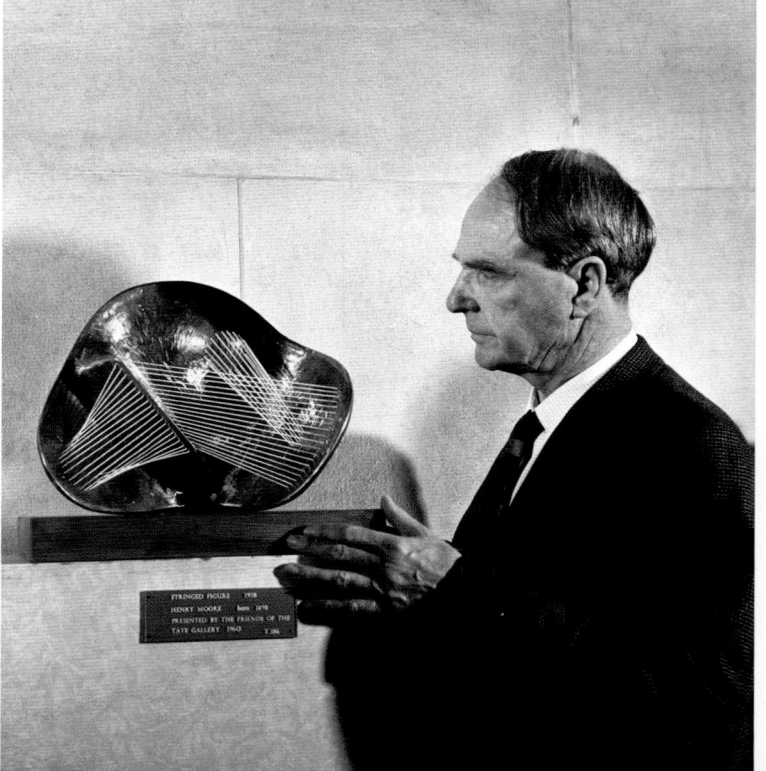

Above: Devon floods affect more than just the local people as Mr and Mrs Howarth carry Rex, the family dog, and Dinah, their pet monkey, to safety.

7th October, 1960

Above right: After being banned for over 30 years, D.H. Lawrence's book, *Lady Chatterley's Lover*, sells out hours after being released. An Old Bailey jury had decided that Penguin was not guilty of publishing an obscene novel, allowing the work to be published as written.

2nd November, 1960

Right: Sculptor and artist Henry Moore, with his creation 'Stringed Figure, 1938', at the Tate Gallery in London during a viewing of six sculptures to be presented to the gallery by the Friends of the Tate Gallery.

28th April, 1961

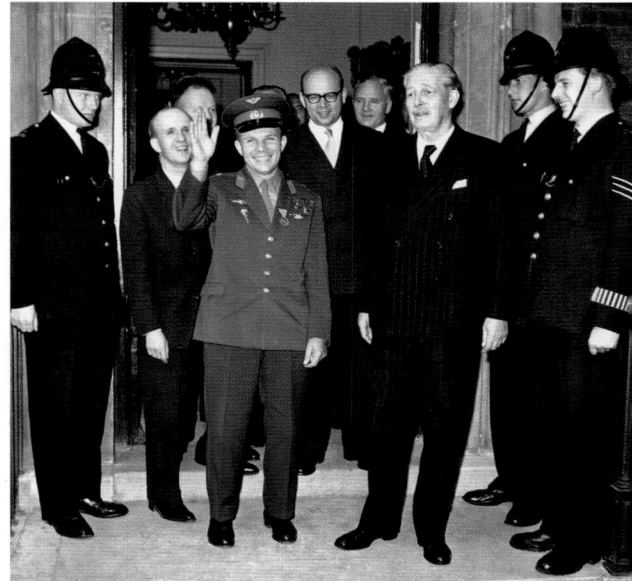

Above: Major Yuri Gagarin, the first man in space, waves to bystanders on his departure from Admiralty House, London. With the cosmonaut are Harold Macmillan (R) and Aleksander Soldatov (glasses), the Soviet Ambassador to the UK. Gagarin had made his historic 108-minute orbit of the earth on 12th April, 1961.

13th July, 1961

Left: Five thousand people sunbathe at Hyde Park's Serpentine Lido in the sweltering London heat. At 4pm, the temperature reached 33.3 degrees, equalling the previous record of 3rd June, 1947.

1st July, 1961

Left: Nice young men. Looking more like a group of bankers than pop stars, Cliff Richard and The Shadows leave London's Heathrow Airport for a Scandinavian tour. L–R: Tony Meehan, Bruce Welch, Cliff Richard, Hank Marvin, Jet Harris.

15th August, 1961

Right: Cabaret star Sandu Scott demonstrates her version of the popular twist. The dance, originally inspired by African American plantation dances, became a worldwide craze, although its pelvic movements were often criticized by parents as being too provocative.

19th January, 1962

Above: Chairman of the British Railways Board Dr Richard Beeching holds aloft a copy of *The Reshaping of British Railways*. In an attempt to reduce the cost of running the nationalized British Railways system, the 'Beeching Axe' fell on more than 4,000 miles (6,440km) of what were considered little-used and unprofitable, mainly rural branch and cross-country lines, and 3,000 stations – a third of the network. The closures provoked outcry from communities that stood to lose their rail services, particularly in the country where often there was no other form of public transport. Although bus services were substituted for lost rail services, these proved to be slower and less popular than the trains, and subsequently most were withdrawn, leaving many areas without any form of public transport. Ironically, the cuts produced nowhere near the savings expected, one reason being that the small branch lines that were axed acted as feeders for the main lines, and the traffic they carried shifted to the roads and never returned.

27th March, 1963

Left: The winter of 1962–3, known as the 'Big Freeze', was one of the coldest winters on record in the UK. Cars can be seen buried almost to roof level as workmen dig through 5ft (1.5m) snow drifts on Westerham Hill in Kent.

31st December, 1962

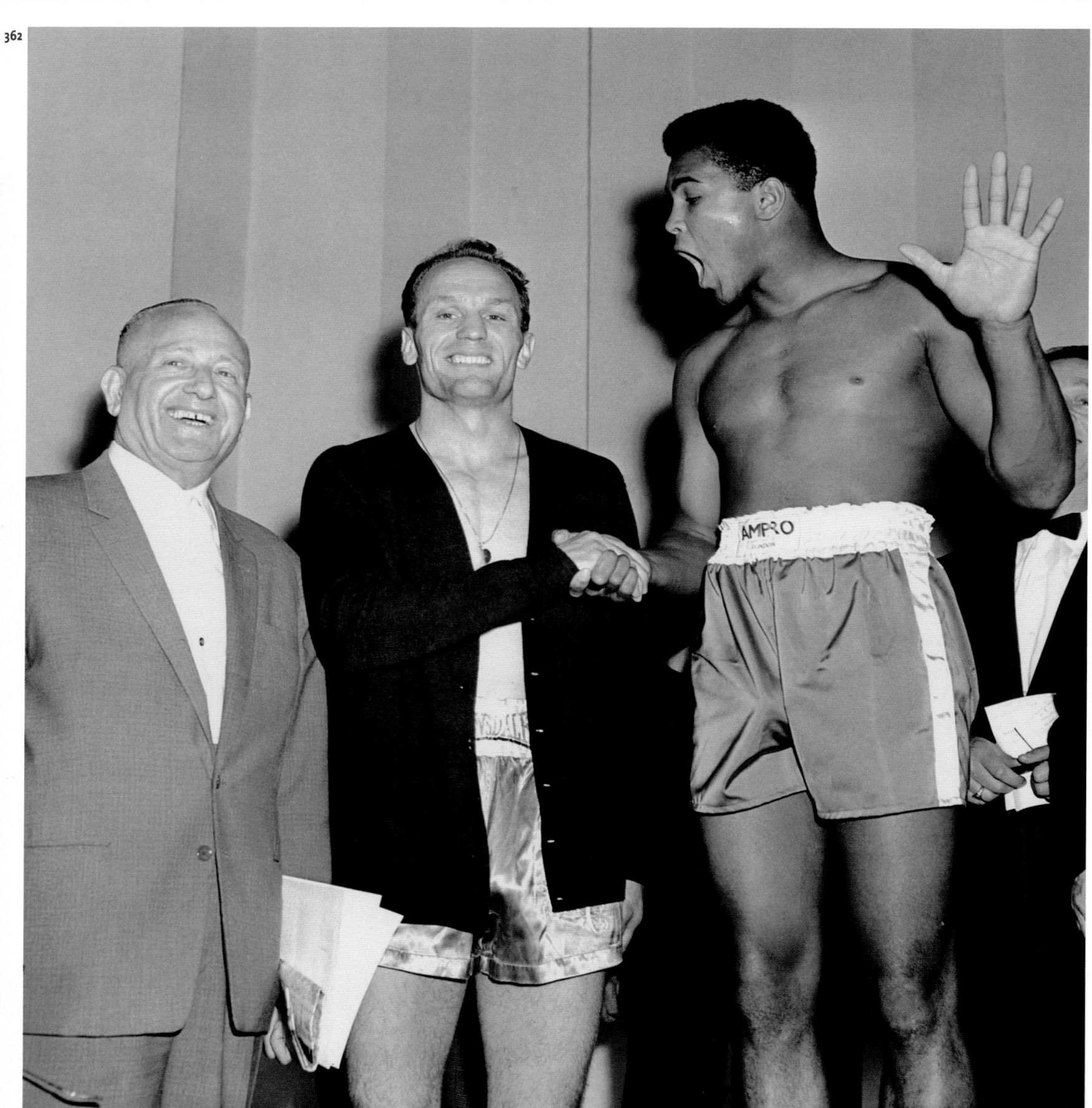

Left: At the weigh-in, Henry Cooper smiles as he offers a crushing handshake to Cassius Clay, who, ever the showman, hams it up for the Press and his adoring fans.

18th June, 1963

Right: Prime Minister Harold Macmillan (R) points out the lie of the land to US President John F. Kennedy during a break in informal talks at Birch Grove, Macmillan's Sussex home. Within five months, Kennedy would be dead, having been assassinated in Dallas, Texas on 22nd November.

30th June, 1963

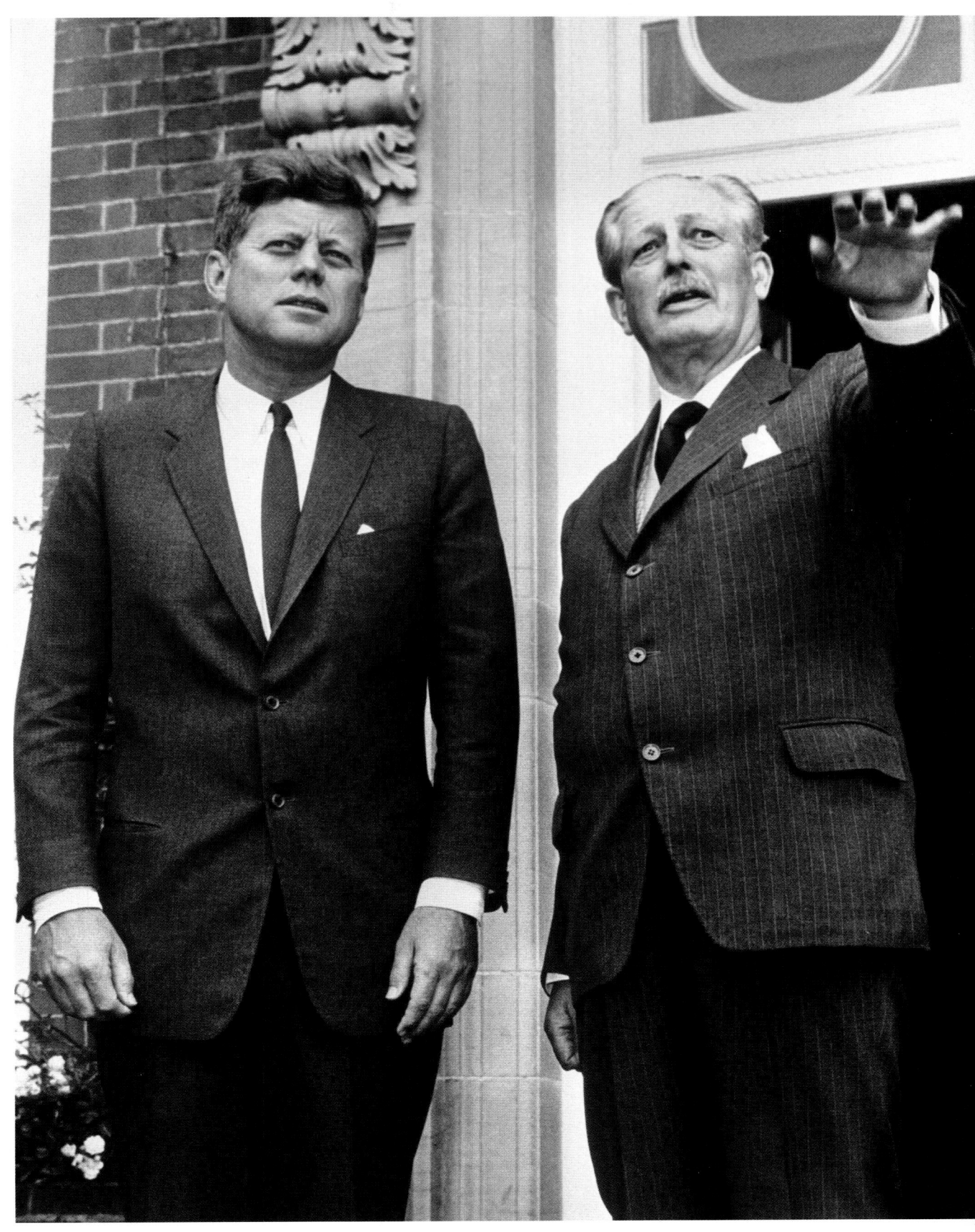

Left: Secretary of State for War John Profumo, whose affair with Christine Keeler, allegedly the mistress of a Soviet naval attaché, forced his resignation after he had lied about it in Parliament. In his letter of resignation, he wrote that his *"statement in the House of Commons on March 22nd regarding relations with Miss Christine Keeler, was not true, and misled the Prime Minister and the House of Commons."*

June, 1963

Right: Christine Keeler (R) and Mandy Rice-Davies leave the Old Bailey after the first day of the trial of Dr Stephen Ward, the 50-year-old osteopath charged with living off the proceeds of prostitution. Both women lived with Ward, who had introduced Keeler to John Profumo at a party. Ward committed suicide before the end of the trial.

22nd July, 1963

Above: This photograph distributed to the press shows (L–R) Bruce Richard Reynolds, Frances Reynolds, Barbara Maria Daly and John Thomas Daly, all wanted in connection with the Great Train Robbery. Reynolds was the leader of the gang that made off with £2.6m after stopping the travelling post office special train from Glasgow to London Euston on the night of 7th August, 1963, just outside Cheddington, Buckinghamshire.

August, 1963

Right: The special post office train involved in the Great Train Robbery. The gang raided the High Value Package Coach immediately behind the engine. This carried valuable packages, including large amounts of cash. Most of their haul was never recovered

August, 1963

Above: A police car escorts the lorry and two Land Rovers that were used to haul £2.6m of used bank notes stolen in the Great Train Robbery. The vehicles were discovered at the robbers' hideout, a Buckinghamshire farm, where the police found fingerprints on a Monopoly board that had been used for a game with real money. Thirteen of the 15-strong gang were captured.

19th August, 1963

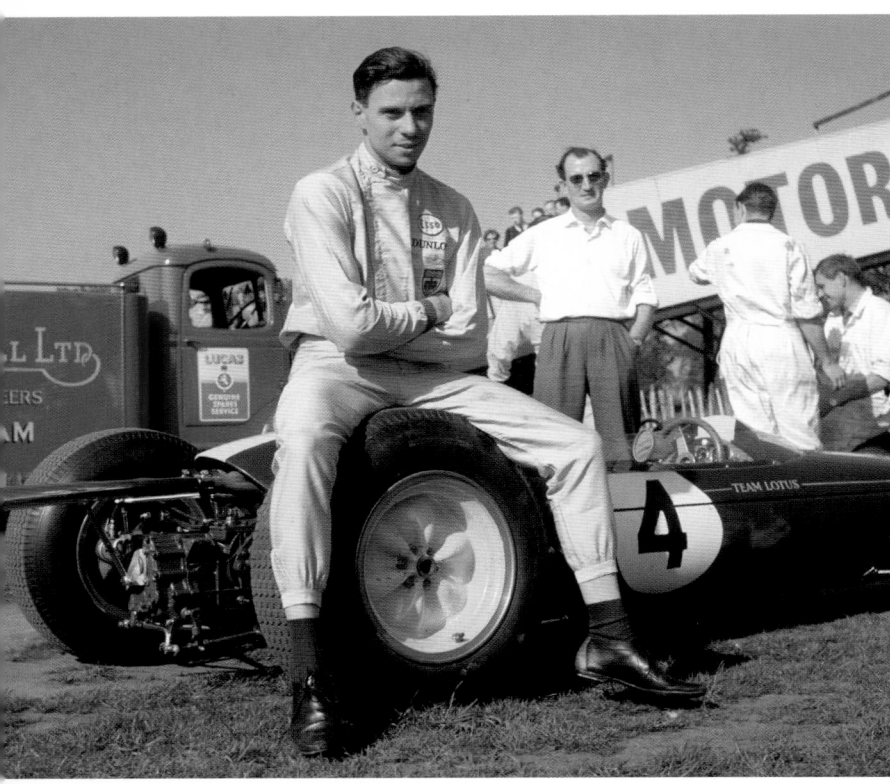

Above: A relaxed Jim Clark sits on the wheel of his Lotus 25. Clark would take the Formula One World Championship in 1963, winning seven out of the ten races. He also raced in the United States at the Indianapolis 500 that year, coming second and gaining Rookie of the Year honours.

24th September, 1963

Right: The TSR-2, a revolutionary new bomber designed for the Royal Air Force, under construction by the British Aircraft Corporation at Brooklands, near Weybridge in Surrey. The machine was intended as a low-level strike aircraft, and was touted as the most advanced and versatile aircraft in the world. The project was cancelled in favour of the American-built General Dynamics F-111, however, a procurement that was also cancelled shortly after.

28th October, 1963

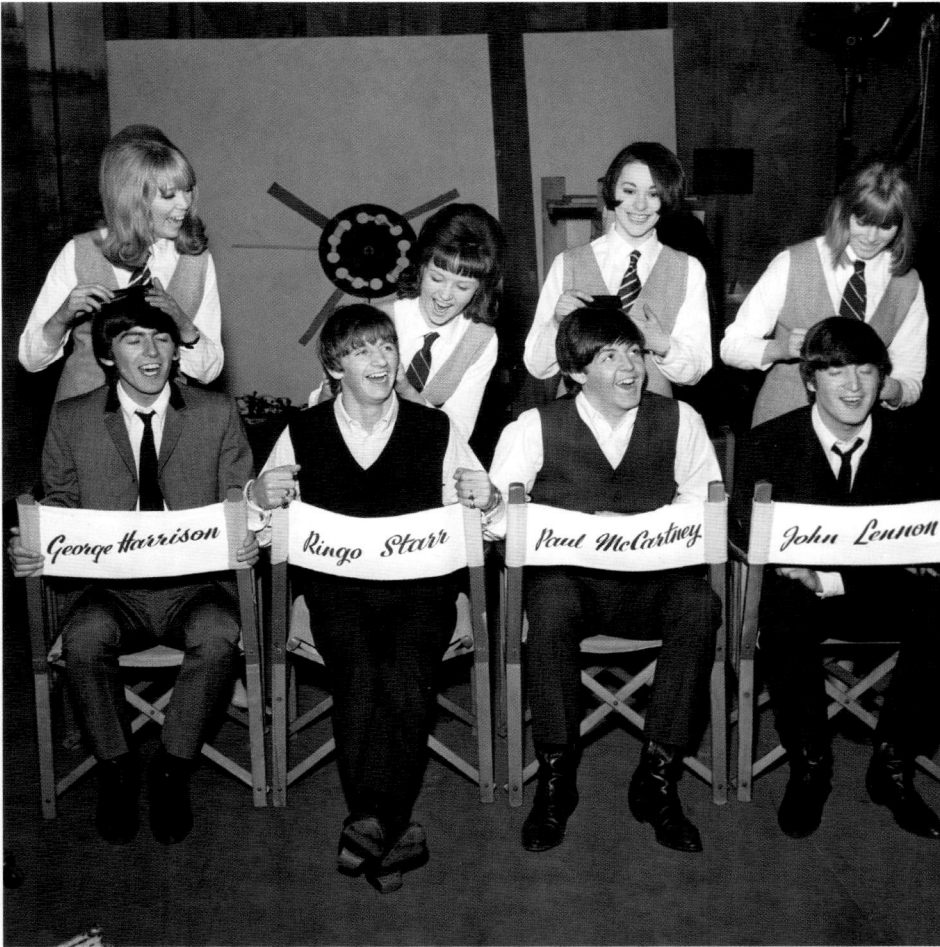

Above: During the filming of *A Hard Day's Night*, The Beatles have their hair styled by four 'schoolgirl fans' from the film: (L–R) Pattie Boyd, Tina Williams, Pru Berry and Susan Whiteman. Boyd, a model, first met George Harrison during filming, and the couple soon started dating. They married in 1966. Later, after breaking up with Harrison, she would marry Eric Clapton, who famously wrote the song *Layla* to express his love for her.

16th March, 1964

Left: Cry Baby Cry. Teenage fans of The Beatles are overcome with emotion at one of the band's concerts in Manchester.

21st November, 1963

Left: Everybody shout now! Lulu, the 15-year-old singer from Scotland, made her debut with the song *Shout*, sung in her characteristically strident voice. The song had been recorded originally by the Isley Brothers.

14th April, 1964

Below: The Yardbirds (L–R: Eric Clapton, Paul Samwell-Smith, Keith Relf, Jim McCarty and Chris Deja) play in the back yard of Lord Willis, who attacked the 'Beatle cult' in a House of Lords speech. The Yardbirds launched the careers of three famous guitarists: Clapton, Jeff Beck and Jimmy Page.

17th May, 1964

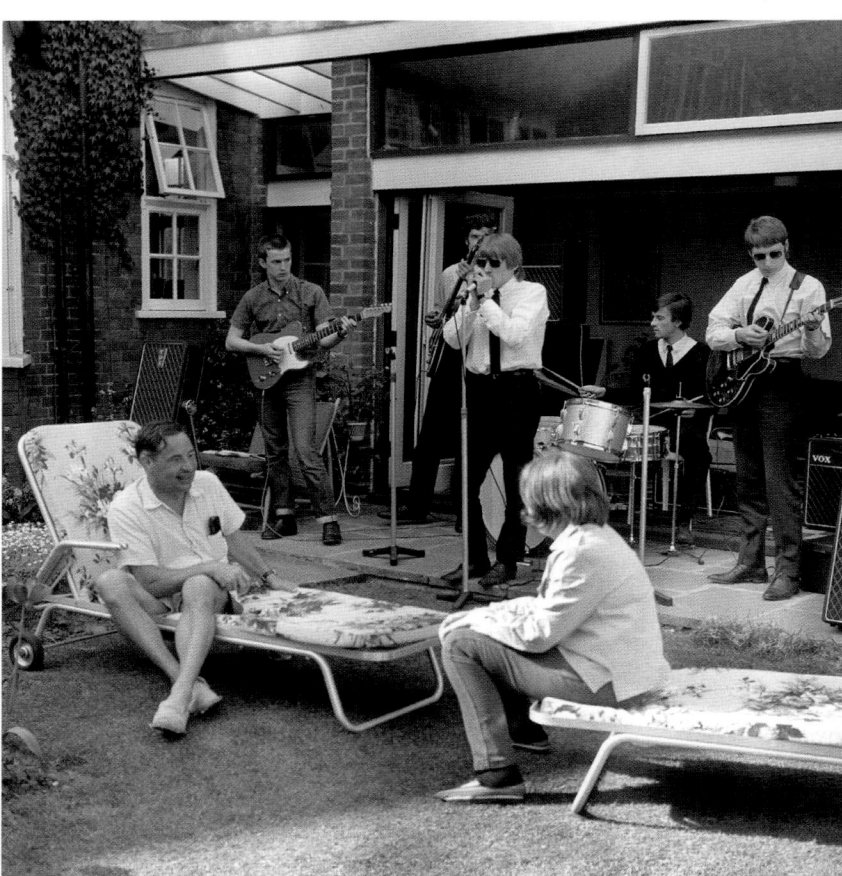

WE SELL FILMS
KODAK

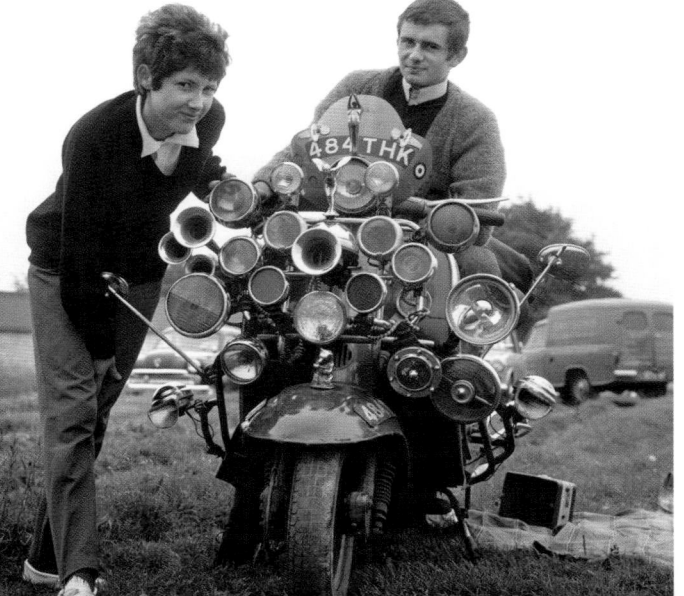

Above: Brighton police arrest youths during fighting between Mods and Rockers on Brighton beach. The Mods, with their stylish clothes and Italian scooters, were the exact opposites of the Rockers, who favoured grubby jeans, leather jackets and oily motorcycles.

18th May, 1964

Left: Mods often lavished as much attention on their scooters as on their clothes, adding vast arrays of spotlights and horns. A prime example is this Vespa owned by Roy Young and Linda Jarvis, who were enjoying a day out at Epsom Downs, Surrey for Derby Day.

31st May, 1964

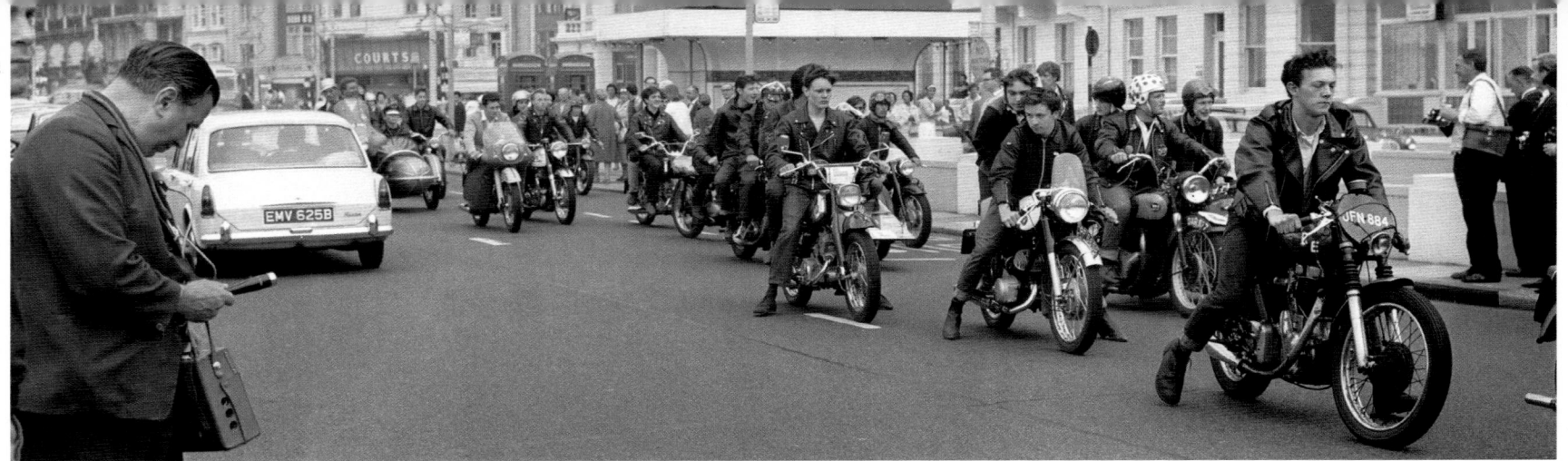

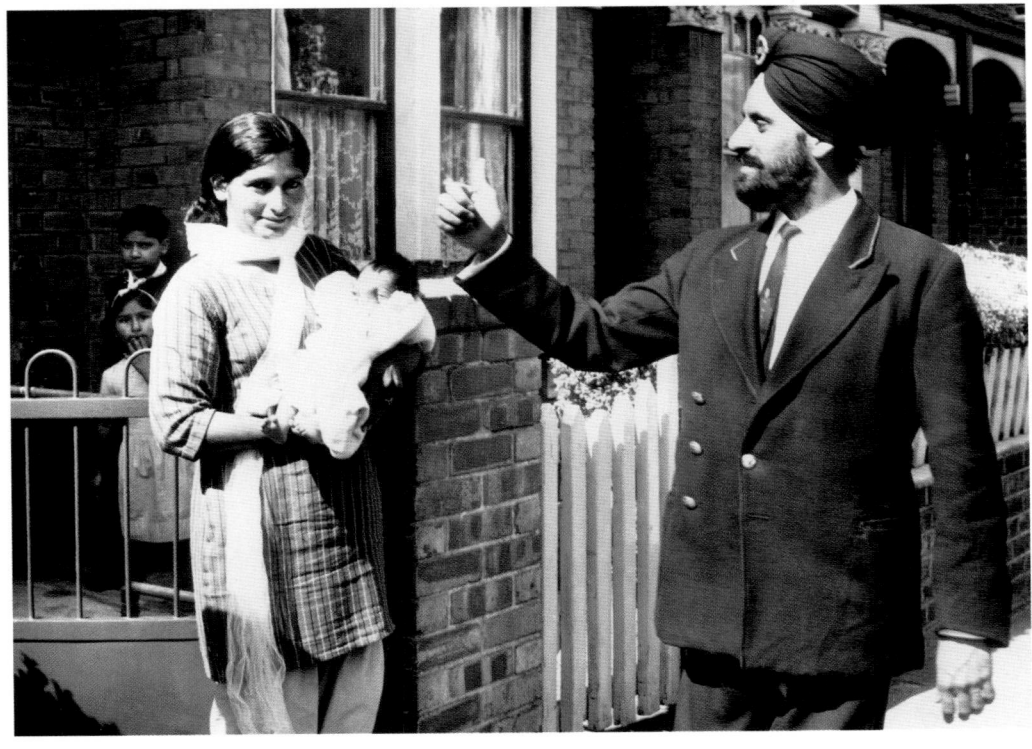

Above left: A group of Rockers, traditional enemies of the Mods, ride their motorcycles along the seafront at Hastings in Sussex. Style was not important to Rockers, who invariably wore grubby jeans and leather jackets. The two groups often clashed in running battles at major seaside towns, as was the case in this instance just after the photograph was taken.

2nd August, 1964

Left: Teenagers window-shop for records in Coventry Street, London. The window display emphasizes 'easy listening'.

1st September, 1964

Above right: Amar Singh, a Sikh train guard who was given permission to wear his turban while on duty on London's Underground, with his wife, Amrid, and their 13-day-old daughter, at their Southall, Middlesex home.

2nd September, 1964

Right: Bad boys. The Rolling Stones are banned from the BBC for showing up late for radio shows: (L–R) Mick Jagger, Bill Wyman, Brian Jones, Keith Richards and Charlie Watts.

12th September, 1964

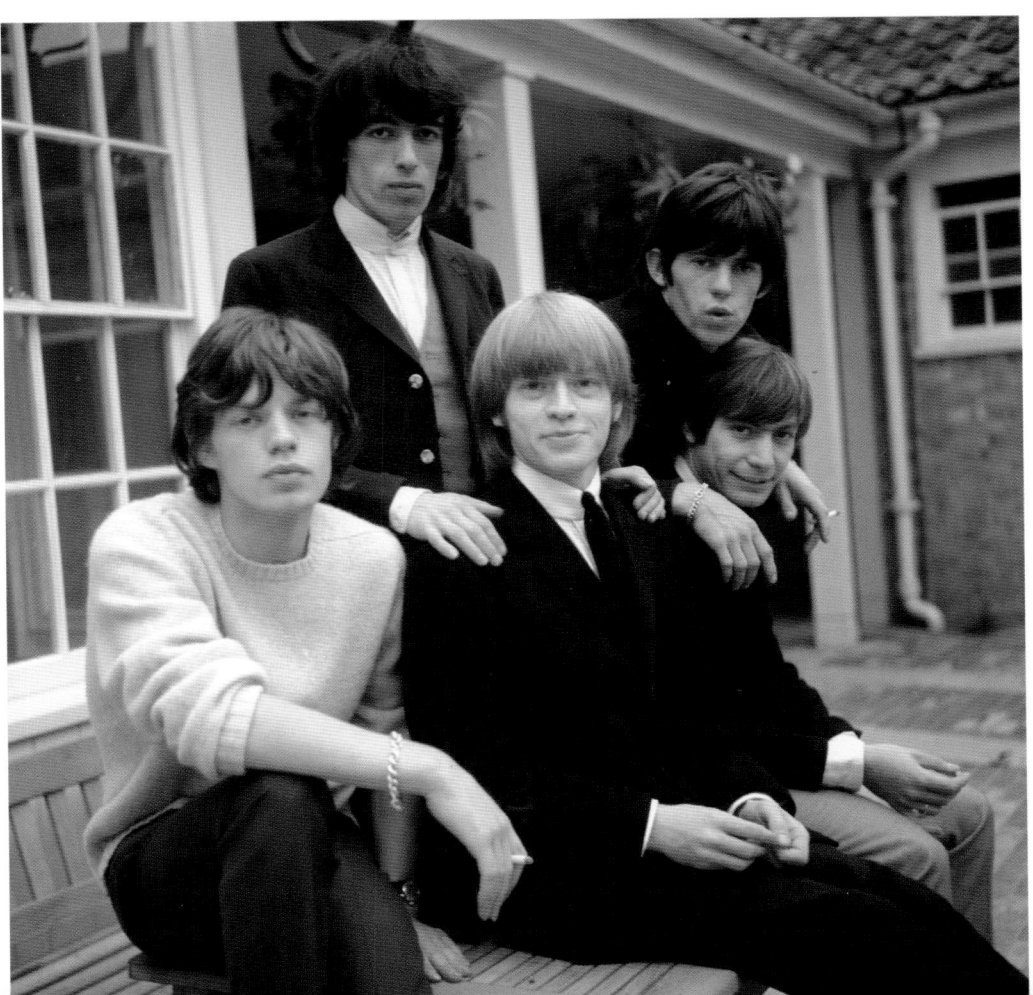

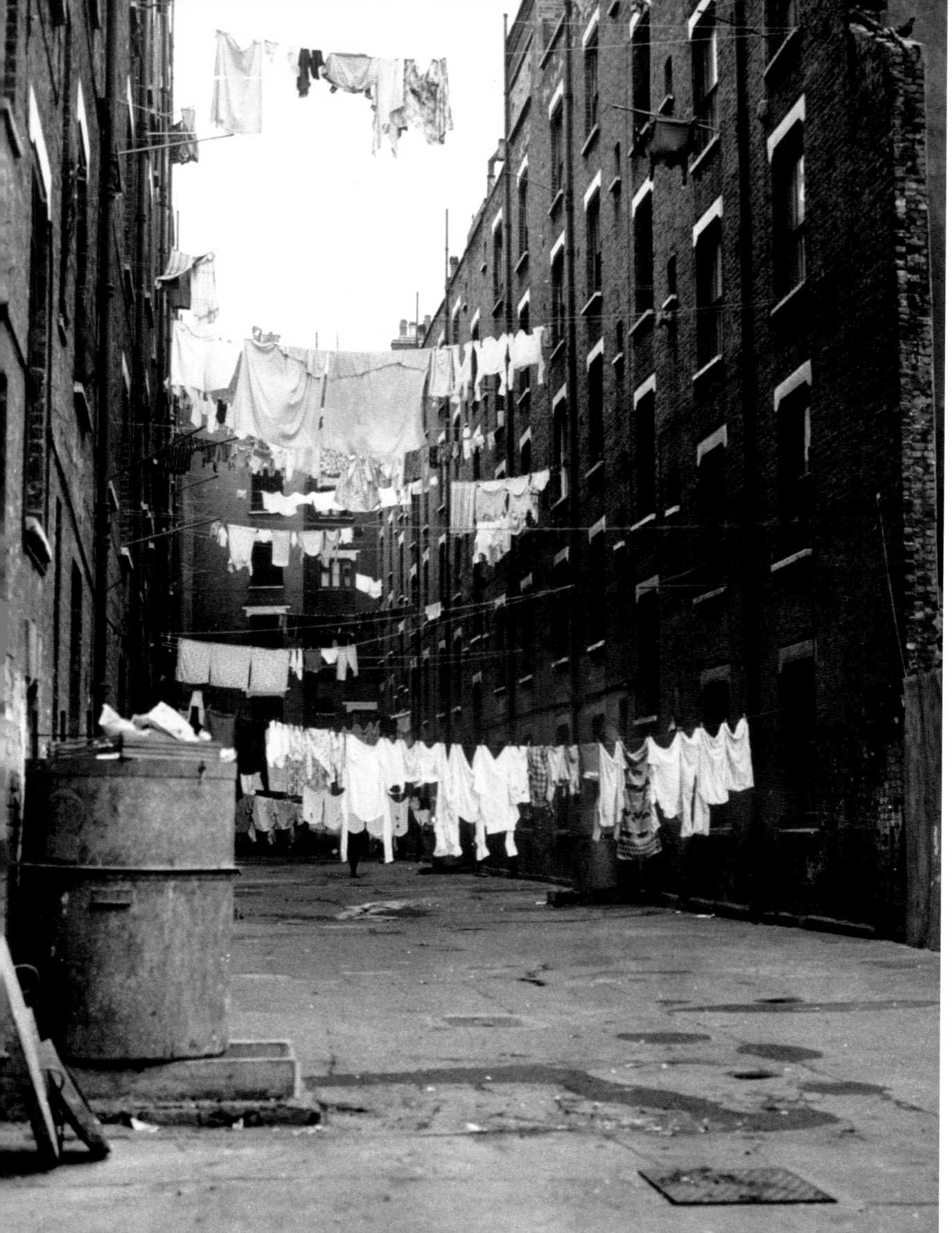

Left: Lines of washing hang over a courtyard between slum tenements in Southwark, south London.

1965

Right: Crowds cram the pavements in silent farewell as the gun carriage bearing the coffin of Sir Winston Churchill is drawn by naval ratings up Ludgate Hill to St Paul's Cathedral in London. Churchill had died on 24th January, at the age of 90, after suffering a severe stroke nine days earlier. It had been the last in a series of strokes that had plagued him since 1949. After the funeral, his coffin was taken by boat along the River Thames, where crane jibs were lowered as it passed, a 19-gun salute was fired by the Royal Artillery and a flight of RAF jets flew overhead. After being carried to Waterloo Station, the coffin was taken by train to Bladon in Oxfordshire, where Churchill was buried in the family plot in St Martin's church, not far from his birthplace at Blenheim Palace.

30th January, 1965

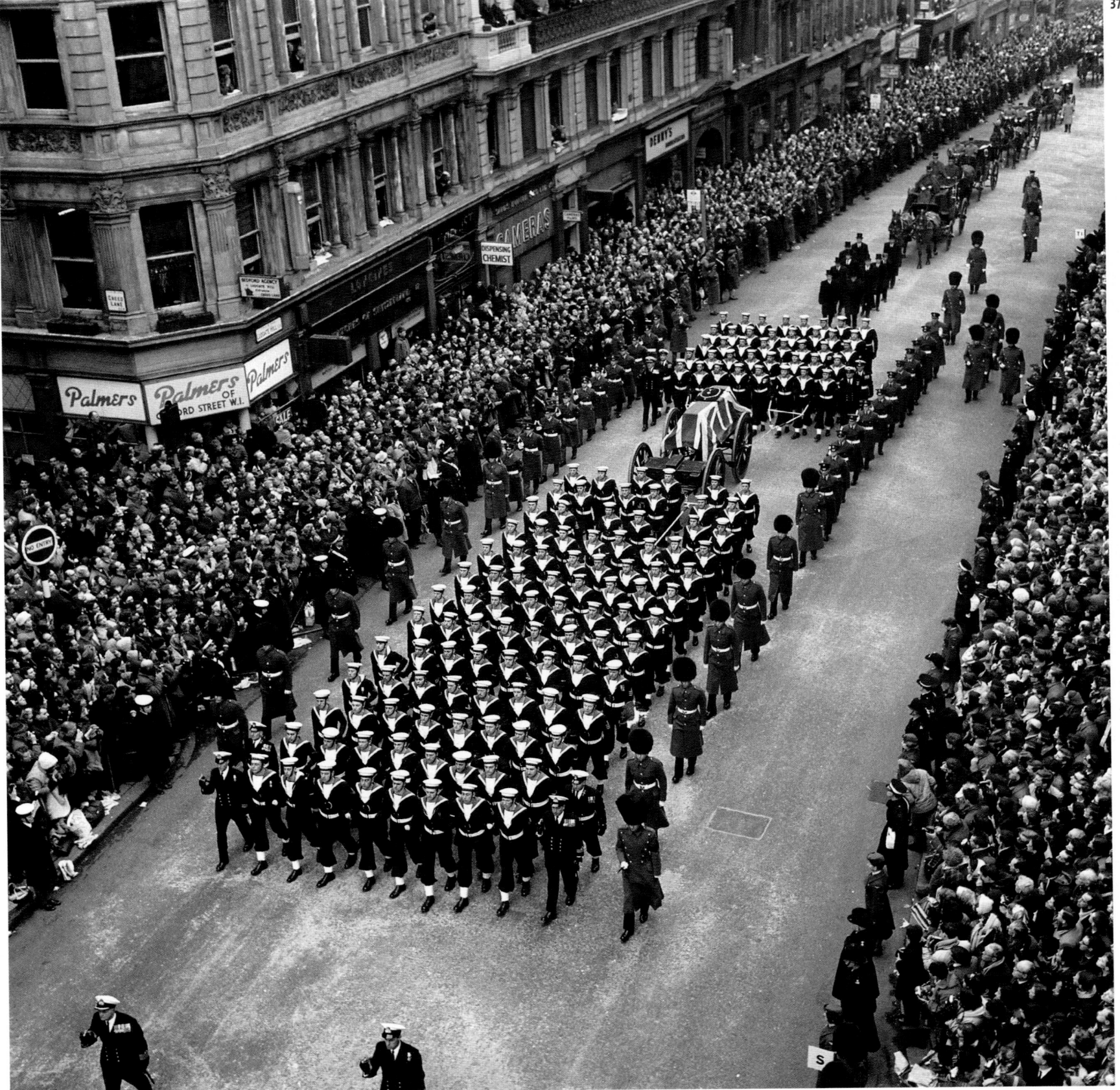

375

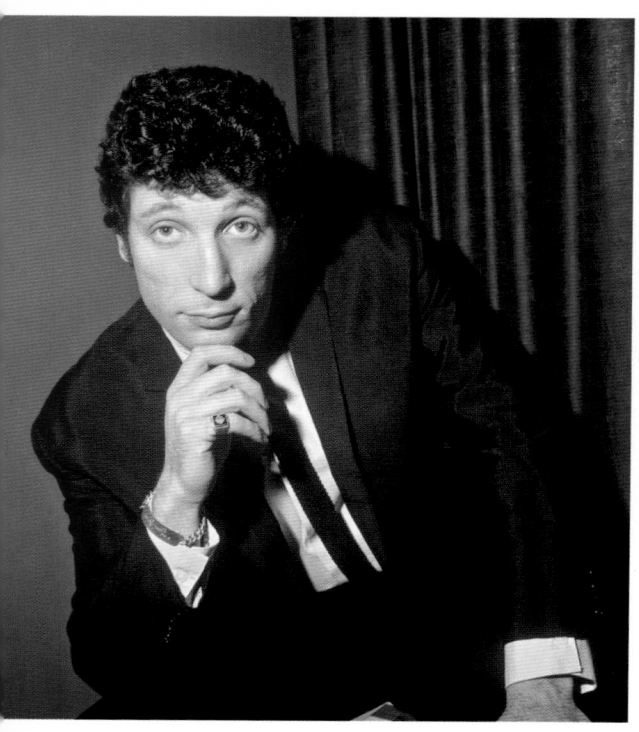

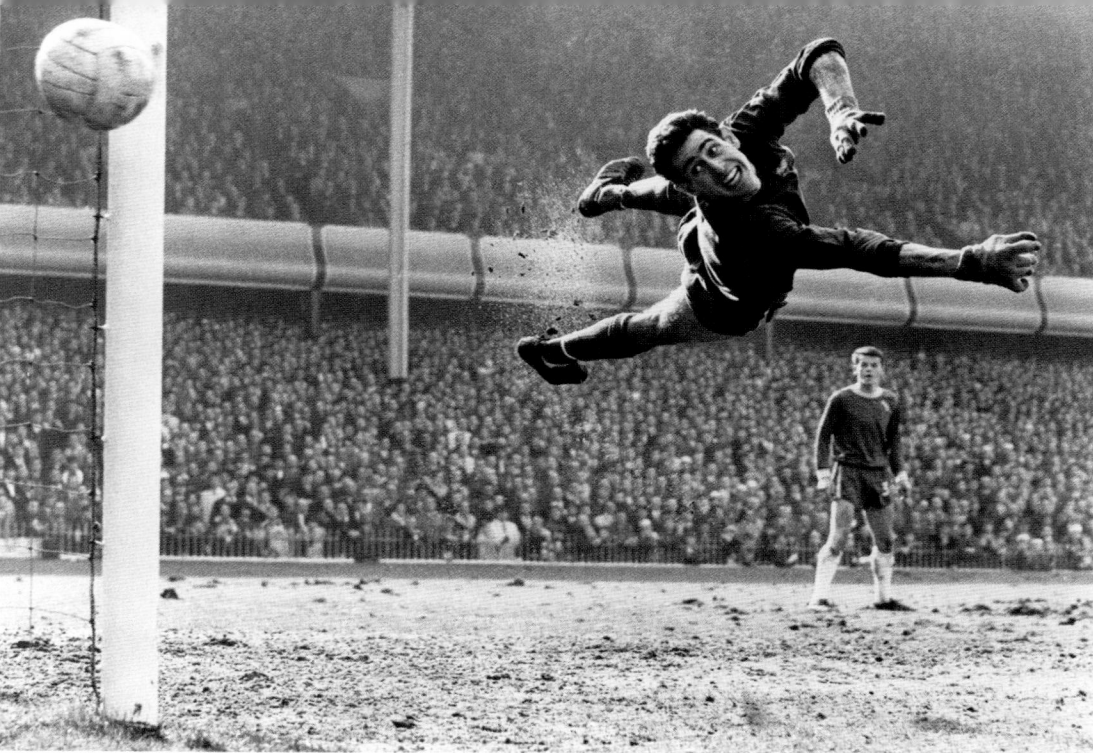

Above: Chelsea goalkeeper Peter Bonetti makes a flying save in the semi-final FA Cup match against Liverpool. Bonetti was known as 'The Cat' because of his lightning reflexes and graceful moves. He played for England between 1966 and 1970.

29th March, 1965

Above left: Fresh from the valleys: Welsh singing sensation Tom Jones. In a career spanning over 40 years, Jones has sold over 100 million records.

25th February, 1965

Left: The inauguration of the John F. Kennedy Memorial at Runnymede, near Windsor: (front row, L–R) Queen Elizabeth, Lord Harlech, Caroline Kennedy, Jacqueline Kennedy (the late president's widow), John Kennedy Jr and Prince Phillip.

14th May, 1965

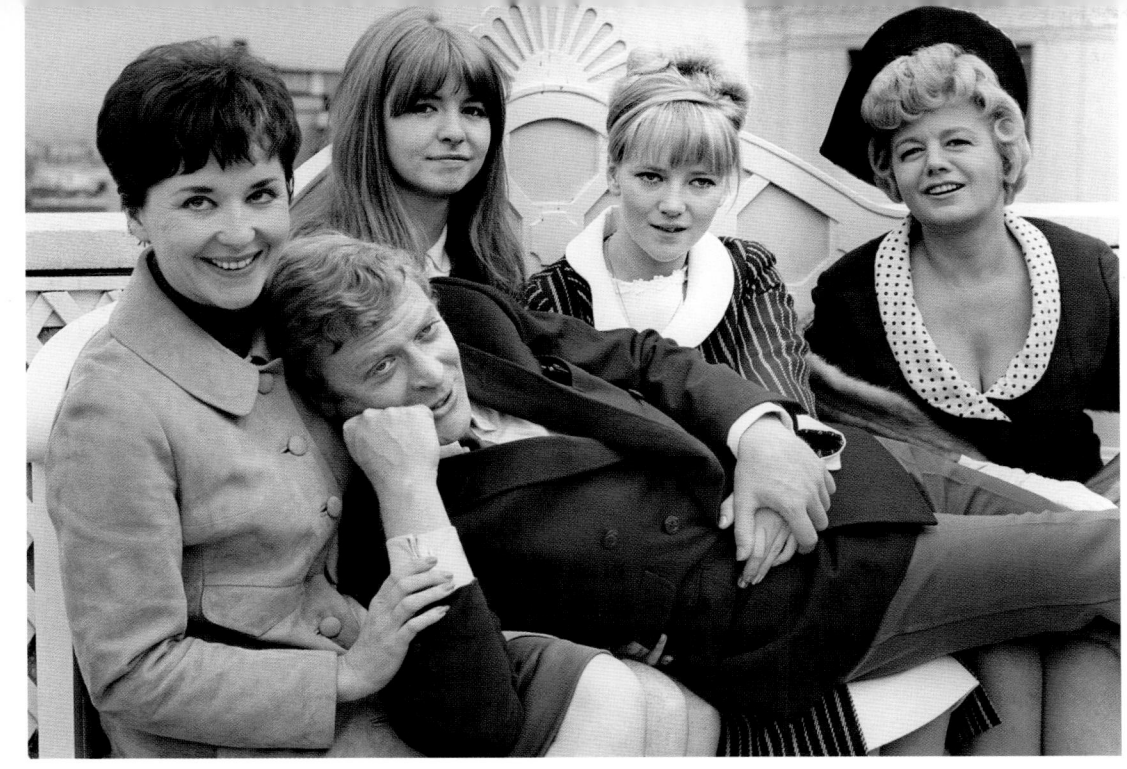

Left: Actor Michael Caine, who plays Alfie Ekins in the film *Alfie*, with some of his co-stars: (L–R) Vivien Merchant, Jane Asher, Julia Foster and Shelley Winters. The film was nominated for several Oscars, including Best Actor in a Leading Role (Caine), Best Actress in a Supporting Role (Merchant) and Best Song (Burt Bacharach and Hal David for *Alfie*, which was a UK hit for Cilla Black).

4th July, 1965

Below: Police mount a search of Saddleworth Moor in Yorkshire for the victims of Ian Brady and Myra Hindley. Five children, aged between 10 and 17 years, were raped and murdered by Brady, assisted by Hindley. Three bodies (of Pauline Reade, Lesley Anne Downey and John Kilbride) were found on the moor, while a fourth, that of Keith Bennett, is thought to be buried there. The fifth victim, Edward Evans, was found at Brady and Hindley's home.

15th September, 1965

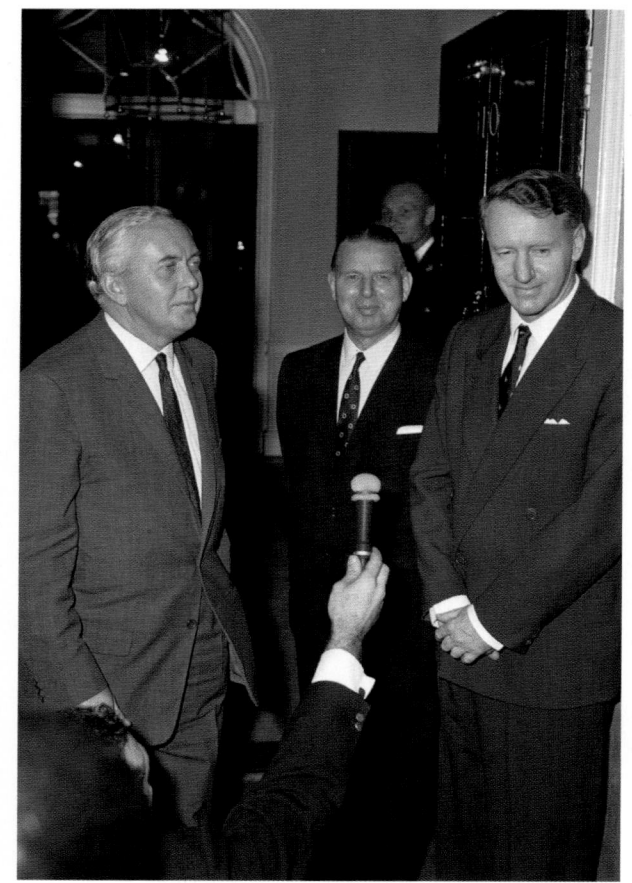

Above: The pirate radio ship Radio Caroline, actually the MV *Mi Amigo*, aground in rough seas between Frinton and Holland-on-Sea in Essex, having been blown from its anchorage by a gale during the night. Five disc jockeys were among those rescued from the vessel by breeches buoy.

20th January, 1966

Above left: Rhodesian Prime Minister Ian Smith (R) is welcomed by Britain's Prime Minister Harold Wilson (L) and Commonwealth Secretary Arthur Bottomley on his arrival at No 10 Downing Street for talks on the future of Rhodesia. Shortly after this meeting, Smith unilaterally declared independence from the UK. He failed to gain international support, however, and the United Nations applied sanctions, although these did not have the desired effect, and he remained prime minister of the country until the end of white rule in 1979.

7th October, 1965

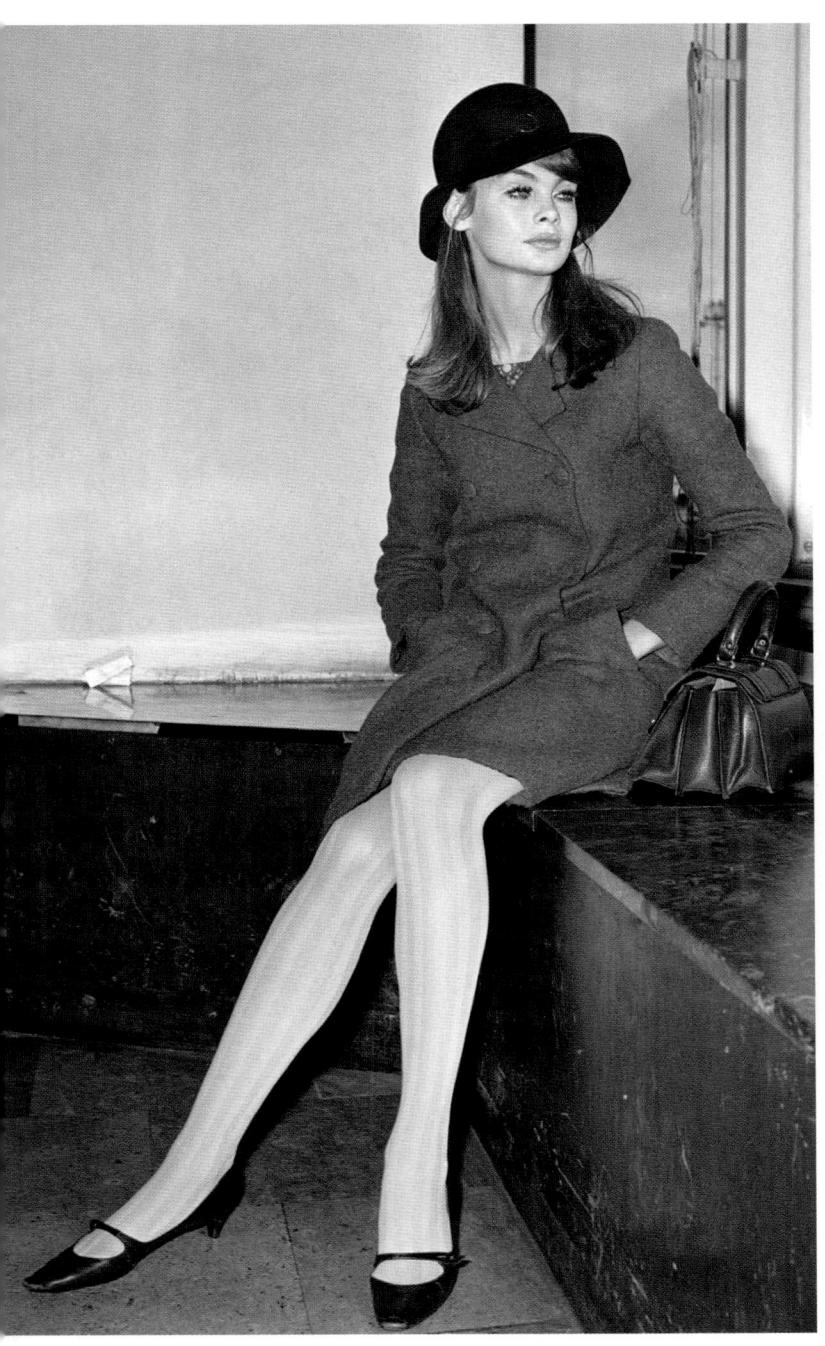

Above: David Corbett holds a cheque for £500, his reward for returning the World Cup trophy, which had been stolen. With him are his wife Jeanne and their dog Pickles, who found the famous trophy in their garden. Pickles briefly became a national hero.

31st March, 1966

Left: Top model Jean Shrimpton waits at London's Heathrow Airport for her flight to Rome. 'The Shrimp' was one of the icons of the 'Swinging Sixties'.

23rd February, 1966

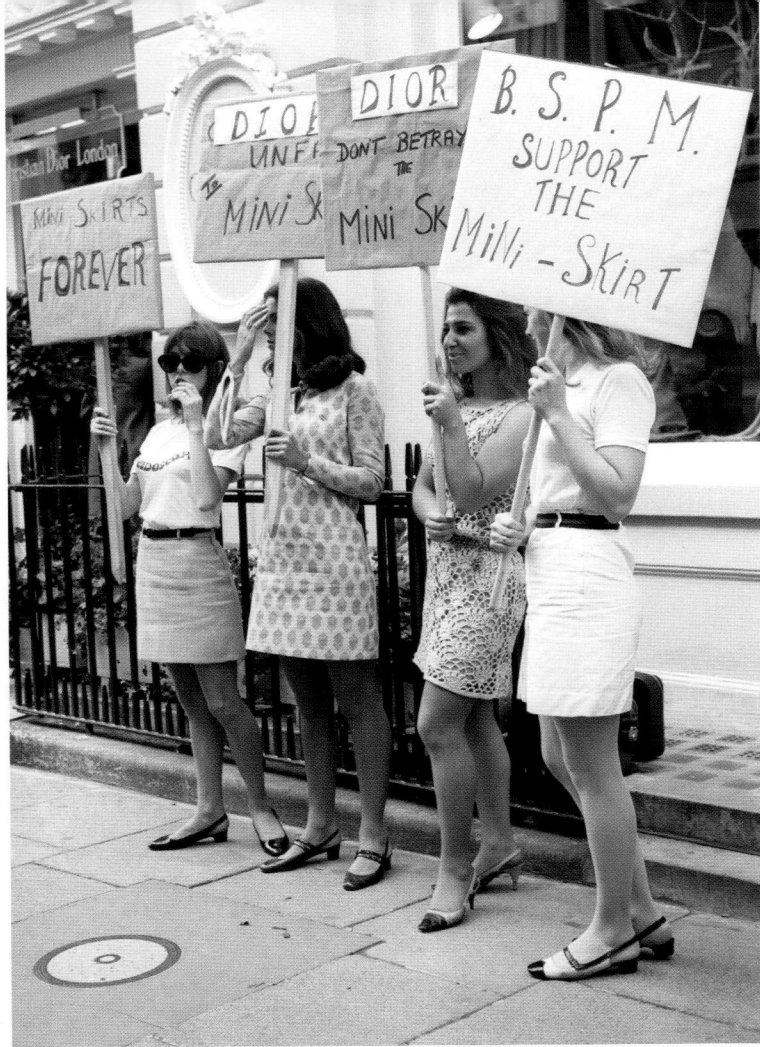

Left: Calling themselves The British Society for the Preservation of the Mini-Skirt, these young women are protesting outside Christian Dior's fashion house about his new below-the-knee creations.

6th September, 1966

Below: Hitching a ride. Supermodel Twiggy, wearing the latest fashion craze, hotpants, plays on the dodgems at Bertram Mills Circus.

January, 1967

Far left: England's captain, Bobby Moore, holds aloft the World Cup trophy after his team beat West Germany 4–2 at Wembley.

30th July, 1966

Left: Francis Chichester aboard his yacht, *Gipsy Moth IV*, at Greenwich, London. Shortly after, he would set sail from Plymouth on a solo round-the-world voyage, stopping only at Sydney, Australia. His route, from west to east, followed that of the great clipper ships and passed around the three great capes of the Southern Ocean: Cape of Good Hope, Cape Leeuwin and Cape Horn. Chichester completed his journey in 226 days of sailing, returning on 28th May, 1967. For his achievement, he was knighted by the Queen with the sword that Queen Elizabeth I had used to knight Sir Francis Drake.

15th August, 1966

Above: The moment immediately before disaster struck Donald Campbell's *Bluebird* on Coniston Water, Cumbria. Campbell died as the jet powered craft somersaulted at 300mph (483km/h) during a world speed record attempt. His body and the remains of the shattered craft were not recovered for 36 years.

4th January, 1967

Left: A convoy of Land Rovers from the 1st Battalion Yorks and Lancs pauses in a Cypriot village to allow a flock of the local brown-faced sheep to pass. Cyprus had been a British Crown Colony until 1960, when it had been granted indepence following an agreement between the UK, Greece and Turkey, although two British military bases were maintained on the island. The population of Cyprus is of Greek and Turkish extraction, and in 1974, Turkey invaded the north, seizing control of just over a third of the island. The Turks evicted any Greeks living in that portion, while Turks in the south fled to the north. The division of the island remains to this day, the northern region being known as the Turkish Republic of Northern Cyprus.

1st February, 1967

Left: Margot Fonteyn and Rudolf Nureyev during a rehearsal of Roland Petit's ballet *Paradise Lost* at Covent Garden in London. The pair danced together for many years, their last performance being in 1988, when Fonteyn was 69 and Nureyev 50. The former Soviet dancer, who had defected to the West in 1961, once said of his collaboration with Fonteyn that they danced with "*one body, one soul*".

20th February, 1967

Below: The supertanker *Torrey Canyon*, broken in two on the Seven Stones Reef, off the west coast of Cornwall, is battered by the waves. The vessel was carrying 120,000 tonnes of crude oil, leading to a major environmental disaster. Attempts to disperse the initial oil spill with detergent failed, and as the ship began to break up, Harold Wilson's government took the decision to burn the remainder to prevent the situation from becoming worse. Accordingly, the ship was bombed by Royal Naval and Royal Air Force jets, using high explosives and napalm. Because of high seas, however, several attempts were necessary to achieve success.

27th March, 1967

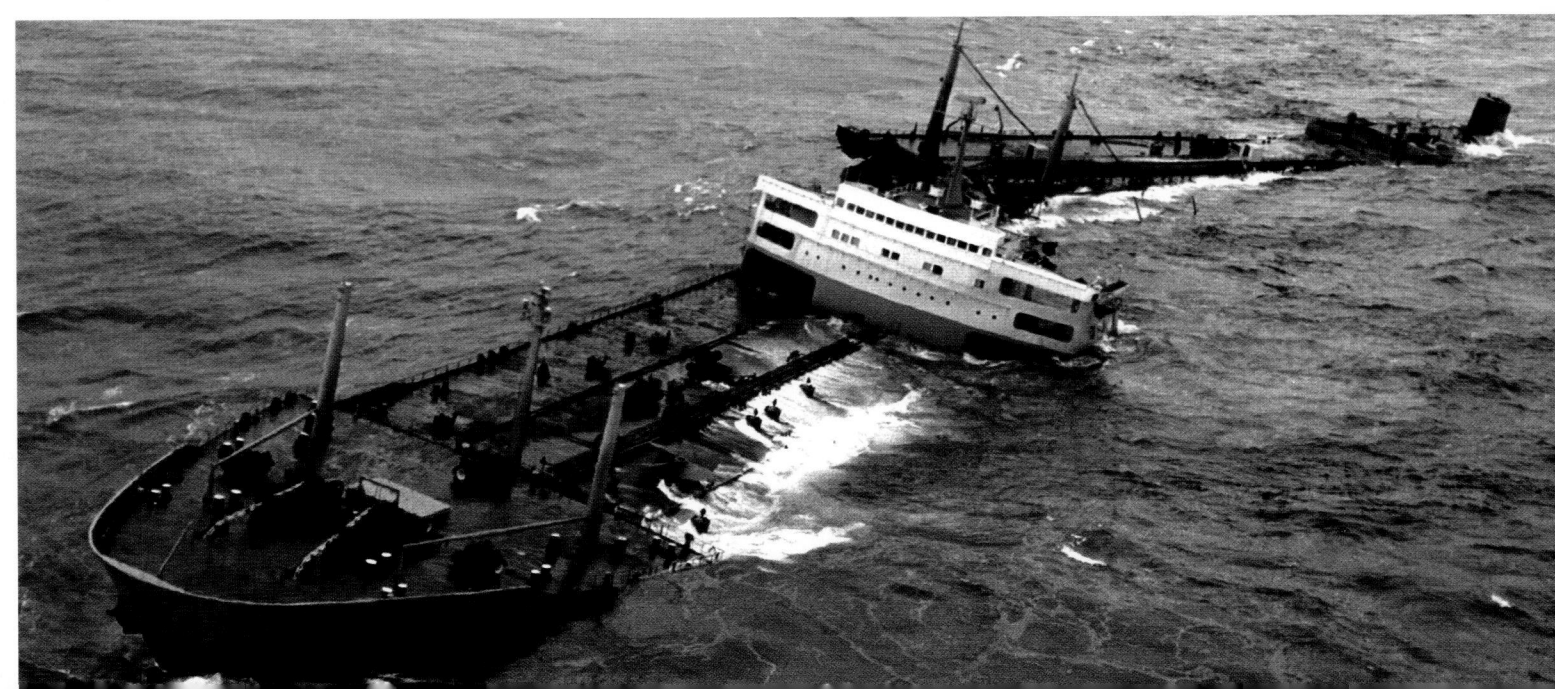

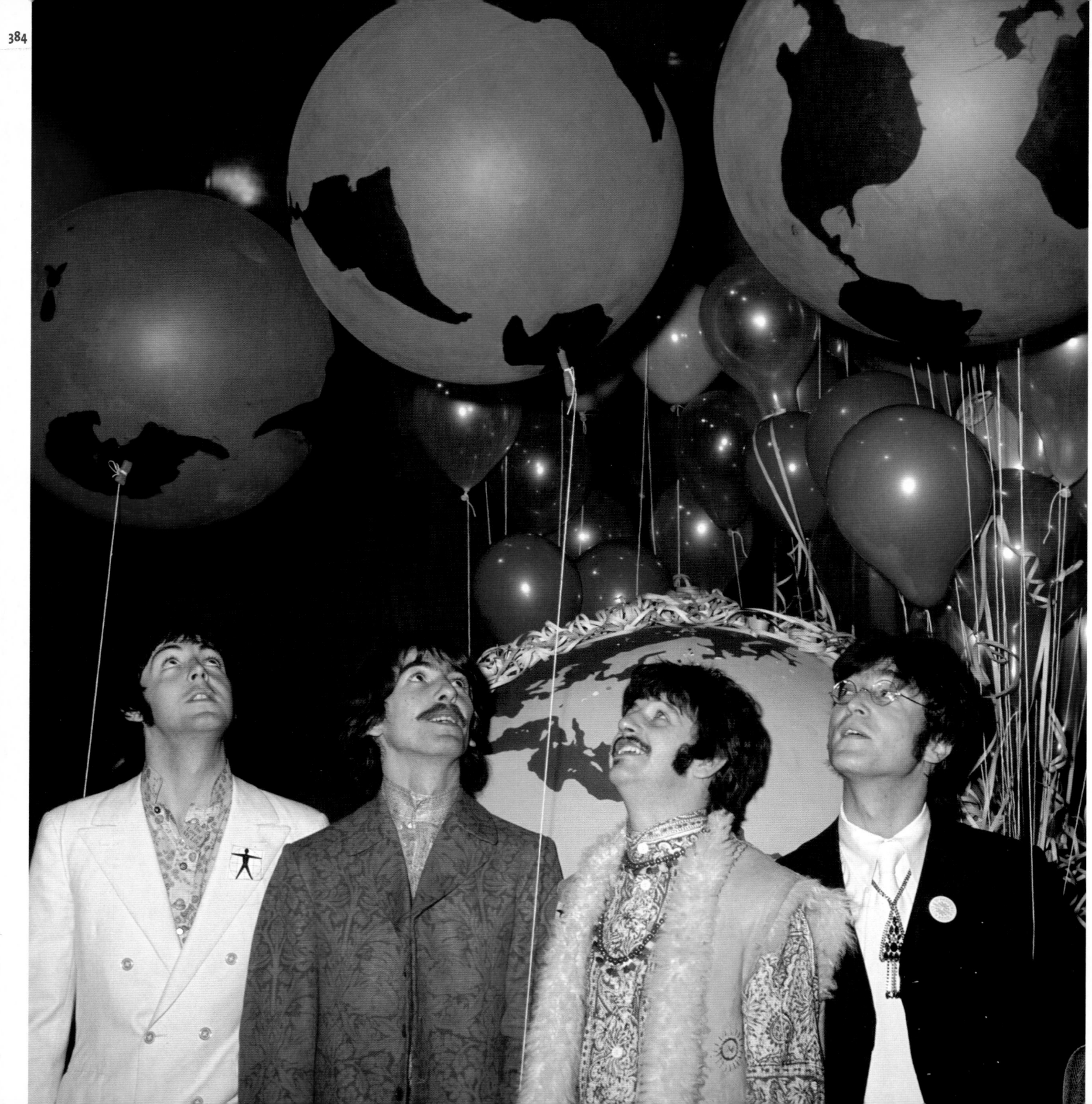

Above: Speaker's Corner in Hyde Park, London, became a smoker's paradise when London's flower children converged to take part in a 'Happening'. The crowd gathered to support a campaign to legalize hashish and marijuana.

16th July, 1967

Left: The Beatles launch the *Sergeant Pepper's Lonely Hearts Club Band* album in the UK. It was the eighth studio album the band had produced and received critical acclaim, spending 27 weeks at the top of the UK album charts.

1st June, 1967

Right: Mary Quant (R) shows her new shoe designs in London. Quant was a popular fashion designer in the 'Swinging Sixties' and is credited with naming the mini-skirt – after her favourite car, the Mini.

1st August, 1967

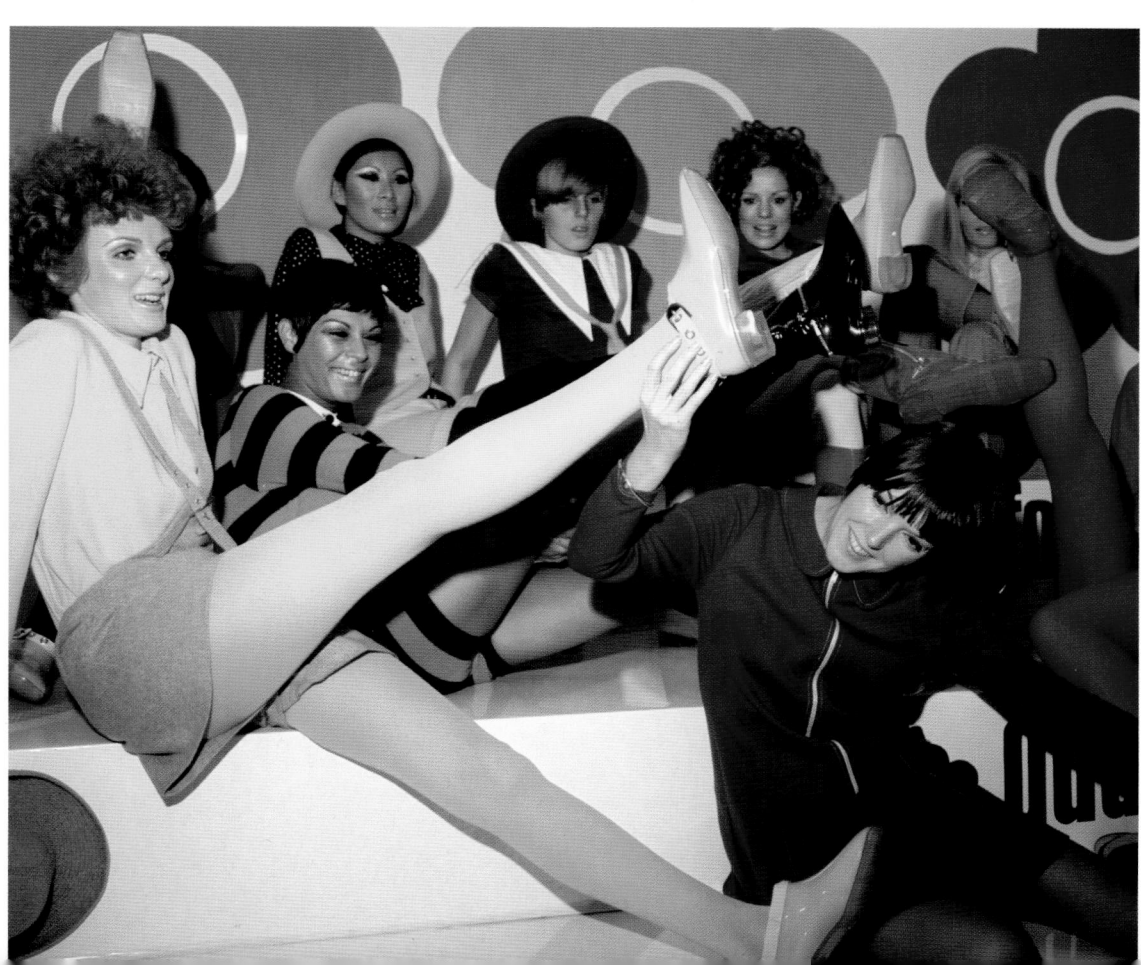

The Test

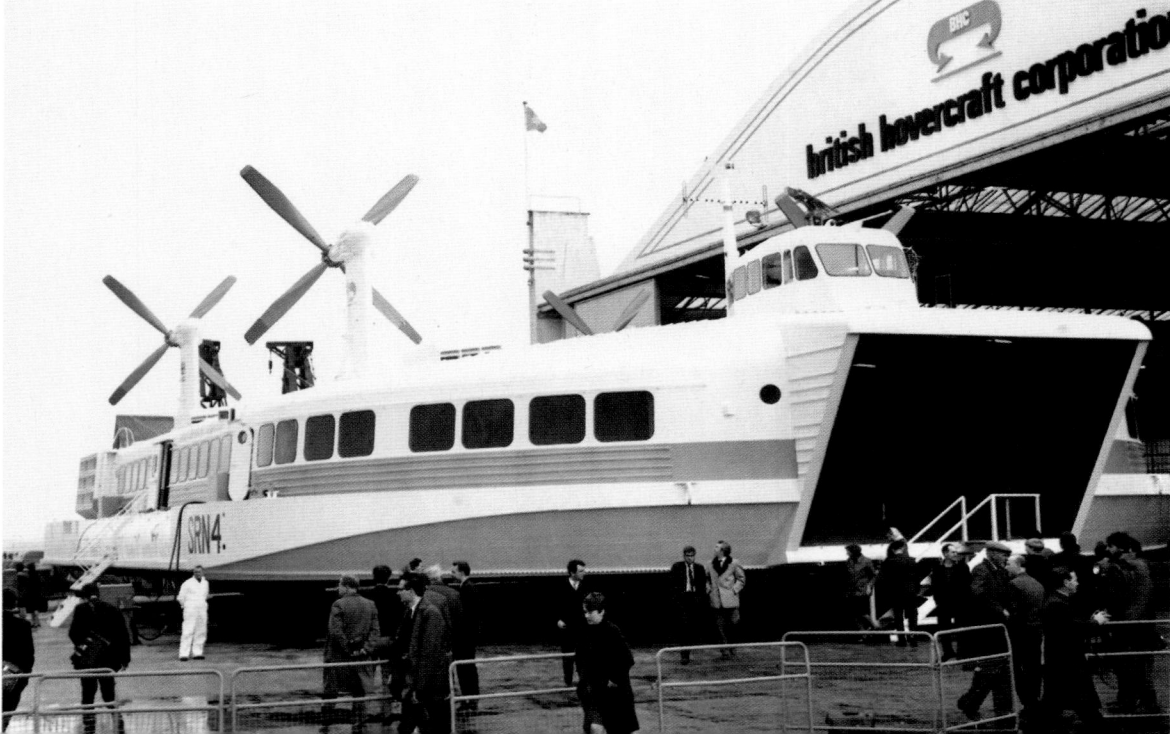

Left: PC Tony Burton demonstrates the Alcotest 80 for Transport Secretary Barbara Castle when she launched a campaign to inform the public of the new breathalyzer law.

19th September, 1967

Below left: The 165-tonne SRN4 is rolled out at the British Hovercraft Corporation's plant at Cowes, Isle of Wight. Designed to carry 254 passengers and up to 30 vehicles, the SRN4 was the largest hovercraft built to date and would operate a successful high-speed cross-Channel ferry service between 1968 and 2000. These craft could cross the English Channel, from Dover to Boulogne, in around 35 minutes, the record being 22 minutes

26th October, 1967

Above right: The renowned ocean liner *Queen Mary*, followed by her escort, HMS *Argonaut*, makes her way down the Solent for the last time. The 81,000-tonne vessel had sailed from Southampton on her final voyage, to Long Beach, California, where she would become a floating hotel and visitor attraction.

31st October, 1967

Right: Clearance work takes place at the site of a rail crash at Hither Green, south London, in which 51 people died and 111 were injured. An evening express train of 12 coaches, travelling from Hastings to London, had been derailed at 70mph (113km/h) due to a broken rail. Most of the carriages had overturned, the sides of two being ripped off.

6th November, 1967

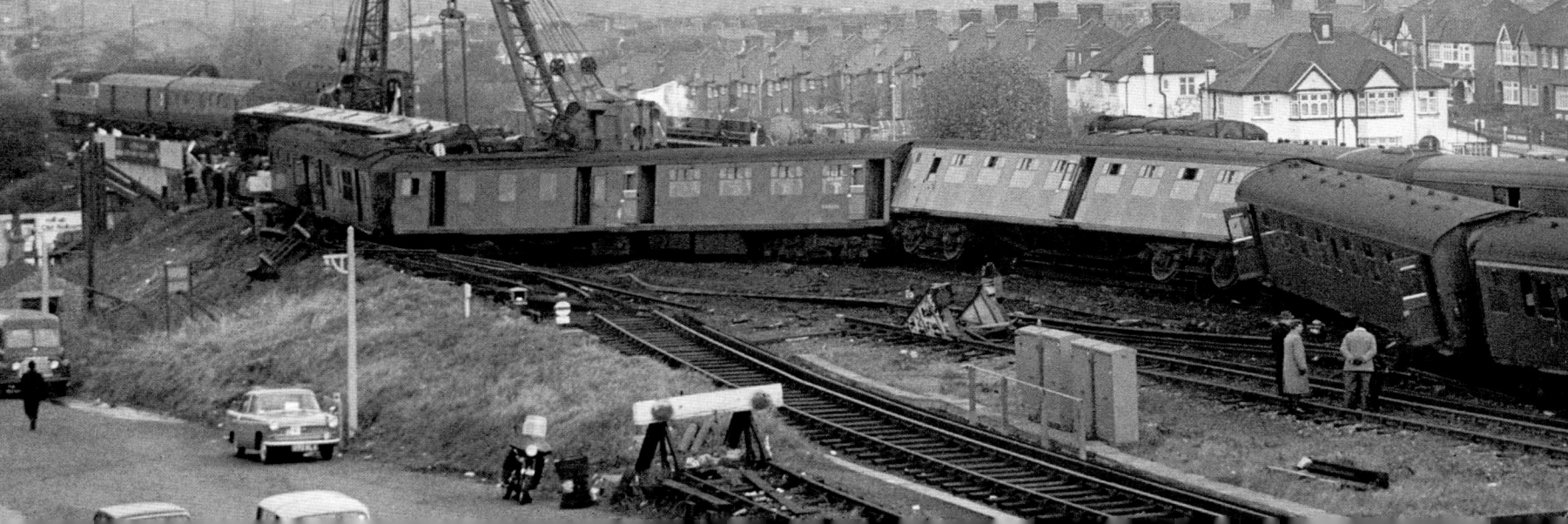

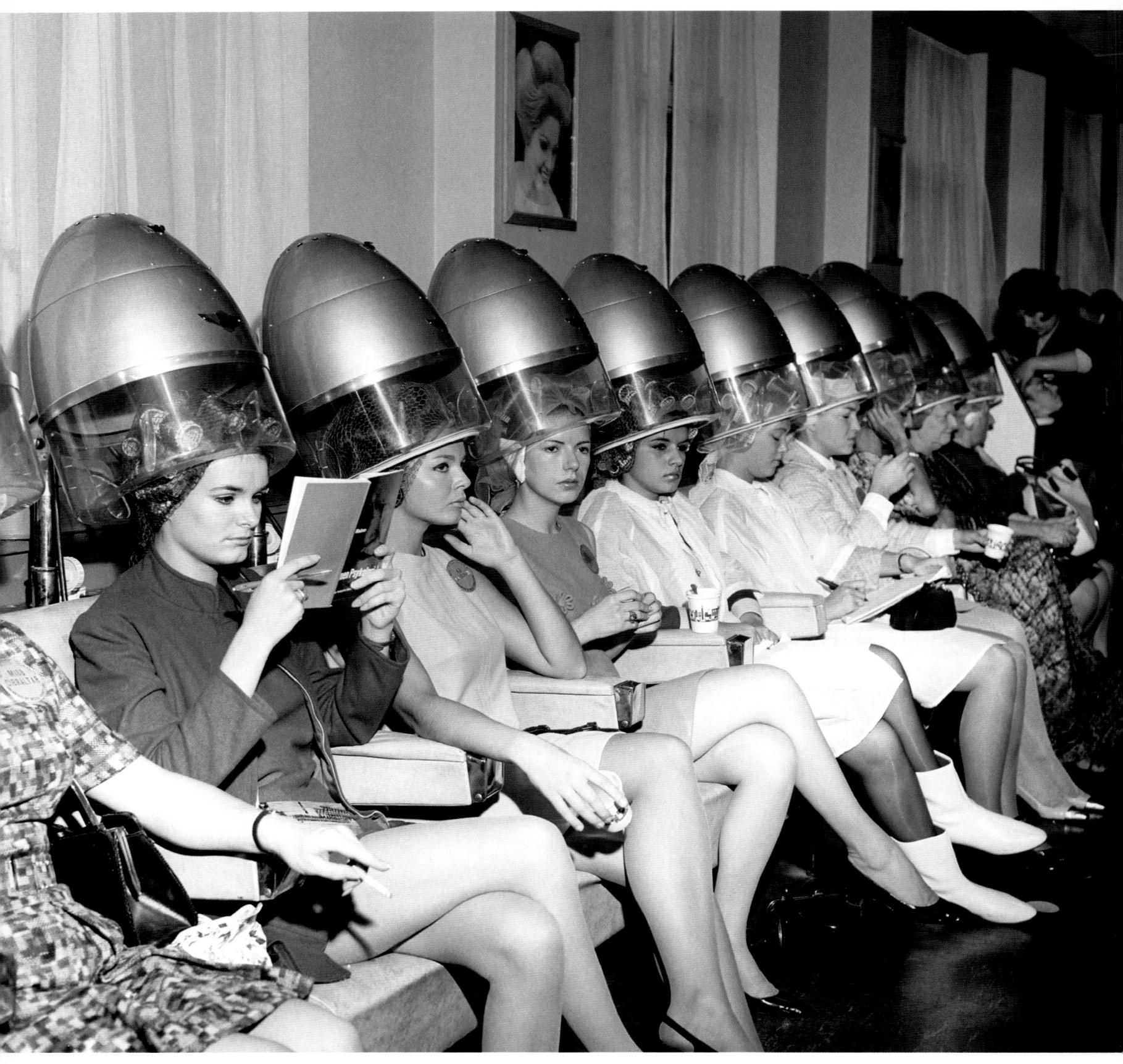

Below: The Mistry family arrives at Gatwick Airport after fleeing from Kenya. Asians had been encouraged to settle in Kenya during the days of British colonial rule, and they played a major role in the administration and commerce of the country. Following the granting of independence in 1963, however, the Kenyan government made it increasingly difficult for Asians to work unless they adopted Kenyan citizenship. Most preferred to accept the offer of a British passport, though, allowing them to move to Britain. Ultimately, thousands would arrive, causing problems for the Wilson government and leading to the 1968 Commonwealth Immigration Act, which required that potential immigrants demonstrate a connection with Britain before being allowed to enter the country.

28th February, 1968

Above: John Hastings (L), deputy master and controller of the Royal Mint, discusses the new decimal coinage with its designer, Christopher Ironside.

15th February, 1968

Left: Here come the curls. Contestants for the 1967 Miss World title have their final hair-dos at a London salon before the contest.

15th November, 1967

Right: Mrs Sislin Fay Allen, who would become Britain's first black policewoman when she completed her training.

15th February, 1968

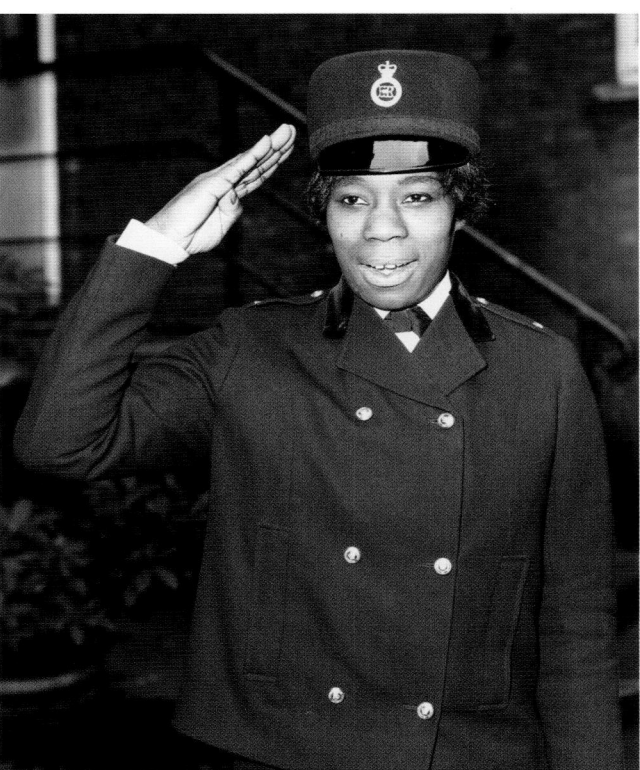

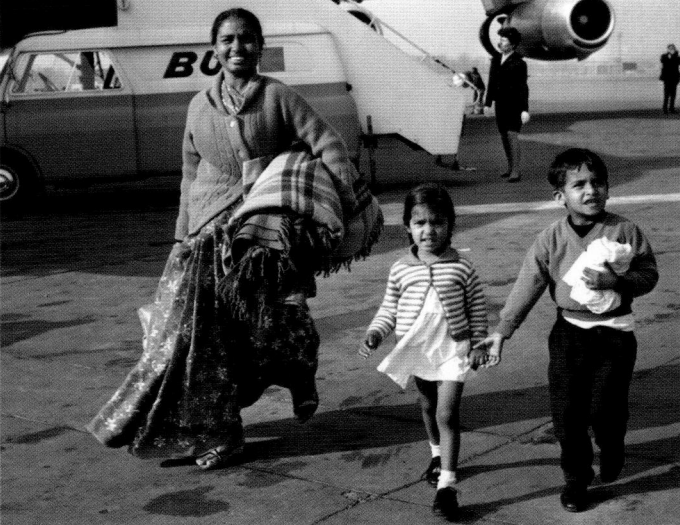

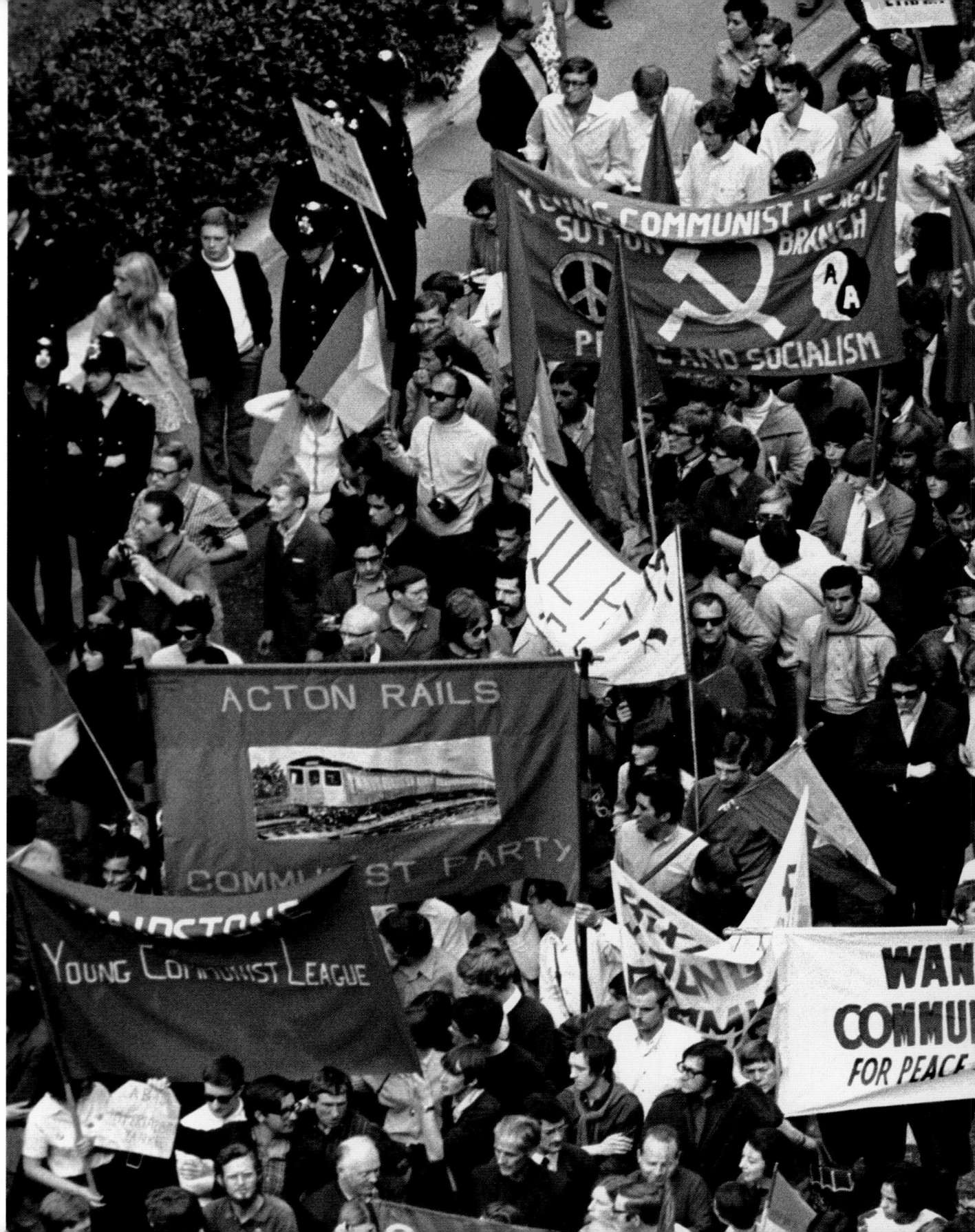

Right: Demonstrators in Grosvenor Square, London during an anti-Vietnam War march to the United States Embassy, following a rally in Trafalgar Square. The conflict between communist North Vietnam and South Vietnam was a 'proxy war' fought as part of the Cold War, between the United States and its Western allies, and the Soviet Union and its communist satellites. Both sides in the Vietnam War were supported by these Cold War protagonists. The USA began dispatching military advisors to South Vietnam in 1950, but in 1965 it entered the conflict by sending in combat troops. Fighting spread to neighbouring Laos and Cambodia, and the USA's involvement escalated considerably. After 1968, American troops were slowly withdrawn, but the South Vietnamese Army alone was unable to stop the advance of the communist forces, and the southern capital, Saigon, fell to them in 1975.

21st July, 1968

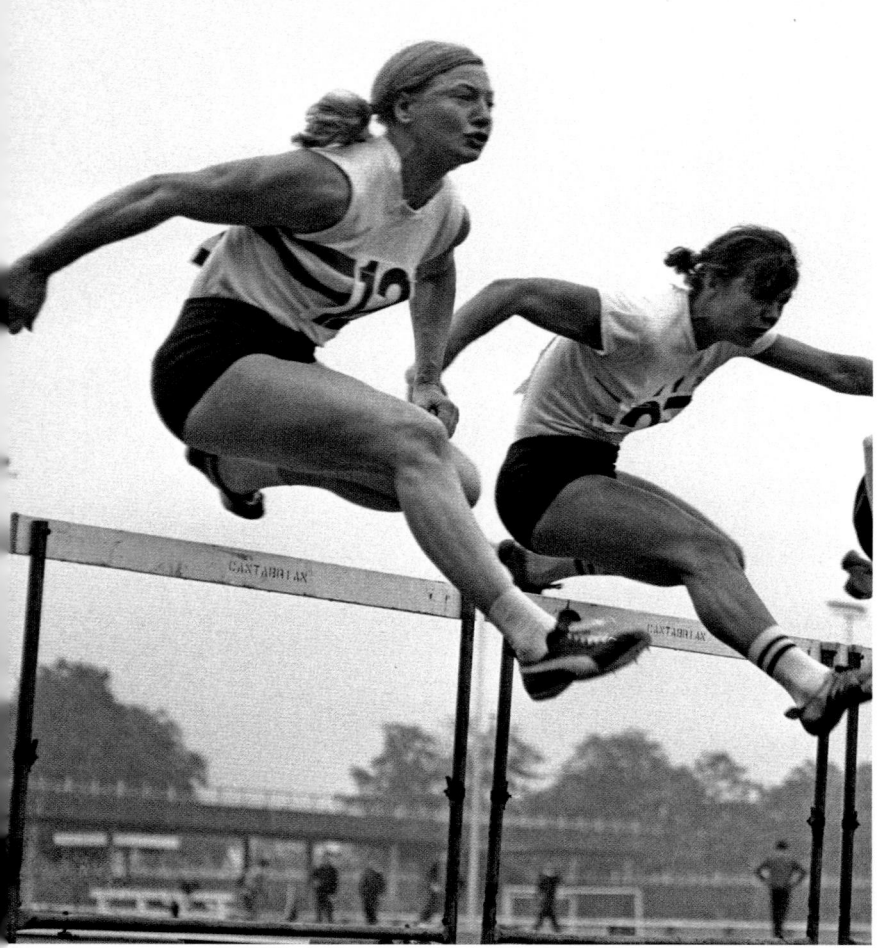

Right: Enoch Powell MP, a skilled orator, debates the immigrant problem with the rector of the Church of St Mary-Le Bow, Cheapside, London during a public meeting. The influx of large numbers of Asians from Kenya prompted Powell to pursue the subject of immigration.

21st January, 1969

Below right: The wreckage of Afghanistan's Ariana Airline Boeing 727, in which 50 people were killed and 15 injured when it crashed in fog at Gatwick Airport.

5th January, 1969

Below far right: Twenty-one-year-old Bernadette Devlin is elected the youngest ever female member of Parliament, and the third youngest of all time. Standing as an independent candidate and backed by the constituency's natural Catholic majority, Devlin wrested the seat of Mid-Ulster in Northern Ireland from the Ulster Unionists.

21st February, 1969

Above: Mary Peters (L) competes in the first heat of the 80m Hurdles during the Women's Amateur Athletic Association's national Senior Pentathlon, at the Crystal Palace Stadium in London. She would go on to win a gold medal in the Pentathlon at the 1972 Olympics in Munich.

9th August, 1968

Right: Eli, the baby elephant, joins rock group The Who, and Nicola Austine (L) and Toni Lee on the 'Magic Bus' from the BBC's Lime Grove studios, to promote their latest single.

9th October, 1968

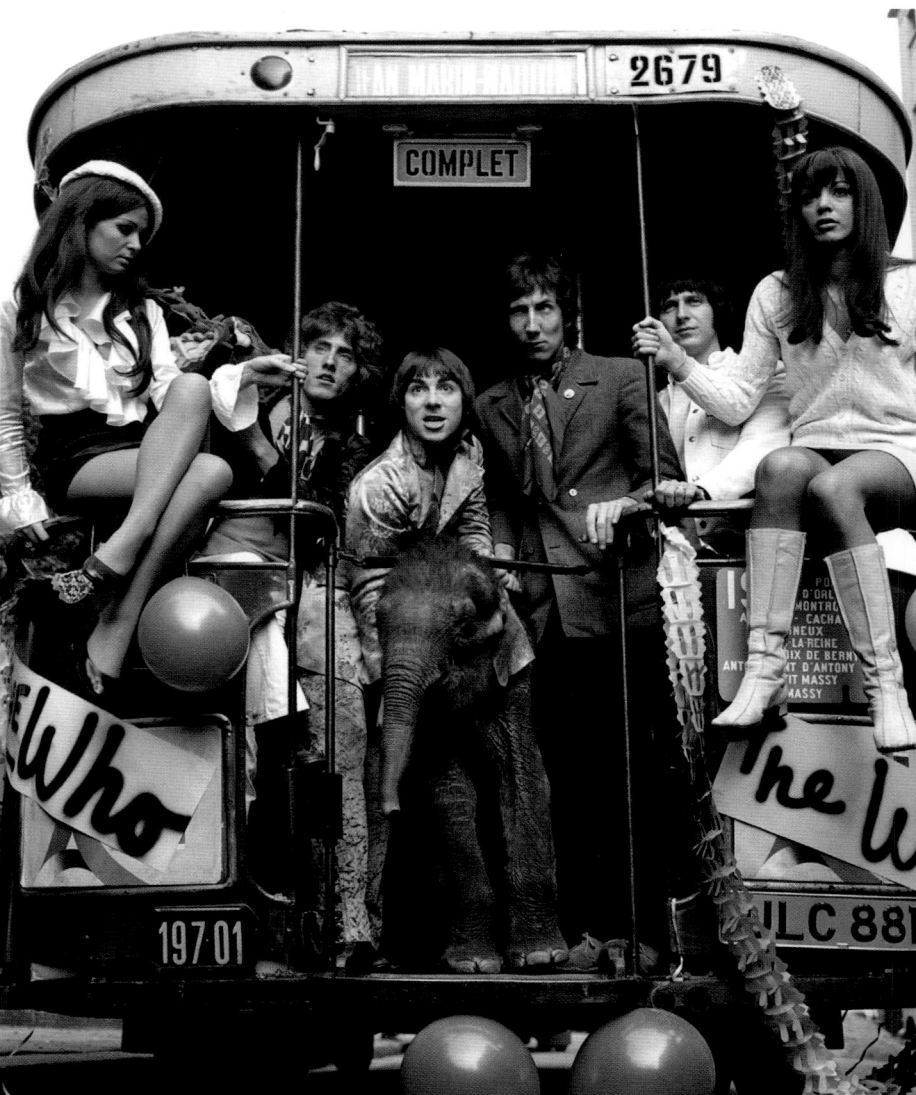

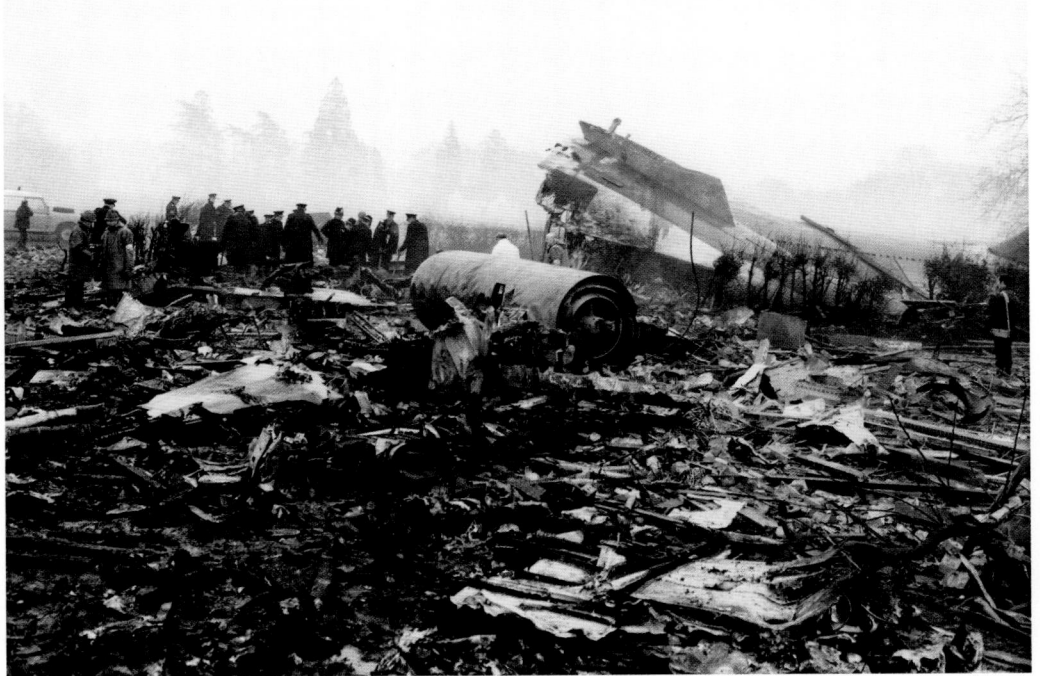

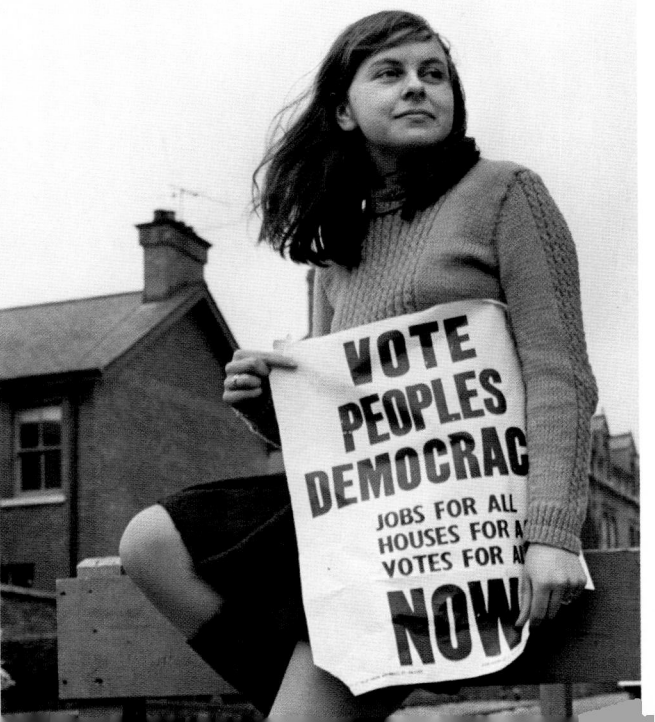

Right: Concorde, the Anglo-French supersonic airliner, first flew on 2nd March, 1969 from Toulouse in France, remaining in the air for 27 minutes before landing. Here, the British prototype, Concorde 002, takes off from Filton, Bristol on its 22-minute maiden flight. The aircraft would not enter service with Air France and British Airways until 1976, but would remain operational for 27 years.

9th April, 1969

Below: A beaming Brian Trubshaw, captain of Concorde 002, at RAF Fairford, Gloucester, where the machine landed after its successful maiden flight from Filton. His comment on emerging from the flight deck: *"It was wizard, a cool, calm and collected operation."*

9th April, 1969

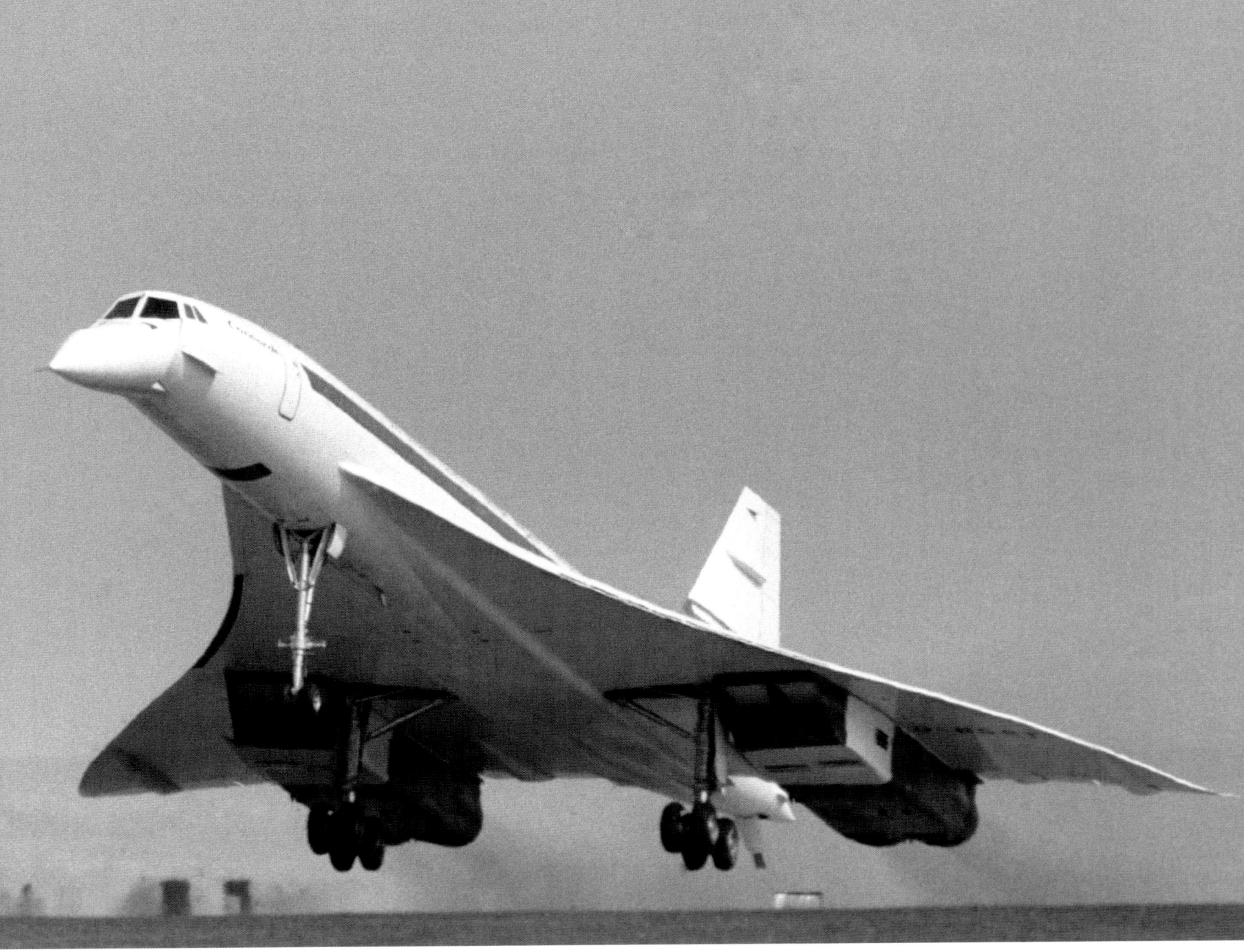

Left: The ward of Caernarfon Castle, in north-west Wales, which dates from 1283, was host to the investiture of Prince Charles as Prince of Wales, during which he was presented with a sword to defend his land, a ring to represent his responsibility and a rod as a symbol of governance.

1st July, 1969

Right: One of Britain's most successful female tennis players, Ann Jones stretches to make a forehand shot during her Wimbledon semi-final against Australia's Margaret Court. Having beaten Court, Jones went on to face the singles title holder, American Billie-Jean King, in the final, emerging triumphant after a three-set battle. Jones would win a total of eight Grand Slam titles during her career: three in singles, three in women's doubles and three in mixed doubles.

2nd July, 1969

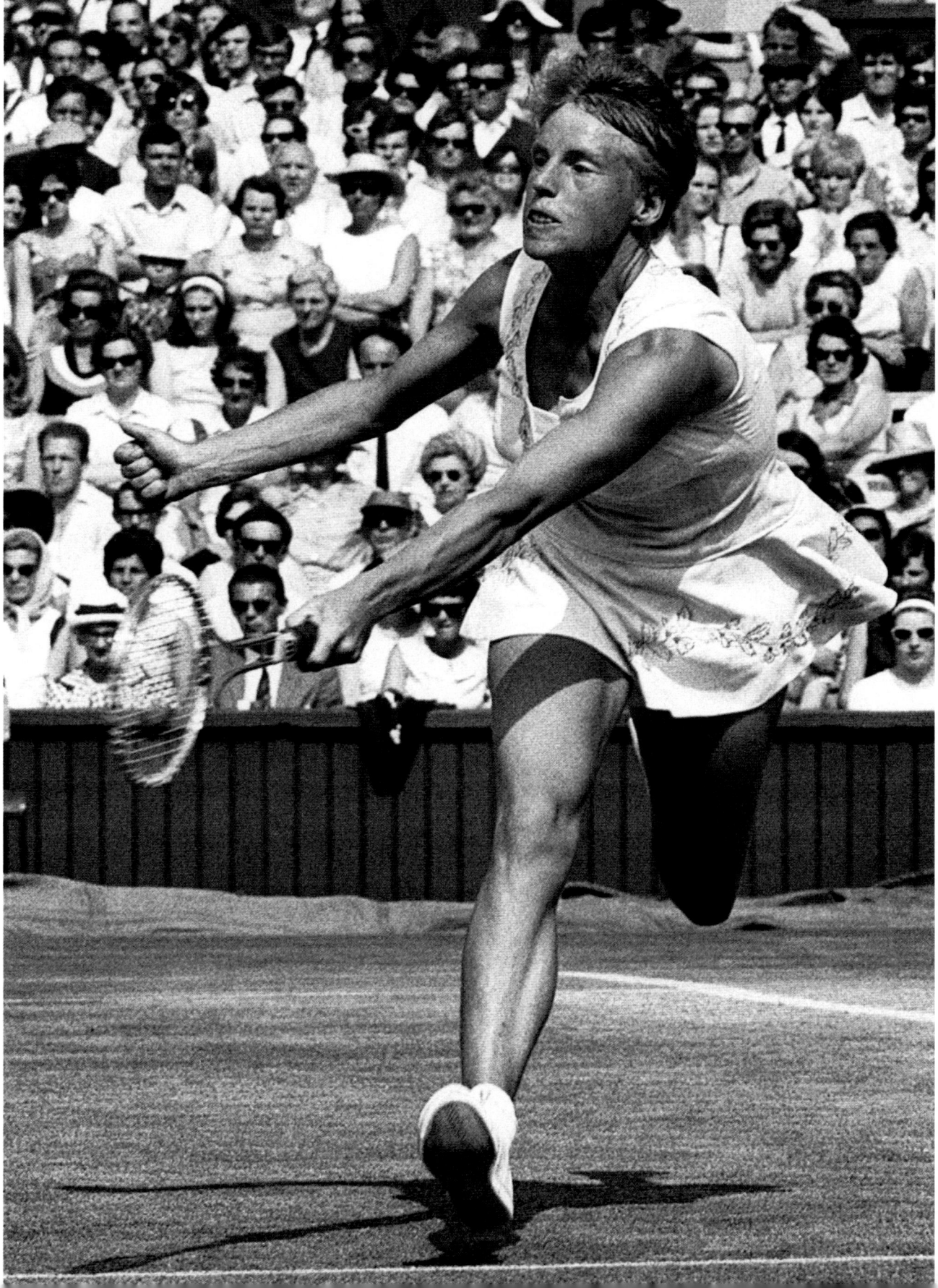

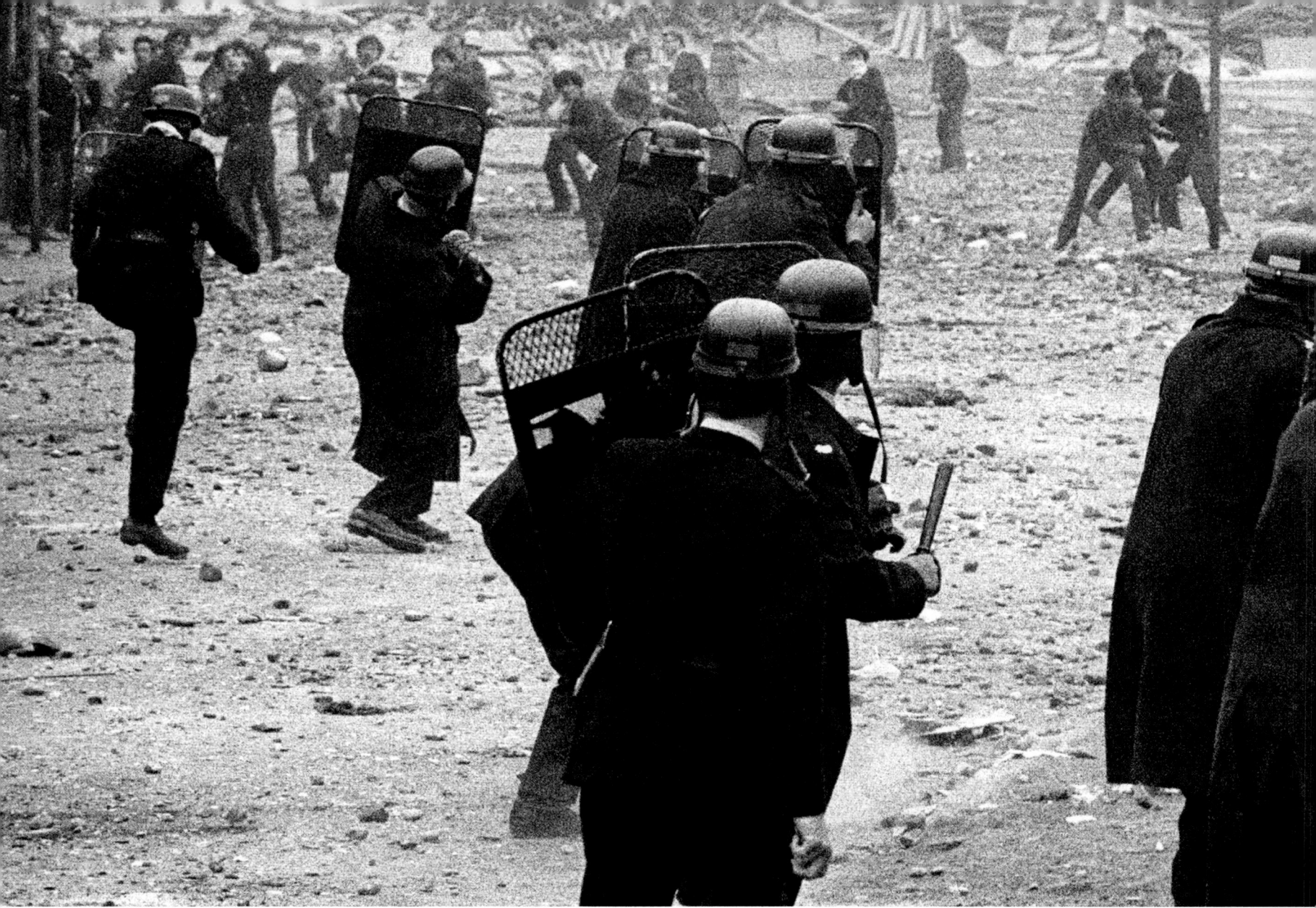

Above: Members of the Royal Ulster Constabulary, wearing motorcycle crash helmets and their standard uniform coats, battle with rioters in the Bogside area of Londonderry. For three days, from 12th to 14th August, 1969, the residents of the Bogside rioted following attempts by the police to disperse nationalists protesting against a loyalist Apprentice Boys parade along the city walls. In the end, the Army was called in to restore order. Known as the Battle of the Bogside, this was the first conflict of the period known as 'The Troubles'.

14th August, 1969

Right: Residents pass in and out of the Bogside area of Londonderry through barbed-wire barricades guarded by British troops, after a night of rioting during which at least five people were shot dead.

15th August, 1969

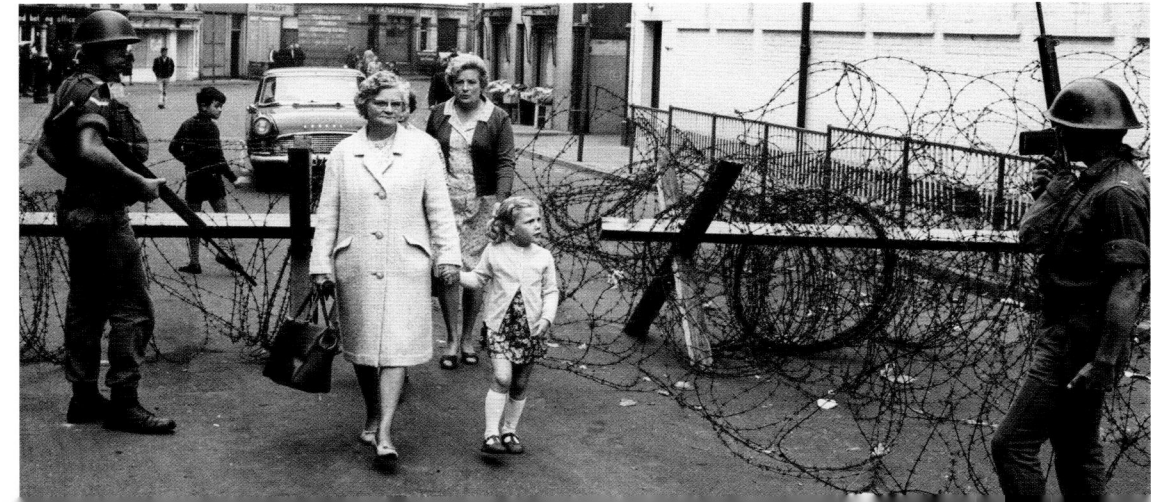

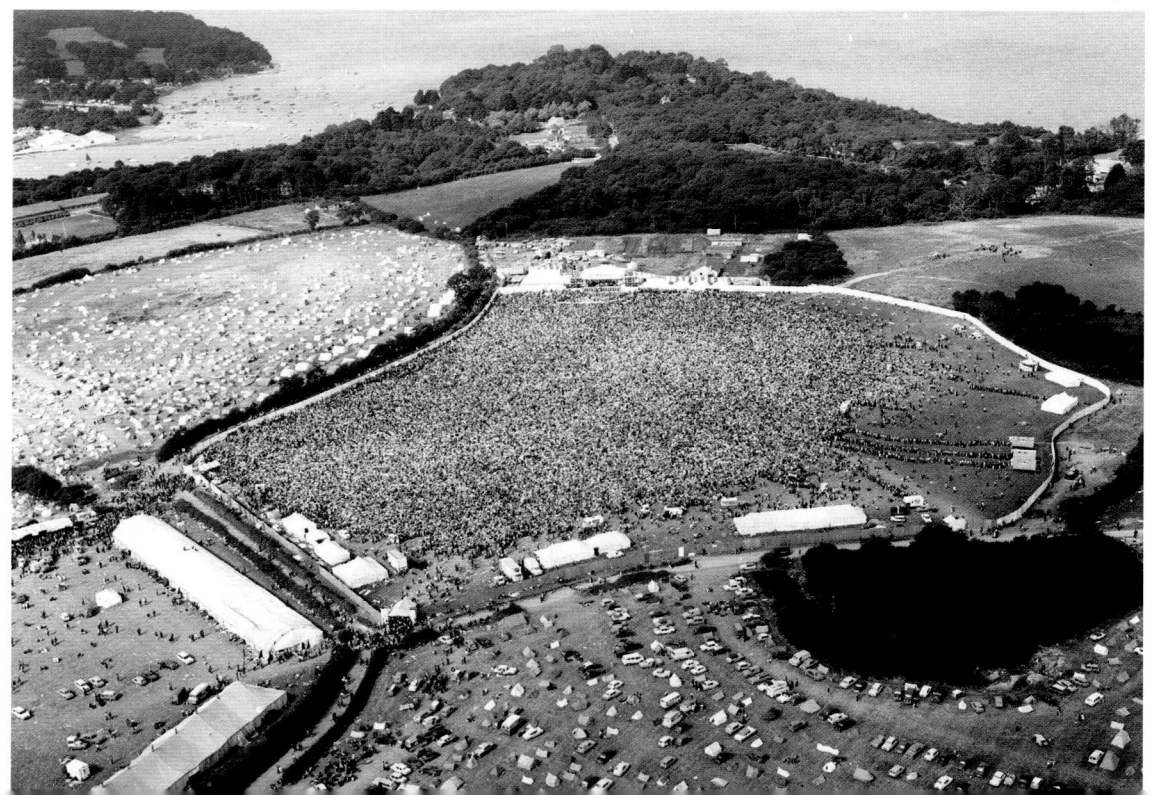

Above: HMS *Conqueror*, the Royal Navy's 3,500-tonne nuclear submarine, is launched at Cammell Laird's shipyard, Birkenhead. The boat's primary role was to search out and destroy enemy submarines. During the Falklands War, *Conquerer* would be responsible for sinking the Argentine cruiser *General Belgrano* with torpedoes.

28th August, 1969

Right: Some 150,000 fans gathered for the Isle of Wight festival, where the acts included Jimi Hendrix, The Who and Bob Dylan, who chose the event to make a comeback. This was the second of three festivals held on the island.

31st August, 1969

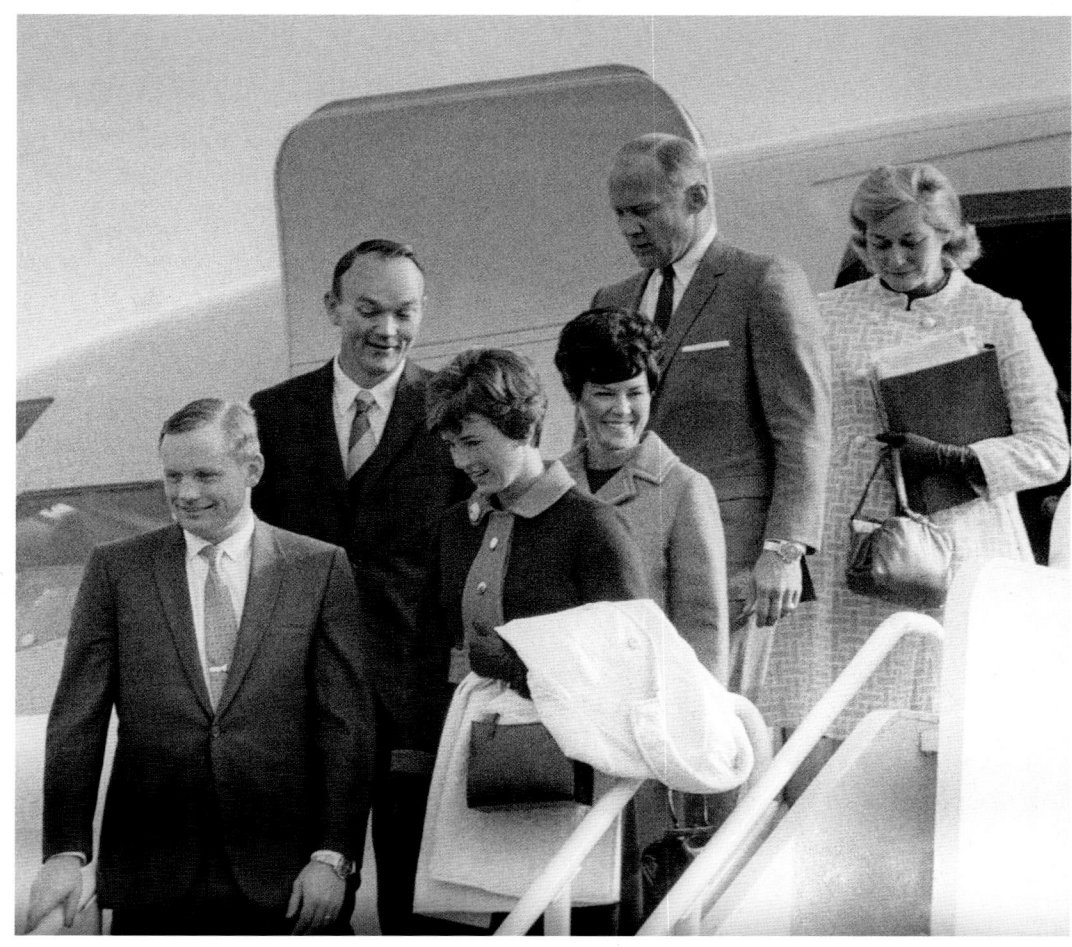

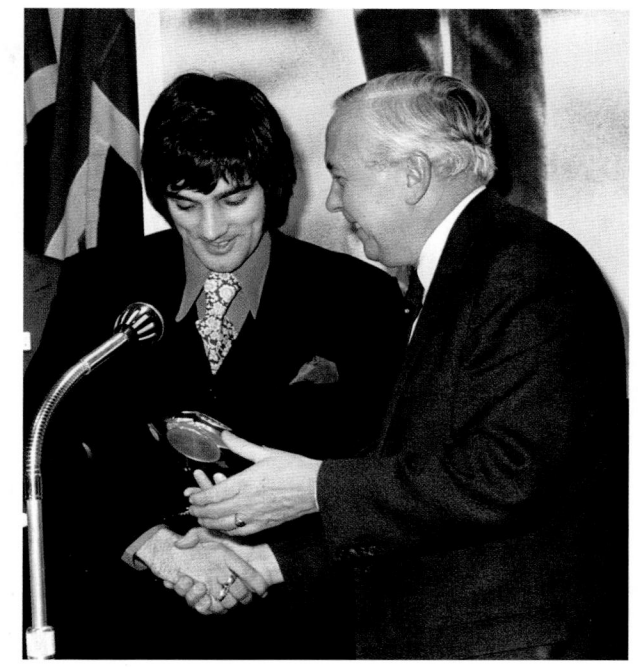

Above: Apollo 11 astronauts (L–R) Neil Armstrong, Michael Collins and Edwin 'Buzz' Aldrin, with their wives Janet, Pat and Joan, touch down at Heathrow Airport during their 22-nation, 38-day world tour after the trio's flight to the moon.

14th October, 1969

Right: Rupert Murdoch examines one of the first copies of his new newspaper, *The Sun*, at The News of the World building in London.

17th November, 1969

Above right: George Best, Manchester United and Northern Ireland soccer star, receives his award from Prime Minister Harold Wilson during the *Daily Express* Sportsman of the Year lunch, at the Savoy Hotel, London.

25th November, 1969

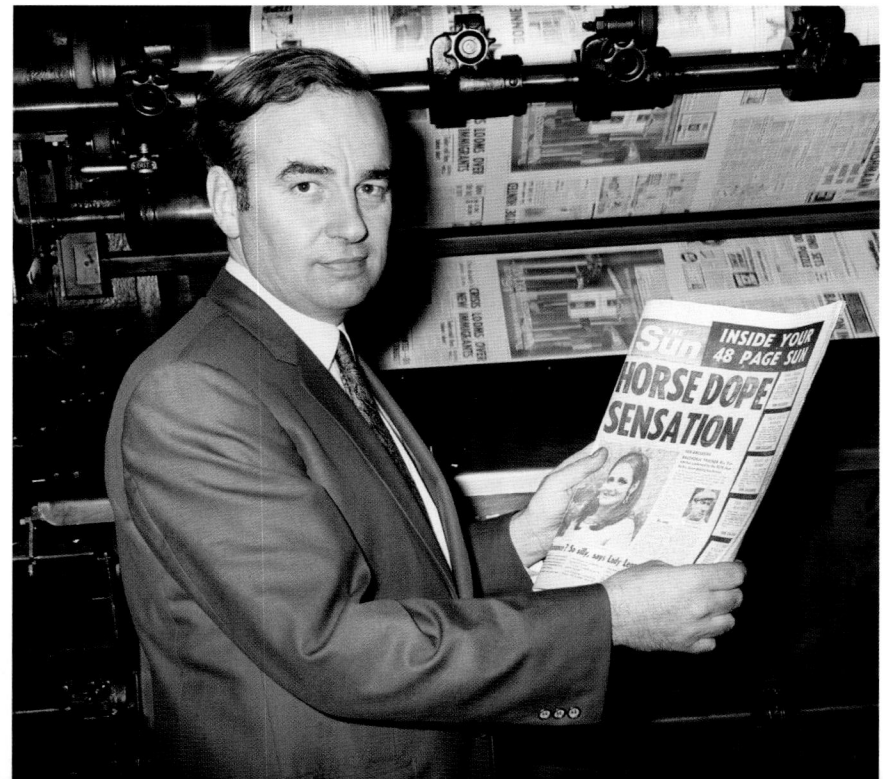

1970s

The dawn of the 1970s saw Britain's arts and entertainment industries fully to the fore, although the rebels of the 1960s were beginning to develop business acumen: Felix Dennis, one of the editors of the underground magazine *Oz*, famously prosecuted for obscenity in 1971, would create a successful publishing empire; Richard Branson would achieve prominence beyond his roots in music; and Malcolm McLaren would run one of the most effective PR campaigns ever for the Sex Pistols. It is easy to see a bridge between the idealistic 1960s and the materialistic 1980s.

In 1979, Margaret Thatcher became the country's first female prime minister. Ironically, the decade leading up to this triumph for the women's movement had seen a more overt exploitation of women as decorative objects than ever before.

For most, though, the 1970s was a time of living by candlelight during the power strikes; of staying at home during the transport strikes; and of avoiding the capital during the Irish terrorist bombing campaigns. But it was also a time of newness, colour and good-humoured fun: outrageous fashions, decimal currency, Space Hoppers, glam rock, punk rock, Pan's People on *Top of the Pops* – and the Queen's Silver Jubilee, celebrated wholeheartedly by a nation that was, despite everything, really rather proud to be British.

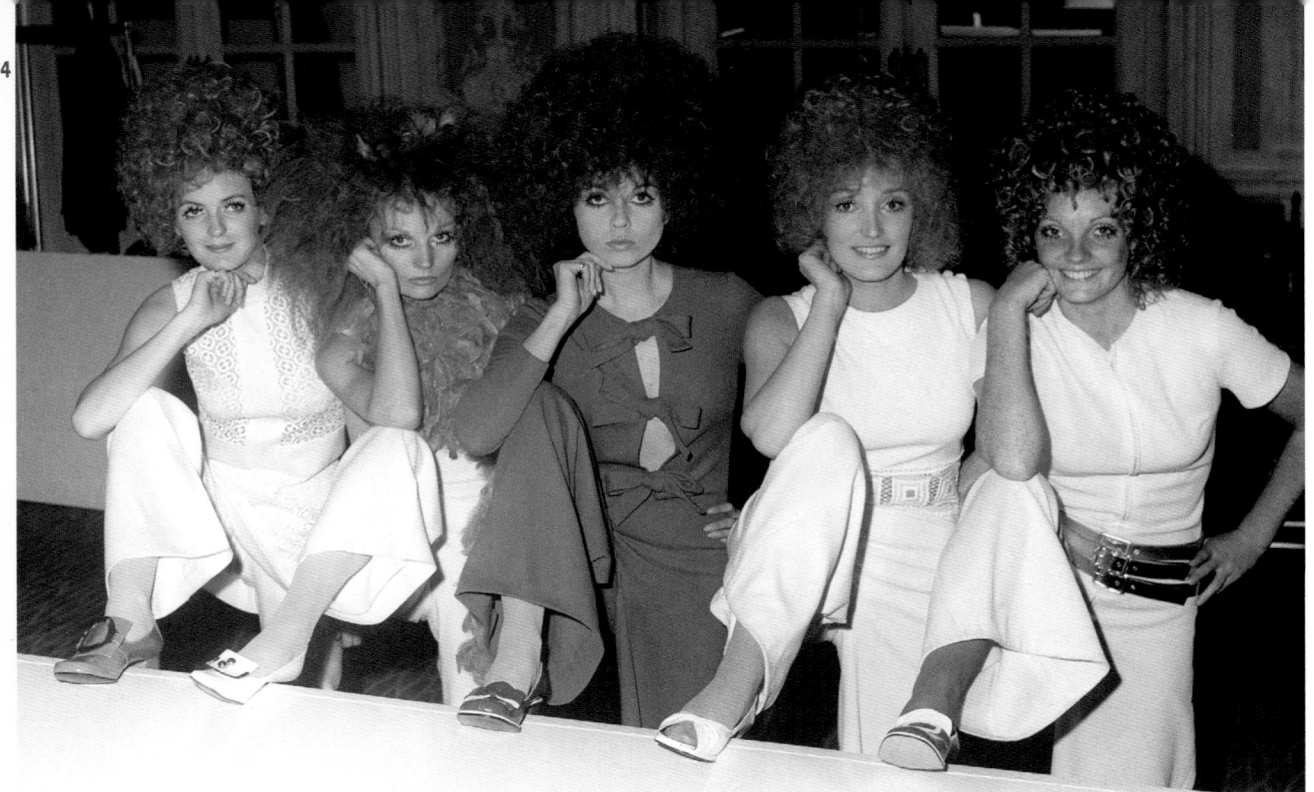

Left: Big hair was a sign of the times in the 1970s. Surprisingly, these models are supposed to be showing off new ranges of shoes from Lotus, George W. Ward, Rayne and Saxone.

12th January, 1970

Below left: Mick Jagger, lead singer of the Rolling Stones, and his former girlfriend, Marianne Faithfull, after the conclusion of the case at Marlborough Street Court, London, in which they had pleaded not guilty to possessing cannabis resin. The charge against Faithfull was dropped, but Jagger was fined £200 with 50 guineas costs.

26th January, 1970

Right: Anti-apartheid protesters outside Twickenham Stadium at the culmination of their mile-long march to the ground, where rugby union team the Barbarians were scheduled to play a match against South Africa.

31st January, 1970

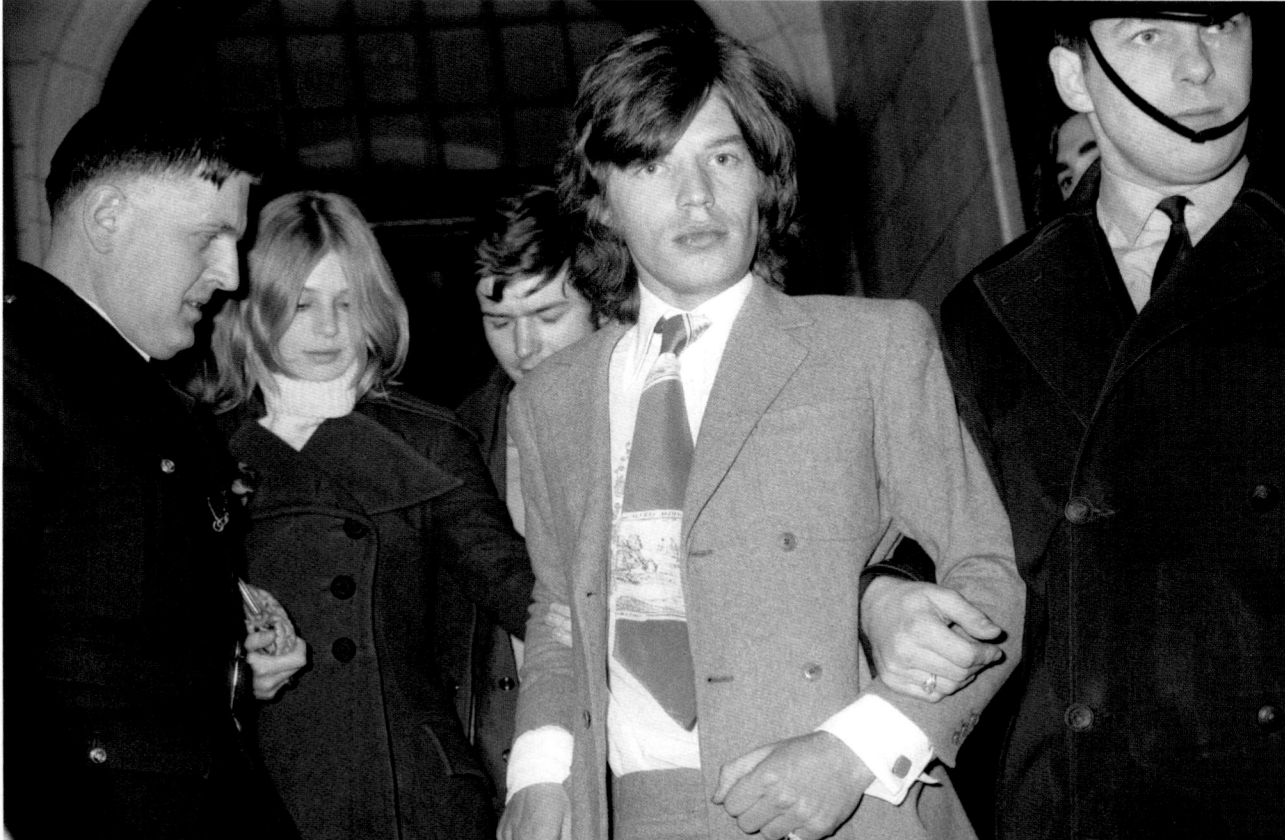

Right: A Central Line tube train enters Epping Station during its journey through a wintry Essex landscape.

4th March, 1970

Below: Model April Ashley, 34, pictured after Justice Ormrod had given his reserved judgement in a nullity action in the divorce court. He ruled that Ashley's register office marriage to Arthur Cameron Corbett was void. The judge held that it had been established that Ashley was not a woman at the time of the marriage and was at all times a man. Ashley was one of the first people to undergo gender reassignment surgery, in 1960, but at that time, it was not possible to change her birth certificate to reflect her true status. That was not made legal until 2005.

2nd February, 1970

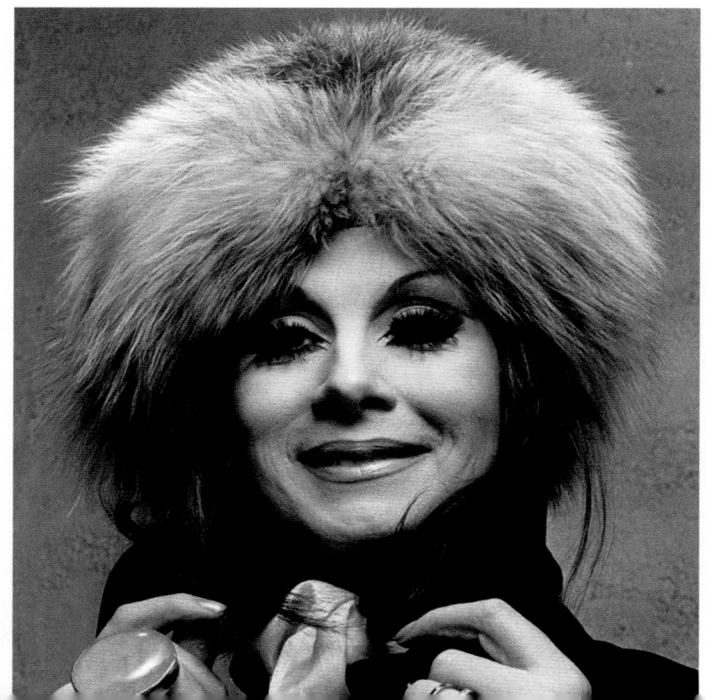

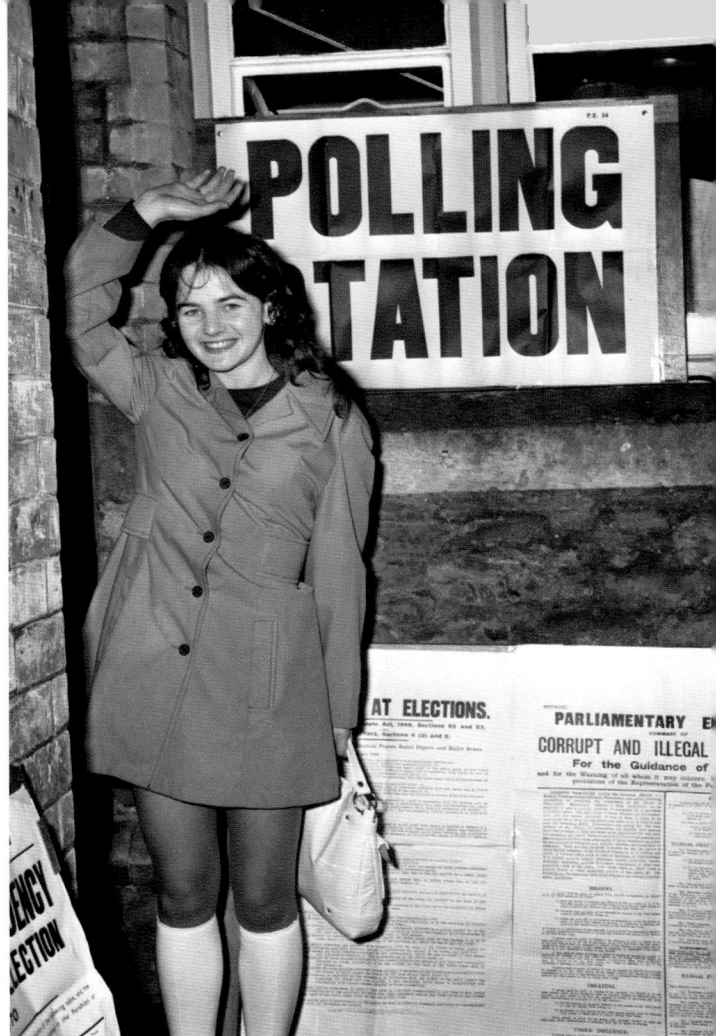

Above: British electoral history was made at the Bridgwater by-election, the first to take place since the minimum voting age was reduced from 21 to 18 on 1st January, 1970. A cheery wave is given by 18-year-old typist Trudy Sellick of North Newton, Somerset, pictured at the polling station where she voted at 7am when it opened.

12th March, 1970

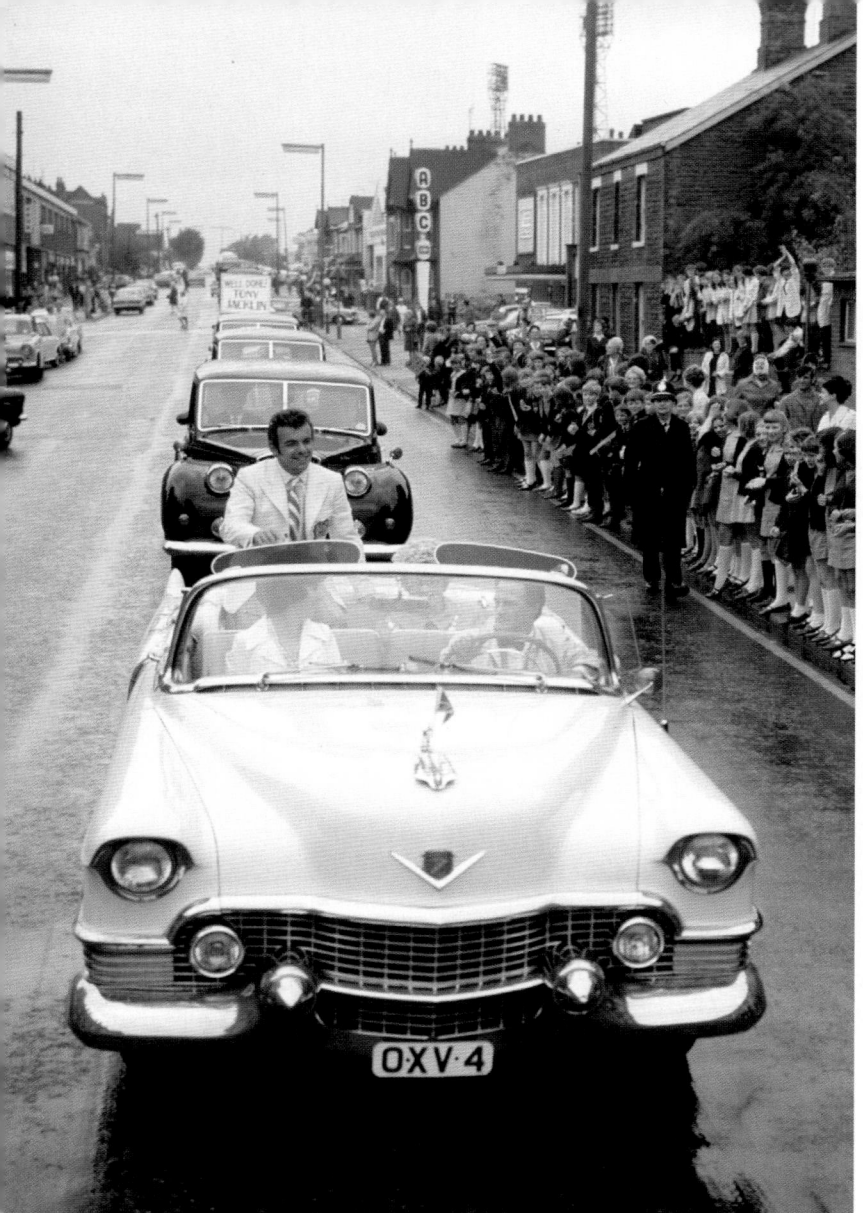

Above: Tony Jacklin, first British winner of the US Open golf championship for 50 years, rides in a vintage white Cadillac at the head of a motorcade in his home town of Scunthorpe, Lincolnshire.

24th June, 1970

Right: Legendary singer and guitarist Jimi Hendrix at the Isle of Wight music festival. Many consider him to be the greatest electric guitarist in the history of rock music. He died in his girlfriend's flat in London a few weeks later, under circumstances that have never been satisfactorily explained.

31st August 1970

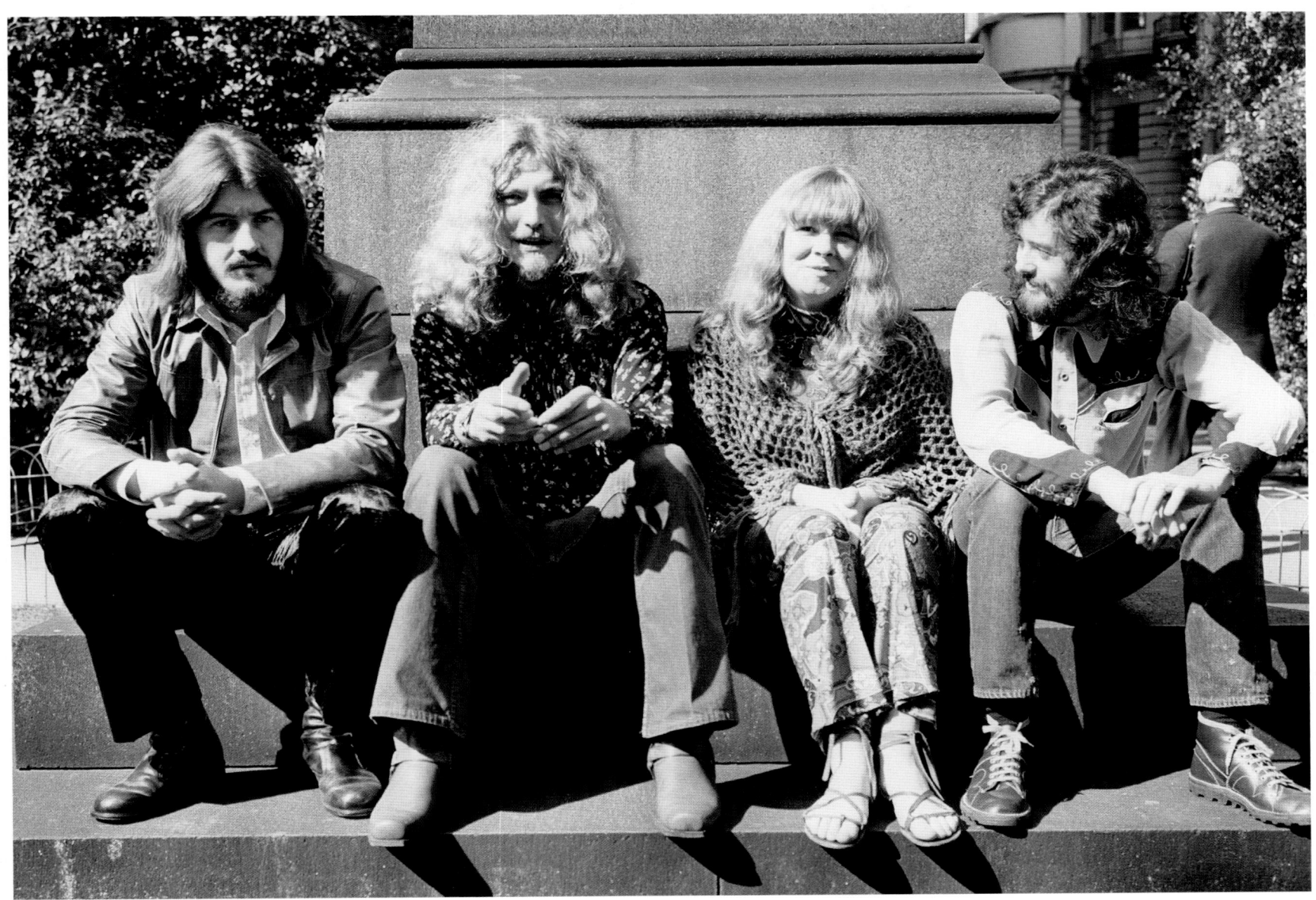

Above: Members of Led Zeppelin, (L–R) John Bonham, Robert Plant and Jimmy
Page, with singer Sandy Denny after receiving their awards in the *Melody Maker*
Pop Poll in London.

16th September, 1970

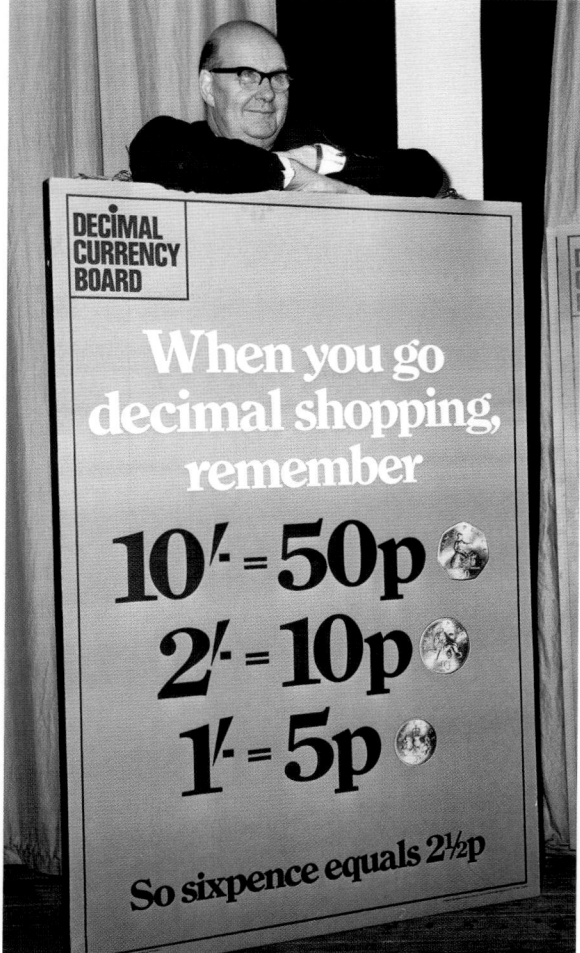

Above: The Queen with Prime Minister Edward Heath, and US President and Mrs Nixon at Chequers in Buckinghamshire. Nixon had been elected president in January 1969. He would win a second term in 1972, but would be pulled down by the Watergate Scandal, which exposed a dirty-tricks campaign waged by his aides against the Democratic Party.

3rd October, 1970

Above right: Lord Fiske, chairman of the Decimal Currency Board, with one of the posters to be displayed as part of an intensive campaign to explain decimal currency in time for its introduction on 15th February, 1971.

29th December, 1970

Right: Hop to it. Helen Archer on a beach in Felixstowe, Suffolk. For many people, the Space Hopper was the real face of 1971. The ridable bouncing ball became a major craze in the early 1970s, and it is still available today.

27th January, 1971

Above: Influential American artist Andy Warhol stands in front of his double portrait of Marilyn Monroe, at the Tate Gallery, Millbank, in London. Warhol was a leading figure in the pop art movement, and he gained world renown as a painter, avant-garde film maker and record producer.

15th February, 1971

Right: Although women had won the right to vote on the same terms as men in 1928, they continued to endure many inequalities throughout the 20th century. Here, members of the Women's Liberation Movement hand in a petition at 10 Downing Street, demanding equal rights on a number of issues.

6th March, 1971

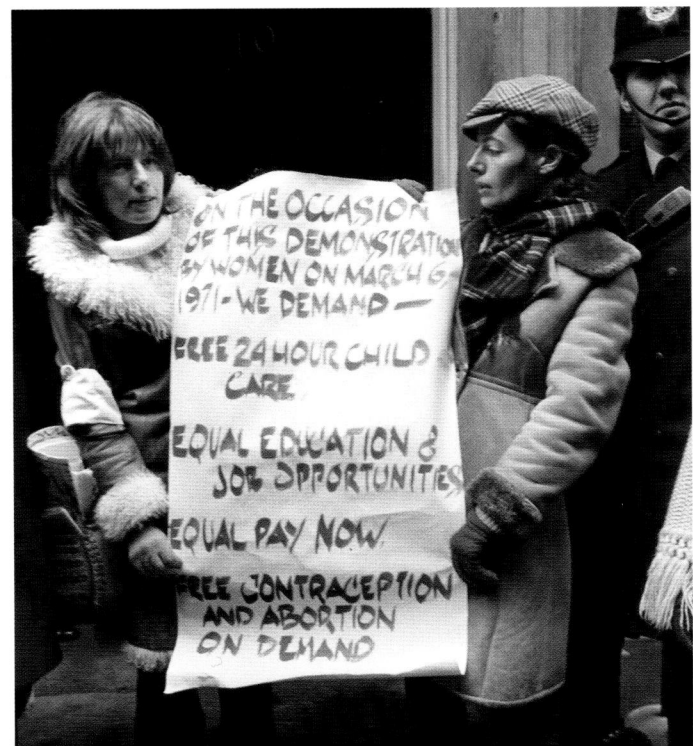

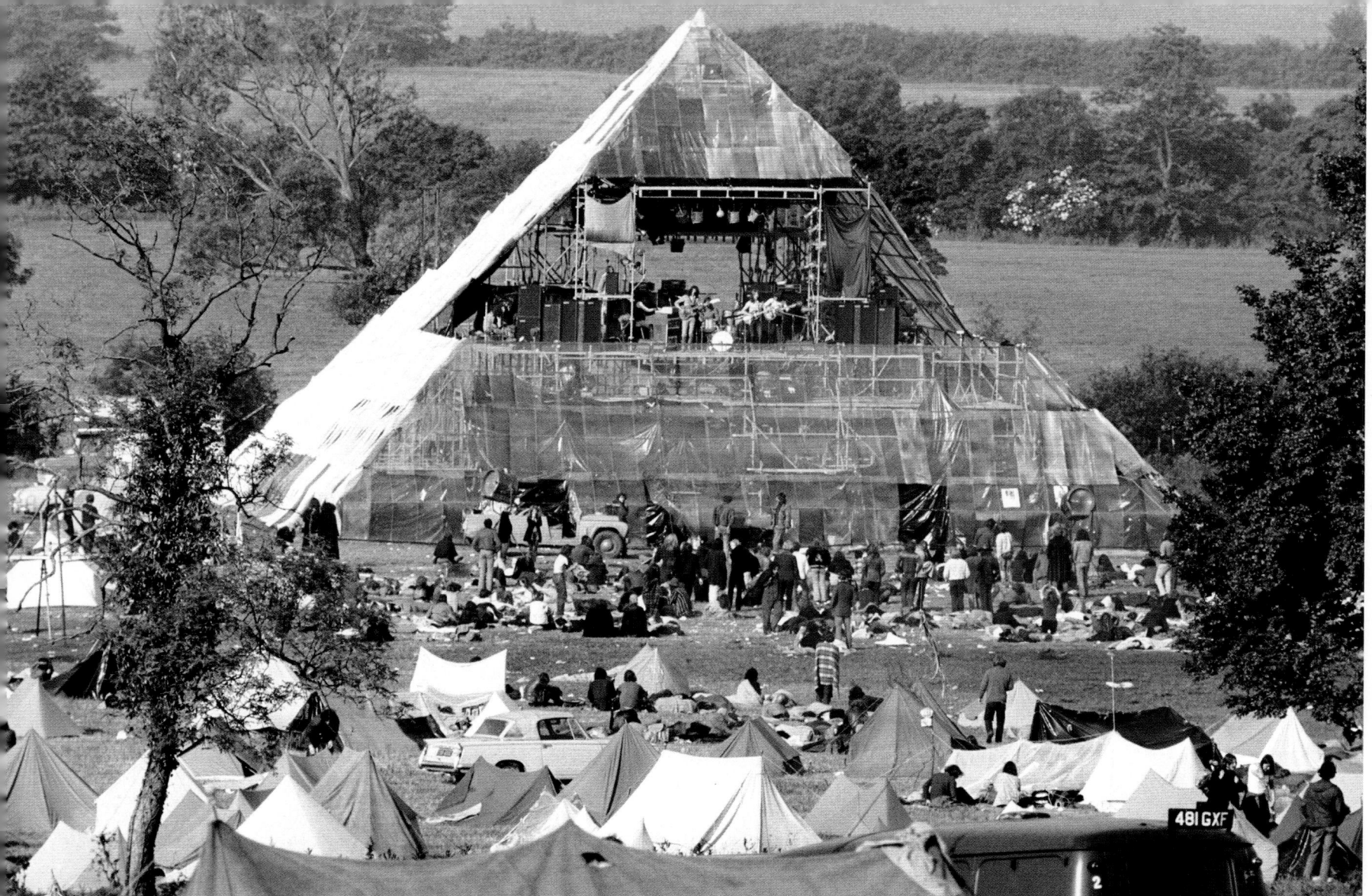

Above: Surrounded by the tents of a 7,000-strong crowd at Worthy Farm in Somerset, a pyramid one-tenth the size of the Great Pyramid shelters the dais for the Glastonbury Fayre, the second free music festival to be held on the site. The event featured, among others, David Bowie, Fairport Convention and Quintessence. Coinciding with the summer solstice, it had a more mystical flavour than the commercialized mega-festivals of later years. Speaking of the pyramid, organizer Andrew Kerr said, "*Imagine, we're going to concentrate the celestial fire and pump it into the planet to stimulate growth.*"

23rd June, 1971

Right: Heavy load. BBC Television's Summer Colour Girl, Christina Lepora, hauls Patrick Moore (L) and James Burke, members of the BBC team covering the Apollo 15 moon landing, in a replica of NASA's Lunar Roving Vehicle (LRV). The real thing was the first of three LRVs that would be taken to the moon to assist exploration. All would be left there.

19th July, 1971

Below: The three editors of *Oz* magazine – (L–R) Richard Neville, Felix Denis and James Anderson – in London for an appeal court hearing to challenge their Old Bailey conviction on obscenity charges. After the original trial, they had been sent to prison, where their heads had been shaved, so they turned up for the appeal wearing long wigs. The appeal court judge overturned the convictions when it was learned that the original judge had misdirected the jury.

3rd July, 1971

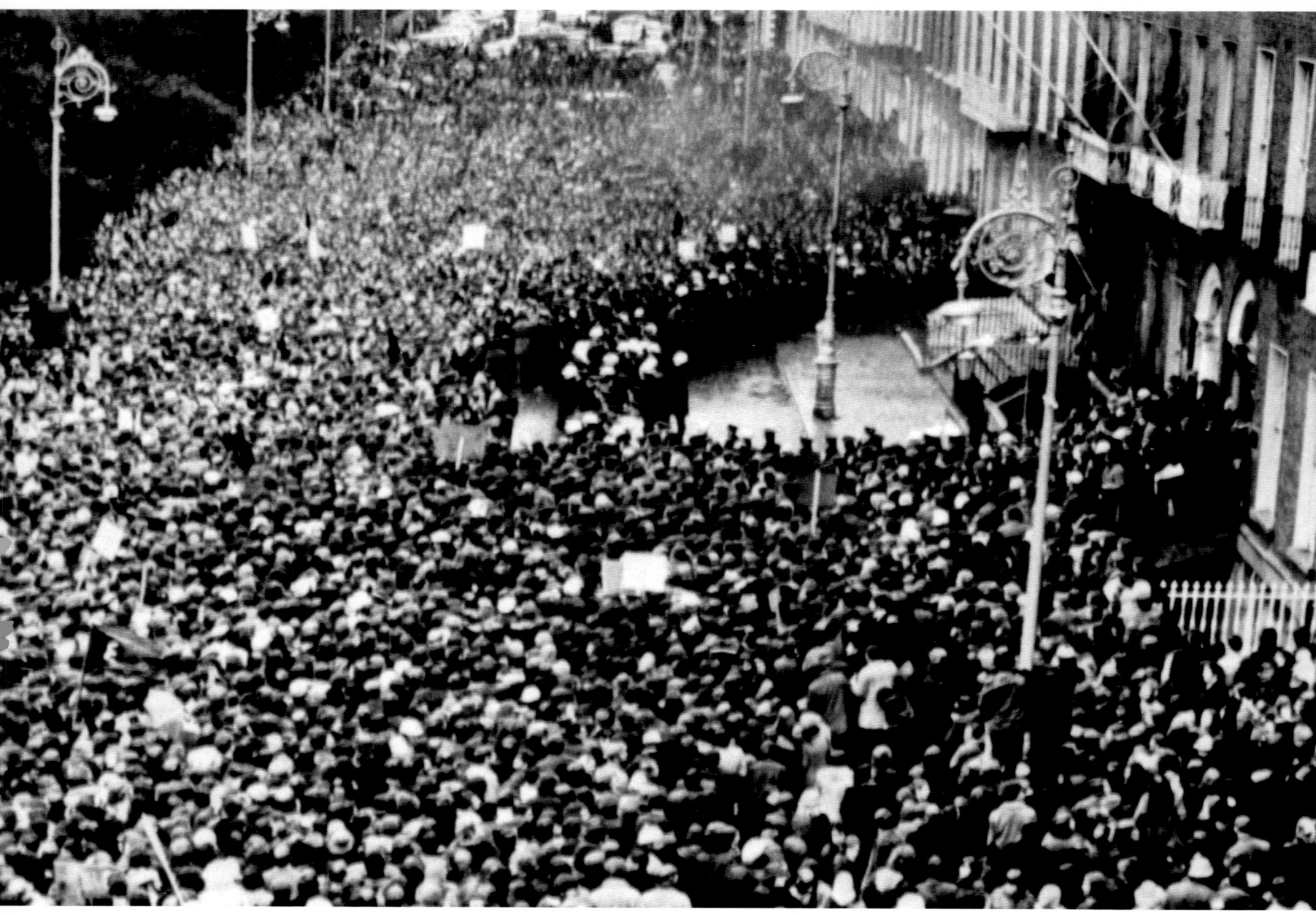

Above: Police attempt to prevent crowds from attacking the British Embassy in
Dublin after troops had shot dead 13 demonstrators in Londonderry on 'Bloody
Sunday' (30th January, 1972). The embassy was firebombed and burned down.

2nd February, 1972

Right: A British paratrooper comforts a young girl in his arms after a terrorist
bomb blast in Donegal Street, Belfast, while a second attends to her injuries.

20th March, 1972

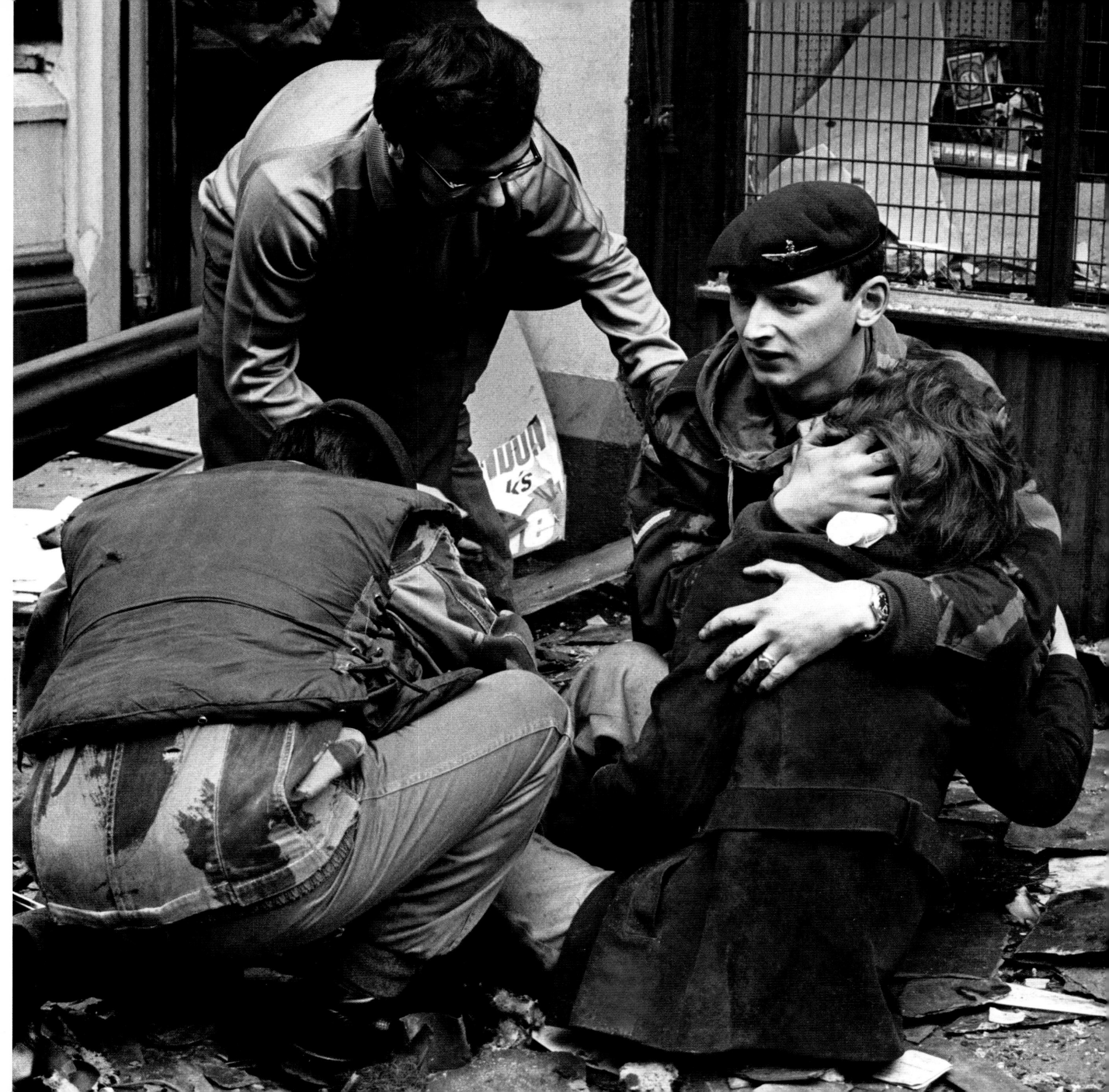

Left: Actress Hilary Pritchard (L) presents the Disc Awards to Rod Stewart, Top British Singer Maggie Bell and Top Singer-Songwriter Gilbert O'Sullivan.

14th February, 1973

Below left: The band Slade during a reception at the Savoy Hotel, London: (L–R) Don Powell, Dave Hill (in hat), Jim Lea and Noddy Holder. Slade was one of the most successful British chart bands of the 1970s, with 17 consecutive top-20 hits. The band is probably best known today for the Christmas hit *Merry Xmas Everybody*, which was their biggest selling single.

1st March, 1973

Right: David Bowie arrives at the Odeon Leicester Square, in London, for the premiere of the James Bond movie *Live and Let Die*. Renowned as a musical innovator, in 1972 Bowie had created the alter ego of the androgynous Ziggy Stardust with the hit single *Starman* followed by the album *The Rise and Fall of Ziggy Stardust and the Spiders from Mars*.

5th july, 1973

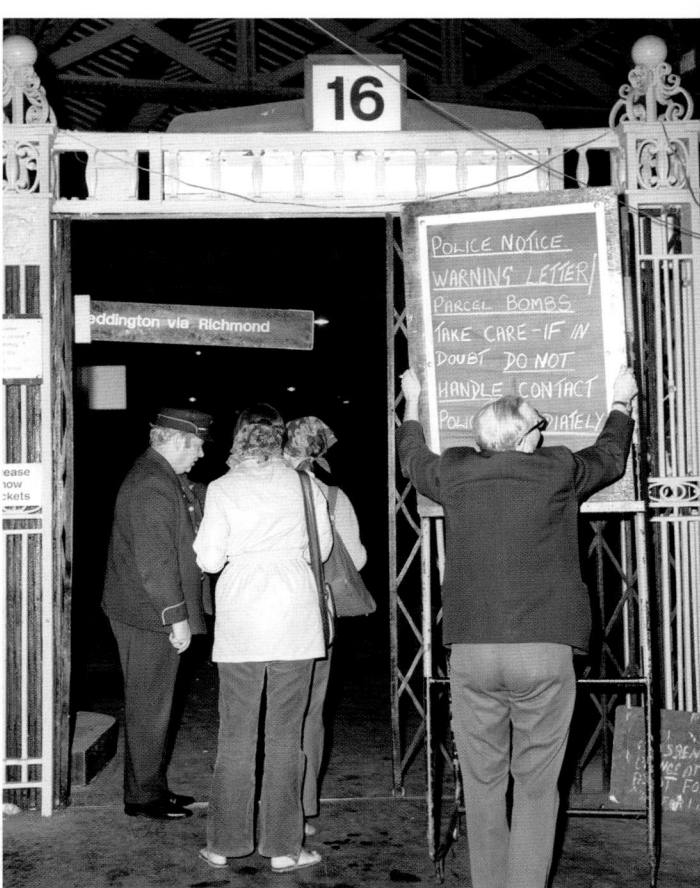

Above: Commuters arriving at Waterloo station, London's busiest terminus, are greeted with hastily written notices warning them to be vigilant about letter bombs. Such a device, believed to have been sent by the IRA, had earlier exploded in the hands of Nora Murray, a secretary to the British military attaché in Washington, DC. The following day, another letter bomb was discovered at the British embassy in Paris.

27th August, 1973

Above: The Queen, with Baroness Spencer-Churchill and Winston Spencer-Churchill, after the unveiling of a statue of Sir Winston Churchill in Parliament Square, London. Winston Spencer-Churchill was the great leader's grandson, who was also an MP.

1st November, 1973

Above: Miss World winner Miss USA, 19-year-old Marjorie Wallace, with runners-up (L–R) Miss South Africa (5th), Miss Jamaica (3rd), Miss Philippines (2nd) and Miss Israel (4th) at the Royal Albert Hall in London.

23rd November, 1973

Left: Princess Anne and Captain Mark Phillips on the balcony of Buckingham Palace after their wedding at Westminster Abbey. They are flanked by bridesmaid Lady Sarah Armstrong-Jones and page-boy Prince Edward.

14th November, 1973

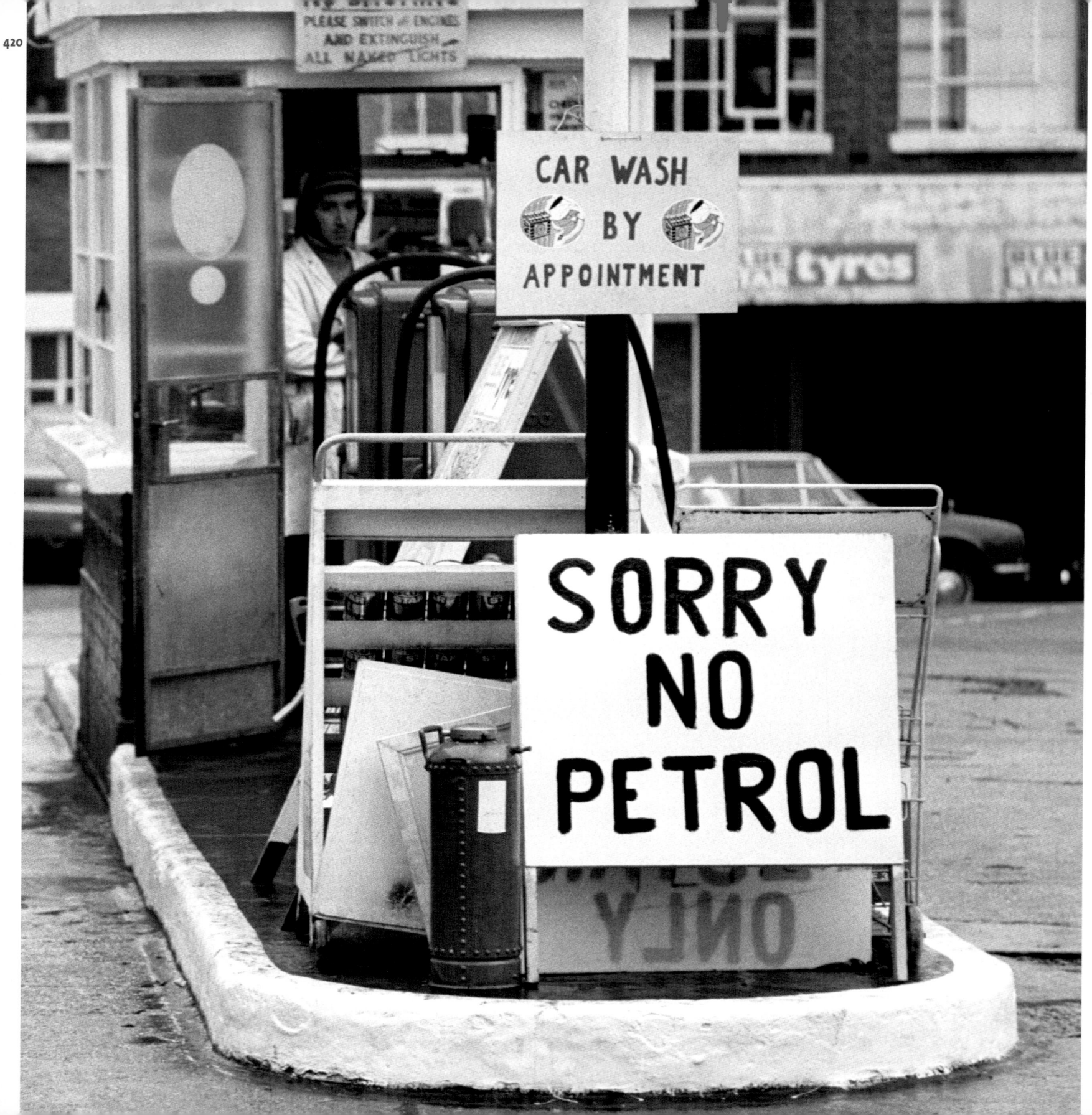

Left: A mounting crisis grips Britain as motorists are forced to hunt for ever-dwindling petrol supplies. The shortage had been caused when the Organization of Arab Petroleum Exporting Countries cut output in an attempt to drive up oil prices and in protest at the United States' support for Israel during the Yom Kippur war against a coalition of Arab states.

4th December, 1973

Below: The Swedish band Abba meet a mounted policeman as they relax in Brighton, after their victory in the Eurovision Song Contest with *Waterloo*: (L–R) Agnetha Fältskog, Björn Ulvaeus, Benny Andersson and Anni-Frid Lyngstad.

7th April, 1974

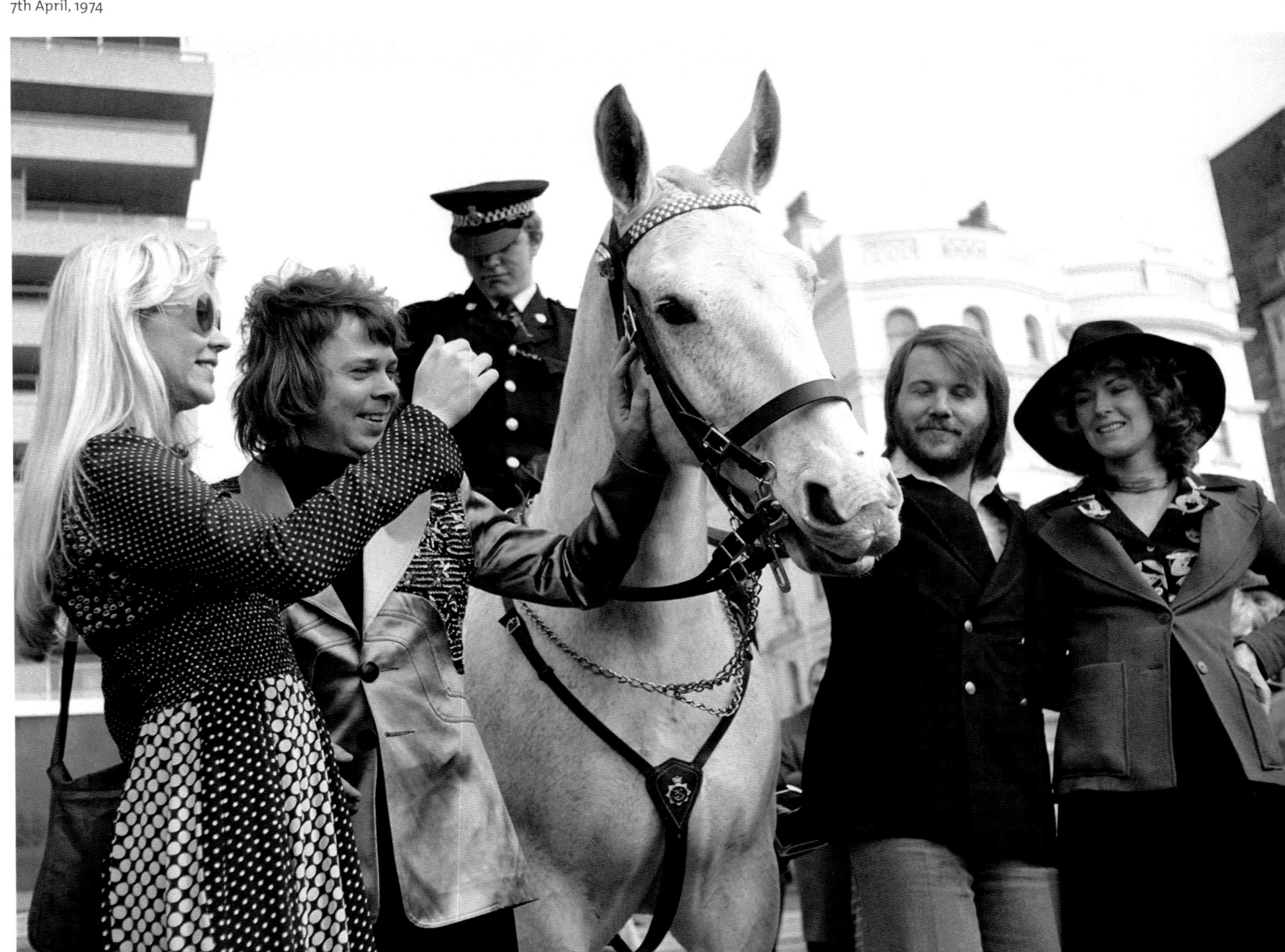

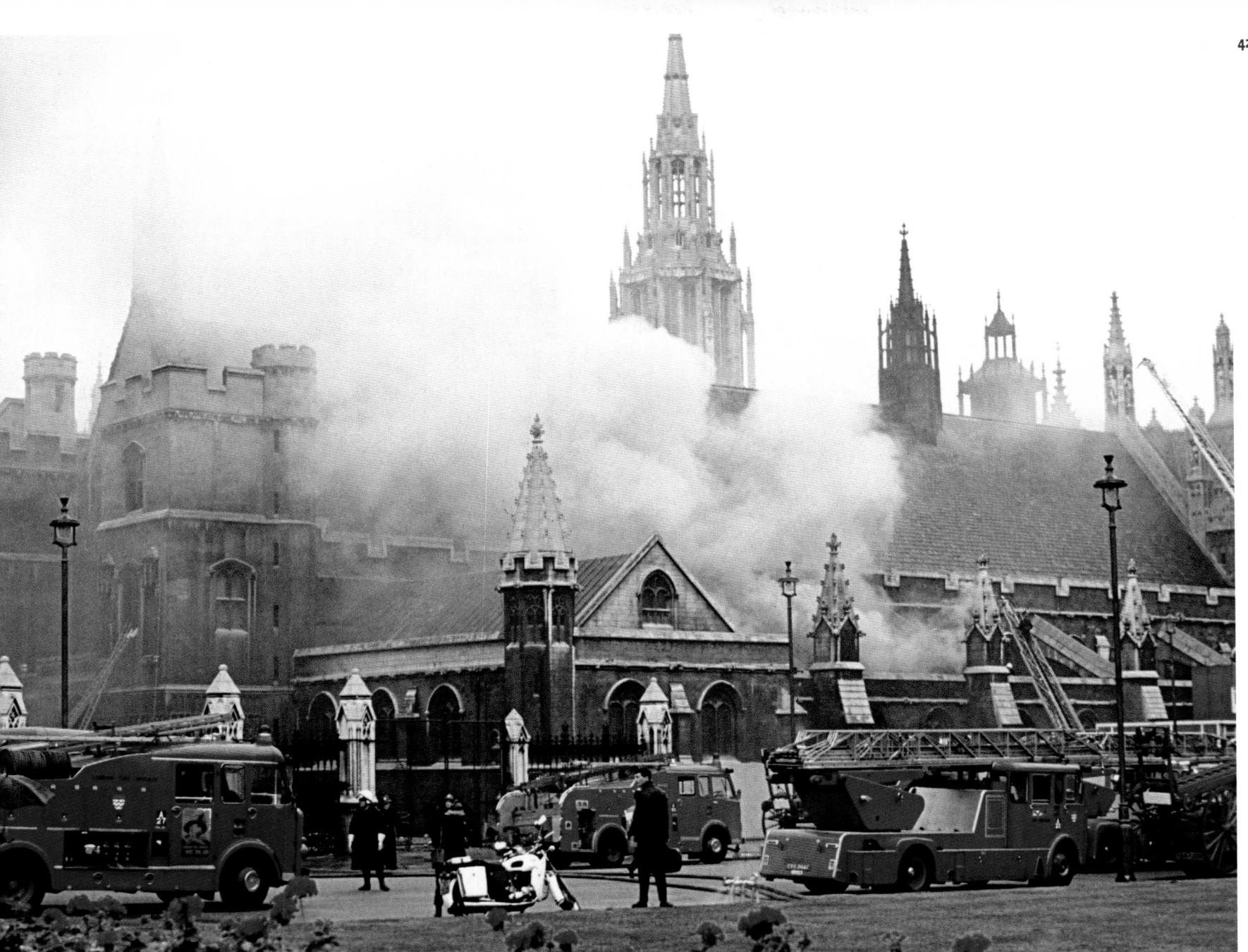

Above: Westminster Hall burns as emergency services tackle a blaze that started when an incendiary device planted by the IRA ignited. Eleven people were injured.

17th June, 1974

Left: The Nypro chemical plant at Flixborough, Lincolnshire, after a chemical explosion that killed 28 and injured a further 36.

1st June, 1974

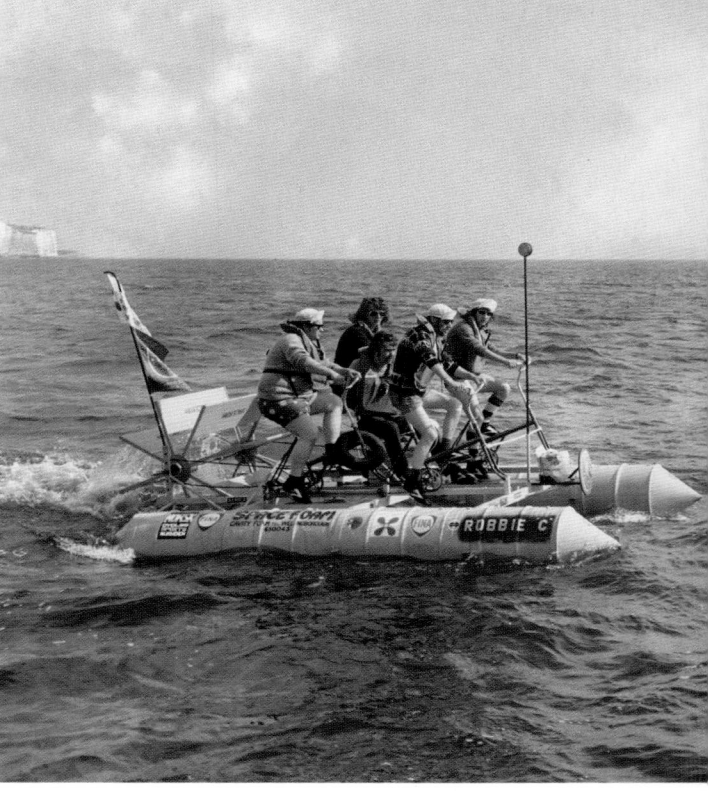

Above: Fish head. A porter at Billingsgate fish market in London demonstrates the lifting power of the traditional flat-topped straw hat.

23rd July, 1974

Above right: Pedal pushers: (L–R) Jack Ward, Mick Birt, Roger Lumley, John Clinton and Peter Birt set out on their attempt to cross the English Channel on a bicycle-powered raft. Worsening weather forced them to give up after two hours.

28th July, 1974

Left: Bunny Girls in their work outfits outside London's Playboy Club in Mayfair make their views clear ahead of a ballot to establish whether the club's staff should join the Transport and General Worker's Union. L–R: Nina Tyrell Pett, Carolyn Moore, Celeste Walter, Jackie Woodcock and Zee Thomkins.

2nd February, 1975

Below: Face blackened, one of the victims of a tube crash at London's Moorgate station is helped to a waiting ambulance. Forty-three people died when a train ploughed into the buffers at the peak of the rush hour. Several others died later from their injuries.

28th February, 1975

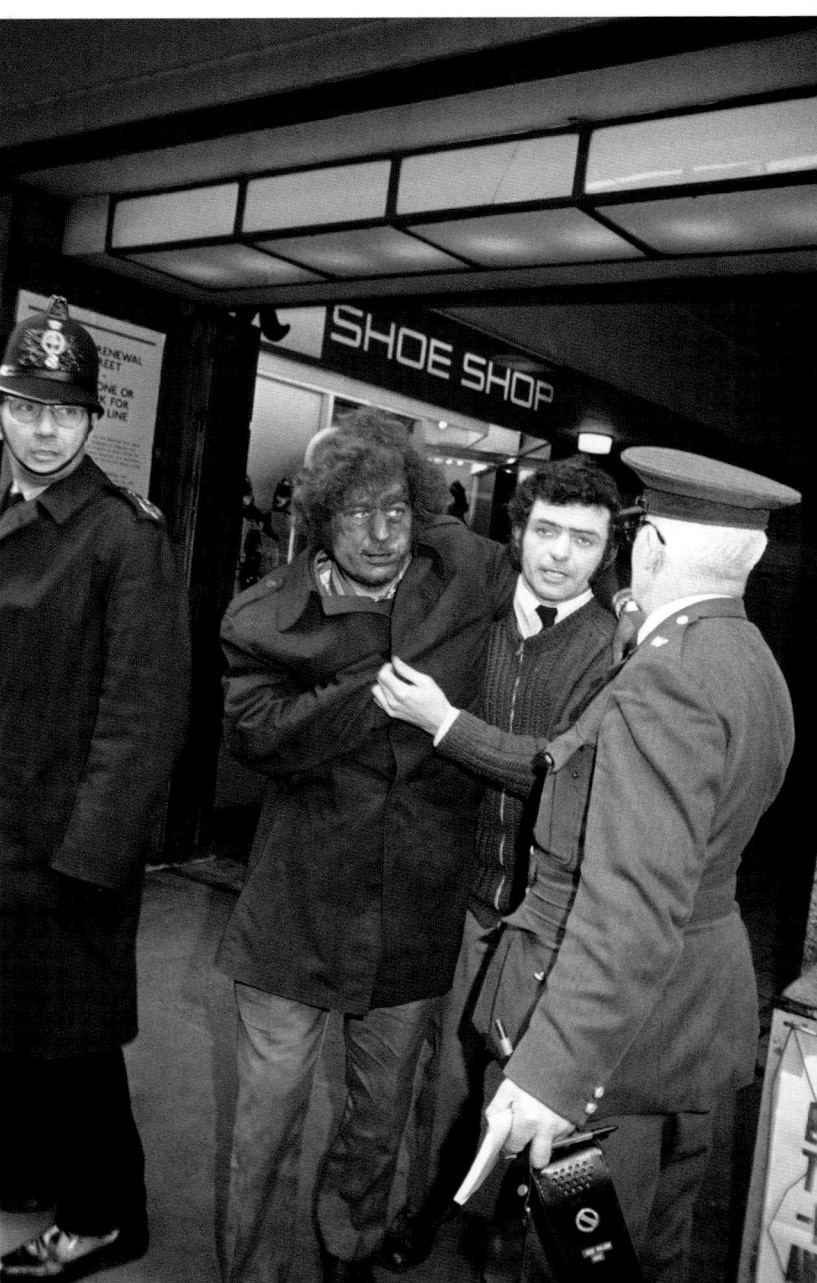

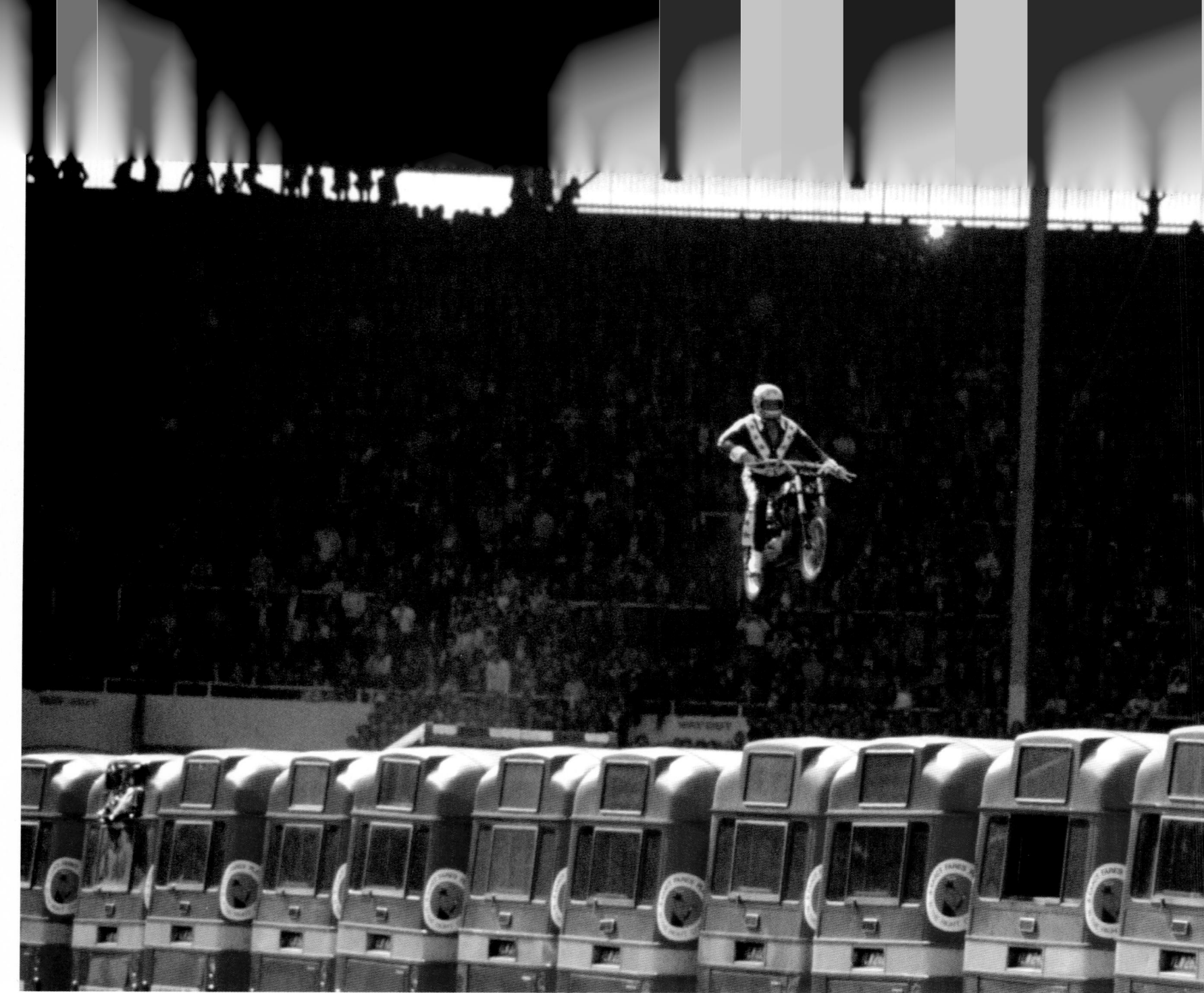

Above: American stunt man Evel Knievel during his display at Wembley Stadium, London, where he attempted to leap his motorcycle over 13 single-decker London buses. He crashed, breaking his pelvis. In severe pain, he announced his retirement to the audience and then walked out of the stadium, ignoring all pleas for him to use a stretcher.

26th May, 1975

Right: Bare faced cheek. To the bemusement of the players, a streaker hurdles the stumps at Lord's during a Test match.

4th August, 1975

428

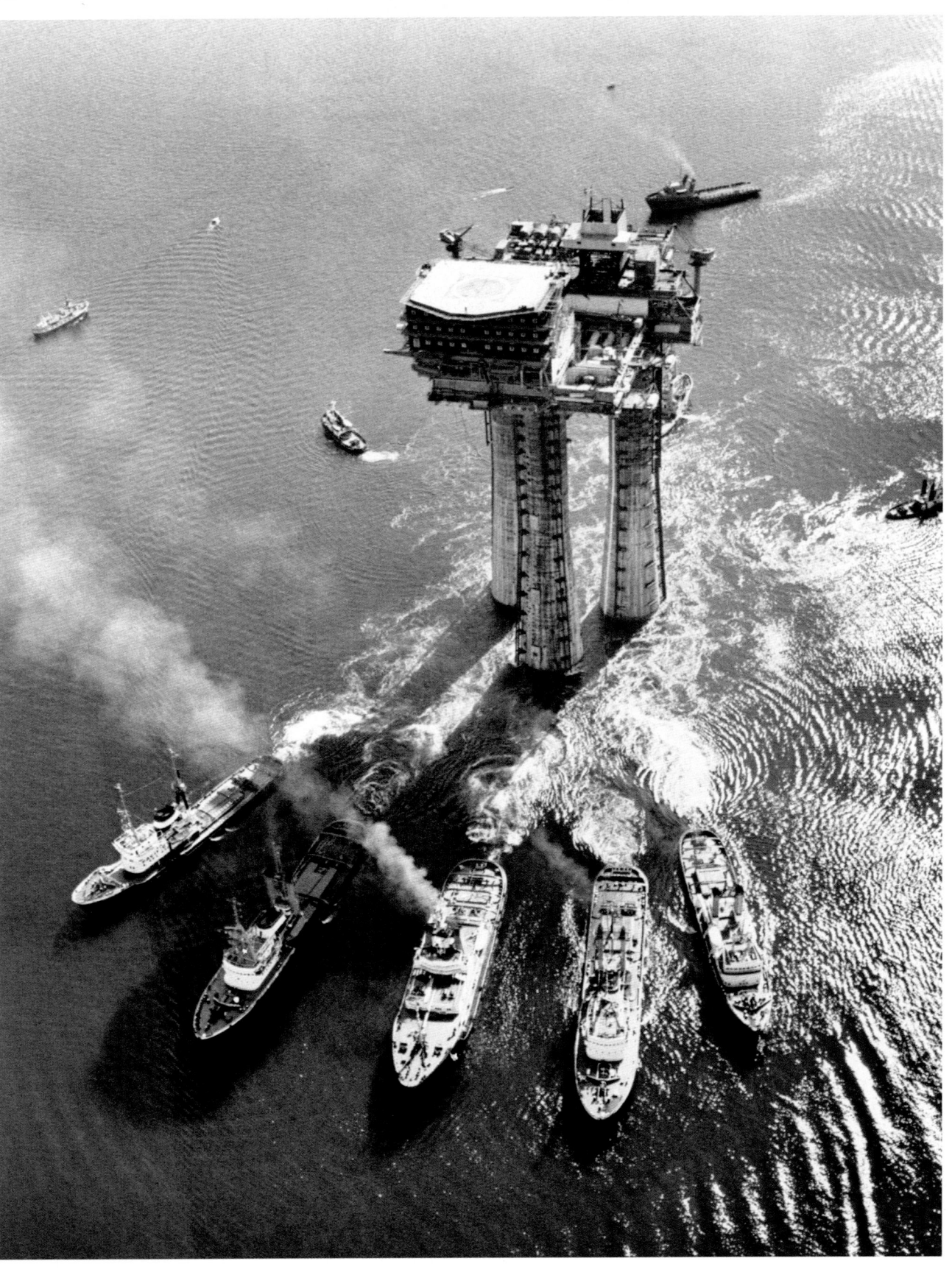

Left: The biggest oil production platform yet built, on its way from Stavanger, Norway, to the Shell/Esso Brent oilfield in the North Sea.

5th August, 1975

Right: Armed police aim at a house in central London where the Balcombe Street gang, four IRA men, were holding a couple hostage. The dramatic siege saw police wielding guns on Britain's streets for the first time in such a public manner. The gang gave themselves up after a six-day stand-off when the SAS were called in.

8th December, 1975

Right: Meriden worker Barry Booth fits the 750cc engine to a Triumph Bonneville motorcycle in the former Norton-Villiers-Triumph factory being operated by a workers' co-operative backed by £5m from the British government. Following announcement of the closure of the factory by NVT, the workers had staged a two-year sit-in, which led eventually to the formation of the co-operative. The enterprise survived for eight years; falling export sales, exacerbated by a strong pound, led to its bankruptcy.

11th August, 1975

Far right: During a dispute between Britain and Iceland over North Atlantic fishing rights, known as the Cod War, a Royal Navy frigate collides with the Icelandic gunboat *Thor*. There were several such cases of vessels ramming each other.

7th January, 1976

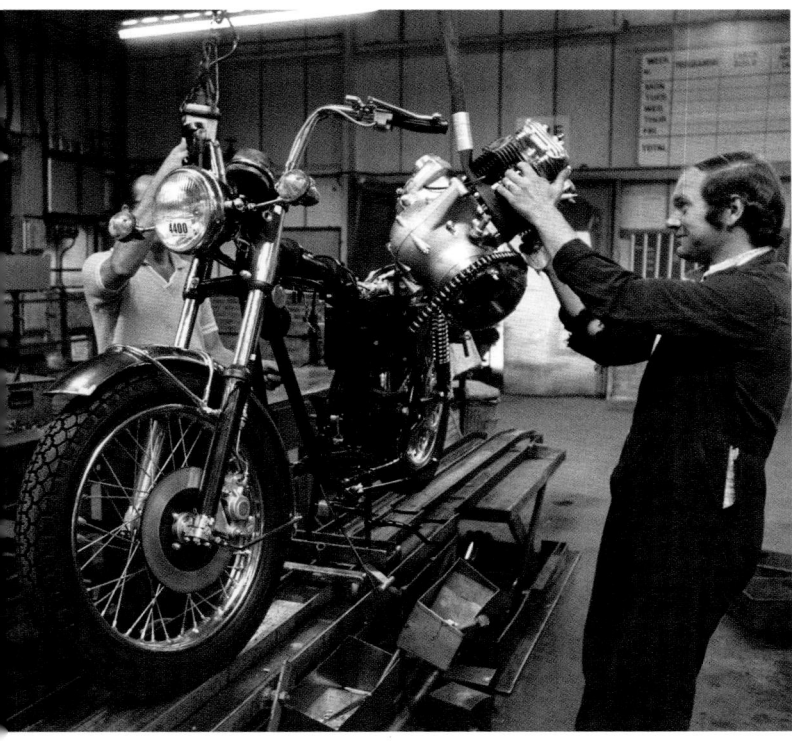

430

Left: BBC Television's *Top of the Pops* resident dancers, Pan's People: (L–R) Ruth Pearson, Mary Corpe, Lee Ward, Sue Menhenick and Cherry Gillespie. A regular feature of the programme since 1968, the all-female troupe was replaced in 1976 by a group of male and female dancers called Ruby Flipper. They were not particularly well received, however, and were soon replaced by another all-girl troupe, Legs & Co.

1st February, 1976

Below Tate Gallery employee Arthur Payne watches over Carl Andre's notorious 'Equivalent VIII', a plain rectangle of 120 fire bricks, at its controversial first UK public showing. The piece was heavily criticized in the press for being a waste of taxpayers' money. Later the work was defaced with paint.

17th February, 1976

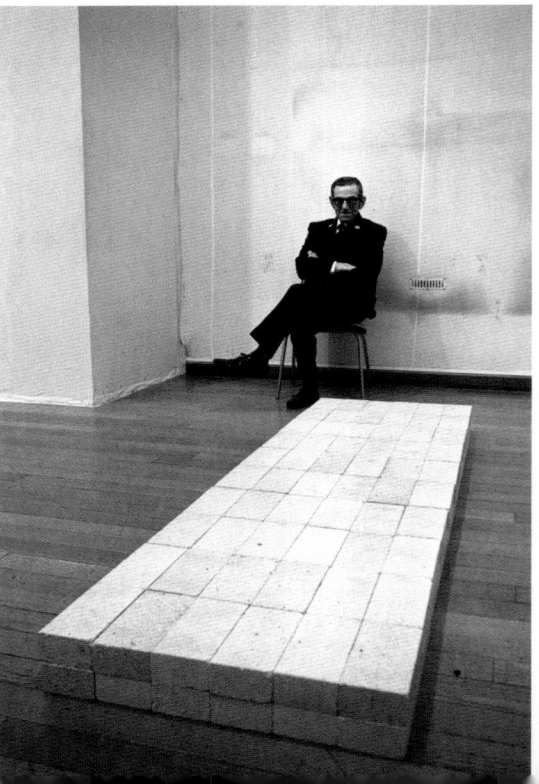

Above Susan Mayor, of the costume department at Christie's auction house in London, with Lord Lucan's coronet and robes, which were auctioned to pay the missing peer's creditors. Lucan disappeared in the early hours of 8th November, 1974 following the murder of his children's nanny, Sandra Rivett. He has not been seen since.

23rd May, 1976

Right British tennis player Virginia Wade in action against Evonne Cawley, at Wimbledon in 1976. A year later, she would win the Women's Singles Championships at Wimbledon during the tournament's centenary year, the last time any British player has won a singles championship at that tournament. During her career, Wade won three Grand Slam singles championships and four Grand Slam doubles championships.

30th June, 1976

432

Left: D Wing in Hull Prison after a four-day riot, which caused £750,000 worth of damage and was the most serious prison incident since the pre-war Dartmoor mutiny. There was no known single cause for the outbreak, which involved over 100 prisoners. The prison was closed for repairs for a year following the disturbance.

14th July, 1976

Above: Staines Reservoir in Middlesex during the prolonged drought of 1976. The summer of that year was the hottest in the UK since records began, compounding a very dry period that had begun in the previous summer. The effects on water supplies were such that in some areas it had to be rationed.

17th August, 1976

Right: Tartan terrors. Young fans cool off outside the New Victoria Theatre, London, where teenagers went wild during a concert by the Bay City Rollers. Succumbing to the phenomenon of 'Rollermania', at least 210 hysterical youngsters were treated for minor cuts and bruises after they flattened the first three rows of seats.

20th September, 1976

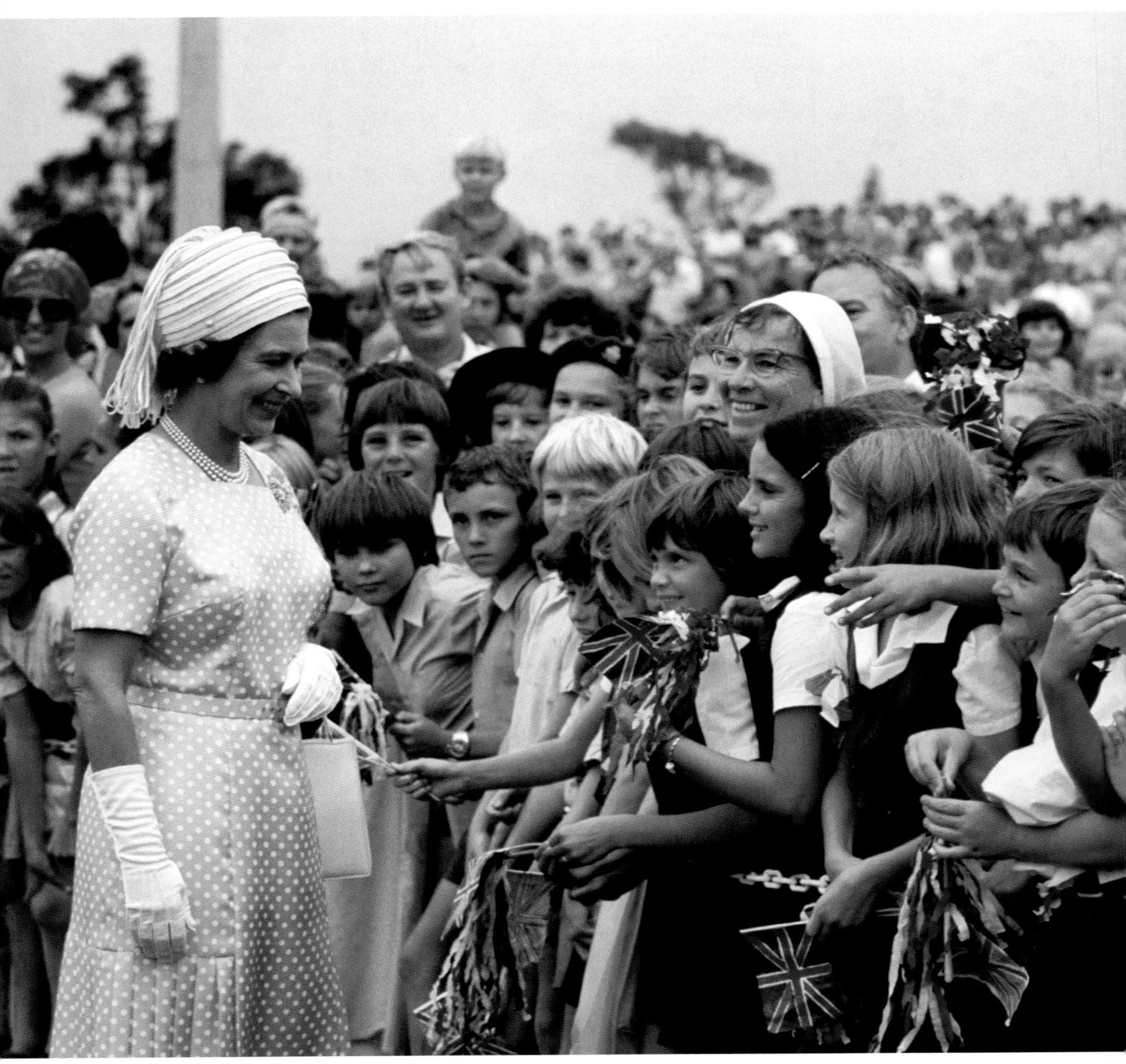

Left: Red Rum wins his third Grand National. With Brian Fletcher in the saddle, the gelding had won in 1973 and 1974, and had come second in 1975. Tommy Stack rode him to second place in 1976, and then to another victory in 1977.

2nd April, 1977

Left: HMS *Belfast*, the last of the Royal Navy's great cruisers, moored in the Pool of London opposite the Tower, where she has become one of the city's most popular landmarks. Launched in 1938, the ship saw action during the Second World War and also the Korean War. Today she is a floating museum operated by the Imperial War Museum.

21st April, 1977

Left: The Queen meets flag-waving school children on her arrival at Brisbane, during her Silver Jubilee tour of Australia. After travelling throughout the UK, to celebrate the 25th year of her reign, the Queen and Prince Phillip undertook a tour of Commonwealth countries, including the Pacific island nations of Fiji and Tonga, New Zealand, Australia, the West Indies and Canada.

9th March, 1977

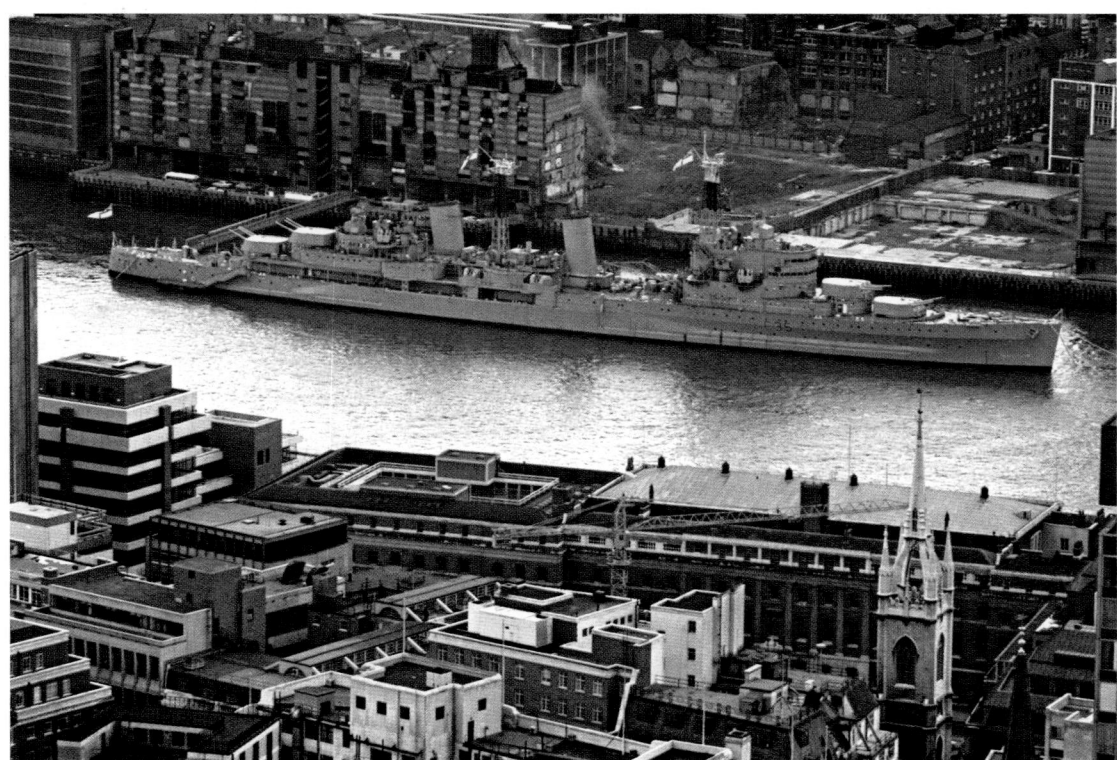

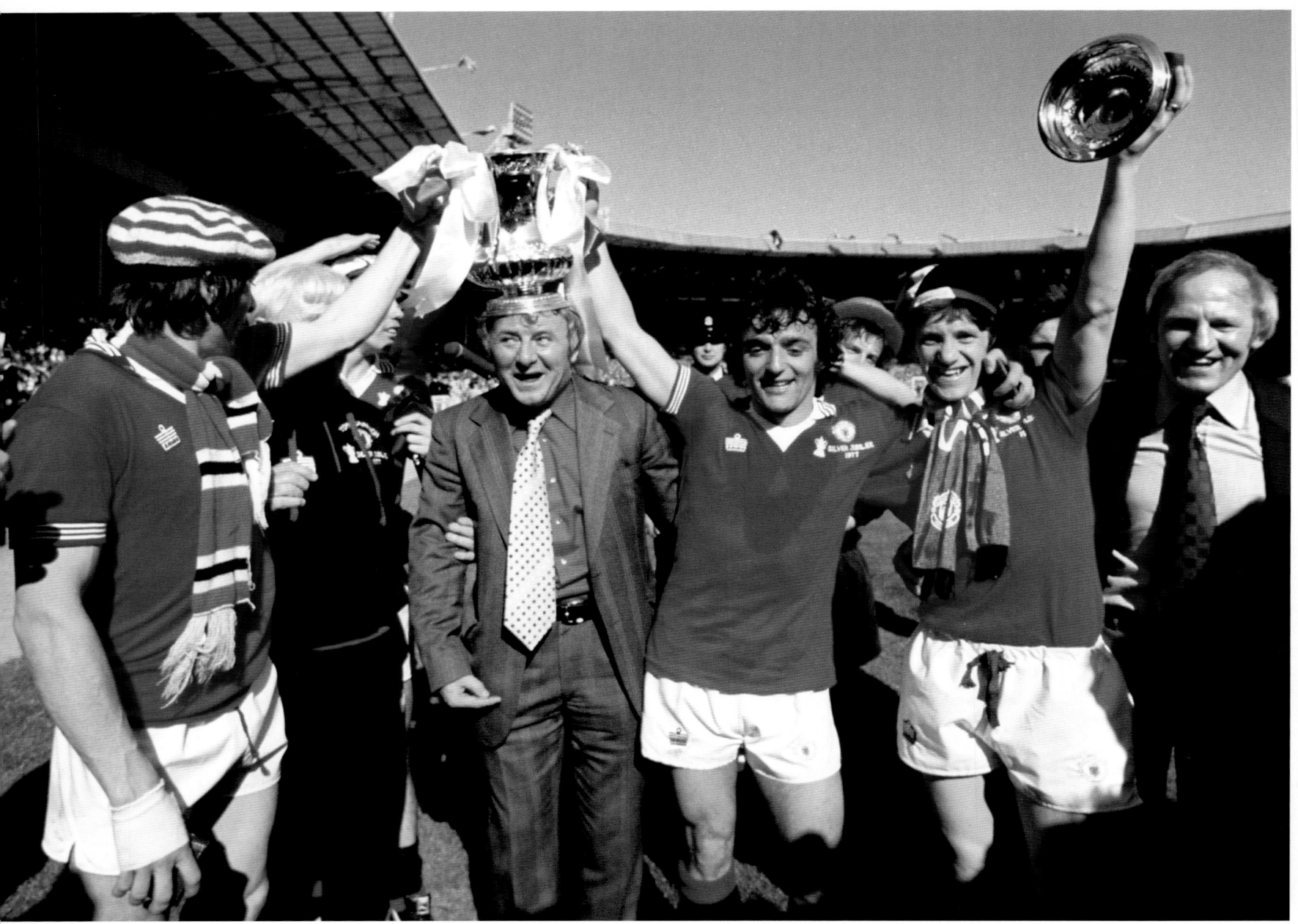

Above: Head trick. Manchester United manager Tommy Docherty tries the FA Cup trophy for size after United beat Liverpool.

10th May, 1977

Right: Jubilant Scotland fans demolish the Wembley goalposts after seeing their team win 2–1 against England.

4th June, 1977

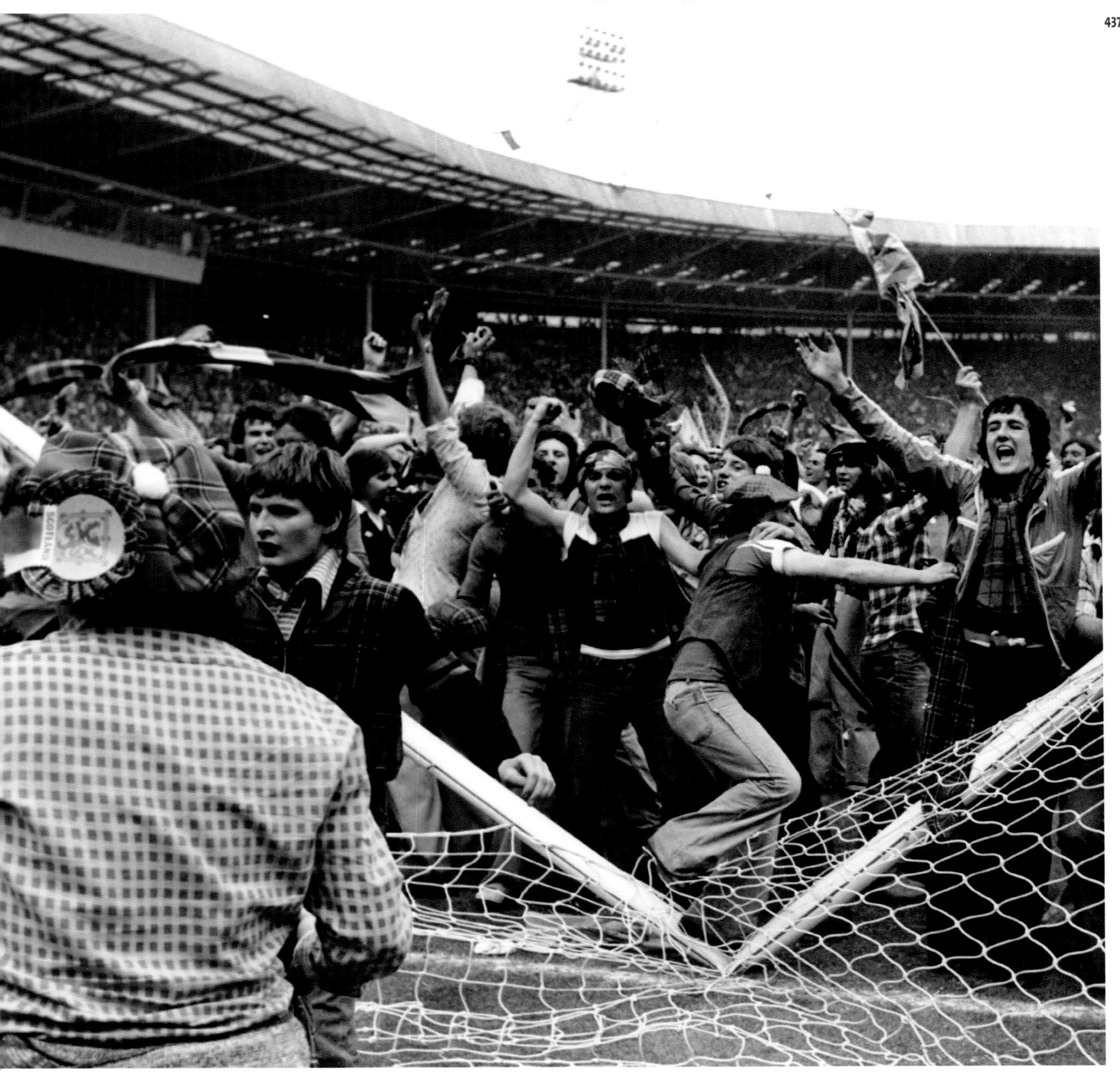

Left: Reigning Formula One World Champion James Hunt raises the trophy after winning the John Player British Grand Prix at Silverstone. The McLaren driver only finished fifth in the championship in 1977, fared even worse in 1978 and retired from racing in 1979. One of his passions was breeding parrots and budgerigars, at which he achieved considerable success. He died from a heart attack in 1993, at the age of 45.

16th July, 1977

Below: A Gay Pride demonstration, near the Old Bailey, marking the start of a prosecution alleging blasphemous libel, which had been brought by anti-pornography campaigner Mary Whitehouse against the newspaper *Gay News* and its editor, Denis Lemon.

4th July, 1977

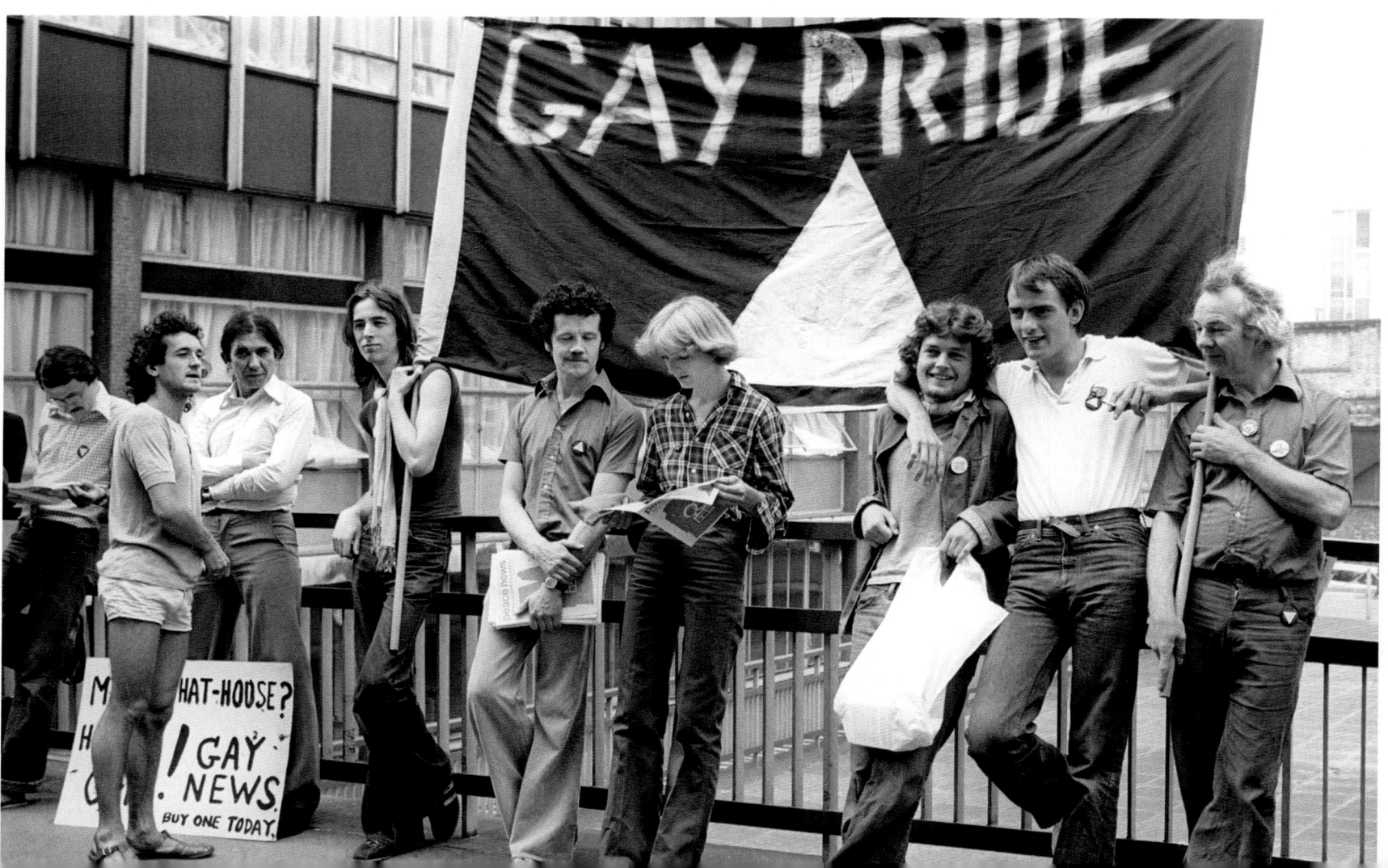

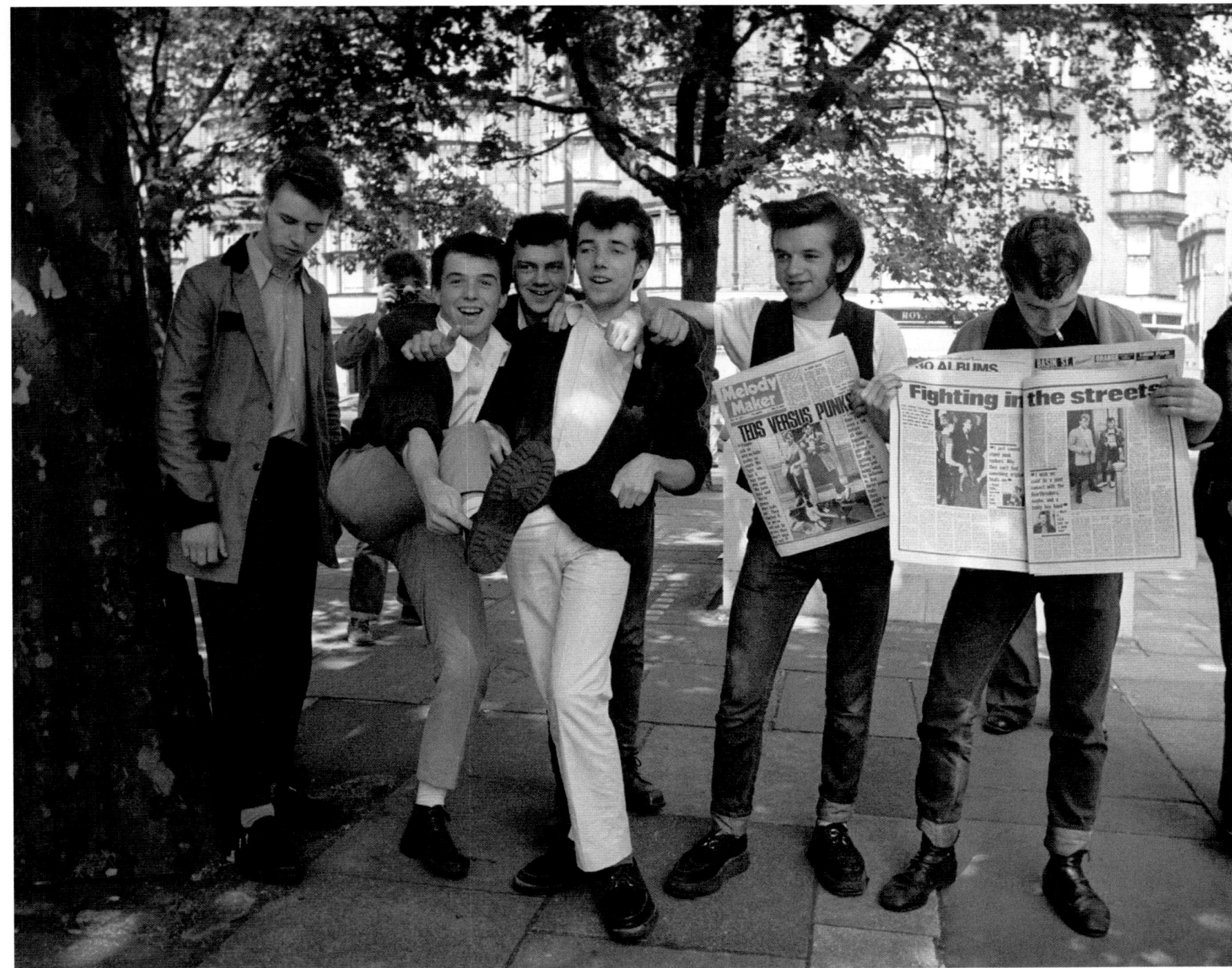

Above: A resurgence in interest in Rockabilly music in the 1970s saw a revival in Teddy Boy styles. These Teds have gathered on King's Road, London to read about their wars with Punks in music papers. Just as the Mods and Rockers of the 1960s had had their battles, so the new youth groups would fight each other.

30th July, 1977

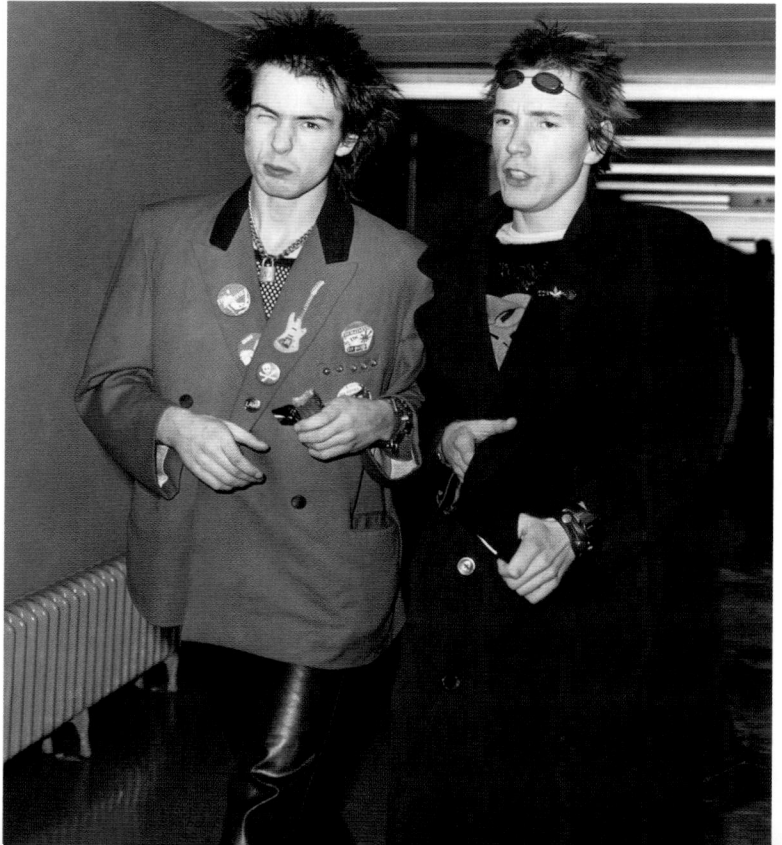

Above: Police struggle to hold back hundreds of pickets as a workers' bus approaches the Grunwick film processing plant, in Willesden, North London. A dispute had broken out between a section of the workforce and the company's owner, George Ward, over pay and conditions. About a third of the employees went on strike and joined the APEX union, but Ward sacked them, as he did not wish to recognize the union. The dispute escalated, drawing in pickets from all over the country. Violence erupted, but Ward stood firm, despite the recommendations of ACAS to reinstate the workers. Eventually, after nearly two years, the strikers called off their action on 14th July, 1978.

17th October, 1977

Left: Bass player Sid Vicious (L) and lead vocalist Johnny Rotten, members of the controversial punk rock group The Sex Pistols, at London's Heathrow Airport before leaving for Luxembourg. In typical anarchic fashion, they hurled abuse at reporters and photographers as they walked to their aircraft.

3rd November, 1977

Right: Colouring by candlelight for seven-year-old Tracy Caulkin and her sister, Jaqui, five, at their home in Woodburn Green as the nation faces another round of blackouts because of a work to rule by rebel power workers.

4th November, 1977

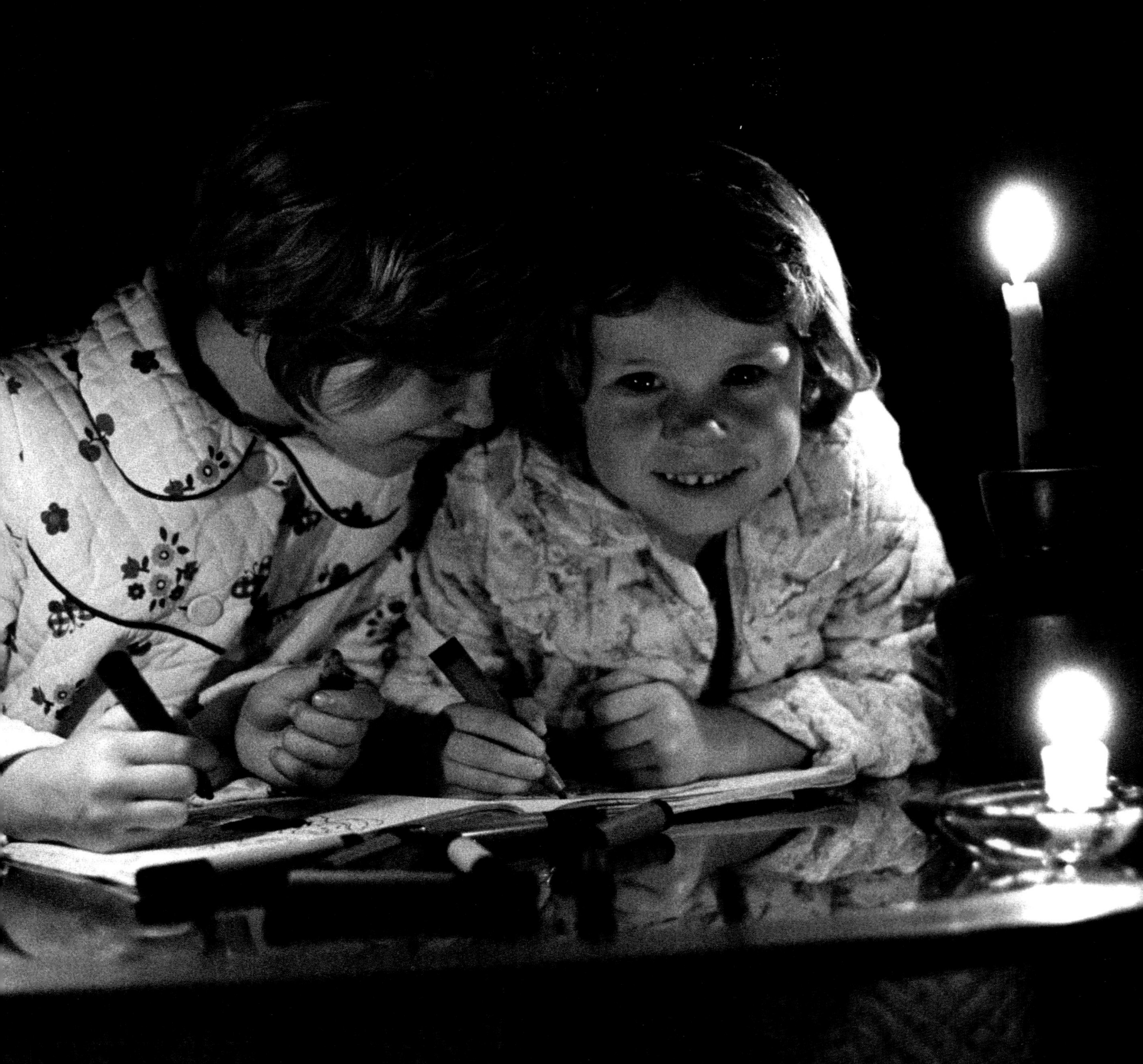

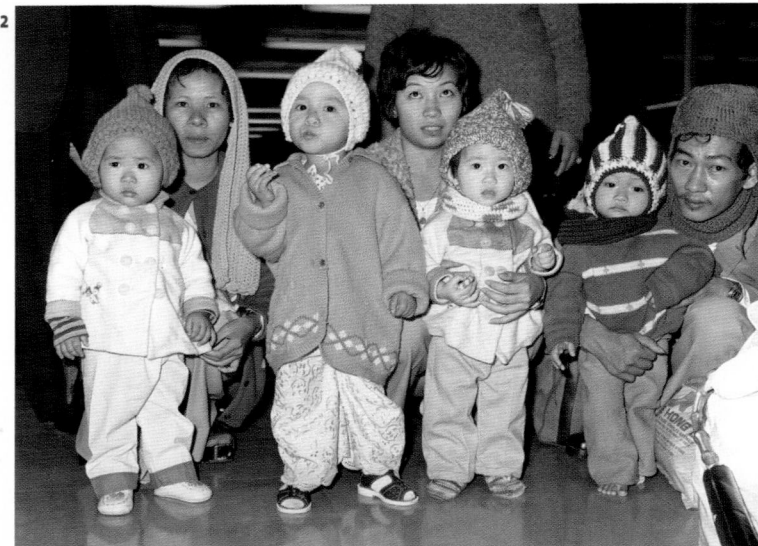

Above: Some of a party of 12 South Vietnamese refugees who arrived at London's Heathrow Airport from Singapore. Following the end of the Vietnamese War in 1975, many people from the south of the country fled the communist regime that had taken over.

12th January, 1978

Below: Comedians Ronnie Corbett (L) and Ronnie Barker at Buckingham Palace after receiving their OBEs from the Queen. Their popular comedy sketch show was broadcast by BBC Television between 1971 and 1987.

7th February, 1978

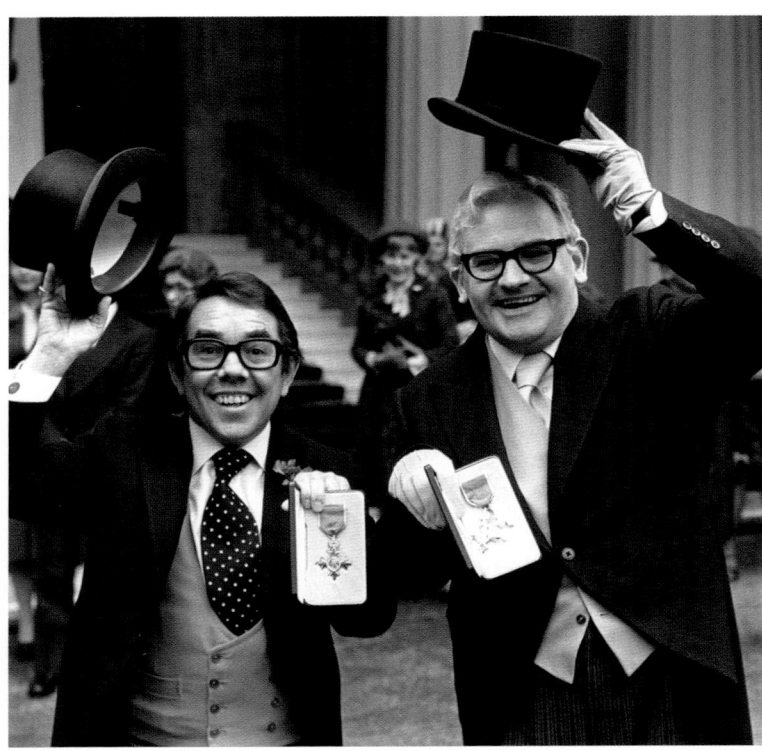

Left: Skateboarder Simon Napper from Chelsea in action on a 'half-pipe' concave ramp at the Sobell Leisure Centre, north London. Purpose-built skate parks allowed skateboarders to perform aerial stunts and other tricks in relative safety compared to the pavements and car parks they were previously obliged to use.

18th February, 1978

Above: Hair of the dog. Finnish model Tuilikki compares hairstyles with three-year-old standard poodle Candy (Alpenden Golden Surprise) at Crufts dog show.

21st February, 1978

Right: Adam Ant and punk icon Jordan attending the premiere of the John Travolta film, *Saturday Night Fever* at the Empire, Leicester Square. Jordan subsequently became a veterinary nurse and breeder of Burmese cats.

23rd March, 1978

Right: Impresario Malcolm McLaren, manager of the Sex Pistols, at Heathrow Airport prior to flying to New York, where band member Sid Vicious was to appear in court, accused of murdering his girlfriend, Nancy Spungen. While on bail, Vicious died of an overdose of heroin. McLaren would die in 2010 of mesothelioma.

13th October, 1978

Above: Under starter's orders. Vera Searle (R), world record holder in the 250m and 440yd races in the 1920s, ready to take on Donna Hartley, current UK 400m record holder. Searle turned to officiating after retiring from competitive athletics, while Hartley became a bodybuilder, winning the Miss Britain Physique trophy in 1988. After that, she switched to teaching line dancing.

5th July, 1978

Right: Swedish tennis star Björn Borg drops to his knees in celebration after beating American Jimmy Connors in a tough Men's Singles Final at Wimbledon. It was his second successive win at the lawn tennis championship.

8th July, 1978

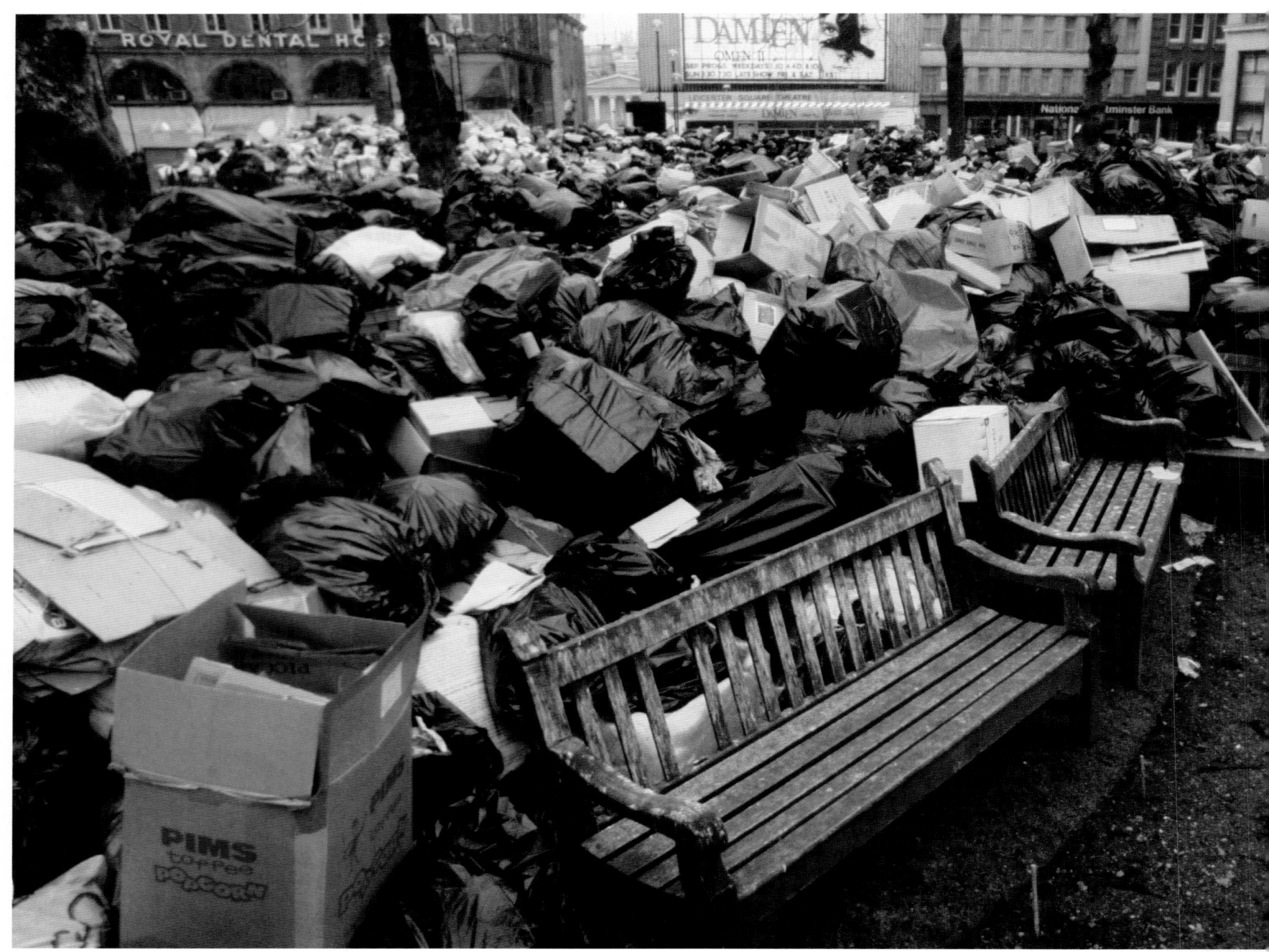

Left: Mountains of rubbish
dumped in London's Leicester
Square, as a result of a strike
by City of Westminster refuse
collectors in support of a pay claim.
Their action was part of a rash
of industrial unrest that became
known as The Winter of Discontent,
which was the result of the Labour
government's attempt to restrict
public-sector pay rises to below five
per cent.

31st January, 1979

Right: The mangled remains of
the blue Vauxhall belonging to
Airey Neave MP, the 63-year-old
Tory spokesman for Northern
Ireland, after a bomb explosion
had ripped it apart, killing Mr
Neave as he drove out of the House
of Commons car park. The Irish
National Liberation Army claimed
responsibility for the bomb.

30th March, 1979

448

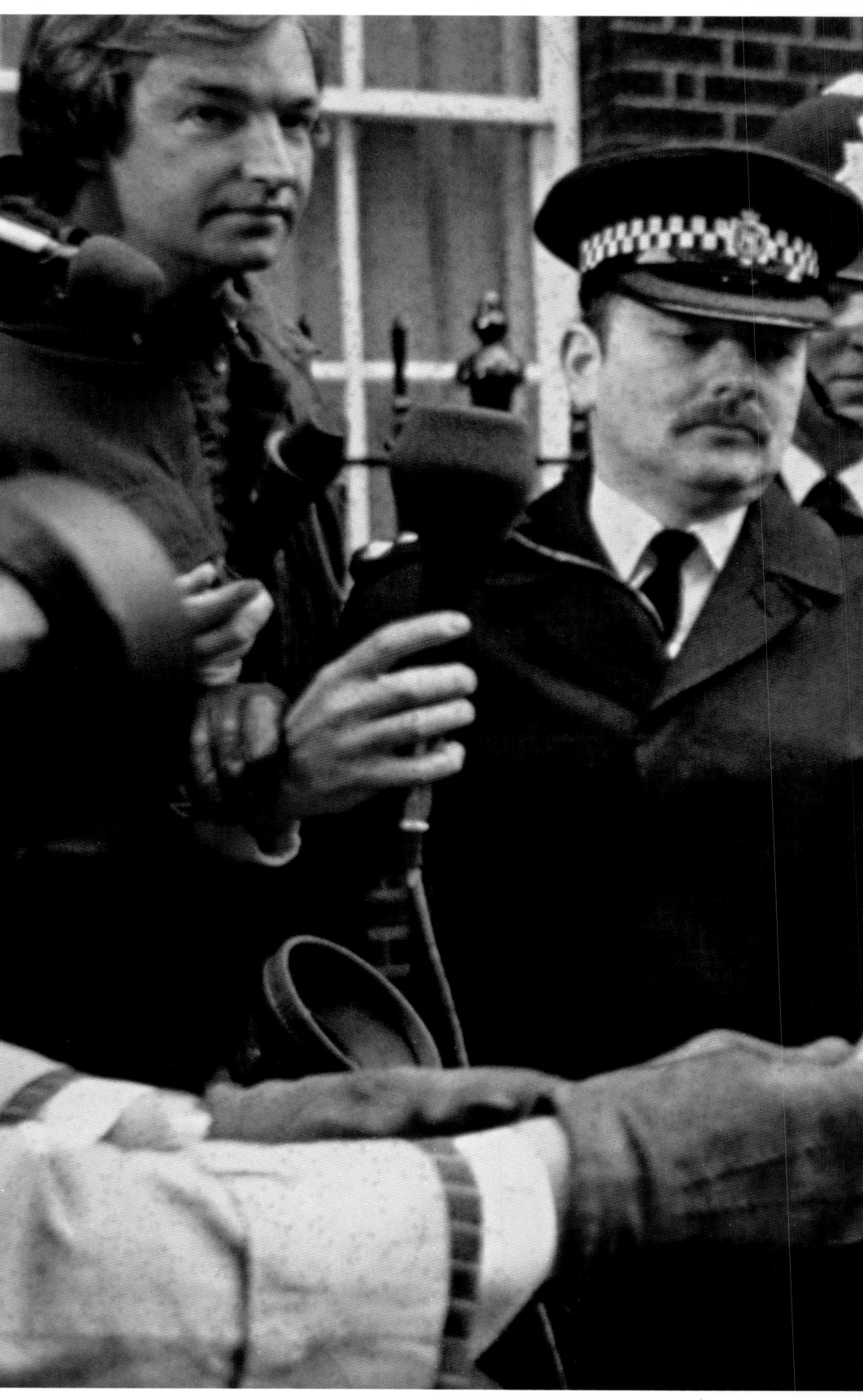

Right: Britain's first woman Prime Minister, Margaret Thatcher, arrives to take up residence at Number 10 Downing Street following the Conservative Party's victory in the 1979 General Election. She would remain in office until 1990, when she resigned the post in the face of a leadership challenge by Michael Heseltine. Thatcher was a controversial figure with strong views; her tough talking gained her the nickname 'The Iron Lady'.

4th May, 1979

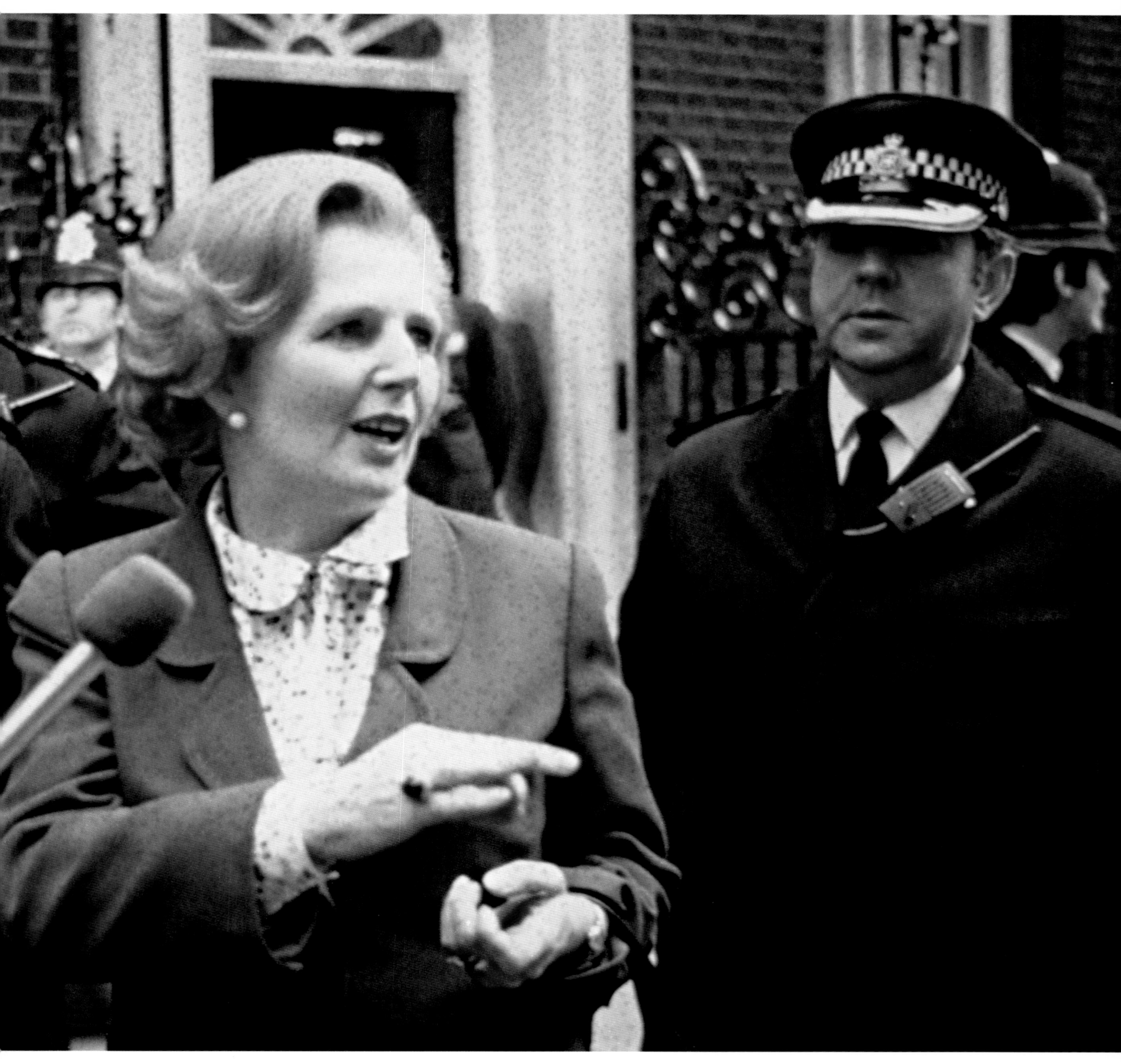

Above: High flyer. A jubilant Sir Freddie Laker, at Gatwick Airport, celebrating his return to the airline business with Skytrain. Laker, who had a long history in the industry, was one of the first to offer a 'no-frills' service and cut-price fares.

14th July, 1979

Above left: Jeremy Thorpe (L), former leader of the Liberal Party, with his solicitor, Sir David Napley, on their way to the Old Bailey in London. Along with three other men, Thorpe had been accused of conspiring to kill Norman Scott, who had claimed to have been a lover of Thorpe. All four were acquitted, but the scandal ended Thorpe's political career.

8th May, 1979

Right: A helicopter crewman checks the dismasted yacht *Grimalkin* for survivors in the wake of the Fastnet Race disaster. Violent storms sank several boats, killing 15.

15th August, 1979

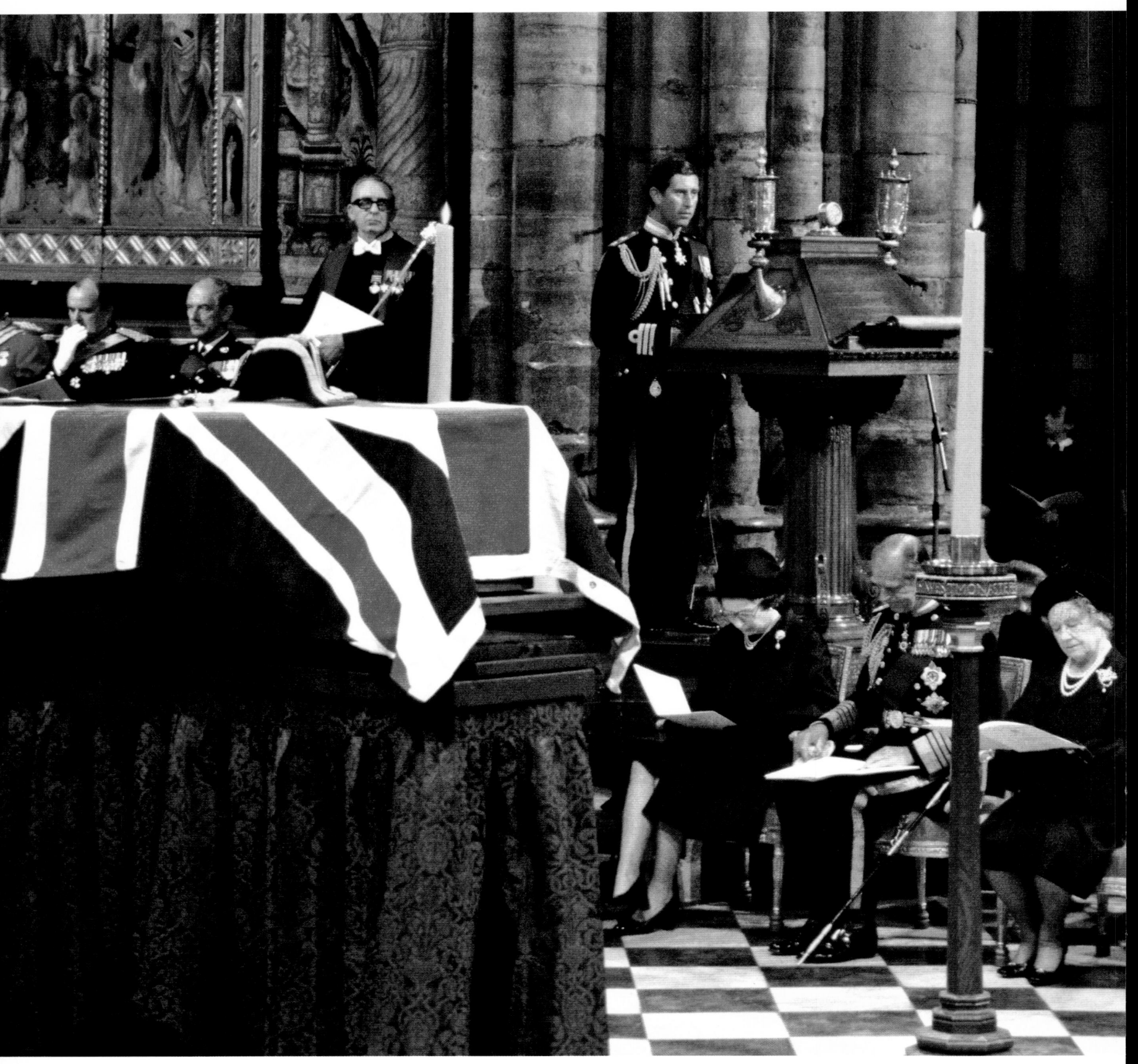

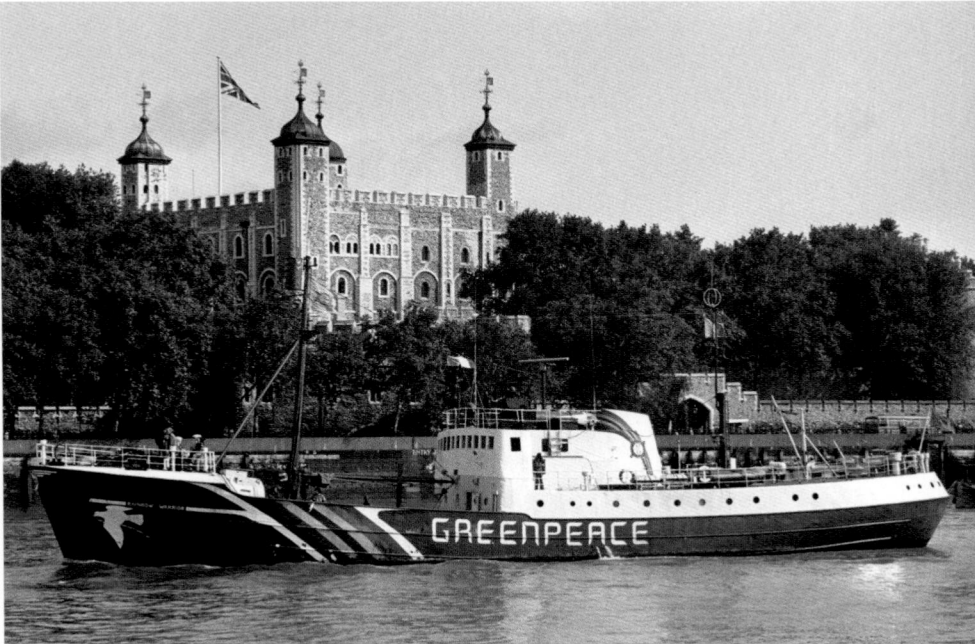

Above: The Greenpeace vessel *Rainbow Warrior* passes the Tower of London before mooring in the Pool of London on her return home from a campaign to hamper Icelandic whaling operations. During her nine weeks in Icelandic waters, the ship was seized three times and her crew arrested twice. More than £20,000 worth of equipment was confiscated by the Icelandic coastguard.

14th September, 1979

Left: Prince Charles reads the lesson during the funeral service for Lord Louis Mountbatten in Westminster Abbey. Mountbatten, 79, had been assassinated by the Provisional IRA, who had planted a bomb in his boat at Mullaghmore, County Sligo in Ireland. Three others were killed by the blast: 14-year-old Nicholas Knatchbull, Mountbatten's grandson; 15-year-old Paul Maxwell, a local youth; and 83-year-old Baroness Braborne. Of Mountbatten's death, Gerry Adams, Sinn Féin vice president at the time, said, "*In my opinion, the IRA achieved its objective: people started paying attention to what was happening in Ireland.*"

5th September, 1979

1980s

If ever a decade formed a bridge between the past and future, it was the 1980s, and the twin pillars of the bridge were money and technology. Who, in 1979, would have imagined that the portable telephone would become both a fashion item and a necessity, not just for business people, but for schoolchildren too? Who could have predicted that a career in finance might be glamorous and exciting? At the beginning of the decade, personal computers, mobile telephones, credit cards, share ownership and property speculation didn't feature highly in the lives of ordinary people, but by its end they seemed to dominate them.

While these aspects of daily life were quietly changing, there was much in the news: conflict in the Falklands, Brixton, Northern Ireland, and on the picket lines of the steel and coal industries; bombs in London and Brighton, and in the air above the Scottish town of Lockerbie – it would be easy to view the decade in those terms alone. But this was also an era of hope, of Live Aid, Comic Relief and the Children in Need appeals, when celebrities began to exploit the media's new telecommunication powers for altruistic good, the public responding with an overwhelming and unprecedented generosity.

Money and technology, changing Britain in every way.

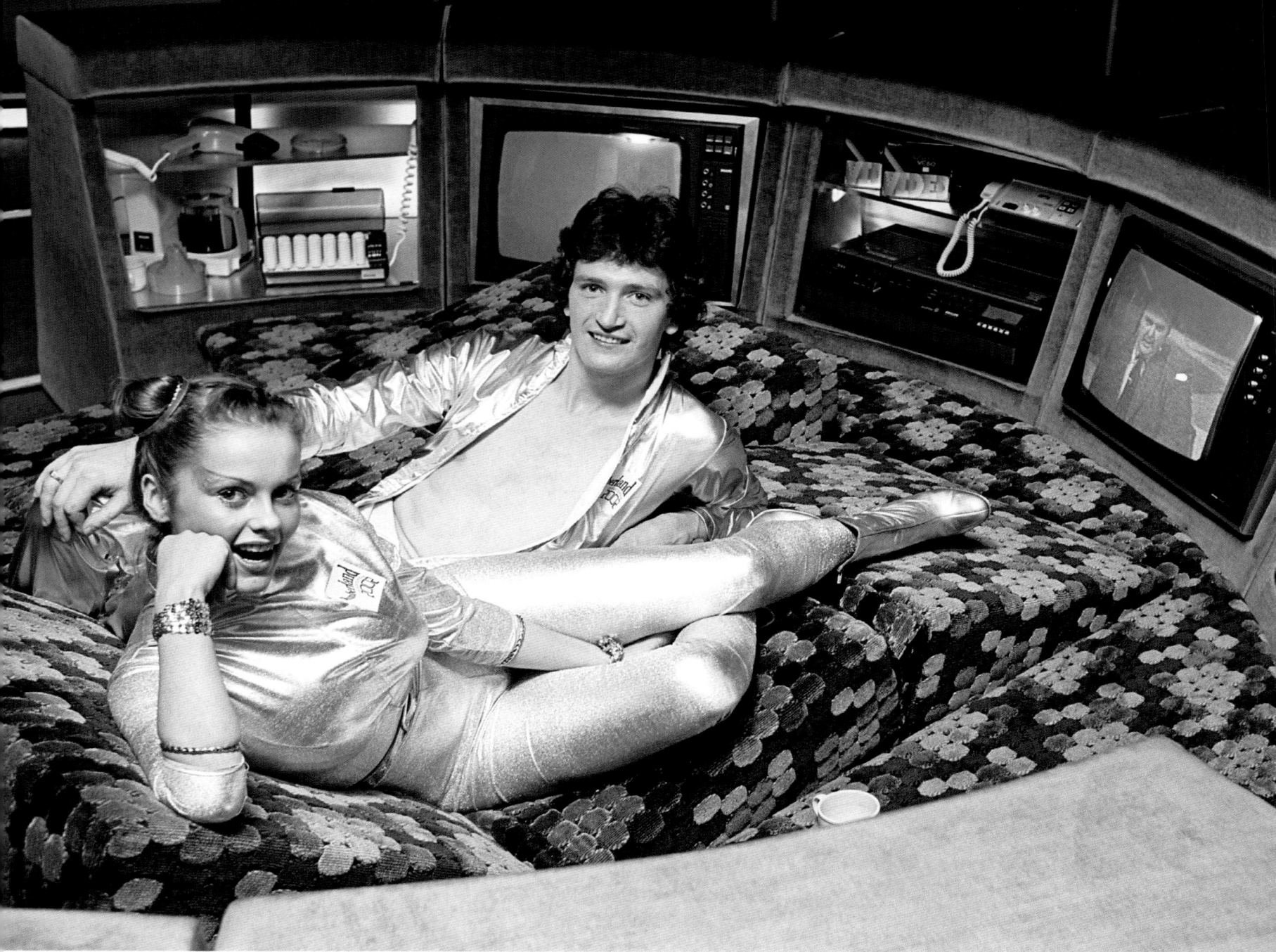

Above: The future is silver lurex pyjamas. The Superbed had everything a modern couple could desire: his and hers televisions, computer controls and a device to set the mood of the moment – all for a mere £80,000.

1st April, 1980

Below: Beach bums. In 1980, Brighton, on Britain's south coast, became the first resort to provide an official naturist beach. The decision to offer such a facility caused much local controversy; one councillor warned that it could become "*a flagrant exhibition of mammary glands*".

4th April, 1980

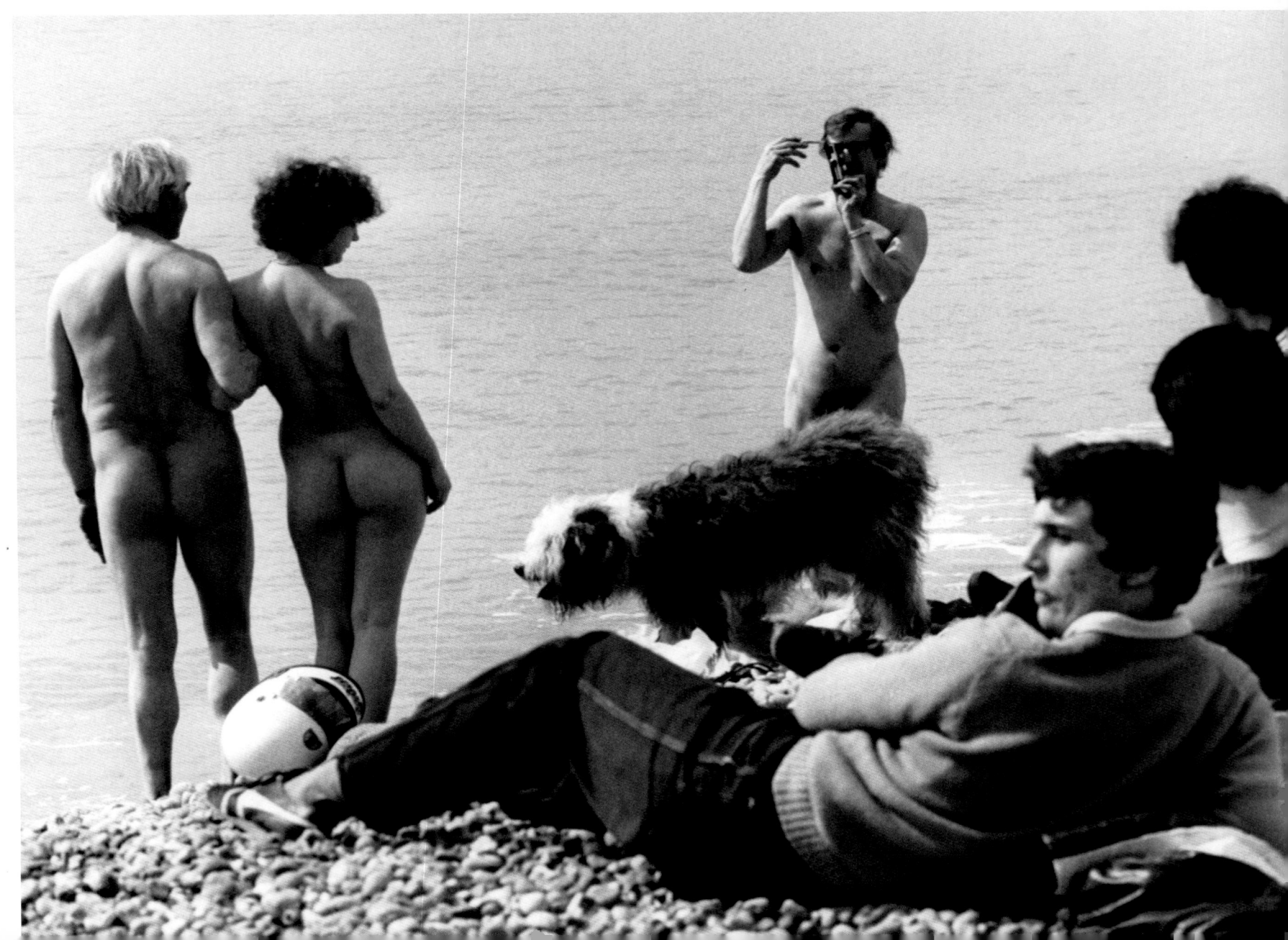

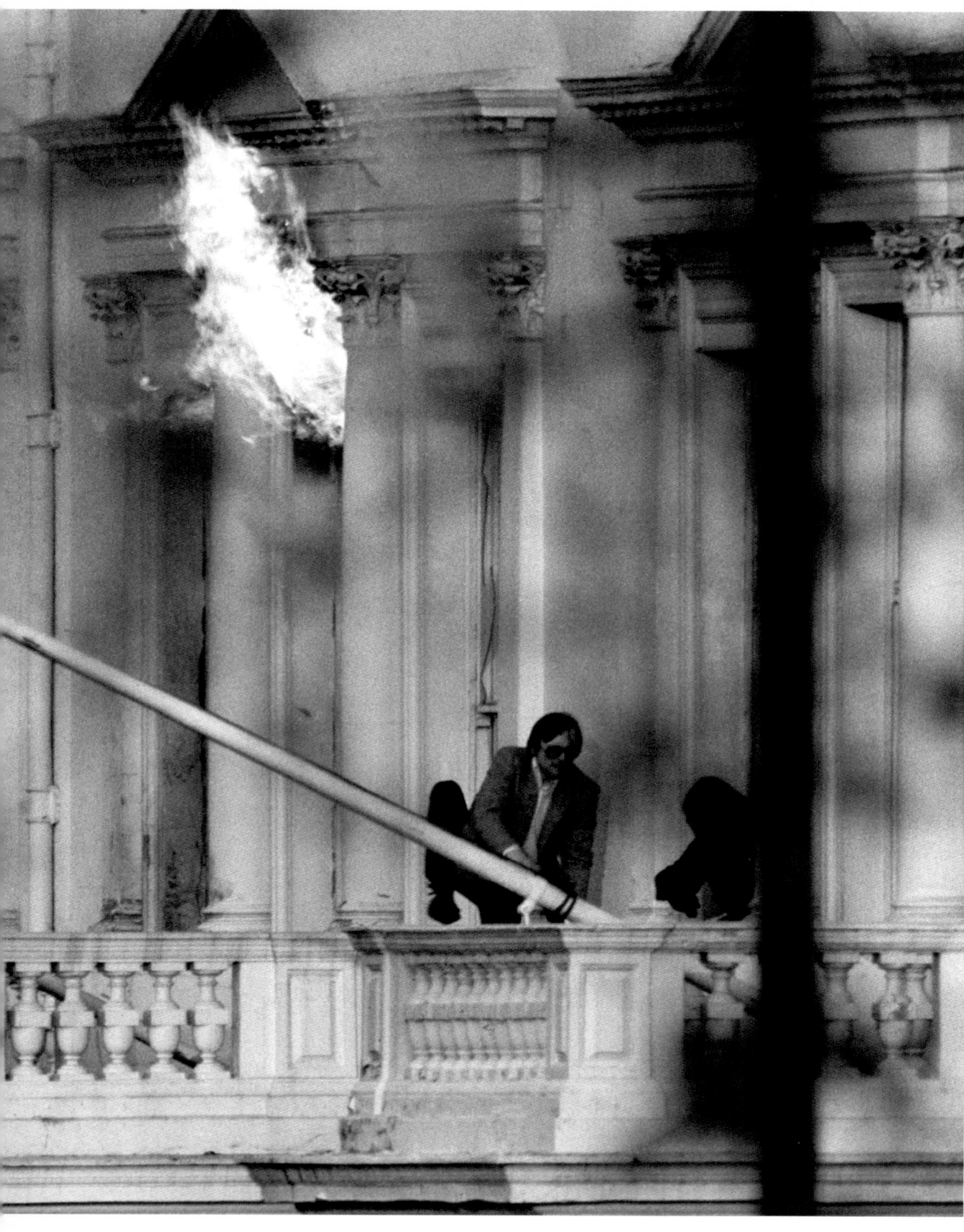

Left: BBC sound recordist Sim Harris scrambles to safety as flames billow from the Iranian Embassy in London after members of the SAS had stormed the building. Inside, six Arab separatists had seized 26 hostages, including Harris and his colleague, Chris Cramer, who were there to pick up visas. A six-day siege ensued, during which five hostages were released, while a sixth was killed. The death prompted Prime Minister Margaret Thatcher to order in the SAS. The assault, which took place in front of TV cameras, led to the deaths of five of the militants, while another hostage was killed by one of the gunmen during the confusion. The remaining hostages were freed.

5th May, 1980

Above right: The new season's hats from David Shilling are named with Ascot in mind: (L–R) 'Double Forecast', 'Dotty Runner' and 'First Past the Post'.

1st June, 1980

Right: Great Britain's Sebastian Coe (R) wins gold as he crosses the line ahead of East Germany's Jurgen Straub (R, hidden) and team mate Steve Ovett (L) in the Men's 1500m at the Moscow Olympic Games.

1st August, 1980

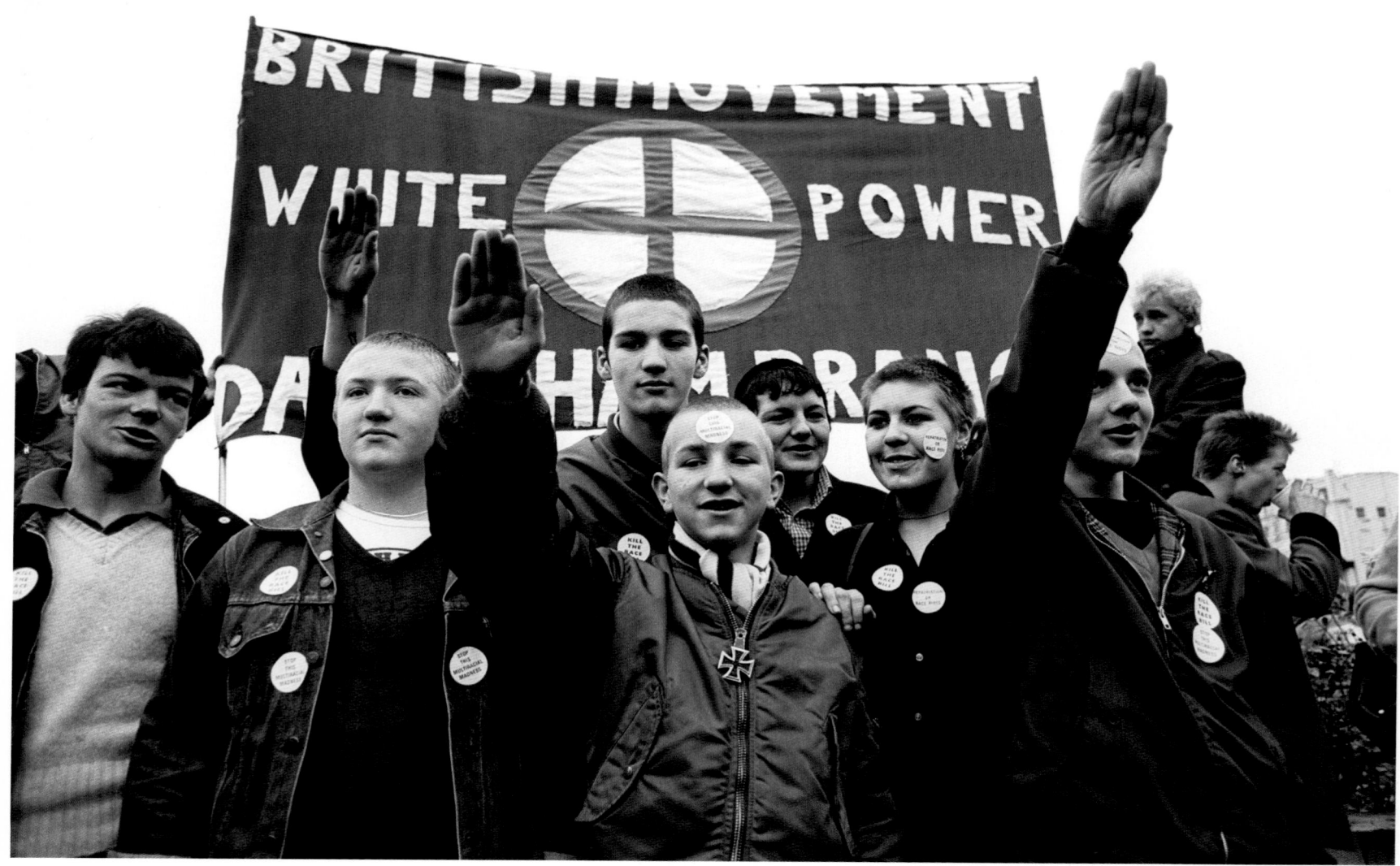

Above: Heil storm. Young skinheads belonging to the rabidly nationalistic British Movement fail to see the irony in giving salutes and wearing regalia associated with the German Nazi Party of the 1930s and 1940s. They were promoting their 'white power' doctrine, during a march in London. The British Movement was a splinter group of the National Front.

23rd November, 1980

Right: The scene outside St George's City Hall in Liverpool, where thousands had gathered to pay tribute to former Beatle John Lennon following his murder by shooting in New York a week before.

14th December, 1980

Below: Serial killer Peter Sutcliffe, who became known as the Yorkshire Ripper, with his wife, Sonia. Sutcliffe was finally convicted of killing 13 women after a six-year investigation; he was jailed for life.

1st December, 1980

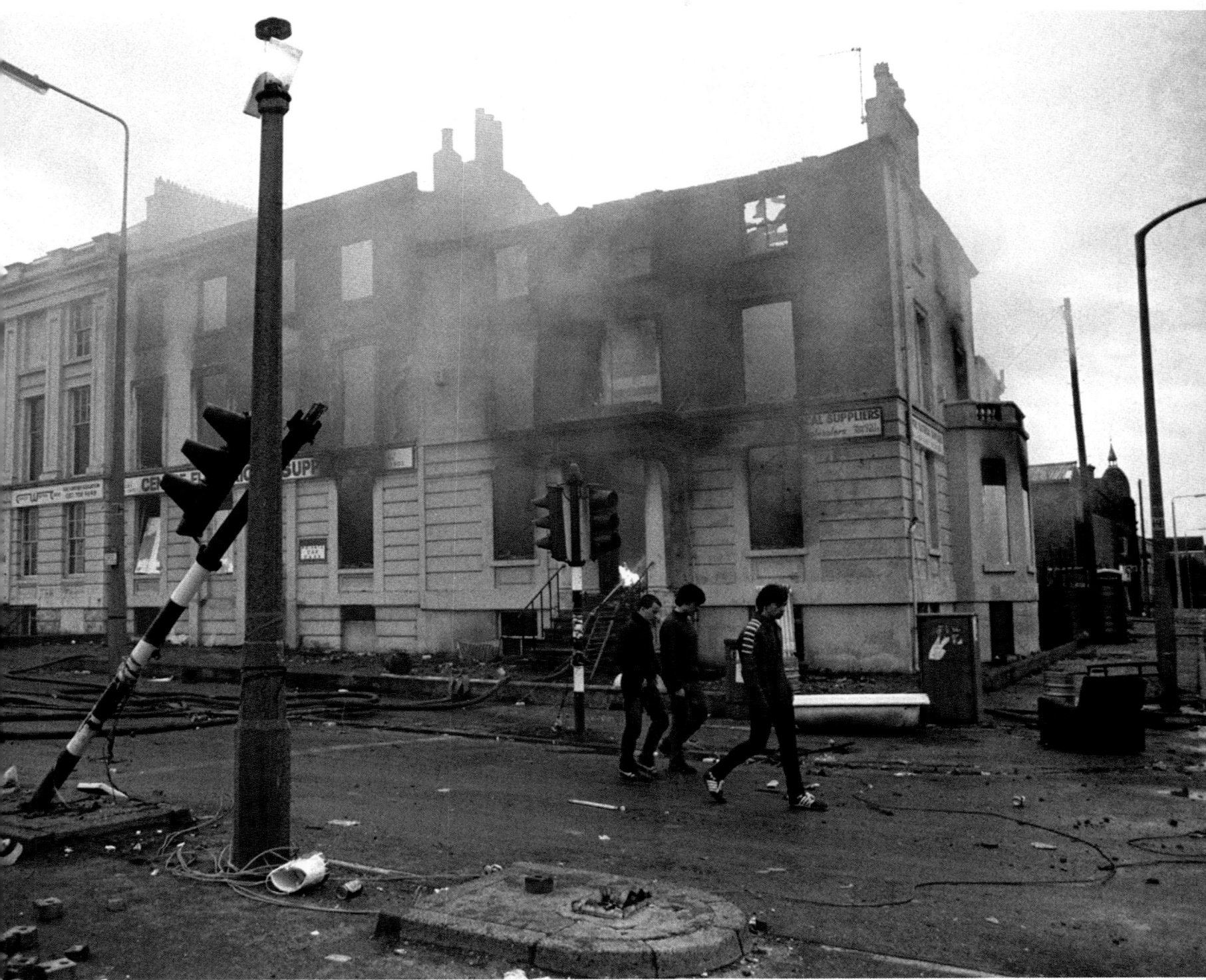

Left: A police van on fire during riots in the deprived area of Brixton, south London. Trouble started after police helped a black youth who had been stabbed: rumours rapidly spread that the youth had died as a result of police brutality.

11th April, 1981

Above: Teenagers survey the devastation following a second night of violent rioting in the Toxteth district of Liverpool. More than 500 buildings were destroyed during the mayhem. Poor relations between the local community and the police, compounded by the heavy-handed arrest of Leroy Alphonse Cooper earlier in the week, triggered the violence.

6th July, 1981

464

Above: Fred English of East Molesey stands with pride outside his house, which he has decorated for the Royal Wedding of Lady Diana Spencer and Prince Charles. Fred has decorated his house for every Royal event since 1930.

1981

Right: The Prince and Princess of Wales are driven in an open carriage to Buckingham Palace after their wedding ceremony at St Paul's Cathedral.

29th July, 1981

Left: Howzat? Australia's Graham Yallop is caught out by man of the match Ian Botham (third R) during the fourth Cornhill Test Match at Edgbaston. England would win the match by 29 runs.

2nd August, 1981

Right: Shergar was named European Horse of the Year in 1981, after which he was retired to Ballymany Stud, Ireland. He was kidnapped in 1983 by masked gunmen and a £2m ransom demanded. The owning syndicate refused to pay: Shergar was never seen again, nor were his abductors brought to justice.

1st September, 1981

Above far right: Rubik's Cube fever at the Games Day '81 Festival of Indoor Games at the Royal Horticultural Society New Hall, London. The cube proved quite a puzzle for Richard Attwater of the 22nd Wimbledon Cub Scout Group. The Rubik's Cube, invented by Hungarian sculptor and professor of architecture Ernő Rubik, has become the best-selling puzzle game in the world.

26th September, 1981

Right: John McEnroe (L) confronts rival Jimmy Connors at the net during a tempestuous Singles final in the Benson and Hedges Championships at Wembley.

18th November, 1981

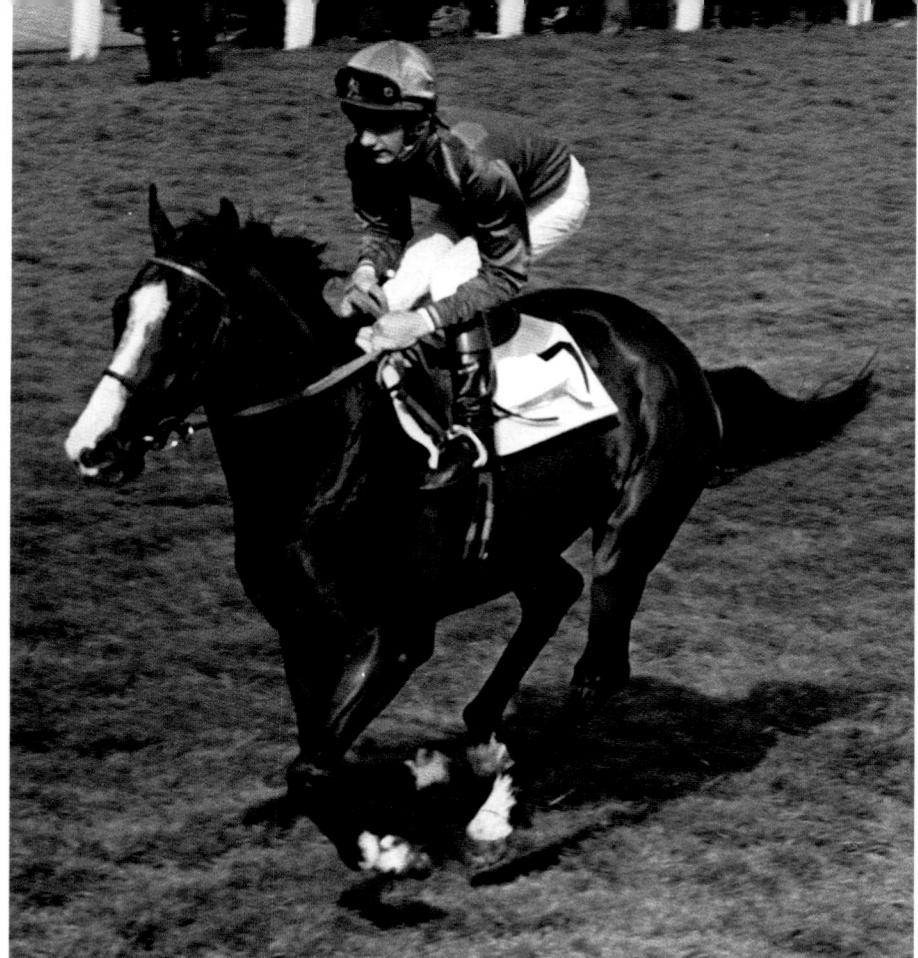

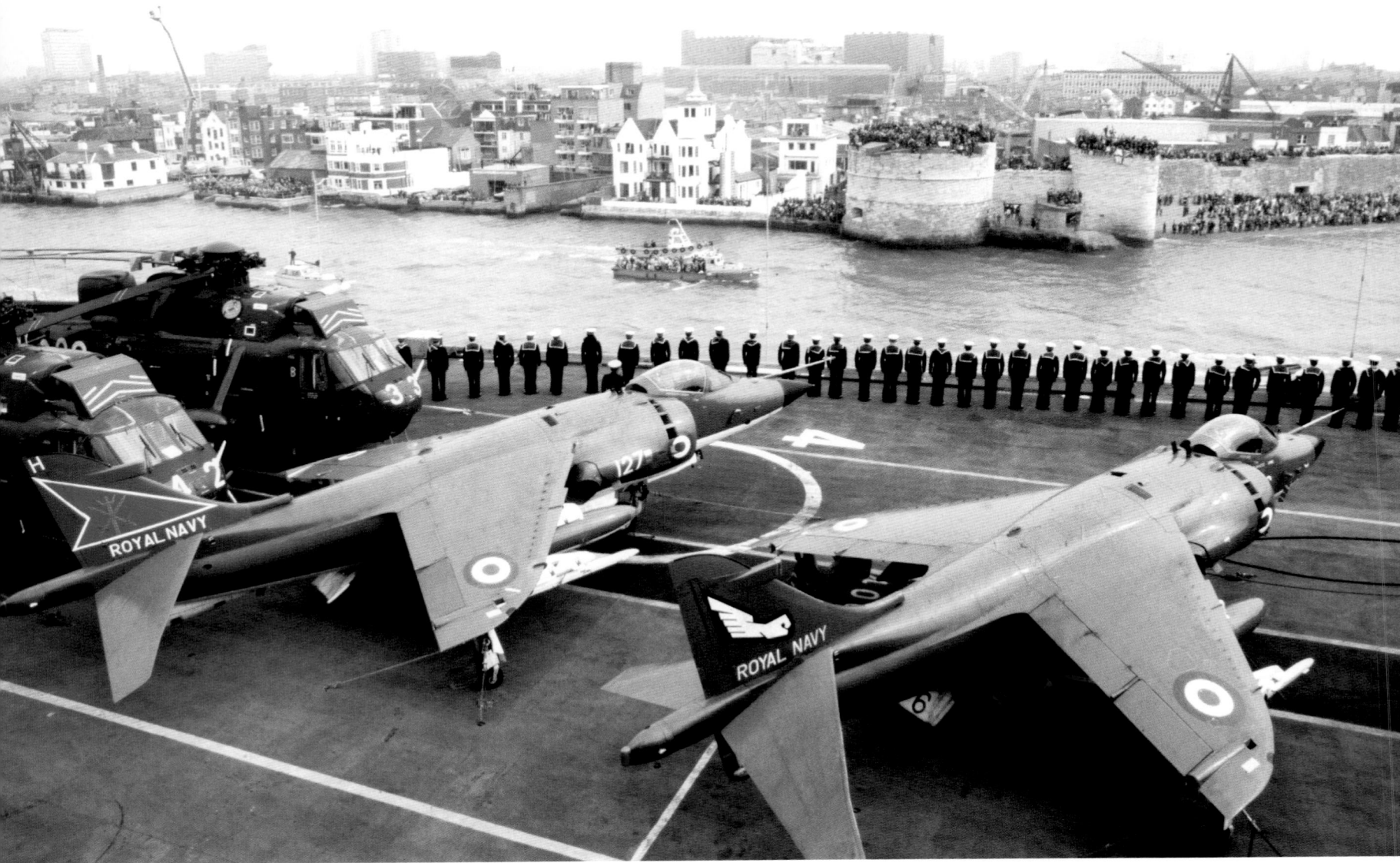

Above: Crew members together with Sea Harrier jet fighters and Sea King
helicopters line the flight deck of HMS *Hermes* as the ship passes the Round Tower,
Portsmouth, at the beginning of a voyage to the South Atlantic. The *Hermes* was
the flagship of the British naval task force sent to repel the Argentine invasion
from the Falkland Islands.

5th April, 1982

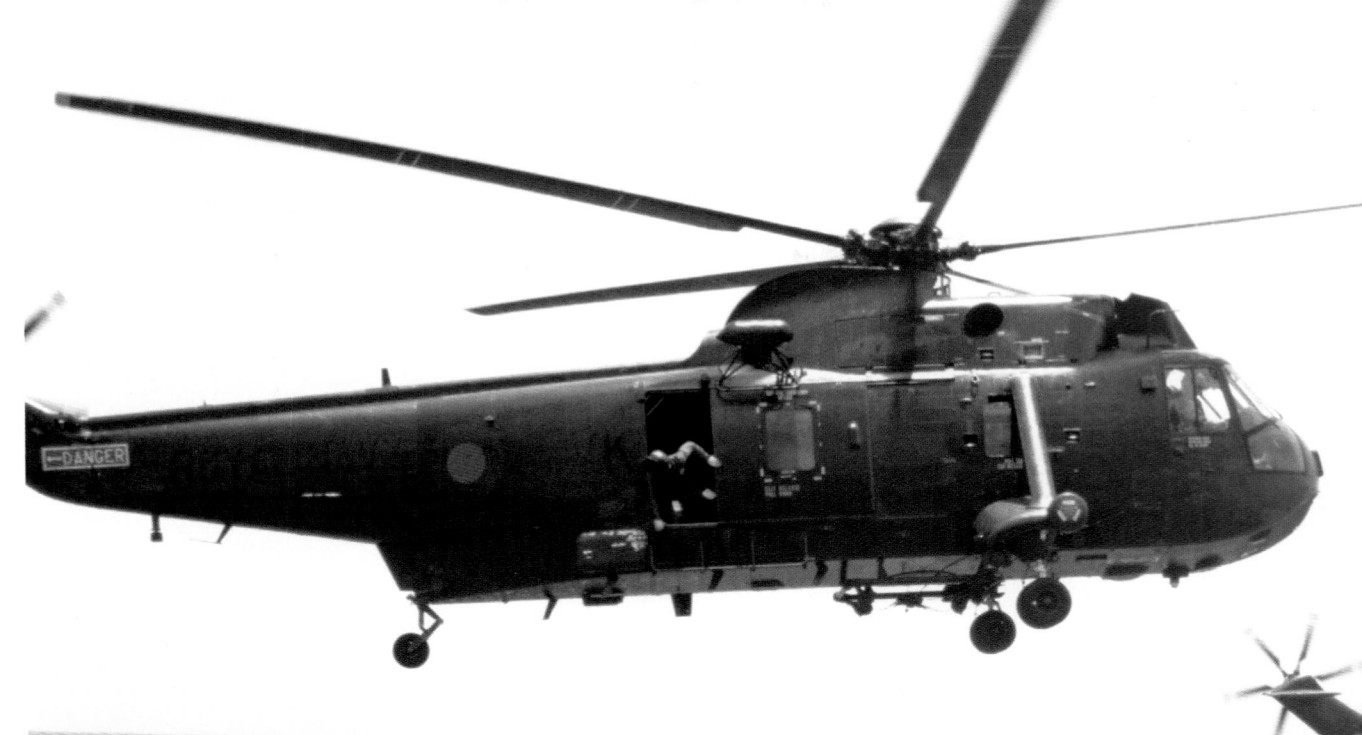

Right: Royal Marine Commandos crouch down on the deck of a British carrier as a Sea King helicopter lands on board during the Falklands Conflict. The Marines played a major role in the amphibious assault on the Argentine forces that occupied the islands.

20th April, 1982

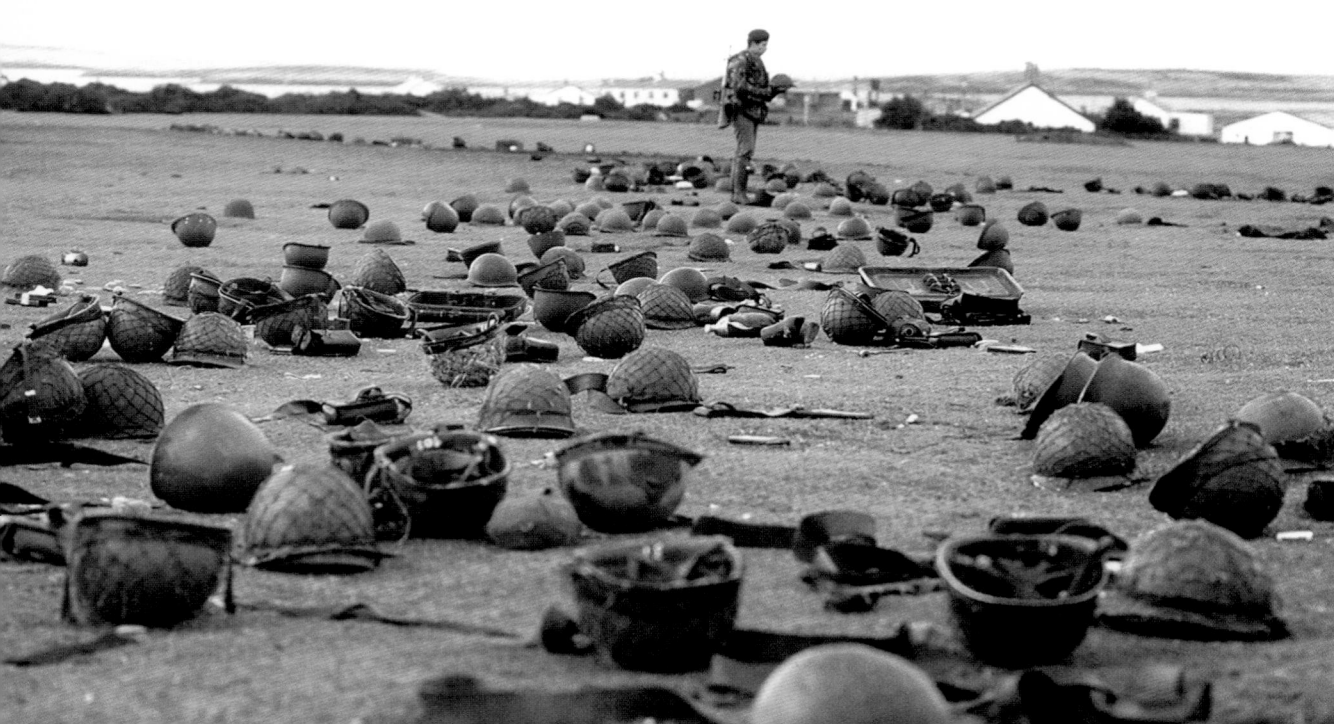

Left: An Argentinian bomb explodes aboard the Royal Navy frigate HMS *Antelope*, killing the bomb disposal engineer who was trying to defuse it. The ship was part of the British Task Force engaged in the recapture of the Falkland Islands following the invasion by Argentina in April 1982.

23rd May, 1982

Below left: A field of steel helmets abandoned by Argentine forces following their surrender to British troops at Goose Green on East Falkland. It was an epic victory for the British, as they were outnumbered by more than two to one. During the battle, 17 Paras were killed, including the CO of 2 Para, Lieutenant Colonel H. Jones, who died while leading a charge against the Argentine positions; he was posthumously awarded the Victoria Cross. Forty-seven Argentinians lost their lives, while 961 were captured.

28th May, 1982

Right: As the supply ship RFA *Sir Galahad* burns in the background, survivors of the Argentine air attack reach the safety of the shore at Port Pleasant on Bluff Cove. A sister ship, the *Sir Tristram*, had also been hit, leading to the deaths of 48 British troops, while 115 were injured.

8th June, 1982

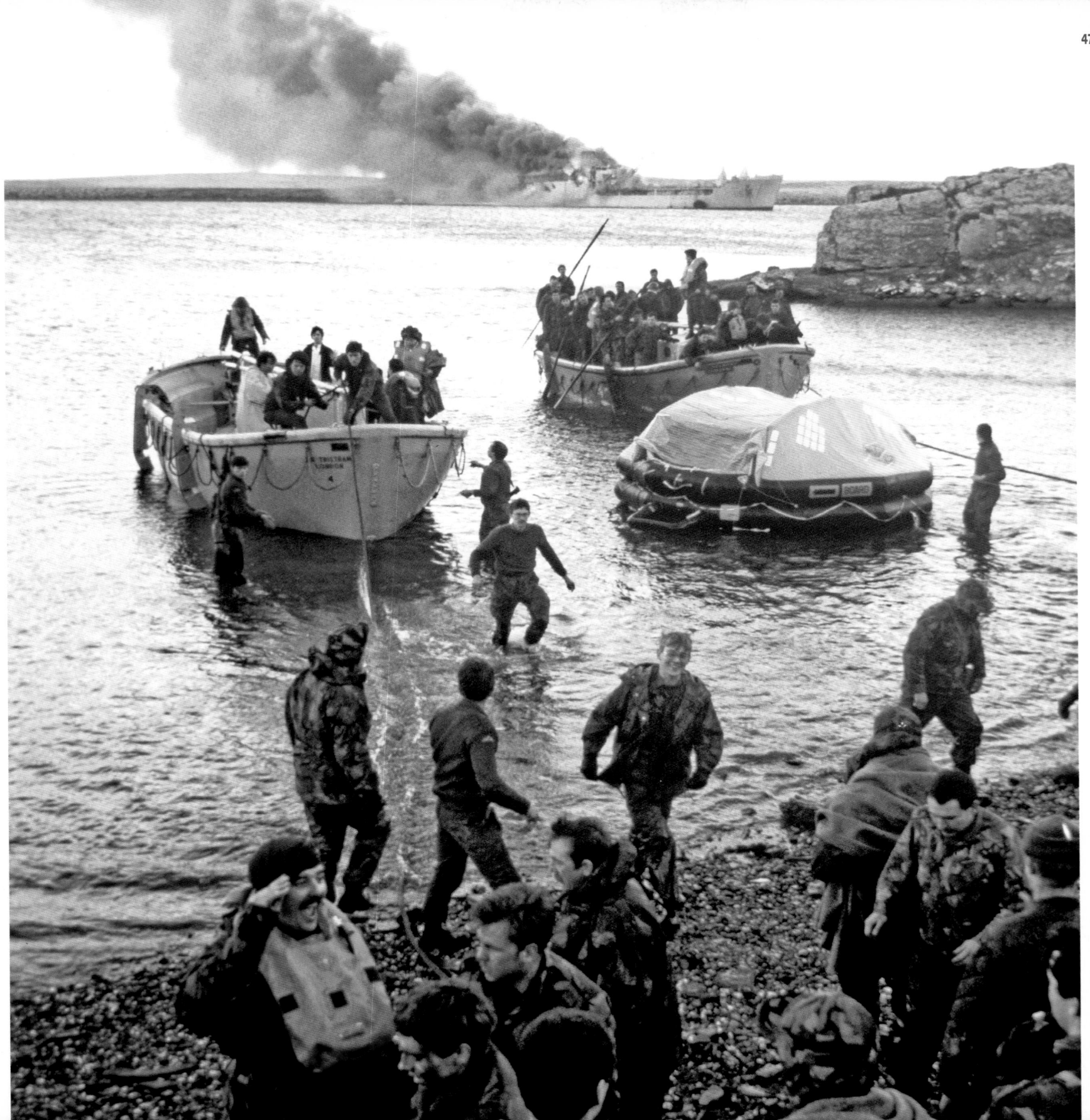

472

Left: One is not amused. After attending
the Trooping the Colour ceremony at Horse
Guards Parade, off Whitehall in London, the
Queen is disconcerted by torrential rain as
she trots back to Buckingham Palace.

12th June, 1982

Above: The P&O liner SS *Canberra* and her complement of troops are escorted up Southampton Water by scores of smaller vessels on their return from the Falkland Islands. Known affectionately as the 'Great White Whale', the vessel had been requisitioned by the Ministry of Defence as a troopship during the Falklands War, being sent to the centre of the conflict.

11th July, 1982

Left: Infamous gangster Ronnie Kray (second L) arrives under heavy guard at Chingford Old Church for the funeral of his mother, Violet Kray. Ronnie had been brought from Broadmoor, while his twin, Reggie, was escorted from Parkhurst Prison, Isle of Wight. Both were serving life sentences for murder. The Krays had been the most prominent perpetrators of organized crime in London's East End during the 1950s and 1960s, but as nightclub owners, they mixed with many well-known entertainers and celebrities, including Frank Sinatra, Diana Dors and Judy Garland.

11th August, 1982

Right: Two policemen take part in an impromptu knees-up with a pair of armoured Amazons during the second day of London's Notting Hill Carnival. The annual event, which takes place over the August Bank Holiday weekend, was started in 1966 and has since grown to become the second largest street carnival in the world.

30th August, 1982

Far right: A sit-down protest by women peace campaigners blockading the Greenham Common air base in Berkshire. The airfield, occupied by the US Air Force, had been selected as a base for ground launched cruise missiles carrying nuclear warheads.

13th December, 1982

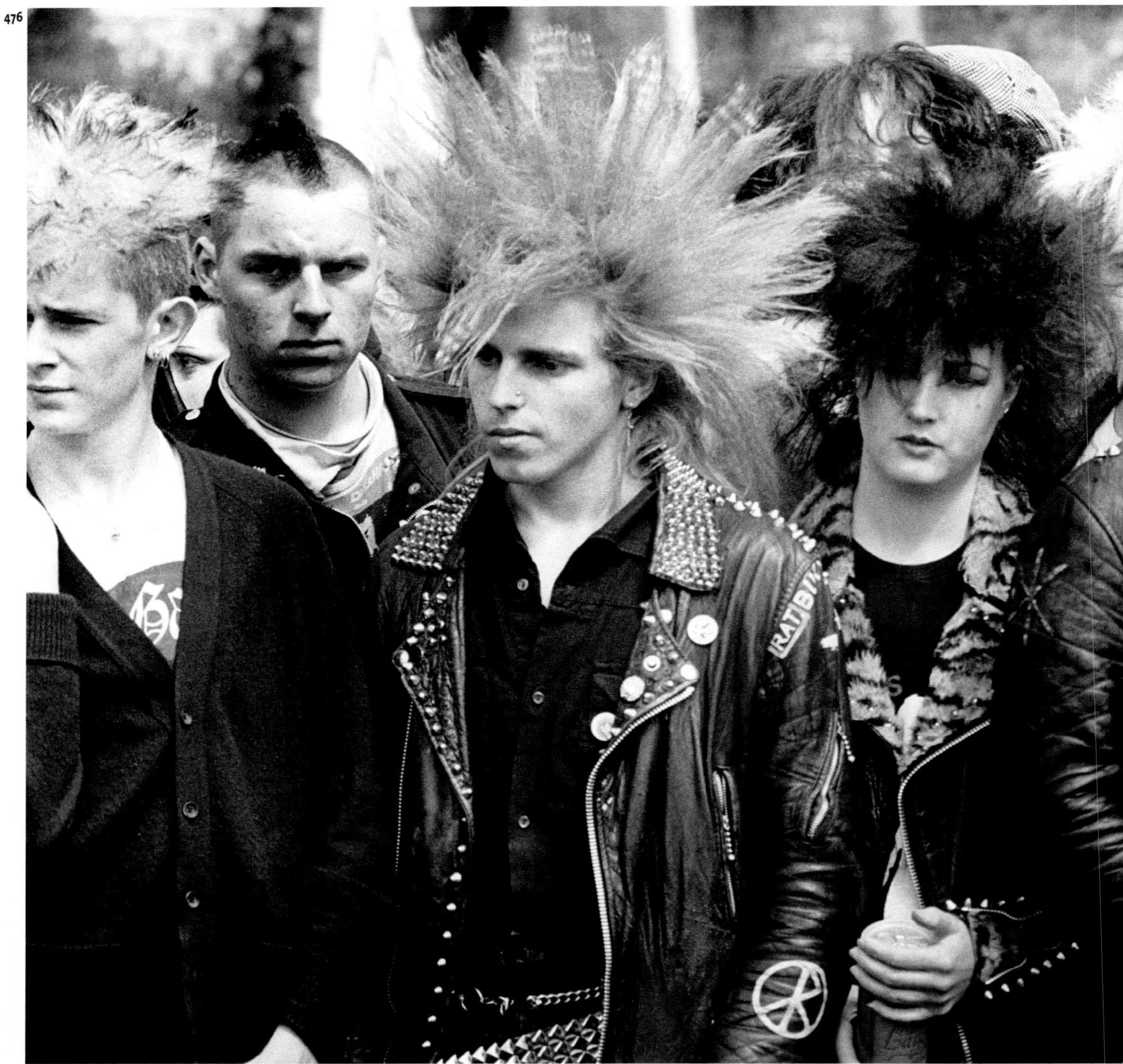

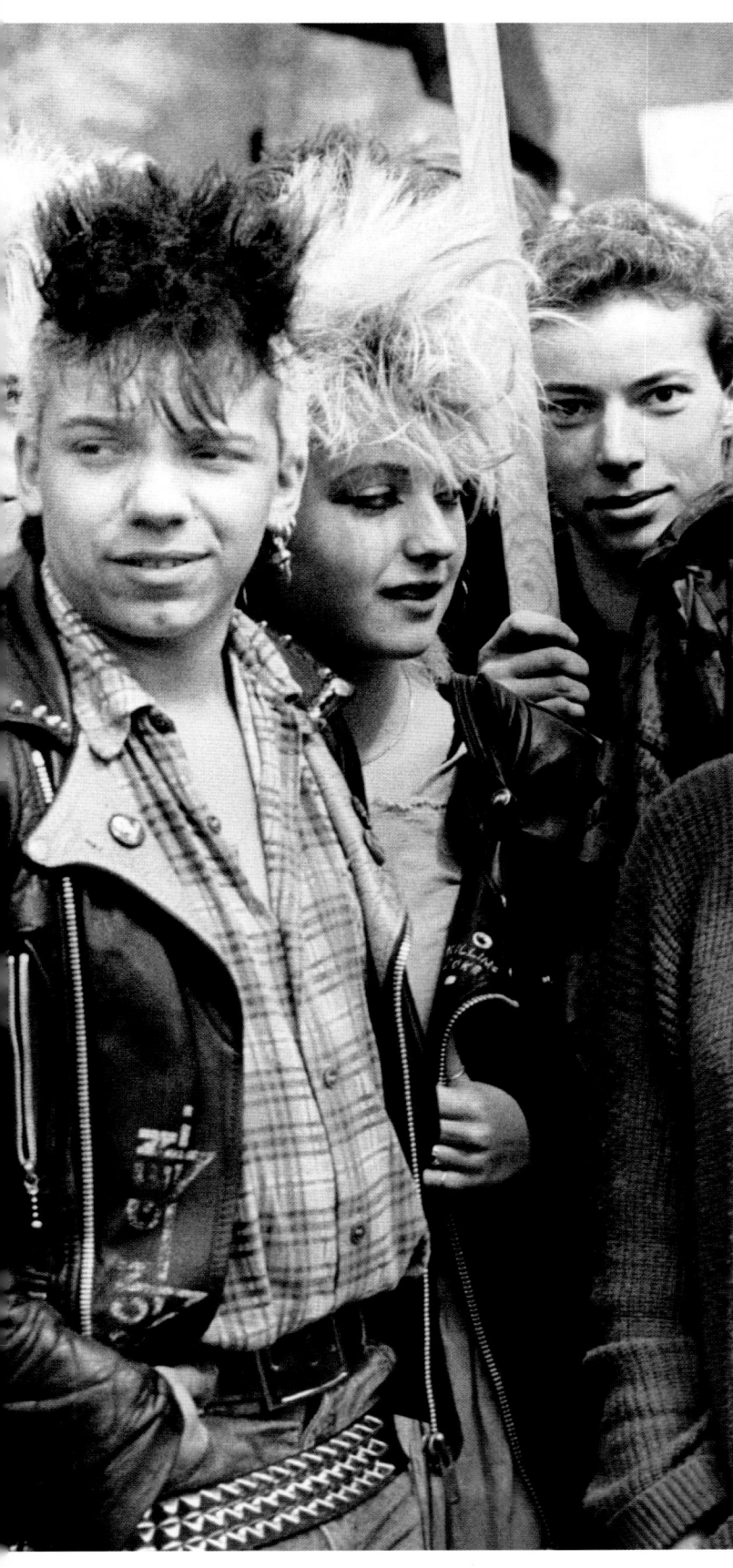

Left: Punks for peace. Dramatic hairstyles are sported by members of the Youth Campaign for Nuclear Disarmament, who marched through Brixton, London as part of the Rock the Bomb Festival of Peace.

7th May, 1983

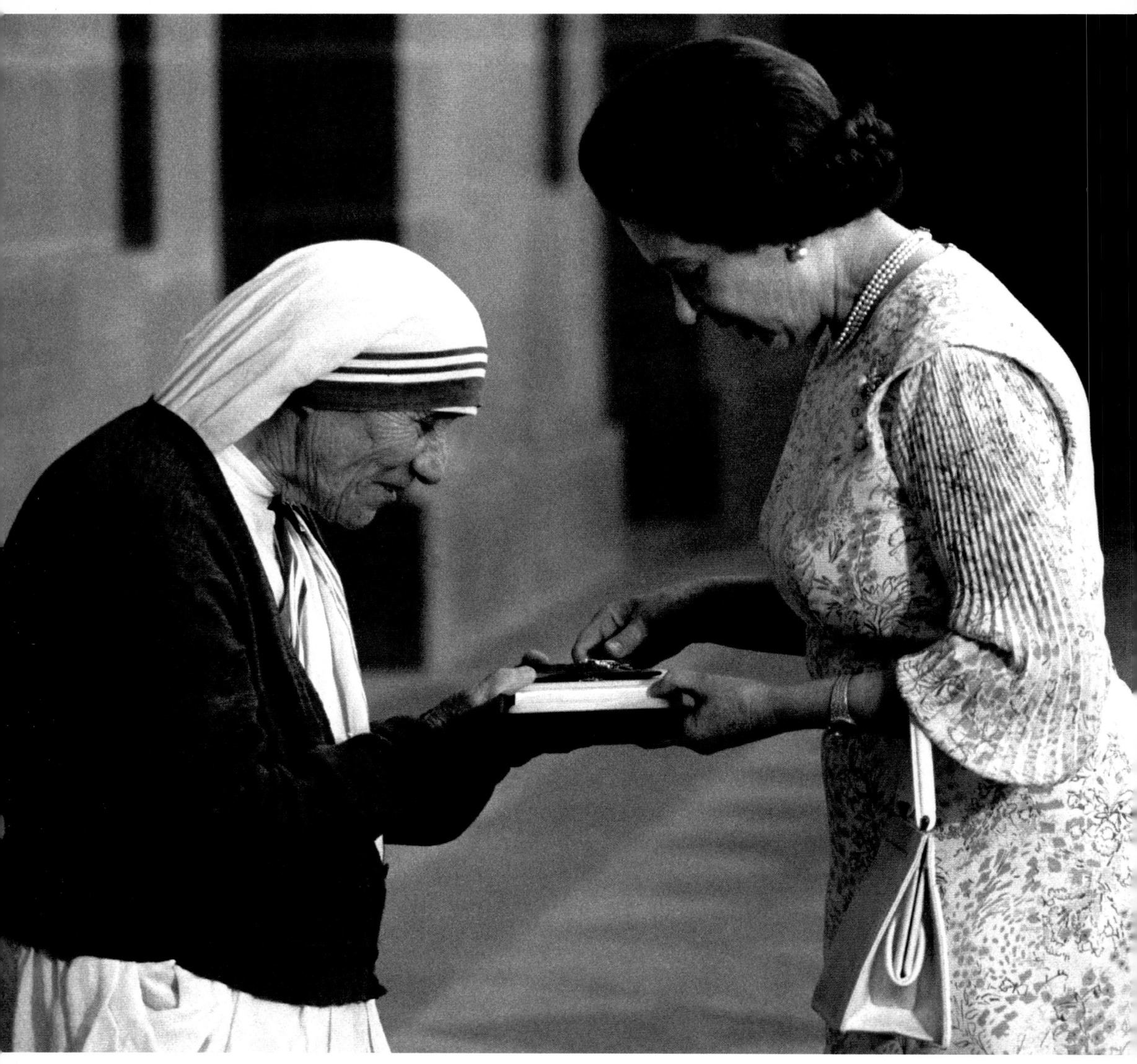

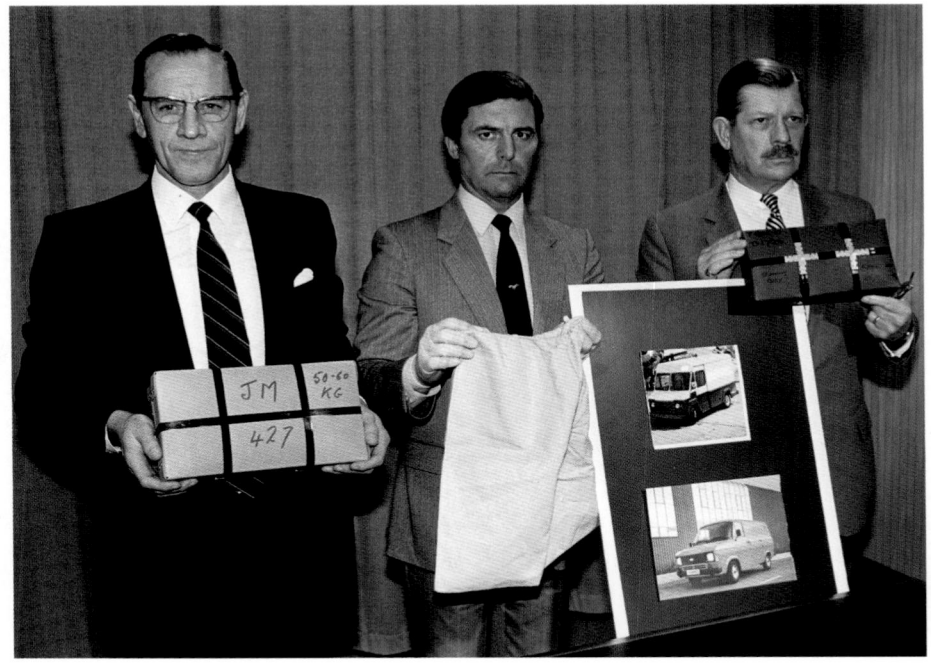

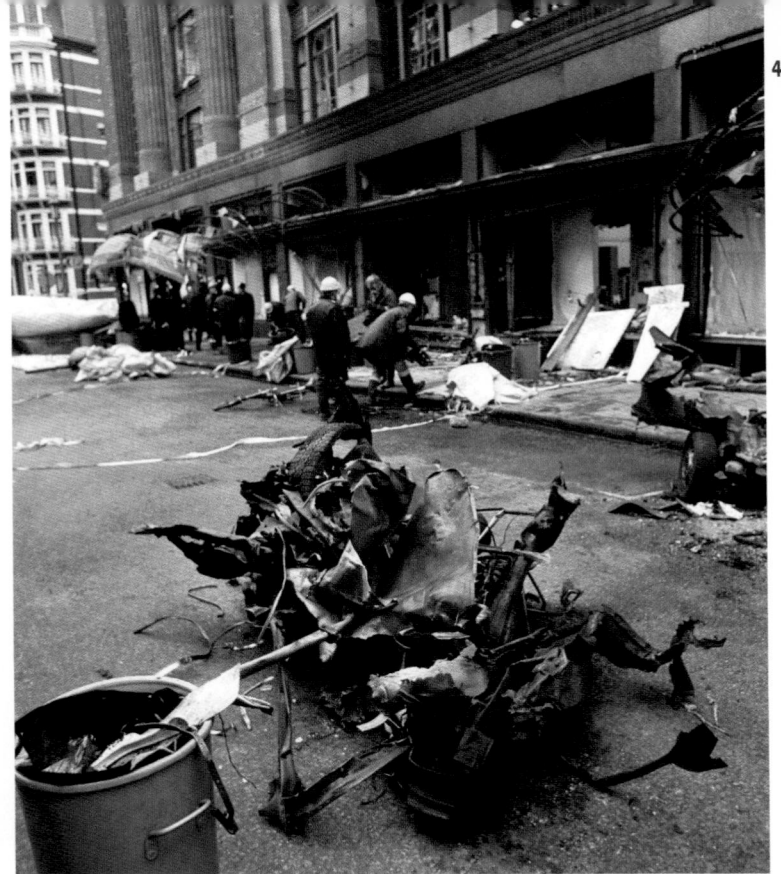

Above: Commander Frank Cater (L), Detective Superintendent Mervyn Atkinson (C) and Deputy Assistant Commander David Powis display two types of box in which £26m of gold bullion was wrapped, a bag used to hood a security guard, and a photograph of the types of van believed to have been used in the Brinks Mat robbery at Heathrow Airport on 26th November, 1983. Only two of the robbers were convicted and little of the haul was recovered; it has been suggested that anyone wearing gold jewellery bought in the UK after 1983 is probably wearing Brinks Mat gold.

29th November, 1983

Left: The Queen presents Mother Teresa, winner of the Nobel Peace Prize in 1979, with the insignia of the Honorary Order of Merit. Mother Teresa founded the Missionaries of Charity in Kolkata (Calcutta), and for over 45 years, she tended the orphaned, sick and dying in India.

24th November, 1983

Above right: The remains of the Austin 1100 used in an IRA car bomb attack that killed five people outside the Harrods store in Hans Crescent, London.

18th December, 1983

Right: Cranes at the Harland & Wolff Shipyard, Belfast, where the *Titanic* was built for the White Star Line in 1909. Nationalized in 1977, H&W suffered mounting losses, being labelled a 'lame duck' by the Heath government. In the 1980s, it launched a series of Single Oil Well Production System (SWOPS) ships, which processed oil en-route from oil fields to their destination, using the gas by-product to fuel the ship's engines; in 1984, H&W delivered the largest bulk carrier ever built, the *British Steel*.

7th January, 1984

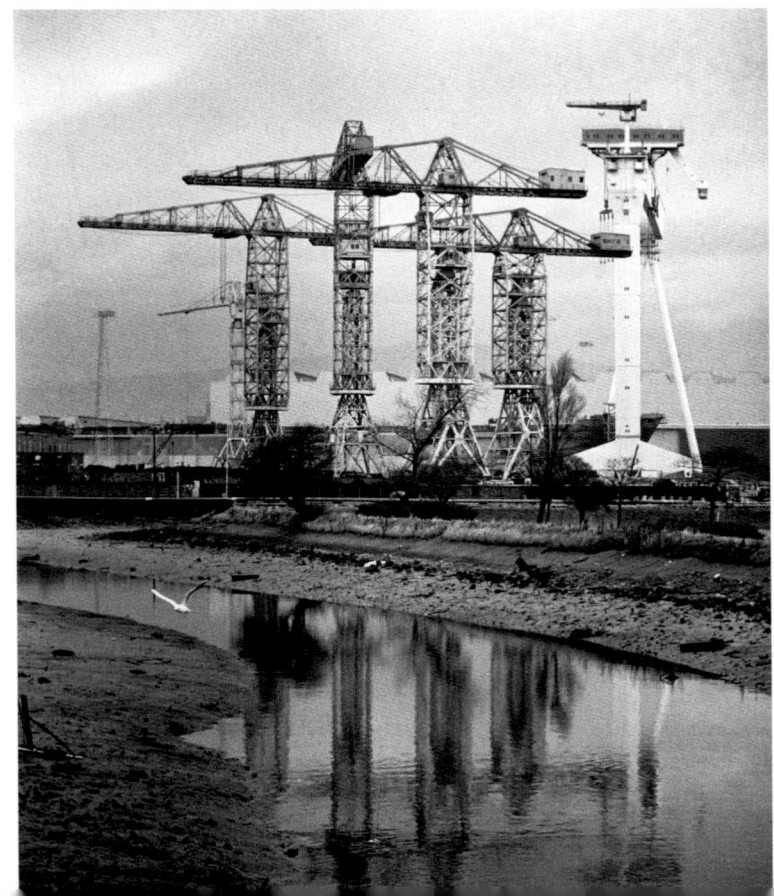

480 Right: National Union of Miners president Arthur Scargill addresses a mass rally in Jubilee Gardens, London during the miners' national strike. The industrial action had been prompted by the announcement by the National Coal Board that 23 pits were to be closed with the loss of 20,000 jobs. The strike quickly became a power struggle between the NUM and Margaret Thatcher's government, but the latter had secretly prepared for the action and eventually broke the union. In the process, the power of the trades unions as a whole was also shattered.

7th June, 1984

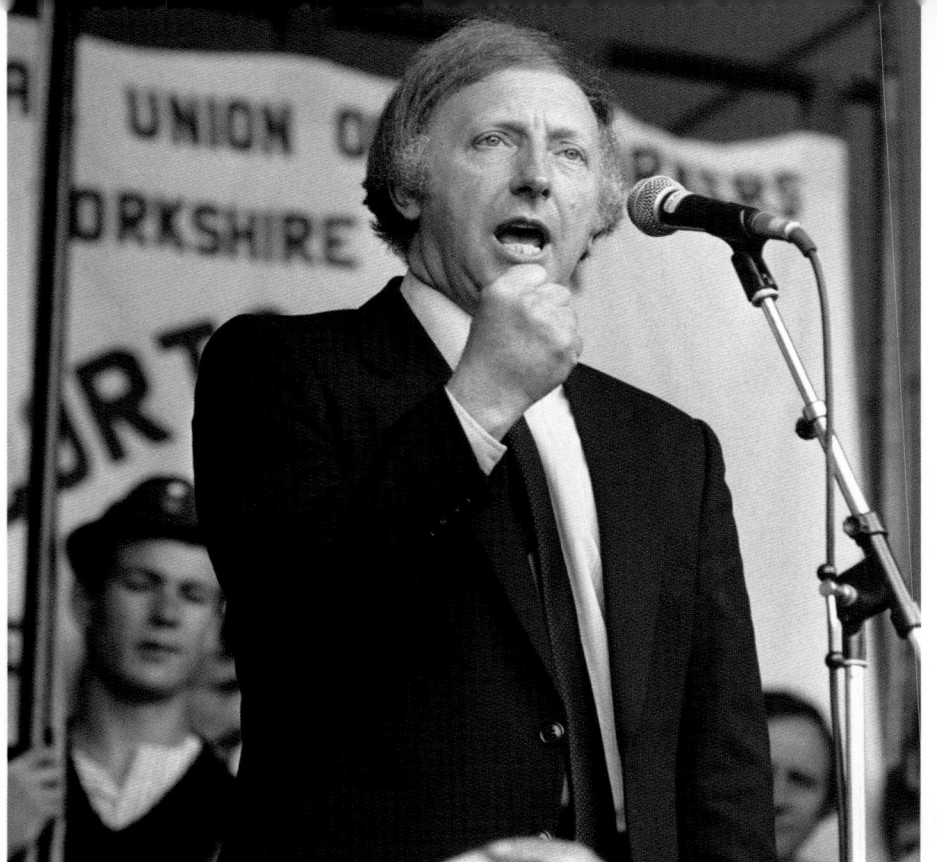

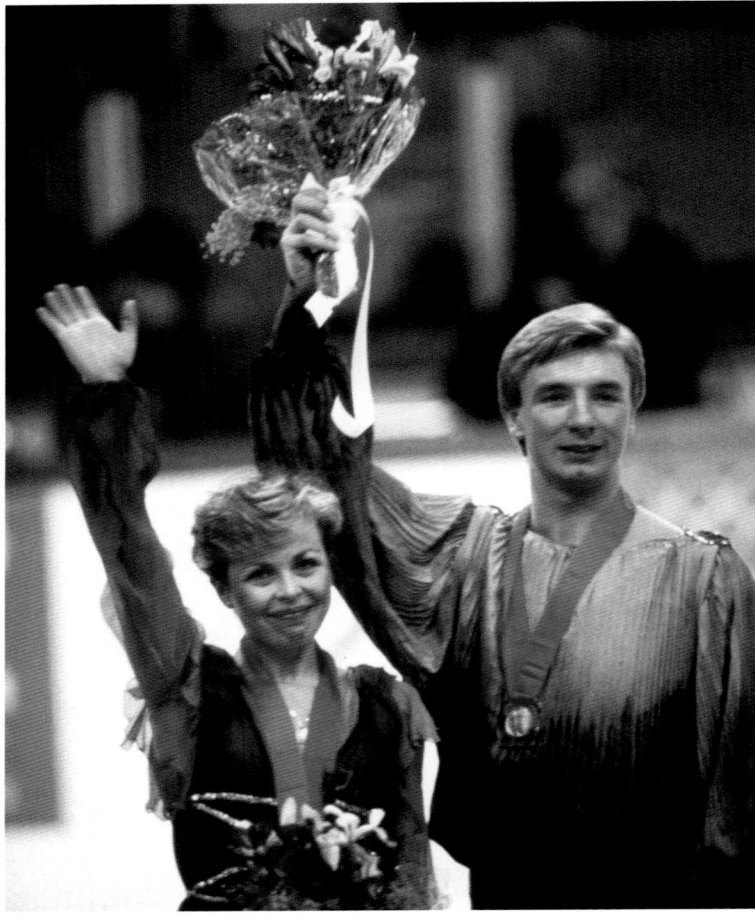

Above: Great Britain's Jayne Torvill and Christopher Dean wave to the crowd after receiving their gold medals for Ice Dance at the Sarajevo Winter Olympic Games.

14th February, 1984

Right: The Queen, US President Ronald Reagan and British Prime Minister Margaret Thatcher at Buckingham Palace, where a banquet had been prepared following the London Economic Summit. Reagan, a former B-movie actor, had become president in 1981 and would win a second term in 1985.

9th June, 1984

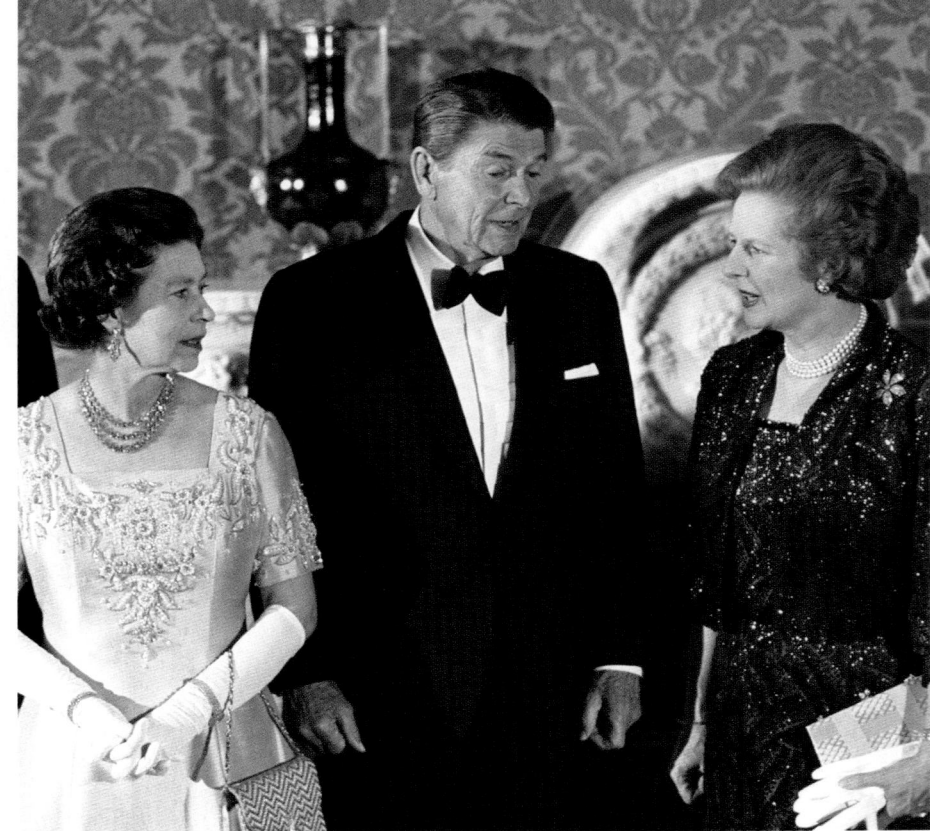

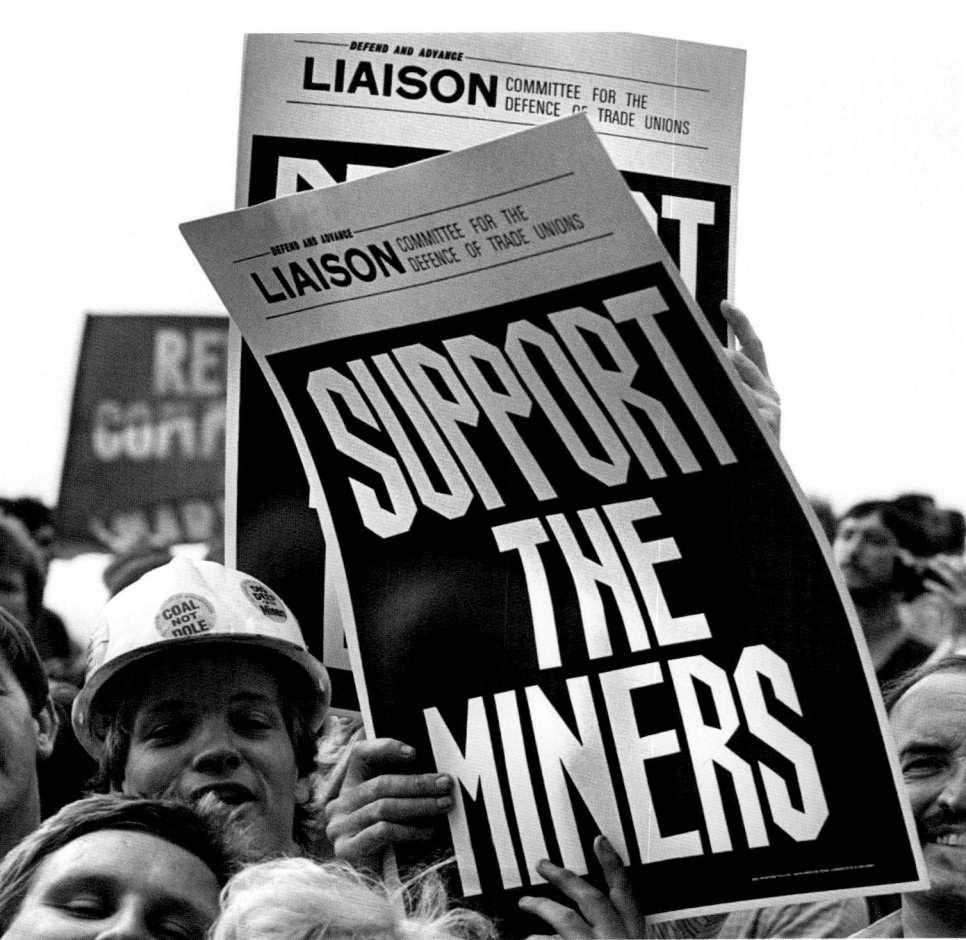

Above: Striking mineworkers demonstrate with placards outside the Trades Union Congress conference in Brighton. Their industrial action would continue until March 1985, almost a year after it had begun.

3rd September, 1984

Right: The scene at the Grand Hotel, Brighton, after an IRA bomb explosion during the Conservative Party's annual conference. The intention had been to assassinate Prime Minister Margaret Thatcher and as many members of her government as possible. In this, the attack failed, but five people were killed and several permanently disabled as a result of their injuries. The bomber, Patrick Magee, served 14 years in prison before being released under the Good Friday Agreement in 1999.

12th October, 1984

Left: Model Samantha Fox at a preview of the London Mid-Season Fashion Show, where designers showcase their early spring collections. Fox was best known for her glamour modelling and was a staple of *The Sun* newspaper's Page Three topless feature throughout the first half of the 1980s, before embarking on a career in pop music. She began her modelling career at the age of 16, first appearing in *The Sun* under the title, "*Sam, 16, Quits A-Levels for Ooh-Levels*".

12th November, 1984

Below: Nicholas Pierce, managing director of Cellular One, speaking to the USA using the world's first truly portable telephone, the Motorola DynaTac, while riding a bicycle through London.

22nd November, 1984

Above: Inventor Sir Clive Sinclair demonstrating his famous flop, the C5 electric vehicle. The 15mph (24km/h) tricycle was the subject of ridicule, and only 12,000 were sold.

10th January, 1985

Right: Strong-arm tactic. Suzuki racer Barry Sheene demonstrates his strength while his wife, Stephanie, looks on. Sheene's many motorcycling injuries had caused him to develop arthritis, and in an attempt to reduce the pain he moved to the warmer climate of Australia in the late 1980s, although he made many return visits to the UK and became involved in racing historic bikes.

1st July, 1985

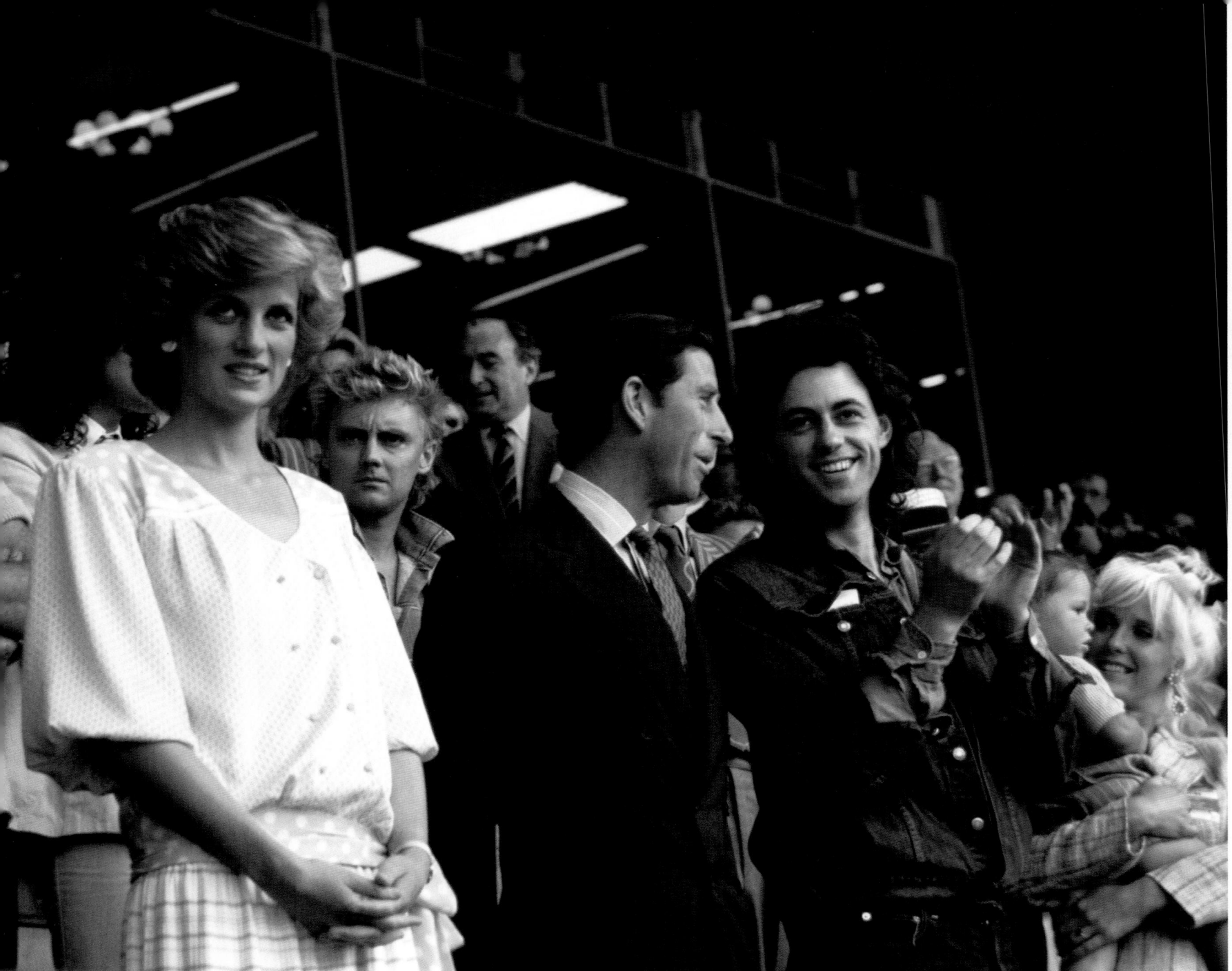

Above: The Princess and Prince of Wales with Bob Geldof at Wembley for the
Live Aid concert, organized by Geldof and Midge Ure to raise millions of pounds
for famine relief in Africa. Geldof's wife, Paula Yates, is on the right. The show
at Wembley was held simultaneously with a similar concert at the JFK Stadium
in Philadelphia, and a television broadcast of the events was watched by an
estimated 400 million people around the world.

13th July, 1985

Above: The huge crowd at Wembley Stadium (72,000) stands as the Guards play the national anthem in honour of the Prince and Princess of Wales, who were there to inaugurate the Live Aid concert, promoted by members of the pop industry to raise funds for famine relief in Ethiopia.

13th July, 1985

Left: L–R: Bono, Paul McCartney, Andrew Ridgeley and Freddie Mercury during the finale of the Live Aid concert. Also visible is David Bowie (R).

13th July, 1985

486

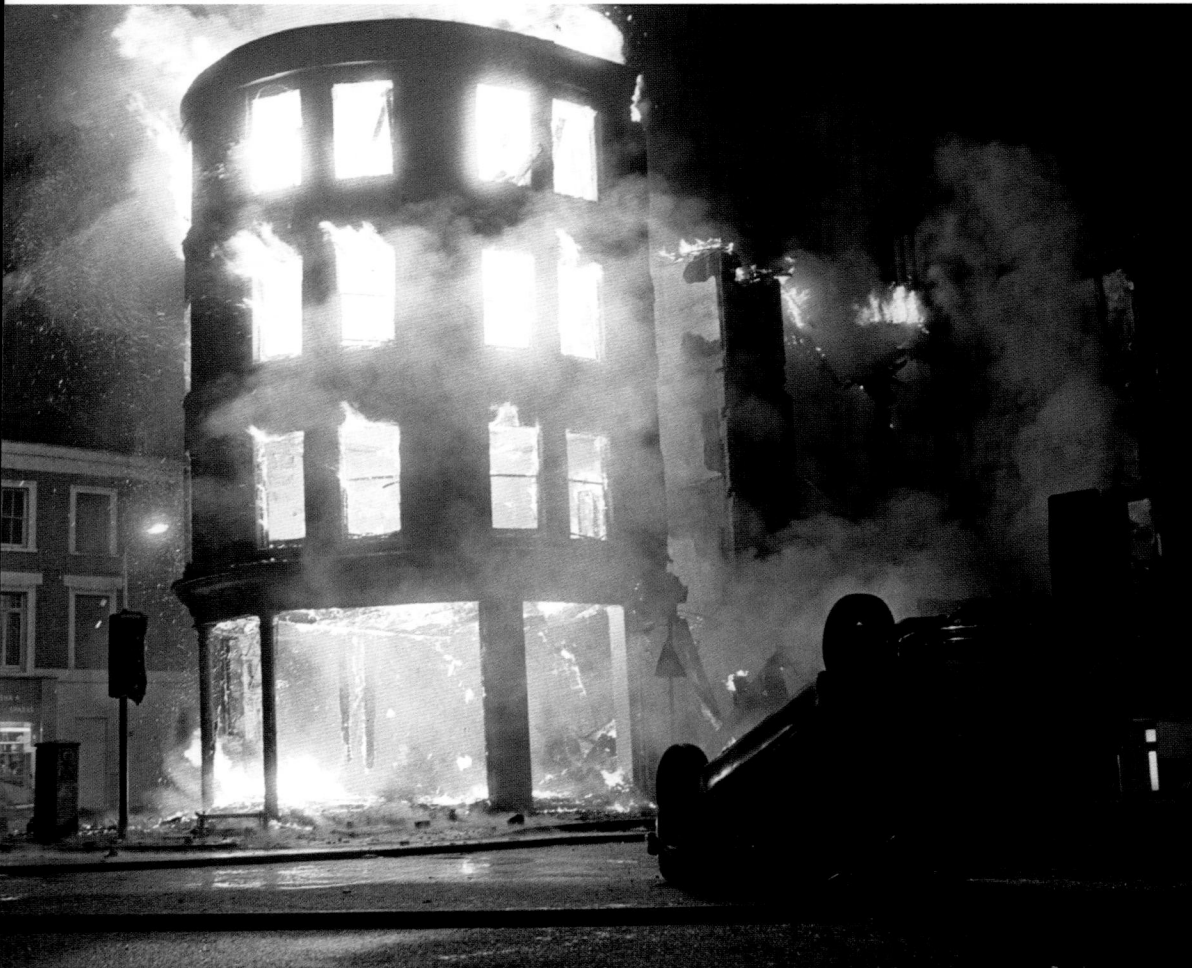

Left: Circus elephants make friends with holidaymakers Graham and Janet Stead on the beach at Great Yarmouth, Norfolk.

2nd September, 1985

Below left: A building consumed by fire on the corner of Gresham Road in Brixton, south London after more upheaval. One person was killed, 50 injured and over 200 arrested during riots after police shot Cherry Groce, the mother of a robbery suspect, in her bed when they raided her house in the early hours. Mrs Groce was crippled by the shooting and spent the next two years in hospital.

28th September, 1985

Right: Boy George (second R) and friends. George was lead singer of the New Wave band Culture Club and was renowned for his gender-bending androgynous style.

5th November, 1985

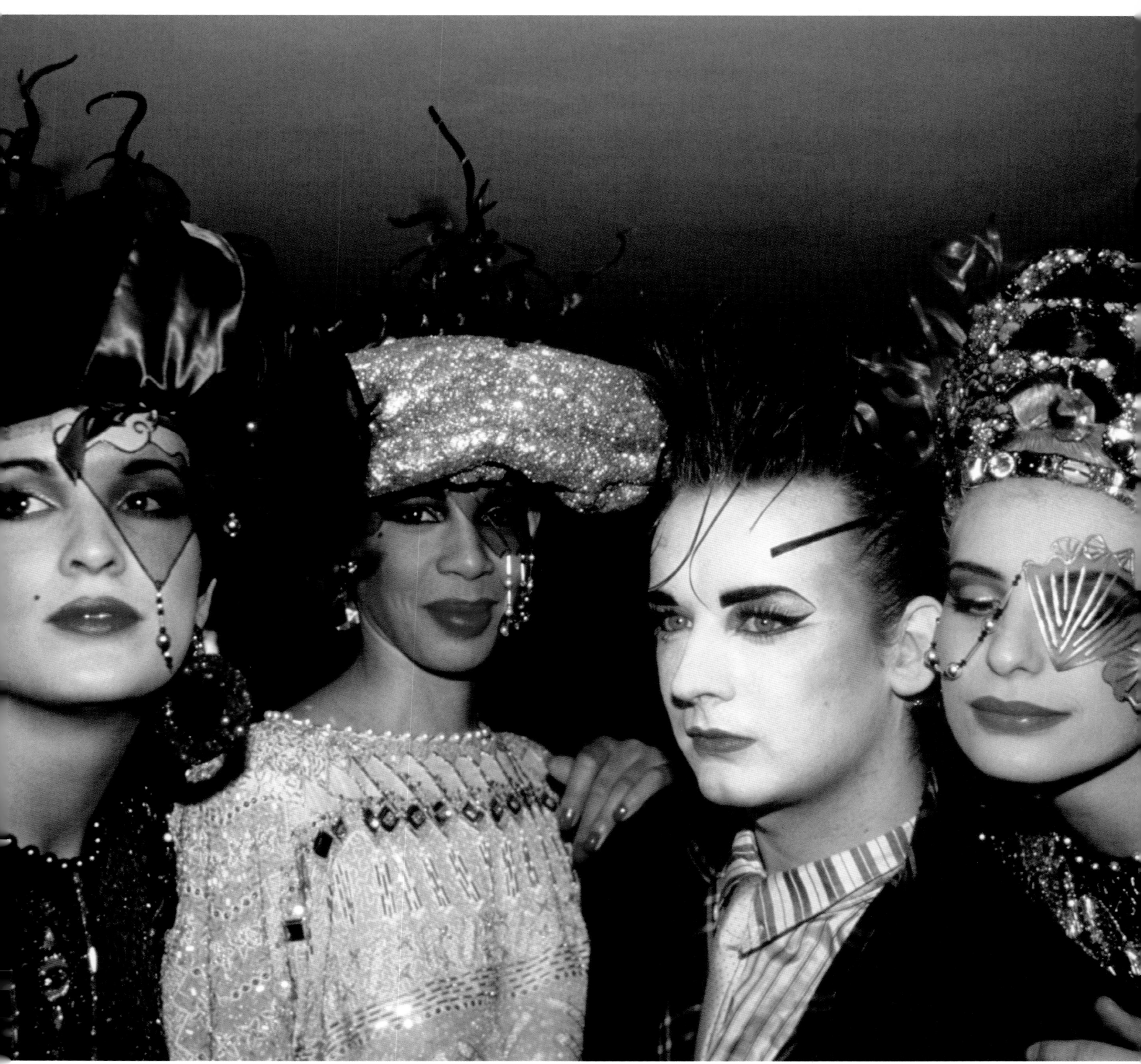

488

Below: Graffiti aimed at Prime Minister Margaret Thatcher left by Protestant protestors in the shadow of the Harland & Wolff shipyard in Belfast, following the signing of the Anglo-Irish Agreement, which gave the Irish Republic a consultative role in the government of Northern Ireland.

18th November, 1985

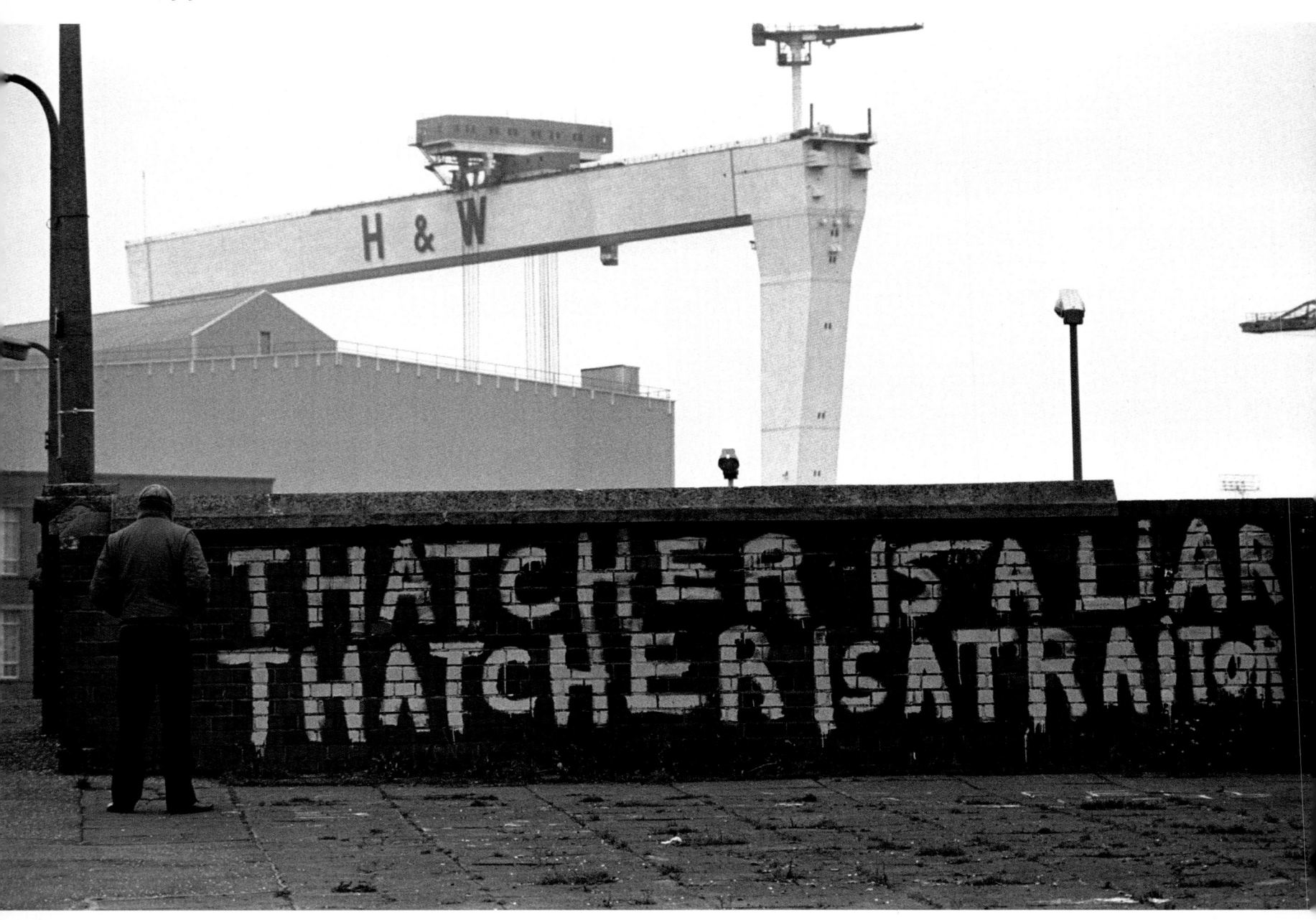

Above: Prime Minister Margaret
Thatcher and French President
François Mitterand at Canterbury
Cathedral for the signing of the
Channel Fixed Link Treaty, clearing
the way for the construction of the
Channel Tunnel.

13th February, 1986

Right: Deputy Assistant
Commissioner Wyn Jones displays
some of the missiles thrown at
police during the previous night's
picket-line violence at the News
International plant at Wapping,
east London. The bitter industrial
dispute was the result of Rupert
Murdoch seeking to impose more
flexible working practices on the
print unions.

4th May, 1986

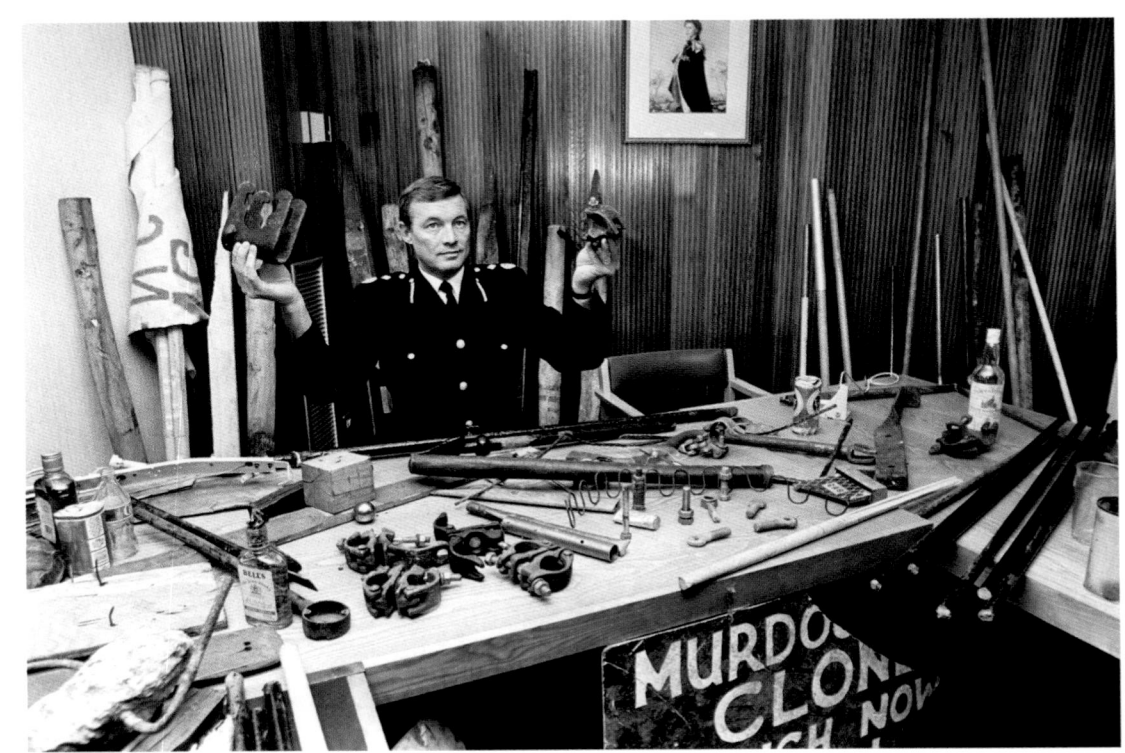

Left: Argentina's Diego Maradona (R) flies past England goalkeeper Peter Shilton after using his fist to score the opening goal – the infamous 'Hand of God' goal – in the quarter-final of the Mexico World Cup. Although illegal, the move went unpenalized, and Argentina won the match 2–1.

22nd June, 1986

Above right: Adoring Wham! fans pay homage to their heroes, George Michael and Andrew Ridgeley, as the stars bound on to the Wembley Stadium stage for their sell-out farewell concert. Some 75,000 were said to be there to see the duo's final appearance together after four years.

28th June, 1986

Right: Britain's Nigel Mansell (foreground) leads the field in his Williams-Honda during the British Grand Prix at Silverstone. He would go on to win the event and would finish the season as runner-up to championship winner Alain Prost.

14th July, 1986

Below right: Watched by 60,000 spectators, Frank Bruno (R) and world heavyweight champion Tim Witherspoon land punches simultaneously during their clash at Wembley Stadium. Witherspoon, of Philadelphia, USA, retained his title after referee Isidro Rodriguez stopped the fight in the 11th round; Bruno was taken to hospital for an X-ray to his jaw. The British fighter received £1m from the promoter, while the champion took home only $100,000, an imbalance that triggered a subsequent legal suit.

20th July, 1986

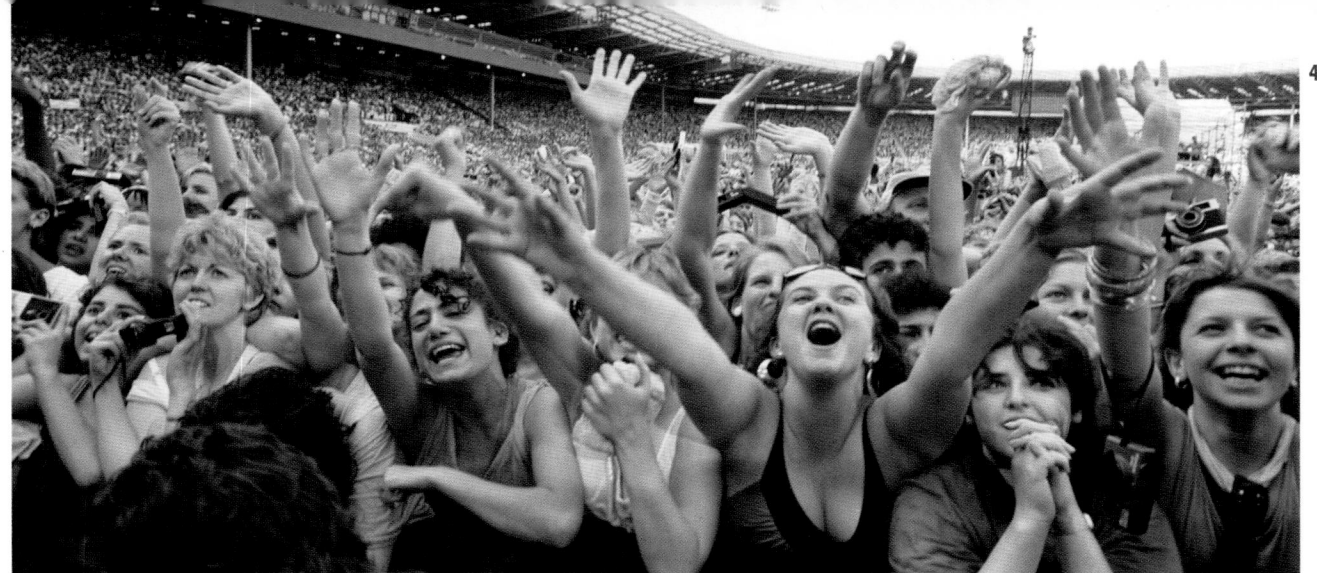

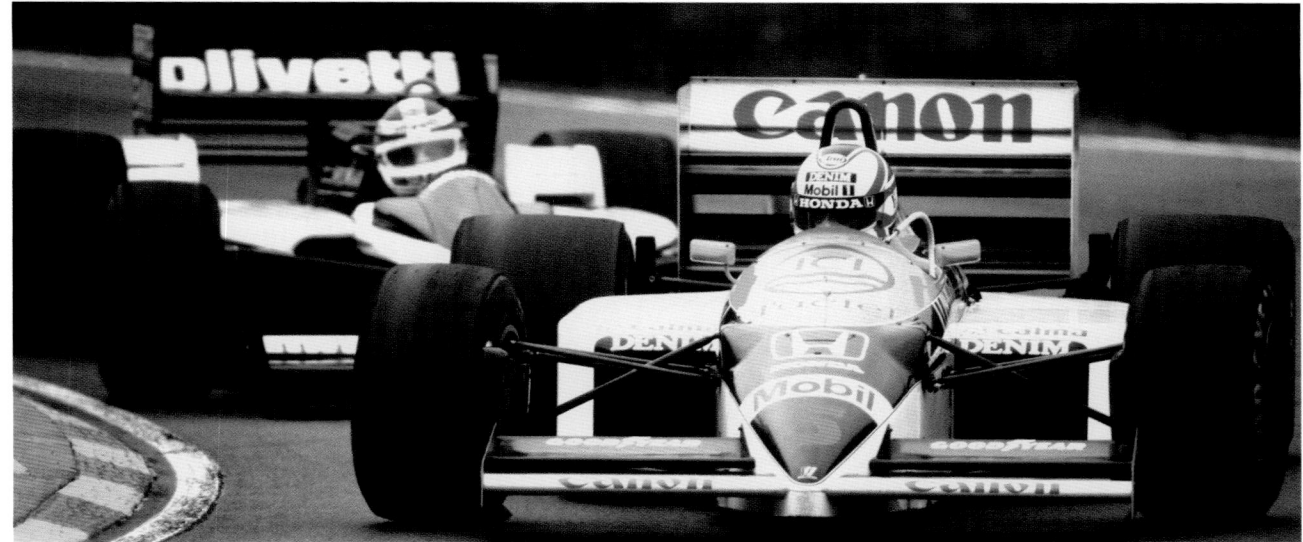

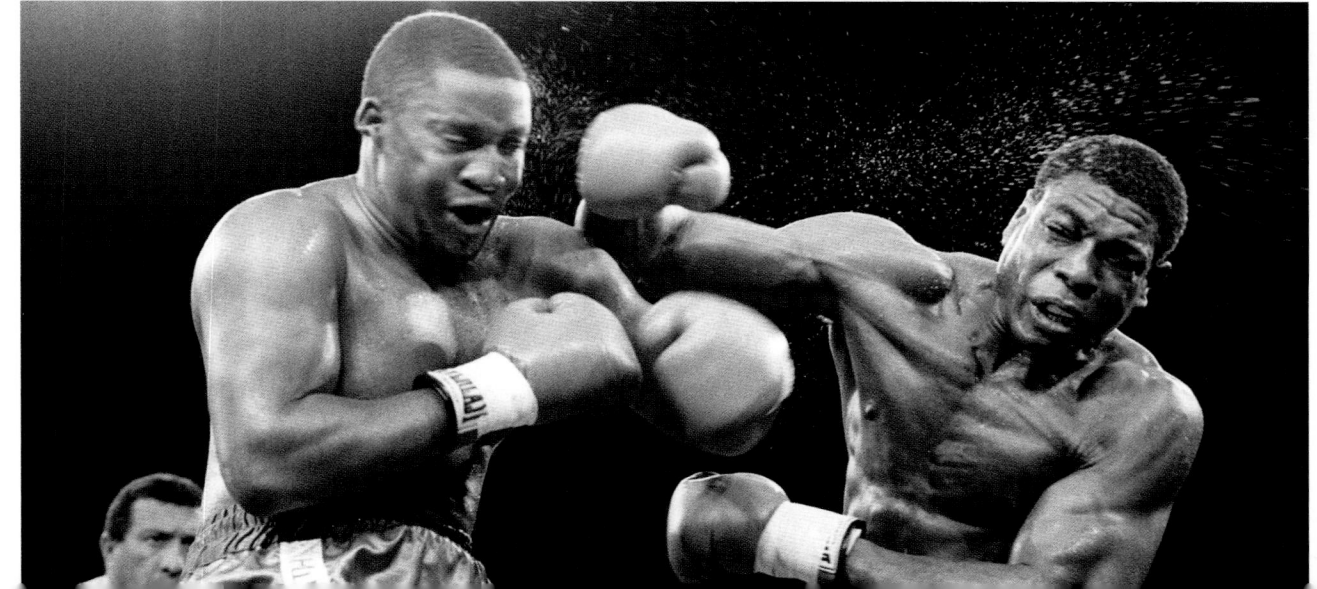

Above: Rescue vessels surround the capsized *Herald of Free Enterprise* outside the Belgian port of Zeebrugge. The car ferry left port with its bow doors open, and as it increased speed, water began to enter the car deck, causing the ship to roll over on its side. Although a rescue operation was mounted by the Belgian Navy, 193 people died in the disaster, which took place about 100 yards (90m) from the shore in near freezing water.

6th March, 1987

Right: Labour leader Neil Kinnock bowling, watched by his wife Glenys, at the Stevenage Leisure Centre during the campaign for the General Election.

6th June, 1987

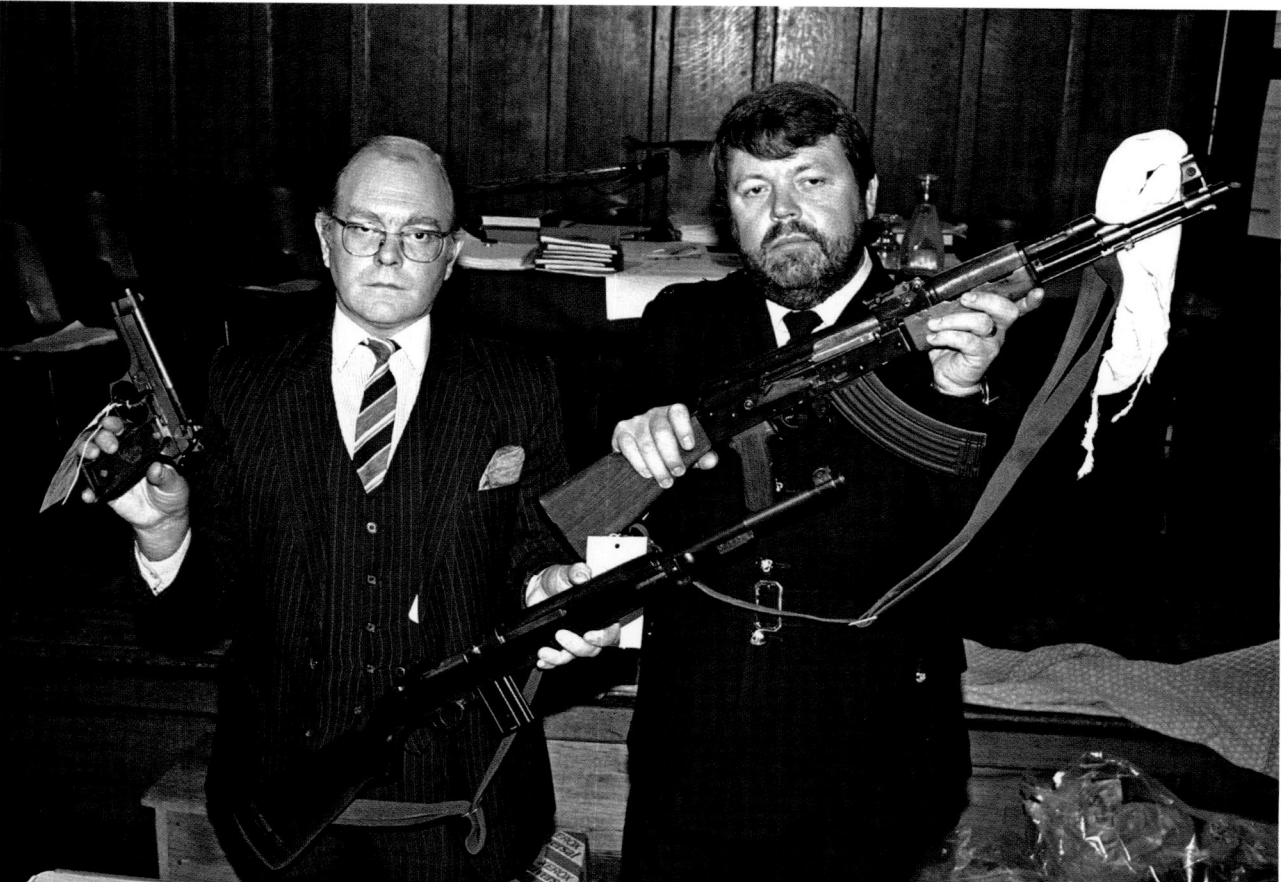

Left: Liar, liar! Author and politician Jeffrey Archer and his wife Mary leave the rear entrance of the High Court, in London, after winning record damages of £500,000 in a libel action against *The Star* newspaper, which had alleged that he had slept with a prostitute. On the 19th July, 2001, Archer was found guilty of perjury and perverting the course of justice at the 1987 trial. He was sentenced to four years' imprisonment.

24th July, 1987

Left: Chief Inspector Laurie (L) and Constable Colin Lilley hold up the weapons used by 27-year-old Hungerford killer Michael Ryan. Included in Ryan's arsenal were an Italian 9mm semi-automatic Beretta pistol, a .30-calibre M1 semi-automatic carbine and a Chinese-made Type 56 copy of a semi-automatic Kalashnikov rifle. All had been legally obtained and licensed to Ryan. He killed 16 and wounded 15 others before shooting himself.

24th September, 1987

Right: Across the southern region of England, thousands of trees were uprooted and buildings damaged in what came to be known as the Great Storm. Frixos Pallas and his family had a lucky escape in the early hours of the morning when this tree demolished their home in Caversham, Reading. Eighteen people died in the UK in what was the worst storm to hit the country since 1703.

16th October, 1987

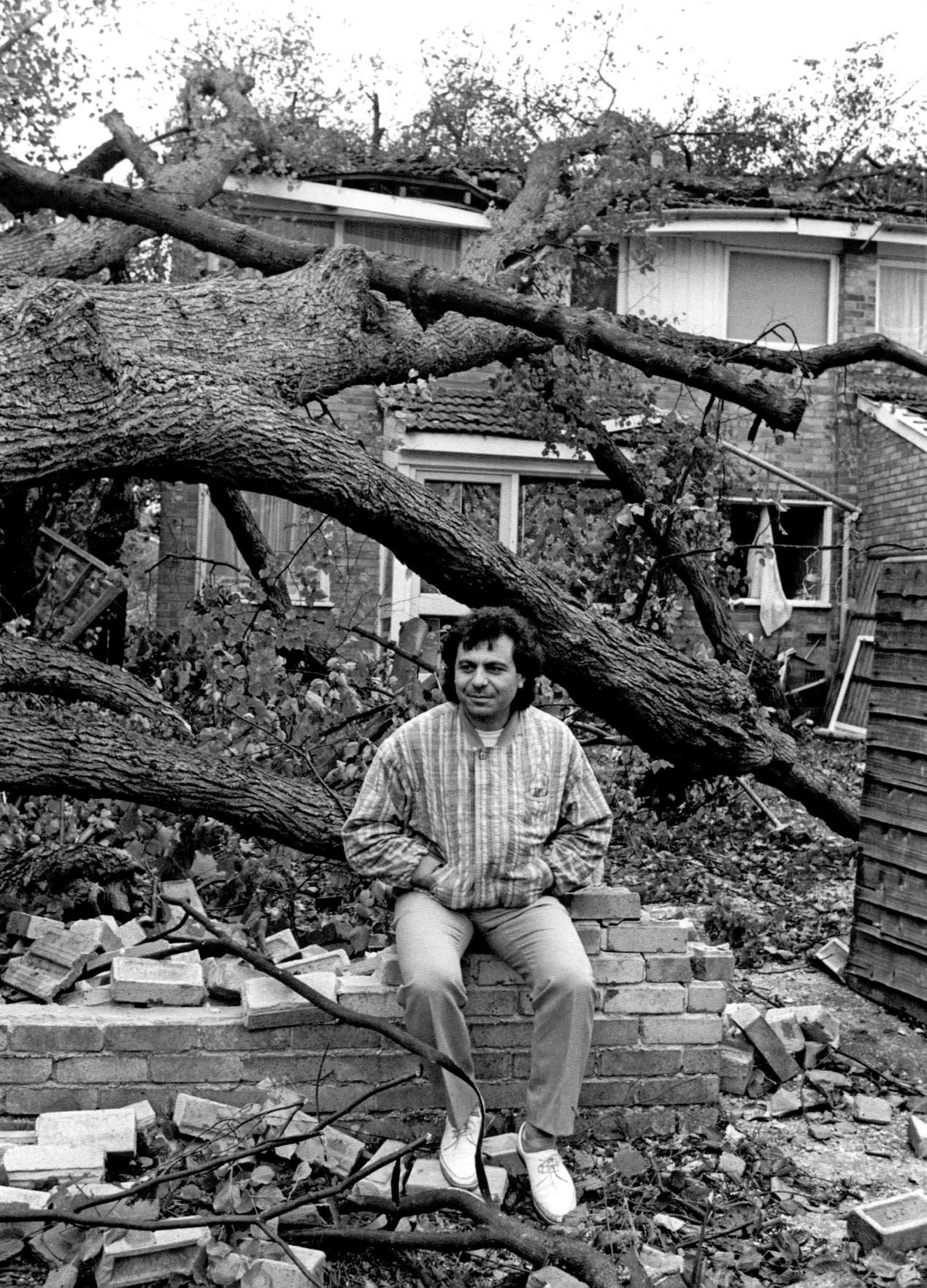

Above: The top of the fire-damaged escalators at King's Cross underground station in London. The fire, which killed 31 people, is believed to have been started on the main escalator up from the platforms when a lit match was dropped by a passenger. It is thought that the match fell through the moving stairway and ignited litter that had collected below.

19th November, 1987

Left: Jill Morrell lights a candle for her fiancé, kidnapped journalist John McCarthy, during a vigil at St Bride's Church in Fleet Street, London. McCarthy had been seized by Islamic terrorists in Lebanon in April 1986; he would spend the next five years in captivity, sharing a cell with Irish hostage Brian Keenan.

31st December, 1987

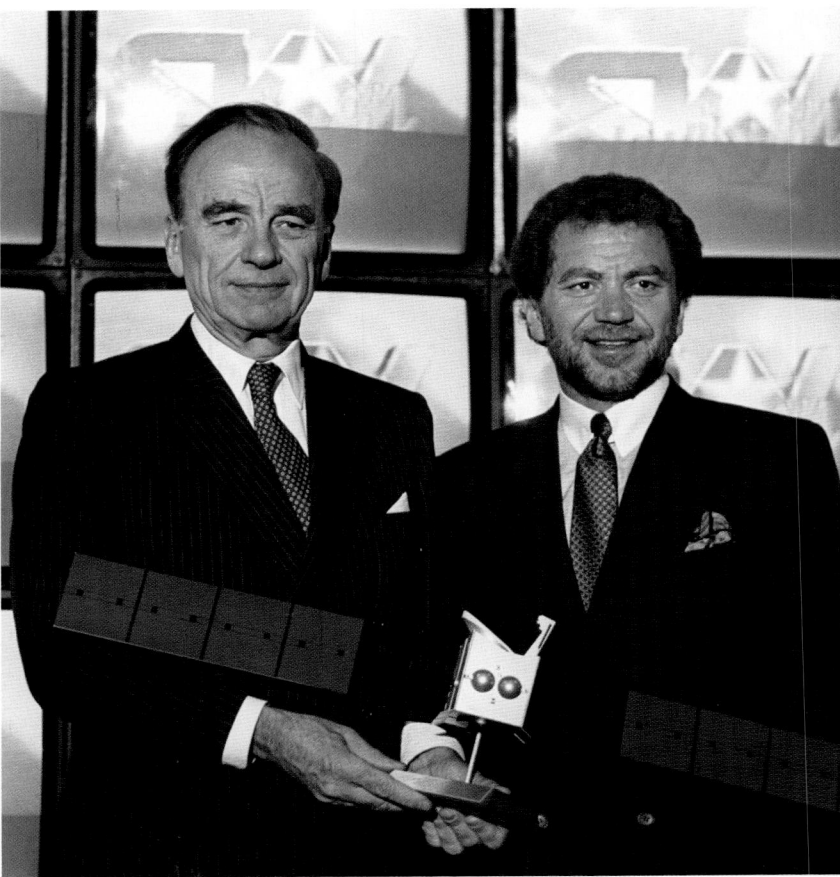

Above: Newspaper tycoon Rupert Murdoch (L) and millionaire businessman Alan Sugar hold a model of the Astra satellite at a press conference in London, where Murdoch announced that he had signed a 10-year lease for three new satellite broadcasting channels. Sugar's Amstrad company had been contracted by Murdoch to manufacture a mass-market satellite dish and receiver for the television service.

8th June, 1988

Left: Housewife Superstar. Dame Edna Everage (alias Barry Humphries) races into the fashion stakes in Chelsea, with a new outfit by Royal designers David and Elizabeth Emanuel. Dame Edna had had the outfit made for 'her' charity appearance in the gala *Sunday with Sondheim*.

25th March, 1988

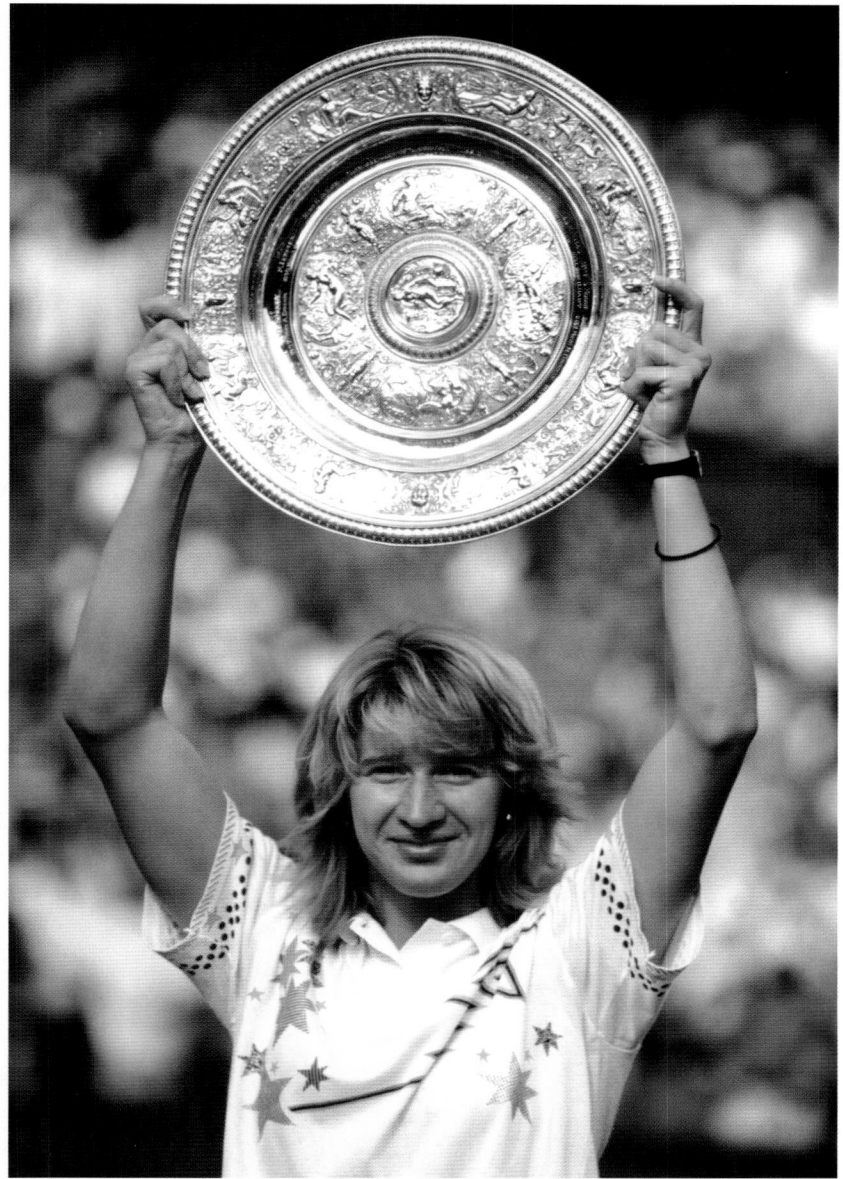

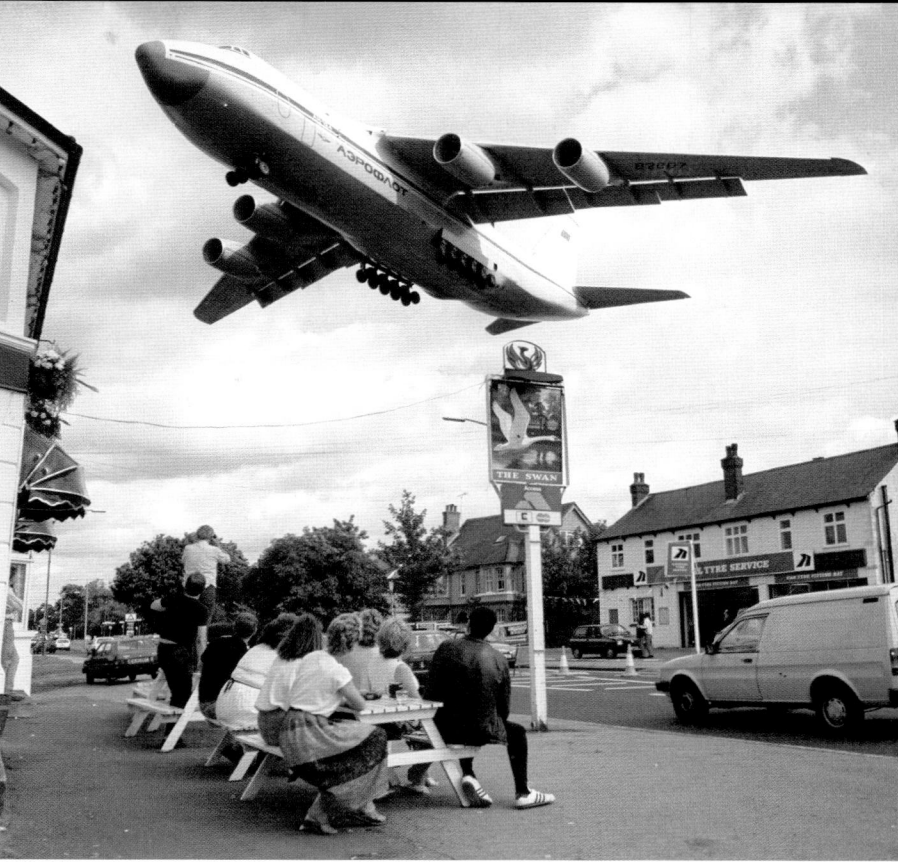

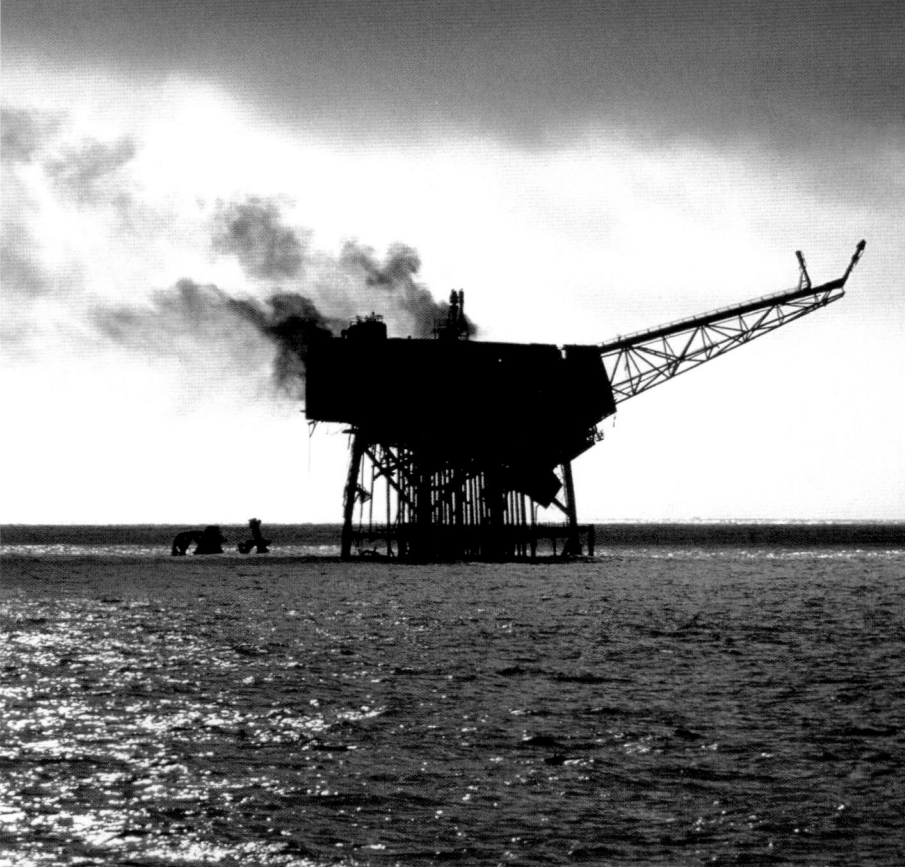

Above: Tennis star Steffi Graf lifts the Ladies' Singles trophy after her three-set victory over Martina Navratilòva at Wimbledon.

3rd July, 1988

Above right: Customers enjoying a quiet lunchtime drink in Farnborough, Hampshire look skyward as a giant Soviet Antonov AN-124 transport, the largest aircraft in the world, roars over their heads on its way to a landing for the forthcoming Farnborough air show.

30th August, 1988

Right: The Piper Alpha oil rig burns off the coast of Aberdeen in the North Sea. The fire became the world's worst offshore oil disaster, killing 167 of the 225 workers on the rig.

8th July, 1988

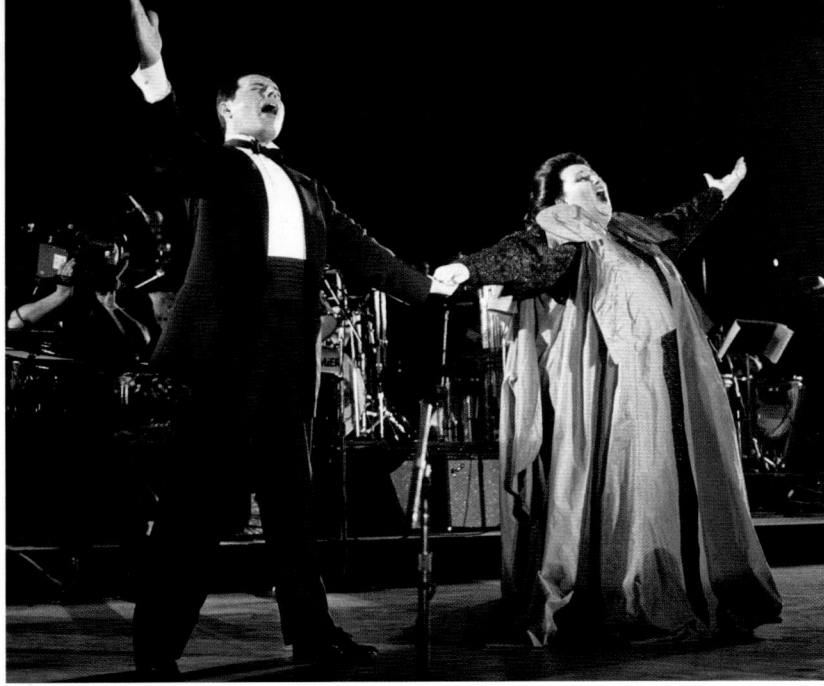

Left: Freddie Mercury and Montserrat Caballé perform their hit song *Barcelona* during an outdoor concert held on the slopes of Barcelona's Montjuïc Park, to celebrate the arrival of the Olympic flag from Seoul in Korea. The song was adopted as the official anthem of the Barcelona Olympics, held in 1992, a year after Mercury's death from bronchopneumonia brought on by AIDS.

9th October, 1988

Below left: Sandy Lyle (L) and Nick Faldo try skimming golf balls in one of the many puddles at Wentworth, where play had been postponed due to torrential rain.

9th October, 1988

Right: The scene of devastation following a rail crash in which 35 people died and 500 others were injured after two early-morning commuter trains, carrying 1,300 passengers between them, collided at Clapham Junction, south London. Shortly afterwards, a third empty train ran into the wreckage, killing some of the passengers who had survived the first crash. Faulty signal wiring, which caused a red light to show green, was partly to blame for the accident.

12th December, 1988

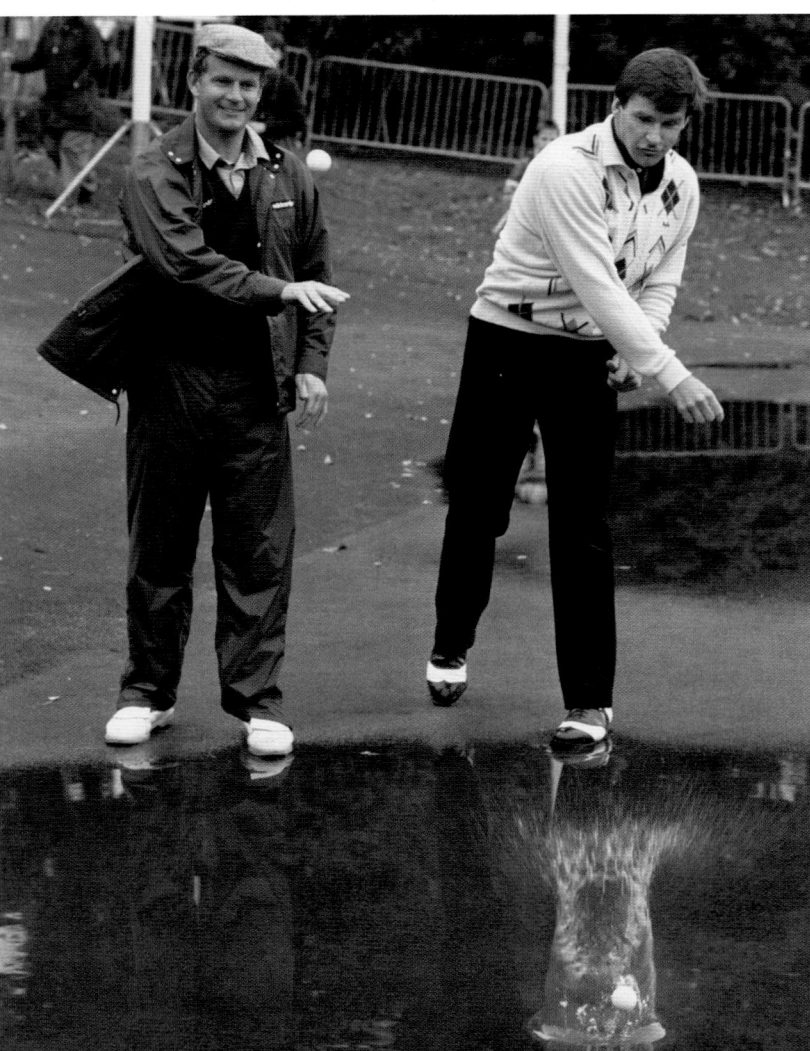

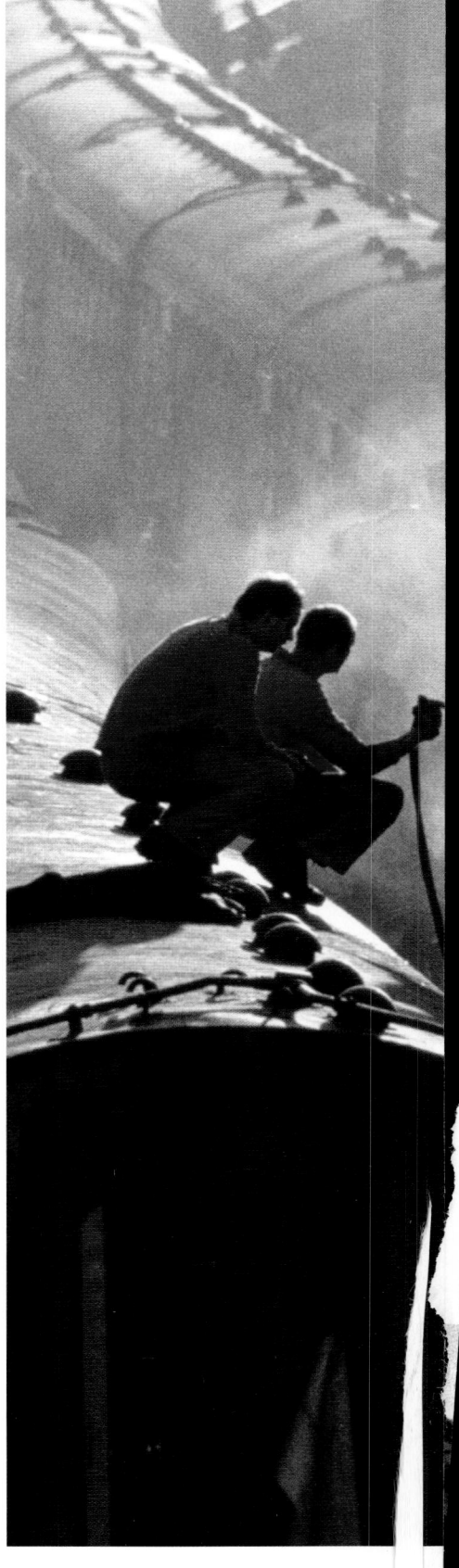

Left: The grey gelding Desert Orchid, ridden by Simon Sherwood, gallops to a famous victory in the Cheltenham Gold Cup. The race was a mile longer than Dessie's believed preference, and rain and snow had made the going heavier than he liked. *Racing Post* readers voted it the best horse race ever.

16th March, 1989

Left: Prisoners protesting about the conditions at Risley Remand Centre, Cheshire, line up on the roof before ending a three-day occupation of D Wing. In 1988, Chief Inspector of Prisons Stephen Tumin had described the prison as *"barbarous and squalid"* and *"dirty and dilapidated"*.

3rd May, 1989

1990s

After the 1980s' headlong rush for home ownership, the 1990s opened to falling property prices. Bank base rates of over 15% added to the misery of over-extended borrowers and to the depressed mood of the times: the boom years were over. Margaret Thatcher resigned as prime minister, attacks on sterling forced Britain to leave the ERM on Black Wednesday, and Barings bank failed. By the middle of the decade, belief in the markets and money had been thoroughly shaken. In 1997, the Conservatives lost the General Election to Labour after 18 years in office.

Then came the news that Diana, Princess of Wales had died, and there was a massive outpouring of public grief. It has been said that events following the Princess's death brought the monarchy closer to falling than at any time since the abdication crisis of the 1930s, but in the end the effect united rather than divided.

The millennium, however, was an issue that did split the country, between those who anticipated a spectacular celebration, and those who predicted that chaos would ensue from computers' feared inability to cope with a date in which the year began with the numeral '2'. As midnight approached on 31st December, 1999, the nation held its collective breath and... nothing happened. The partygoers carried the day, and the story of Britain in the 20th century was complete.

Above: Phil Collins and Annie Lennox after being named the best British male and female artists at the 1990 Brit Awards.

18th February, 1990

Right: Protesters demonstrate against the Community Charge (commonly known as the Poll Tax) in Whitehall. The tax had been introduced by Margaret Thatcher's Conservative government and prompted a series of mass protests throughout the country. This demonstration was the largest, but it degenerated into rioting and looting, which continued until 3am the following morning. Thatcher would resign later in the year, to be replaced by John Major, who scrapped the tax.

31st March, 1990

Below: Agriculture minister John Gummer and his four-year-old daughter, Cordelia, tuck into beefburgers at the East Coast Boat Show in Ipswich. It was a controversial attempt by Gummer to calm public fears over the danger of bovine spongiform encephalopathy (BSE), commonly known as mad-cow disease, in British beef.

16th May, 1990

508

Left: Making a point. American singing star Madonna performs to a crowd of 74,000 fans at London's Wembley Stadium during her Blonde Ambition Tour. Her conical corsetry was the work of French designer Jean Paul Gaultier.

20th July, 1990

Above right: A flight of Royal Air Force Panavia Tornado GR1 fighter-bombers returning to RAF Brize Norton from Dhahran Military Air Base, Saudi Arabia, following a six-week deployment during the first Gulf War. The war was the aircraft's combat debut, and nearly 60 were deployed by the RAF.

17th September, 1990

Right: British Warrior tanks, at Bremerhaven docks in Germany, await deployment to the Gulf as Coalition forces begin to assemble following the Iraqi invasion of Kuwait. By mid-October, there would be 15,000 British troops in the Gulf region.

30th September, 1990

Right The 800ft (244m) Canary Wharf Tower under construction in London's Docklands development. The 50-storey structure, the tallest building in the UK when it was completed, contains 27,000 tonnes of British steel fastened together by 500,000 bolts.

6th November, 1990

Far right: Tunnelling teams from Britain and France celebrate the breaking through of the final underground section of the Channel Tunnel, creating the first ground-based connection to the Continent since the Ice Age.

20th November, 1990

Left: Soldiers belonging to the Royal Engineers, part of the 1st Armoured Division, take cover as live mines explode during exercises in Saudi Arabia, in preparation for the Gulf War. Having traditionally been trained and equipped for warfare in Europe, British forces were not best placed to carry out a desert campaign, and had to be hastily retrained and re-equipped for the coming conflict.

12th January, 1991

Below left: Demonstrators march from Embankment, central London, in protest against the Gulf War. Their pleas fell on deaf ears, however, and the action to oust Iraqi forces from Kuwait went ahead. The Coalition forces, led by the United States, expelled the Iraqis, causing heavy losses, but not before the invaders had ignited many Kuwaiti oil wells.

26th January, 1991

Right: A white Ford Transit van burns outside the Banqueting House in Whitehall, London after a mortar attack on Downing Street. The attack had been carried out by the Provisional IRA in an attempt to assassinate Prime Minister John Major and his ministers. Three 4ft-long (1.2m) shells were shot automatically from the van towards Downing Street: two failed to explode, but the third detonated in the garden of No 10, where a Cabinet meeting was in session to discuss the Gulf War. No member of the government was hurt, although four other people received minor injuries from flying debris. Of the attack, John Major said, "It is time they learned that democracies cannot be intimidated by terrorism, and we treat them with contempt."

7th February, 1991

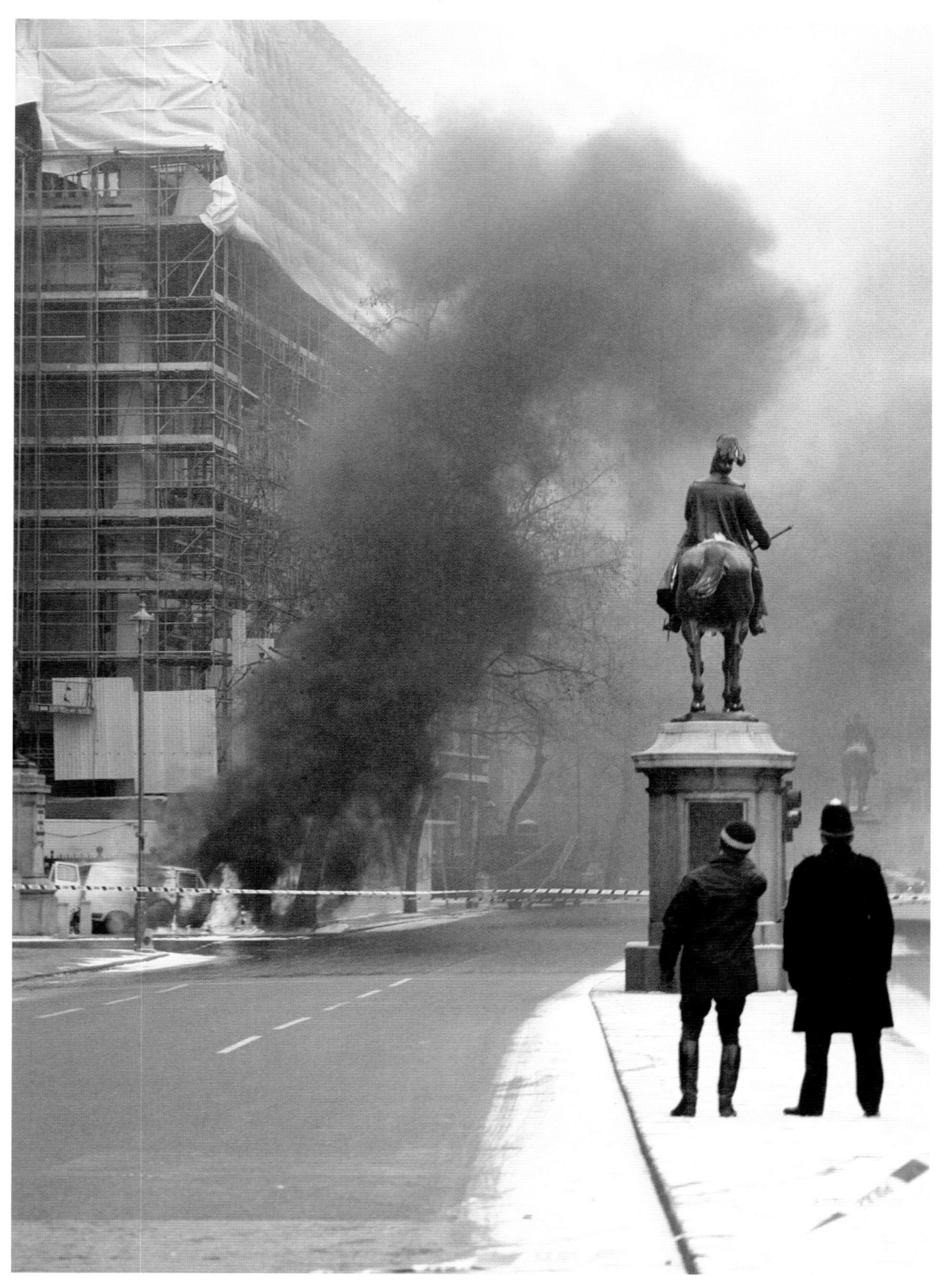

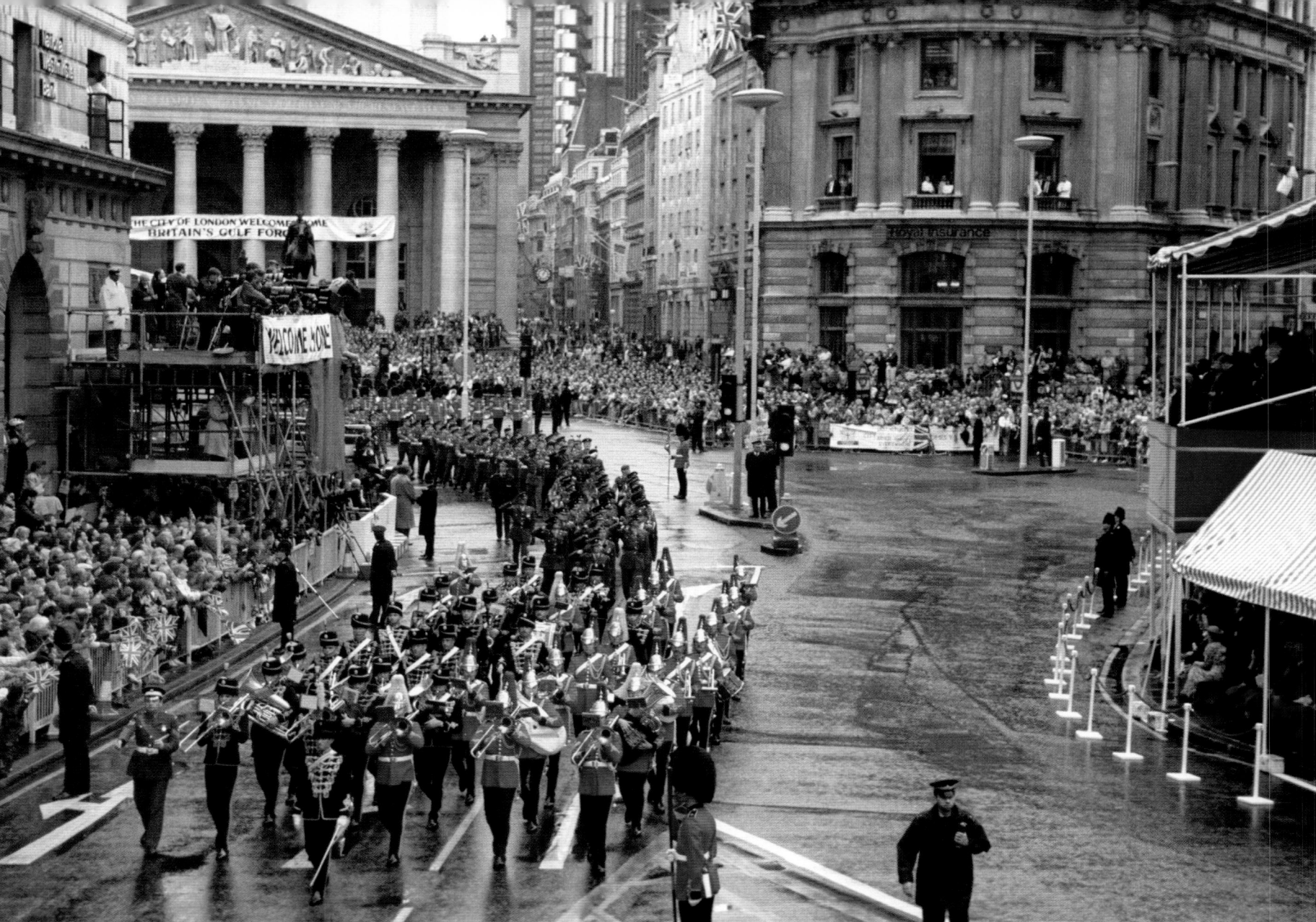

Above: Following the successful conclusion of the Gulf War, a cavalry band leads troops through London during the victory parade. On 28th February, 1991, Iraq had accepted all UN resolutions and withdrew its forces from Kuwait.

21st June, 1991

Above right: A soldier from the British 7th Armoured Brigade – the 'Desert Rats' – wears an improvised facemask and goggles to protect himself from the dust and sand of the desert while on exercise in Saudi Arabia. The barrel of his machine gun has been sealed with adhesive tape for the same reason.

2nd October, 1991

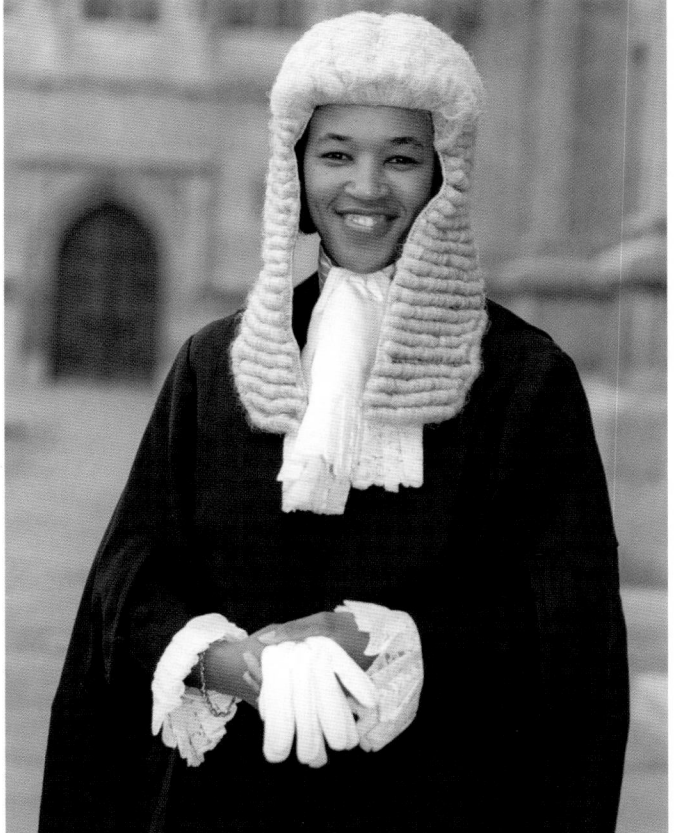

Above: Freed Middle East hostage Terry Waite arrives at RAF Lyneham in Wiltshire. Waite had been sent to Lebanon by the Archbishop of Canterbury to negotiate with Islamic Jihadis for the return of four hostages, including journalist John McCarthy. He had already enjoyed some success in this role in other hostage situations in the Middle East, but on this occasion the Islamists imprisoned him, holding him for a total of 1,763 days.

19th November, 1991

Left: Patricia Scotland becomes Britain's first black woman Queen's Counsel (QC), after being sworn in at the House of Lords. Scotland would be appointed a life peer as Baroness Scotland of Asthal in 1997; a decade later, she would be made Attorney General, the chief legal advisor to the government, by Prime Minister Gordon Brown. She would be the first woman to hold this office since its inception in 1315.

9th October, 1991

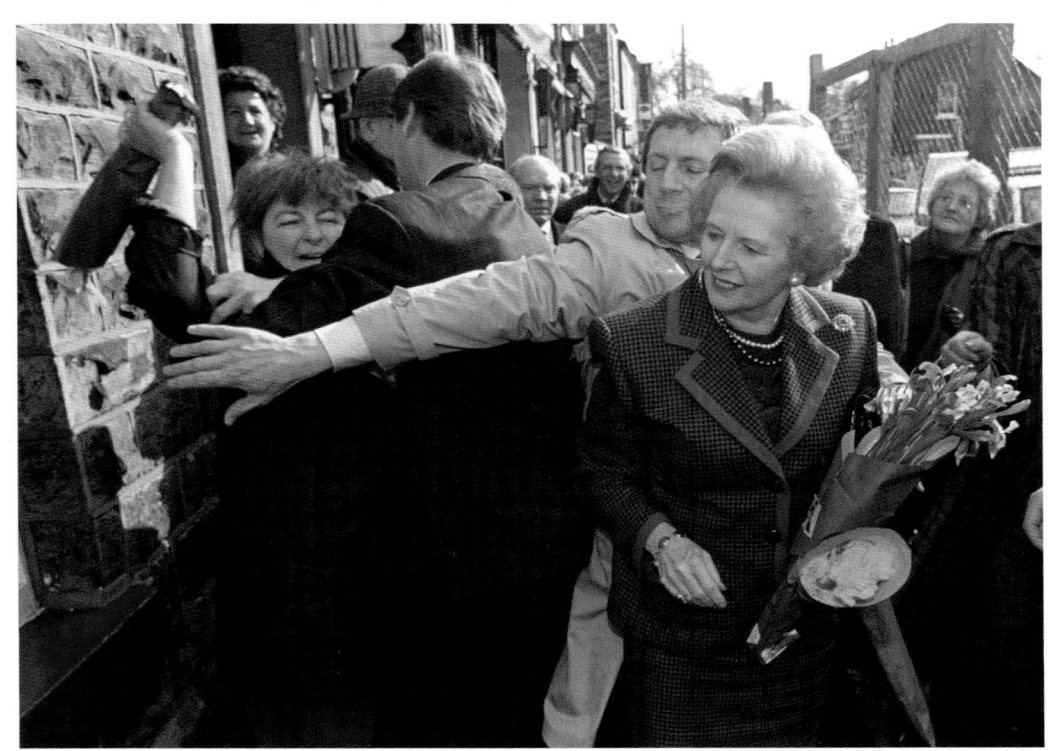

Left: With her marriage to Prince Charles in the process of breaking up, Diana, Princess of Wales cuts a forelorn figure in front of the Taj Mahal in India. The famous mausoleum was built by the Mughal emperor Shah Jahan in memory of his favourite wife, Mumtaz Mahal.

11th February, 1992

Above right: Former Prime Minister Margaret Thatcher is attacked by a woman wielding a bunch of flowers, during a walk-about in Marple Bridge, Stockport. Thatcher probably provoked a greater emotional response in people than any other prime minister.

23rd March, 1992

Right: The scene of the Provisional IRA's bomb blast at St Mary Axe in the City of London. Damage to the buildings was so severe that they were later demolished. London's famous 'Gherkin' office tower now stands on the site. Three people were killed in the explosion.

10th April, 1992

Left: Australian singer
Kylie Minogue with
Italian designer Gianni
Versace at the opening
of his new shop in
London. Versace would
be shot dead on 15th July,
1997 outside his Miami
Beach home by Andrew
Cunanan, who later
committed suicide.

28th May, 1992

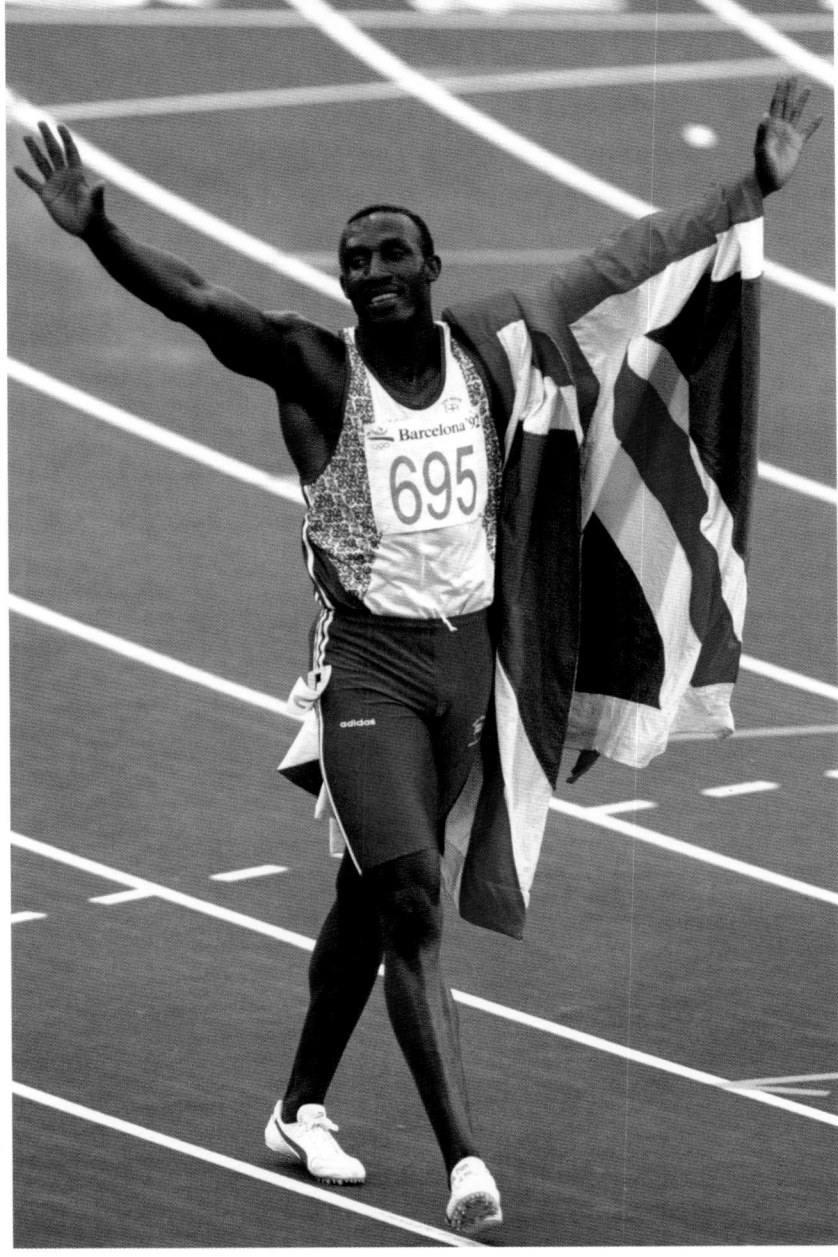

Above: At the Barcelona Olympic Games, Britain's Linford Christie celebrates winning the Men's 100m event. At 32, he was the oldest Olympic 100m champion by four years. Christie is the only British male athlete to have won gold medals in all four major competitions: the Olympics, and World, Commonwealth and European championships. During his career, he won 23 major championship medals and 10 gold medals.

1st August, 1992

Right: Sally Gunnell wins gold for Britain in the 400m Hurdles at the Barcelona Olympics. She would set a world record and win a gold medal in the same event at the World Championships in 1993. Gunnell is the only woman to have held the European, World, Commonwealth and Olympic 400m Hurdles titles at the same time.

5th August, 1992

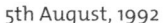

Above: Firemen tackle a fierce blaze at Windsor Castle, where one of the greatest collections of art in the world was threatened with destruction. The castle, one of the Queen's official residences, was severely damaged by the fire. To help meet the very high expense of restoring the building, Buckingham Palace was opened to the public.

20th November, 1992

Right: The stricken oil tanker *Braer*, aground off the coast of Shetland. The vessel was carrying 85,000 tonnes of crude oil, but of a relatively light type that was more easily dispersed by wave action, lessening the impact of pollution.

6th January, 1993

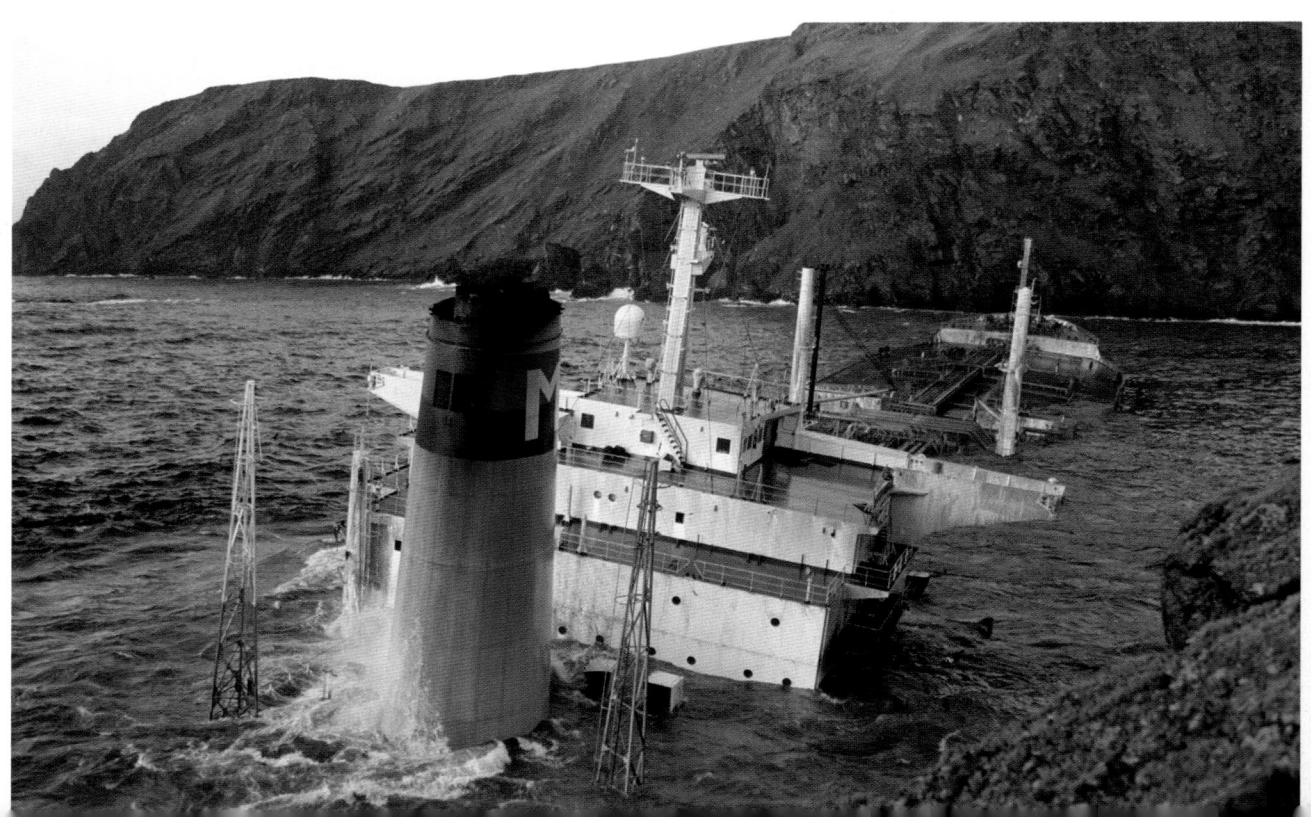

Below: Holbeck Hall Hotel in Scarborough after a massive landslip. Scarborough Borough Council was held liable for the destruction of the hotel after it was found to be in breach of its duty of care to maintain the supporting land.

8th June, 1993

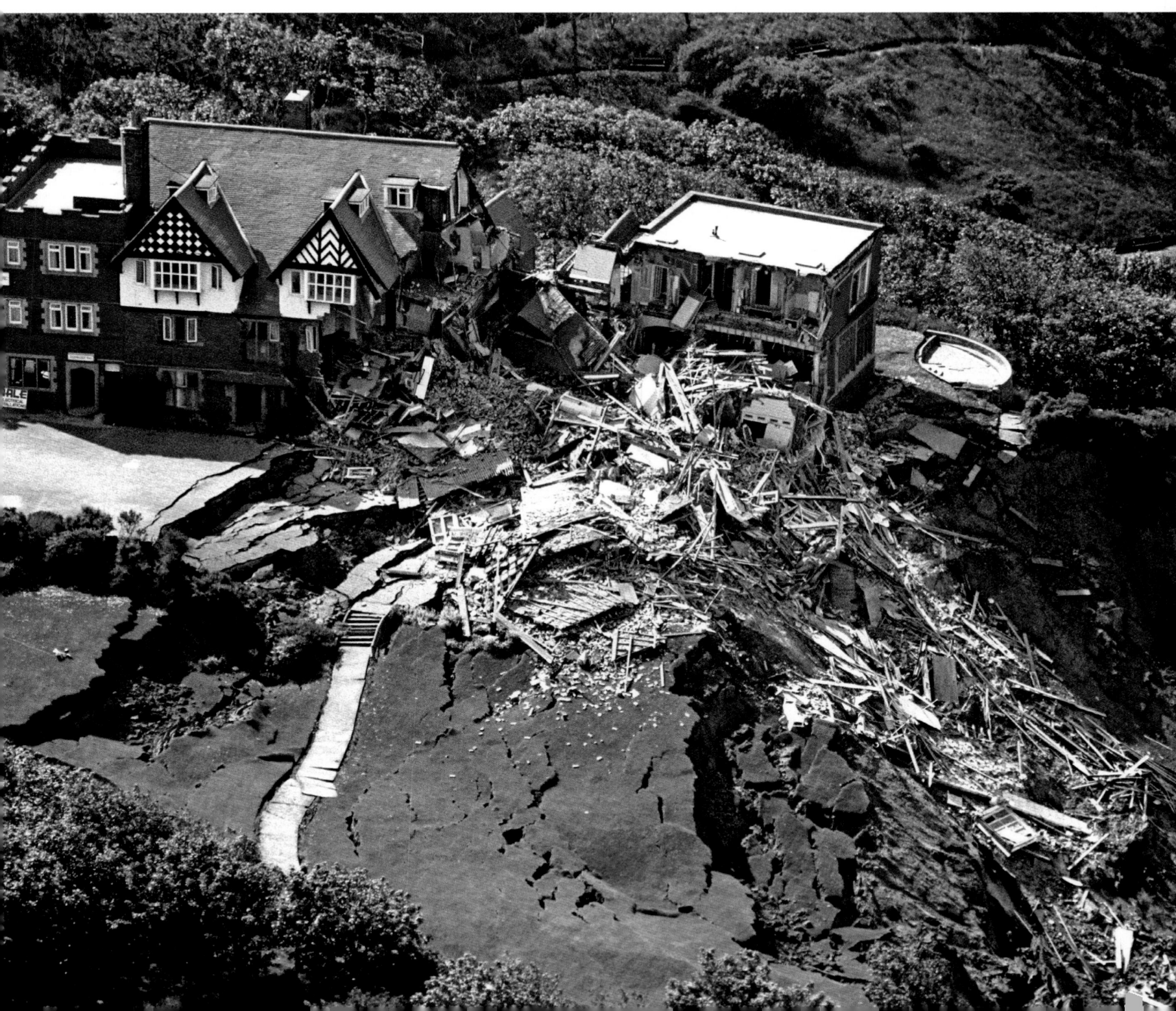

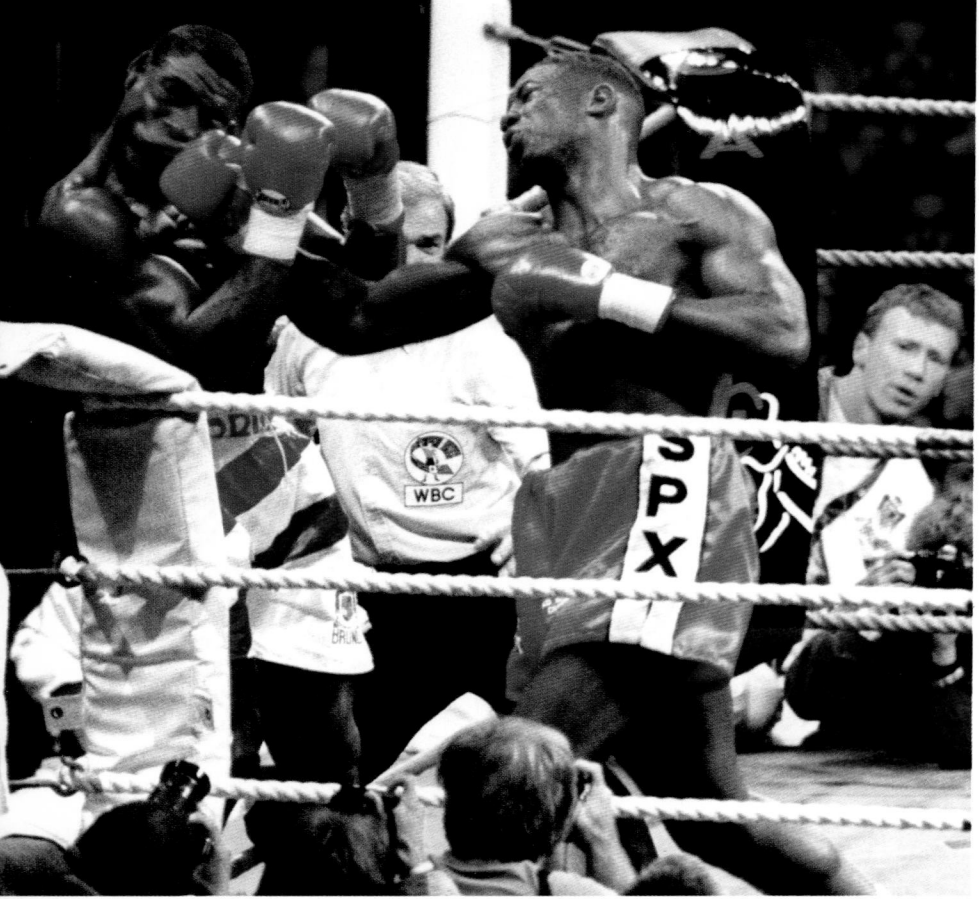

Above left: The first female director general of MI5, Stella Rimington, on the day the British security service held the first photocall of its 84-year history. Rimington was the first DG to have her name openly publicized; she pursued a campaign for more openness and public transparency in the security service until she quit the post in 1996. Her work since has been as a non-executive director of such companies as Marks & Spencer and the BG Group.

16th July, 1993

Left: Lennox 'The Lion' Lewis (R) catches Frank Bruno with a right hook, during the WBC World Heavyweight title fight at Cardiff Arms Park, Cardiff, Wales. In the seventh round, referee Mickey Vann warned Lewis about holding and hitting, but Bruno was unable to recover, and soon after Vann stopped the match.

1st October, 1993

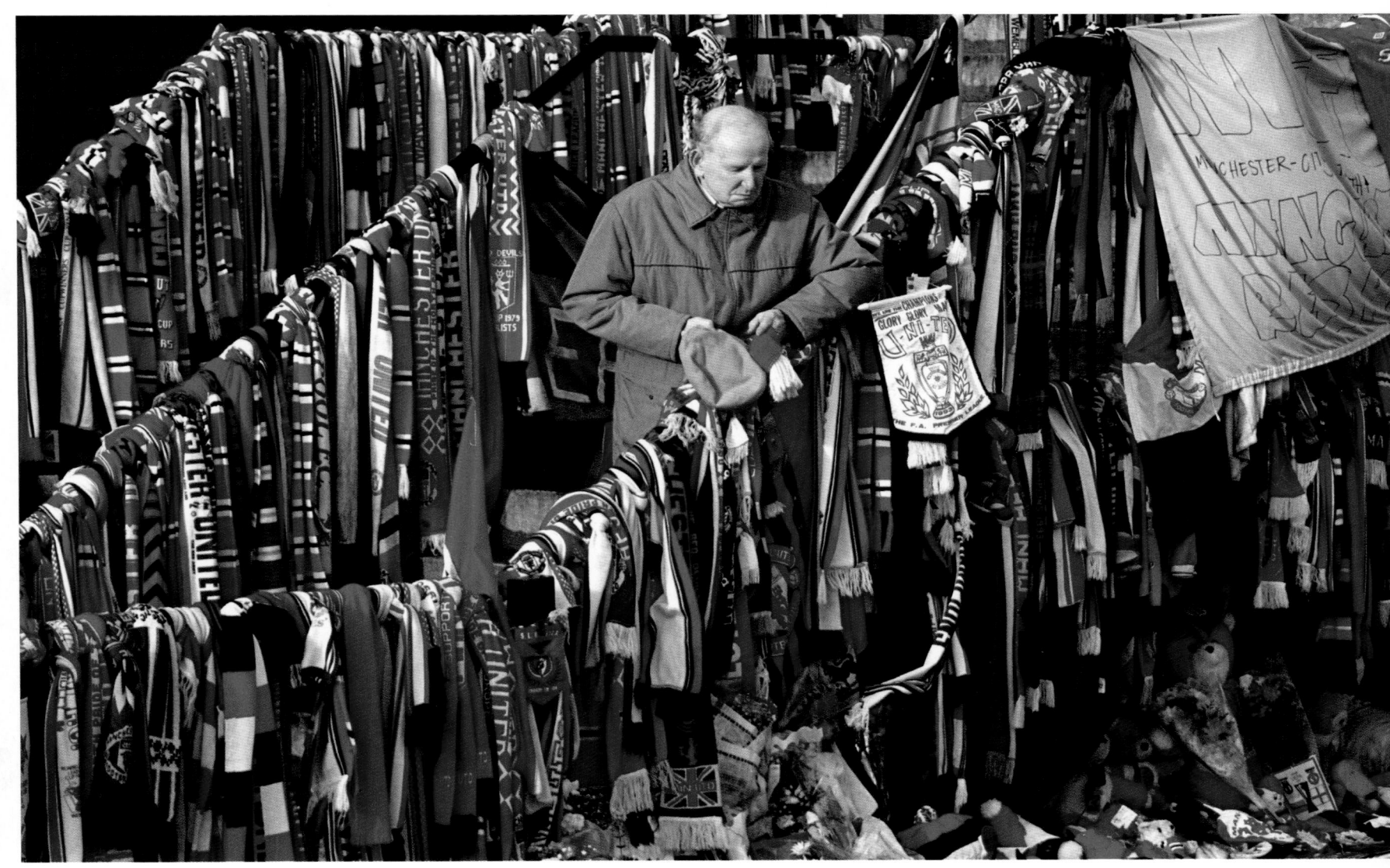

Above left: Sinn Féin President Gerry Adams (R) helps carry the coffin of IRA man Thomas Begley, at his funeral in Belfast. Begley and nine civilians had been blown up by the bomb he was carrying when it exploded prematurely. His target had been Johnny Adair and other members of the Ulster Defence Association.

27th October, 1993

Above: Arthur Ludden, a Manchester United fan for over 60 years and blind for the past five, touches the scarves at the shrine of tributes to the late Sir Matt Busby at Old Trafford. The legendary manager had died of cancer, aged 84.

26th January, 1994

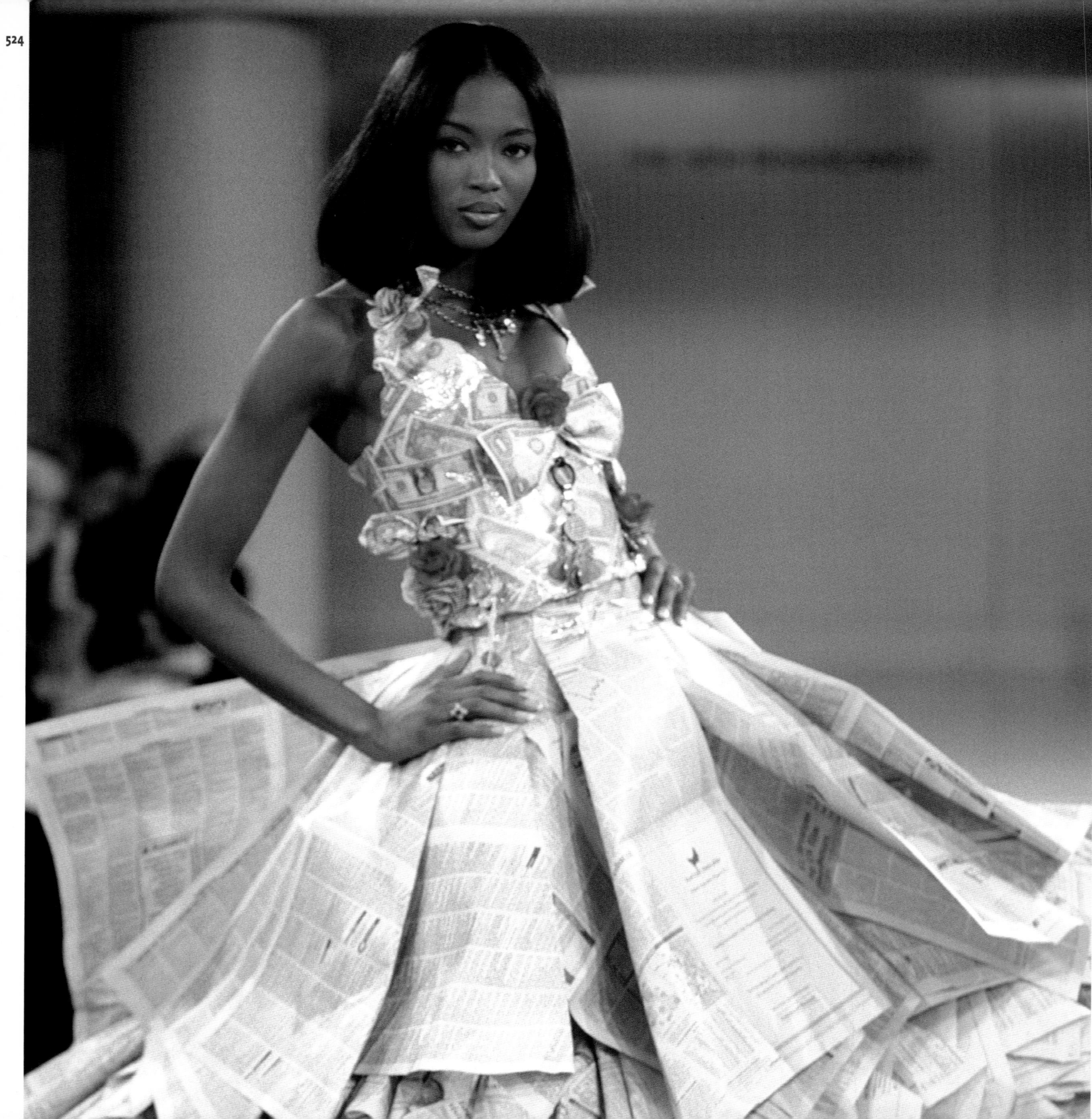

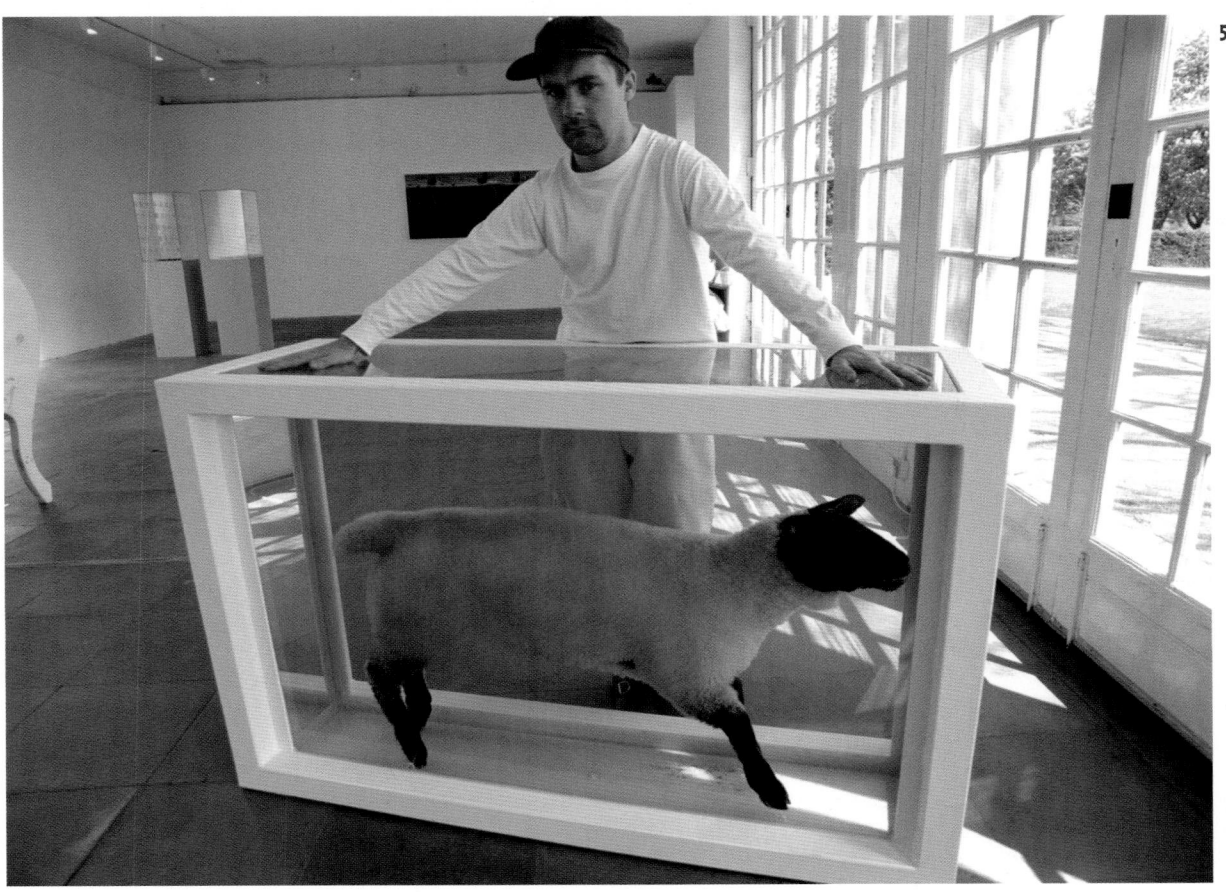

Left: Paper doll. Model Naomi Campbell wears a wedding dress made from newspapers and dollar bills, part of the New Renaissance collection at the Harvey Nichols and Perrier New Generation Designers Show.

24th February, 1994

Right: Controversial British artist Damien Hirst with 'Away from the Flock', a dead lamb suspended in formaldehyde, which was featured in an exhibition at London's Serpentine Gallery. During the exhibition, Mark Bridger, an artist from Oxford, poured black ink into the tank and retitled the work 'Black Sheep'. Hirst was not amused and insisted on Bridger's prosecution. He received two year's probation. Hirst, 28, achieved notoriety with sculptures that concentrated on putrefaction.

3rd May, 1994

Right: That dress. Actor Hugh Grant and Elizabeth Hurley arrive for the charity premiere of the film *Four Weddings and a Funeral*. "*That dress was a favour from Versace because I couldn't afford to buy one. His people told me they didn't have any evening wear, but there was one item left in their press office,*" said Hurley of the event. "*That dress*" landed her the position as the face of Estée Lauder.

11th May, 1994

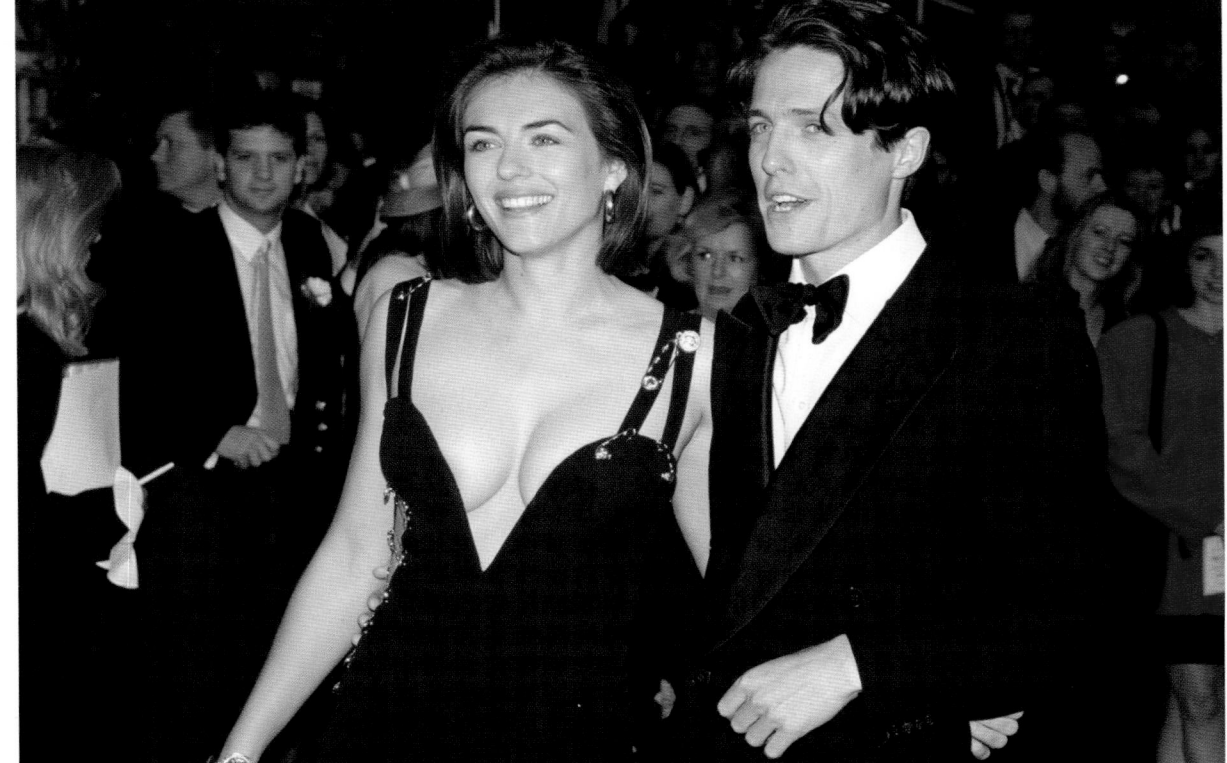

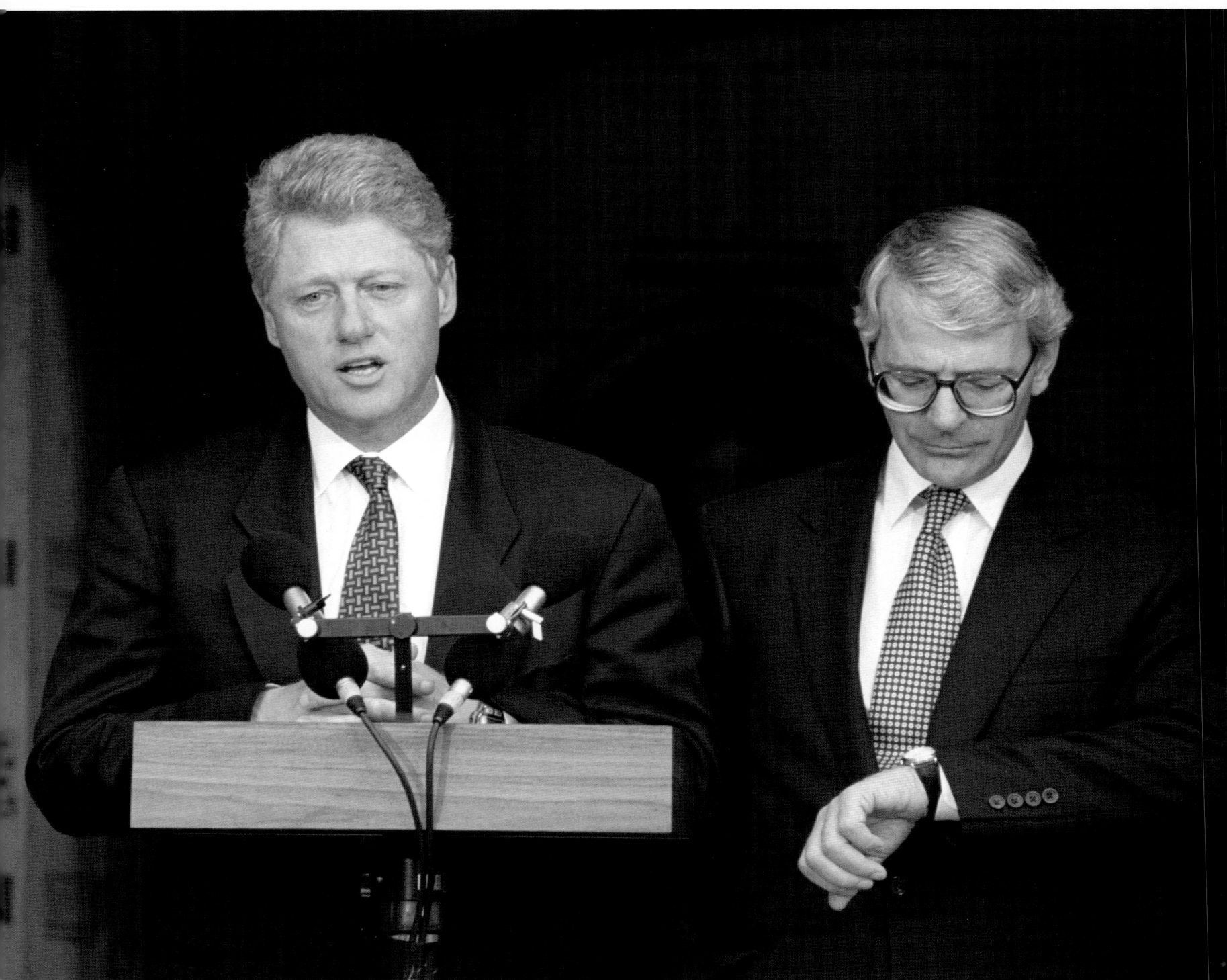

Above: *"Hurry up, Bill."* Prime Minister John Major checks his watch as US
President Bill Clinton addresses the media at Chequers. Clinton had become
president in the previous year and would serve two terms at the White House.
His second term would be marred, however, by the revelation that he had had an
affair with Monica Lewinsky and lied about it.

5th June, 1994

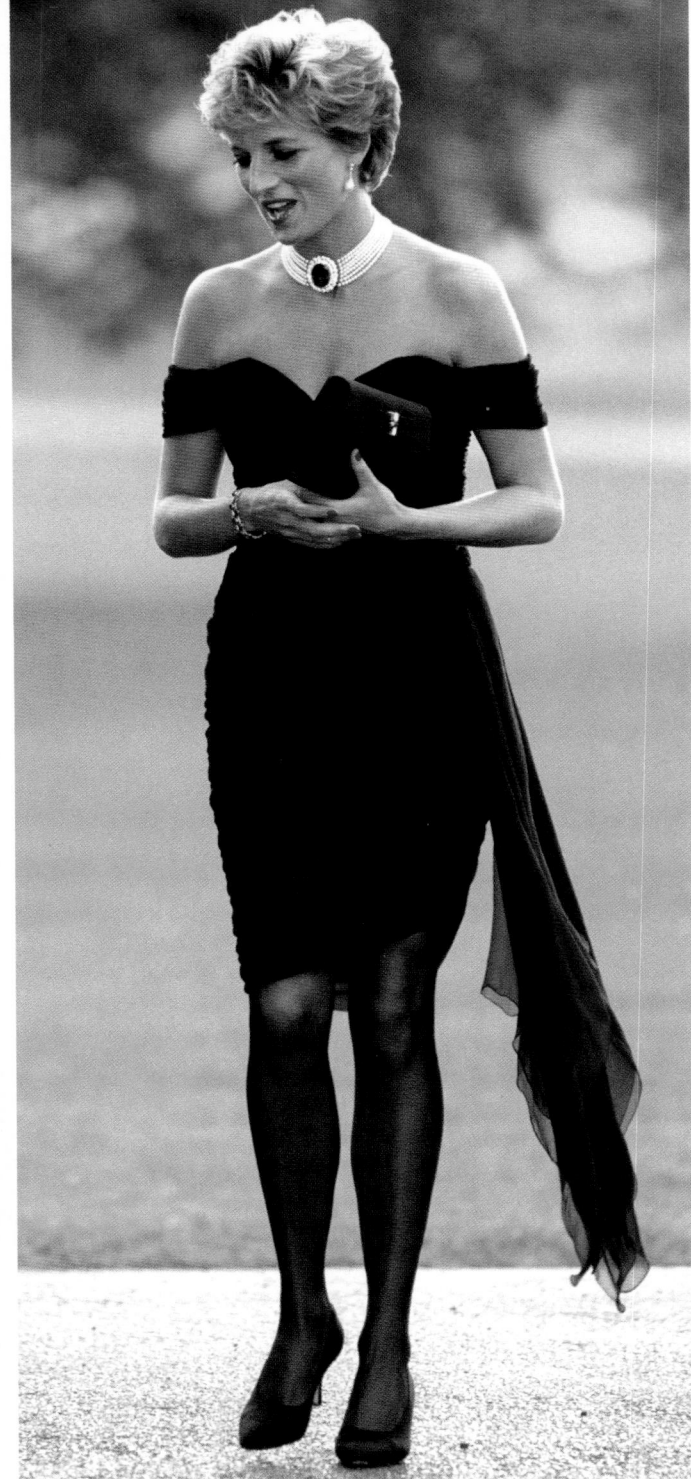

Above: That dress II. Diana, Princess of Wales arrives at London's Serpentine Gallery, wearing an eye-catching black chiffon dress by Christina Stamboulian. Famously, the dress helped her upstage Prince Charles, who went on TV that evening to give his side of their marriage break-up.

29th June, 1994

Below: Colin Jackson in the heats of the 110m Hurdles at the European Athletics Championship, Helsinki. He would go on to take the gold medal. During his career specializing in the 110m Hurdles, Jackson would win an Olympic silver medal, and become world champion three times, European champion for 12 years and Commonwealth champion twice.

11th August, 1994

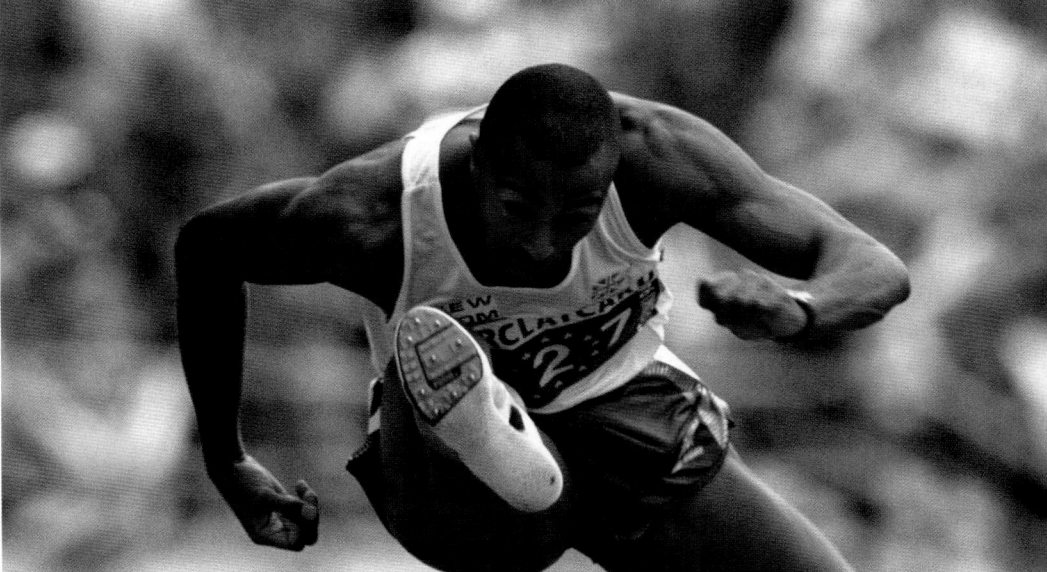

528

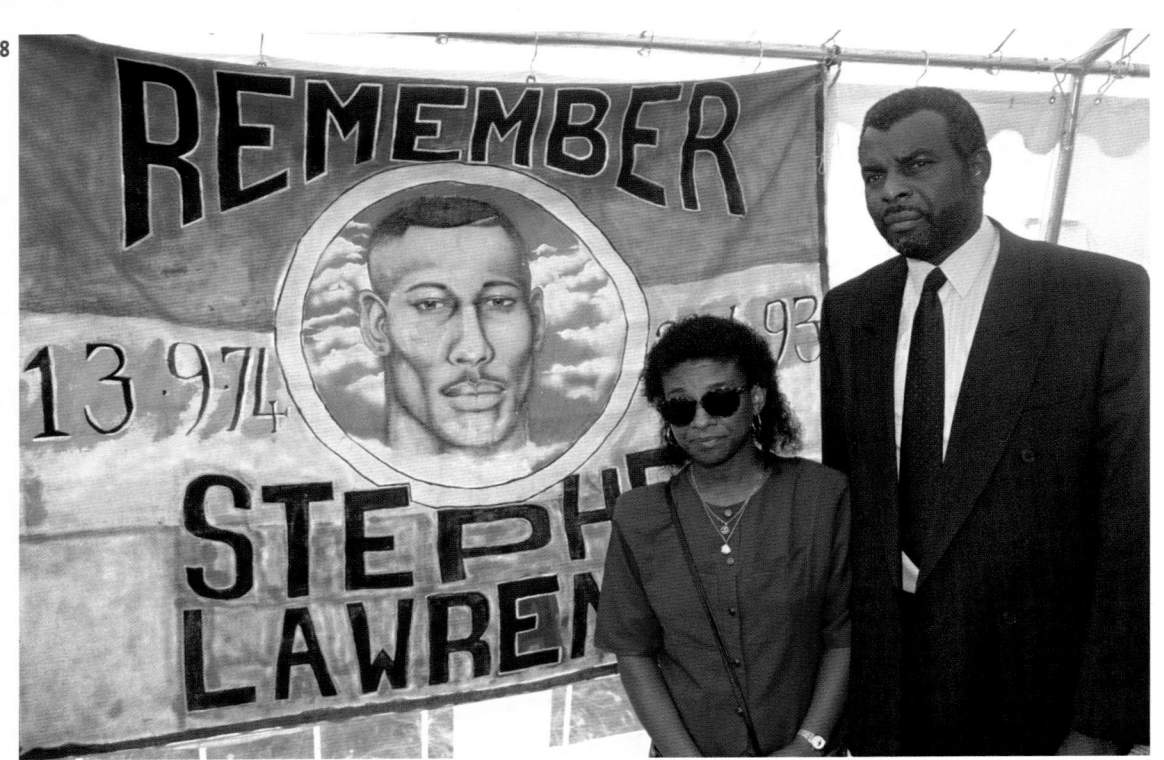

Left: Doreen and Neville Lawrence outside Belmarsh Magistrates' Court, south London, for the first day of the family's private prosecution accusing four men of killing their son, Stephen. Aged 18, he had been stabbed to death at a bus stop in Eltham, south-east London on 22nd April, 1993. The Lawrences exposed the shortcomings in the Metropolitan Police investigation of their son's murder, and they continue to speak out on racial inequality in Britain.

23rd August, 1995

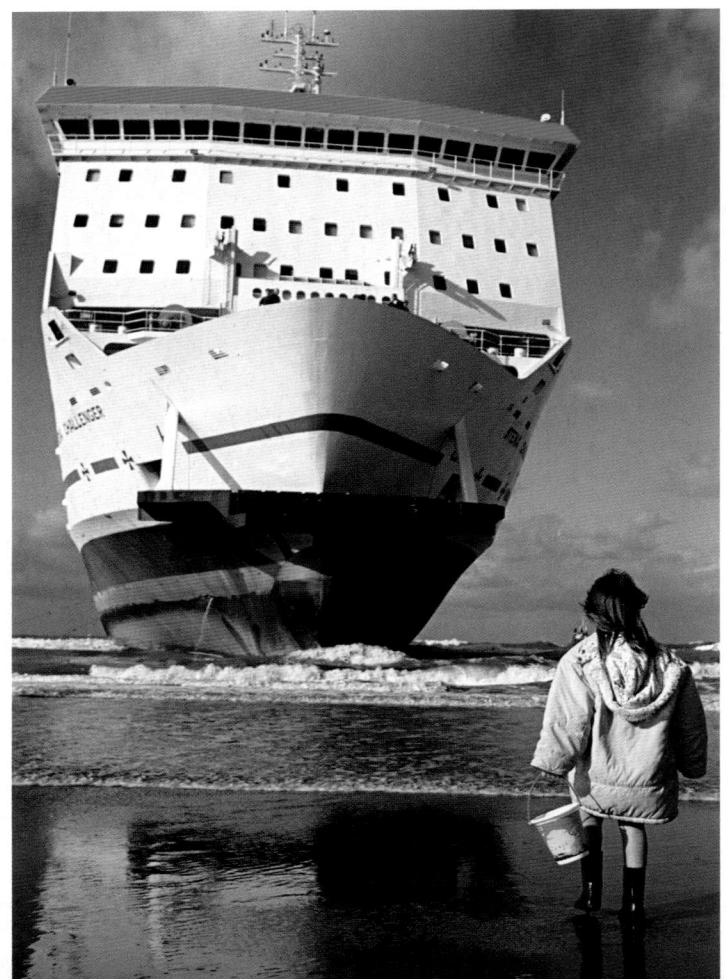

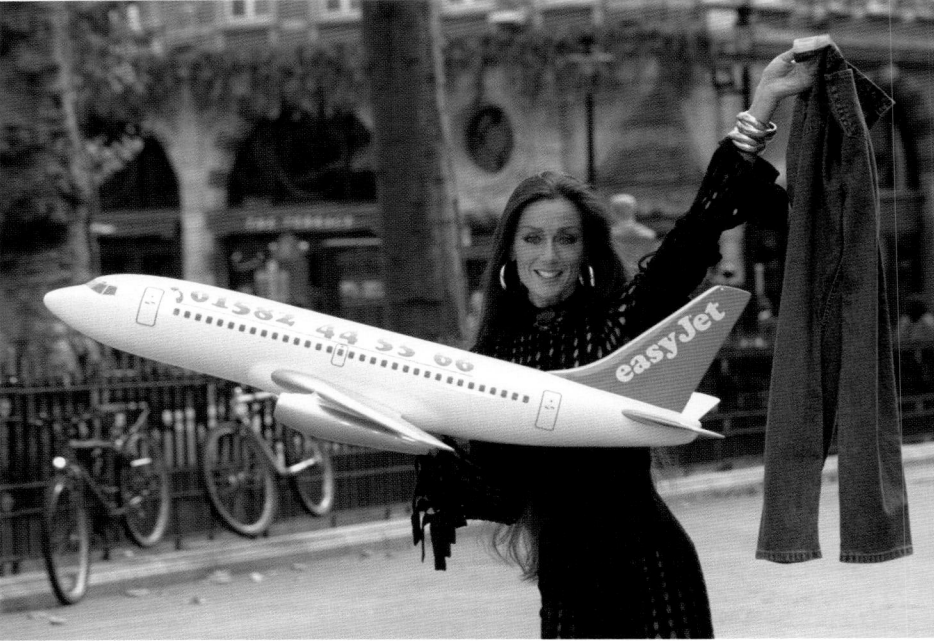

Above: Lorraine Chase helps launch easyJet's low-cost service to Edinburgh and Glasgow from Luton Airport. The airline's aim was to fly passengers to Scotland for less than the cost of a pair of jeans.

18th October, 1995

Left: The ferry *Stena Challenger* aground just outside the French port of Calais.

20th September, 1995

Right: Michael Jackson swings out over the audience in a crane hoist while performing his hit *Earth Song* at a star-studded Brit Awards ceremony at London's Earl's Court. The performance descended into farce, however, when Pulp's Jarvis Cocker ran on to the stage in protest at the content of the show, which depicted Jackson as a Christ-like figure surrounded by children. Cocker was questioned by police under suspicion of injuring some of the children, but no charges were brought.

19th February, 1996

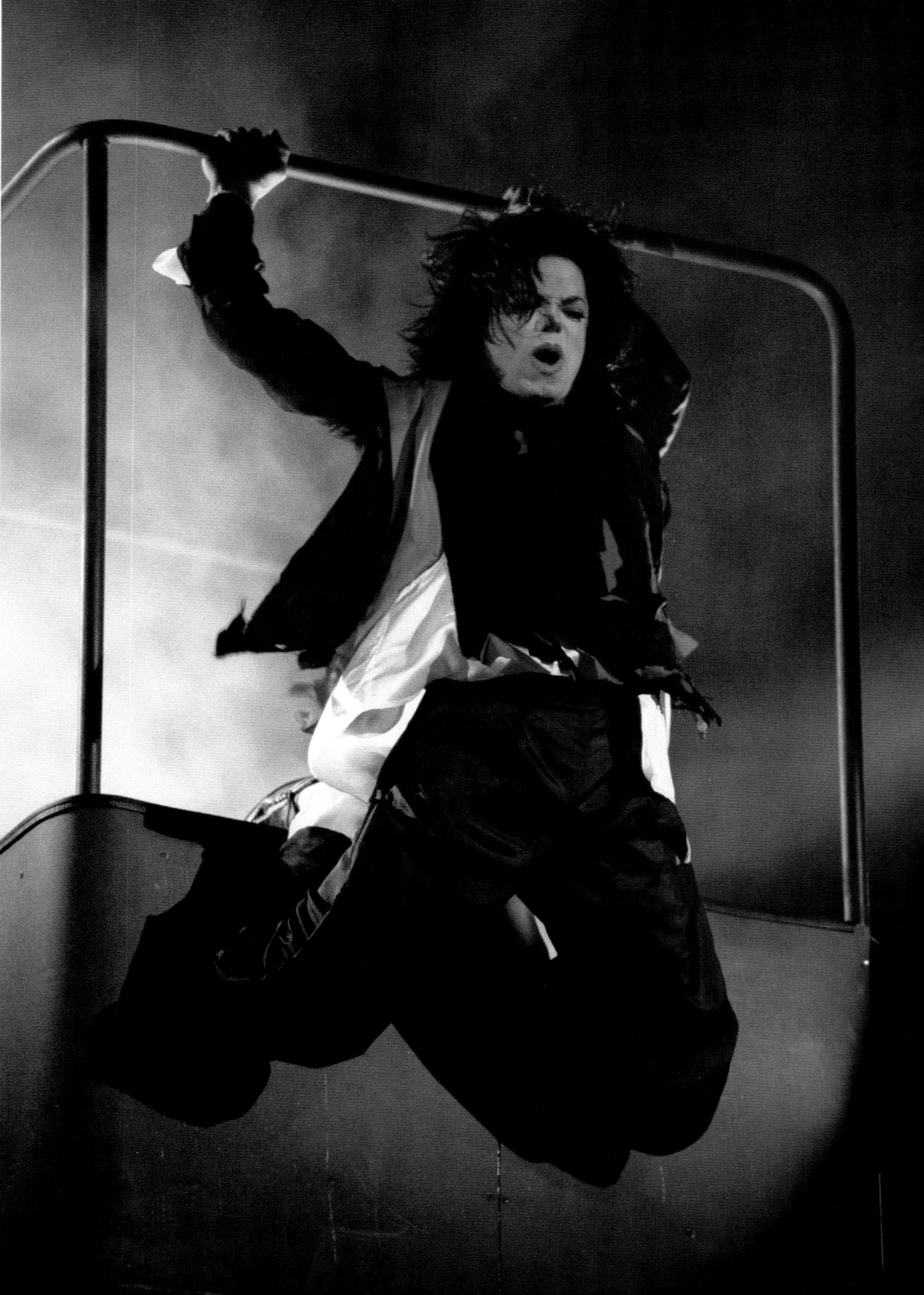

Above: The mangled remains of a bus blown apart by an IRA bomb in the Aldwych, London. The blast occurred on 18th February, just nine days after the IRA had ended a ceasefire by detonating a bomb in Docklands, which killed two and caused severe damage to several buildings. The bus bomb apparently exploded unexpectedly, killing the terrorist who was transporting it and injuring eight others.

20th February, 1996

Right: Seventeen red roses stand close to the gates of Dunblane Primary School, representing the young children and their teacher who had been shot dead by gunman Thomas Hamilton. After carrying out the mass murder, Hamilton committed suicide by shooting himself.

14th March, 1996

Above: Animal rights activists demonstrate outside the Ministry of Agriculture in London as government ministers and scientists meet to consider how to solve the crisis in the British beef industry, caused by the discovery that bovine spongiform encephalopathy – mad-cow disease – had crossed into humans. The government was considering the slaughter of four million cattle over the age of 30 months.

25th March, 1996

Right: The start of the 1996 London Marathon at Blackheath, south-east London. The marathon had been inaugurated by former Olympic champion Chris Brasher and Welsh athlete John Disley in 1981. The event has become one of the top five international marathons, and it is renowned for the enormous amounts of money raised for charity by participants.

21st April, 1996

Above far right: In the Euro 96 Group A match, at London's Wembley Stadium, Paul Gascoigne scores England's second goal in spectacular fashion as Scotland's Colin Hendry (R) can only look on powerless.

15th June, 1996

Far right: Great Britain's Tim Henman dives for the ball on his way to victory in his first-round game against Yevgeny Kafelnikov at Wimbledon. Henman would go on to reach the quarter finals before losing out to Todd Martin.

25th June, 1996

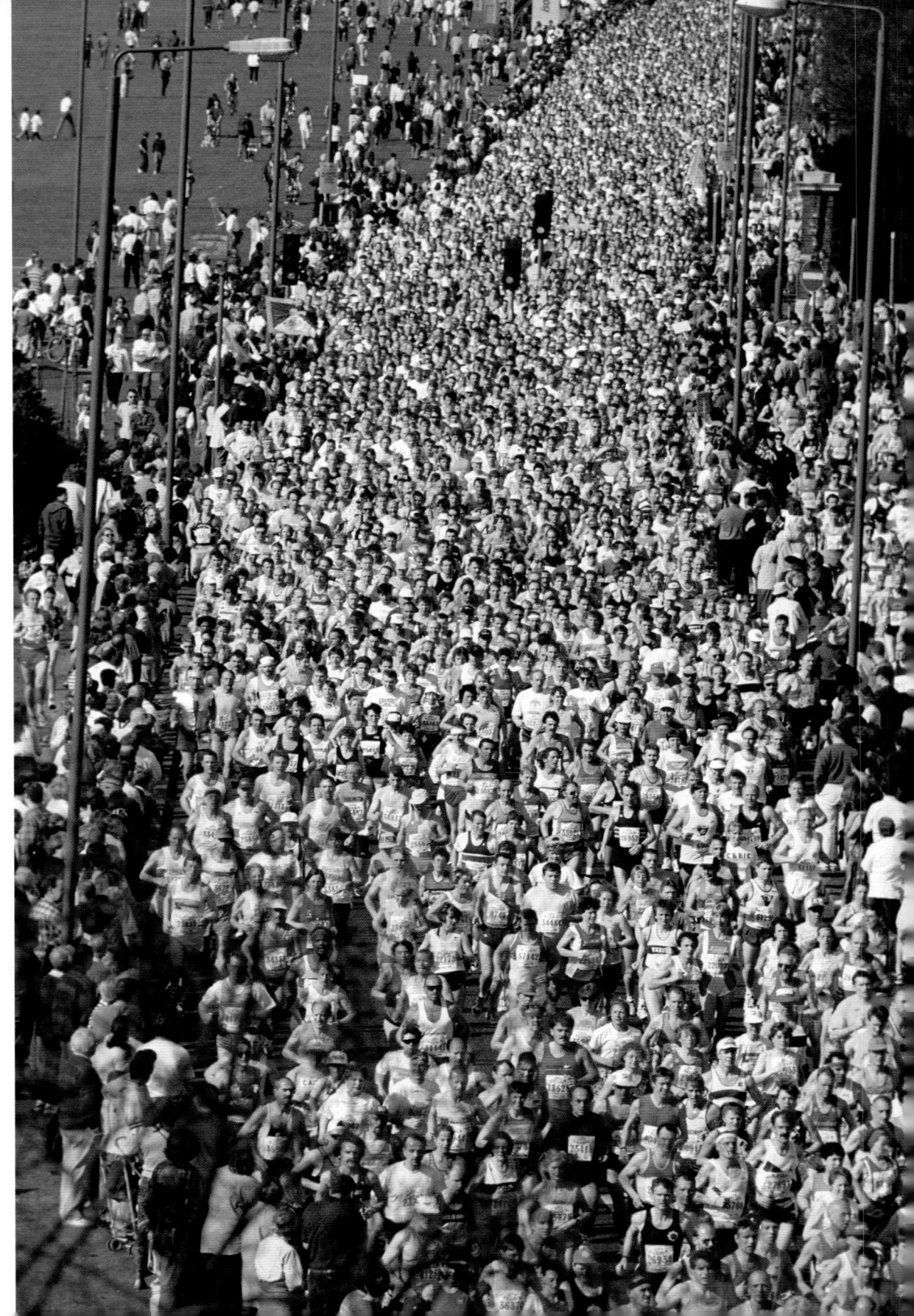

Right: A Protestant Orange Lodge band marches on Belfast's Ormeau Road while Catholic residents are barricaded in their own streets behind security vehicles. The animosity between the two religious groups has been responsible for much of the violence in Northern Ireland.

12th July, 1996

Below: At the Olympic Games in Atlanta, Georgia, Matthew Pinsent and Steve Redgrave of Great Britain win the gold medal in the Coxless Pairs rowing event. It was the second consecutive Games that the pair had taken gold in the class.

27th July, 1996

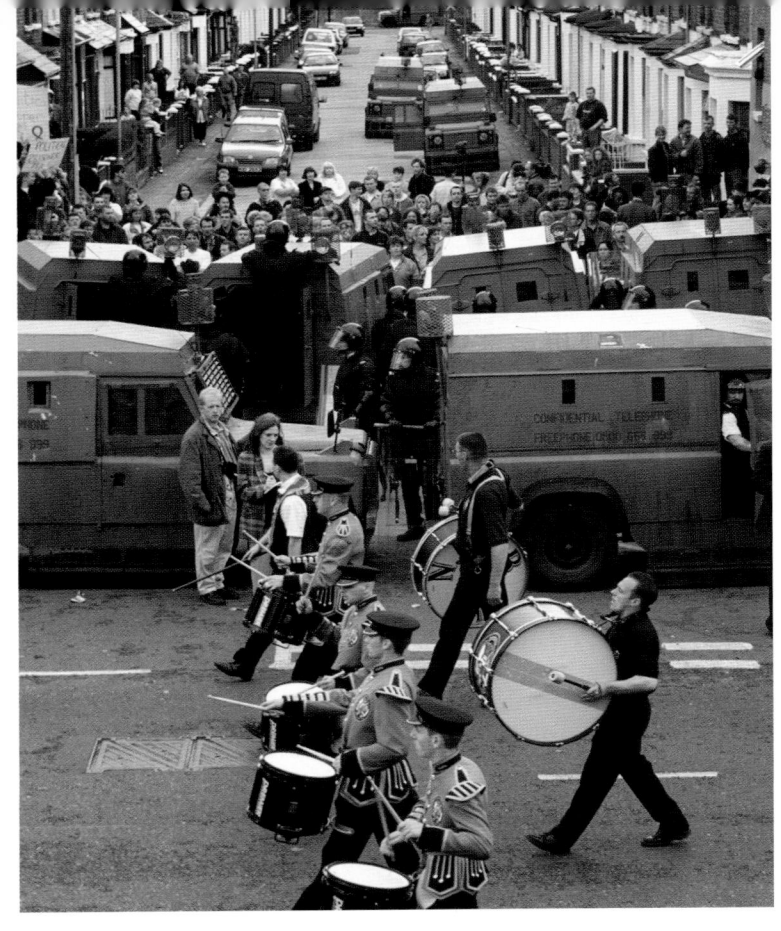

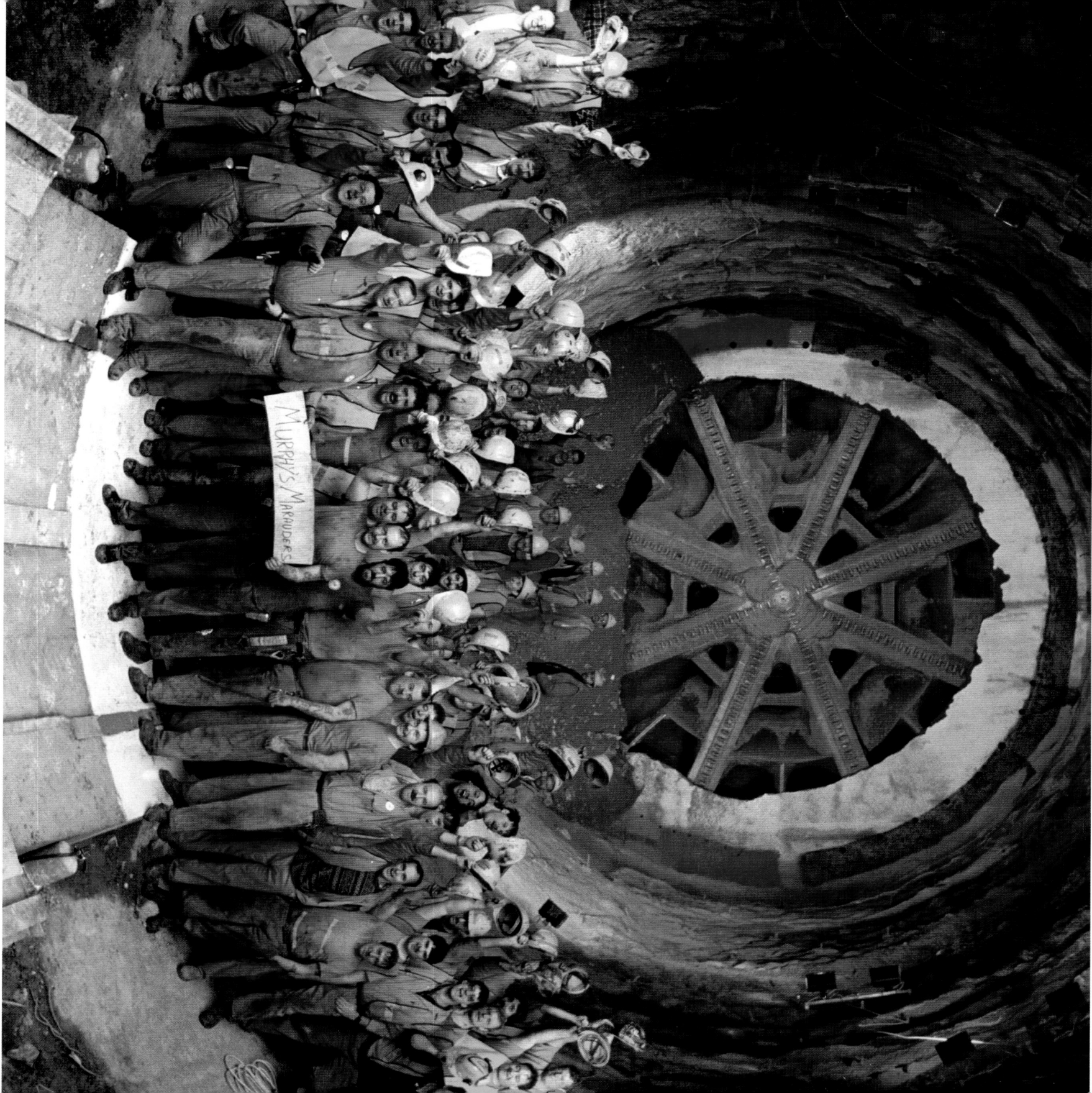

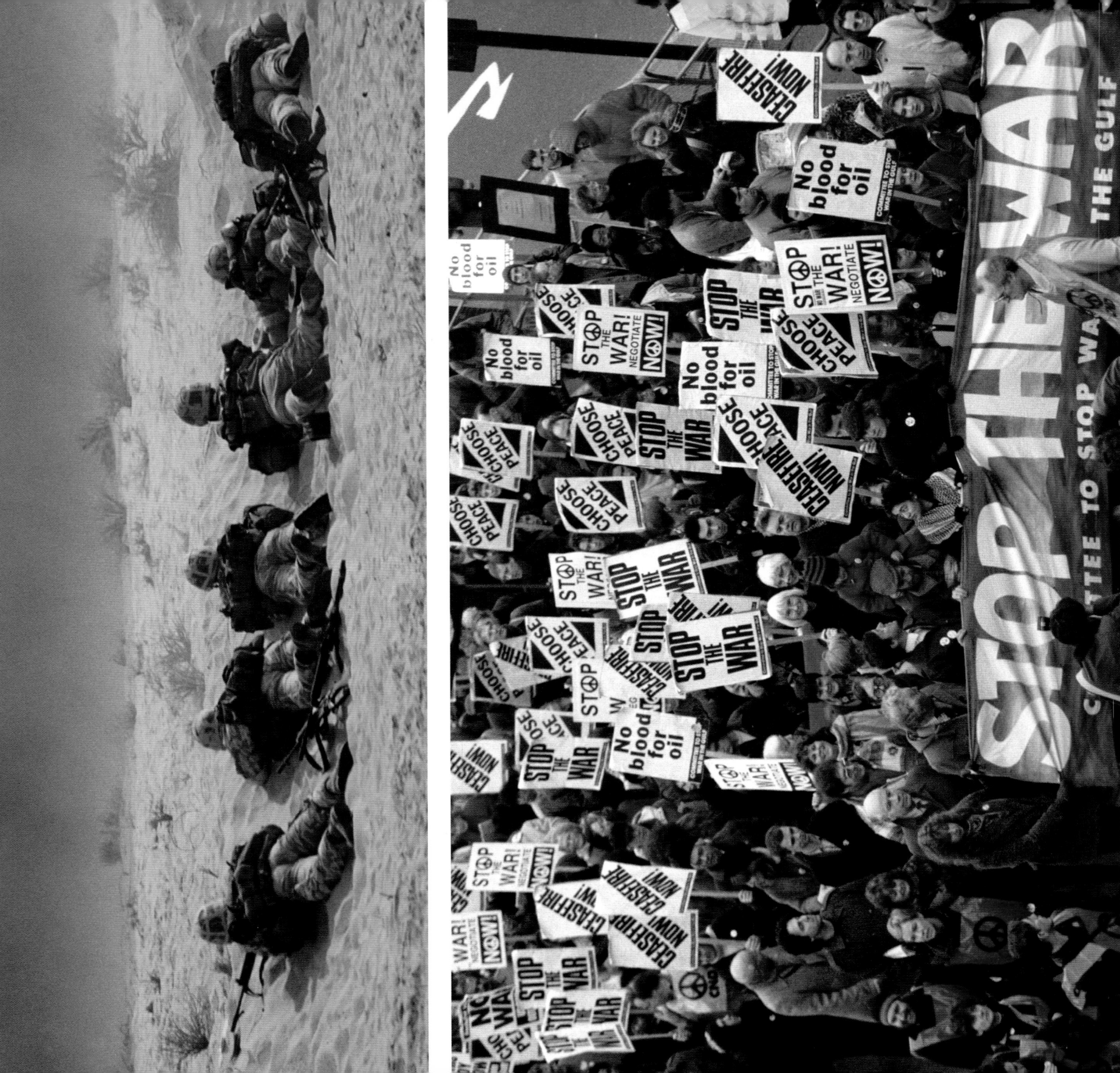

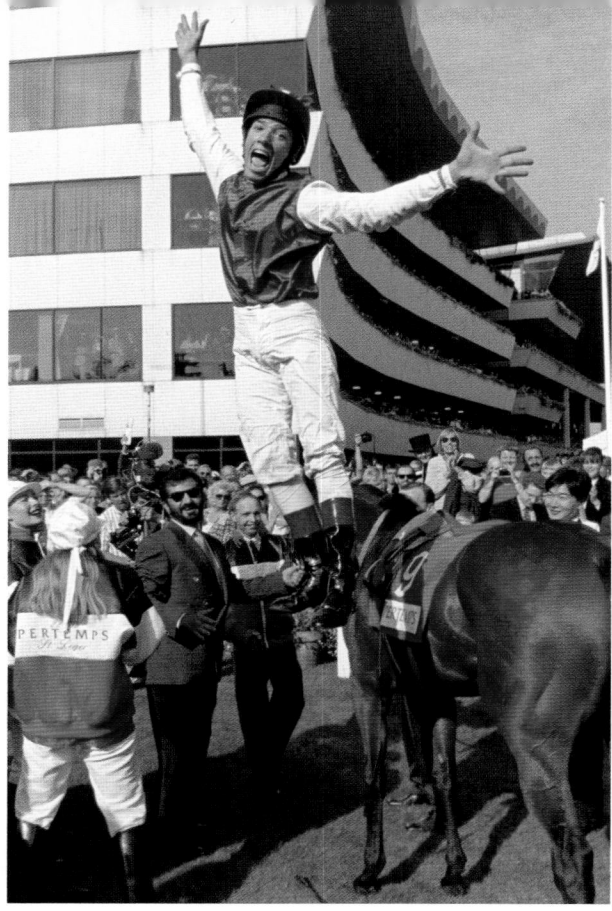

Left: At Doncaster Racecourse, Frankie Dettori dismounts in typically exuberant fashion after winning the St Leger on Shantou.

14th September, 1996

Below: Michael Schumacher and Mika Häkkinen pour champagne over new World Champion Damon Hill at the end of the Japanese Grand Prix. Hill was following in the footsteps of his famous father, Graham Hill, who had won the title in 1962 and 1968.

13th October, 1996

536

Below: Britain's first astronaut, Helen Sharman, at the unveiling of her wax figure at The London Planetarium. The figure, modelled by sculptor Sue Kale, is dressed in an exact replica of the Russian spacesuit Helen wore on her eight-day flight to the Mir space station. In 1989, Helen had answered a radio advertisement – *"Astronaut wanted – no experience necessary"* – and had been selected from 13,000 applicants to take part in Project Juno, the historic Soviet space mission, becoming the first Briton in space.

17th October, 1996

Above: All ship-shape. Richard Tilt (L), the director general of the Prison Service, and Trevor Williams, responsible for emergency prison accommodation, tour a former Pontins holiday camp, shaped like an ocean liner, near Heysham in Lancashire. The site had been proposed as a temporary prison.

28th January, 1997

Left: Diana, Princess of Wales wears body armour and a face shield to tour a minefield during a visit to Angola to see for herself the carnage the explosive devices can cause. Her high-profile support for the International Campaign to Ban Landmines, prompted by the terrible injuries they can cause to children, is thought to have influenced the signing of the Ottawa Treaty, which led to an international ban on the use of anti-personnel mines.

15th January, 1997

Above: Hale-Bopp, the brightest comet seen for over a century, above Glastonbury Tor, Somerset. Rumours abounded that the comet was being followed by an alien spacecraft, prompting a mass suicide by followers of the American Heaven's Gate cult. They claimed they would leave their bodies to travel to the space ship.

3rd April, 1997

Left: Environmental campaigner Swampy, on the site of the proposed second runway at Manchester Airport, announces that he will be standing in the General Election. The man dubbed the most famous eco-warrior in the country had joined campaigners protesting at the £172m development. Swampy was renowned for his tunnelling exploits.

31st March, 1997

Above right: An eerily quaint photograph of serial killers Fred and Rosemary West. The couple were responsible for the rape and murder of at least 12 young women and girls during the 1970s, many of the crimes having occurred at their home in Gloucester.

19th April, 1997

Right: Firefighters at the scene of an explosion at a British Gas plant in Runcorn, Cheshire. Nine people were taken to hospital, and 60 firefighters were called in to tackle the conflagration. Over 100 residents had to be evacuated from a nearby street.

24th April, 1997

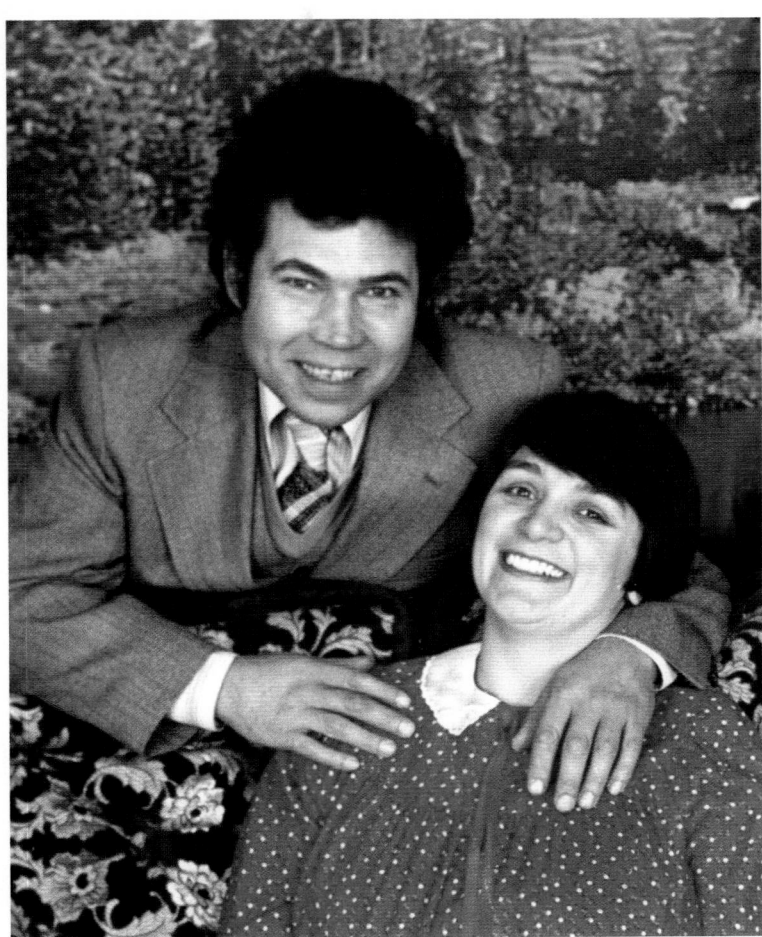

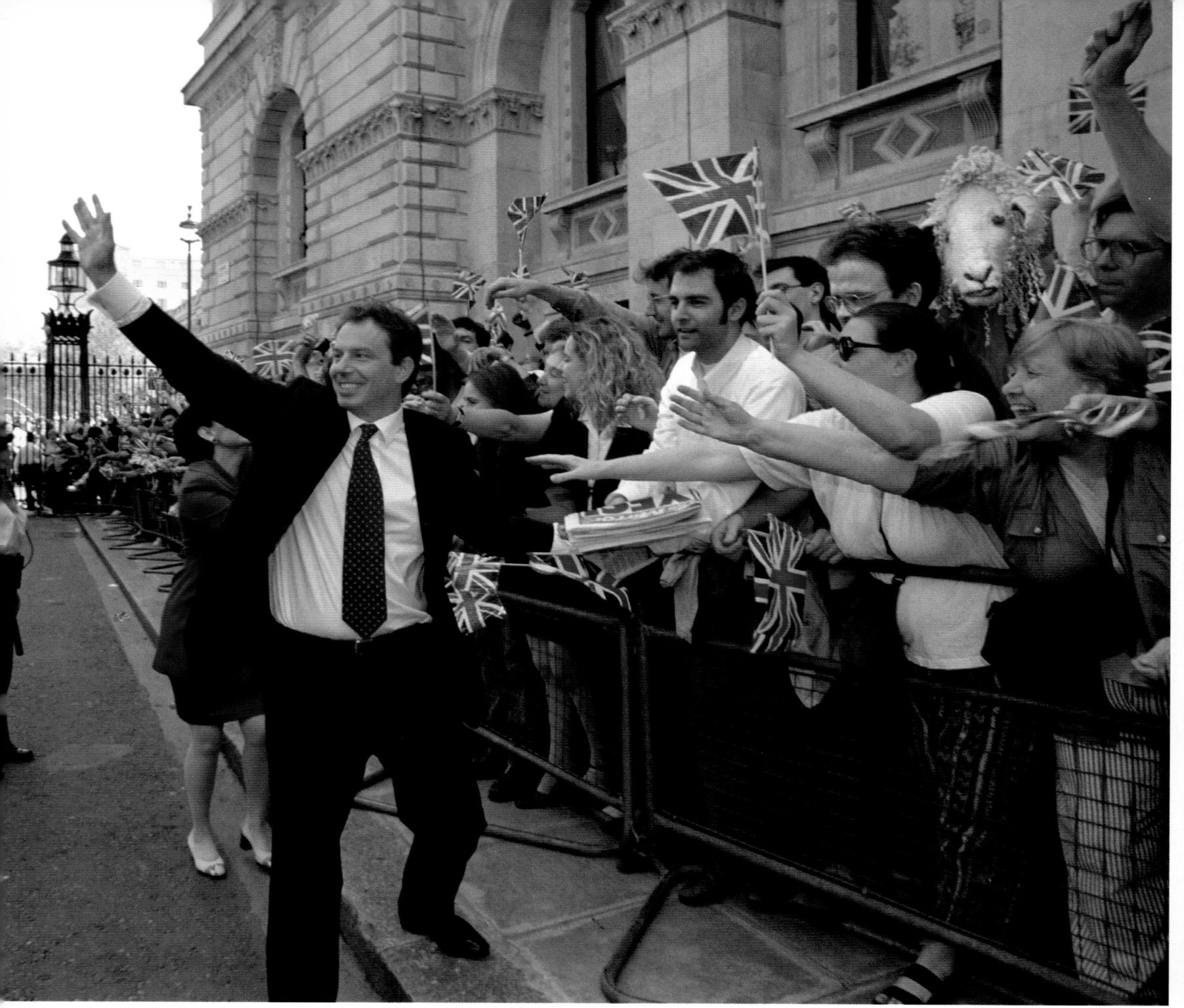

Above: New Prime Minister Tony Blair and his wife, Cherie, greet well-wishers as they walk into Downing Street. Labour had just gained a landslide victory in the General Election, leaving the Tories with their poorest result since 1832. Blair was the youngest prime minister since Lord Liverpool in 1812.

2nd May, 1997

Below: One is overcome by girl power! A somewhat bemused Prince of Wales, his face smudged with lipstick, makes friends with the Spice Girls. The group had an electrifying effect on statesmen and world leaders: Nelson Mandela described meeting them as *"an honour"*. L–R: Melanie Chisholm (Sporty Spice), Geri Halliwell (Ginger Spice), Emma Bunton (Baby Spice), PoW, Melanie Brown (Scary Spice) and Victoria Adams (Posh Spice).

9th May, 1997

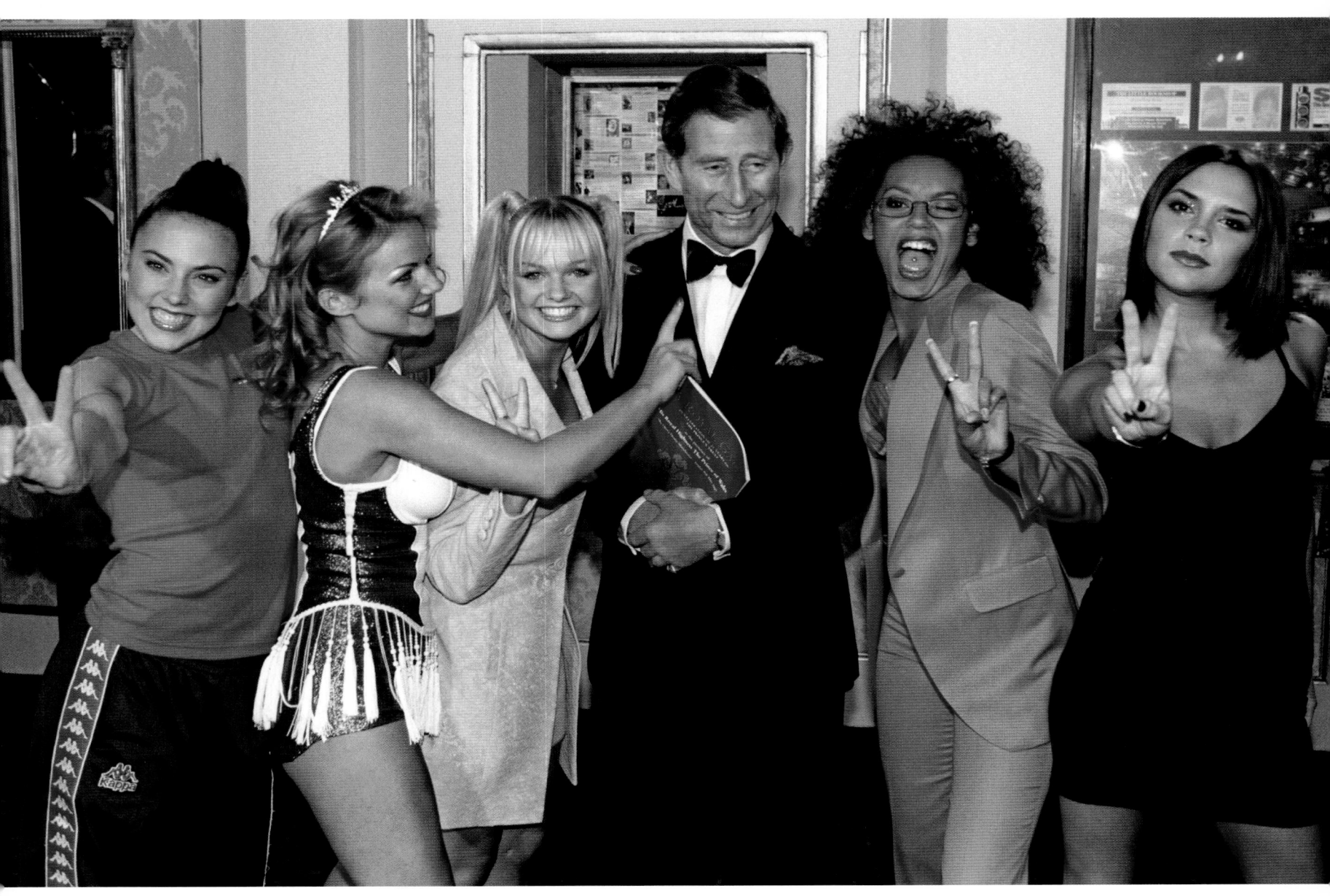

Left: Dolly the sheep, the world's first cloned animal, after being sheared by world champion shearer Geordie Bayne, from Hawick, at the Roslin Institute, near Edinburgh, to raise money for the cystic fibrosis charity.

20th May, 1997

Below left: Internationally renowned sculptor David Mach, 41, known for his large-scale works using everyday materials, stands on his latest creation, 'Brick Train' in Darlington. The sculpture, unveiled in the birthplace of passenger railways, is made entirely of bricks and was built by 36 men who usually build houses. The £670,000 cost of the giant locomotive was mainly covered by a grant from the Lottery Arts Fund.

23rd June, 1997

Right: Grey skies failed to dampen the party mood as the annual Notting Hill Carnival processions took to the streets.

24th August, 1997

544

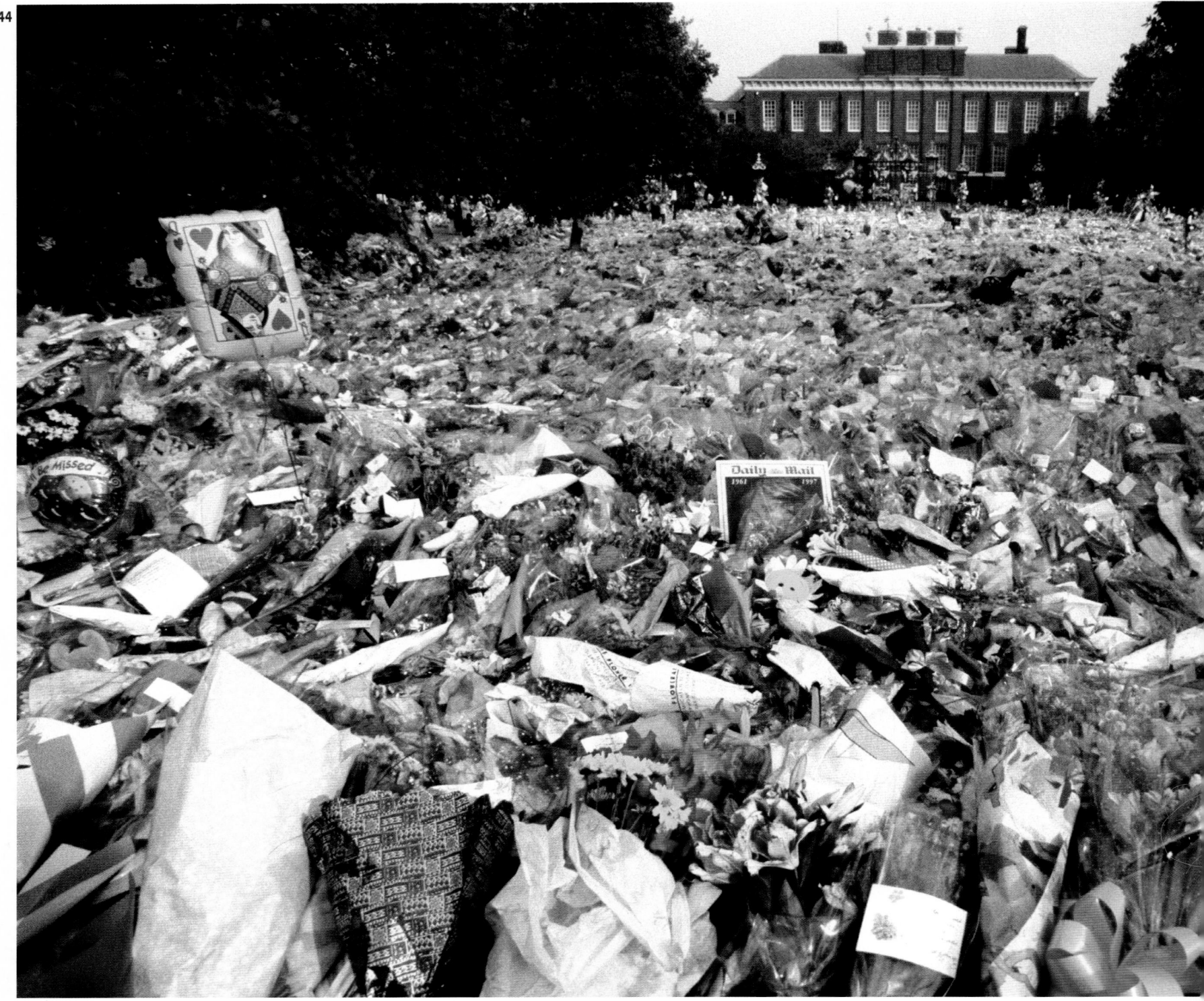

Above: A sea of flowers outside Kensington Palace in memory of Diana, Princess of Wales, who had died in a car crash in Paris on 31st August, 1997. Her death prompted an unprecedented outpouring of public grief.

2nd September, 1997

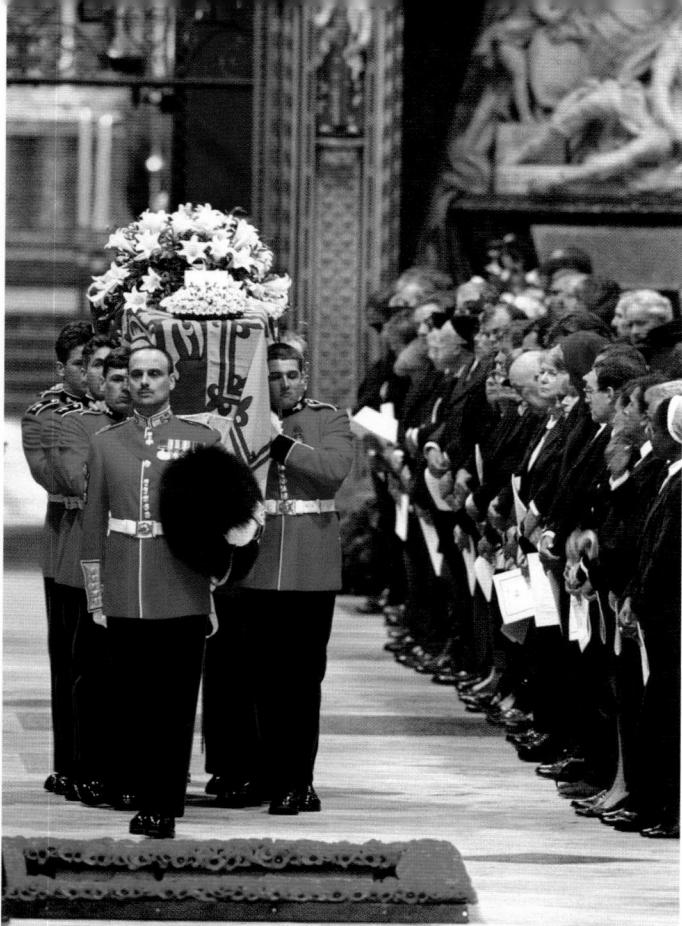

Left: The bearer party of Welsh Guardsmen carries the coffin of Diana, Princess of Wales out of Westminster Abbey following the funeral service.

6th September, 1997

Below: L–R: Earl Spencer (the Princess's brother), Princes William and Harry (her sons), and Charles, Prince of Wales wait as the hearse carrying the coffin of Princess Diana prepares to leave Westminster Abbey. It is thought that around 2.5 billion people watched the funeral, which was televised.

6th September, 1997

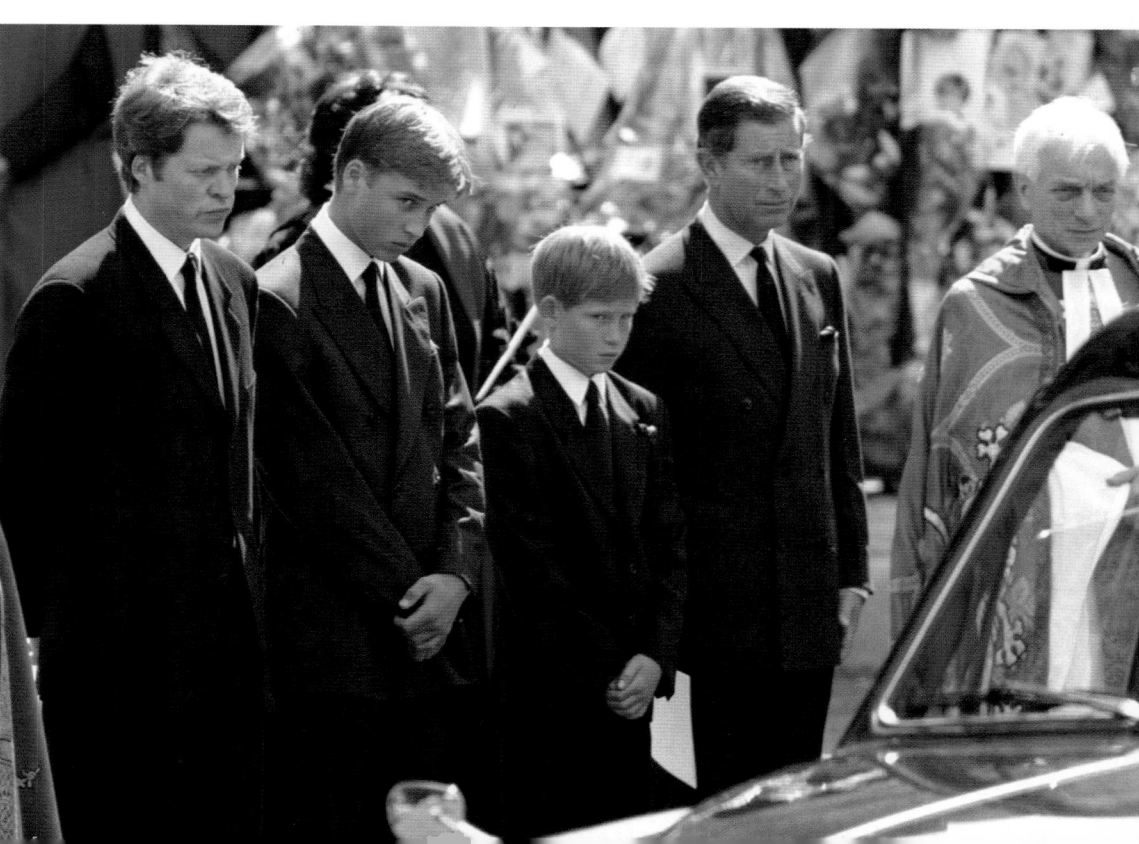

546

Right: Locals gather to watch as the wings are attached to Antony Gormley's controversial new north of England landmark – a gigantic steel sculpture, entitled 'Angel of the North', by the A1 Gateshead bypass in Tyneside. The 66ft (20m) tall sculpture was prefabricated from weather-resistant steel and designed to withstand winds of over 100mph (160km/h).

15th February, 1998

Below: Tote Cheltenham Gold Cup winner Cool Dawn, ridden by Andrew Thornton, leads the field over the jumps.

19th March, 1998

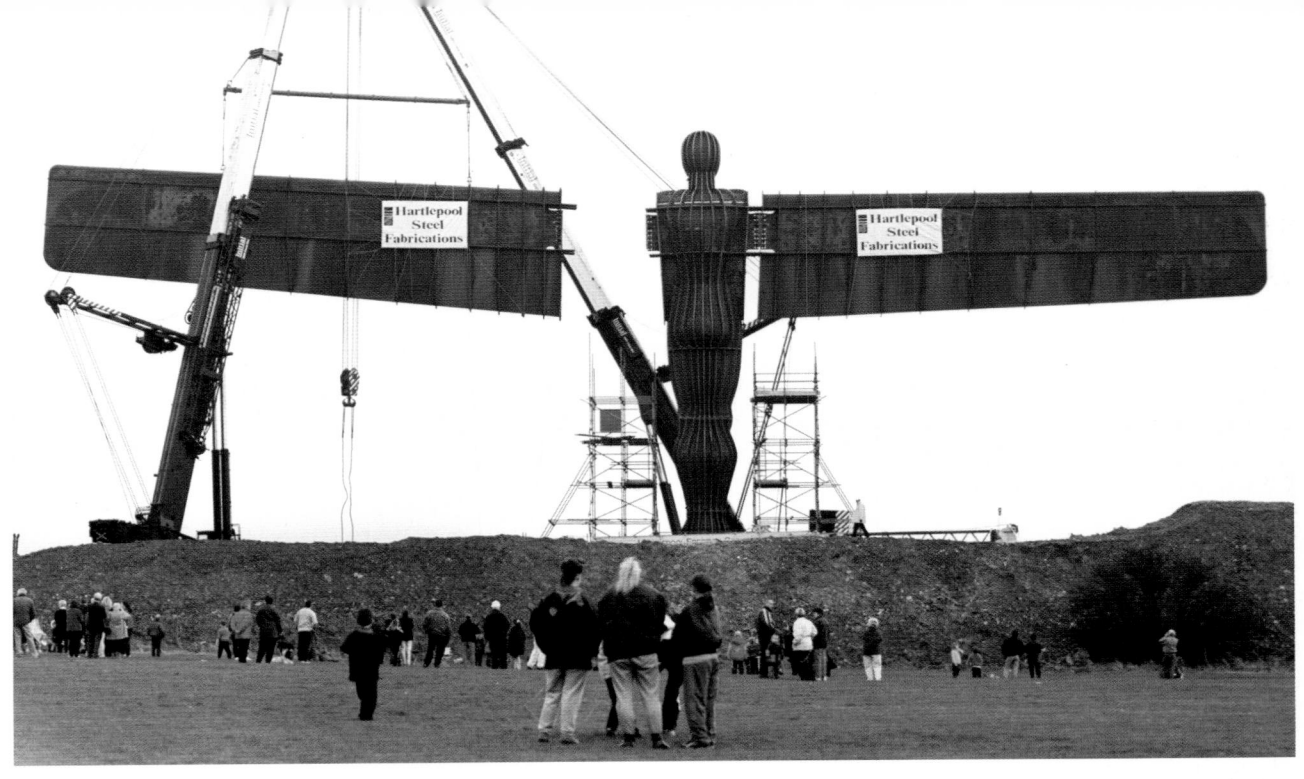

Below: Arsenal manager Arsene Wenger with the FA and League cups as the team takes a victory drive from the Highbury ground to Islington Town Hall to celebrate its double win.

17th May, 1998

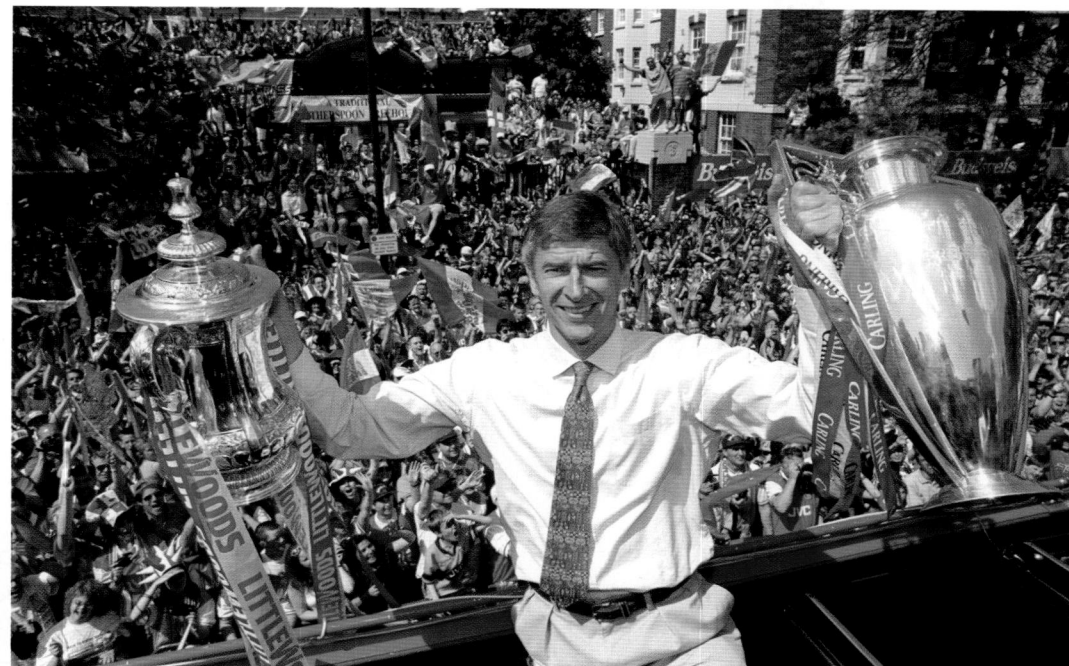

Above: Hello sailor! One of many flamboyant participants in London's annual Gay Pride Parade. A major feature of the parade is a 328ft (100m) rainbow flag, which is carried by the marchers. The event has grown to become the largest outdoor event in the UK, attracting a million people in 2009.

4th July, 1998

Left: Splashing out. As temperatures in the capital reach 25 degrees, Londoners are warned of the 'heat island' effect, whereby buildings and paved areas trap heat, causing higher than usual incidences of heatstroke. These two young women are taking no chances.

6th August, 1998

Far left: England's Darren Gough (second R) celebrates after taking the wicket of South Africa's Makhaya Ntini (L), to win the Fifth Cornhill Test, and the series, for England at Headingly.

10th August, 1998

Below far left: At the 17th European Athletics Championships, in Budapest, Hungary, Great Britain's Denise Lewis celebrates after winning the Heptathlon. She would win a gold medal in the event at the 2000 Sydney Olympics.

22nd August, 1998

Left: Welterweight Jane Couch (R) lands a punch on German boxer Simona Lukic, at Caesar's Palace, Streatham, London; she would win the bout with a technical knockout in the second round. Couch became the first officially licensed British female boxer in March 1998, after claiming sexual discrimination by the British Boxing Board of Control, which had refused to grant her a professional licence. Supported by the Equal Opportunities Commission, Couch had the decision overturned by tribunal.

25th November, 1998

Overleaf: Nearing completion, the Millennium Dome on the Greenwich peninsula stands out against the London skyline. The Queen would attend the opening ceremony on 31st December, 1999.

29th December, 1998

Above: Ravers from Britain get in the party mood at the MTV Ibiza 99 Extravaganza, celebrating all aspects of dance culture in San Antonio, as part of the annual San Antonio Festival.

24th August, 1999

Right: A Virgin airship flies over the still horizontal Millennium Wheel (London Eye) in central London. The wheel was sponsored by Virgin's rival, British Airways, and Virgin boss Richard Branson was taunting the airline with the slogan, "*BA Can't Get It Up!!*" The Millennium Wheel was supposed to have been lifted to its full 450ft (137m) height – three times taller than Tower Bridge – earlier that month, but when the anchor clips holding the support cables started to buckle under the weight, the mission had been aborted. The wheel finally opened to the public in March 2000, and it remains a major London attraction.

28th September, 1999

Right: Fireworks explode in a dazzling display over one of London's most recognizable landmarks, the clock tower of St Stephens (Big Ben), at the stroke of midnight, announcing the dawn of a new millennium. The 20th century had finally come to an end.

31st December, 1999

2000s

As the debris of the New Year revels was swept away, people awoke on 1st January, 2000 to the dawn of not only a new year, but also a new decade, a new century and a new millennium. Reason indeed for optimism. That outlook would be needed, too, for it would seem as though the bad news simply wouldn't stop: foot-and-mouth disease decimating the country's livestock; the deaths of Princess Margaret and the Queen Mother; race riots; terrorist bombings in London and Glasgow; the banking system in crisis; flooding and other extreme weather due to global warming; the scandal of MP's expenses; the MMR jab and swine flu scares. And underpinning it all, the controversial War on Terror in Afghanistan and Iraq, which still raged as the first decade of the 21st century came to an end.

Britons needed the indomitability and stoicism of earlier generations, who had weathered the storms of two world wars and the Depression of the 1930s. And they found that spirit when it came to celebrating the Queen's Golden Jubilee, not to mention the success of British athletes at the Olympics of 2000, 2004 and 2008, and in many other sporting endeavours. Life, as it turned out, was not all doom and gloom. There were reasons to be cheerful and, in the words of a famous wartime poster, to keep calm and carry on.

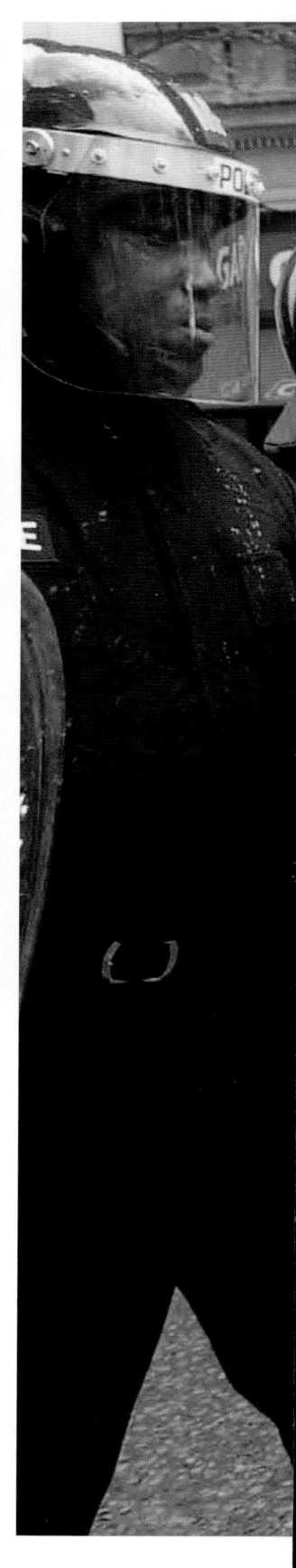

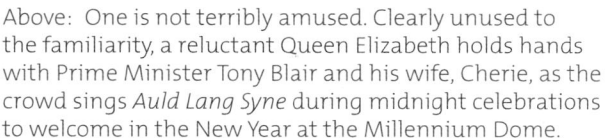

Above: One is not terribly amused. Clearly unused to the familiarity, a reluctant Queen Elizabeth holds hands with Prime Minister Tony Blair and his wife, Cherie, as the crowd sings *Auld Lang Syne* during midnight celebrations to welcome in the New Year at the Millennium Dome.

1st January, 2000

Right: An anti-capitalism demonstrator, dressed in a carnival fairy costume, taunts riot police with a feather duster in Trafalgar Square, central London during a march from Parliament Square.

1st May, 2000

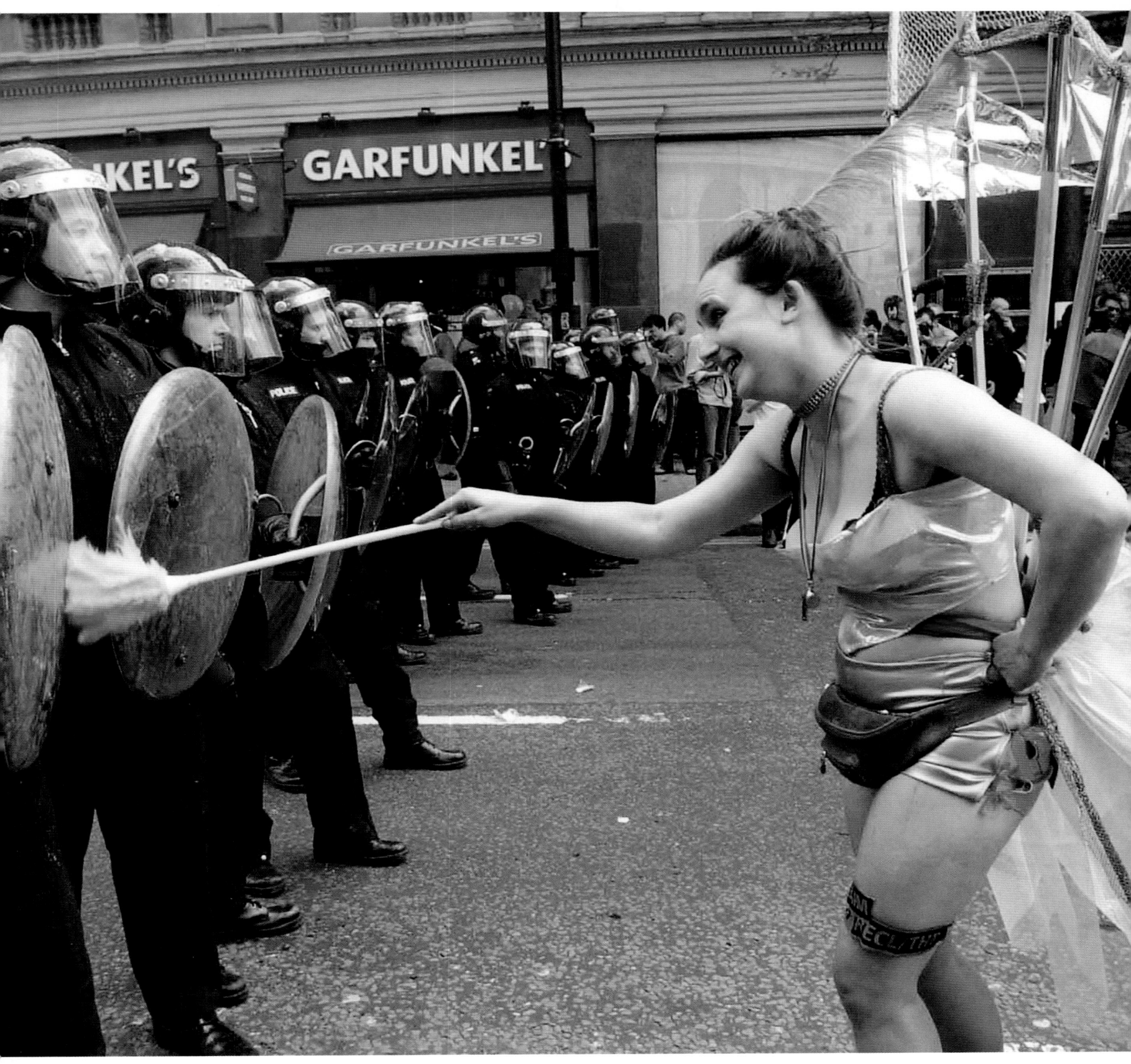

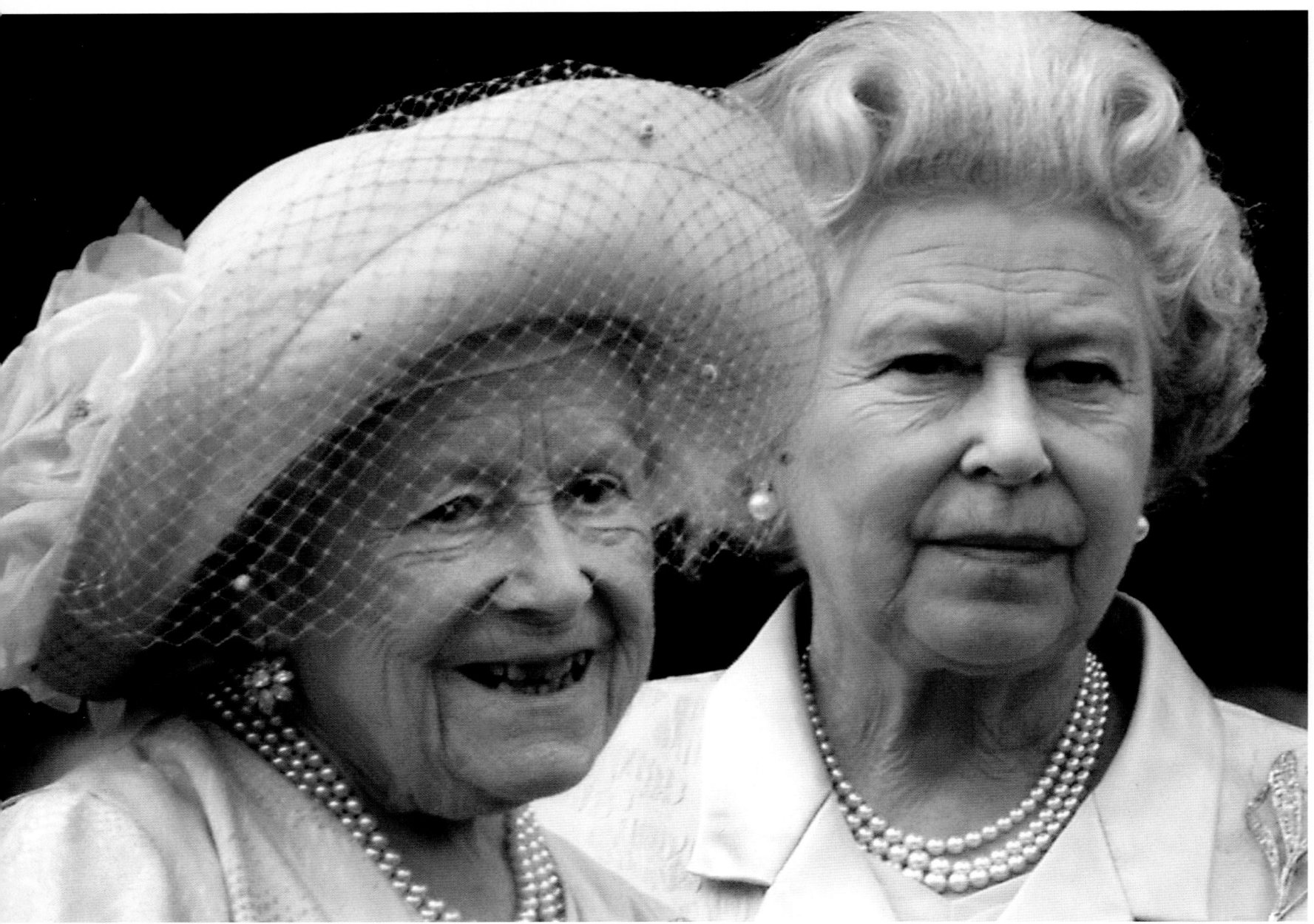

Above: The Queen Mother celebrates her 100th birthday from the balcony of
Buckingham Palace with her daughter, Queen Elizabeth II. Thousands of people
flocked to the streets outside the Palace to cheer the longest living Royal in the
history of the British monarchy.

4th August, 2000

Right: Eleven-year-old actor Daniel Radcliffe (C), who is to play the title role in the forthcoming film *Harry Potter and the Sorcerer's Stone*, based on the book by J.K. Rowling, with co-stars Rupert Grint (Ron Weasley) and Emma Watson (Hermione Granger) at the Berkeley Hotel in London.

23rd August, 2000

Below Great Britain's rowers (L–R) Matthew Pinsent, Steve Redgrave and James Cracknell, along with Tim Foster (not pictured), celebrate after winning the gold medal in the Men's Coxless Four rowing final at the Olympic Games in Sydney, Australia.

23rd September, 2000

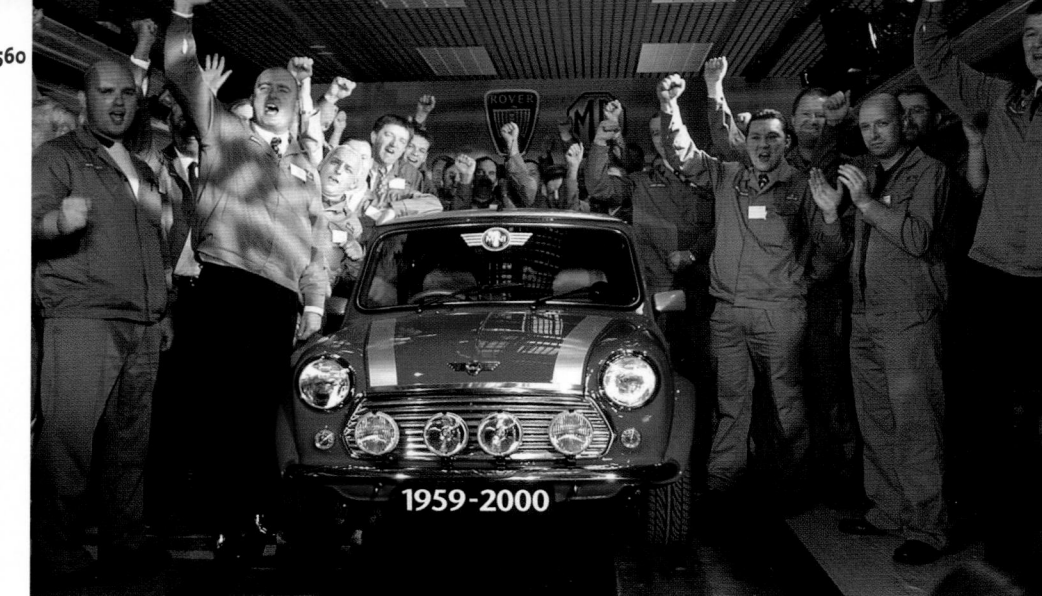

Above: Workers cheer as the 5,387,862nd and final classic Mini rolls off the line at the MG Rover Group factory in Longbridge, Birmingham, after 41 years of continuous production.

4th October, 2000

Right: Heads up! Aston Villa Captain Gareth Southgate (L) leads the charge for a loose ball during the team's FA Premiership football match against Everton at Goodison Park, Liverpool.

5th November, 2000

Below: Waves crash against Dover's promenade after parts of Britain were lashed by a massive overnight storm that claimed at least two lives and caused millions of pounds of damage.

3rd October, 2000

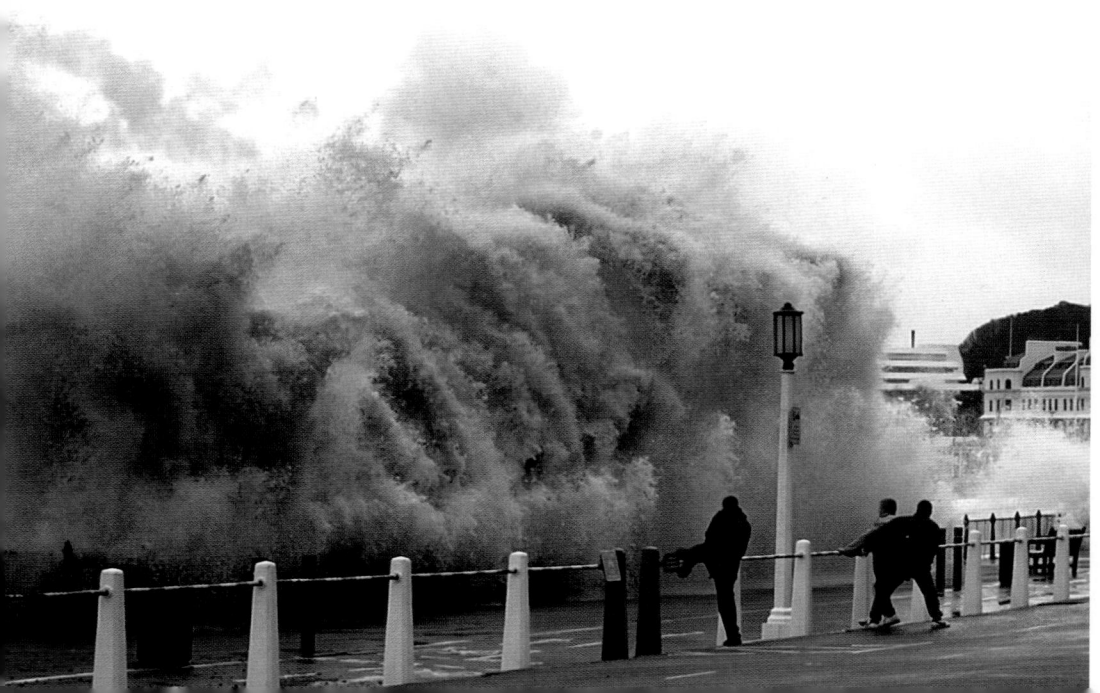

Above: A great plume of acrid smoke rises into the blue wintry sky from a pit on Netherplace Farm, Lockerbie in Scotland, where all the cattle and sheep are being burned. The farm was the first in Scotland to be affected by the outbreak of foot-and-mouth disease.

4th March, 2001

Right: Smoke billows from a burning barricade on Abbey Street in Bradford as members of the Asian community and police continue to clash after a day of violence in the city. Rioting had broken out following racial tension between the area's ethnic minorities and the white majority.

7th July, 2001

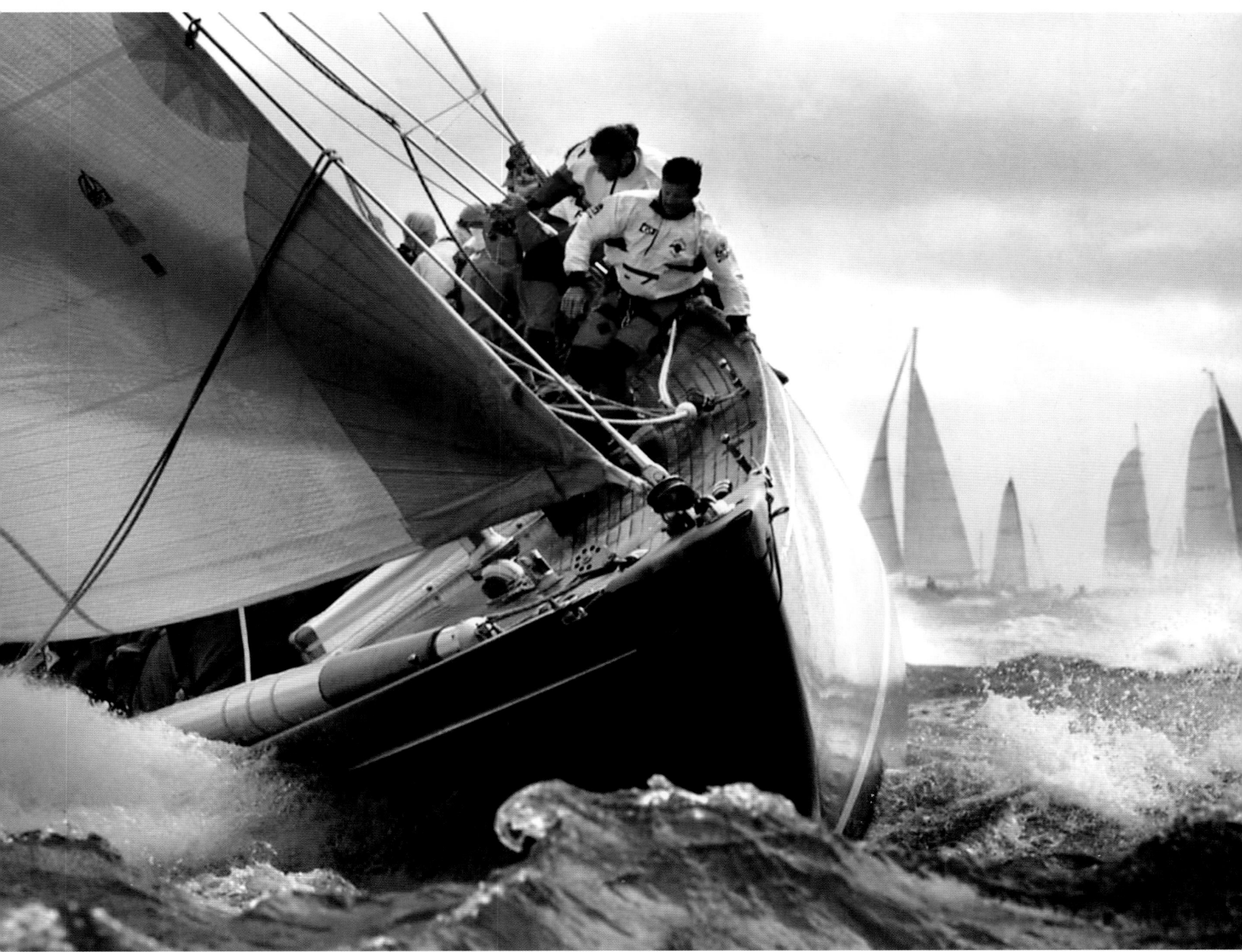

Above: Sir Thomas Lipton's famous J-class yacht *Shamrock V* pounds through heavy seas in the Solent, off Cowes, Isle of Wight on the first day of racing at the America's Cup Jubilee Regatta.

19th August, 2001

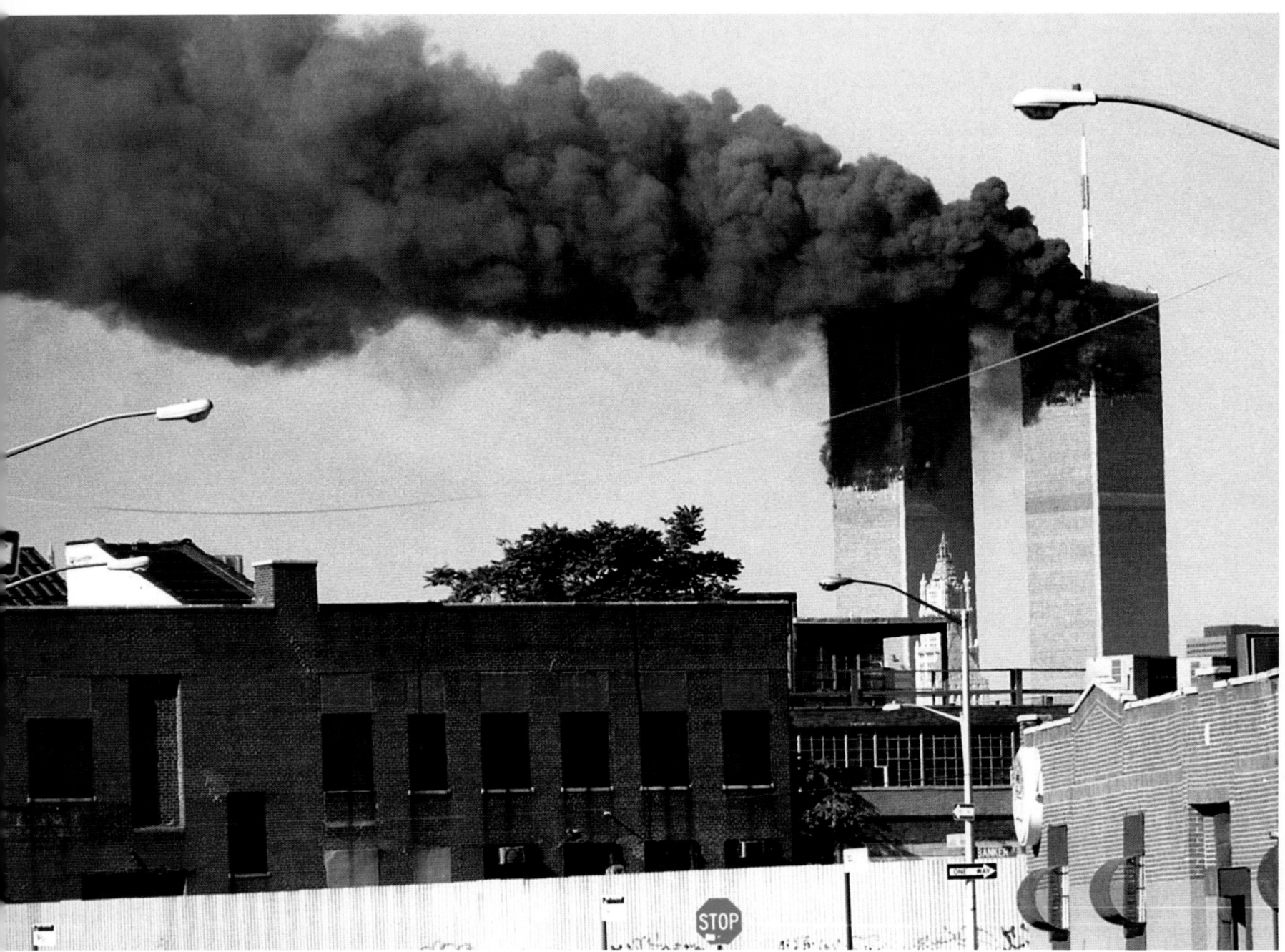

Above: Dense smoke from fires burning within the twin towers of New York's World Trade Center stains the sky. Al-Qaeda terrorists had crashed two hijacked airliners into the buildings, killing thousands, including Britons. Another plane had been seized and flown into the Pentagon in Washington, while a fourth, possibly headed towards the White House, had crashed after passengers had fought back against the hijackers. .

11th September, 2001

Left: A fire truck ploughs through a cloud of thick dust in the immediate aftermath of the destruction of the World Trade Center in New York. Rescue workers would face an enormous task in recovering the bodies of those killed in the terrorist attacks on the twin towers and the Pentagon in Washington.

12th September, 2001

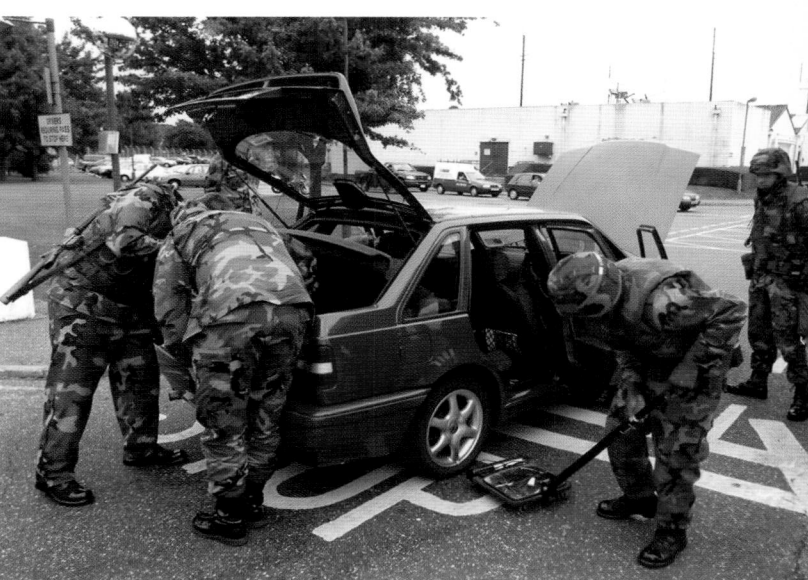

Above: US servicemen carry out an intensive search of every vehicle entering the USAF base at RAF Mildenhall, Suffolk, in a heightening of security after the terrorist attacks carried out in New York and Washington.

15th September, 2001

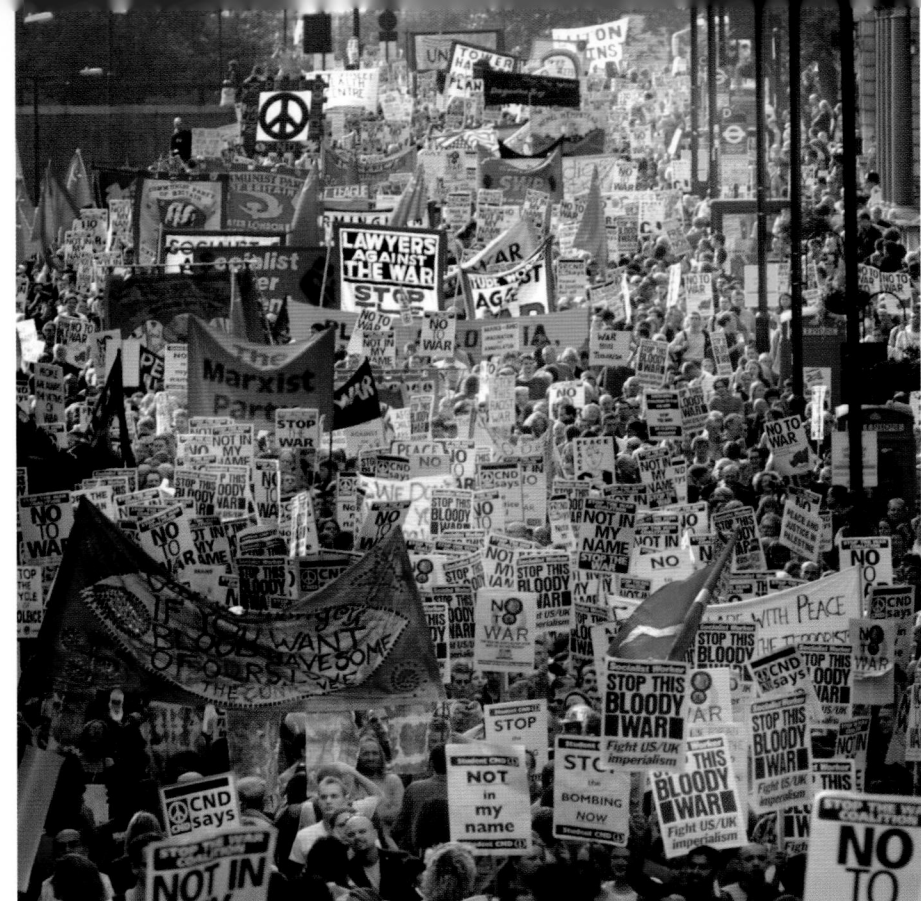

Left: Protesters on their way to Trafalgar Square from London's Hyde Park, as the march organized by CND against military strikes on Afghanistan gets under way. The assault on Afghanistan had been prompted by the Al-Qaeda attacks on New York and Washington: the terrorist group operated training camps in the country with the connivance of the ruling Taliban.

13th October, 2001

Below: Royal Marines from 40 Commando huddle together with their equipment as the Royal Navy Sea King helicopter that flew them in takes off. The Marines were taking part in exercise Saif Sarrea in Oman. With conflict in Afghanistan and increasing belligerence toward Iraq, Britain's forces were on an urgent training schedule in the Middle East.

19th October, 2001

Left: Australian pop princess Kylie Minogue performing on stage during the Smash Hits T4 Poll Winners Party at the London Arena in Docklands. She would be voted the world's sexiest star, taking the title ahead of such celebrities as Catherine Zeta-Jones, Britney Spears and Nicole Kidman.

9th December, 2001

Below: The final two contestants in the first series of the television talent show *Pop Idol*, Gareth Gates (L) and Will Young, face to face at a photocall in Stephen Street London, following the voting off of Darius Danesh. Young would go on to win and develop a successful pop career. Gates would also become a professional singer, but would concentrate his efforts on stage musicals.

3rd February, 2002

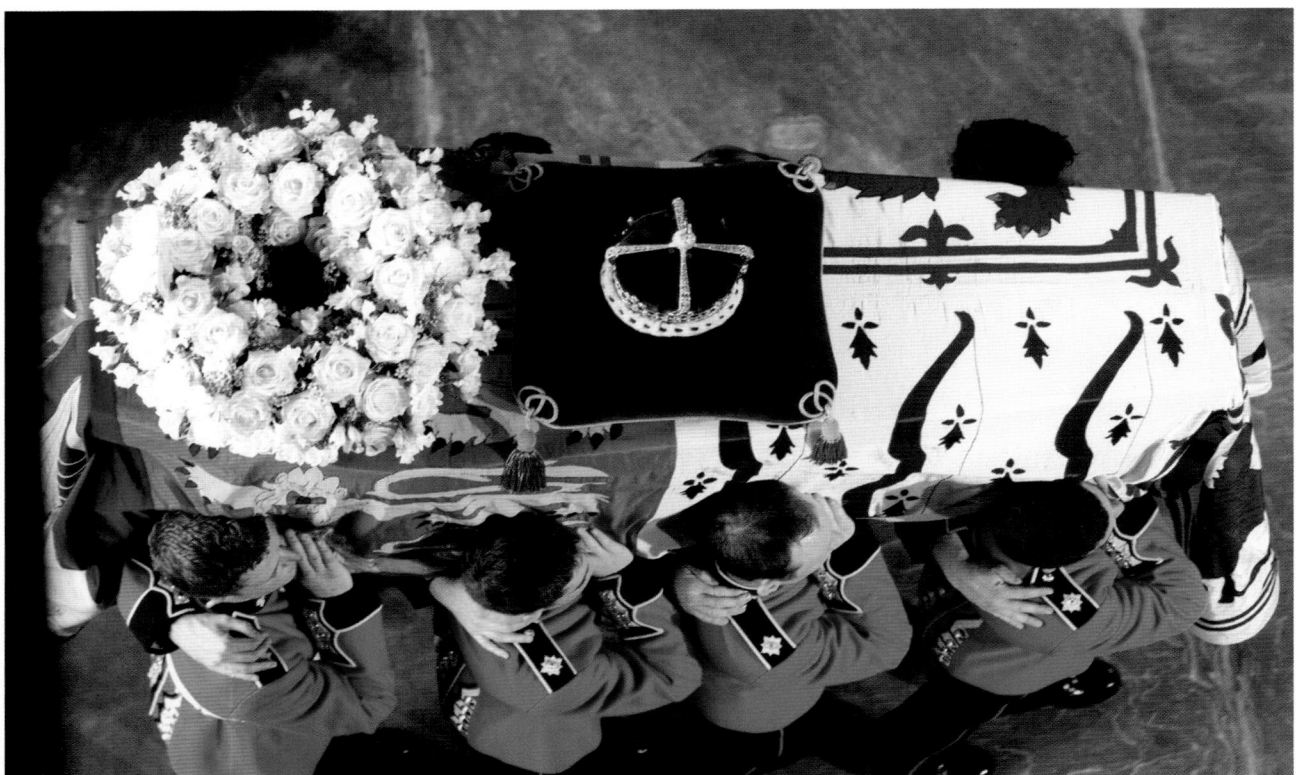

Left: Two military knights maintain a vigil at the coffin of Princess Margaret before her funeral in St George's Chapel, Windsor Castle. Some 400 family, friends and staff were expected at the service. Princess Margaret, the younger sister of Britain's Queen Elizabeth II, had died on 9th February, 2002, aged 71.

15th February, 2002

Below left: The coffin of Queen Elizabeth, the Queen Mother is carried into Westminster Hall, where she will lie in state until her funeral at Westminster Abbey. She had died on 20th March, 2002, at the great age of 101.

5th April, 2002

Left: Flora London Marathon participant LLoyd Scott, from Rainham in Essex, takes a break for lunch in Goddards Pie and Mash House, Greenwich. Scott was walking the London Marathon in full diving gear for the CLIC charity, based in Bristol. Scott has raised more than £4m for cancer charities.

15th April, 2002

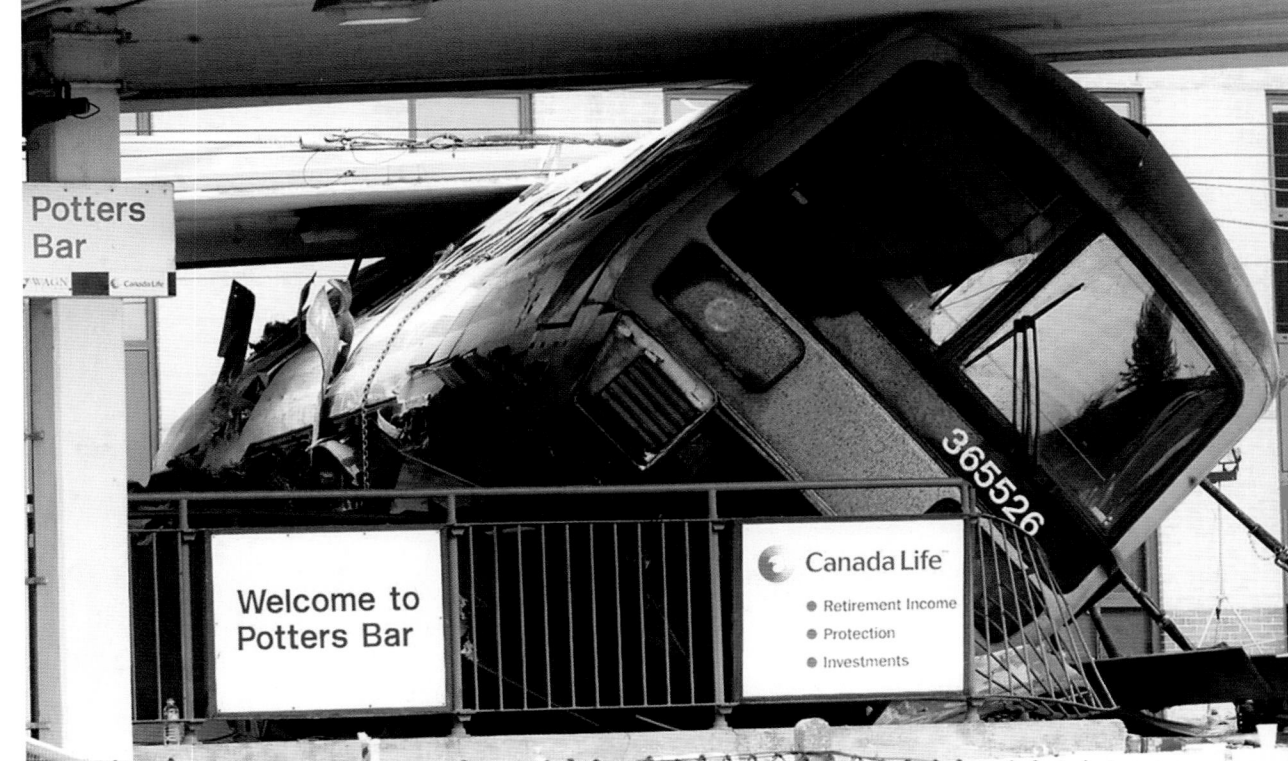

Right: Part of a train is wedged beneath the platform canopy after a high-speed rail crash at Potter's Bar station, Hertfordshire. The accident, caused by faulty points, killed seven and injured 76. Railtrack, responsible for track maintenance, said it was not aware that there had been any problems on that stretch of track. The company's comment came after reports that both passengers and drivers had felt a bump when trains crossed the accident point.

11th May, 2002

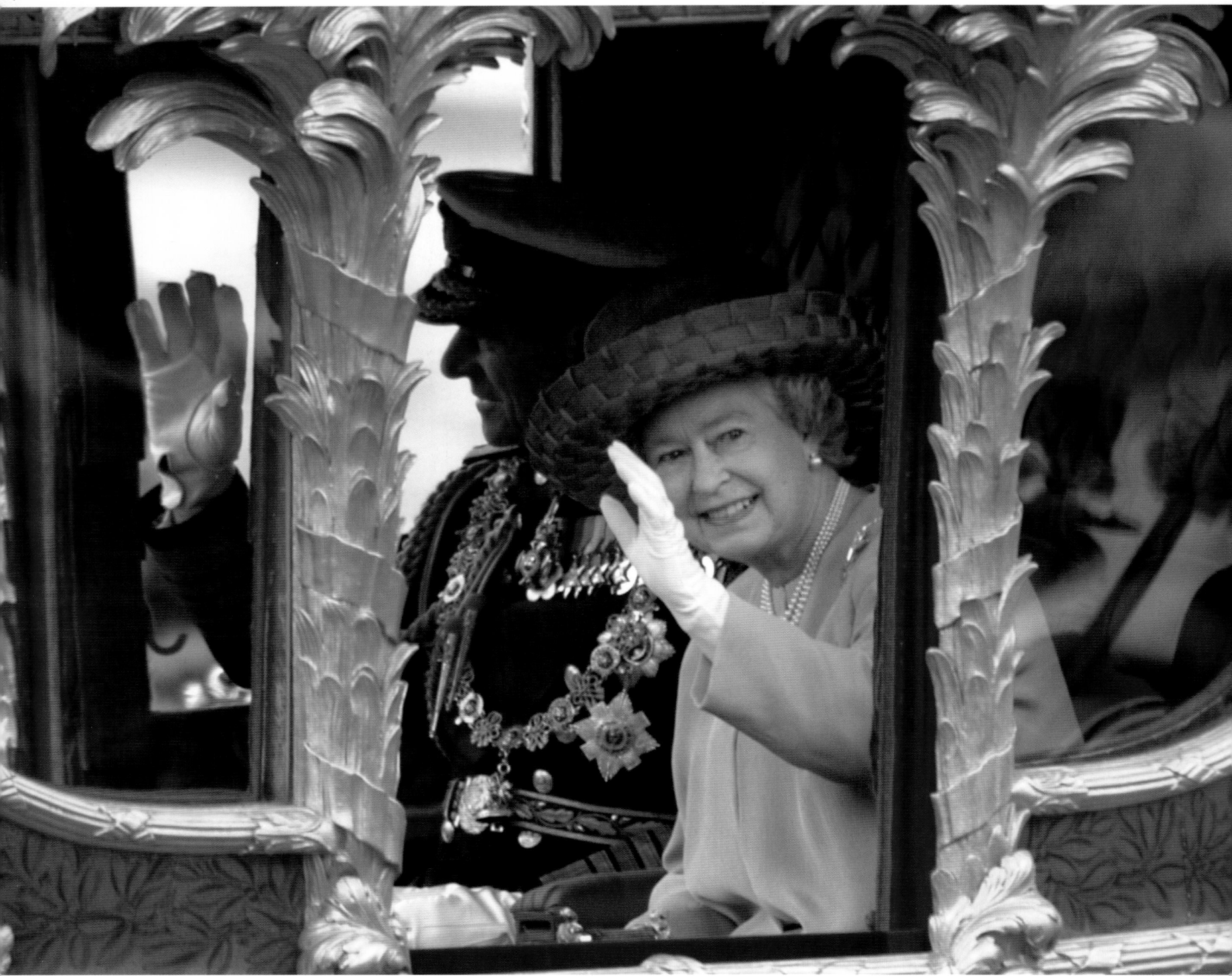

Above: Queen Elizabeth II and the Duke of Edinburgh wave to the crowds as they
are driven in the Gold State Coach from Buckingham Palace to St Paul's Cathedral
for a service of thanksgiving to celebrate her Golden Jubilee.

4th June, 2002

Above: The Beinn An Tuirc wind farm on the Kintyre peninsula in Scotland. The giant propellers continue to be controversial and face opposition in many areas, but wind farms are a major aspect of Britain's programme to generate electricity from renewable sources. One of the arguments against them is that they can have a detrimental effect on radar installations.

8th July, 2002

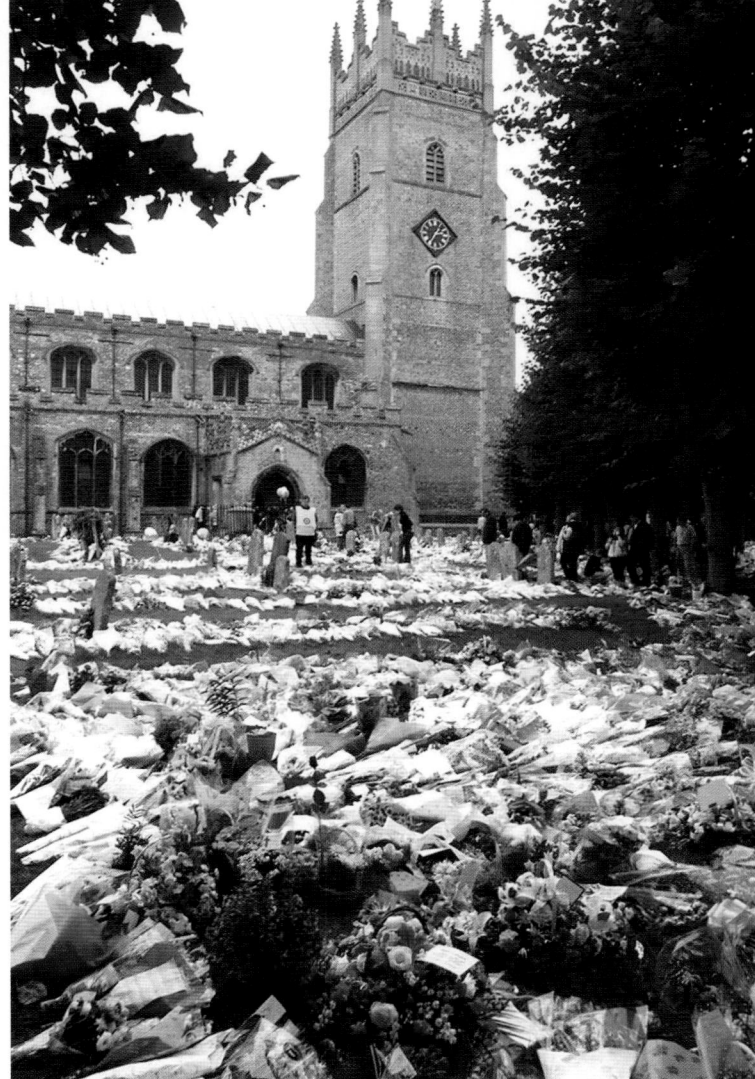

Above: Flowers left by the public in the graveyard of St Andrew's Church, Soham, in Cambridgeshire, in memory of Holly Wells and Jessica Chapman. The two 10-year-old girls had been murdered by 28-year-old school caretaker Ian Huntley.

26th August, 2002

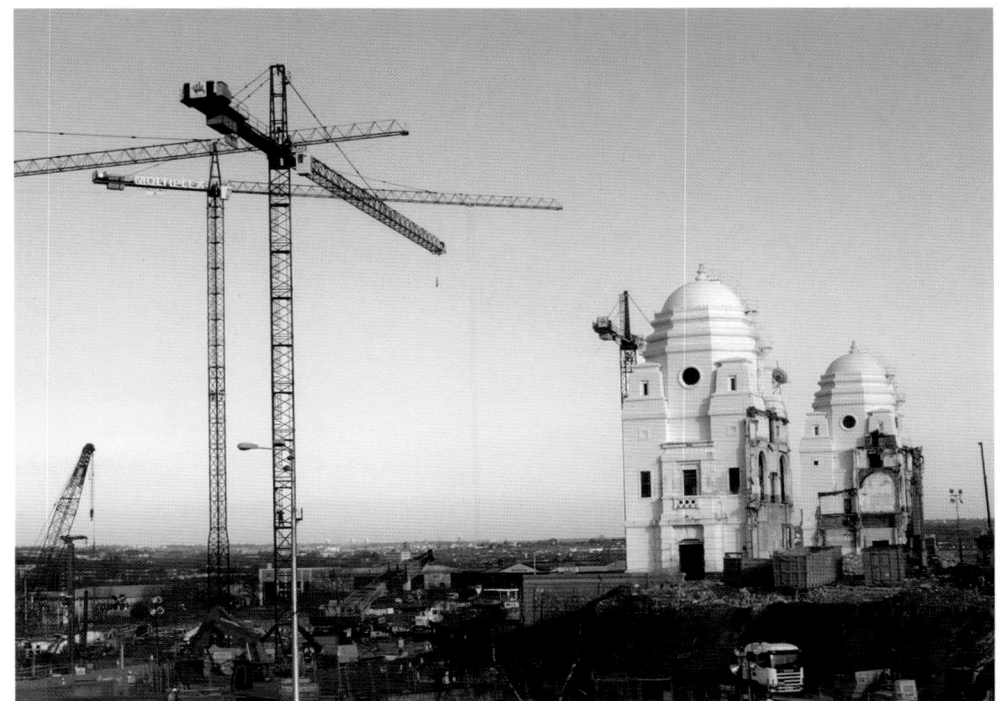

Left: Wembley Stadium's famous twin towers are all that remain of the structure in west London, which had been demolished to make way for a new facility. The towers would also soon be knocked down, the process being started by Ray Tidmarsh, from Dawlish in Devon, who had won the right in a radio competition. When completed, the new Wembley would be the largest football stadium in the world, with every seat under cover and no restricted views. The arch – with a span of 1,033ft (315m) – would be the longest single-span roof structure in the world.

6th February, 2003

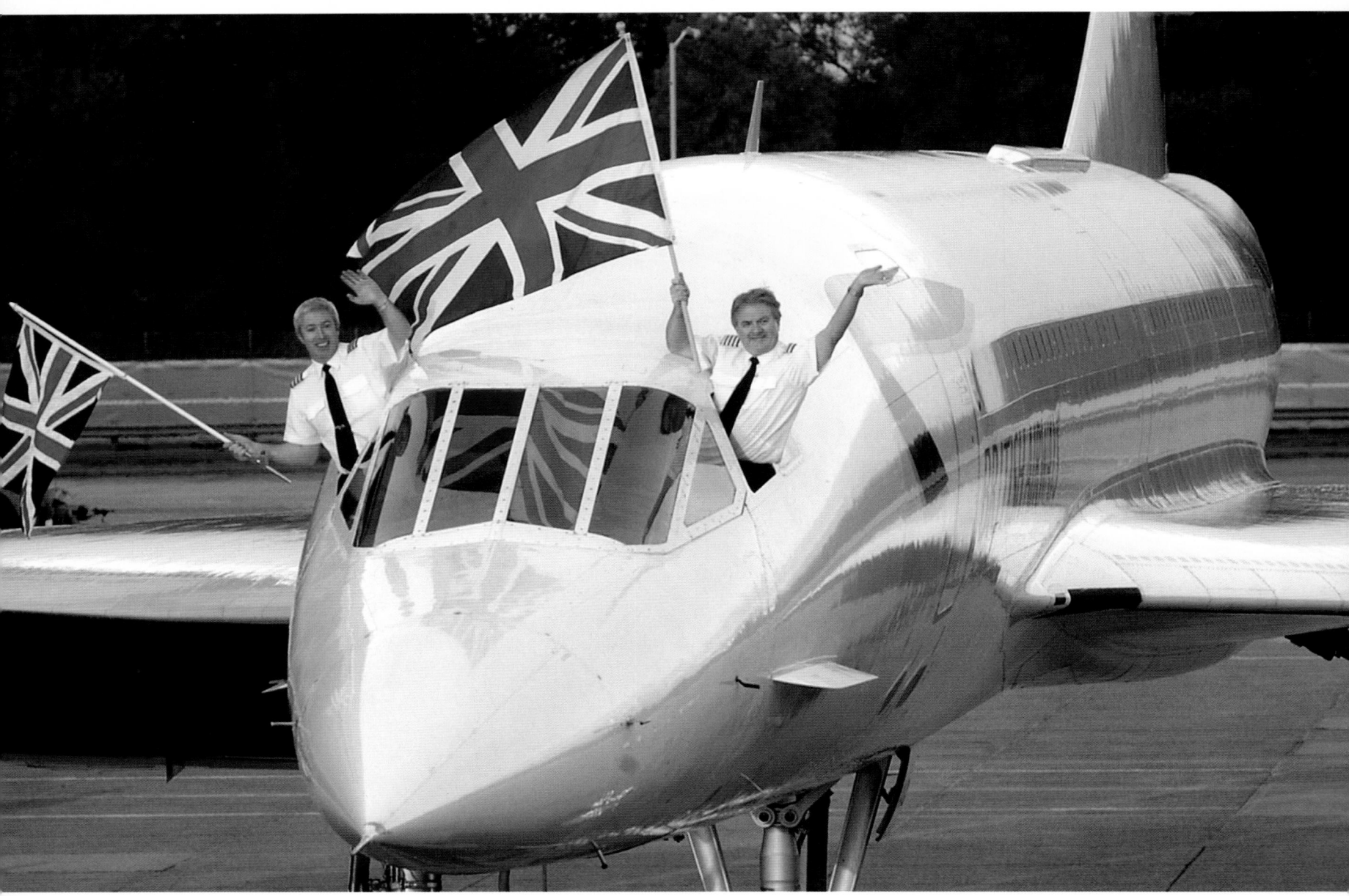

Above: End of an era. Captain Mike Bannister (R) and Senior First Officer Jonathan Napier wave from the cockpit of a British Airways Concorde at London's Heathrow Airport, on the day that the world's first supersonic airliner retired from commercial service. Thousands of people gathered at the airport to see three of the aircraft land one after the other.

24th October, 2003

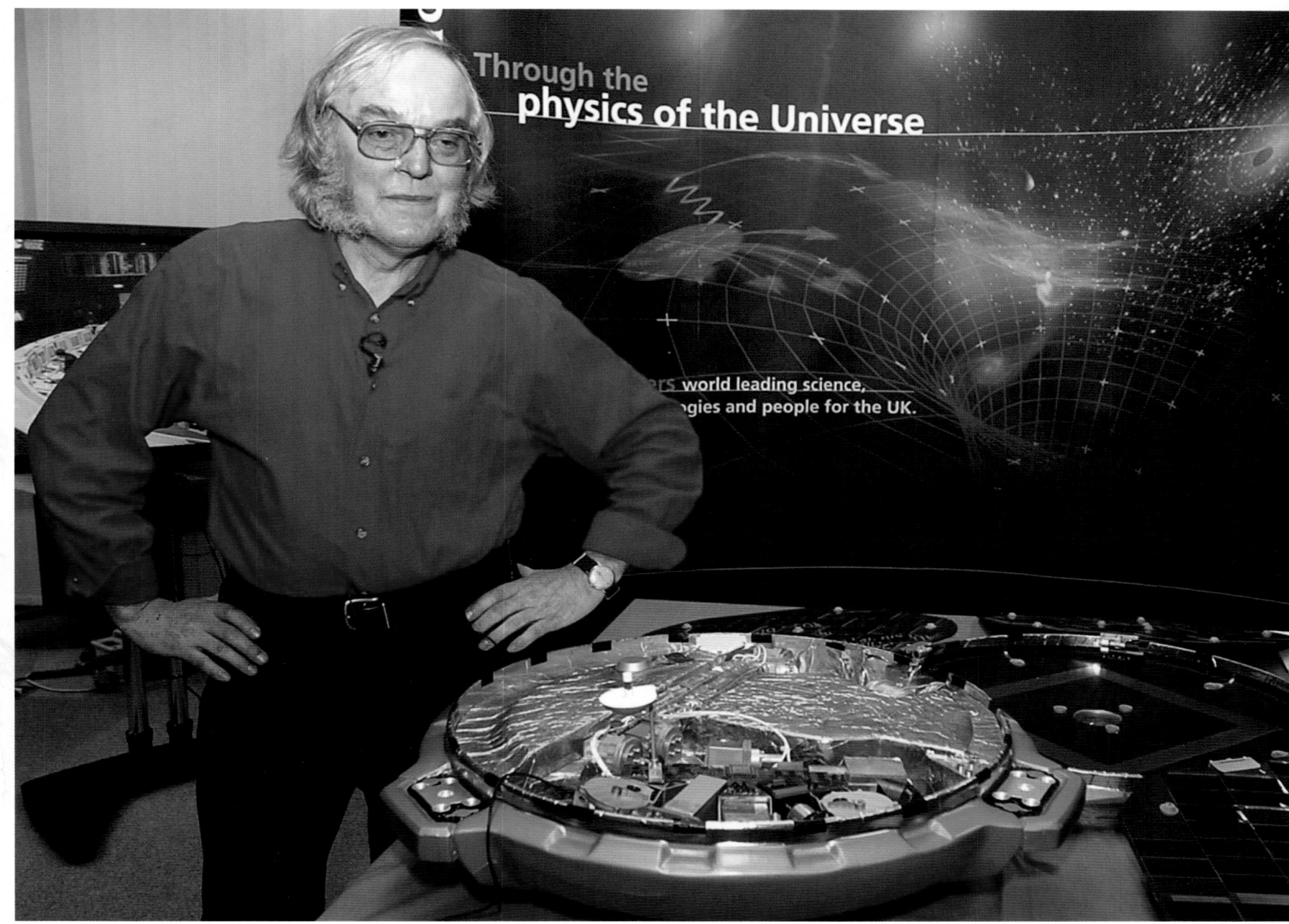

Above: Professor Colin Pillinger, chief scientist of the Beagle 2 Mars lander project, during a press conference after his team had failed to receive a signal from the lander telling them that it had safely reached the surface of the planet. Despite several attempts to communicate with the probe, no contact was made and its fate remains a mystery.

25th December, 2003

Above: A large crowd welcomes the world's biggest and most expensive cruise liner, Cunard's *Queen Mary 2*, as she arrives at her new home port of Southampton. The £550m ship would be officially named at Southampton by the Queen on 8th January; four days later, the 150,000-tonne vessel would leave on her sold-out maiden passenger voyage to Fort Lauderdale, Florida.

26th December, 2003

Right: A giant Union Flag is projected on to the front of Buckingham Palace at Christmas.

26th December, 2003

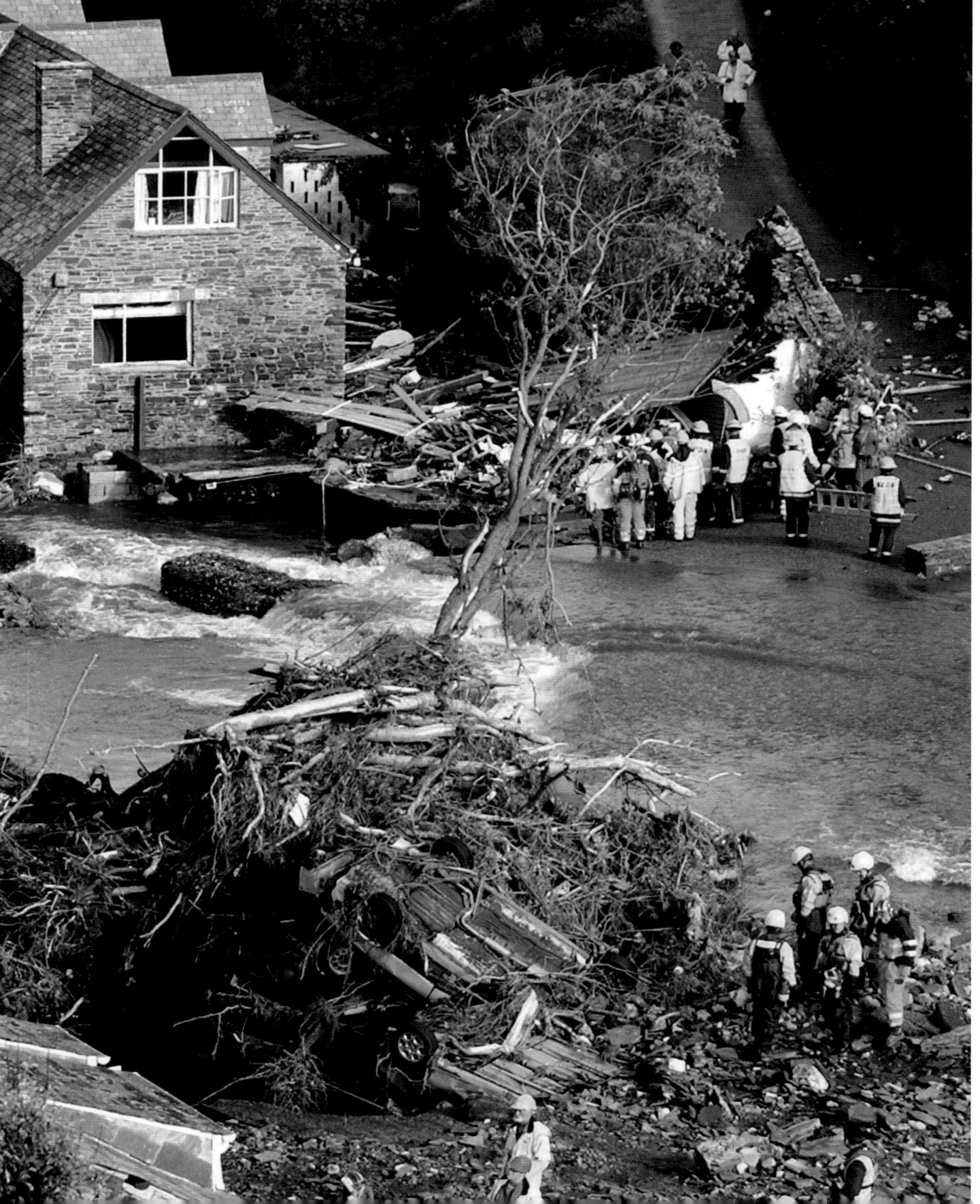

Left: Emergency services personnel contemplate the devastation caused by a wall of water that tore through the picturesque holiday spot of Boscastle in north Cornwall after torrential rainfall. A massive rescue operation involving several helicopters was put into action to save the residents of the flood ravaged coastal village.

17th August, 2004

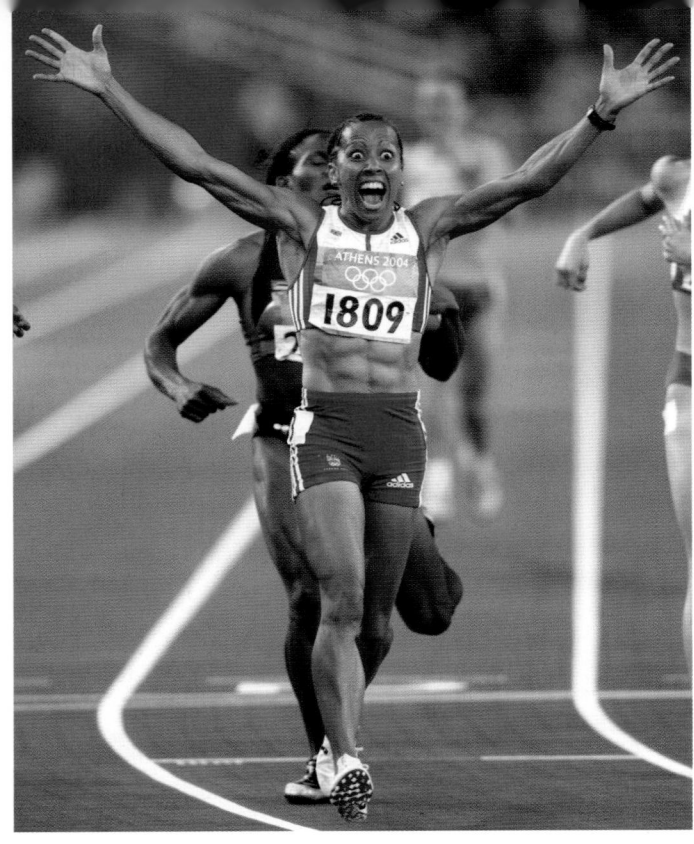

Above right: Great Britain's gold medal winner Kelly Holmes celebrates winning the 800m during the Olympic Games in Athens, Greece. Holmes would also win gold in the 1,500m, and for her achievements would be made a Dame Commander of the Order of the British Empire (DBE) in the New Year's Honours List of 2005.

23rd August, 2004

Right: Down and out. England's Michael Vaughan is stumped by Indian wicketkeeper Dinesh Karthik for 74 during the final NatWest Challenge match at Lord's Cricket Ground, London. The three-match challenge was won by England 2–1.

5th September, 2004

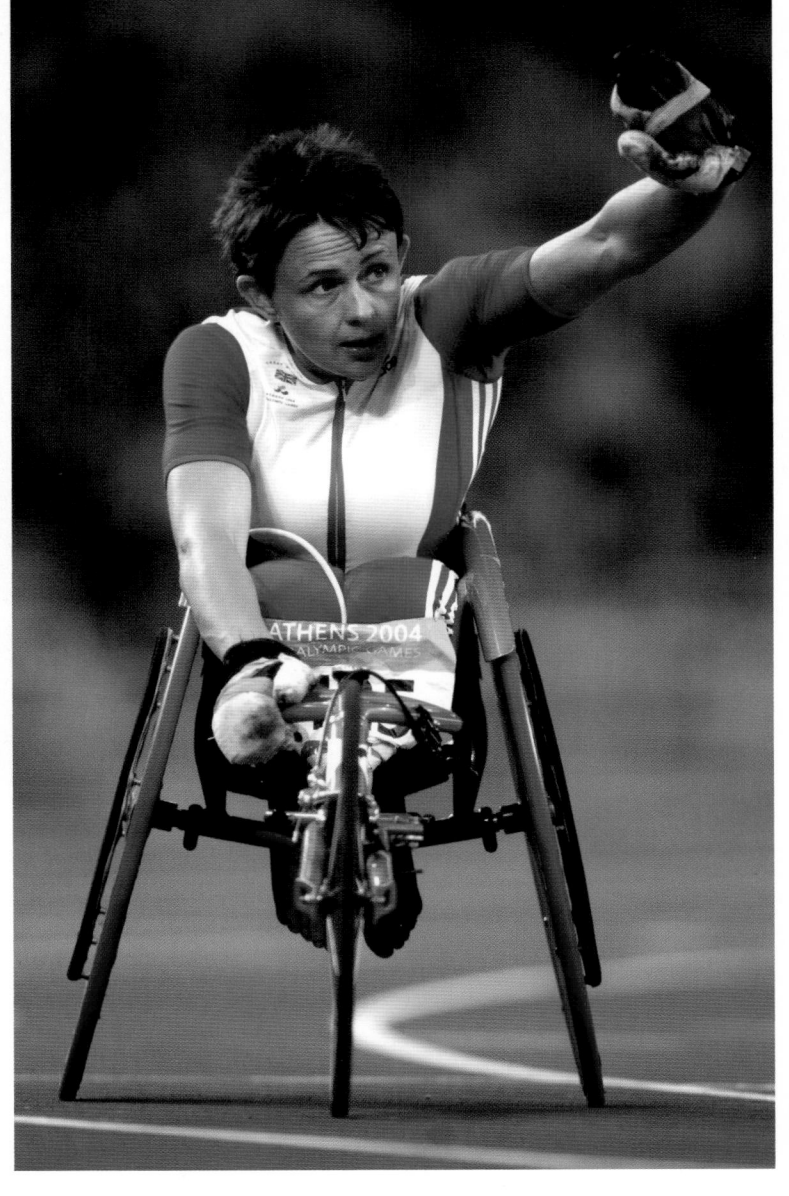

Above: First World War veteran Henry Allingham, 108, with a Nieuport biplane at the British Air Services Memorial, which had just been unveiled at St Omer Airfield in France. Allingham was the last surviving founder member of the Royal Air Force.

11th September, 2004

Right: Great Britain's Tanni Grey-Thompson waves to her family after finishing the Women's T54 200m final in fourth place at the 2004 Paralympic Games in Athens, Greece. She would win gold medals in the 100m and 400m events.

27th September, 2004

Above: Superdads. Fathers 4 Justice defendants (L–R) Jason Hatch, Dave Pyke, Mark Peacock and Pat Lennon arrive at Weston-super-Mare Magistrates Court, where four supporters look down from the roof. The pressure group for fathers' rights had staged a number of protest stunts, and on 13th September, 2004, Hatch and Pyke had even managed to evade Buckingham Palace security and scale the building.

20th October, 2004

Right: Soldiers from A Company of the Black Watch on patrol around Ahmed Al Ahamadi near Camp Dogwood, Iraq. They have reverted to wearing helmets after the deaths of three of their comrades in a suicide attack at a vehicle checkpoint on the previous day.

4th November, 2004

Above: Ellen MacArthur celebrates on board her yacht B&Q/Castorama. She had just smashed the record for the fastest person to sail single-handedly around the world non-stop, having completed the journey in 71 days, 14 hours, 18 minutes and 33 seconds. For her achievement, she was made a Dame Commander of the Order of the British Empire (DBE).

8th February, 2005

Left: The image of a medal displaying the slogan *'London 2012 Candidate City'* is projected on to Big Ben. Similar images also would appear on other famous London landmarks, such as Tower Bridge and the Shell Building, as the London 2012 bidding team entertained the International Olympic Committee (IOC) in their attempt to win the Olympic Games for London.

18th February, 2005

Above: Iron man. A dog seems puzzled by one of a hundred life-size, cast-iron, naked figures that form 'Another Place', the latest work of art by Antony Gormley, renowned for his 'Angel of the North'. The figures are dotted across Crosby beach near Liverpool..

14th June, 2005

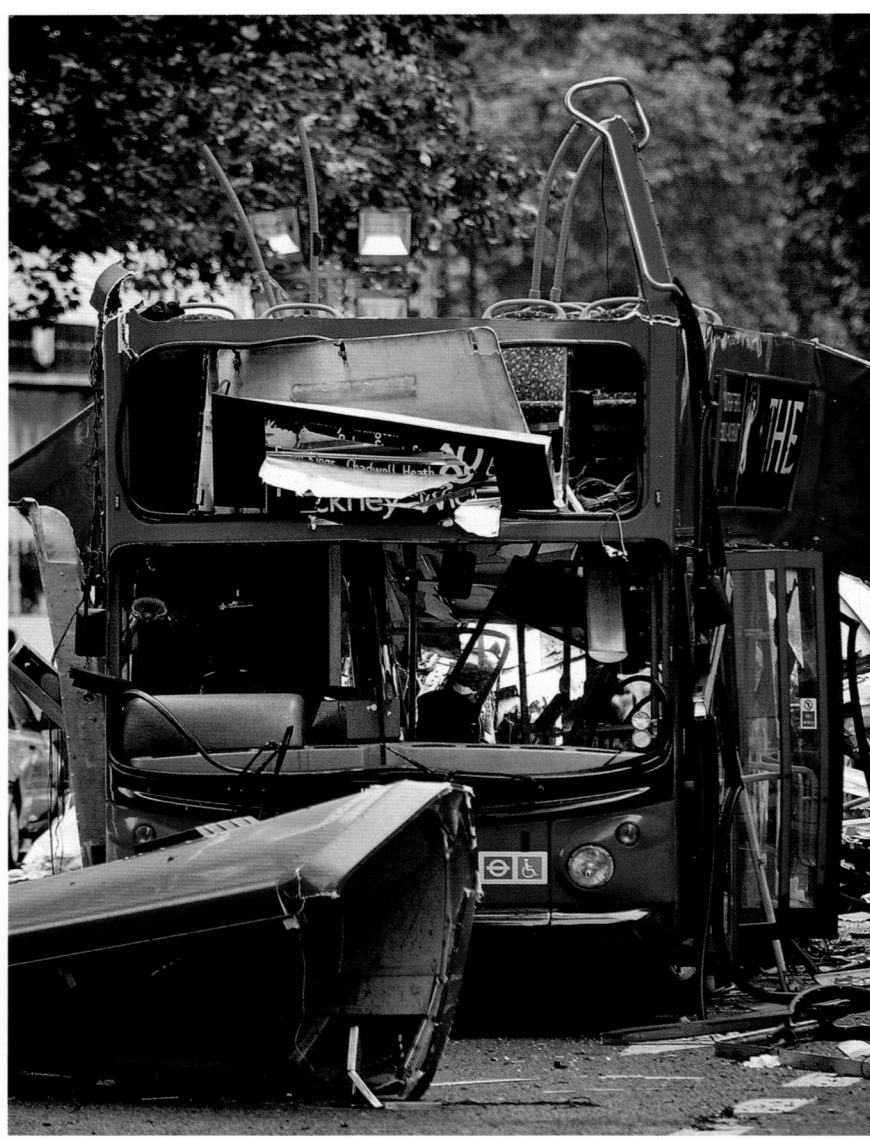

Above: The remains of a double-decker bus in Tavistock Square, London, following the terrorist suicide bomb explosion of 7th July. The blast coincided with three similar explosions on the Underground system. Fifty-two innocent people died.

8th July, 2005

Right: Poppies flutter down over Buckingham Palace and the crowds packing the Mall to commemorate the 60th anniversary of the end of the Second World War. They had been dropped from the RAF's vintage Lancaster bomber.

10th July, 2005

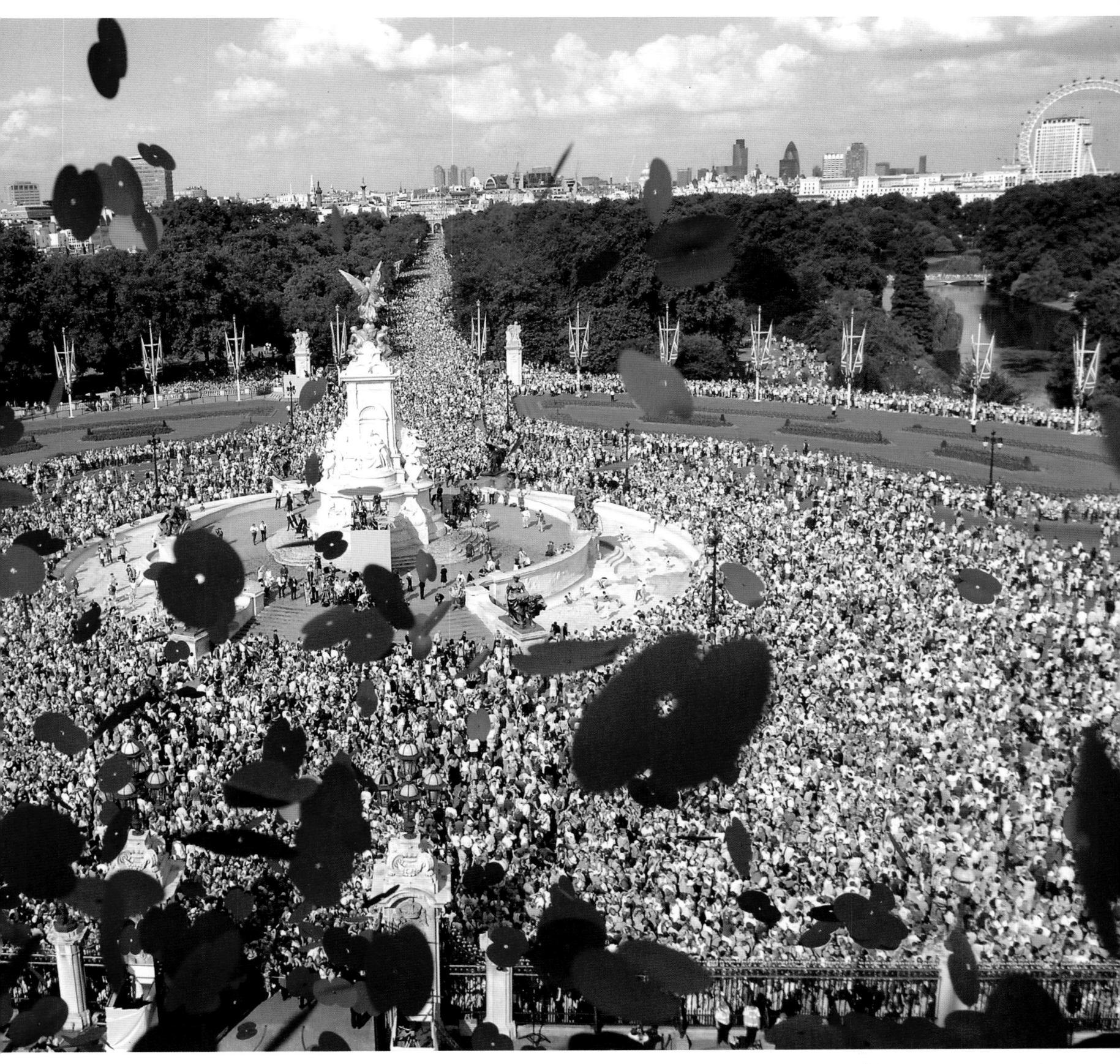

584

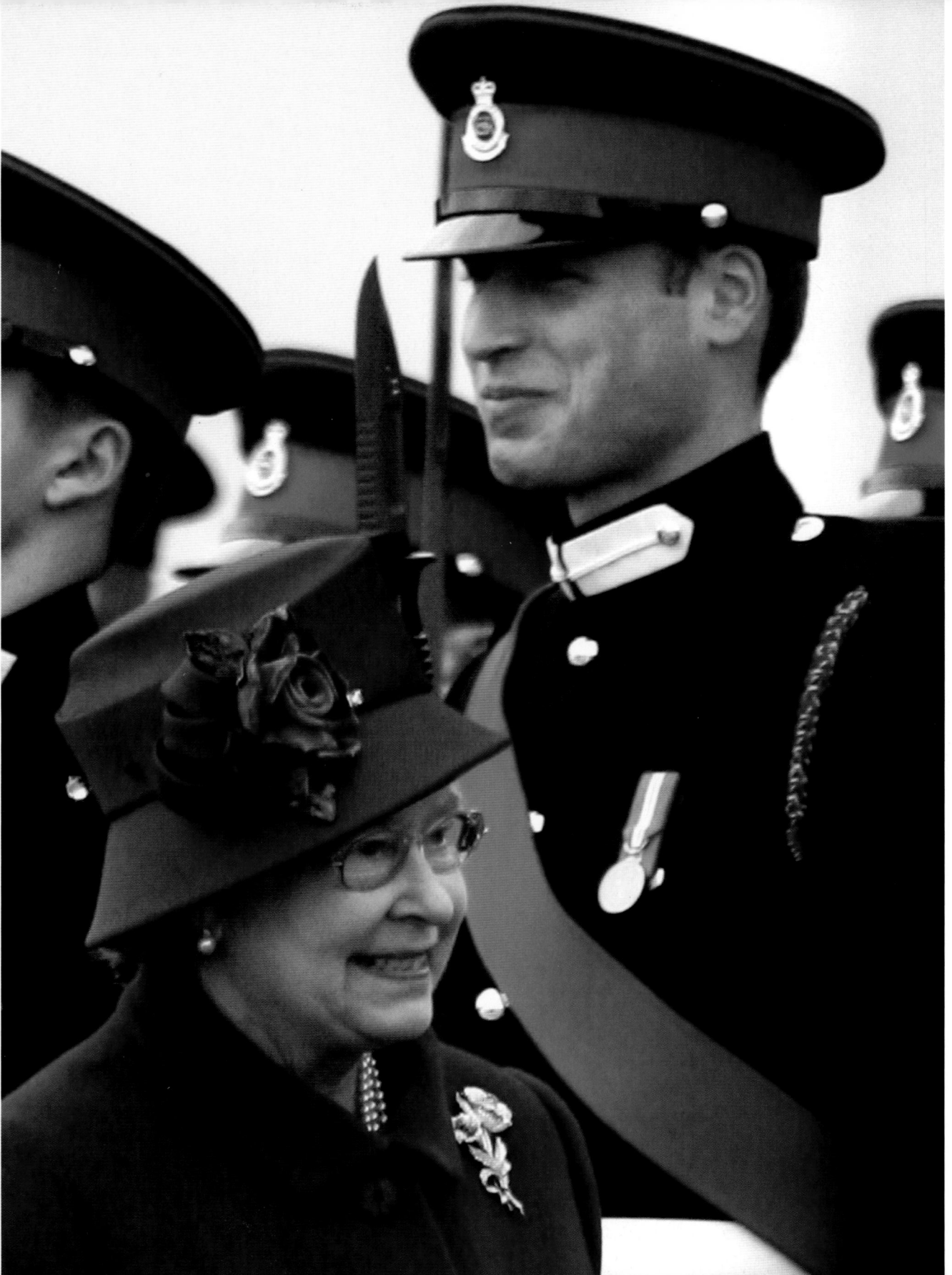

Left: Eyes front. the Queen
inspects Army officer graduates
during the Sovereign's Parade
at Sandhurst Royal Military
Academy at Camberley in Surrey.
Trying hard not to giggle is her
grandson, Prince William.

15th December, 2006

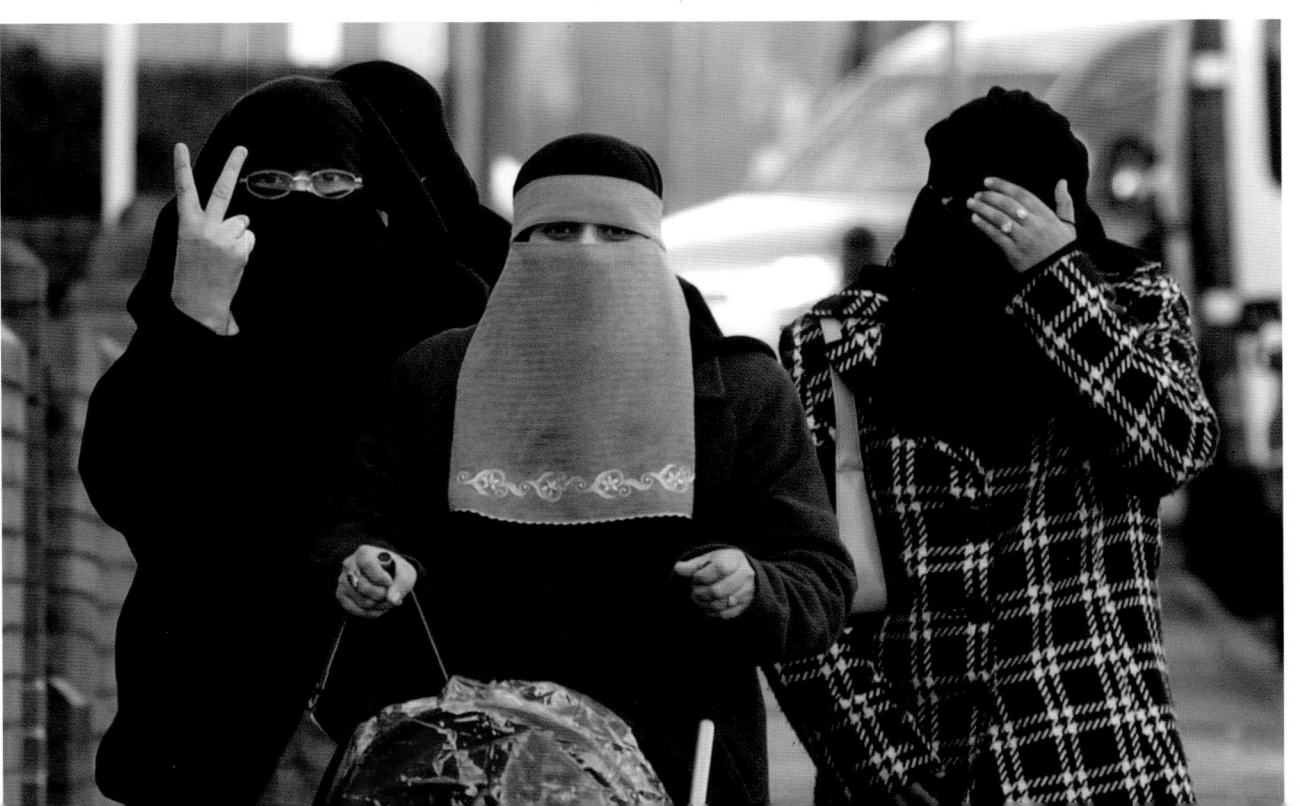

Above: The stricken cargo ship MSC *Napoli*, aground just off Branscombe beach, near Sidmouth, Devon. As the containers began to slip from the ship, all manner of items were washed up on the shore, including motorcycles, wine casks, dog food and cosmetics.

23rd January, 2007

Right: Conflicts in Iraq and Afghanistan, together with suicide bombings in London, caused tensions with Britain's Muslim communities, and extremists on both sides sought to stoke up animosity. These three women in Spark Hill, Birmingham show their contempt of the camera.

31st January, 2007

Left: The striking architectural detail of the Scottish Parliament building at Holyrood, Edinburgh. Designed by Catalan architect Enric Miralles, who died before its completion, the building was opened by Queen Elizabeth II on 9th October, 2004. Although controversial and not well received by all, the building has won a number of awards, including the 2005 Stirling Prize.

31st January, 2007

Above: Leader of the Conservative Party, and future Prime Minister, David Cameron (L) walks through the Benchill area of Wythenshawe during a visit to Manchester. Behind him, Ryan Florence, 17, shows his feelings about the politician by making a gun gesture.

22nd February, 2007

Above: Tattooed lady. Singer-songwriter Amy Winehouse performs during an exclusive Vodafone TBA concert at Circomedia in Bristol. Known for her powerful contralto vocals, Winehouse was the first British singer to win five Grammys, including Best New Artist, Record of the Year and Song of the Year (all for her second album, *Back to Black*, in 2006). Her problems with drugs and her self-destructive behaviour, however, have gained her much adverse media attention.

19th April, 2007

Above Having inherited the post from Tony Blair, who had resigned, new Prime Minister Gordon Brown and his wife, Sarah, take possession of their official residence, 10 Downing Street, London.

27th June, 2007

Below: Supporters of Dr Andrew Wakefield, and Professors John Walker-Smith and Simon Murch outside a General Medical Council hearing in central London. The three men had published a report suggesting that the MMR vaccination was responsible for children developing autism. The study caused a major health scare, but subsequently was discredited.

16th July, 2007

Left: The cabin cruiser *Vino Calypso*, owned by Steve Blake and kept at Bredon on the Severn near Tewkesbury, awaits rescue as it balances precariously on three wooden poles that have held it in place since recent high flood waters receded.

10th August, 2007

Right: Members of a Welsh Guards mortar platoon fire on Taliban positions in support of an operation carried out by the Worcestershire and Sherwood Foresters Regiment in Helmand Province, Afghanistan.

16th August, 2007

591

Above: In sombre mood, Princes Charles, William and Harry leave a service of thanksgiving for the life of Diana, Princess of Wales at the Guards' Chapel, London.

31st August, 2007

Right: In the zone. McLaren Mercedes driver Lewis Hamilton focuses his thoughts ahead of the Brazilian Grand Prix at Interlagos, São Paulo, Brazil, the last race of the Formula One season. He was four championship points ahead of his nearest rival, Kimi Räikkönen, but a gearbox problem during the race would consign him to seventh place, while Räikkönen would win, taking the championship. However, Hamilton would become world champion in 2008.

21st October, 2007

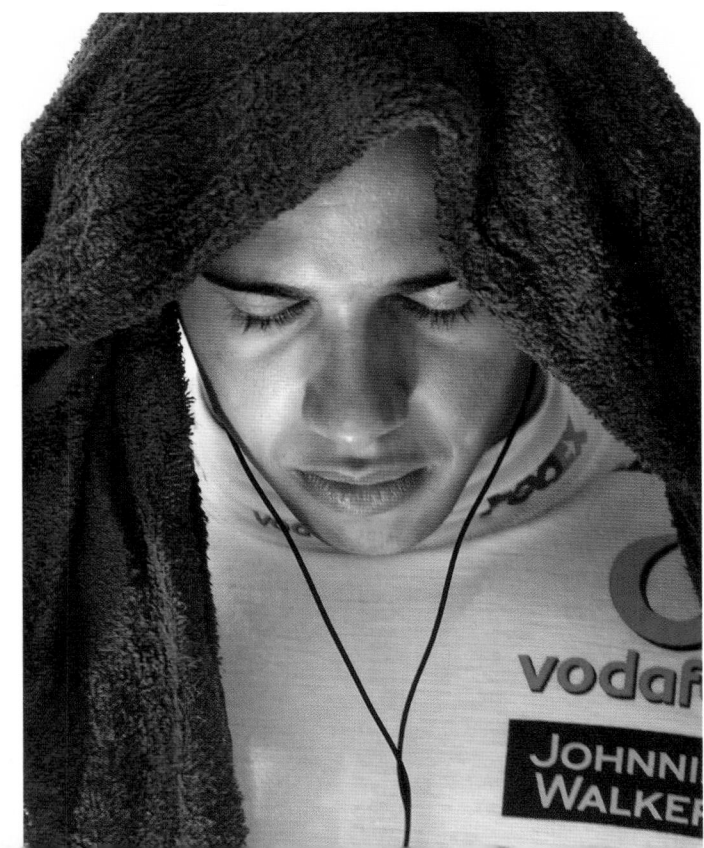

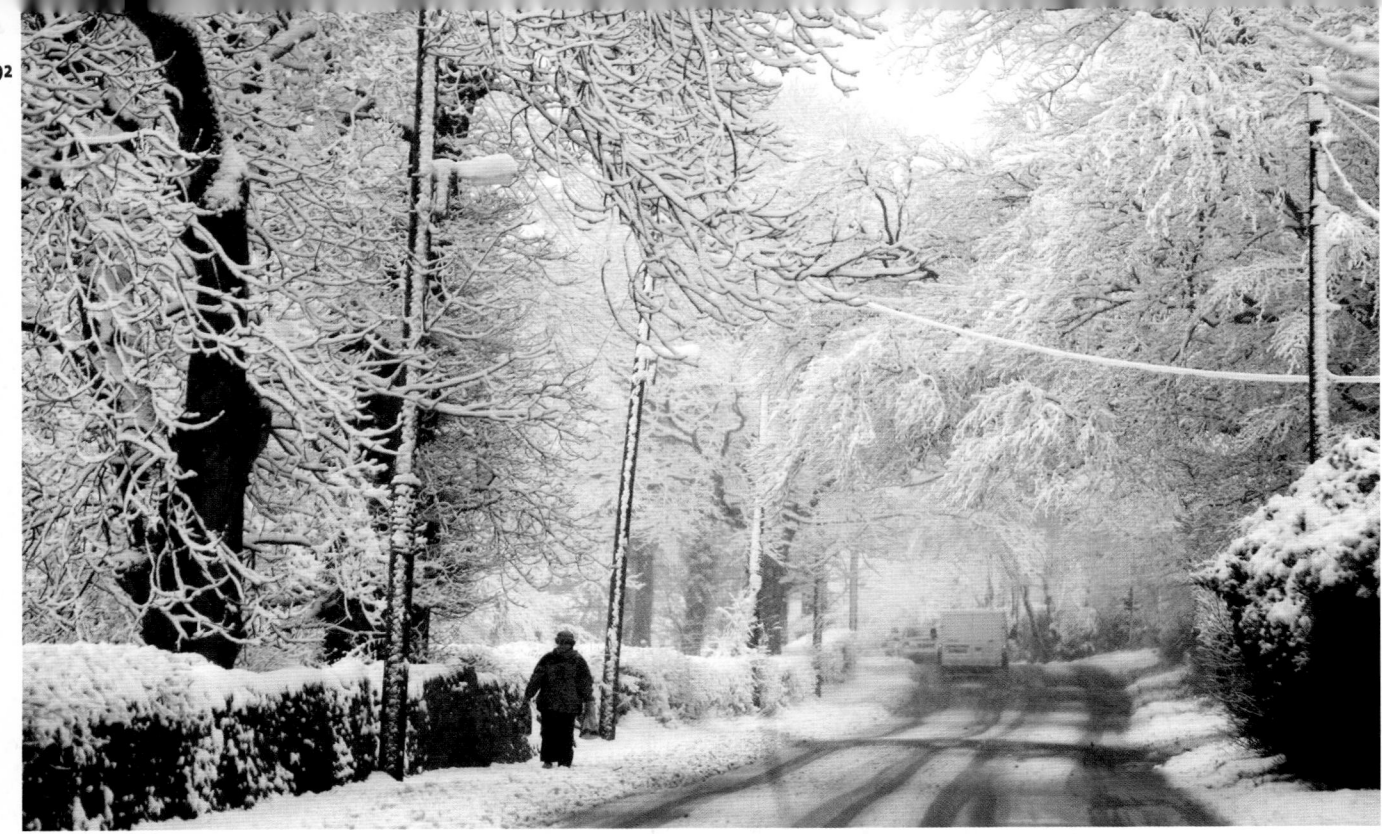

Left: A woman and motorists struggle through the snow blanketed landscape in Hexham, Northumberland after a spell of severe weather had hit the North of England and Scotland

21st January, 2008

Right: Prince Harry, having been commissioned a second lieutenant in the Blues and Royals of the Household Cavalry Regiment, mans a 50mm machine gun during a spell of duty in Helmand Province, southern Afghanistan.

28th February, 2008

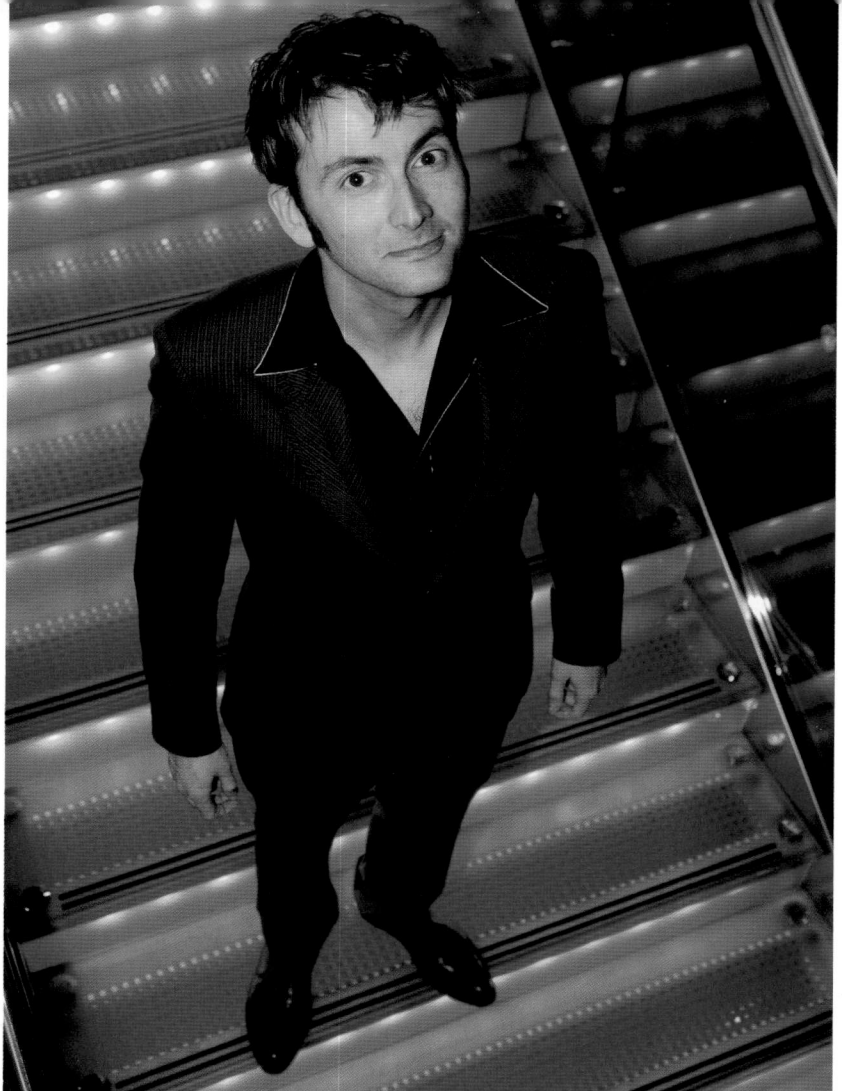

Left: Actor David Tennant arrives for the screening of the fourth series of the BBC's hit television show *Doctor Who*, at the Apollo West End in central London. Tennant played the tenth incarnation of the famous Time Lord from 2005 to 2010.

1st April, 2008

Right: Police and anti-war protesters clash during a demonstration organized by the Stop The War Coalition in Parliament Square, central London, against the visit of US President George W. Bush.

15th June, 2008

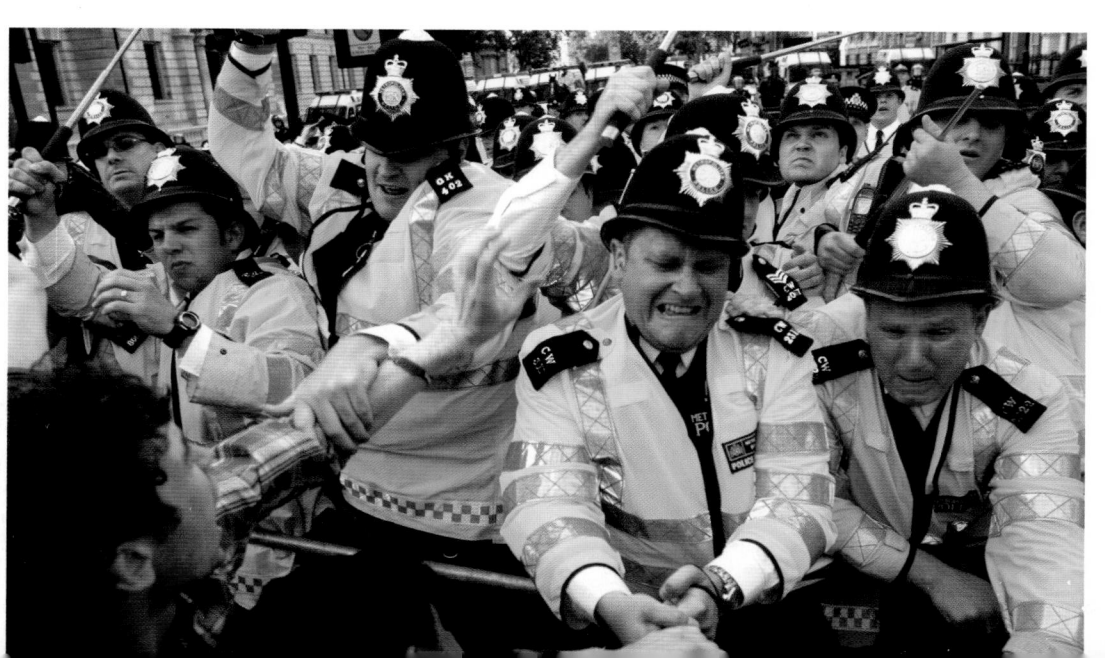

594

Below: Chris Hoy, a member of Great Britain's Olympic cycling team. The multiple world champion would win three gold medals at the 2008 Olympics in Beijing, the first Briton to do so for 100 years.

24th July, 2008

Bottom: Flying the flag. Christine Ohuruogu is overjoyed after winning gold in the Women's 400m at the National Stadium at the 2008 Beijing Olympic Games in China.

19th August, 2008

Above: Beneath a shower of confetti and to public acclaim, Great Britain's Olympic and Paralympic athletes gather for a celebration in Trafalgar Square, after a victory parade through London. The able-bodied athletes had collected 19 gold, 13 silver and 15 bronze medals, while the Paralympians had garnered a staggering 42 gold, 29 silver and 31 bronze medals.

16th October, 2008

Left: With a deafening roar, and trailing red, white and blue smoke, the RAF's crack aerobatic team, the Red Arrows, flies over the Tyne Bridge to give a rousing send-off to the competitors in the BUPA Great North Run in Newcastle. The event is the most popular half-marathon road race in the world.

5th October, 2008

Left: Established in 1909, the Woolworths discount chain rapidly became a high-street fixture with over 800 stores. It failed to ride out the recession, however, and was forced into administration in 2008. All the stores were closed with the loss of 27,000 jobs.

27th December, 2008

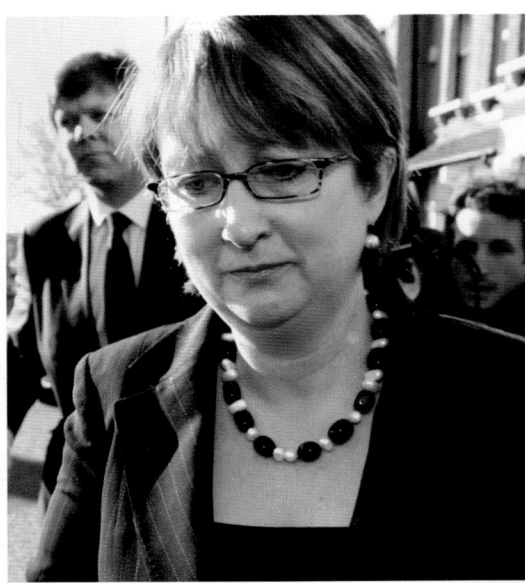

Above: Home Secretary Jacqui Smith leaves her south London home after it had been revealed by the *Sunday Express* that she had claimed expenses from the Commons for the rental of two adult films from Virgin Media. Subsequently, it was announced that she had broken the rules on second-home expenses and was ordered to apologize. She would stand down from her government post after a Cabinet reshuffle in June.

30th March, 2009

Left: Prime Minister Gordon Brown and recently elected US President Barack Obama shake hands during a press conference at the Foreign and Commonwealth Office in London. Obama was in London to attend the G20 Summit meeting called to address the global financial crisis.

1st April, 2009

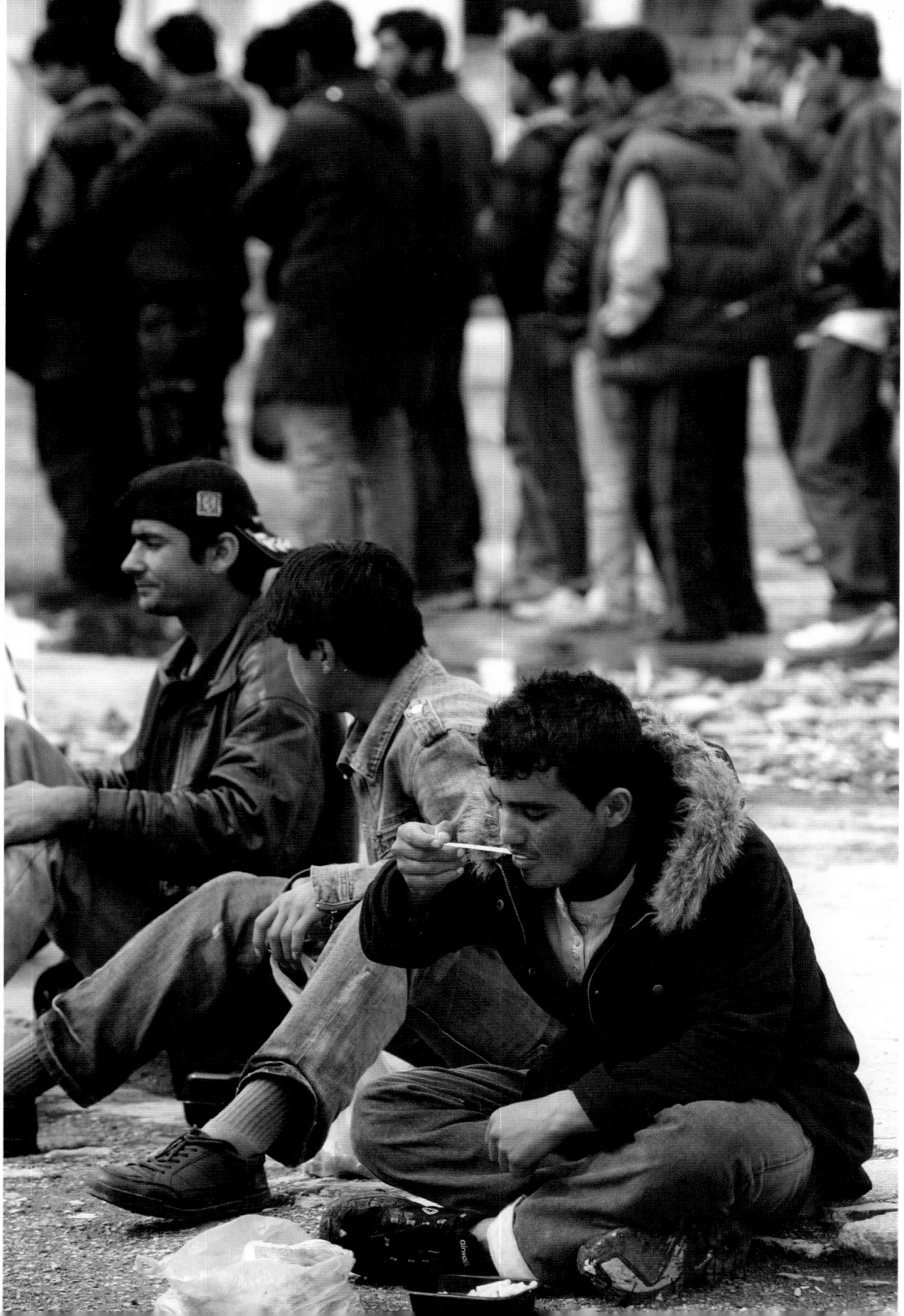

Left: Economic migrants at a camp in the French port of Calais receive food handouts from a local charity. The men, from many different countries, were hoping to find a way across the English Channel to the UK. Many would attempt to smuggle themselves in by hiding in lorries.

17th April, 2009

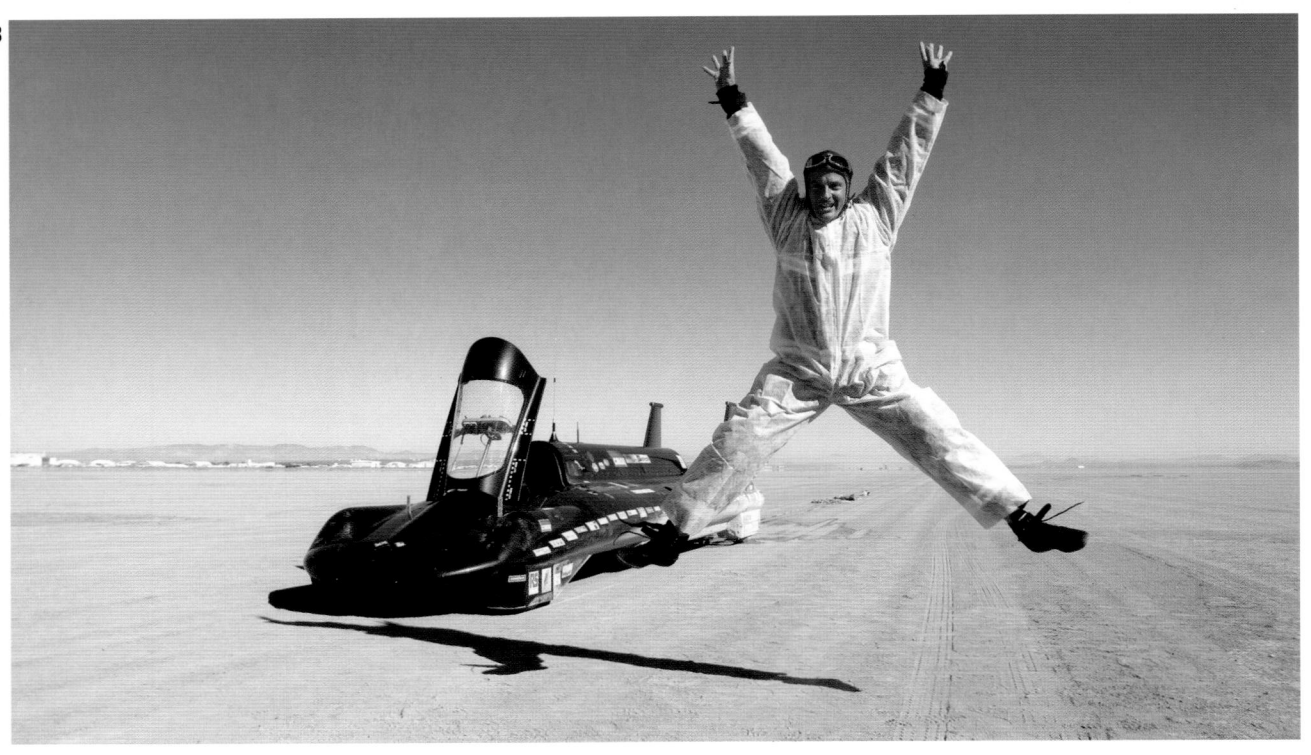

Left: All steamed up. Don Wales, driver of the British Steam Car, leaps for joy after averaging 148.308mph (238.672km/h) in two runs across Rogers Dry Lake on Edwards Air Force Base in California's Mojave Desert, to break the land speed record for a steam powered car, which had been set by the team's other driver, Charles Burnett III, on the previous day at 139.843mph (225.049km/h).

26th August, 2009

Below: Concertgoers enjoy the music and celebrations during the Last Night of the Proms at the Royal Albert Hall in London. The Promenade concerts were founded in 1895 and take place mainly at the Albert Hall, although other venues are also used on the last night.

12th September, 2009

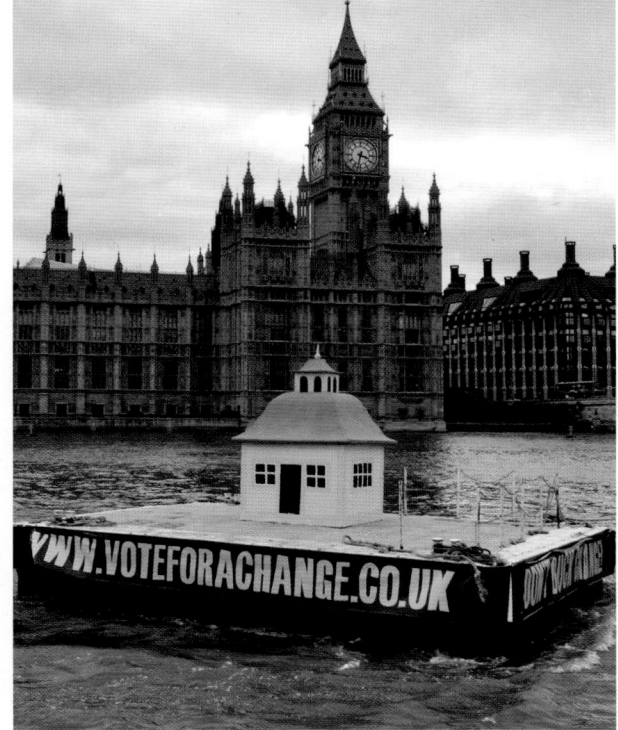

Above: A hundred Riflemen of the 2nd Battalion, The Rifles march through the streets of Croydon, Surrey to the town hall to celebrate their return from a six-month operational tour in Afghanistan. Such homecoming parades had become commonplace, allowing the public to show their appreciation of the work done by the troops.

29th October, 2009

Above: In the light of the scandal over MP's expense claims, a giant duck house is towed past the Houses of Parliament, in a demonstration by the Vote For a Change campaign. The duck house was a large-scale copy of one claimed for by Sir Peter Viggers, which cost the taxpayer £1,645. The revelations about MP's expense claims led to widespread resignations among politicians and outrage among the public.

5th November, 2009

602

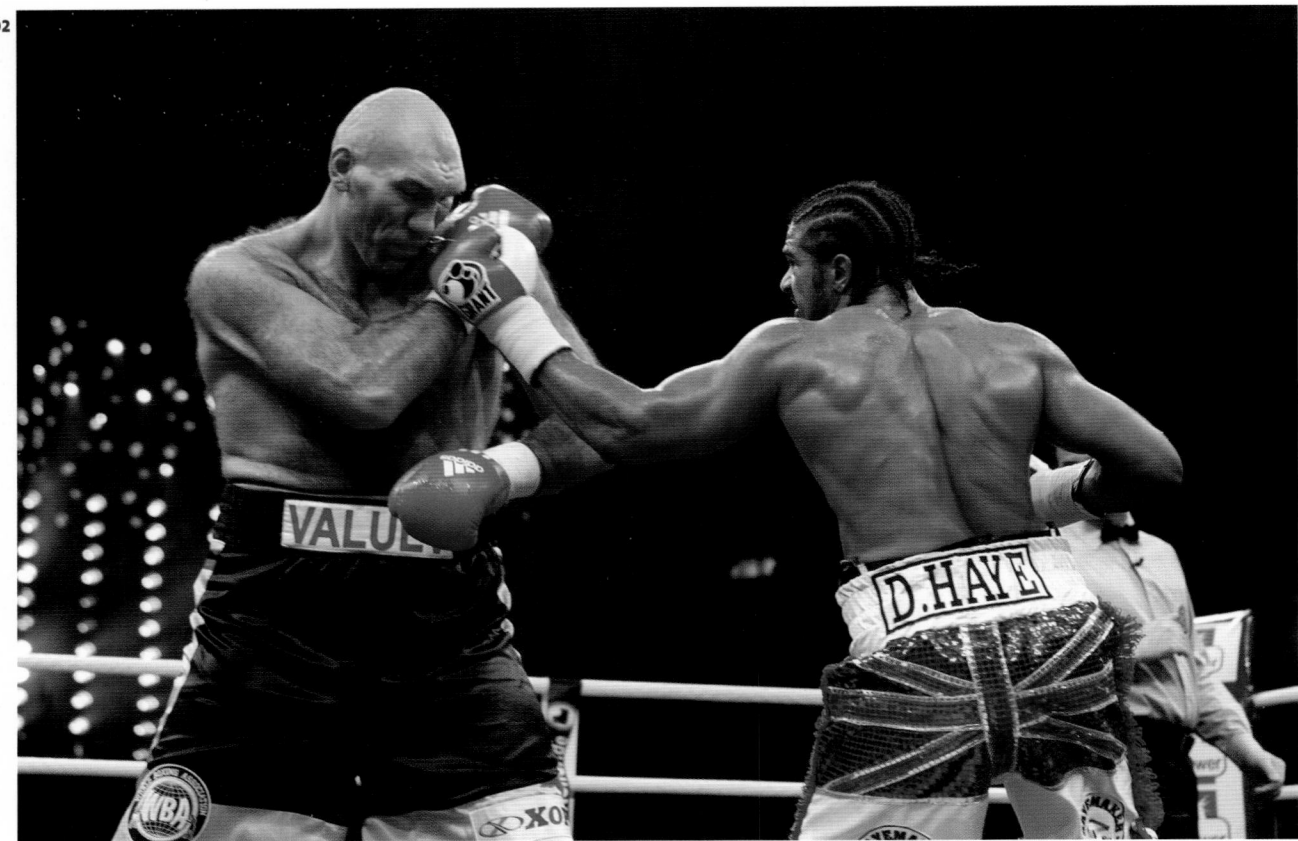

Above: David and Goliath. England's David Haye (R) on winning form against Nikolai Valuev during the WBA World Heavyweight title fight at the Nuremberg Arena, Germany. Hay would defeat the 7ft (2.1m) Russian on points.

7th November, 2009

Right: The Young Ones? Sir Cliff Richard (L) and the Shadows, (L–R) Hank Marvin, Bruce Welch and Brian Bennett, at HMV's Oxford Street store, where they would sign copies of their new DVD of greatest hits, *The Final Reunion.*

30th November, 2009

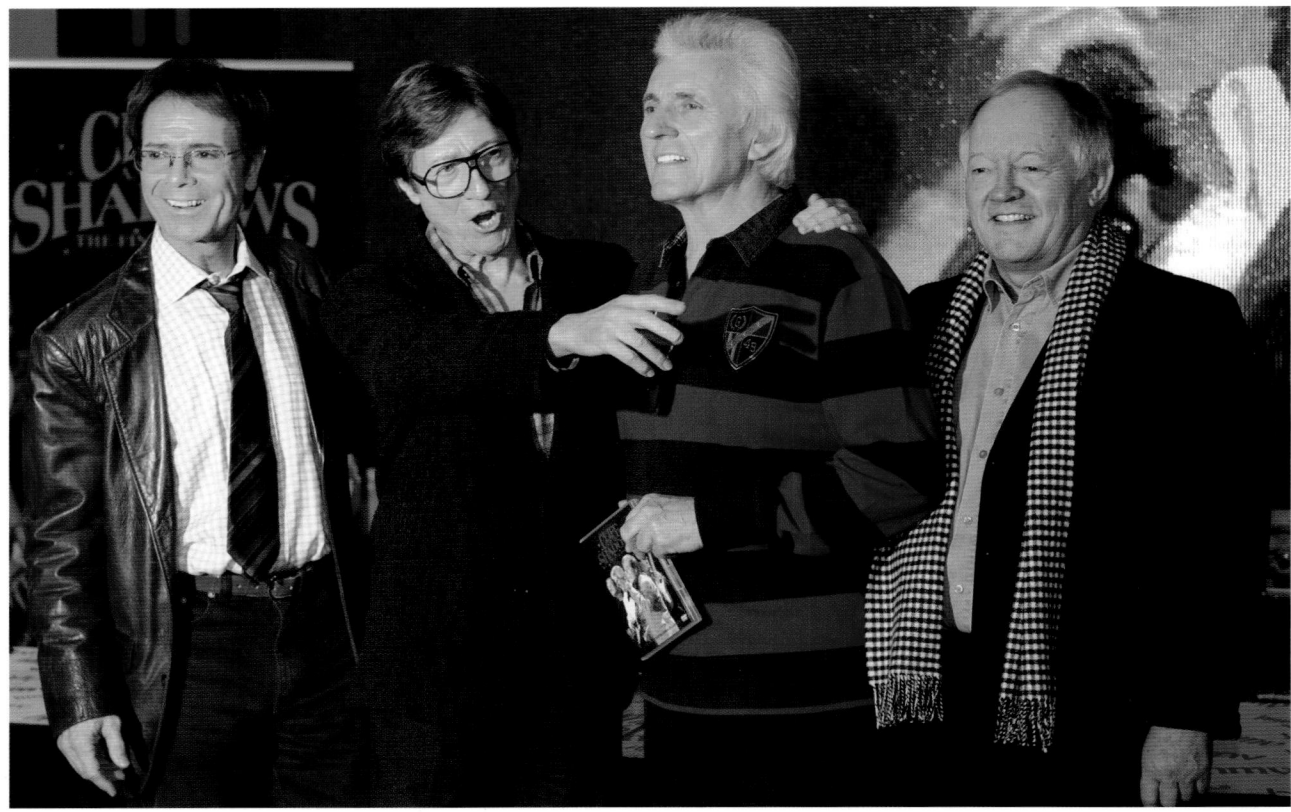

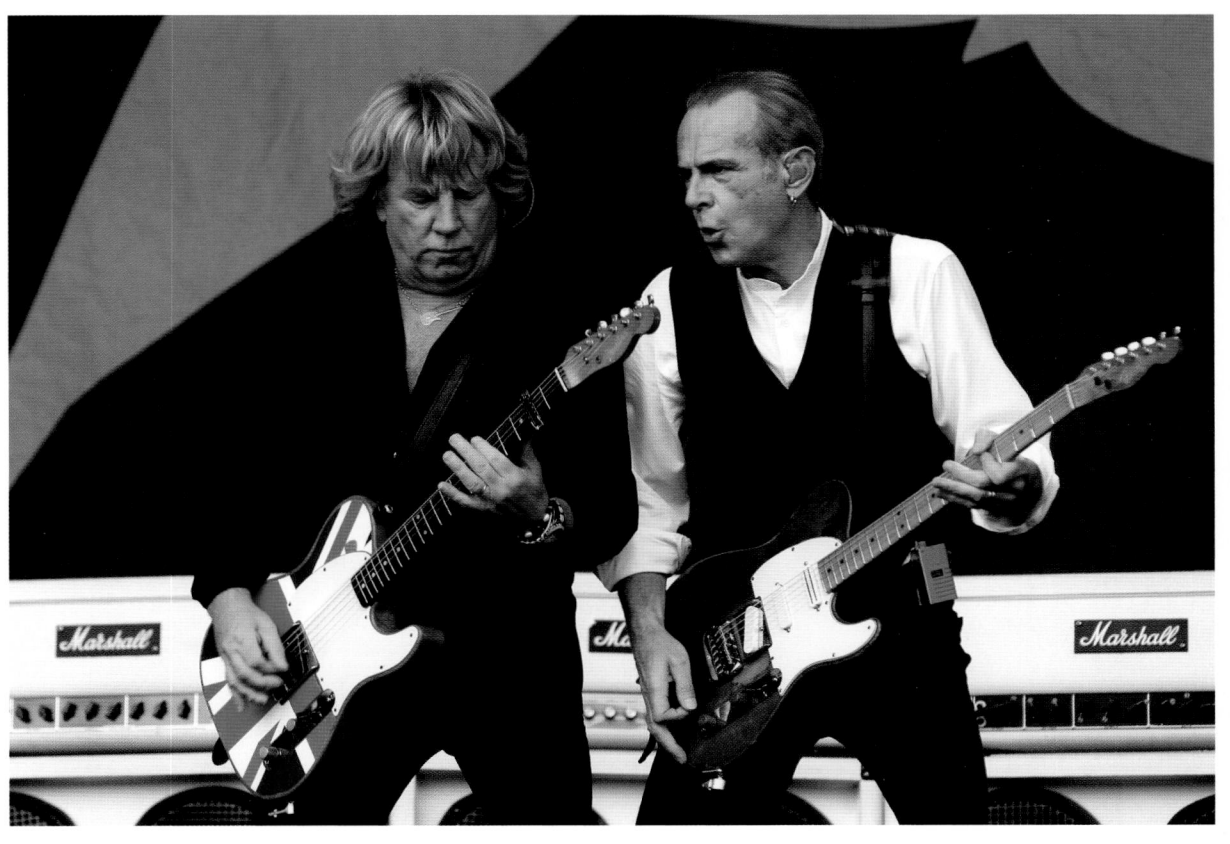

Above: Rocky situation. Customers queue outside a branch of the Northern Rock building society in York, as savers across the country seek to withdraw their money from the crisis-hit bank. Ultimately, the government would step in and take over the institution.

14th December, 2009

Right: Rockin' all over the world. Rick Parfitt (L) and Francis Rossi of Status Quo, who were crowned Britain's hardest working band after notching up more major concerts in 2009 than any other group. They had played to over 250,000 fans in 27 different arenas. They would be awarded OBEs in 2010.

28th December, 2009

INDEX

The Publishers gratefully acknowledge Press Association Images, from whose extensive archives the photographs in this book have been selected. Personal copies of the photographs in this book, and many others, may be ordered online at www.paphotos.com

PRESS
ASSOCIATION
Images

AMMONITE
PRESS

For more information, please contact:
Ammonite Press
AE Publications Ltd, 166 High Street, Lewes, East Sussex, BN7 1XU, United Kingdom
Tel: +44 (0)1273 488006 Fax: +44 (0)1273 472418
www.ammonitepress.com

1860 1890
1895
1901 1878 190
1908 193
1915 1912 19
1922 1935 1951 19
1925 1928
1931 1934
1936 1939 1953
1940 19
196